GREEK & ROMAN ARCHITECTURE

D. S. ROBERTSON

SECOND EDITION

CAMBRIDGE

AT THE UNIVERSITY PRESS

1971

Published by the Syndics of the Cambridge University Press
Bentley House, 200 Euston Road, London NW1 2DB
American Branch: 32 East 57th Street, New York, N.Y. 10022

ISBN
0 521 06104 0 clothbound
0 521 09452 6 paperback

First edition 1929
Second edition 1943
Reprinted with corrections 1945
Reprinted 1954 1959 1964
First paperback edition 1969
Reprinted 1971

This book was formerly published with the title
A Handbook of Greek & Roman Architecture

Printed in Great Britain
at the University Printing House, Cambridge
(Brooke Crutchley, University Printer)

PREFACE TO FIRST EDITION

The aim of this book is to state briefly but clearly the main facts in the history of Greek, Etruscan, and Roman architecture, from the earliest times to the foundation of Constantinople, so far as they are at present known. In dealing with this vast theme my endeavour has been to keep my main narrative free from confusing detail and to direct attention to essential matters. In this part of the book I have tried to give an intelligible account of a limited number of important buildings, while in Appendix I I have tabulated chronologically, with comments, about three hundred and seventy distinct monuments. I have further relieved the text by concentrating in Appendix II almost all bibliographical information, and by compiling a Glossary of ancient and modern technical terms, which forms Appendix III. All these Appendices contain full cross-references to the text and illustrations, and the General Index takes account of the whole book, including the Appendices. In the Appendices and in most of the illustrations dimensions are given in metres, according to the general practice of scientific publications, but for the reader's convenience those mentioned in the text of the book have been converted[1] approximately into English feet. In this matter I have been at pains to ascertain the truth, but the discrepancies between good authorities and even between the text and plates of a single publication are sometimes baffling, and some dimensions could only be calculated from the scales attached to illustrations.

In constructing the Bibliography I have not contented myself with a bare list of books and articles, but have tried to make it easy for the reader to get further information about individual buildings and about important features of structure and decoration. My model was the admirable *Register* which von Duhn contributed in 1892 to the second edition of Durm's *Baukunst der Griechen*, and the Greek part of my list is partly based upon an interleaved copy of that work which I have used for many years. It need scarcely be said that none of my Appendices

[1] The equations 1 yard = ·914 metres and 1 metre = 1·094 yards are sufficiently accurate for ordinary purposes.

aims at completeness. The field of selection was overwhelmingly large, and I can only hope that their general usefulness may be thought to compensate for their faults of omission and inclusion.

I have seen many of the chief buildings and ruins in Greece, Italy, and Southern France, but my knowledge of ancient architecture is mainly derived from long study of English and foreign periodicals and monographs, and of the special publications of important sites and monuments, which often contain valuable collections of comparative material. My incalculable debt to these sources can only be expressed in general terms. I do not think that I owe very much to any hand-books except to those of Josef Durm, *Die Baukunst der Griechen* (third edition, 1910) and *Die Baukunst der Etrusker: Die Baukunst der Römer* (second edition, 1905), and to G. T. Rivoira's *Architettura Romana* (1921: English translation, 1925). Like all English students I am also indebted to *The Architecture of Greece and Rome*, by W. J. Anderson and P. Spiers, the second edition of which (1907) was almost my first introduction to the subject: the greatly improved third edition in two volumes (revised and rewritten for Greece by W. B. Dinsmoor and for Rome by T. Ashby) appeared in 1927 when my manuscript was practically complete, but before it went to press, so that I was able to use it in the final revision of my text. In estimating my debt to the work of others I must not omit the name of Dr A. B. Cook, Reader in Classical Archaeology in the University of Cambridge, to whose lectures on Greek and Roman Architecture I listened with delight more than twenty years ago. He helped me generously in my first attempts to acquire an independent knowledge of the subject, and has always allowed me to draw freely on his incomparable knowledge of the material remains of Classical Antiquity.

It is my pleasant duty to offer the warmest thanks to those who have helped me in various ways in the preparation of this book. My col-league Mr A. S. F. Gow found time to read the whole in proof, and made many suggestions of the greatest value. Dr R. A. Nicholson, Sir Thomas Adams's Professor of Arabic in the University of Cambridge, most kindly provided me with uniform transcriptions of the many Arabic place-names which I had met in a confusion of English, French,

German, and Italian spellings. My wife relieved me of most of the labour involved in the preparation of the General Index and both the manuscript and the proofs owe much to her criticism and to that of my two sons.

For permission to reproduce drawings and photographs I am indebted to many individual scholars, learned societies, and public institutions. Sir Arthur Evans generously allowed me to reproduce all that I wished from his *Palace of Minos* (Figs. 2 *a*, 2 *b*, 3, 4, 8 of this book), including the new plans which appeared in his second volume in 1928, and the late Sir Alexander B. W. Kennedy most kindly lent me the negative of the photograph (Pl. XI *a*) of the Khazna in his *Petra: its History and Monuments*, 1925. M. Albert Ballu allowed me to reproduce the plan of Timgad (Fig. 86) from his *Ruines de Timgad*, 1911, and M. Charles Dugas gave the same permission for illustrations (Figs. 60, 61) in his *Sanctuaire d'Aléa Athéna à Tégée*, 1924. M. le Marquis de Vogüé allowed me to use illustrations (Figs. 99, 133) from his father's *Syrie Centrale*, 1865–1877. Prof. Dr W. Dörpfeld, with characteristic generosity, gave me free permission to use all his published drawings, and Prof. Dr Th. Wiegand, Director of the Generalverwaltung der Staatlichen Museen, Berlin, allowed me to use all the illustrations whose copyright he controls, whether in his private or in his official capacity, including those (Figs. 18, 19, 64, 67, 68, 70, 78, 79, 80, 84, 85, 95, 96, 97, 112, 124, 125, Pls. VII, VIII *a*, XIII, XIX *a*) in the great German publications of Miletus, Priene, Magnesia, and Baalbek. He even lent me, with a kindness for which I can offer no adequate thanks, the unique print of the original photograph of the Ecclesiasterion at Priene (Pl. VII), the negative of which was destroyed during the war in an English air-raid. Prof. Dr E. Buschor kindly allowed me to reproduce his drawing (Fig. 26) of the Gorgon pediment of Corcyra, and Prof. Kurt Müller sent me a photograph of the model from the Argive Heraeum (Pl. I *b*, *c*), while Dr W. Wilberg gave me leave to reproduce his drawings of the Ephesus library (Figs. 119, 120) in the *Jahreshefte* of the Austrian Archaeological Institute. I must also thank Prof. Dr E. Krüger, Director of the Provincial Museum at Trier, for allowing me to reproduce two drawings (Figs. 121, 122) from his

Trierer Römerbauten, 1909, and for supplying me with a photograph (Pl. XXI *b*) of the Porta Nigra. Mr M. Ziffo of Athens allowed me to use his photographs of the Parthenon and Propylaea (Pls. IV *a, b*), and the Director-General of the Constantinople Museum sent me a photograph of the capital from Larissa in Aeolis (Pl. II *b*).

The Trustees of the British Museum allowed me to reproduce illustrations (Figs. 39, 40, 41) from Hogarth's *Excavations at Ephesus*, 1908: the Councils of the Societies for the Promotion of Hellenic and Roman Studies and the Managing Committee of the British School at Athens allowed me the use of various photographs (Pls. I *a*, II *a*, V *c*, XI *b*, XXIV *a*) and also of illustrations from the *Journal of Hellenic Studies* (Fig. 77) and from the *Annual of the British School at Athens* (Fig. 15). The Syndics of the Cambridge University Press lent me two illustrations (Figs. 6, 49) from the *Cambridge Companion to Greek Studies*, and the Delegates of the Clarendon Press, Oxford, gave me permission to reproduce Figs. 104, 105, 106, and 109 from G. T. Rivoira's *Roman Architecture*, 1925. The Committee of the Society of Antiquaries of London gave me leave to use the plan of Silchester (Fig. 132) published in vol. LXI of *Archaeologia*, and the Committee of the Egypt Exploration Society allowed me to borrow an illustration (Fig. 45) from Flinders Petrie's *Naukratis*, I, 1886. The Committee on Publication for the American School at Athens permitted me to reproduce several illustrations (Figs. 54, 55, 56, 57, Pl. V *a*) from Stevens and Paton, *The Erechtheum*, 1927. The Archaeologisches Institut des deutschen Reiches gave me free permission to use their *Jahrbuch* and *Mitteilungen*, and the *Programm zum Winckelmannsfeste*, from which I have taken Figs. 22, 23, 47, 82, 123, 134, and Pl. I *b* and *c*. They also took most generous pains to secure me the photographs from which are reproduced Pl. I *b* and *c* and Fig. 59 *a*, and the Preussische Akademie der Wissenschaften were not less kind in allowing me to draw on their *Abhandlungen* for illustrations (Figs. 43, 66, Pl. VI) of the temples at Samos and Didyma. I am also indebted to the Österreiches archaeologisches Institut for leave to use two drawings (Figs. 119, 120) from their *Jahreshefte* and to the Lanckoroński'sche Zentralkanzlei of Vienna for allowing me to take Figs. 98, 115, 116, and 117 from Lanckoroński's

Städte Pamphyliens und Pisidiens, 1890 and 1892. The R. Accademia Nazionale dei Lincei allowed me to reproduce three illustrations (Figs. 103, 129, 130) from their *Monumenti Antichi*, and the R. Scuola archeologica italiana in Atene to use two illustrations (Figs. 5, 21) first published in their *Annuario*. The R. Soprintendenza alle Antichità di Etruria showed great kindness in securing me the photographs from which Pls. VIII*b* and XXIII are taken. To the Direzione del Bullettino della Commissione archeologica del Governatorato di Roma I owe the inclusion of Fig. 87 and to the Greek government that of Fig. 20 from the Ἀρχαιολογικὸν Δελτίον. The Archaeological Society of Athens allowed me to take Fig. 1 from the Ἐφημερὶς Ἀρχαιολογική and Fig. 12 from Tsountas' Ἀκροπόλεις Διμηνίου καὶ Σέσκλου, 1908.

It remains to thank the following publishing firms for kindly sanctioning the reproduction of pictures from the books specified: C. H. Beck'sche Verlagsbuchhandlung, Munich (Fig. 50: Judeich *Topographie von Athen*), A. C. Black & Co., London (Figs. 110, 118: Middleton *Remains of Ancient Rome*), E. de Boccard, Paris (Figs. 25, 46, 81, Pls. V *b*, XXII: *Fouilles de Delphes* and *Exploration archéologique de Délos*), F. Bruckmann A.G., Munich (Figs. 88, 89: *Glyptothèque Ny-Carlsberg*), Eleutherodakis, Athens (Figs. 9, 10, 11, 13, 71: Dörpfeld *Troja und Ilion* and *Das griechische Theater*, Rodenwaldt *Tiryns*), Wilhelm Engelmann, Leipzig (Figs. 92, 114, 126, 128, 131: Overbeck *Pompeji* and Mau *Pompeji im Leben und Kunst*), Wilhelm Ernst & Sohn, Berlin (Fig. 65: Adler *Mausoleum zu Halikarnassos*), Établissement Firmin-Didot, Paris (Fig. 94: Lebas-Reinach *Voyage archéologique en Grèce et en Asie Mineure*), Th. G. Fisher, Leipzig (Fig. 35: Wiegand *Archaische Porosarchitektur der Akropolis zu Athen*), J. M. Gebhardt's Verlag, Leipzig (Figs. 7, 16, 27, 36, 42, 44, 53, 107, 111, 113, 127: Durm *Baukunst der Griechen* and *Baukunst der Etrusker: Baukunst der Römer = Handbuch der Architektur* Band I, Band II), Paul Geuthner, Paris (Figs. 60, 61: Dugas *Sanctuaire d'Aléa Athéna à Tégée*), Walter de Gruyter & Co., Berlin (Figs. 74, 75, 76, 83, 93, 100, 101: Noack *Eleusis*, von Gerkan *Griechische Städteanlagen*, Delbrück *Hellenistische Bauten in Latium*), Verlag B. Harz, Berlin and Vienna (Figs. 72, 73: von Gerkan *Das Theater von Priene*), Longmans, Green & Co., London

(Fig. 63: Wood *Discoveries at Ephesus*), Macmillan & Co., London (Figs. 2*a*, 2*b*, 3, 4, 8, 24, 34, 58: Evans *Palace of Minos*, Frazer *Pausanias's Description of Greece*), Ch. Massin & Co., Paris (Figs. 108, 135, Pls. IX*a*, *b*, *c*, XXIV*b*: Hébrard and Zeiller *Spalato*, d'Espouy *Fragments d'Architecture antique*), John Murray & Co., London (Fig. 14: Schliemann *Tiryns*), Verlagsbuchhandlung Julius Springer, Berlin (Figs. 17, 28, 29, 30, 30 *a*, 31, 32, 33, 37, 38, 52, 62, 90, 91: Curtius and Adler *Olympia: die Ergebnisse*, Koldewey and Puchstein *Die griechischen Tempel in Unteritalien und Sicilien*), Weidmannsche Buchhandlung, Berlin (Fig. 102: Jordan-Huelsen *Topographie der Stadt Rom im Altertum*): and also the following photographic firms for permission to reproduce the Plates to which their names are attached, Levy et Neurdein, Paris (Pls. XIV *b*, XV, XX *a*, *b*, XXI *a*), Fratelli Alinari, Florence (Pls. III *a*, *b*, X *a*, *b*, XII *a*, *b*, XIV *a*, XVI *a*, *b*, XIX *b*), and Giani, Florence (Pl. VIII *b*).

I take this opportunity of mentioning one recent publication not included in my Bibliographical Appendix, the first part (*Prehellenic and Early Greek*, by F. N. Pryce) of the new *Catalogue of Sculpture in the Department of Greek and Roman Antiquities of the British Museum*, 1928. This should be consulted especially for the 'Treasury of Atreus' at Mycenae, for the Croesus temple at Ephesus, and for the temple of Apollo at Naucratis.

Finally I must express my sincerest thanks to the staff of the Cambridge University Press for their unfailing skill and courtesy.

D. S. ROBERTSON

Trinity College Cambridge
December 1928

PREFACE TO SECOND EDITION

The call for a reprint reached me at a moment when circumstances precluded a complete rewriting such as I had long had in mind. I have reluctantly left the illustrations unchanged, but I have tried to revise the whole text and the Chronological Tables in the light of recent research. I have made a great many substantial changes, and I have justified these, where necessary, by additional footnotes, distinguished by square brackets.

The Bibliography was a difficult problem. My accumulations of new matter, though considerable, were not systematic or exhaustive, and I could not spare time, as I did for the first edition, to examine all relevant publications and select the most important. I finally decided to leave the Bibliography untouched, except for corrections and for the insertion of some older works which I had wrongly omitted, but to call attention to all later publications (rather more than a hundred) named elsewhere in the book by placing an asterisk against the heading and adding a page-reference in square brackets. I hope that I have not missed much of importance, but advanced students must understand that this new bibliographical matter is mostly confined to buildings and subjects discussed in the text, and that for things mentioned only in the Bibliography and Chronological Tables (and also for some things in the text, especially in the Roman sections) they will in general be wise to search the periodicals of the last twelve years for themselves.

The following appear to me the most useful publications of the period, apart from those dealing with particular sites and buildings: for Greek architecture, C. Weickert, *Typen der Archaischen Architektur in Griechenland und Kleinasien*, Augsburg, 1929, and Lucy T. Shoe, *Profiles of Greek Mouldings* (Text and Plates), Harvard, 1936 (both these are invaluable, though they unfortunately exclude Magna Graecia and Sicily), Humfry Payne, *Necrocorinthia*, Oxford, 1931, for Corinthian influence on early Doric architecture, and for detailed studies of

the terracotta metopes and revetments and the stone sculpture of temples in Corfu, at Thermum, and elsewhere, E. Buschor, *Die Tondächer der Akropolis*, Berlin and Leipzig, 1929, W. Wrede, *Attische Mauern*, Athens, 1933, W. Darsow, *Sizilische Dachterrakotten*, Berlin, 1938, and the second edition of W. Judeich's *Topographie von Athen*, Munich, 1931; and for Roman architecture, S. B. Platner and T. Ashby, *A Topographical Dictionary of Ancient Rome*, Oxford, 1929.

I may add that since 1928 I have visited Greece twice and also Sicily and South Italy, and have examined many of the chief monuments.

In conclusion I must thank those who have helped me by pointing out faults in the first edition, especially Prof. W. B. Dinsmoor, who reviewed it in the *American Journal of Archaeology* in 1932, and my colleague Mr A. W. Lawrence, who has suggested many corrections and has given me many valuable references.

<div style="text-align: right">D.S.R.</div>

Trinity College, Cambridge
December 1940

Postscript. I must add my warmest thanks to Professor J. D. Beazley, who has read the whole of this edition in proof, and has made many valuable corrections and suggestions. Since the book went to press I have also received from Professor A. J. B. Wace a preliminary account of important discoveries made by Dr Sp. Marinatos and himself in the Mycenaean storeroom of the National Museum at Athens, which throw new light on the restoration of the façade of the 'Treasury of Atreus' at Mycenae (see p. 33 *infra*). A full report of this communication (illustrated) has been sent by me to the *Journal of Hellenic Studies*, and an account will also appear in the *American Journal of Archaeology*, but I have the permission of both scholars to make what use of it I can in this book.

The most striking novelty is the proof that upon the square plinth which rested on the capital of each of the large half-columns stood a similar smaller half-column. These small half-columns, which reached to the crowning cornice, were plain to the height of fifty centimetres, and decorated above that point with carved ornament, which resembles that of the larger half-columns but goes round spirally and does not

zigzag. The small half-columns had at the top of their shafts convex collars with bead-ornament, and it is likely that the larger half-columns had such collars too. The arrangements above the lintel and the filling of the relieving triangle were as suggested in *B.S.A.* xxv, p. 342, except that the triple bands of spirals in red stone shown in the British Museum *Catalogue of Sculpture*, I, i, 1928, fig. 22, were probably separated by plain bands of red stone: the rest of the façade seems likewise to have been decorated with plain bands of stone (partly red, partly variegated), with bands of rosettes and spirals intervening. For the position of the small half-columns Wace compares the pilasters similarly placed on the façade of the 'Tomb of Clytemnestra'.

These discoveries need to be checked in the future by comparison with casts of fragments in other museums and by re-examination of the actual façade, but their preliminary interpretation seems convincing.

Second Postscript. A reprint has given me the chance of making a few corrections: see especially p. 244, n. 3, and p. 252, n. 2. Attention may also be called to three publications which I have seen since my second edition was published: (1) W. A. McDonald, *The Political Meeting Places of the Greeks*, Baltimore, 1943, which throws much light on some of the types discussed in Chapter xi; (2) L. Kjellberg, *Larisa am Hermos*, dealing with the site called in my book 'Larisa in Aeolis'. Of this work I have seen only Vol. ii, *Die Architektonischen Terrakotten* (in two parts, Text and Plates), edited, after Kjellberg's premature death, by Å. Åkerström, Stockholm, 1940. This is important for the study of early terracottas in Asia Minor and elsewhere: it confirms the belief (see p. 195 of this book) that the architectural terracottas of Etruria are mainly derived from models in Aeolis and Ionia through Phocaea; and (3) A. Andrén, *Architectural Terracottas from Etrusco-Italic Temples* (Text 1940, Plates 1939), published at Lund.

CONTENTS

xiv *Contents*

LIST OF ILLUSTRATIONS

with their Sources

A. TEXT

B. PLATES (following page 232)

CHAPTER ONE

Sources of Knowledge. Materials and Methods

Eighteen centuries ago one magnificent architectural tradition ruled Europe, Africa, and Asia, from the Rhine to the Sahara, from the Atlantic to the Euphrates. The purpose of this book is briefly to trace the sources of this tradition and its development till the foundation of Constantinople in the fourth century of the Christian era. The tradition was complex. In the lands which lie round the Mediterranean men built long before the dawn of history, and their manner of building was conditioned by the materials that lay round them, by their special needs of safety or comfort, by their racial origins and contacts. In Egypt, especially, and in Western Asia, countless splendid monuments were raised thousands of years before the foundation of the Roman Empire. The architecture of the Graeco-Roman world was affected by many external influences, sometimes profoundly: but in classical times they were tributaries swelling that main stream which we can follow backwards step by step till it almost eludes our search, though still far from its source, some seven centuries before the birth of Christ. We do not lose the stream in a single channel. Our earliest knowledge shows us three main schools, obviously akin but obviously differentiated: the school of Etruria and Latium, the school of Greece proper, South Italy and Sicily, and the school of Greek Asia Minor. It would not be unreasonable to start at this point: but the earlier architectures of the Mediterranean area are of fascinating interest, and it is certain that some of their influences went to the making of classical architecture. The native architectures of Egypt and the Near East cannot here be discussed, except incidentally: but this book will begin with a brief sketch of the oldest architecture of the Aegean area, to the close of the Mycenaean age, followed by an account of the scanty remains which help to bridge the dark period which followed the Dorian invasions. The earliest buildings of Italy will be treated chiefly at a later point, in connexion with the architecture of Rome.

A few preliminary words are necessary, to indicate the nature of the evidence on which this book is based. First and most important are the surviving monuments. Apart from bridges, aqueducts, triumphal arches, and unroofed theatres and amphitheatres, few Greek or Roman buildings

stand to-day even superficially intact: the so-called Theseum at Athens and the Maison Carrée at Nîmes are striking exceptions. Only a very few, mostly roofed with more durable materials than timber, preserve the main lines of their interior form: notably the Pantheon at Rome. These fortunate buildings have been saved, as a rule, by their continued use in mediaeval times, often as churches. Others have survived in the deserts of Africa and Syria, abandoned at the ebb of Roman civilization. Far more numerous are the buildings of which parts only still stand, chiefly groups of columns: such ruins are found on countless sites, especially in Asia Minor, Greece, Italy, and Sicily. The great majority are temples, which were often built of stronger materials than civil or domestic structures, and were protected, till the adoption of Christianity, by their sacred character. In the Middle Ages, it is true, many were abandoned to the quarryman, who spared only what he could not conveniently use. But luckily their most striking features tempted him least. The rectangular blocks of the walls were easy to pull down and ready for immediate use: but the lofty columns, with their heavy and elaborate superstructure, were at once dangerous to handle and difficult to use. Marble, however, was always useful for the lime-kiln.

To these visible remains has been added in modern times, especially during the last hundred years, an ever-increasing mass of evidence, recovered by excavation, of a kind especially valuable for Greek temple architecture. A dozen fragments, with the dimensions of the foundations, may enable a trained investigator to reconstruct with certainty the main features of a temple of which nothing had remained above the soil. Such reconstructions, however, always difficult except for temples, become less and less certain, even for these, as we deal with older remains. Until about the middle of the sixth century B.C. there was great local variety both in construction and in decoration. The upper parts of the archaic 'Temple of Ceres' at Paestum, for instance, are just sufficiently preserved to prove that it would have been impossible to reconstruct them correctly on the analogy of contemporary monuments. Of the upper portions of the famous Heraeum of Olympia, apart from its tiling, and of the general appearance of the earliest temple of Orthia at Sparta—one of the oldest known—we can assert practically nothing. Yet it is for these very early buildings that our debt to excavation is greatest: imperfect as the new material is, it is all that we have, and it throws invaluable light on Greek architectural development. For our understanding of Etruscan and Latin temples the evidence of excavation is also of supreme importance, while for

our knowledge of architecture before 1000 B.C. we depend almost entirely upon the digging of the last half-century, especially upon the work of Schliemann and his successors at Mycenae, Tiryns, and Troy and upon that of Evans and others in Crete and the islands of the Aegean.

In comparison with this solid material, the evidence of ancient writers and of ancient inscriptions, though exceedingly useful, is of minor importance. Of technical writers on architecture only one has survived, Vitruvius Pollio. The effect on Renaissance architects of the study of Vitruvius was in some ways unfortunate, but, if his merits and defects are fairly estimated, his great value must be recognized. He was a practising architect, and his knowledge of his subject is far greater than his defects of expression and his confused handling of his authorities might suggest. He wrote under Augustus, at a moment when the special developments of Roman architecture had scarcely begun, and his outlook is fundamentally Hellenistic. His knowledge of architecture earlier than the fifth century B.C. is slight: he thought of it somewhat as Sir Joshua Reynolds thought of Raphael's predecessors. He has, however, preserved useful information about Etruscan temples, and also about the earlier stages of those Roman constructional methods which were to lead in the next century to the Flavian palace on the Palatine, and thereafter to the dome of the Pantheon, the Baths of Caracalla, and the Basilica Nova of Maxentius and Constantine.[1]

Important architectural knowledge may be gathered incidentally from Greek and Roman writers of all ages from Homer onwards. The richest storehouse of information is the invaluable guide-book of Pausanias, who in the second century A.D. visited and described the chief cities and sanctuaries of Greece. From inscriptions[2] we can learn interesting facts about methods of construction, payment of workmen, and the like: and sometimes, as in the case of the naval arsenal built at the Piraeus by Philo of Eleusis in the second half of the fourth century B.C., we can reconstruct on paper, from inscriptional evidence alone, a building which has left no material trace. To these various sources of knowledge we must add ancient representations of buildings in fresco, vase-painting, reliefs, coins, and other works of art, including stone and terracotta models: and also the scrawls of ancient idlers, and

[1 See now A. Boëthius in ΔΡΑΓΜΑ *Martino P. Nilsson...dedicatum*, Lund, 1939, 114: *Vitruvius and the Roman Architecture of his Age*.]
2 For the important fragments of the marble Plan of Rome (*Forma Urbis*) of the early 3rd cent. A.D., see Appendix II, pp. 352, 353.

drawings and descriptions, by mediaeval, Renaissance and modern observers, of buildings now damaged or destroyed.

The materials used by builders in the Mediterranean area were mainly determined by the geological natures of the various districts and by the abundance or scarcity of timber. Stone, clay and wood are the fundamental materials, used everywhere from first to last. The art of forming clay into sun-dried bricks, often combined with a timber frame-work, goes back almost to the earliest times of which we have knowledge. Burnt clay on the other hand, though long familiar to potters, was scarcely used in architecture, except for pipes and sometimes for pavements, till the seventh century B.C. Terracotta roof-tiles were almost unknown to the architects of the prehistoric period, being at most confined to the 'Early Helladic' age in Greece proper,[1] and burnt brick was probably not used for the construction or facing of walls or columns till after the time of Alexander the Great: one of the earliest examples is a Hellenistic palace in Mesopotamia,[2] the ancient home of this technique: the material is rare till the time of Augustus. Sun-dried bricks normally stood on a stone socle, and were often protected by a coating of lime. Lime concrete was used for pavements in prehistoric and later times, but the use of lime as mortar was exceptional, though not unknown, before the Hellenistic period. Rubble and Cyclopean walls[3] were usually mortared with clay, while the regular masonry of classical times was usually dry-jointed, and strengthened[4] by metal dowels and clamps, whose gradual development provides an important means of dating. The development of concrete as a building material will be traced in a later chapter;[5] with rare exceptions, this technique is late Hellenistic and Roman. The stones chiefly used are the various local limestones. Rubble, clay-mortared, was used from the earliest times, and this is combined with a facing of carefully cut masonry in Minoan and even in neolithic work: in Crete the two faces were sometimes united with wooden clamps. Unfaced rubble was often plastered with lime. Regular ashlar masonry occurs in 'Early Minoan' times (the Cretan chronology is explained in the next chapter). Rubble and even regular masonry was often combined, in Minoan and Mycenaean walls, with wooden beams,

1 An instance is the 'Early Helladic' round building at Tiryns (p. 24), which used both thin stones and terracotta tiles probably on its flat roof, but the tiles may have formed a pavement. Similar tiles of the same period were found at Asine.
2 See p. 235.
3 'Cyclopean' walls are characteristic of Mycenaean fortifications: they are built of unshaped stones, large and small: this old technique must be carefully distinguished from 'polygonal', for which see p. 42.
4 See p. 42. 5 See pp. 232 ff.

sometimes in a complete 'half-timber' framework. The Cretan and Mycenaean architects, like the later Greeks, sometimes used especially hard or beautiful stones in exposed or prominent positions, but marble is rare before the sixth century B.C. In Italy marble was little used before the fall of the Republic, and was then often a mere veneer over brick and concrete.

It is doubtful whether stone columns of circular or polygonal section were used in the Aegean area or in Italy before the seventh century B.C., though they were common in Egypt from very remote times. The Cretans used square stone pillars, but largely, though not exclusively, in basements, and often as supports for wooden columns in more important rooms above. The wooden column or pillar upon a raised stone base, for columns usually circular, was the typical Minoan and Mycenaean form: the stone half-columns on the façades of some 'beehive' tombs are probably copies of wooden models. Wooden columns were also used in the very early days of Doric architecture, and the introduction of stone columns in the seventh century B.C. was perhaps an imitation of the immemorial practice of Egypt.[1] In Italy, and especially in Etruria and Latium, the free use of wood, combined with elaborate terracotta decoration, continued much later than it did east of the Adriatic and developed on original lines.

This brief introduction may close with a few general remarks of tentative character upon the relation of Greek architecture to its great Egyptian and Oriental forerunners. It seems certain that the Greek architecture of the seventh and later centuries B.C. was essentially a direct development of local traditions, and that the influence of Egypt, at this stage, was confined in the main to this—that it stimulated the Greeks to substitute stone for timber and sun-dried brick. It is true that Greek architecture was undoubtedly affected by the great influx of foreign art, chiefly Asiatic, which took place in the seventh century B.C. But this influence, which was largely diffused by portable objects of luxury, such as metal vessels and embroidery, was probably confined to decorative motives: the Ionic capital is the most important architectural feature which may be of Oriental origin.[2] It is probable that Egyptian and Asiatic models had an effect upon the prehistoric architecture of Crete: but the extent of these influences is difficult to define, and it is certain that Crete was not always the learner.

[1 An E.H. III house at Eutresis in Boeotia had a column of sun-dried brick supporting roof-timbers: see H. Goldman, *Eutresis*, Harvard, 1931, p. 25.]
2 See p. 60.

Minoan Crete, Troy, and pre-Mycenaean Greece

The Greeks never forgot the proud civilization which flourished in their country in the second millennium B.C. but its visible remains were few and mysterious, and it was left for the German merchant, Heinrich Schliemann, in the second half of the nineteenth century, to probe the secrets of Troy, Tiryns, and Mycenae, and to prove that Homer's world was no poet's dream. The first result of his work was to confirm the Homeric picture of a Greece dominated by the Argive plain, in conflict with north-western Asia dominated by Troy. Scholars named the newly discovered culture 'Mycenaean' and many regarded the Argolid or Boeotia as its original home. Schliemann himself had guessed the importance of Crete. He desired to excavate Cnossus near its north coast, a city associated by Homer and later Greek writers with the rule of a great sea king, Minos, two generations before Troy fell. His instinct was not at fault, but his wish was unfulfilled, and the uncovering of the marvellous palace of Cnossus was reserved for Sir Arthur Evans. We know now that the chief source of the 'Mycenaean' culture was neither the Argolid nor Boeotia, but Crete. There, and especially at Cnossus, we find an almost unbroken development from neolithic times, deeply influenced from the first by Egypt and Asia but marked by striking originality. In old Greece the later stages of Cretan culture were sharply imposed upon a more primitive civilization. The relative dates of many of these prehistoric buildings can be fixed by the evidence of stratification, especially with the help of associated pottery: the absolute dates depend chiefly upon contacts with Egypt, and reflect the uncertainties of Egyptian chronology. The fascinating problem of the racial character of the early Cretans is beyond the range of this book. We cannot read their writing, and we do not know if they were in any sense Greeks, but they certainly influenced the origins of Greek culture. Light may be thrown on these matters by recent advances in the decipherment of Hittite records.

It is necessary at this point to say a word of the Cretan chronology, due chiefly to Evans and now generally accepted. It will save trouble to combine with it the similar classification which Wace and Blegen have evolved for Greece proper. The divisions in each scheme are to

some extent arbitrary, and the absolute dates become less and less certain as we approach the neolithic age. Evans named the Cretan culture 'Minoan' after the great sea-king of tradition. Wace and Blegen chose the name 'Helladic' for the stages of the mainland culture, in order to emphasize its independence of Crete. Both names have been criticized, but both are convenient.

The following table,[1] in which E.M., M.M. and L.M. mean Early, Middle, and Late Minoan, and E.H., etc., Early Helladic, etc., shows in parallel columns the approximate dates B.C., the beginnings of some of the Egyptian dynasties, and the beginnings of the Minoan and Helladic periods.

Dates B.C.	Egyptian dynasties	Minoan periods	Helladic periods
3000	1st	E.M. I	E.H. I
2800	4th	E.M. II	—
2400	7th–10th	E.M. III	E.H. II
2200	11th	M.M. I	E.H. III
2000	12th	M.M. II	M.H.
1800	13th–17th (Hyksos)	M.M. III	—
1600	18th	L.M. I	L.H. I
1500	—	—	L.H. II
1400	—	L.M. III (at Cnossus preceded by L.M. II)	L.H. III
1100	21st	Approximate end of Mycenaean civilization Dorian invasions	

We know the ground-plans of a few Cretan houses of the neolithic age; some of them lie beneath the palace of Cnossus. They show straight sides and angular corners. This is interesting, for the isolated blocks which formed the earlier stages of the palace itself, though rectangular in general plan, often had rounded corners. In general, however, there is little curvilinear architecture in Crete, except in some tombs and other wholly or partly subterranean structures. The most striking exception is a large oval house of M.M.[2] date, at Chamaezi, in the Siteia province

1 This list must not be regarded as more than a rough guide. For recent discussions see *Cambridge Ancient History*, I, 1923 and II, 1924, and H. R. Hall, *The Civilization of Greece in the Bronze Age*, 1927. A parallel classification of island chronology as 'Cycladic' is here ignored, and so are the subdivisions of the Minoan periods, which are too technical for this book. [See further note on p. 26.]
2 The abbreviations E.M., M.M., etc., will be used henceforth.

(Fig. 1), which was elaborately subdivided, and perhaps contained an open court: but this seems to be a freak due to the lie of the site. Another remarkable feature of the neolithic houses of Crete is the presence of fixed hearths, which are almost unknown in Minoan architecture.

From the vast mass of Cretan buildings brought to light in the last quarter of a century a very few must here be selected; and it would be unreasonable to deny the chief place to the "Palace of Minos." The

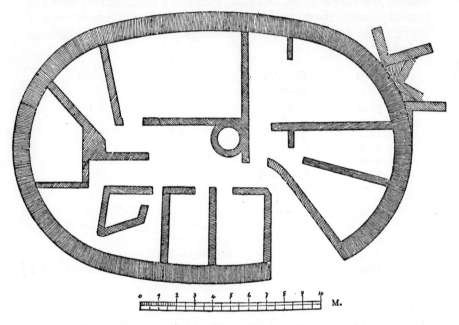

Fig. 1. House of Middle Minoan I date at Chamaezi, Crete

building is so large and complex that only the most summary description can here be attempted. Figs. 2*a*, 2*b*, and 3 show[1] the latest published plans of the palace in its full development, when it formed a continuous mass of building enclosing a rectangular courtyard, the Central Court, which measured about 190 feet from north to south by about 90 feet from east to west. Figs. 2 *a* and 2 *b* show the ground-floor of the west and east sections of the palace, Fig. 3 the first floor or 'Piano Nobile' of the former. In the M.M. I period, before which its history can hardly

[1] Owing to the reduction of scale the distinctions of shading in Figs. 2*a* and 2*b* are partly obscured.

be traced,[1] this continuous mass was a series of isolated or almost isolated blocks with straight sides and in many cases rounded corners: a keep perhaps stood to the west of the northern entrance. At the end of M.M. III the palace was ruined,[2] probably by an earthquake, and it was greatly modified in the subsequent rebuilding, which began in a period of transition between M.M. III and L.M. I. The Central Court covers the crown of a hill, itself gradually formed by generations of neolithic settlers and then artificially levelled: the slope is sharpest to east and south. The palace was not defenceless, but it was no impregnable fortress, like Tiryns or Mycenae. It was a sea-king's home, built to resist riots or raids, but helpless if the fleet were lost.

The most impressive approach was from the south, where a causeway carried the highroad from Phaestus across a deep ravine, and a magnificent stepped portico ascended the slope to the south-west corner of the palace. This causeway and portico date from M.M. I, and this approach was much modified after the disastrous earthquake of M.M. III. Neither this nor any of the other entrances led direct into the court. A typical M.M. entrance, the West Porch, opened from a paved court lying west of the palace. It faced north[3] and consisted of a roofed loggia, with its open side divided by a single wooden column on a plain stone disk. At the back were two doors, one into a throne-room, with a porter's lodge attached, the other into the Corridor of the Processions which led south to the south-west corner of the palace and there turned east. This eastward continuation of the Corridor of the Processions,[4] shown in Fig. 3, gave access, through the South Propylaeum, to the upper floor of the west section of the palace and was flanked to the south by an unroofed terrace. It was also connected directly with the Central Court, and staircases probably linked it both to the South-West Porch,[5] at the upper end of the stepped portico which ran up the slope from the ravine, and also to the South Porch further east, which became very important after the earthquake of M.M. III. The South Corridor, at a lower level,

1 This is chiefly due to the fact that the M.M. builders levelled the surface down to the neolithic stratum.

2 A very destructive earthquake also happened at the close of M.M. II.

3 Originally it had faced west and communicated more directly with the Central Court.

4 Owing to the slope of the hill to the south the Corridor of the Processions, starting on the ground level, becomes part of the upper storey: to follow the descriptions of the south part of the palace, the two plans, 2 *a* and 3, must be used together.

5 The details of the South-West Porch are conjectural, and the staircase is not shown on the plans.

Overleaf: Fig. 2*a*. The Palace of Cnossus, West Section. Fig. 2*b*. The Palace of Cnossus, East Section. (From Evans, *The Palace of Minos*, vol. II, part ii, Plans A and B)

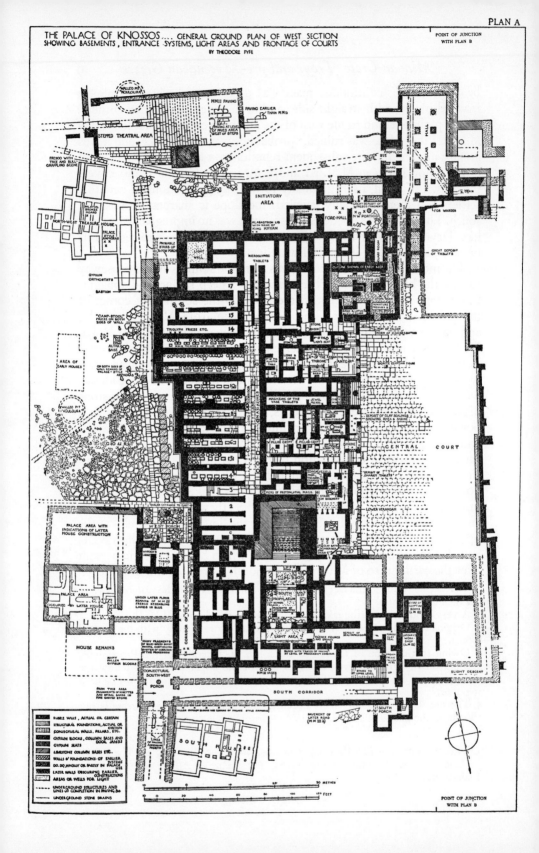

THE PALACE OF KNOSSOS.... GENERAL GROUND PLAN OF WEST SECTION
SHOWING BASEMENTS, ENTRANCE SYSTEMS, LIGHT AREAS AND FRONTAGE OF COURTS
BY THEODORE PYFE

POINT OF JUNCTION
WITH PLAN B

POINT OF JUNCTION
WITH PLAN B

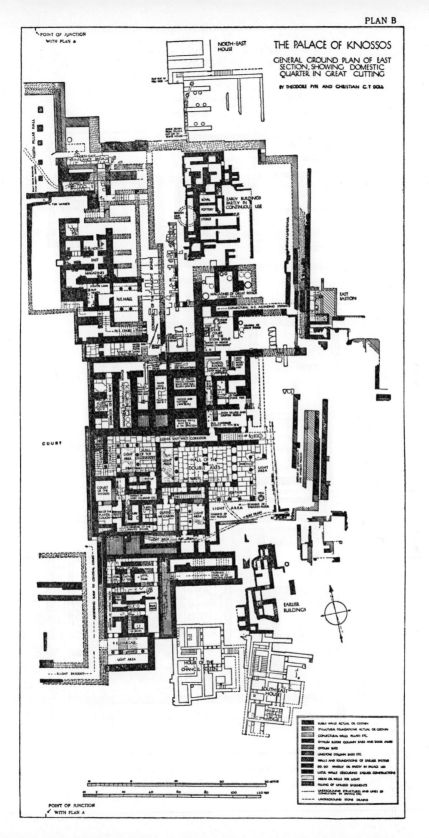

THE PALACE OF KNOSSOS

GENERAL GROUND PLAN OF EAST
SECTION, SHOWING DOMESTIC
QUARTER IN GREAT CUTTING

BY THEODORE FYFE AND CHRISTIAN C.T. DOLL

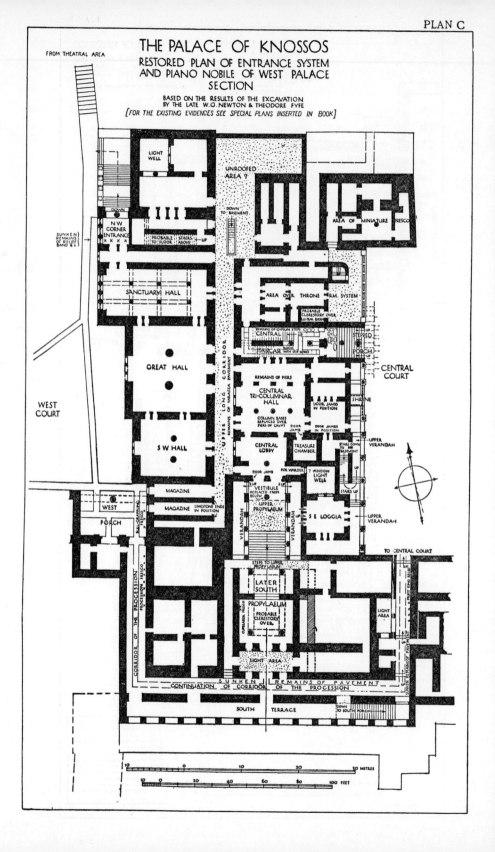

THE PALACE OF KNOSSOS
RESTORED PLAN OF ENTRANCE SYSTEM AND PIANO NOBILE OF WEST PALACE SECTION

BASED ON THE RESULTS OF THE EXCAVATION
BY THE LATE W.O. NEWTON & THEODORE FYFE
[FOR THE EXISTING EVIDENCES SEE SPECIAL PLANS INSERTED IN BOOK]

connected the South and South-West Porches. The South Propylaeum, which was remodelled at the end of M.M. III, will be described at a later point. The whole of this area of the palace rested on massive artificial substructures.

The sea side was the side of danger, and the northern entrance was guarded, though perhaps not very strongly. The outer gate faced west, and led into a passage running south to the Central Court. This entrance was frequently remodelled, but was always defended by towers and bastions: it entered the court under the east side of the M.M. I keep, which by M.M. II had ceased to be isolated. The other entrances must here be ignored, but attention may be called to the North-West Corner Entrance, which does not appear on the older plans: its existence seems certain, though its exact form is conjectural.

The buildings west of the Central Court, which were remodelled after the M.M. III earthquake, were divided on the ground-level by the Long Corridor, running north and south, above which on the first floor ran a corresponding passage, probably open to the sky. To the west of the Long Corridor lay on the ground floor a series of magazines, to its east the chief official quarter, in which the lower rooms were largely religious in character. Under the floor of the long gallery and of the magazines a remarkable series of sunk receptacles or cists was contrived in M.M. III. In M.M. I this quarter consisted of three more or less isolated blocks but this separation ceased in the reconstruction which followed the earthquake of M.M. III.

The later arrangements of the western section of the palace must next be briefly described, with the help of Figs. 2 *a* and 3. The restoration of the first floor or 'Piano Nobile' in Fig. 3 is based on prolonged investigation of the ground-floor walls and pillars and of sunken portions of the upper storey, many of which remained supported by fallen masses of sun-dried bricks from above. In general the new work of this period was much less substantial than that of the preceding epoch. The details are, of course, partly conjectural. On the ground-level the most remarkable features are the South Propylaeum and the Throne Room: on the upper level the chief interest attaches to the great halls on each side of the Long Corridor and to the arrangements connecting these with the South Propylaeum and with the Central Court.

The South Propylaeum was connected, as we have seen, with the eastward continuation of the Corridor of the Processions. It is a remarkable forerunner of the classical Greek type of propylaeum, which consists of two open porches, each containing a pair of columns, pro-

Facing: Fig. 3. The Palace of Cnossus. Restored Plan of Entrance System and Piano Nobile of West Section. (From Evans, *The Palace of Minos*, vol. ii, part ii, Plan c)

jecting outwards and inwards from the wall which contains the actual gate. Propylaea of similar type, though without columns, occur still earlier, as we shall see, in the Second City of Troy, and there are magnificent later examples on the acropolis of Tiryns. The Trojan and Tirynthian examples are nearer the classical model in this, that they are gates pierced in fortified walls separating open areas; the South Propylaeum of Cnossus, deeply embedded in the palace, is really an elaborate entrance-hall. The form shown in Figs. 2 *a* and 3 dates from the reconstruction after the M.M. III disaster. As originally built, after the less serious catastrophe of M.M. II, the Propylaeum was considerably wider, but not otherwise different: the original side-walls can be seen in the plans, parallel to the later on the east and west. The column-bases of the southern section were slightly oval, with their major axis in line with the side-walls. They are examples of an early type found also at Phaestus. The northern pair have disappeared, but traces of their position remain.

The Throne Room, in which a throne was found in position, lies behind an ante-room which opened from the north part of the west side of the Central Court: it contains a typical 'Lustral Basin' at the bottom of a flight of steps. South of this ante-room is a wide opening, with a central column, from which a flight of steps led up to the Central Staircase, which joined the north end of the system of halls connected with the South Propylaeum. To this upper floor we must now turn.

East of the Upper Long Corridor its main feature was the Central Tri-Columnar Hall, sufficiently explained in Fig. 3. This was connected with the southern entrance system by the Central Lobby and the Upper Propylaeum, which had single central columns, and stood at the head of a flight of steps, probably flanked by columnar verandahs. At the foot of the steps, across a narrow open passage, opened the northern part of the South Propylaeum. The great halls west of the Long Corridor are also sufficiently shown in Fig. 3.

East of the court (Fig. 2 *b*) the central area is the most interesting. This Domestic Quarter, no doubt rightly so named, lay in a deep M.M. II cutting, and its buildings, though modified in L.M., date chiefly from M.M. III. The pavement of the court was level with their first floor, and the collapse of sun-dried bricks from still higher storeys has caused the ground and first floors to be wonderfully preserved. In the north-west corner of the Domestic Quarter stood the Grand Staircase, which led in a series of bold turns to the level of the court and thence to the upper floors. Its broad features are certain, but the

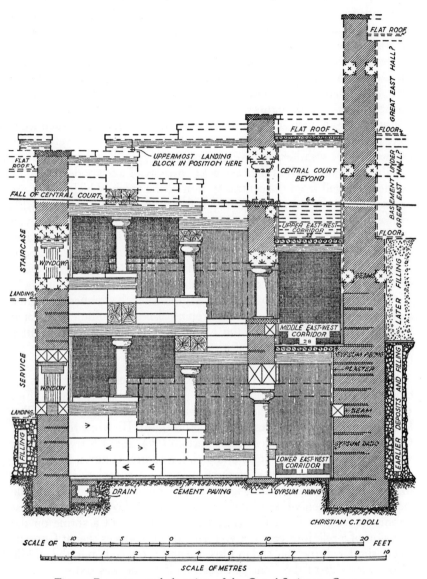

Fig. 4. Reconstructed elevation of the Grand Staircase, Cnossus
(From Evans, *The Palace of Minos*, I, fig. 247)

free supports were of wood, and Doll's reconstruction (Fig. 4) includes uncertain features, especially the shape of the columns. The staircase lay at the end of an east-west corridor, the north boundary of the Domestic Quarter. The ground-floor rooms of this area were almost identical in plan with those immediately above them. The finest room was the 'Hall of the Double Axes,' a typical Cretan structure, differing notably from the 'megaron'[1] halls of Troy and old Greece. It is the room of a hot climate, elastic and variable: draughts were not avoided, but courted. At one end is a light-well—an open shaft, of the full height of the building: such wells were perhaps crowned with some sort of canopy, but they were partly exposed to the weather, and were consequently built of hard materials. A window in this well lit the east-west corridor. Two wooden columns divided the well from the central section of the room, which had doors on both sides. Five wooden piers left four wide openings between this section and the equally large ante-room, which communicated by seven similar openings with an outer colonnade opening on to a terrace. The inner dimensions of the whole hall, including the ante-room, are about fifteen by fifty-three feet. Though curtains or folding doors were certainly placed between the piers, nothing could contrast more strongly with the great halls of Troy and the Argolid, which shunned draughts, and contained a central hearth: the Cretan palaces were doubtless heated by braziers. To the north of the Domestic Quarter the substructures clearly indicate the presence of a great hall on the higher level, overlooking the Central Court.

An interesting feature of these palaces is the use of peristyles or cloister courts. There is a fine example (93) in the Phaestus palace (Fig. 5), and another in its neighbour, the small palace of Hagia Triada. The Phaestus palace, which preserves far more M.M. III work than that of Cnossus, had a splendid entrance portico (67), about forty-three feet wide, with eleven broad steps and a single central column.

Of the outer appearance of these palaces no complete idea can be formed, but something can be learnt from Cretan frescoes and from the façades of the 'beehive' tombs of Mycenae. Fig. 6 shows one of the most important frescoes from Cnossus, a representation of a shrine on the occasion of a religious ceremony. There are clear traces that at Cnossus a very similar shrine, marked in Figs. 2 *a* and 3, opened on to the middle of the west side of the Central Court. This shrine was sixteen feet six inches wide, and differed from that shown in the fresco chiefly in this, that, whereas in the fresco the raised central compartment contains two

1 See pp. 20 ff., 25 and 29 ff.

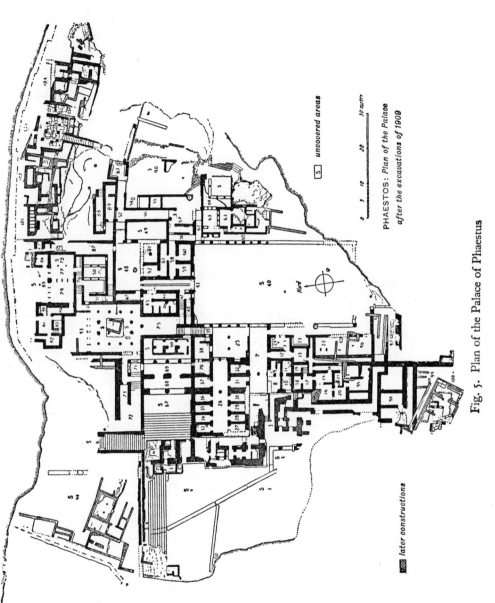

PHAESTOS: *Plan of the Palace*
after the excavations of 1909

S *uncovered areas*

later constructions

Fig. 5. Plan of the Palace of Phaestus

columns and the wings one each, in the actual example this arrangement is reversed. It should be observed that the temple, as the later Greeks understood it, is unknown to Minoan architecture.[1] Architecturally two points in the fresco call for special remark: the shape of the columns, which were certainly wooden, and the ornament shown below the central pair. The ornament will be discussed in the next chapter in connexion with Tiryns.[2] With regard to the columns there has been

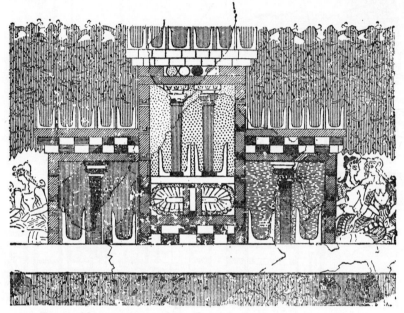

Fig. 6. Miniature fresco from Cnossus showing columnar shrine

much controversy, but it is now certain that many Minoan and My-cenaean columns, though not all, tapered like chair-legs, from capital to foot, reversing classical practice: the evidence of a few carbonized relics of actual columns is too uncertain to be used, but that of frescoes, reliefs, and miniature models is conclusive. The amount of the taper, however, has been exaggerated by many writers: it was always slight. The green marble half-columns from the 'Treasury of Atreus'[3] at Mycenae may now be studied at leisure in the restoration in the British Museum (Plate I*a*) which incorporates many original fragments. The capitals resemble those shown in the frescoes and other contemporary

[1 See further note on p. 26.] 2 See pp. 30 ff. 3 See p. 33.

representations. In general, these capitals are crowned with a rectangular block, like the Doric abacus,[1] and have at least one large convex moulding below it. The abacus is usually separated from this by a concave moulding, and there may be more mouldings, both convex and concave. It is difficult to doubt that there is a real connexion between these columns and those of early Doric, especially when we observe that the various methods of decorating their shafts include fluting, sometimes convex, but sometimes concave, as in classical types. The half-columns flanking the entrance of the 'Tomb of Clytemnestra' at Mycenae have thirteen concave flutes, which implies twenty-six in a free column: a miniature ivory column from Mycenae has twenty-four. In classical work twenty-four is the rule in Ionic, and occurs in Doric. Other column-forms are represented in Minoan works of art: especially striking are those seen on the steatite 'Boxer Vase' from Hagia Triada (Fig. 7) and on other Cretan objects, with an upward taper and a curious top member not fully understood. Except in certain lamps we find little in Crete to recall Egyptian column types. There are several fragments of stone cornices of stepped formation, like exaggerated Ionic[2] architraves, and this seems to have been a typical feature. With regard to roofs, most of the evidence points to flat terraces, as in the private

Fig. 7. 'Boxer Vase' from Hagia Triada, Crete, with detail on larger scale. (From *Handbuch der Architektur*, Band 1, J. M. Gebhardt's Verlag, Leipzig, Germany)

houses now to be described: but some gems and tombs suggest that the gabled roof was not unknown.

The plans of Cretan private houses vary greatly, and there is little direct evidence for their outward appearance: but of this a unique monument, found at Cnossus, gives us a clear notion. The monument, two specimens from which are shown in Fig. 8, consists of a number of small porcelain plaques originally set in a wooden frame, perhaps a box-lid. Some represent water, vegetation, goats, oxen, Cretans, and negroes: most are houses and towers, some seen from the back, and the

1 See p. 42. 2 See p. 47.

whole scene represented a fortified city by the sea, perhaps during a siege. The date is M.M. II, and the design recalls that of a later silver vase found at Mycenae. The houses look strangely modern. Doors and windows are plainly shown: the scarlet colour of some of the latter perhaps represents tinted shutters. Some of the walls show wide jointed masonry, others beam-ends, real or painted. The roofs are of the terrace type, though some are slightly curved: many carry small projecting rooms, perhaps lanterns over light-wells.

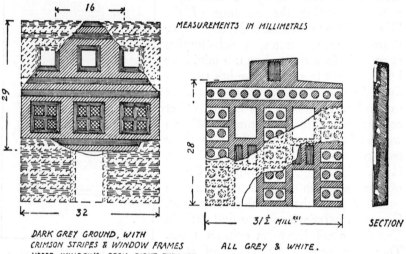

Fig. 8. Restored drawings of Faïence House-Fronts from Cnossus
(From Evans, *The Palace of Minos*, I, Fig. 224)

Finally we may remark that Cretan builders, like Cretan painters, were clever, gaudy, and fanciful. Excellent sanitary engineers, up to all the tricks of their trade, always ready to substitute rubble, stuccoed or veneered, for solid stone, where safety allowed, they startle us by their modernity, even by their vulgarity.[1]

Of the prehistoric architecture of the other islands there is here no space to speak. It resembles that of Crete, though mainland influences appear as early as M.M., especially in Melos. But the fully developed megaron hall[2] first appears in Melos at the end of L.M., probably as an importation from the mainland. It is doubtful whether it ever got a

[1 See further note on p. 26.]
2 See pp. 21 ff., 25 and 29: as a technical term *megaron* is modern.

footing in Crete. Before we pass to Greece proper, however, a word must be said of Troy, which stood on the hill of Hissarlik, south-east of the Mediterranean end of the Hellespont. The hill contains the ruins of nine superimposed settlements, the earliest of the beginning of the

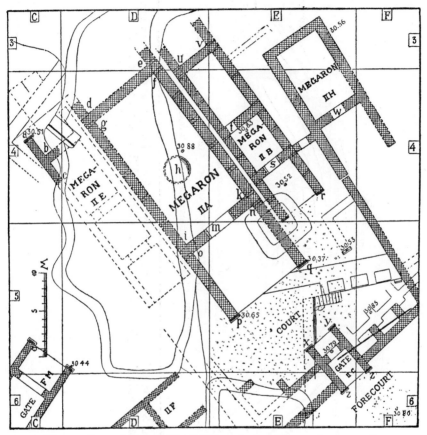

Fig. 9. Part of Second City of Troy (scale of metres in square *C*5: heights in metres above sea-level)

Bronze Age, the last the Ilium of Augustus. The most important for us are the second, which seems to have been destroyed about the beginning of M.M. II, and the sixth, contemporary with L.M. III. Troy had wide foreign connexions, by sea and land, with both Europe and Asia, and it is interesting to find here, in the first and second cities, clear examples of the megaron hall. The plan in Fig. 9 shows the chief

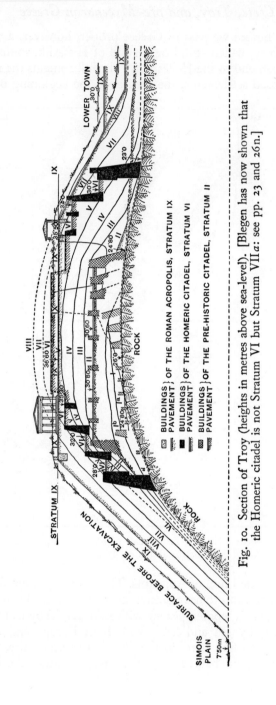

BUILDINGS } OF THE ROMAN ACROPOLIS, STRATUM IX
PAVEMENT }

BUILDINGS } OF THE HOMERIC CITADEL, STRATUM VI
PAVEMENT }

BUILDINGS } OF THE PRE-HISTORIC CITADEL, STRATUM II
PAVEMENT }

Fig. 10. Section of Troy (heights in metres above sea-level). [Blegen has now shown that the Homeric citadel is not Stratum VI but Stratum VIIa: see pp. 23 and 26n.]

buildings of the second city, isolated from the rest. The megara, especially the largest, II *A*, about thirty-three feet wide and perhaps about sixty-six feet long, closely resemble those of the Mycenaean palaces of the Argolid: they are rectangular halls, with central hearths, entered from an open porch by a single door: there may be an ante-room also, as in II *B*. The shallow false porches at the backs of these Trojan megara were probably designed to protect the back wall, and seem to be unconnected with the classical opisthodomus.[1] Wooden columns on stone bases were used in the second city. The ends of the side-walls of the porches were faced with wood, for the protection of their upper parts, which were of sun-dried brick. These wooden prototypes of the classical anta[2] recur at Tiryns and Mycenae, and in the early Doric Heraeum of Olympia. Another feature common to the second city of Troy, Tiryns, and classical Greece is the type of defensive gate or propylaeum[3] (II *C* in figure 9) in the inner walls: the outer gates (for instance *FM*) are similar, but have an inner chamber between the porches.

The sixth city was the immediate predecessor of Homer's Troy, which was largely rebuilt from its ruins after its destruction by an earthquake not long before 1300 B.C. This Homeric city ('VII*a*') was burnt a century later. Only the outer ring of these two cities remains, for the Roman engineers, as Fig. 10 shows, seeking space for architectural splendour, cut the top clean off the hill: and by a strange chance Augustus, in honouring the cradle of his race, blotted out for ever the ruins of Priam's palace. Thus it was that Schliemann missed the true Homeric city, which he wrongly identified with the second settlement. The sixth city was a marvel: its masonry was exquisitely finished, and its walls and towers were strong and skilfully designed. It was built in concentric terraces. Of the surviving buildings, one of the most striking is VI *C* (Fig. 11), a building of the megaron plan, with a very shallow porch. A stone column-base was found in position in the main room, apparently one of three along the central axis. It measures externally about thirty-four by sixty-six feet.[4]

When we turn to Greece proper, we find a series of prehistoric architectural styles very different from those of Crete. The neolithic period lasted late, especially in the north: the First Helladic Bronze Age culture had affinities with the Cyclades and Crete, and spread from the south: but no overpowering Cretan influence reached the mainland till the Middle Helladic period, nor did it culminate till the Late Helladic or

1 See p. 39. 2 See p. 39. 3 See pp. 13 f., 29, and 118.
[4 See further note on p. 26.]

Mycenaean age. It is therefore not surprising that we find in the late Helladic palaces of Tiryns and Mycenae important elements that are not derived from Crete.

The earliest buildings hitherto found in Greece show a great variety of forms. An early Bronze Age stratum at Orchomenus in Boeotia contained circular houses, which were of stone below, but were apparently crowned by converging pseudo-domes of sun-dried brick: some had an inner width of nearly twenty feet. Other early round houses are known, and in Early Helladic times a mysterious round

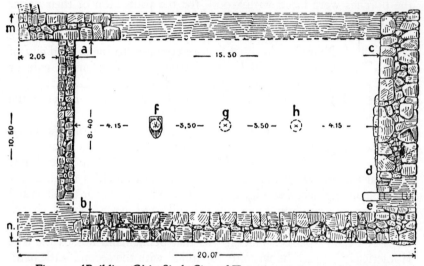

Fig. 11. 'Building C' in Sixth City of Troy (measurements in metres)

building of elaborate construction, perhaps a palace, was erected on the summit of the acropolis of Tiryns: its outer diameter was nearly ninety feet.[1] Round buildings seem also to be imitated in various prehistoric pots, but it is dangerous to draw confident conclusions from such material.

The circular 'beehive' tombs of Mycenaean times will be discussed in the next chapter.[2]

We find also in many parts of Greece, including Olympia and the acropolis of Tiryns,[3] curvilinear houses of a short 'horseshoe' or elongated 'hairpin' shape, with one straight end. Few, if any, are earlier than M.H. or L.H. Some have straight sides, with a curved apse:

[1 For this round building see *Tiryns*, III, 1930, pp. 80 ff.]
2 See pp. 32 ff. 3 For examples of this type in Aetolia see pp. 51 ff.

this type persisted till classical times. At Orchomenus such houses lie in a stratum between round and rectilinear buildings, but the tempting conclusion that this succession means a local evolution is certainly false. Early rectilinear houses show great variety of plan. The most interesting type, found chiefly in Thessaly (Fig. 12) is a variety of the megaron: the surviving examples are probably later than those of Troy II, but

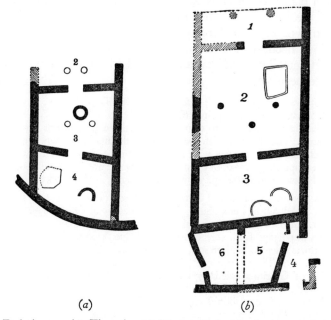

(a)　　　　　　　(b)

Fig. 12. Early 'megara' in Thessaly: (*a*) Dimini, (*b*) Sesklo. In (*a*), which is backed by the curved town-wall, room 3 is 6·35 metres wide, and in length varies from 4·20 metres to 5·50 metres: in (*b*) room 2 measures 8·25 × 8·50 metres

belong to a much more primitive culture. They differ from the Trojan type chiefly in the frequent addition of an inner room behind the main hall, and in the fact that the hearths are often not in the centre. Wooden posts or columns were sometimes used in the porches and in the interior: they were not raised on stone disks, as in Minoan and Mycenaean buildings, but buried in the soil like stakes. Both the origin and influence of these various types have provoked a world of speculation. Bulle[1] derived the rectilinear from the round by way of the horseshoe

[1] *Orchomenos* I, *Abh. Bayr. Akad.* XXIV, 1907, ii, pp. 47 ff.: Bulle did not suppose that this evolution actually took place at Orchomenus.

type: Leroux[1] derived the rectilinear from the horseshoe, but derived the horseshoe not from the round hut but from the screened cave. Boethius[2] connected the horseshoe with the semicircular fire-screen of branches still used by savages and found in northern Europe in neo-lithic times: the rectilinear he considered an essentially timber form, probably evolved in the great forests of central Europe. The developed megaron plan was certainly known in the Baltic region as early as the close of the Bronze Age, and this much at least seems likely, that the megaron type came to Greece and Troy alike from the north,[3] and maintained itself, at Tiryns and Mycenae, against the southern traditions of Crete. The next chapter will deal with the great monuments of the Mycenaean age.

1 *Les Origines de l'Édifice Hypostyle*, 1913, pp. 17 ff.

2 *B.S.A.* xxiv, 1919/1921, pp. 161 ff.

3 Some scholars look rather to central and northern Asia Minor for the origin of the megaron. The early Trojan examples would fit either hypothesis, and Asia Minor itself had much contact with northern Europe, especially by way of Thrace and the Hellespont. [Houses of the megaron type are now known in South Palestine from the Hyksos period (see p. 7): W. F. Albright, *A.J.A.* xxxvi, 1932, p. 559.]

[p. 7, n. 1 and p. 20, n. 1. For Minoan Crete see now the rest of Evans, *Palace of Minos*, and J. D. S. Pendlebury, *The Archaeology of Crete*, 1939.

p. 18, n. 1. But see p. 61, n. for the important sub-Minoan temple at Karphi in Crete. An important L.M. shrine is that at Asine (5·00 m. by 7·00 m., with two inner supports): see A. W. Persson, *Uppsala Universitets Årsskrift*, 1930, Progr. 3.

p. 23, n. 4. On Troy seven campaigns by the archaeological expedition of the University of Cincinnati, led by C. W. Blegen, have thrown much new light. I have modified the text of this chapter in some details (especially for Homeric Troy), but the student should consult *A.J.A.* from xxxvi, 1932 onwards. The building called 'VI *F*' now surpasses 'VI *C*' in interest. Its inner dimensions were *c.* 8·50 m. by *c.* 11·70 m., and it was in two storeys, with twelve inner wooden columns on stone bases: see *A.J.A.* xxxix, 1935, p. 577.

Buildings of megaron type, even older than Troy I, have been found at Thermi in Lesbos: see W. Lamb, *Excavations at Thermi*, 1936.]

Mycenaean Greece and Homeric Architecture

The Mycenaean or Late Helladic Age may be held to begin, like the Late Minoan Age of Crete, about 1600 B.C. By this date powerful dynasties seem already to have arisen in various cities of the Argolid and Boeotia; between them they probably controlled most of central and southern Greece. Their culture so closely resembled that of Crete that some scholars postulate Cretan conquest and colonization. Tiryns and Mycenae were already flourishing places in the M.H. age, but the remains of their palaces are almost entirely L.H., and we shall here be little concerned with anything earlier.

The great hill-fortress of Mycenae claims the first place. It was the seat of Agamemnon, and the heart of the Achaean confederacy: and it was here, in 1876, that Schliemann's labours first found an adequate reward. The fortress was not a city but a citadel: the royal residence, and the administrative headquarters. The later palace, built early in L.H. III, lay like its predecessor on the crown of the hill, in a series of concentric terraces. The domestic quarter, at the very top, has been almost destroyed: somewhat lower lay a nearly square court, from which opened several rooms, including the great megaron, to which we shall return. The approaches to this court included a fine staircase in two flights. The palace contained some strikingly Cretan features, such as entrance-porches with single central columns and rectangular pillars in the basements. The vast fortification walls, which encircle the hill, with the strongly protected Lion Gate, which had a 'relieving triangle'[1] filled with a carved slab over the lintel, were contemporary with the later palace, and the builders took pains not to destroy the famous shaft tombs, which belonged to an earlier dynasty. It is likely that the 'Treasury of Atreus' was the resting-place of the king who built these fortifications; but these 'beehive' tombs must be described at a later point.[2]

Tiryns is better preserved, and is more suitable for detailed treatment here.[3] A royal citadel, like Mycenae, it lies on a long limestone ridge, artificially levelled into three terraces. The actual palace (Fig. 13) occupied the highest terrace, towards the south. In its surviving form

1 For the 'relieving triangle' see p. 33 and Fig. 15.
2 See pp. 32 ff. [3 See now *Tiryns*, III, 1930.]

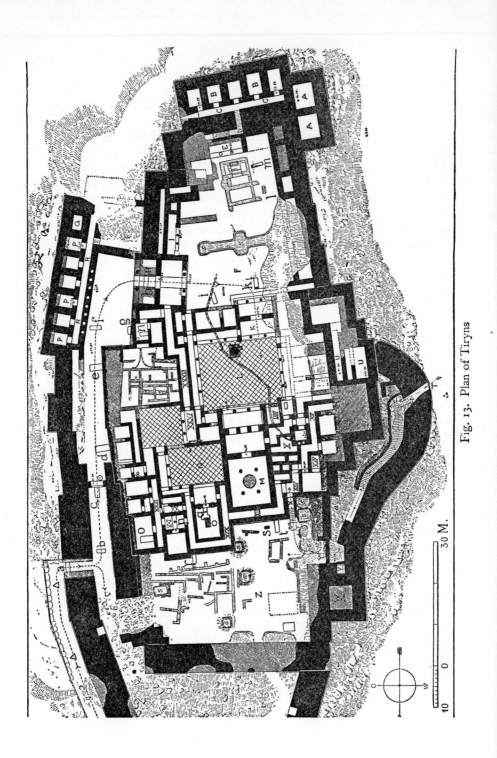

30 M.

Fig. 13. Plan of Tiryns

it is mainly contemporary with the later palace of Mycenae, and, though considerable traces of an earlier palace have been discovered,[1] this also was not older than L.H.

In its final state, the whole ridge was strongly fortified and the walls (if we ignore small posterns) were pierced only at one point, a narrow gap (*a*) on the east. This gap was approached by a long sloping ramp (Δ) commanded by the fortress walls: and the man who had passed the gap was still far from the heart of the palace. To reach the upper terrace he must pass along a passage thirty feet wide between outer and inner walls and barred at one point by a strong gate (Θ) resembling the Lion Gate of Mycenae. At *e* he had to pass a wooden gate. At the end of this passage he would enter a small court, and two great gates, the Outer and Inner Propylon (*h* and *k*), still separated him from the real palace courtyard. These Propyla deserve attention, for they are of the familiar classical type—two open porches each containing two columns, projecting outwards and inwards from the wall which contains the actual gate. This type is foreshadowed at Troy and in the South Propylaeum at Cnossus already described.[2] At Tiryns, as in all Minoan and Mycenaean buildings, all columns were of wood, and stood on raised stone disks. The approaches had not always been so elaborate: in the old palace the Outer Propylon was the direct entrance gate through the fortifications, and it was then, as Fig. 13 indicates, much more massive than it was afterwards made: moreover the fortifications were at this time confined to the upper terrace. The elaborate system of concealed passages and magazines in the heart of the walls also belongs to the later palace.

The palace falls into two distinct quarters, connected only by a few passages, easily barred. The first court, which measured about fifty-two by sixty-six feet, was almost surrounded by colonnades and contained a large megaron (*M*). The lines of the older palace were here quite different, and did not include a megaron at this point. The inner quarter, possibly reserved for the women, had two smaller courts, one of which contained a smaller megaron (*O*). These two megara form, with that of Mycenae, the most striking known examples of their type. The larger megaron at Tiryns and that of Mycenae both have an ante-room between the porch and the main room. At Tiryns this ante-room was separated from the porch by wooden piers, which left three openings,

1 There were settlements on the hill in the E.H. and M.H. periods also.
2 Propylon and Propylaeum are synonyms: the names given in the text are in general use.

each of which could be closed by wooden doors, while a single opening, nearly seven feet wide, closed only by a curtain, connected the ante-room with the main room, which measured about thirty-two by thirty-nine feet. The upper parts of the walls of the megara were constructed of sun-dried brick and their whole inner surface was stuccoed and frescoed. The floors were of concrete, elaborately ornamented, and all contained central hearths. The ends of the side-walls of the porches were faced with wood, as in the Second City of Troy. It is uncertain whether the roofs were flat or gabled: if flat, they must have been lit by 'lanterns'. From the size of the column-bases it has been inferred that at Mycenae, at least, the porch was in two storeys, the upper part forming a gallery. If so, the megara must have resembled classical temples much less than might otherwise be supposed. In the large court of Tiryns a round altar, later made square, faced the megaron.

Along one side of the porch of the large megaron at Tiryns was found a curious series of seven interlocked blocks of alabaster (Fig. 14), inlaid with blue glass paste. They had apparently rested upon a beam fitted into a gap between the concrete floor and the wall, and seem to have supported a wooden bench. Doubtless a corresponding set stood on the opposite side, but there a later structure caused their removal.[1] Their resemblance to Doric triglyphs and metopes[2] is very striking: four of the blocks—the 'triglyphs'—are upright oblongs: the 'metopes' are the same height, but wider, and are set back from the 'triglyphs' into which they are grooved. They are ornamented with two elongated half-rosettes with inner patterns, which meet without intersecting. A similar decorative scheme occurs elsewhere, for instance in the Cnossus fresco already described (Fig. 6), where it is below a column, and as a painted dado in the courtyard and megaron porch of the Mycenae palace: but it was also used above columns, as on the façade of the 'Treasury of Atreus',[3] on a miniature gold shrine from Mycenae, and probably in some examples at Cnossus.[4] Sometimes the decorative unit is one 'triglyph' flanked by two half 'metopes', as in a piece of glass-paste from Menidi shown in Fig. 14, but sometimes the 'metope' forms a unit, as in the gold shrine just mentioned, and in a fragment of wall-

1 See p. 36. 2 See p. 43.

3 See p. 33. The fragment from Mycenae shown in Fig. 14 was excavated by Schliemann inside the citadel. It is of red breccia. For lists of the instances of this ornament, see *A.J.A.* 1917, p. 126 (L. B. Holland), and *B.S.A.* xxv, p. 236 (W. Lamb) and for a discussion see Fyfe and Evans in *The Palace of Minos*, II, pp. 605 ff.

4 See *The Palace of Minos*, II, pp. 591 ff. and Figs. 368 and 370.

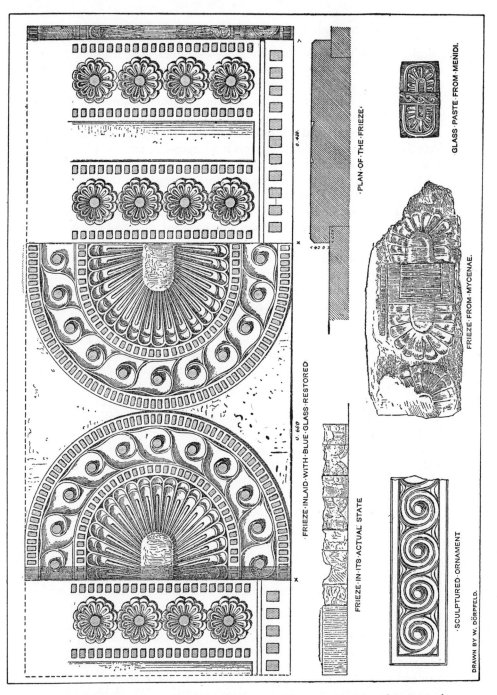

Fig. 14. Alabaster frieze from Great Megaron, Tiryns, with other fragments: in the restored alabaster frieze the tops of the 'triglyphs' are shown blank only because the surface has perished.

painting from Orchomenus. In these examples the 'triglyphs' are decorated in various ways: some of those shown in frescoes were almost certainly of wood. This variety of form and position is characteristic of the freedom of Minoan and Mycenaean architectural decoration. There is at present no evidence to show that the Doric frieze was derived from this ancient scheme, and the position of the Doric triglyphs seems to have a constructional origin: but it is not impossible that the two forms have some real historical connexion.

Of the smaller rooms at Tiryns the most interesting is the bathroom, which lies between X and XII in Fig. 13. Its floor consisted of one twenty-ton block of limestone, with a raised edge, and a gentle tilt to a drain at one corner. The room was panelled and the bathers used terracotta baths.

We have still to consider the circular 'beehive' or tholos tombs, the most impressive of all the remains of prehistoric Greece. There are few ancient structures, comparable with them in scale, whose interior effect can still be appreciated. They are only one type out of many, but space forbids a general discussion of prehistoric tombs. In Crete certain large communal village tombs, mostly in the Mesará plain, near Phaestus, resembled the tholos tombs in plan, but they were of rough construction, and must have had flat roofs; they were not subterranean, though earth was heaped round the lower courses; the doorways, framed by three stones, were reached through an ante-chamber in the earth. They date from E.M. or very early M.M. and their connexion with the mainland tholoi is doubtful. The Royal Tomb at Isopata in Crete, dating from M.M. III, is rectangular in plan, with the long walls converging like the sides of a Gothic arch, though without the arch principle. The Mycenaean examples, of which the most famous is the 'Treasury of Atreus' (Fig. 15), probably belong to L.H. II and III.[1] Many have been excavated in recent years, including one at Orchomenus in Boeotia, which Pausanias[2] visited and greatly admired.

The mainland tholoi were certainly royal tombs, and it is unlikely that more than one, on the average, was built for one dynasty in one generation. At Mycenae those of the earliest group are of rubble limestone. Next comes a group built of shaped ashlar limestone, with

1 Wace gives strong grounds for this conclusion, but Evans assigns the 'Treasury of Atreus' to the close of M.M. See *B.S.A.* xxv, 1921/1923, *J.H.S.* xlv, 1925, pp. 45 and 74, and xlvi, 1926, pp. 110 ff., and *The Palace of Minos*, ii, p. 697. [See also Wace in A. W. Persson's *Royal Tombs at Dendra near Midea*, 1931, p. 140. See also Evans, *The Shaft Graves and Bee-Hive Tombs of Mycenae*, 1929; but Wace's later excavations have finally established his own case: the Treasury of Atreus was built about 1350 B.C. See *Antiquity*, 1940, pp. 233 ff.] 2 ix, 38, 2.

elements of harder conglomerate, which are not, however, cut with the saw: in this group 'relieving triangles' over the lintels first appear. The latest group includes the 'Treasury of Atreus'. These latest tombs are built of conglomerate ashlar, shaped with the saw. In all cases the bulk of the tomb was excavated in a hillside, the original slope being about level with the door-lintels, which must have been dragged into position up the hill. In the latest group enormous blocks were used: it has been calculated that the inner lintel of the 'Treasury of Atreus', still in position, weighs over a hundred tons. The tops of the 'domes', which were built throughout of overlapping horizontal courses, with their faces cut to the proper curve, were constructed in the open, but afterwards covered with earth. The doors were approached by a straight dromos, or passage, cut in the hillside.

Fig. 15 shows a section and plan of the 'Treasury of Atreus', which explains itself. The inner diameter of the circular room is about forty-eight feet and its height about forty-three feet. The side chamber was probably used for earlier remains displaced by fresh interments in the circular room. Such chambers are not common, but a tomb found in the Argolid, at Asine, has more than one. The façades at this period were very elaborately decorated. The door of the 'Treasury of Atreus' was flanked with half-columns[1] of green marble (Plate I*a*), and the upper parts were veneered with slabs of red marble, carved with a variety of ornaments, including rosettes, representations of beam-ends, and the 'triglyph-metope' scheme.[2] The relieving triangle over the lintel was certainly filled, like that over the Lion Gate, with a light carved slab, in this case of red marble, but the remains of the façade as a whole are too scanty for any general reconstruction.[3]

Of the countless other Mycenaean sites, one of the most striking is the fortress of Gla in Boeotia, which stands on a rocky eminence near the east side of Lake Copais. It has often been an island, but it seems certain that in Mycenaean days, as now, the lake was artificially drained. The fortress was a city rather than a palace, enclosed in an enormous wall. The inner buildings are closely packed, for strength and defensibility, and there is no normal megaron. The city seems to have had a brief life and a violent end.

Before leaving the Mycenaean age, something must be said of the architecture mentioned in the *Iliad* and the *Odyssey*. Our view of this must be influenced by our conception of the date and character of the

1 See p. 18. 2 See p. 30.
3 This and the preceding paragraph are based on Wace's account in *B.S.A.* xxv. [See further p. xii *supra*.]

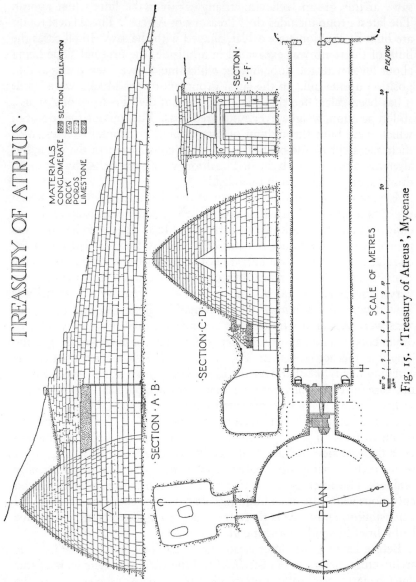

TREASURY OF ATREUS.

MATERIALS
CONGLOMERATE ROCK
POROS
LIMESTONE

SECTION ▢ ELEVATION ▢

SECTION·A·B·

SECTION·C·D·

SECTION·E·F·

PLAN

A

D

SCALE OF METRES

Fig. 15. 'Treasury of Atreus', Mycenae

Homeric poems, which cannot here be discussed. If, as seems likely, each poem is substantially the work of one poet, and both were composed on or near the coast of Asia Minor about the ninth century B.C., the poems are obviously full of archaism, and this archaism may extend to their descriptions of architecture. But most readers will feel that in any case the poet or poets visualized with fair clearness certain definite architectural types. It is not so easy to say exactly what these types were. The fullest possible description of a building, unaccompanied by plans, sections, and elevations, is almost bound to be ambiguous, and neither the *Iliad* nor the *Odyssey* gives any full descriptions. Even the palace of Odysseus, which is the most elaborately treated, is difficult to understand. The poet presupposes a general acquaintance with such buildings, he uses familiar words in more than one sense, and he uses many technical terms without explanation. In general, Odysseus' palace seems to have resembled the mainland buildings of the L.H. period, though it was not a fortress like Tiryns or Mycenae. Priam's palace, which was built throughout of smoothed stone and housed his fifty sons and his twelve sons-in-law, was a grander affair, but we cannot pretend to reconstruct it. In front of Odysseus' palace lay an open courtyard or αὐλή, whose single entrance-gate was the sole means of communication between the palace and the outside world. This gate had a porch and stood open in the daytime, but could be closed with double doors. The wall of the αὐλή had coping-stones, and was perhaps mainly built of sun-dried brick: inside the αὐλή were open sheds (αἴθουσαι), and the court was used as a farmyard. In its centre stood an altar of Zeus Herkeios: we may compare the altar at Tiryns. The rustic house of the swineherd Eumaeus also had an αὐλή containing pigsties: its walls were of unworked stones, topped with thorns, and strengthened outside with oak logs: Achilles' quarters before Troy were a timber copy of a normal palace, and there the αὐλή was fenced with stakes. But we must return to Ithaca. Opposite the outer gate lay the μέγαρον in the narrower sense, but here our difficulties begin. It is almost certain that this μέγαρον was a great hall, like those of Tiryns and Mycenae, but it has even been argued, without gross conflict with the text, that it was a second court, surrounded by cloisters. If it was a hall, it seems to have been entered from the αὐλή through a door behind a porch, and there may have been an ante-room. A passage (λαύρη) apparently ran along one side of the hall, connecting certain inner chambers, directly or indirectly, with the αὐλή. In emergency, a man could escape from the hall into the λαύρη through an

ὀρσοθύρη, seemingly a window in the wall of the hall. The position of the women's quarters is disputable. They could be isolated by the locking of a single door, but they were very close to the hall: Penelope could hear from her room loud noises in the hall, and some passages almost suggest that she could see into it. There were various isolated structures, including Odysseus' bedroom, presumably circular, built of stone round an olive tree, which furnished the support for his bed, and a definitely circular θόλος of uncertain function, possibly identical with the bedroom. Some passages[1] suggest that the hall had a gable roof, and this type is perhaps implied in a simile[2] in the *Iliad*, but the evidence is not conclusive. Part at least of the roof of Circe's palace was a flat terrace reached by a stair or ladder,[3] but it would be rash to conclude that the two palaces were of fundamentally different types.

Temples are mentioned in both poems. Some were perhaps mere shrines, like those which the priest Chryses had frequently roofed to please Apollo,[4] but others were clearly solid buildings, though they may have been small. Only four such are named, two of Athena, two of Apollo. Troy has one of each, Athens one of Athena, Pytho, the later Delphi, one of Apollo. The Athenian temple seems to have formed part of 'Erechtheus' strong palace'. That at Pytho was oracular, and had a stone threshold. Athena's temple at Troy had lockable doors, and apparently contained a seated image.[5] It has been argued that such a building and statue could not have been described before the sixth century B.C., but this is a rash conclusion: we may remember the dais in the old Spartan temple,[6] and the statue basis of the Ephesian Artemisium which may belong to the seventh century.[7]

It is impossible to say how late any Minoan or Mycenaean palace survived. Many doubtless perished before 1000 B.C., and few, if any, can have been visible when the earliest surviving Greek temples were built, though an early Doric temple was perhaps built on the ruins and at the level of the great Tiryns megaron, utilizing some of its walls and column-bases.[8] Some of the tomb façades may in any case have remained to influence the architects of the archaic age.

The next chapter will deal with the existing relics of the architecture of the dark ages which followed the collapse of the Mycenaean civilization.

1 *e.g. Od.* XXII, 239. 2 *Il.* XXIII, 712. 3 *Od.* XI, 62.
4 *Il.* I, 39. 5 *Il.* VI, 297 ff. 6 See p. 53. 7 See p. 91.
[8 To the references on p. 378 add now K. Müller in *Tiryns*, III, 1930, p. 215: he thinks that the megaron itself survived as a temple till it was burnt *c.* 750 B.C., that the Doric temple was then built, and that the surviving capital and tiles (pp. 67 and 69) date from a reconstruction in the late seventh century B.C.]

The Dark Ages. Technical Terms. The Earliest Temples

The period now to be considered is the darkest in the history of Greece. Tradition is scanty and hesitating, and the remains of buildings are few, obscure, and difficult to date. A doubtful light breaks in the seventh century B.C., and early in the sixth we find ourselves in the full stream of the Doric and Ionic traditions. Henceforth, to save space, it will be desirable to use certain simple technical terms and to assume a knowledge of the main features of ordinary Doric and Ionic. A brief account of some of the chief Greek mouldings will therefore be followed by an account of ground-plans, and by descriptions of a typical Doric and a typical Ionic column and entablature, that is to say,[1] all the parts lying above the capitals of the columns. These technical terms are here given in their current English forms, which are more convenient than any pedantic reproduction of the correct Greek or Latin names: the reader will find in Appendix III a select alphabetical glossary which contains some of the chief ancient names which have good authority.

The subject of mouldings, though vitally important, must be treated very briefly.[2] To speak first of the profiles: apart from the flat fillet, they may be divided into those of single curvature and those of double curvature. The former include mouldings of strictly circular section, such as the plain convex roundel and some concave flute-hollows, and various subtler ones, such as those found convex in the echinus[3] of the Doric capital, and convex and concave in the torus and hollows of the Ionic column-base. Of those of double curvature the commonest in early work is the cyma reversa,[4] or Lesbian cymatium, in which the projecting half, usually the upper, has the convex outline. The cyma recta, in which the projecting half is concave, ending in a narrow straight fillet, has been the usual profile of the sima or gutter of temples since the end of the fifth century B.C., but is uncommon earlier. It is closely connected with the 'Doric hawksbeak', which is a common crowning

1 In strict language the sima or gutter is not reckoned part of the entablature.
[2 See further note on p. 61.]
3 The technical terms, such as *echinus*, used in these paragraphs are defined on pp. 41 ff.
4 The names *cyma recta* and *cyma reversa* are established barbarisms: cyma (κῦμα) should be neuter. It is important not to confuse *cyma* and *sima*.

moulding in Doric as late as the fifth century B.C. and is in fact often a cyma recta whose upper, concave curve is concealed by a beak-like overhang:[1] the hawksbeak was probably invented in terracotta gutters.

Most of these mouldings have their typical ornament, whether painted only, as usually in Doric, or carved also, as usually in Ionic. The roundel[2] has the bead-and-reel, and when so adorned is often called an astragal: the 'echinus' or 'ovolo' profile has the egg-and-tongue: the cyma reversa has the heart-shaped leaf-and-dart; the Doric hawksbeak has a simple leaf-pattern: the cyma recta and flat or slightly concave surfaces have lotus and palmette, or scrolls of foliage. Egg-and-tongue and bead-and-reel seem both in origin to be leaf-patterns.

Fig. 16. (*a*) Leaf-and-dart; (*b*) egg-and-tongue, both from Erechtheum (From *Handbuch der Architektur*, Band 1, J. M. Gebhardt's Verlag, Leipzig, Germany)

All these mouldings and ornaments appear in various illustrations in this book. An early cyma reversa, with archaic leaf-and-dart, is shown in the echinus and abacus of the rosette capital from the Ephesian Artemisium in Fig. 41. The volute capital from the same temple in Fig. 40 illustrates the archaic egg-and-tongue. Rather later non-Attic forms of both mouldings are shown in the restored façade of the Treasury of Siphnos in Plate III*a* and in that of the Treasury of Massalia (?) in Fig. 46. The fifth-century Attic form of the cyma reversa, with a convex egg-like bulge of the sides of the leaves of the leaf-and-dart, is shown in Fig. 16, from the Erechtheum, which

1 The earlier hawksbeaks have no convex curve below.
2 The name 'roundel' itself is often used to imply the presence of this ornament.

also illustrates fifth-century egg-and-tongue. This bulging type of leaf-and-dart was not adopted in Asia Minor: the non-Attic type of the fourth century is shown in Figs. 18 and 19, in the abacus of the Ionic capitals of the temple of Athena Polias at Priene: the echinus of these capitals and the mouldings above and below the dentils, are some of the many illustrations of fourth-century non-Attic egg-and-tongue. The sima or gutter in Fig. 19 illustrates the cyma recta. The various stages in the development of the bead-and-reel may also be seen in these and in many other illustrations. The Doric hawksbeak may be seen as the crowning moulding, under the gutter, of the sloping cornice of the temple of Zeus at Olympia in Fig. 17.

With regard to ground-plans, little need here be said in anticipation of the general narrative. The term 'cella' is applied either to the whole of a temple except its surrounding outer colonnade, or, more narrowly, to its principal room. The porch or ante-room is called the pronaos: it is usually open, in which case its side walls normally terminate in rectangular pilasters called antae, whose forms are various and interesting. The mouldings of their capitals seldom have much resemblance to those of the columns. Doric anta-capitals are usually crowned by the hawksbeak: in Ionic the mouldings are often very elaborate and rich. If the porch has columns, these may be either between the antae, when they are called *in antis*, or in front of them, in various arrangements, when they are called prostyle. The porch itself, or even the temple, can be described as *in antis* or prostyle. If there is a division behind the cella, it may be either an adyton—an inner sanctuary reached from the cella— or an open porch, opisthodomus, a duplicate of the pronaos, usually with no door in its back wall: such false porches are rare in buildings lacking a surrounding colonnade, though there are a few double temples without outer colonnades, which have a genuine porch at each end. The general position of the outer or peripteral colonnade, conveniently called the pteron, is obvious from the various ground-plans and illustrations in this book. Its varieties will be discussed as we meet with actual examples. It was of the full height of the building, and was covered by the same roof. Such peripteral colonnades were at all periods confined to temples, though low external colonnades were[1] sometimes placed round houses.

Figs. 17, 18 and 19 give illustrations of a typical Doric and a typical Ionic column and entablature. The first (Fig. 17) is taken from the early

[1] See p. 310. Ictinus seems to have planned a peripteral colonnade round three sides of the Telesterion at Eleusis (see p. 171), but this was in a sense a temple.

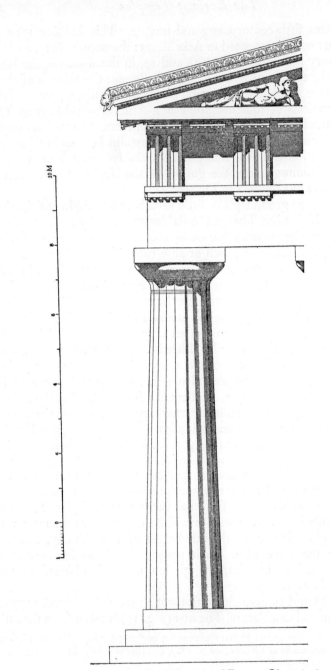

Fig. 17. Typical Doric: Angle of Temple of Zeus at Olympia (restored)

fifth-century B.C.[1] temple of Zeus at Olympia, which was built of local conglomerate, covered, as stone temples almost always were, with fine marble stucco. Several features common to Doric and Ionic will be dealt with in connexion with this figure.

Above the concealed or barely visible euthynteria or levelling-course, not shown in this illustration, which connects the buried foundations with the visible superstructure, come three steps, a usual, but not an obligatory, number, which, together with the platform of which they are the edge,[2] form the crepis or crepidoma, the solid basis of the whole structure. In large temples, these steps were too high for practical use, and a flight of smaller steps, often between parapets,[3] or a gradual sloping ramp,[4] was usually provided at least at the principal end of the temple. So far there is no essential difference between Doric and Ionic.

The Doric column springs directly from the stylobate, the outer part of the top of the crepis, without any base. Its shaft has twenty flutes,[5] which usually meet in sharp edges or arrises, whereas in Ionic the normal number is twenty-four and the hollows are almost always divided by narrow strips of unfluted surface. The shaft is usually, as here, built of separate drums to which fluting was applied after the columns were erected: the joints in this case were wholly concealed by the marble stucco. The construction of these drums will be discussed in the next paragraph. The shaft tapers or diminishes from the bottom upwards, and this 'diminution' often, as here, takes the form of a very delicate curve, the entasis, of which more must be said at a later point.[6] Near the top of the shaft may be observed three incised necking-grooves. This feature is not very old, and its appearance, early in the sixth century B.C., heralds the abandonment of that hollow moulding at the base of the echinus which is described below. It is significant that some early temples[7] were later modernized by the double process of filling up the hollow moulding with stucco and adding necking-grooves. The grooves first appear as a simple bevelling of one face of the joint between the block forming the capital with a short section of the shaft—an almost invariable method of construction—and the top of the rest of the shaft: and this treatment is typical also of fifth-century buildings, such as the Parthenon. The

1 See p. 112.
2 The Greeks confined κρηπίς to the outer edge: see p. 382 *s.v.* Crepidoma.
3 See Fig. 66. 4 See Fig. 60.
5 Sixteen flutes are found in many of the earliest Doric temples, but this number is rare after the early sixth century B.C. Twenty-four and eighteen (see p. 81, n. 1) are also found in Doric, but very rarely. For an early exception to the rule of twenty-four in Ionic see p. 94. 6 See p. 116.
7 For instance temple C at Selinus, for which see p. 71 and Fig. 28.

grooves, however, were often multiplied in the sixth and fifth centuries: we find four more than once in the sixth century, and three frequently in the sixth and fifth, even as late as the temple of Apollo at Bassae: two is a rarer number.

Monolithic shafts, of one piece except for the capital block,[1] are rare in large buildings, Doric or Ionic, between the sixth century B.C. and the Roman period. The joints between drum and drum usually fitted closely only for a ring round the edge. Within this ring lay a rough surface, and then a shallow circular sinking, with a deep hole in its centre, for the reception of wooden blocks, empolia, which contained the wooden dowels or poloi which connected the drums. This system of close fitting at the edges only, anathyrosis, was usual also both in the vertical and horizontal joints of the rectangular blocks of which the walls were built. The blocks in the same course were connected by metal clamps, those in different courses by metal dowels, both usually of wrought iron, and molten lead[2] was used to secure both clamps and dowels in position. A thin coat of lime mortar was sometimes added to ensure the closeness of the joint. It may here be added that 'polygonal' construction, in which large stones of irregularly curved outline were exactly fitted together, is found chiefly in the sixth and fifth centuries B.C., and mainly in terrace and fortification walls. The most famous example is a late sixth-century terrace wall at Delphi, the earliest perhaps the late seventh-century stage of the Telesterion[3] at Eleusis, which is also one of the few examples of its use in a roofed building. It is a common error to attribute this difficult and expensive technique to the Mycenaean age.

The Doric capital, as we have seen, is almost always carved of a single block, which includes a short section of the upper part of the shaft as far down as the necking-rings. The capital proper consists of a spreading convex moulding, the echinus, and a low square block, the abacus. The lower part of the echinus is almost always, as here, decorated[4] with a flat strip, with incised horizontal hollows. In early

1 In Ionic the base is usually a separate block.

2 Lead was also sometimes used to secure foundation joints, for instance in the fifth century B.C. in the Erechtheum at Athens.

3 See p. 169, n. 3. Another example, perhaps of c. 500 B.C., is the Doric temple of Themis (?) at Rhamnus, for which see Appendix I, under that date. Some fine examples are Hellenistic, and polygonal masonry was also used in Italy, for town and terrace walls, as late as the early Empire. See further p. 387.

4 Among the few early Doric capitals which have a completely smooth echinus are some from the Olympian Heraeum (p. 63): for more elaborate decoration see p. 78 (the Paestum temples).

work there is usually a deep hollow moulding at the base of the echinus, suggestive of Minoan types[1]: but this feature disappears about the middle of the sixth century B.C. On the abacus rests the architrave or epistyle, the main stone or marble beam running from column to column: in Doric the architrave is normally smooth, with vertical front and back faces. Structurally,[2] its front and back portions usually consist of separate blocks, of which those to the back are collectively called the antithema: in front, a smooth projecting band, the taenia, forms its upper termination. Above the architrave comes the frieze: this consists in front of alternate triglyphs and metopes, but at the back, which was visible, it has a continuous smooth surface, like that of the architrave. The triglyphs are thick blocks, whose height exceeds their width, divided into three smooth vertical bands by two complete and two half grooves: these do not reach to the top of the triglyph, which is adorned with a smooth projecting band. Below each triglyph, on the face of the architrave under the taenia, is a smooth band, the regula, of the width of the triglyph: from the underside of the regula hang six stone pegs or guttae. The metopes are of the same height as the triglyphs, but wider, being approximately square, and they are set back from the face of the triglyphs: their only ornament, unless they carry figures carved in relief, is a flat projecting band across their tops. The metopes are often thin slabs, grooved into the triglyphs, and the whole frieze, like the architrave, has a solid antithema: but the details of construction varied. There is normally one triglyph to each column and one to each intercolumniation. Above the frieze comes the cornice, a series of heavy blocks projecting to form a sort of continuous stone eaves. The visible underside has a downward tilt resembling but not always identical with that of the roof. To avoid the over-shadowing of the frieze, the cornice has under its projecting part (corona) a low bed-mould of which the vertical face is flush with the surface of the triglyphs. The lower edge of the projecting corona is undercut, to help in the drip of rain-water, and its upper edge is crowned with a moulding, usually, as here, the Doric hawksbeak. The underside of the corona is adorned with mutules, thin flat rectangular slabs carrying eighteen guttae,[3] like those under the regulae, in three rows: the spaces between the mutules are called viae. There is one mutule over each

1 See p. 18, Fig. 6, and Plate I*a* for the Minoan type, and p. 72, Fig. 28 for an example of the groove in archaic Doric.
2 Horizontal joints in the architrave are very rare.
3 The mutules of the archaic Cabirion of Samothrace (see p. 332) had inserted guttae, perhaps of bronze. [For archaic mutules without guttae see E. Gàbrici, *Mon. L.* XXXV, 1933, pp. 148, 218.]

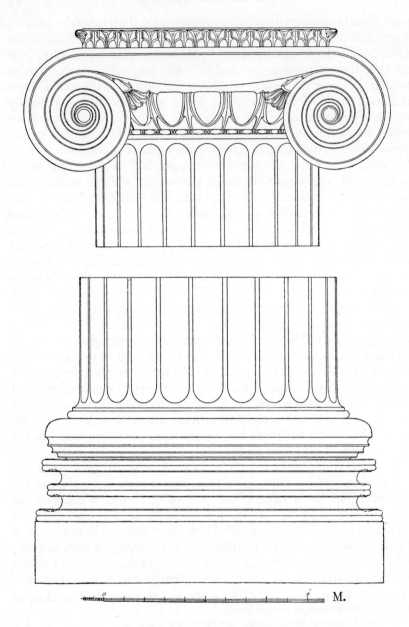

Fig. 18. Typical Ionic: Column of Temple of Athena
Polias, Priene (restored)

triglyph, one over each metope: in early work those over the metopes are sometimes narrower[1] than those over the triglyphs. In non-peripteral Doric buildings the frieze which runs over the porch is usually, but not always,[2] carried round the sides: the architrave also is in theory usually carried round, but being flush with the wall it hardly reveals its presence except by the taenia and regulae at its top. Above the cornice the arrangements varied greatly, and it will be best to post-pone consideration of them till the Ionic column and entablature, up to the cornice, have been described.

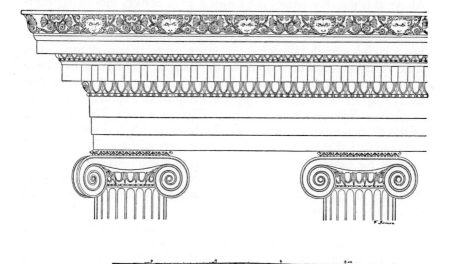

Fig. 19. Typical Ionic: Entablature of Temple of Athena
Polias, Priene (restored)

We may therefore pass at once to Figs. 18 and 19, which are taken from the temple of Athena Polias at Priene, of the second half of the fourth century B.C., which was built entirely of marble. Fig. 18 shows the base and capital of a column, most of the shaft being omitted for the sake of space: the smaller diameter of the upper part, due to 'diminu-tion', should be observed. Fig. 19 shows a corner of the entablature of one of the long sides: the pediment and raking cornice are not here

1 See pp. 72 and 83, Figs. 28 and 35, for examples.
2 The sixth-century B.C. Megarian Treasury at Olympia is an exception, but its sides were hardly accessible. Only the fronts of the columns were here properly fluted. Treasuries were small temple-like structures erected in Panhellenic sanctuaries by various cities, each in its own accustomed style.

shown. Attention need here be called only to those features which differ from Doric. First, the columns rest upon moulded bases, which themselves often stand upon square plinths resembling the Doric abacus, though these plinths are optional. The bases of the Priene temple show the Ephesian form of the old Asiatic type, normal in classical Ionic, except at Athens in the fifth and fourth centuries, till Hellenistic times. This type consists below of a member formed of three sets of double roundels, divided by two deep concave mouldings, the scotiae or trochili; the lowest pair of roundels projects most, the central pair least. Above this member comes the torus, a large convex moulding, horizontally fluted: at Priene, exceptionally, the upper half of this fluting is omitted. The Samian type,[1] which hardly lasted beyond the fifth century B.C., has a single tall concave member below the convex torus. The Attic type,[2] perhaps derived from the Samian, consists of two large rings of convex moulding of which the upper ring has a smaller diameter than the lower, and between the two rings a spreading concave moulding. Examples may be seen in Figs. 55 and 68. The lower end of the shaft terminates in a roundel, above which is a vertical fillet, followed by a sharp inward curve, the apophyge of the shaft: the general form of the Ionic flutes has been described above. At the top of the shaft is a second slighter apophyge, curving outwards again, crowned with a flat fillet, and then with a convex roundel, which is usually carved with the bead-and-reel. Immediately above this roundel almost always comes the joint between shaft and capital. The Ionic capital, unlike the Doric, has quite different front and side views and is meant to be seen chiefly from front or back. It begins with a flat-topped moulding with a profile like that of the Doric echinus, and therefore conveniently called the echinus: it is usually carved with egg-and-tongue. Above this lies the volute-member, which resembles a bolster laid on the echinus, with its loose ends wound up in dropping spirals on each side of the shaft. On the front and back faces there is a wide shallow concave[3] channel (canalis), edged by small mouldings, between the echinus and the abacus: this channel curls round into the spirals of the volutes, which usually have button-like eyes (oculi) at their centres. At the sides the echinus is usually covered and partly absorbed by the under surface of the volute-member, and in front palmettes often, as here, mask the angles where the echinus vanishes under them. The abacus is usually square in plan, and often, as here, has the cyma reversa profile, carved with the

1 See p. 97, Fig. 44. 2 See pp. 122 and 125.
3 Convex in some archaic work.

Lesbian leaf-pattern. The sides of the volute-member, which are called the pulvinus or 'cushion', resemble reels pinched up below, and are decorated in various ways.[1]

The angle columns of an Ionic pteron or porch presented an awkward problem, as they had to be seen from two adjacent sides. The earliest surviving or recorded specimens seem to be those of Athenian buildings of the second half of the fifth century B.C. These adopt the solution always found in later work, which is illustrated in Figs. 19, 53 and 56: the two external faces each have the ordinary front-view form, and the volute at the angle, which does double duty, is bent out at an angle of forty-five degrees. The little-seen inner angle is variously treated.

The architrave is usually, as here, in three bands or fasciae, of unequal height, each projecting a little beyond that below.

In early work the fasciae are often omitted, and there may be only two. Above the top fascia runs an egg-and-tongue over an astragal, and above this again come the dentils, a row of small projecting rectangular members connected with the corona, or projecting part of the cornice,[2] by an egg-and-tongue over an astragal: other mouldings are sometimes added below the cornice. The corona is concave below and has crowning mouldings on its front face. An alternative to the dentils is the continuous Ionic frieze, usually sculptured. This is first attested for the small Treasuries[3] built at Delphi by Ionian cities in the sixth century B.C., and it was usual in fifth-century Ionic architecture at Athens. There is no certain case of the combination of frieze and dentils before the fourth century B.C., and the continuous frieze was probably not used in the entablature of important Ionic temples in Asia, which all seem to have had dentils, before the third century B.C.

It is strange that in Asia the frieze was so slow in establishing itself above the architrave. In other positions friezes, both of stone and terracotta, are found early in Greek temples in Crete and Asia, for instance at Prinia[4] in Crete, at Larisa[5] in north-west Asia Minor, and in a very old temple at Apollonia[6] in Thrace, where the decoration seems to be Ionic in style: terracotta friezes are also characteristic of early Etruscan[7] and Latin temple architecture, which was under strong Ionian influence. Moreover, the Asiatic Greeks in classical times loved the continuous frieze. In the early sixth century B.C. Doric temple at Assos[8] and in the

1 See p. 92, Fig. 40 and p. 121, Fig. 51.
2 In late work the dentils become no more than part of the bed-mould of the cornice.
3 See pp. 100 ff. 4 See p. 56. 5 See p. 59.
6 See E. D. Van Buren, *Greek Fictile Revetments*, 1926, p. 187.
7 See p. 198. 8 See p. 84.

late fifth-century B.C. Nereid Monument[1] at Xanthos we find architraves carved like friezes, and the archaic temple[2] of Artemis at Ephesus treated both column-drums and sima as fields for continuous figure sculpture. Again, both the Nereid Monument and the fourth century B.C. Mausoleum[3] at Halicarnassus had several friezes on the podia or pedestals on which they stood. The prestige of the dentils and the feeling that they were incompatible with the continuous frieze must have been very strong. Probably dentils and frieze represent the same part of a timber prototype,[4] small rafter ends, exposed in the one case, faced with planks or terracotta slabs in the other. In non-peripteral Ionic buildings the frieze or dentils are carried round the sides: so is the architrave, though in archaic buildings it is sometimes reduced in height,[5] and we find often, below the architrave, crowning mouldings and ornaments (the epicranitis) along the sides resembling those of the anta-capitals.

We may now consider the arrangements, both in Doric and Ionic, above the level of the horizontal cornice. Till after the fourth century B.C., in Doric, though not in Ionic, the sloping or raking cornice above the vertical gable-end or pediment[6] usually differs in height and mouldings from the horizontal cornice, and has no mutules on its underside till Hellenistic times.[7] In Ionic dentils were not placed under the raking cornice till the end of the third century B.C.,[8] but the raking cornice was usually identical in form with the horizontal cornice. In the fourth century B.C., however, we find in the temple of Athena Polias at Priene, from which Figs. 18 and 19 are taken, an elaborate series of mouldings under the raking cornice, resembling, except for the absence of dentils, those between the architrave and the horizontal cornice. This feature is absent from the sixth century B.C. Ionic treasuries at Delphi, and from the Athenian Ionic temples of the fifth century B.C. Both in Doric and Ionic the raking cornice is almost always crowned by a continuous gutter or sima, in early times made of terracotta, later usually of marble. Under the pediment the horizontal cornice needed no sima,[9]

1 See p. 135. 2 See p. 94. 3 See p. 151.
4 Some rock-cut tombs in Lycia, Paphlagonia, and elsewhere in Asia Minor are copied from timber structures which appear to illustrate this origin of the dentils.
5 So in the Siphnian Treasury at Delphi (see pp. 100 f.).
6 The pediment was closed by a vertical back-wall, the tympanum. In Doric it usually contained sculpture, but in Ionic this was rare. Details will be found in the course of this book. [See further note on p. 61.]
7 For an example, about 150 B.C., see p. 160.
8 For example in the temple of Zeus at Magnesia on the Maeander after 197 B.C.
9 The Treasury of Gela at Olympia however has such a sima: see p. 55 [and note on p. 61].

but along the sides of the temple it often had one. This lateral sima was always pierced with holes to let out the rain-water: the holes were usually masked by heads of lions, but other forms occur, including rams' heads and plain tubular spouts. These openings were usually placed at frequent intervals, but in early Doric temples there was often only one lion-head spout at each corner. Often there was no sima along the sides, and a row of upright ornaments called antefixes was placed along the cornice: originally these masked the ends of the 'covering tiles' which protected the joints between the 'rain tiles', whereas the sima was formed by turning up the edges of the rain tiles. Antefixes are combined with unpierced lion-heads at the four corners in the later temple of Aphaia in Aegina and in the Parthenon. Antefixes are rare in Ionic, except as[1] ornaments on the top of a sima: the same scheme is found in Doric. Ornaments called acroteria were usually placed above all three angles of each pediment: in early work they were of terracotta, but later of stone or marble: they stood on blocks projecting from the raking cornice.[2]

We have now reached the tiles, which rested, except for the lowest rows above the cornice, on a system of wooden rafters and lighter timbers supported by the main beams of the roof. With a few obscure exceptions[3] gabled roofs seem to have been covered with thatch or wooden shingles till about 700 B.C., but from that date onwards we find a system of terracotta 'rain tiles', with their joints protected by 'covering tiles' of the same material. In some early buildings, but perhaps not the very earliest, both rain and covering tiles are semi-circular, like split drain-pipes, the former being placed with the hollow upwards: the usual and probably the earliest scheme has flat rain tiles with side ridges, often linked or overlapping in many ingenious ways, and over the joints narrow covering tiles, curved below, but usually, except in Sicily and Italy, finished on top like small gable roofs. There were special covering tiles along the ridge of the roof, often adorned with palmettes. Terracotta tiles were usually bedded in clay. In the sixth century B.C. marble tiles, imitating terracotta forms, begin to appear. At first they were sometimes confined to the lowest rows, but from the fifth century B.C. onwards, in all important temples, they almost drove terracotta from the field, though stone tiles are also found, especially in Sicily and Italy where marble was hard to get. Marble tiles rested directly on the timbers.

It may here be added that both in Doric and Ionic peripteral temples

1 For this see p. 131, Fig. 56 (North Porch of Erechtheum, restored).
[2 For acroteria see now *Das Akroter...I. Teil: Archaische Zeit* by K. Volkert, Düren-Rhld, 1932.] 3 See p. 4, n. 1.

the main beams of the ceiling which joins the pteron to the inner building lie just above the level of the outer frieze, and also just above that of the frieze on the wall of the cella proper, if there is one. Such inner friezes are rare in Ionic, and in Doric are usually confined to the façades of the pronaos and opisthodomus: they are not found where the cella lacks open porches. One common feature of temple walls should also be mentioned, the practice of setting a series of large slabs, orthostatai, on the outer side of the wall, as a sort of dado below the more normally constructed upper parts. This feature is probably a survival from the period of sun-dried brick, when the orthostatai and their backing were alone of stone. Elaborate foot-mouldings to walls, resembling column-bases, are common in Ionic. The outer walls of the cella of a peripteral building usually have crowning mouldings, the epicranitis, more elaborate in Ionic than in Doric. It should be added that a few early temples[1] had pediments only above the principal façade, the roof at the back having three slopes, like the sides of a pyramid.

In this brief summary much has perforce been neglected, but in conclusion something must be said of two further matters, the colouring and the lighting of Greek temples. It has already been remarked that temples built of inferior stone were usually covered with fine marble stucco: the surface was consequently almost always marble, though often a mere film. This surface was regularly painted by the obscure 'encaustic' method, which involved the heating of wax, with bright colours, chiefly red and blue, a fact which should always be remembered, though the evidence is seldom sufficient to justify modern restorations. In Doric there was probably, as a rule, little colour below the taenia and regulae at the top of the architrave: the necking-bands of the shaft and the rings at the base of the echinus were often picked out in red, but painting on echinus and abacus was probably exceptional. Ionic capitals were perhaps usually adorned with colour. In Doric the taenia, the under surface of the cornice, the plain surfaces of metopes, and the tympanum of the pediment were often red, the triglyphs, regulae, and mutules blue, the guttae being variously treated. Other colours, including green yellow black brown and gold, were probably used chiefly for the delicate patterns of cornice and sima mouldings, and for the unrealistic painting of the figure sculpture. Ionic was doubtless at least as richly painted as Doric, perhaps more richly, but the evidence is scanty.

1 See p. 67, the Temple of Apollo at Thermum.

The lighting of temples has been much discussed. Since coffered timber ceilings were probably almost universal, it is likely that, apart from lamps, light came, as a rule, only from the door, though windows[1] are not quite unknown: the brightness of the Mediterranean sky must not be forgotten. It is possible that in exceptional cases openings in the ceiling admitted light from the translucent marble tiles, and tiles pierced with holes occur very occasionally. If portions of the roof were ever omitted, this practice was certainly rare.[2]

It is time to return from these anticipations of the classical period to the dim dawn of true Greek architecture. It will be best to begin with Greece proper and the West, the sphere of later Doric, and then pass to the lands east of the Aegean, where Ionic afterwards reigned. It is in Greece itself that we find the most important known post-Mycenaean buildings earlier than the seventh century B.C.[3]

The oldest was discovered in the Aetolian sanctuary of Thermum, where we find (Fig. 20) a continuous series of buildings ranging from Helladic to late Hellenistic times. We are here concerned chiefly with a building called 'Megaron B', but this cannot be understood without references to its predecessors, which strictly fall outside the limits of this section. Its successors, an important group of archaic temples, will be discussed in the next chapter.[4] The very earliest remains, primitive circular huts, may here be ignored. Next comes a group of M.H. or L.H. buildings, partly rectilinear, and partly of the 'hairpin' type which was mentioned in an earlier chapter.[5] All were built of small stones in their lower parts, carrying walls of wood and clay, and thatched with reeds: the chief walls were tilted inwards, and the roofs were probably curved like barrel-vaults. The chief of the 'hairpin' buildings has been named 'Megaron A'. Its main axis is roughly north and south: its length was between seventy and eighty feet. The side walls are straight for one-third of their length, but then curve very slightly till they meet in the sharp bend at the north. Cross-walls divided the interior into a porch and two inner chambers: the porch was itself

1 For instance, the east room of the Erechtheum (p. 130) had a window each side of the door: the temple of Zeus at Labranda in Asia Minor had windows all round: the date is perhaps Hellenistic. There was also a series of windows in the cella wall of the Temple of Bel at Palmyra (p. 222), of the first century A.D., in the Temple of Baalsamîn on the same site, and in some other Roman temples. [See now R. Herbig in *J.D.A.I.* XLIV, 1929, pp. 224 ff.]
2 Colossal temples not wholly roofed, such as the Didymaion of Miletus (p. 153), are an easily intelligible exception.
[3 But see notes on pp. 61 and 105.] 4 See p. 66. 5 See p. 24.

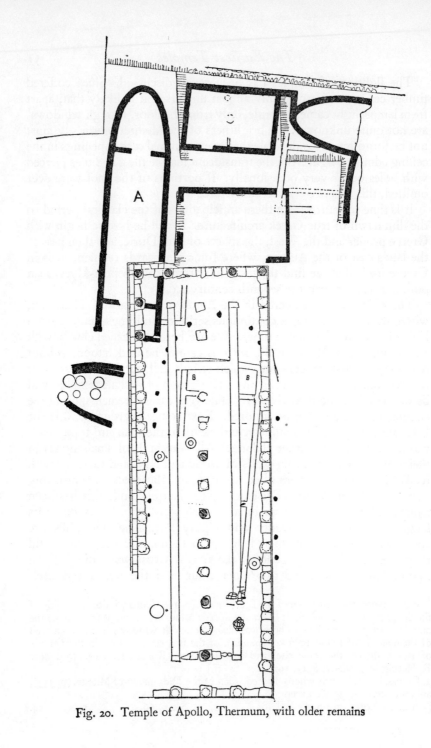

Fig. 20. Temple of Apollo, Thermum, with older remains

partly closed by a wall, which left a gap at one corner. 'Megaron A' was certainly a house or palace.

'Megaron B', which was about seventy feet in length, was later than the 'Megaron A' group, and can be proved to have lasted long. Its latest excavator, Rhomaios, believes that its architect saw 'Megaron A' standing, and that the architects of the archaic temples saw 'Megaron B'. It is, in any case, certain that 'Megaron B' has strong technical affinities both with its predecessors and with its successors. Its original date was perhaps the tenth century B.C. At first sight it might pass for an archaic temple: it looks, at a glance, rectilinear and rectangular, and it is divided by cross-walls into three chambers. But close inspection has revealed a fairly strong curve in the short north wall (it is oriented like 'Megaron A'), and a subtler curve in the east wall: the west wall is mostly destroyed. The porch resembled that of 'Megaron A'. A further feature of great interest is the presence of eighteen thin slabs of stone lying round 'Megaron B', and obviously connected with it. These certainly carried wooden posts, and form the earliest known Greek example of the peripteral scheme characteristic of classical architecture. They seem to be a later addition, and they are oddly arranged, for they are not parallel with the walls of the building, but are set in an elliptical curve, which recalls the shape of the north end of 'Megaron A'. At the south end, however, the line of the building was probably followed, the posts running straight across from east to west. Some, at least, of the posts seem to have been rectangular, and to have stood in slots built up with small stones. 'Megaron B' may have been either a house or a temple: it is not impossible that it was built as the one and ultimately became the other.[1] On its ruins, with a slightly different orientation, was built the most important of the archaic temples, that of Apollo.

Less impressive, but scarcely less important, are the remains (Plate II *a*) of the oldest temple of the goddess Orthia (later identified with Artemis) at Sparta: here, for the first time, we have to do with an indisputable temple. The remains were assigned by their excavator Dawkins, on the evidence of stratification, to the end of the ninth century B.C., and they can scarcely be later than the eighth.[2] This old temple received curved rain-tiles and covering-tiles and semicircular antefixes in the seventh century B.C., and was replaced by another in the sixth. Fortunately the orientation was slightly changed, and parts of the

1 The temple of Demeter Thesmophorus at Thebes was said to have been Cadmus' palace (Pausanias IX, 16, 5).
2 Rodenwaldt (*Ath. Mitt.* XLIV, 1919, pp. 175 ff.) suggests that they may be as late as the seventh, but he is trying to prove the late appearance of temples in Greece. [See now R. M. Dawkins, *The Sanctuary of Artemis Orthia at Sparta*, 1929.]

old west and south walls escaped, together with an interior row of flat horizontal stones, parallel to the south wall. The lower parts of the walls were of thin slabs set on edge, on a foundation of pebbles: the upper were of sun-dried brick, which has melted into red earth, and at intervals in the south wall, corresponding to the flat stones inside, upright timbers were set in simple stone sockets. It is clear that wooden posts or columns ran down the inside of the temple, and that the cross-beams of the roof rested partly on these and partly on the timbers in the side walls. The length of the temple is uncertain, but there was probably a single row of inner columns, in which case the width was about fifteen feet. An earth dais about three feet wide, faced with stone slabs, occupied the west end. The original form of the roof is unknown. The single central row postulated for this temple is a scheme known to the Bronze Age, in Thessaly and at Troy and Tiryns, and is not uncommon in archaic work, both Doric and Ionic. The nearest certain parallel in Minoan architecture is the single-columned porch. There is little in Greece to place beside this temple or 'Megaron B', though an obscure group of early temples in the precinct of Apollo Corynthius at Corone near Longà in Messenia perhaps includes some eighth-century structures.[1]

Here may also be mentioned an interesting little terracotta model, found in the excavation of the Heraeum of Argos, part of which is shown in Plate I*b*. It seems to date from the eighth century B.C. The restoration shown in Plate I*c* is not wholly correct.[2] The building represented is perhaps the contemporary form of the temple of Hera: this building was rectangular in plan, with a prostyle porch, of two columns only, in the line of the side-walls of the cella, which projected as very short antae beyond the cross-wall which contained the door. The columns are lost in the models: they seem to have been joined to the antae near their tops by horizontal struts. There was a flat roof, projecting beyond the walls, and a steeply pitched roof above, set a little back, an arrangement which suggests the fusion of two traditions. The flat roof covered the porch, and there was a pediment at each end, the front one containing a large door or window, but the pitched roof did not, as in I*c*, reach beyond the ends of the side-walls of the cella. These side-walls have triangular ventilation holes. The painting of the model is not realistic, but we may guess that the building was of half-timbered sun-dried brick, with wooden columns and a thatched or shingled roof. This type of porch, two prostyle columns carrying a pediment, is rare, but not unknown. There is an example, dating from the first half

[1 and 2 See further notes on p. 61.]

of the sixth century B.C., in the precinct of Demeter at Gaggera near Selinus in Sicily, and another at Sunium[1]: it occurs also in Etrusco-Latin temple architecture, for instance in the temple at Alatri.[2]

At Gonnos in Thessaly stood a curious archaic temple of Athena, built of small stones[3] on a horse-shoe plan, about thirty feet long, with perhaps two columns in its porch. It has left terracotta remains, including metopes, assigned to the seventh and sixth centuries B.C. It was rebuilt in the fourth or third century B.C. with the same plan. There was probably a similar building in the neighbouring town Homolion.

The Heraeum of Olympia was probably built in the seventh century B.C., and it had predecessors, but both this and certain other definitely Doric early buildings may be postponed to the next chapter. It will, however, be convenient to mention here a group of somewhat later buildings, which belong to the Doric area, but lack distinctive Doric features, and have therefore been named 'pre-Doric'.[4] One example seems to belong to the late seventh century, while some are of the sixth or later. All are externally plain rectangles entered by a single door in one of the short sides, and they have neither columns nor friezes. The earliest are two superimposed temples of Demeter at Gaggera near Selinus in Sicily. The older was perhaps built soon after the foundation of Selinus in 628 B.C.: its early sixth-century successor, which repeated its main lines, was at first divided internally into three rooms, each entered by a central door: it was modified later. It had a gable roof and pediments, but the profiles of the horizontal and raking cornices are unique, and their junction at the corners is so clumsy as to suggest that the builders were used to flat roofs. There is a similar building on the Selinus Acropolis and another at Agrigentum (the Greek Akragas), and the original form of the early sixth-century Treasury of the Sicilian city Gela at Olympia was even simpler, being a single rectangular room, with gable roof and pediments, perhaps entered from one of the short sides. At this stage the Treasury was adorned with a singularly elaborate scheme of painted terracotta cornice-casing, sima, and ante-fixes, including the somewhat rare feature of a sima on the horizontal cornice under the pediment.[5] A flat-roofed Doric porch, of six columns and two engaged half-columns, was added to one of the long sides a century later. Two small temples on Mount Cotilius near Bassae in

1 For both of these see p. 325. 2 See p. 199.
3 For buildings of similar plan on the Athenian Acropolis see pp. 84 and 113. See also p. 163 for the 'Council House' at Olympia.
[4 See also note on p. 61.] [5 See p. 48, n. 9 and note on p. 61.]

Arcadia, perhaps of the sixth century B.C., resemble those of Gaggera. It should be added that the cellae of some of the chief early peripteral temples in Sicily are of this 'pre-Doric' type, though surrounded by the complete Doric apparatus of columns, frieze and cornice.[1] This type of porchless rectangle is not confined to the Doric area, as the later part of this chapter will show.

We may now pass to the east of the Aegean, and may begin with Crete, which contains some very early temples of exceptional interest.[2]

The oldest are probably two rectangular structures found by Pernier near the village of Prinia, in the ruins of a strong hill-city which commanded the road from Cnossus to Phaestus. Its private houses of post-Minoan date show definite Minoan survivals. The temples may both be assigned to the seventh century B.C. The more important (Fig. 21) has been named 'Temple A'. It was entered from the east, through a pronaos, which was probably open with one square central pillar: the whole building measured about twenty-five by fifty feet externally. Between the porch and the cella was a single door, flanked on the inside by semicircular disks, for the support of wooden half-columns or door-posts. A well-constructed sacrificial pit, containing burnt bones, was found in the centre of the cella, and there were two stone bases which probably supported wooden columns, one before the pit, and one behind it. Most interesting of

Fig. 21. 'Temple A', Prinia (restored)

all, there were found among the ruins many fragments of architectural sculpture in limestone. Some of these came from a frieze about three feet high, carved with horsemen in relief, with traces of painting. Others belonged to two almost identical seated 'goddesses' each resting upon a sort of architrave: one side of each of these architraves was carved with a procession of animals (stags in one case, panthers in the other), and the under surface of each was adorned with a standing goddess in sunk relief. The seated figures must therefore have occupied some raised position: Pernier would place them in the upper part of the main door, facing one another, and supported from below by a single

[1 and 2 See further notes on p. 61.]

wooden column. The frieze he would place in the ordinary external position, above a wooden architrave. There are remains of volutes, probably acroteria from the roof-angles. No tiles were found, and Pernier supposes the roof to have been flat.[1] 'Temple B' is similar, but less regularly planned and worse preserved. The porch was entered by a central door, and there was an inner room at the back. There was a sacrificial pit, as in 'A', but only one conical stone behind it, seemingly not a column base. Pernier is not quite certain that 'B' was a temple.

The temple of the Pythian Apollo at Gortyn, in the same region of Crete, is probably not much later, and despite alterations its original form is certain. It was almost square (measuring about sixty-five feet in width by about fifty-five in depth) and extremely plain. Two steps ran all round, on a low sill course, and a single door opened in the middle of the east side. The material was local limestone. The walls were solidly and carefully built: their outside was covered with archaic inscriptions, some of which may be as old as the seventh century B.C. The interior was perhaps faced with bronze plates[2]: the only surviving decoration consists of two slight rectangular projections at each end of the façade, each with a convex moulding in its inner angle. There is no trace of early inner columns, but from the size of the building it seems certain that such existed. Inside to the right of the door there is a sunk pit, which had a lid: this pit is set at an oblique angle to the rest of the building. About 200 B.C. a porch was added, faced with six Doric half-columns, and in the third century A.D. the whole cella was rebuilt, chiefly of the old materials, an apse was thrown out of the west wall, and eight Corinthian columns, in two rows, inserted.

In Asia Minor the oldest important remains have been found in Aeolis, the north-west corner of the country. Here, for the first time, we find stone columns and terracotta tiles and simae, and feel ourselves definitely upon the border-line of the classical styles. The most famous of these buildings is the temple (Fig. 22) excavated by Koldewey at Neandria in 1889. This town stands upon a rocky hill about thirty miles south of Troy. Its early prosperity was soon lost, and late in the fourth century B.C. Antigonus swept its remaining inhabitants, with those of many other small towns, into his new foundation Antigonia (later Alexandria) Troas. The temple was already standing when Neandria

[1 R. J. H. Jenkins in *Dedalica*, 1936, 79, argues that the 'goddesses' are much later in style than the horseman frieze (which he places before 650 B.C.) and may be a restoration.]

2 This practice was fairly common: the best known example is the temple of Athena Chalkioikos at Sparta.

was remodelled in the fifth century B.C. and internal evidence suggests that it was built in the seventh. Constructed chiefly of strong local limestone, it stands on a sort of raised base or podium, without steps. The temple was a simple rectangle measuring externally about thirty feet by about sixty-nine, entered by a single door in the north-west end: it ran from north-west to south-east. Down the middle stood a row of seven stone columns, baseless and unfluted, with considerable diminution. The roof was clearly gabled, for it had tiles, which were very archaic: the columns no doubt carried the wooden ridge-beam of the roof. The capitals (Fig. 23) consisted of three main elements; these

Fig. 22. Temple at Neandria

were found separate, but Koldewey was almost certainly right in combining them. At the bottom came a ring of leaves, in some cases strongly undercut, then a convex moulding, also adorned with leaves, and lastly the most striking element, a double volute, designed, like the classical Ionic capital, to be seen chiefly from front or back—here, indeed, only from the front, the side of the door, for the backs are carelessly executed. The volute-member consists of two large spirals which spring upwards and outwards from the shaft, as if a pliant stick were split at the end, and each half curved outwards into a spiral. The space between the spirals is solid, and decorated with a fan-like pattern: this portion rises higher than the spirals, and forms a comparatively small bearing-surface for the beam above. Very similar capitals have been found in the neighbouring island of Lesbos, especially in a ruined church at Kolumdado: the site of the temple from which these were carried, perhaps that of Apollo Napaios, has lately been identified at the ancient

Nape. But the only ones yet discovered which equal and even surpass those of Neandria in elaboration come from Larisa (Plate II*b*), also in north-west Asia Minor. The site of the Larisa temple has now been

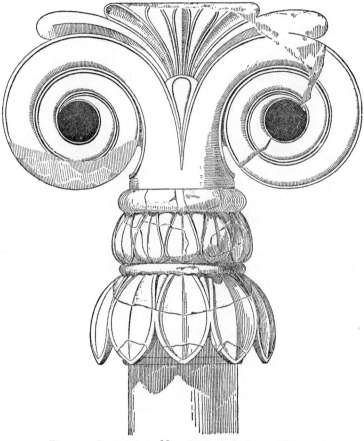

Fig. 23. Capital from Neandria temple (restored)

found, and important architectural terracottas, including continuous friezes, were associated with the capitals.[1] The Kolumdado columns had unfluted shafts and simple bases, consisting of a very small convex moulding resting on a very large one, both being plain.

The connexion of this type of capital, best called 'Aeolic',[2] with

[1 See further note on p. 61.]
2 Koldewey called them 'proto-Ionic', but this name implies a theory. Dinsmoor's recent use of 'Aeolic' for the palm-capitals of Delphi (see p. 101) is confusing.

earlier Asiatic and later Ionic forms is always being discussed, but no agreement has been reached. We must first form a clear picture of the differences between this type and that of Ionic proper. In Ionic the volutes do not spring from the shaft: the whole volute-member is a separable cushion laid upon the shaft, and the prominent flat-topped echinus separates from the shaft the continuous channel which joins the two side spirals. Whether this difference implies diversity of origin is disputable. The echinus may represent the overhanging leaf-moulding of Neandria and Larisa: in some archaic Ionic examples it takes a similar form. We also find, in the capitals of various non-architectural columns from Athens and Delos, methods of treating the volutes intermediate between that of Aeolic and that of Ionic. It may be that the classical Ionic form is an adaptation[1] of the Aeolic scheme of *decoration* to a special type of timber *construction*, the 'bracket-capital' so often found in modern wooden buildings—a rectangular (not square)[2] block of wood lying between the top of a post and the beams. On the other hand, capitals which appear to resemble those of Ionic are shown on Hittite and Iranian reliefs, and the Aeolic and Ionic types may be originally unconnected.[3] The intermediate forms of Athens and Delos may well, in any case, be a fusion rather than a stage in evolution.

Whether or not the Aeolic capital gave birth to the Ionic, its own origin is probably to be found in Asiatic and Egyptian types. Decoratively it is simply a variety of the famous 'palmette' pattern, which the Minoan Cretans seem to have borrowed from Egypt and which the Greeks of the seventh and sixth centuries obtained afresh from oriental sources. We see both in Egypt and in Babylonia, in paintings and reliefs, capitals which appear to resemble the Aeolic. For the most part, indeed, these represent flimsy or temporary structures, and in some cases the artist may have intended the side-view of a circular or four-sided capital: but there exist also certain semi-architectural half-columns in tombs in Cyprus, with capitals of the Aeolic type, showing strong Egyptian influence, and similar capitals, ascribed to the tenth century B.C., have been found at Megiddo, and others at Samaria, and it seems almost certain that the Aeolic school borrowed from the East.[4] Critics

1 Weickert has suggested that the Ionic spirals represent the profile view of a hanging leaf-pattern on the sides of the capital: see *Das lesbische Kymation*, 1913, p. 44.
2 The abacus in the Croesus temple at Ephesus is a narrow oblong: see p. 94.
[3 For Iran see E. E. Herzfeld, *Archaeological History of Iran*, 1935, p. 32.]
[4 See Sir George Hill, *A History of Cyprus*, Vol. I, Cambridge, 1940: he dates the earliest Cypriot examples sixth century B.C.]

have tried to derive the Aeolic capital from particular vegetable forms, and have located the original adaptation in Crete, Asia, or Egypt.

In Asia Minor, in the sixth century B.C., we find Ionic in full development; but the next chapters must be devoted to early Doric.

[p. 37, n. 2. For mouldings see now Lucy T. Shoe, *Profiles of Greek Mouldings*, Harvard University Press, 1936, which deals with all stone and marble remains east of the Adriatic from the seventh to the second century B.C. She argues forcibly that the cyma reversa, first found at Ephesus c. 560 B.C., and unknown to sixth-century Miletus, Myus, Samos, or Naucratis, is derived from the essentially Ionic 'ovolo' profile by the addition of a reverse curve to its non-projecting end; and that the cyma recta is similarly derived from the essentially Doric and very ancient 'cavetto', a vertical surface ending in a sharp concave outward curve and crowned with a plain fillet. The cyma recta first occurs in the early sixth century at Garitsa in Corcyra and the hawksbeak a little later at Athens.

p. 48, n. 6. It may be added that the height of a Greek pediment was usually to its width between 1:7 and 1:9, and that the practice of the fifth century B.C., both in Doric and Ionic, favoured 1:8 or a shade over 8. This is often expressed as an inclination of 1 in 4. The development was irregularly from high to low pitch.

p. 48, n. 9. A few other Sicilian examples of sima on horizontal cornice of this date are known: see W. Darsow, *Siȝil. Dachterrakotten*, Berlin, 1938, p. 38.

p. 54, n. 1. More very early temples are now known, for instance the ninth-century B.C. apsidal temple of Hera Akraia at Perachora near Corinth. See Humfry Payne, *Perachora*, 1940, pp. 27 ff. and p. 322 *infra*.

p. 54, n. 2. See G. P. Oikonomos, '*E. 'A.* 1931 and also the important eighth-century B.C. temple-models from Perachora published in Humfry Payne, *op. cit.* pp. 34 ff., and P. Mingazzini's list in *Mon. L.* XXXVIII, 1938, p. 921: also D. Burr, *Hesperia*, II, 1933, p. 547.

p. 55, n. 4. Add now two temples of the late sixth century B.C. at Taxiarchis in Aetolia, each of stone and divided into two rooms, the inner being deeper. The larger temple, 7·32 m. × 11·25 m., has in its wide entrance-door two rectangular stone pillars with simple bases and capitals. There was a gabled roof with plain horizontal and raking cornices, but no definitely Doric features. The proportions are careful (*e.g.* length: breadth :: 1½ : 1). See K. Rhomaios, '*A. Δελτ.* X, 1926 (1929), pp. 1 ff.

p. 56, n. 1. For these 'pre-Doric' and similar buildings at Selinus see now E. Gàbrici in *Mon. L.* XXXV, 1933, pp. 137 ff.: there is evidence that some of the early Selinus terracottas come from purely timber temples.

p. 56, n. 2. Add now for Crete the early eighth-century B.C. rectangular temple at Dreros (5·50 m. by 9·50 m.) published by Sp. Marinatos in *B.C.H.* LX, 1936, pp. 214 ff., and the even older temple at Karphi, dated c. 1000 B.C., a city notable also for houses of the megaron type, excavated by J. D. S. Pendlebury and others and published in *B.S.A.* XXXVIII, 1937–38, pp. 57 ff.

p. 59, n. 1. For the Larisa capital see now L. Kjellberg in *Corolla Archaeologica Principi Hereditario Regni Sueciae...dedicata*, 1932, pp. 238 ff. He dates it c. 575 B.C. and regards it as the latest example of the type. For the temple see *A.A.* 1934, cc. 363 ff.: it is restored with a podium and cella like those of Neandria, and the same orientation, but the cella is less long in proportion, and is supposed to have had a pteron, restored as 9 by 6 dipteral on the façade, but no inner columns. The cella survived from an earlier stage. For the terracottas see L. Kjellberg in *Eranos*, XXVIII, 1930, pp. 49 ff.]

The Earliest Doric and its Timber Prototypes

We may now turn to the most interesting of all early Doric buildings, the Heraeum, or temple of Hera, at Olympia. According to a tradition recorded by Pausanias,[1] it was built by Oxylus, the leader of an Aetolian invasion of Elis about 1100 B.C. Dörpfeld, who excavated the Heraeum, was long inclined to accept this date for the bulk of the surviving building: but from the first many archaeologists found it impossible to reconcile its highly-developed ground-plan with such vast antiquity, while others laid stress upon certain comparatively late objects found under its walls. Renewed digging by Dörpfeld and Buschor has made it certain that the existing building belongs to the late seventh century B.C.: but it also appears that it is only the latest of a series of super-imposed structures, having been preceded by a peripteral temple, itself the successor of a non-peripteral one. The oldest, non-peripteral, temple had much the same plan as its successors, but extended less far to the west. This temple, after being substantially modified, was burnt. The second temple was built at a higher level, and seems to have anticipated all the chief features of its successor's plan. This temple, which may never have been finished, did not perish by fire: the surviving building is a deliberate reconstruction. The three temples probably succeeded one another quickly, perhaps within a century: it seems that the site was repeatedly damaged by land-slides from the neighbouring hill.[2]

The existing building (Fig. 24), like its immediate predecessor, is surrounded by a peripteral colonnade: this colonnade has six columns[3] at the ends, and sixteen along the sides, counting, as always, the angle columns twice. The temple proper has pronaos, cella, and the oldest known opisthodomus, and each porch has two columns between antae: that is, they are distyle *in antis*. These features are surprisingly advanced, but the materials and constructional methods are those of the preceding age. The walls, to the height of some three feet, are of excellent masonry: above that they were of sun-dried brick,[4] and

1 V, 16, 1.
[2 See further note on p. 68.]
3 Such temples are called *hexastyle*, whatever the number of columns on the flanks: so tetrastyle, octastyle, etc.
4 The melting of this brick preserved from destruction the famous Hermes of Praxiteles, which stood in the temple.

the antae were consequently, as at Troy[1] and Tiryns, faced with
wood. Further, the columns were originally of wood. This is certain,
on two grounds: first, Pausanias,[2] in the second century A.D., found that
one of the two columns in the opisthodomus was of oak: secondly, the
surviving columns are an extraordinary mixture, ranging from the
style and technique of the seventh or early sixth century B.C. to Hellen-
istic or Roman forms. It is obvious that they were gradually erected
during many centuries. Yet columns of some sort must have existed
from the first, and the only possible conclusion is that they were of
wood. Inside the cella a series of short walls, perhaps of the full height
of the temple, originally projected inwards, at right angles to the

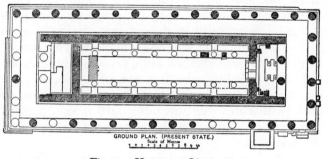

GROUND PLAN. (PRESENT STATE.)
Scale of Metres

Fig. 24. Heraeum, Olympia

side-walls, so as to form shallow side-chapels: later these were cut
away. These cross-walls corresponded in position to alternate pteron
columns—a kind of correspondence rare in classical work, and prob-
ably connected with the technique of timber and sun-dried brick: it
recalls the correspondence of wall-timbers and columns in the old temple
at Sparta. The cross-walls of the Heraeum may have ended in engaged
columns, and there was probably originally a free column between
each pair of cross-walls, corresponding to the other pteron columns.
When the walls were removed, free columns probably replaced them.
We know nothing of architrave, frieze or cornice, which were doubtless
of wood: the column-spacing[3] seems to support the view that there
was a triglyph and metope frieze. The roof was gabled from the first,
for it has left terracotta tiles and acroteria of some of the earliest known

1 See pp. 23 and 30.
2 V, 16, 1. Pausanias does not suggest, as most modern writers imply, that he knew
or guessed that any other of the columns had once been wooden.
3 See p. 111.

types: it also had a flat ceiling, as we know from Pausanias.[1] The inner projecting walls and the inner columns, unlike the pteron, seem to be legacies from the very earliest form of the temple.

Some recent critics have minimized the importance of the wooden elements of the Heraeum, regarding them as provincial copies of stone models. It seems preferable to stress the connexion between Elis and Aetolia, and to regard the Heraeum as the descendant of 'Megaron B', and an essential link in the chain of Doric development. The slow substitution of stone columns for wooden ones is strange. It is possible, as Dörpfeld suggests, that the wooden columns were taken over ready made from the older peripteral temple. Presumably the new fashion proved irresistible soon after the surviving temple was finished, and modernization began almost at once, but progressed slowly, through lack of funds. The majority of the columns, however, seem to be archaic. These differ much in style and construction, but many fall into groups of two or three of identical form, probably the gifts, from time to time, of cities or individuals. It is not, of course, certain that the Olympian Heraeum was the first Doric temple with stone columns: it may well be that this step was taken further east, perhaps in the Argolid, and stone columns may have appeared earlier still in Crete, Cyprus, or Asia Minor.

This is a suitable point to consider the question whether the typical Doric features—columns and triglyph frieze—already existed in a wooden form, or were first introduced in stone. It is difficult to doubt that they were traditional wooden forms. There is nothing like the triglyph frieze in any known earlier architecture, except possibly, as we have seen, in the Minoan and Mycenaean.[2] The Doric column does resemble in some respects a rare Egyptian type, of which the best known though not the oldest examples are in rock-hewn tombs at Beni-Hasan; and though this type was not used in Egypt after the sixteenth century B.C. specimens of it were doubtless visible in the seventh century, for some are visible now. But the Doric column is really more like Mycenaean[3] and Minoan ones, and it is incredible that a new and exotic form should have spread so fast, with no essential variation, through the whole of the western Greek world. Early Doric columns are often thick and heavy, but some of the oldest of all are extremely slender, with

1 V, 20, 4. 2 See pp. 30 f.
3 The capitals of some archaic columns of Doric type from central Italy closely resemble those of the 'Treasury of Atreus': see R. Delbrück in *Röm. Mitt.* XVIII, 1903, p. 160, Fig. 7.

widely spreading capitals, and this type closely resembles certain Doric columns shown in Athenian vase-paintings, which seem to be of wood. Of this slender type the most striking examples are the remains of twelve columns (Fig. 25) from the sanctuary of Athena Pronaia at Delphi, which are assigned to a lost seventh-century temple: they are perhaps the oldest definitely Doric members known, and their height was probably about six and a half times their lower diameters, which means that they were about as slender as the famous columns of the fourth-century B.C. temple of Zeus at Nemea (p. 145), though they tapered far more sharply.[1] The forms of the triglyph frieze are in themselves, like the Ionic dentils, suggestion of a wooden origin, especially the guttae of the regulae and mutules: the triglyphs probably represent ornamental wooden facing of beam-ends,[2] the metopes the open spaces between: the recent suggestion that the triglyphs represent crenellations is less plausible.[3] In any case they were probably conventionalized before their translation into stone. It has also been suggested that the peripteral scheme was borrowed from Egypt, though it is there extremely rare, and has no close resemblance to Greek types: 'Megaron B' is a much more plausible ancestor.

Next to the Olympian Heraeum,[4] the most important temples which stand close to the timber tradition are those of Thermum, the largest of which, that of Apollo Thermaios, was built over the remains of 'Megaron B'.[5] But, before this is described, a word should be

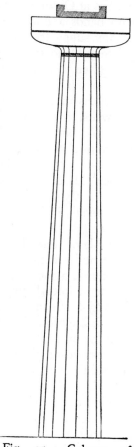

Fig. 25. Column of Temple of Athena Pronaia, Delphi (restored). (From *Les Fouilles de Delphes,* II, I Pl. XIII)

[1 See further note on p. 68.]
2 This view is as old as Hellenistic times: cf. Vitruvius, IV, 2, 2.
3 L. B. Holland in *Am. Journ. Arch.* XXI, 1917, pp. 117 ff., XXIV, 1920, pp. 323 ff.
4 Other Doric temples which seem to have had a timber stage have been found at Pherae in Thessaly (*Arch. Anz.* 1926, col. 249) and Calydon in Aetolia (see p. 362).
5 See p. 53.

said of certain other timber structures known to have survived till a late date, chiefly in the Peloponnese. Pausanias[1] saw near the Temple of Zeus at Olympia a wooden column, decayed with age, held together with bands and adorned with a poetical inscription: it stood under a canopy supported by four columns, and was said to be a relic of the palace of Oenomaus, destroyed by lightning. So did Manuel Comnenus strengthen with metal and honour with a pious couplet Constantine's column, injured by lightning, at Constantinople. Again, near Olympia, in the Elis market-place, Pausanias saw a low temple-like building, without walls, its roof upheld by columns carved of oak—the tomb, an old man told him, of Oxylus, the Aetolian founder of the Heraeum. He mentions also a very old temple of Poseidon Hippios,[2] near Mantinea in Arcadia, built by Trophonius and Agamedes of oak logs fitted together. He did not see it, for the Emperor Hadrian had enclosed its dangerously sacred ruins in a larger temple: it may be compared to the Portiuncula in Santa Maria degli Angeli at Assisi, except that it was inaccessible. At the Achaean colony of Metapontum, in South Italy, was a temple of Juno (Hera)[3] with vinewood columns. We know also of a few temples with walls of sun-dried brick, but this material was not necessarily associated with timber.

The peripteral temple of Apollo Thermaios (five[4] by fifteen), which dates from the middle or second half of the seventh century B.C., has a remarkable ground-plan (Fig. 20, p. 52). It was exceptionally narrow, even for an archaic temple, and had a central row of inner columns: it measured on the stylobate about 40 by about 126 feet. It was not entered through a porch, nor yet through a door pierced in a solid wall; instead, the first of the inner row of the columns stood *in antis*, in the opening between the side walls of the cella, the gaps on each side of it being closed by wooden doors. There was an opisthodomus, of double the usual depth, with a single column *in antis*, and one more column behind it. More interesting still are the facts of the material and construction. The sanctuary was twice sacked late in the third century B.C., and the ruins show signs of a hasty restoration: but it is likely that the columns were originally of wood, which, as at Olympia, was gradually replaced with stone. The material of the upper part of the

1 V, 20, 6. 2 VIII, 10, 2.
3 Pliny, *Nat. Hist.* XIV, 9.
4 This convenient way of stating the number of columns on the fronts and flanks of a peripteral colonnade will be used from this point on: angle columns are counted twice.

walls is uncertain: probably not stone, and possibly wood. The entablature was probably of wood to the last, and there were terracotta metopes, which evidently fitted into wooden triglyphs: the metopes were painted with figure-subjects in an archaic style, apparently by Corinthian artists: they must have remained in position in Hellenistic times, for one of them was repainted at that period.[1] There were also some very archaic antefixes and others of later style. It is demonstrable, from the form of the roof-tiles, that the temple had only one pediment,[2] in front: at the back the roof sloped down to the eaves. The sanctuary contained two or three other temples of similar construction, but these have not yet been adequately published: one temple had terracotta triglyphs,[3] each worked in a single piece with a metope.

At Cyrene in Tripoli an early peripteral Doric temple has been found under the later temple of Apollo. In its original form, dating from about 600 B.C., it consisted of a porchless cella, with an inner adyton, surrounded by a peripteral colonnade (six by eleven). The foundations were very shallow, and the walls, which were about four and a half feet thick, were of stone only to a height of about two and a half feet, the rest being of sun-dried bricks, remains of which have been found. The inner width of the cella was about twenty-three feet, the inner length of the cella proper about forty-four feet, that of the adyton about nineteen feet. There were two rows of sixteen-fluted stone columns, on stylobates, in each room, five on each side in the outer part, two on each side in the inner: and these carried upper rows of smaller stone columns. Fragments of the capitals have been found, and also of the entablature, which is now known to have been of stone and to have included triglyphs, resembling those of the older temple of Aphaia at Aegina, and pedimental sculpture. The right aisle had a series of stone-lined receptacles, with bolted stone lids, under its pavement, reminiscent of the Cnossus[4] magazines. In the middle of the cella was a round pit,

[1 For these metopes see now Humfry Payne, *B.S.A.* xxvii, 1926, pp. 124 ff.]
2 A similar roof-tile found at Tiryns may belong to the temple perhaps built on the ruins of the megaron (p. 36). Apsidal buildings had only one pediment.
3 Terracotta triglyphs and metopes are rare: such triglyphs occur in early buildings at Elis and Olympia, and such metopes at Calydon in Aetolia (assigned to the seventh or sixth century) and at Gonnos in Thessaly: see E. D. van Buren, *Greek Fictile Revetments*, 1926, p. 35, etc., and the references under Gonnos and Calydon in Appendix ii. The terracotta relief of the second half of the sixth century B.C. from Reggio-Calabria, the ancient Rhegium, illustrated and discussed by N. Putortì (see p. 367, *s.v. Rhegium*), is certainly architectural but not certainly a metope.
4 See p. 13.

between two and three feet across and about a foot deep, which contained ashes. Archaic tiles and antefixes were found, and a fine marble acroterion, with a Gorgon's head, was added in the fifth century B.C. This temple was not burnt, but fell into decay, and about the middle of the fourth century B.C. its pteron was entirely rebuilt, and the old cella wall encased with new masonry. The rebuilt temple was burnt in the second century A.D., and in the subsequent rebuilding the inner arrangements of the cella went the way of the pteron.[1]

It should be added that, apart from Etruria and Latium, considered in chapter twelve, architraves partly or wholly of timber were occasionally combined with stone columns in later Greek architecture. The roof and ceiling of the cella was at all periods wooden, and so, in Doric west of Adriatic, and at Olympia till the fourth century B.C., were the ceilings of early peripteral colonnades.[2] The use in the same Western school of terracotta to encase[3] and protect stone cornices also points to timber models.

[1 The Cyrene temple has now been published by L. Pernier, *Il Tempio e l' Altare di Apollo a Cirene*, Bergamo, 1935. The dimensions shown on p. 324 are calculated from the plans given in this book.]
2 In peripteral colonnades of exceptionally wide span wooden beams were sometimes used in late times: for instance in Hermogenes' pseudodipteral temple of Artemis at Magnesia, built about 130 B.C., where the span was about twenty feet: Hermogenes seems also to have used wooden pteron beams for no special reason in his peripteral temple of Dionysus at Teos. See pp. 154 ff.
3 See p. 72 and Fig. 28.

[p. 62, n. 2. For the Heraeum see now W. Dörpfeld and others, *Alt-Olympia*, Berlin, 1935, 2 vols.
p. 65, n. 1. H. Sulze in *A.A.* 1936, p. 14, argues that the archaic Doric capital from Tiryns (see next page) and a similar capital in the Museum at Agrigento rested on wooden shafts, and that this was the usual early practice and is shown on vase-paintings. He does not mention the early Cretan palm-capital to which I refer on p. 101, n. 4. R. Hampe in *A.A.* 1938, p. 359, identifies a bronze plate found at Olympia in 1936 as the ornament of the hollow moulding below the echinus of a wooden Doric capital.]

CHAPTER SIX

Sixth-Century Doric

The number of archaic Doric temples and treasuries[1] of which sub-
stantial remains survive is very great, and it is impossible to treat them
exhaustively. Select dated lists of these and other Greek and Roman
buildings will be found in Appendix I. Apart from those already de-
scribed, few can plausibly be assigned to a date earlier than 600 B.C.
The earliest temple of Athena Pronaia at Delphi probably belonged to
the late seventh century, but it has left only its columns,[2] already
described. The earlier temple of Aphaia in Aegina had similar capitals,
but its plan is conjectural: and an extremely archaic capital found at
Tiryns cannot with certainty be assigned to the temple[3] perhaps built
on the ruins of the great megaron. More important is the large temple
of Artemis found in 1910 at Garitsa in Corfu, the ancient Corcyra.[4]
It had been almost wholly destroyed, but there was sufficient evidence
to determine its approximate size, about 69 by 155 feet on the stylobate,
and also the fact that it was octastyle (with eight columns on its short
sides, instead of the commoner six) and 'pseudodipteral' (see p. 73).
Its chief interest lies in its splendid pedimental sculptures, a huge
Gorgon flanked by panthers with mythological scenes timidly intro-
duced at the sides (Fig. 26). It must belong to the early sixth century.
Fragments of stone reliefs, assigned to the second half of the seventh
century B.C., were also found in the scanty remains of a Doric temple
built above the topmost ruins of the palace at Mycenae: they have been
thought pedimental, but are probably metopes.[5]

Several partially surviving temples, both in Greece proper and in the
West, must belong to the very early years of the sixth century B.C. Among
the oldest are two at Syracuse, that of Apollo or Artemis on Ortygia, and
the Olympieum on the right bank of the Anapos. Both were peripteral

1 See p. 45, n. 2.　　　　2 See p. 65, and Fig. 25.　　　　3 See p. 36.
[4 Now published or to be published by G. Rodenwaldt in *Korkyra, Archaische
Bauten und Bildwerke*, but only a short anticipation of vol. II of this work (*Alt-
dorische Bildwerke in Korfu*, 1938) has been accessible to me. The temple had an
Ionic frieze over the pronaos, but probably triglyphs over the opisthodomus; for
the style and date of the sculptures see also Humfry Payne, *Necrocorinthia*, 1931,
244 ff.: he decides for *c.* 590–580 B.C.]
[5 See now G. Rodenwaldt in *Corolla Ludwig Curtius...dargebracht*, Stuttgart,
1937, pp. 63 ff., and R. J. H. Jenkins, *Dedalica*, 1936, p. 50. I have also had private
information from Professor A. J. B. Wace throwing doubt on their architectural
character.]

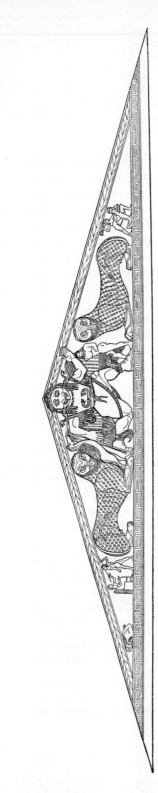

Fig. 26. Pediment of temple at Garitsa, Corcyra (restored by Dr E. Buschor: blank spaces are left where slabs are missing in each corner)

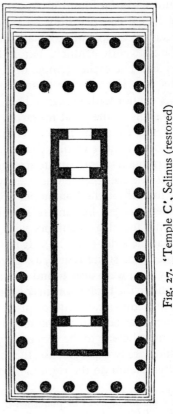

Fig. 27. 'Temple C', Selinus (restored)
(From *Handbuch der Architektur*, Band 1, J. M. Gebhardt's Verlag, Leipzig, Germany)

and hexastyle, and the latter at least had seventeen columns on the flanks (six by seventeen). This proportion is never found after the sixth century B.C. and the general tendency is towards a gradual reduction in the number of side columns, till we reach the fourth-century and Hellenistic ideal, which is six by eleven: the number of the columns is, to some extent, but not entirely, a function of the general proportions of the cella. The sequence, however, is very erratic, and six by eleven occurs, as we have seen (p. 67), in the very early temple of Apollo at Cyrene. With these two Syracusan temples may be grouped the temple at Tarentum, of which only two columns survive. All three have lost their entablatures, which is unfortunate, for the column-spacing of the Ortygia temple raises difficult problems about its frieze. The columns are so close, especially on the flanks, that there is scarcely room for the normal number of triglyphs and metopes, however narrowed. Probably there were triglyphs only over the columns, connected by wide oblong metopes, as in a very early building at Delphi, whose remains were buried in the foundations of the Treasury of Sicyon. This early building was tetrastyle, and its metopes have interesting reliefs: it has been regarded[1] as the oldest Treasury of Syracuse, the very city with which we are concerned, but is probably Sicyonian. Possibly, however, at Ortygia the frieze was wholly omitted, as it was in the later archaic Doric temple at Cadachio or Kardaki in Corfu, where similar difficulties arose from the fact that the spacing of the columns was abnormally wide.[2]

To the sixth century, but perhaps to its second half, belongs also one of the grandest of all archaic Doric temples, the famous 'Temple C' of Selinus (Fig. 27). It was peripteral (six by seventeen), and measured about 79 by 209 feet on the stylobate. The height of the columns was equal to nearly five lower diameters. Its cella was of the old porchless type, divided internally into ante-room, cella proper, and adyton: but its architect obtained the effect of an inner porch by a device which is also attested for the Ortygian temple, and for the slightly later 'Temple F' at Selinus. This device is a duplication of the façade of the peripteral colonnade by a second row of exactly similar columns, joining the third columns from the angles of the side colonnades. The result is a variety of the peripteral scheme, though the columns of this second row may easily be mistaken for those of a prostyle porch belonging to the cella: it is almost confined to the early Western

1 See Dinsmoor in *Bull. corr. hell.* 1912, p. 471. [See further note on p. 89.]
[2 This temple also is published or to be published in vol. III of Rodenwaldt's *Korkyra*, for which see note on p. 69.]

school, and is the nearest approach in Doric to the dipteral Ionic schemes of Ephesus and Samos.[1] In detail the most interesting features of C are the sculptured metopes and the painted terracotta decorations, which included cornice casings and a pierced sima of unusual form (Fig. 28). A terracotta Gorgon's head, over eight feet

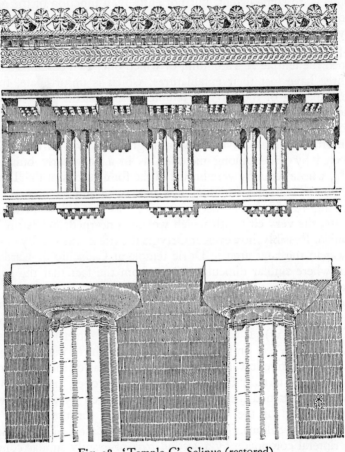

Fig. 28. 'Temple C', Selinus (restored)

high, of which scraps have been found on the site, certainly adorned the middle of a pediment, but it has been ascribed to an earlier temple believed to lie under the present C. It was argued by Koldewey and Puchstein that the raking cornice of C met the horizontal cornice some distance from the angle of the façade, a curious scheme to which a parallel has since been discovered in the archaic temple of Apollo Daphnephoros

[1] In the dipteral scheme there is a double pteron all round, e.g. Fig. 39 (Ephesus).

at Eretria: but for C the evidence is not conclusive.[1] It will be observed that the mutules over the metopes are less than half the width of those over the triglyphs, that the triglyphs are almost as wide as the metopes, and that the metopes are not squares but upright oblongs. These are all archaic features. Archaic also are the columns, with their rapidly diminishing shaft and wide-spreading curved echinus, with a deep hollow moulding at its base. We may observe the necking-grooves,[2] added at a later date, when the hollow was obliterated with stucco.

Temples D and F at Selinus are probably rather later than C. The chief peculiarity of either temple is the presence in F of a stone curtain-wall, panelled in a manner suggestive of timber construction (Fig. 29), joining the pteron columns to about half their height.

It should be observed at this point that in these early temples the peripteral colonnade is treated with a freedom unknown to later Doric architects. In part this is an especially western characteristic, due to the adaptation of the hexastyle scheme, fully developed, to the old porch-less type of cella. The hexastyle façade is the natural companion of the ordinary porch *in antis*, which is the rule in Greece proper even in very early work. The six columns correspond respectively to the flank pteron columns, to the antae, and to the pair of porch columns; and where the number of columns in the porch is odd, so are the columns of the pteron façade. The temple of Apollo[3] at Thermum (Fig. 20) has one column in the porch, five on the façades, the so-called 'Basilica'[4] at Paestum (Fig. 30) three in the porch, nine (not seven, for it is approximately pseudodipteral) on the façades. A result of this correspondence is that in such temples the side ptera are approximately the width of either one or two intercolumniations. With the porchless cella and wooden ceilings there was nothing to determine the position of the pteron columns, even on the façades, and early Western ptera tend to expand beyond the orthodox distance of about one inter-columniation width from the cella walls, but do not as a rule aim at or attain true 'pseudodipterality', which is exact *doubling* of the normal width between cella and pteron without (as in dipteral) inserting a second row of pteron columns. In the West, with the introduction of porches with columns, whether prostyle or *in antis*, we begin to find greater regularity on the façades, and some instances of exact or approximate[5] pseudodipterality, but this affects the width of the side

[1 E. Gàbrici, *Mon. L.* xxxv, 1933, p. 167, has proved Koldewey and Puchstein right about the cornice: also that the Gorgon's head belongs to C and the 'earlier temple' is very doubtful.] 2 See p. 41. 3 See p. 66. 4 See p. 76.
5 The 'Basilica' at Paestum (Fig. 30) approximate, and temple G at Selinus (Fig. 37) exact. [To these add Garitsa in Corcyra and Foce del Sele near Paestum: see pp. 69 and 81, n. 1.]

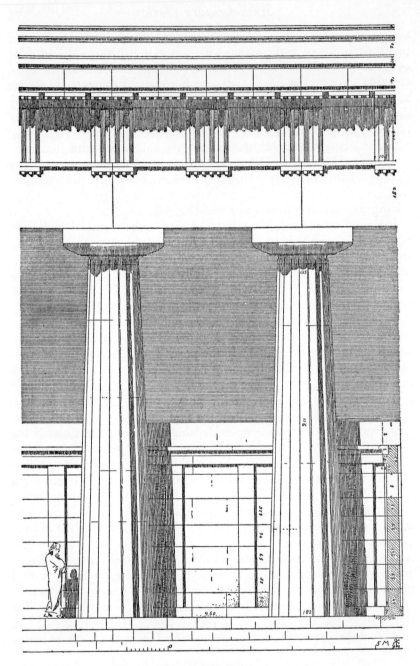

Fig. 29. 'Temple F', Selinus (restored)

colonnades only, and as late as the fifth century, in Greece as in the west, the front colonnade tends in Doric to be deeper than those at the sides, for aesthetic and practical reasons, while the back colonnade sometimes equals that of the sides, sometimes that of the front, and is sometimes intermediate. In the fourth century and later the front and back ptera are usually either[1] the same width as those of the sides or exactly double that width, that is to say pseudodipteral.

Further, in early work, both Doric and Ionic, the distance between column and column often differs on the fronts and on the flanks, and this difference sometimes survives, in a subtle form, in the fifth century, and occurs occasionally even in the fourth: but after the sixth century the rule in Doric is approximate or absolute equality of inter-columniations, except for the modifications extorted by the problem[2] of the angle triglyph and except for occasional widening of the central front intercolumniation: such equality is found even in the middle of the sixth century B.C. in the 'Temple of Ceres' at Paestum. In early Ionic, as far as our scanty evidence goes, the front intercolumniations diminish in width towards the angles, but are all wider than those of the flanks,[3] at least on the principal façade, and this scheme is found also in later Ionic[4]: in Doric, likewise, both front and back intercolumniations are often wider than those of the flanks: so in the Olympian Heraeum, the Ortygia temple, C at Selinus, and the Pompeii Greek temple, among the earliest group: in the temple of Corinth and the 'Tavole Paladine' at Metapontum, in the second half of the sixth century: and later in the temple of Aphaia in Aegina, the temple of Zeus at Olympia, and the temple of Apollo at Bassae. The opposite scheme is found, however, in the early D and F and in the transitional G at Selinus, and in two important fifth-century buildings, the Olympieum of Agrigentum and the 'Temple of Poseidon' at Paestum. In some cases the differences are slight.

The two oldest temples at Paestum, on the west coast of Italy, some fifty miles south of Naples, to which reference has already been made, are of quite exceptional interest. The Greek name of the city was Poseidonia, and it was a colony of the Achaean colony Sybaris. The

1 In Doric the rule for the long sides is usually that the outer faces of the side walls of the cella should be in line with the axes of the penultimate or antepenultimate façade columns. In Ionic the rule is the axial correspondence of the antae and side walls with the corresponding pteron columns.
2 See pp. 106 ff.
3 For the arrangements of the early Ionic temple of Samos see pp. 95 ff.
4 See further, p. 111.

oldest, the so-called 'Basilica' (Fig. 30), really, it would seem, a temple of Poseidon,[1] must date from the early sixth century. It is an extraordinary building. Nothing remains above the level of the architraves, except part of the antithema of the frieze course, but the entablature probably resembled the very unusual one of the slightly later 'Temple of Ceres'. The 'Basilica' was one of the temples with a central row of inner columns, and it had, as has been remarked, an odd number of columns both in its porch (three *in antis*) and on its façade (nine), and was almost, but not quite, pseudodipteral. There were eighteen columns on

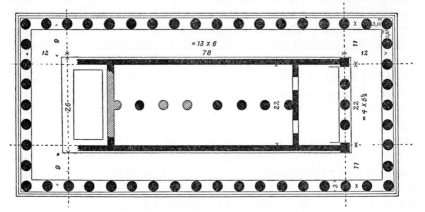

Fig. 30. 'Basilica', Paestum (restored)

the flanks. The temple measured about 80 by 178 feet on the stylobate. The inner columns were as large as those of the pteron, which is exceptional. The cella walls have mostly been looted, and it is not surprising that early students failed to see that it was a temple: its great altar has, however, been discovered in the usual position opposite its chief façade. There was probably an adyton at the back. The detailed peculiarities of its columns (Fig. 30a) will be discussed in connexion with those of the somewhat more normal[2] 'Temple of Ceres'.

This is comparatively well preserved, and we can visualize its general appearance. Fig. 31 shows its plan, Fig. 32 a drawing of one angle, partly restored in fact and a little more on paper, on the evidence of

1 This name is traditionally associated with the fifth-century B.C. temple at Paestum, mentioned above, for which see p. 136.
2 There is no evidence that this temple was that of Demeter (Ceres), but the name is established.

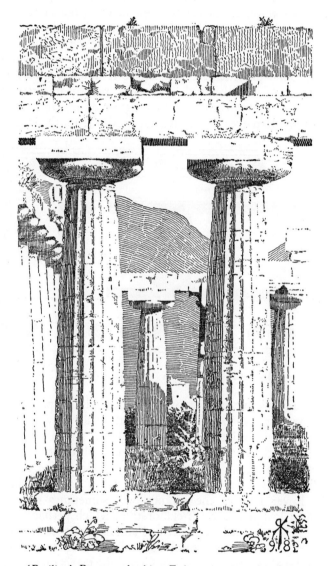

Fig. 30a. 'Basilica', Paestum, looking E, between second and third columns
from N on W side

fallen fragments.[1] The temple was hexastyle (six by thirteen) and measured about 48 by 108 feet on the stylobate: there was probably a tetrastyle prostyle porch at the east end of the cella, but none at the west. A simply moulded column-base is said to have been found in the porch: if it belonged to the building, it may be a rare variety of Doric, or the porch columns may have been Ionic. There were no inner columns. The ground-plan was exceptionally careful and regular. The columns, like those of the 'Basilica', diminished rapidly in a strongly curving line, as in those deliberately exaggerated drawings which magnify for dull modern eyes the elusive entasis of the Parthenon. The

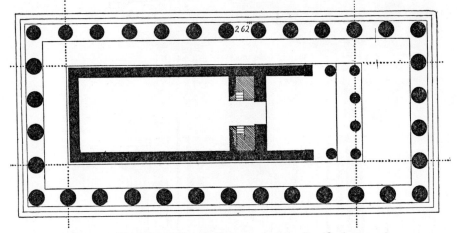

Fig. 31. 'Temple of Ceres', Paestum (restored). (Scale 1 : 300)

upper ends of the flutes curved in many cases outwards and projected as an ornamental moulding, above which came often a plain convex roundel (as in Tuscan[2] and sometimes in early Ionic) and an unfluted strip sometimes carved with delicate ornament. The capitals of both temples had the typical archaic hollow moulding at the base of the echinus, sometimes filled with carved leaf-mouldings (Fig. 33): and in the 'Basilica' the lower part of the echinus was sometimes decorated with ornament in low relief. Such elaboration, which perhaps shows Ionic influence, is very rare except at Paestum, and elsewhere is mostly confined to non-architectural columns serving as pedestals. In both the 'Basilica' and the 'Temple of Ceres' the taenia on the architrave was replaced by an elaborate moulding, and regulae and guttae

[1 For a probable correction of Fig. 32 see note on p. 89.] 2 See p. 201.

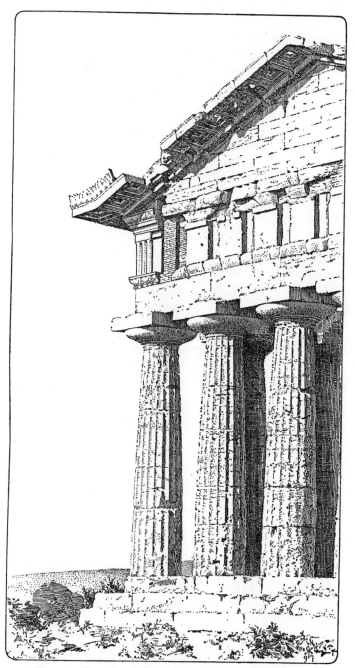

Fig. 32. 'Temple of Ceres', Paestum (partly restored)

were omitted. The frieze of the 'Temple of Ceres' was of unique[1] construction: long blocks rested cantilever-wise on the parts of the architraves over the columns, and the triglyphs were grooved into these blocks, every other triglyph masking a joint: the metopes were formed

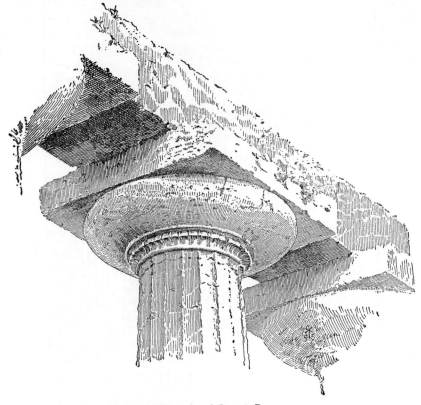

Fig. 33. 'Temple of Ceres', Paestum

by the visible face of the long blocks: the antithema was similarly constructed, but exact correspondence in the joints was avoided. The frieze of the 'Basilica' did not share these peculiarities. The cornice of the 'Temple of Ceres' was even stranger. It had no mutules or guttae, but was decorated beneath with a series of coffered sinkings: and instead of running horizontally all round the building, so as to form, on the short sides, the floor of a pediment crowned by a separate raking cornice, it

1 For a partial parallel in the Athenian Propylaea see p. 120.

boldly soared aloft, after turning the corners from the long sides, so that there was no horizontal cornice on the façades, and no pediment floor. A heavy moulding, not usual in Doric, ran horizontally all round the building, between frieze and cornice. It is impossible to contemplate this attractive and original temple without a touch of disappointment that later Doric architects set their face against bold experiment, and concentrated their amazing gifts upon the elaboration of subtleties.[1]

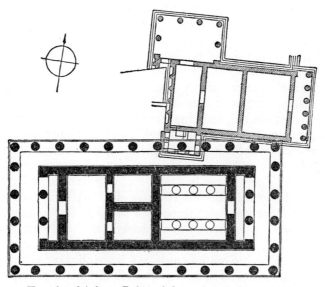

Fig. 34. Temple of Athena Polias, Athens (restored), with Erechtheum

On the mainland of Greece the most important known group of early Doric buildings is connected with the Athenian Acropolis. We know them only through nineteenth-century excavation, for many were

[1 To the two old temples of Paestum must be added two important temples discovered at the Foce del Sele (ancient Silaris) some thirteen miles further north. The smaller (8·90 m. × 17·22 m., tetrastyle prostyle) is assigned to c. 575 B.C., the larger (18·65 m. × 38·97 m. on the euthynteria, with cella 6·14 m. × 14·92 m., pseudo-dipteral 8 × 17) to c. 500 B.C. Both have yielded well preserved details, including capitals of columns and antae. The earlier column-capitals have a deep hollow moulding below the echinus, the later are decorated like those of the 'Temple of Ceres' at Paestum. The later temple has remarkable carved mouldings of Ionic type and its columns have 18 flutes. For further details and for the carved metopes also found see P. Zancani-Montuoro and U. Zanotti-Bianco in *N.S.* 1937, pp. 207 ff. ('Heraion alla Foce del Sele').]

partly or wholly destroyed during the sixth century B.C., in order to yield space for more ambitious schemes: and almost all the survivors were smashed and burnt by Xerxes' troops. We possess large portions of their actual fabric, mostly buried in the vast substructures of the Parthenon terrace, which were far advanced before the Persian invasion, but partly built into the north wall of the Acropolis.

Only one[1] important foundation has been found, that of the temple of Athena Polias (Fig. 34) which stood close to the later Erechtheum. The labours of successive students have gradually disentangled from the chaos of fragments those portions which belong to this temple, and we now know a great deal about its structure and appearance. It occupied part of the site of the Mycenaean palace of the old kings of Athens, Homer's 'strong house of Erechtheus'. Of this palace some traces remain, but their interpretation is doubtful, and it is possible that a more primitive temple preceded that which we are about to consider. This temple was first erected, to judge from its style, in the first half of the sixth century B.C. It was not peripteral,[2] and it had a real porch, distyle *in antis*, at each end: for it was a double temple, and each porch was a pronaos, giving access to one portion of the cella. It measured about 40 by 110 feet. The western half consisted of a cella behind which lay two adyta side by side, the eastern of a single cella, apparently with two rows of inner columns, three to a row. Including the porches, the building was approximately one hundred Attic[3] feet long, and it has therefore been identified with the 'Hekatompedon' or 'hundred-foot temple', known both from literature and inscriptions: but this identification[4] may be wrong. The bulk of the building was of poros, soft local limestone, but the foundations were of harder stone, and metopes, sima, and tiles were of marble. The capitals (Fig. 35) were very archaic, and there were two-third mutules over the metopes. The pediments contained poros sculpture of which much survives: one held the famous group of Heracles wrestling with the fish-bodied Triton, balanced by a friendly monster, with three human heads and bodies, and three entwined snaky tails. The acroteria were panthers and Gorgons, but their exact arrangement is uncertain. The sculpture was brilliantly coloured, and there was much carved and painted ornament, even on the underside of the raking cornice, where flying cranes were delightfully represented as if seen

1 Except that of the earlier Propylaea, for which see p. 89.
[2 But see p. 84, n. 1 for recent attacks on this view.]
3 The Attic foot used in all Athenian buildings till Roman times was 0·328 metres: the English foot is 0·3048 metres. See p. 149 for the Roman 'Attic' foot.
4 See p. 113.

from below. The changes made in the Polias temple later in the sixth century will be described[1] at a later point.

Fragments survive from about a dozen archaic buildings on the Athenian Acropolis and its neighbourhood, ranging from the close of the seventh century to the last quarter of the sixth. One, which

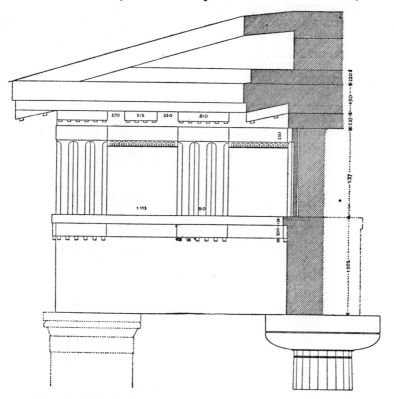

Fig. 35. Temple of Athena Polias, Athens, older form (restored view and section). (Measurements in metres and centimetres)

perhaps stood on part of the site later occupied by the Parthenon, was probably a temple even larger than that of Athena Polias: but this building, and a possible curvilinear predecessor, will more conveniently be discussed in a later chapter[2] in connexion with the Parthenon itself. Of the other buildings, the most curious was one with an apse, and perhaps with a porch tristyle *in antis*: it seems to have sur-

1 See p. 88: [also p. 84, n. 1]. 2 See p. 113.

vived till Pericles built his Propylaea in the middle of the fifth century
B.C.[1]

Two more archaic buildings must be described before we consider the
movement which led, in the second half of the sixth century, to the
crystallization of earlier freedom in the 'canonic' style which culmi-
nated in the masterpieces of the fifth. The first is the strange temple
at Assos in Mysia, some forty miles south of Troy. This is the only
important example of archaic Doric east of the Aegean. The city of
Assos stood on a lofty cliff, a spur of Ida, looking south across the

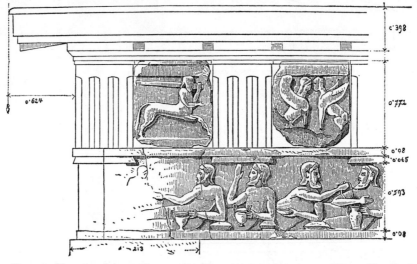

Fig. 36. Temple of Assos (restored). Measurements in metres. (From *Handbuch
der Architektur*, Band I, J. M. Gebhardt's Verlag, Leipzig, Germany)

Adramyttian gulf to Lesbos, and the temple occupied its highest
point. Its plan was very simple—a pronaos distyle *in antis*, and
a single narrow cella, without inner columns, surrounded by a
pteron, six by thirteen. It measured on the stylobate about 46

[1 W. H. Schuchhardt argues forcibly in *A.M.* LX/LXI, 1935/36, 1–99, that the ori-
ginal Polias temple (dated 580–570 B.C.) was peripteral. Between the groups of
Heracles with Triton and the three-bodied monster he places two lions killing a
bull, and in the other pediment two couchant lions, each flanked by a snake:
and he restores over the architrave of the pronaos a frieze of terracotta lions applied
to a poros background. He also accepts an 'earliest Parthenon' (dated *c.* 600 B.C.)
as the one other early large building on the Acropolis, following H. Schrader,
J.D.A.I. XLIII, 1928, 54 ff. See also W. Züchner, *A.A.* 1936, 305 ff. O. Broneer
in *Hesperia*, VIII, 1939, 91 ff., accepts Schuchhardt's views, and throws new light
on the pedimental sculpture.]

by 100 feet. The material was an exceptionally hard local stone, not stuccoed: paint was applied direct to the stone. The columns of the pteron (those of the pronaos are lost) are individual, and hard to date, but by most criteria they seem very archaic: they are slender, but that, as we have seen, is a known early type: they are also widely spaced. The outstanding oddity of the temple is the presence of relief sculpture on the architraves (Fig. 36), which are treated like an Ionic frieze: this sculpture was probably confined to the façades and some bays of the flanks. The metopes also had sculpture, but probably not the pediments. The dating of the temple depends partly on purely architectural features, partly on the style of the sculptures. It is an imitative provincial work, conceivably due to Athenian influence, and this makes the problem unusually difficult. The balance of expert opinion favours the first half of the sixth century, and this date is probably right, but some good authorities put it between 550 and 500 B.C.

Another interesting work of the early sixth century is the archaic 'Tholos' at Delphi, a circular peripteral building with a Doric frieze: a link between the prehistoric round house and a long line of charming buildings, of which the most famous stands beside the Tiber at Rome.[1]

Of the transitional Doric structures of the second half of the sixth century the most important are perhaps, in the West, the 'Temple of Hercules' at Agrigentum and 'Temple G' at Selinus, and in Greece proper the temple of Corinth, the peripteral rebuilding of the Polias temple at Athens, and the Alcmaeonid temple at Delphi: but the mass of material is now overwhelming.

'Temple G' at Selinus (once called 'T', and probably a temple of Apollo) is of exceptional interest (Fig. 37). It was planned on a colossal scale, and it was so long building that there are great differences of style, as in a mediaeval cathedral, between its earliest and latest parts; this is especially noticeable in the pteron. Alone among early Doric buildings it is quite strictly pseudodipteral,[2] and the architect may possibly have aimed, as those of the Hellenistic age certainly did, at producing a false appearance of dipterality. Temple G is one of the half-dozen giants of Greek temple architecture. It was about the same size, measured on the stylobate, as the sixth- and fourth-century forms of the Ephesian Artemisium, the late sixth-century form of the Heraeum at Samos, the fifth-century Olympieum of Agrigentum, the fourth-century temple of Artemis or Cybele at Sardis, and the Hellenistic Didymaion near Miletus, which ranged from about 160 to 180 feet by about

1 See p. 211. [For the old Tholos see now P. de la Coste-Messelière, *Au Musée de Delphes*, 1936, pp. 50 ff.] 2 See p. 73.

340 to 370 feet. The Athenian Olympieum, planned, perhaps, as an
Ionic dipteros by an Athenian tyrant, carried forward in Corinthian
by a Hellenistic king, and finished by a Roman emperor, was as long as
some of these, but narrower. There is much talk of the megalomania
of Rome: yet we should not forget that the Romans in their boldest
efforts never planned any temple larger in area than these, and that
the largest ancient temples were small beside some mediaeval and

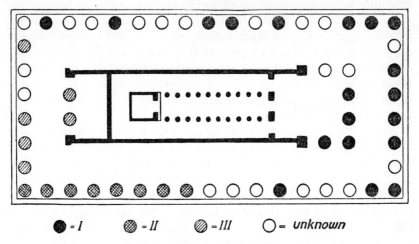

●=*I* ⊕=*II* ⊘=*III* ○=*unknown*

Fig. 37. 'Temple G (T)', Selinus

Renaissance churches. But we must return to Temple G, which
measured about 164 by 362 feet. It seems to have been designed to
have a prostyle eastern porch, a cella, and a closed adyton. The
eastern pteron and porch, which are strictly archaic, were executed
according to plan: but by the fifth century, when the western end was
building, fashion had changed, and the new architects insisted on
erecting an open opisthodomus, with two columns *in antis*, on the
adyton foundations. Religious needs were satisfied by the erection of
a small shrine inside the western part of the naos. Somewhat similar
compromises between art and religion are found in the 'Temple of
Hercules' at Agrigentum and in the early fifth-century temple of Aphaia[1]

1 The temple of Aphaia at Aegina has an opisthodomus, but the priests evidently
wanted an adyton, and during the course of erection a door was cut in the back wall
of the opisthodomus, and its porch was so heavily enclosed in a metal lattice as to
become a sort of adyton. There was a similar lattice in the pronaos, but this con-
tained doors, while that in the opisthodomus was permanently closed.

in Aegina. The earliest and latest columns (Fig. 38) form a striking contrast: the earlier are slender, with a spreading echinus, deeply hollowed at the base. The same hollow is found in an intermediate type from the western part of the south pteron, but the fifth-century capitals

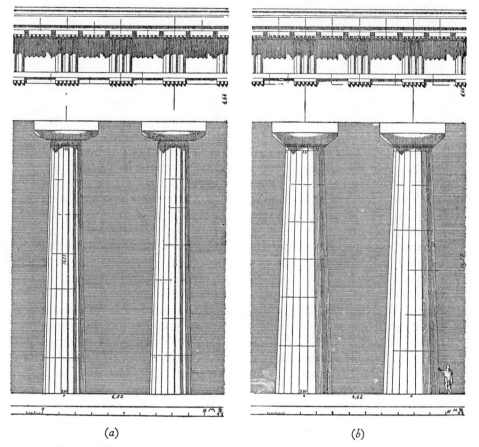

(a) (b)

Fig. 38. 'Temple G (T)', Selinus: (a) earliest, (b) latest columns (restored)

lack it. On the plan (Fig. 37) the earliest and latest columns are marked *I* and *III*, the intermediate type *II*. G has a double row of interior columns, comparatively so small that they probably carried more than one upper tier of columns.

The temple of Apollo at Corinth, the reconstructed Athenian Polias temple, and the Alcmaeonid temple of Delphi form a group of hexastyle

peripteral structures closely connected in style. The Corinth temple is probably the earliest of the three, but until recently its age was much exaggerated, and it is still sometimes placed second to the Olympian Heraeum in chronological lists of Doric temples. Its thick heavy columns, about four and a third lower diameters, though vaguely suggestive of antiquity, are not really a very early feature, and its capitals cannot well be older than the middle of the sixth century B.C. The shafts of the columns are monolithic, but this method of construction, though early, does not die out till the fifth century B.C.[1] There were two porches *in antis*, probably a pronaos and an opisthodomus, with an adyton in addition behind the cella. The flank columns numbered fifteen, and it measured about 70 by 175 feet on the stylobate. Of the entablature only some frieze fragments and terracottas survive.

Of the peripteral form of the Athenian Polias temple (six by twelve) we know far more, though not a stone stands above its foundations. It was probably begun by Pisistratus about the middle of the sixth century and finished by his son Hipparchus twenty or thirty years later: it measured about 70 by $142\frac{1}{2}$ feet on the stylobate. In most respects it was a typical early canonical structure, lacking the oddities of its predecessor, of which only the walls survived the reconstruction. It was built of harder limestone, but was almost equally sparing in the use of marble. The decoration of the pediments, however, was of that material: the more important was a magnificent battle of gods and giants, of which the central group was Athena killing a giant. It is possible that certain surviving fragments of marble relief come from a continuous Ionic frieze substituted during the rebuilding for the old triglyph frieze round the cella: but attractive as this theory is (for it makes this temple a model for the Parthenon), there are technical difficulties, and many archaeologists reject it.[2] It is likely that in its peripteral form this temple had tetrastyle prostyle Ionic porches, and Fig. 34 should probably be so modified. The fate of this old temple after 479 B.C. is disputed. Dörpfeld holds that when the Persians had departed it was hastily repaired, without its pteron, and so stood till the Christian era, blocking the southern side of the later Erechtheum, with its lovely Maiden Porch. The problem is mainly of historical interest, and is extremely complicated.[3] It is probable that the old temple was in fact re-

1 The Roman revival of this practice, for shafts of valuable material, is not here in point. [For the date of the Corinth temple see further p. 326.]

[2 The theory is vigorously defended by H. Schrader in *Die archaischen Marmorbildwerke der Akropolis*, 1939, pp. 387 ff., a work important also for the pedimental sculptures.]

[3 See now W. B. Dinsmoor, *A.J.A.* XXXVI, 1932, pp. 143 ff., 307 ff.]

built, as Dörpfeld assumes, but it was perhaps finally destroyed by a fire (recorded by Xenophon) in 406 B.C., immediately after the completion of the Erechtheum. Perhaps connected with the Pisistratid rebuilding of this temple, but probably dating from the early fifth century, was the older form of the Propylaea of the Athenian acropolis: a simple and beautiful marble structure, consisting, in essence, of two Doric porches distyle *in antis*, before and behind a great gate in the fortress wall.

The Alcmaeonid temple of Delphi gains a peculiar interest from its association with Athenian politics, and from references to its erection both by Pindar and by Herodotus. It fell into ruins, perhaps through rain and subsidence, and was rebuilt between 370 and 330 B.C., but its position on a narrow artificial terrace in a hill-side sanctuary crammed with monuments forced the later architects to adhere closely to their predecessors' lines. The French excavators have established the main facts about the sixth-century temple. Its predecessor, traditionally the fourth temple, was burnt in 548 B.C., on the eve of the fall of Delphi's great patron, Croesus of Lydia, and the new building was soon begun. It was hexastyle (six by fifteen), measuring about 78 by 195 feet on the stylobate, and was originally designed to be all of limestone, except for the steps, the orthostatai, the cornice, and the roof-tiles, which were to be of marble. In 513 B.C. the Alcmaeonidae, exiled from Athens, took over the work, and acquired fame and favour by using marble, beyond their contract, also for the architrave, frieze, and pediment of the eastern end, and for the two columns of the eastern porch. There is no archaeological evidence that any of the pteron columns were ever of marble, but marble was used for the ornaments of the eastern door, and for the inner pavement and columns. These are the facts which justify Herodotus' statement (v, 62) συγκειμένου σφι πωρίνου λίθου ποιέειν τὸν νηόν, Παρίου τὰ ἔμπροσθε αὐτοῦ ἐξεποίησαν: 'though their contract was to make the temple of poros, they finished off its front with Parian marble'. It was complete by 505 B.C.

One other sixth-century Doric building of the greatest interest—the Hall of the Mysteries at Eleusis—will be described at a later [1] point: and a few late sixth-century Doric works, showing strong Ionic influence, will be mentioned at the end of the next chapter.

1 See pp. 169 ff.

[p. 71, n. 1. It now appears that the 'Old Treasury of Syracuse' was Sicyonian, but monopteral (4 × 5) and not a Treasury: its base was c. 4·29 m. × c. 5·57 m., and its date c. 560 B.C.: see P. de la Coste-Messelière, *Au Musée de Delphes*, 1936, 41 ff. p. 78, n. 1. F. Krauss in *R.M.* XLVI, 1931, pp. 1 ff. rejects the spread in the raking cornice of the 'Temple of Ceres' shown in Fig. 32: it seems to have been straight.]

Archaic Ionic

The temple of Assos has already carried us out of Europe, and it is time to turn to the chief surviving early examples of Ionic, the true style of Greek Asia. We have considerable remains of two huge temples of the first rank, the Artemisium of Ephesus and the Heraeum of Samos, and traces of what was perhaps an interrupted Pisistratid imitation of them at Athens: and at Samos there are also remains of a large peripteral building contemporary with the older dipteral form of the Heraeum. We have also almost complete knowledge of one Ionic treasury at Delphi, the Siphnian, and important elements of three others in or near the same precinct. In Delos and other islands we have scantier remains of small buildings of the same type, and of some on a rather larger scale: for instance a non-peripteral temple in Naxos, apparently never finished, which measured about 42 by 114 feet. From the Greek treaty-port of Naucratis, in the Nile delta, we have some very individual fragments. In the West there is very little: the earliest form of the Ionic[1] temple at Locri Epizephyrii in South Italy seems to have left no architectural details.

We are fortunate in possessing so much of the penultimate and latest stages of the temple of Artemis at Ephesus: for at both these stages the architects were pioneers and their work was a model. We are not concerned in this chapter with the fourth-century temple, which survived till the ruin of paganism, but with its immediate predecessor, which Croesus of Lydia (as both tradition and inscriptions prove) had helped to build before his overthrow by Cyrus of Persia in 546 B.C. This building is commonly called the Croesus temple: the name has been criticized, but is too convenient to drop. It was burnt down in the fourth century B.C., but its foundations and a little of its superstructure were retained as a substructure for the new temple, the floor of which was raised about seven feet. This increase in height necessitated an extension of the steps all round: to support this extension, a small limestone pier was thrown out opposite each column of the pteron, and between them was rammed much of the decorative detail of the burnt temple. Our knowledge goes back beyond the Croesus temple, for the

1 See p. 103.

latest excavation, by Hogarth, revealed three successive older structures. The oldest (perhaps of the seventh century) consisted of a statue basis, covering a marvellous foundation deposit of coins, ornaments and ivories: this basis continued to the last to support the chief statue of the goddess in the exact centre of the later temples. Opposite this basis was a separate platform, perhaps for an altar. Later these structures were united and enlarged, but we do not know at what point a real temple was first erected, for we have no trace of any superstructure older than the Croesus temple.[1] The temple was deeply buried: even the ruined

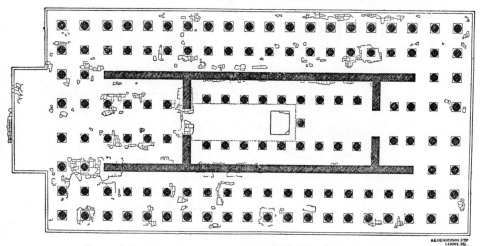

Fig. 39. Sixth-century temple of Artemis, Ephesus (restored)

floor of the fourth-century temple lay fifteen feet down under alluvial soil. The deeper soundings involved heavy pumping operations.

The Croesus temple itself was a vast affair, executed with a freedom and variety which recalls mediaeval architecture. The upper step measured over 180 by nearly 360 feet, and the cella was surrounded by a double pteron of enormous columns: in the outer row, there were eight[2] on the façades, twenty along the flanks. The axis, as usual, ran east and west, but the entrance, abnormally, was from the west.[3] The columns were of solid marble, but the walls, faced with marble, had a limestone core. There was a deep pronaos *in antis*, which probably contained eight columns in four pairs, and there was either an adyton or an opisthodomus. There were probably interior columns, but their

[1 and 3 See further notes on p. 105.]
2 Possibly, as Lethaby suggests, there were nine at the back, as at Samos (p. 97).

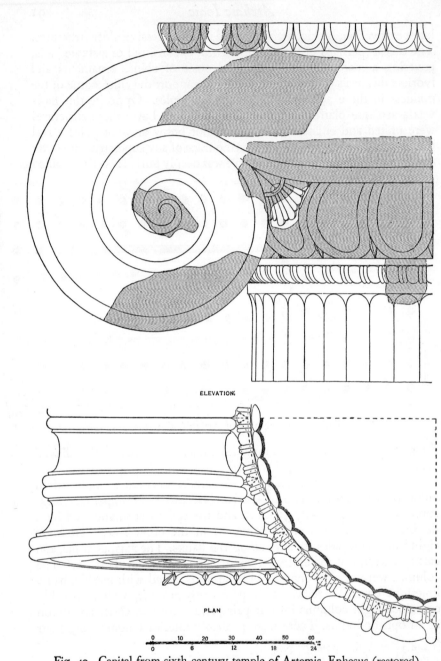

ELEVATION

PLAN

0 10 20 30 40 50 60
0 6 12 18 24

Fig. 40. Capital from sixth-century temple of Artemis, Ephesus (restored)

positions are conjectural: Pliny the Elder[1] says that there were 127 columns in all, but this may have been true only of the fourth-century

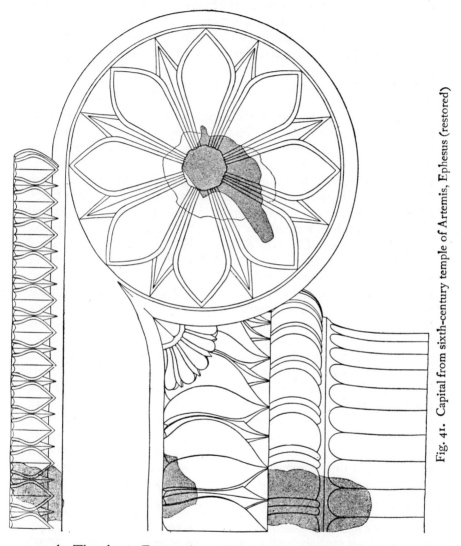

Fig. 41. Capital from sixth-century temple of Artemis, Ephesus (restored)

temple. The plan in Fig. 39 shows Henderson's attempt to comply with Pliny's statistics. Of the appearance of the whole we can form no

1 *Nat. Hist.* XXXVI, 95.

adequate idea, for we lack essential data. We do not know the height of the columns, and we know practically nothing of the entablature, apart from scraps of the cornice, and of the egg-and-tongue on which it rested, except for the marble sima, which was a huge parapet, decorated in relief like a frieze, and pierced with lion-head rain-spouts. The angle of the pediment has been inferred only from a dubious fragment. There may have been no frieze, but, if so, there were probably dentils. The architraves (which are wholly lost) had to cover[1] enormous spans. If the central intercolumniation of the façades (as at Samos) was wider than the rest, the distance from axis to axis of the central columns must have been about twenty-eight feet, the unsupported span more than twenty-one feet: it must, in any case, have approximated to these figures: on the flanks the interaxial distance was some seventeen feet. Except for their height, we are well acquainted with the columns. The bases (Fig. 42) showed a primitive stage of that form of the Asiatic type[2] which later became orthodox, except at Athens: they rested on square plinths. The capitals were mostly (Fig. 40) of the same general form as classical ones, from which they differ chiefly in the very wide spread of the volute member, in the fact that the channel has a convex surface, in the absence of a button or 'eye' at the centre of the spiral, in the oblong shape of the abacus, and in the generally archaic character of both the profiles and the carved ornaments of the mouldings. Certain capitals (Fig. 41) substituted rosettes for the volute spirals, and some columns substituted Lesbian mouldings, with leaf ornament, for the egg-and-tongue of the abacus and for the convex torus of the base: probably the same columns which had the rosettes. It is likely that these columns were exceptional variations on the traditional scheme. The shafts had from forty to forty-eight shallow flutes, sometimes alternately broad and narrow, with sharp Doric edges. Some columns had figures in relief carved on their bottom drums (Fig. 42)[3]: there were also some square pedestals similarly carved. There is evidence for the names of several architects, but their connexion with the various epochs is obscure.

1 The tempting suggestion that the architraves were of wood (as Noack, *Eleusis*, 1927, p. 145 assumes, at least for the Heraeum of Samos where the spans were slightly less) is difficult to reconcile with the detailed accounts of the hauling and placing of the architraves given by Vitruvius (x, 2, 11) and Pliny (*N.H.* xxxvi, 96), which are almost certainly based on the lost treatise by Chersiphron and his son Metagenes (Vitruvius vii, *praef.* 12). Both father and son were architects of the temple, and probably of the Croesus temple, though Hogarth connects them with the latest of the earlier buildings. 2 See Fig. 18, p. 44.
[3 This restoration must not be accepted in detail: see F. N. Pryce, *Catalogue of Sculpture in...the British Museum*, i, i, 1928, p. 49.]

The Heraeum of Samos was equally famous, and is in some respects better preserved, but it is not yet fully published. Herodotus[1] calls Rhoecus of Samos, who worked for Croesus, its first architect, and seems to imply that the original temple was standing in his own day. But Pausanias[2] records a Persian burning, after which it was still a

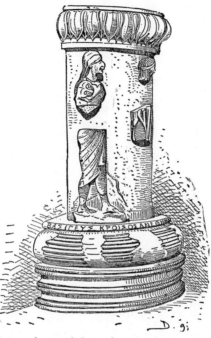

Fig. 42. Base and carved drum from sixth-century temple of Artemis, Ephesus (as formerly restored in British Museum). (From *Handbuch der Architektur*, Band 1, J. M. Gebhardt's Verlag, Leipzig, Germany)

marvel to see. Recent excavation has proved that the Rhoecus temple was burnt and that a complete rebuilding about 130 feet further west was begun, probably by Polycrates, in the second half of the sixth century. Much of the detail of the older temple has been recovered from the later foundations: it is like the later work, but smaller and finer.[3] The later temple (Fig. 43), which measured about 179 by 366 feet on the stylobate, is of the same general type as the Artemisium; it was dipteral on the flanks, tripteral at the ends, and contained 133 columns,

1 III, 60. 2 VII, 5, 4. [3 See further note on p. 105.]

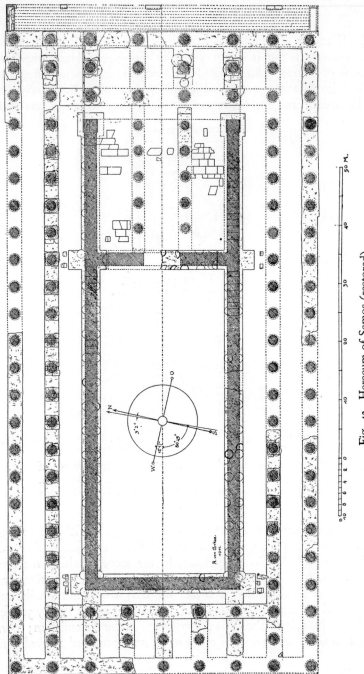

50 M.

Fig. 43. Heraeum of Samos (restored)

of which ten stood in the pronaos. The outer row had twenty by eight, except that at the back there were nine columns in each row, clearly a device to reduce the free span of the architraves; at the front the spacing was graduated from the centre, the widest interaxial measurement being nearly twenty-eight feet. The cella was seventy-five feet wide, and it never had a proper roof, though its smaller predecessor seems to have possessed one. Two dates may be distinguished among the columns: the ten in the pronaos and the twelve in front of them are the earlier,

Fig. 44. Column-base from the Heraeum, Samos
(From *Handbuch der Architektur*, Band I, J. M. Gebhardt's
Verlag, Leipzig, Germany)

and only their bases and capitals were of marble: the rest, which seem to be Hellenistic, had also marble shafts, and the work was never really finished. The shafts of the older temple resembled those of the Croesus Artemisium, but those of the later temple had normal Ionic fluting: many however were never fluted at all. Some, at least, had a narrow uncarved necking-band separated by a fillet from the echinus of the capital. The forms of the capitals resembled the orthodox ones of Ephesus, except that the volutes spread so wide that they fell quite clear of the echinus, which was structurally part of the shaft, with a clean joint *above* it: a rare phenomenon,[1] for usually the echinus has only a

1 It is found also in the Erechtheum: see p. 134.

partial or theoretical existence under the overhanging spirals, which are carved from the same block. The bases (Fig. 44) have already been mentioned as having perhaps inspired the Attic type.[1] Of the entablature little has been published.

The independent peripteral 'South Building' at Samos, already mentioned, if correctly interpreted, was very strange. It was built by Rhoecus and measured about 25 by 50 feet on the stylobate, and it would have been a peripteros (probably 9 by 18) but for the complete omission of the nine columns of the façade. There was a deep pronaos and a single central row of inner columns both in pronaos and in cella. Buschor guesses that it was an Odeum or Music Hall.[2]

The temples of Naucratis deserve a special account. The surviving foundations consist chiefly of plain porchless rectangles, with or without inner divisions: but one (that of the Dioscuri) had a shallow porch divided from the cella by free and engaged pillars, on a scheme like that of the temple of Athena Nike at Athens.[3] All were of sun-dried brick faced with plaster: besides the Dioscuri, Hera and Aphrodite had identifiable temples, while the few surviving architectural details appear to belong entirely to a vanished temple of Apollo. The fragments fall into two sets, of which the earlier, of limestone, illustrated in Fig. 45, may belong to the early sixth century, and are among the oldest purely Ionic members known: the later, of marble, cannot here be discussed. In some of the earlier columns a wide necking-band, with a lotus pattern in low relief, adorned the upper part of the shaft, between the tops of the flutes and the crowning astragal, which was abnormally large and carried a huge egg-and-tongue echinus, of an archaic drooping form reminiscent of the Neandria leaf-moulding. Above this Petrie restored a heavy convex moulding. The spirals, as at Samos, fell clear of the echinus, but the only fragment of the volute-member found was smashed by natives before it could be photographed. Such ornamental necking-bands are rare but not unique. They occur also (as we have seen) in archaic Doric capitals at Paestum[4]: in Ionic they are found at Locri, in the Erechtheum at Athens, in the Nereid monument at Xanthos in Lycia, and in Roman work. Undecorated necking-bands occur at Samos, and the Ionic examples may perhaps be treated as a Samian group, distinct from the more

1 See p. 46, and further, pp. 122 and 125.
[2 For all these Samos buildings see further note on p. 105. A. W. Lawrence (*Herodotus*, 1935, p. 274) suggests that some of the Hellenistic columns of the Heraeum have replaced archaic ones seen by Herodotus.]
3 See Fig. 53, p. 126. 4 See p. 78.

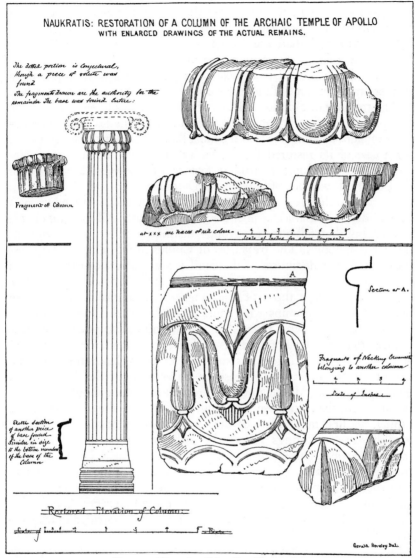

NAUKRATIS: RESTORATION OF A COLUMN OF THE ARCHAIC TEMPLE OF APOLLO
WITH ENLARGED DRAWINGS OF THE ACTUAL REMAINS.

Fig. 45. Temple of Apollo, Naucratis

influential school of Ephesus. The lower parts of the Naucratis column, if correctly restored, were strange: the base was not unlike those of Samos, though it had large and somewhat unusual mouldings, but between base and shaft are shown two smooth conical members, the lower with a slight diminution, the upper with a stronger one. The effect is of a slender shaft artificially adapted to a base designed for a stouter one, as in some of the stolen columns of early Christian churches.

The treasury of Siphnos at Delphi[1] (Plate III *a*) is in effect by far the best preserved of early Ionic buildings, though little except its foundations remains *in situ*. It is also the most familiar to Northern sightseers, for a cast of its restored façade, faulty in detail, but not essentially misleading, was long a striking feature of the picture-galleries of the Louvre. It was one of four similar Delphian buildings, all of marble: three stood in the great sanctuary, one in the precinct of Athena Pronaia (the modern Marmaria), a short distance to its east. All four are distyle *in antis*, but they fall into two groups, distinguished by the character of their free supports. The treasuries of Cnidus and Siphnos substituted for columns female figures of the familiar archaic *korē* or maiden type: female figures so employed were known in antiquity as Caryatids. The other two, perhaps those of Clazomenae and Massalia (the modern Marseilles), had columns with Ionic bases, but with Doric flutes and palm-capitals somewhat resembling a well-known Egyptian type. It is unlucky that of each pair the later is the better preserved, for the Siphnian at least, for all its charm, has the fault of over-elaboration: it is an almost vulgar attempt to eclipse an older and simpler masterpiece. The Siphnian and Massalian treasuries each measured about twenty by twenty-eight feet. In these little buildings, though they lack the Ionic capital, we first meet many of the salient features of the Ionic order: notably base-mouldings round the walls, consoles, the continuous sculptured frieze, and the profusion of carved ornament. In the Siphnian treasury a large astragal ran all round the outside of the wall-base, and also round the inside of the porch: the Massalian had at this point a large convex moulding, with horizontal grooving, exactly like the top member of an Asiatic Ionic base. Consoles—volute-shaped brackets— are used to support the lintels of the doors. Few decorative features of ancient architecture have enjoyed more prolonged success: it is perhaps most familiar as the support of the Victorian marble mantelpiece. These early consoles, however, have only one spiral twist, at the bottom,

[1] It has not yet been finally published.

whereas classical consoles usually have[1] two twists, in opposite direc-
tions. Dentils do not occur in these treasuries, a fact of which the
significance has already been noted.[2] The Siphnian treasury, at least,
had pedimental sculpture, which is rare in Ionic: it is curiously treated,
being in relief below, free-standing above. The architrave was smooth,
as in Doric, not divided into fasciae[3]: along the sides it was reduced
in height. Both pairs of Caryatids stood on moulded pedestals, and
both pairs had elaborate capitals between their heads and the archi-
traves. In each case, if we ignore minor mouldings, a cylindrical
member (polos), with figures in relief, was surmounted by a sort of
large spreading echinus, and that by an abacus; and in each case the
echinus was carved. But all this carving was livelier in the Siphnian
treasury, especially on the echinus, where the earlier sculptor was
content with a scheme of radiating leaves, but the later, somewhat
inappropriately, carved in high relief two lions killing a deer. For the
rest, the photograph of the French restoration of the Siphnian treasury
(Plate III *a*) must speak for itself. Its chief demonstrable faults, re-
vealed by later investigation, are these: (1) the position of the astragal
at the foot of the wall: it should run round the inside of the porch:
(2) the inclusion of a few details belonging to the Massalian treasury:
(3) the exaggerated lowness of the antae and Caryatids, and the exces-
sive narrowness of the antae: (4) the exaggeration of the lowness and
narrowness of the door: this was in fact framed with the same decora-
tive scheme on all four sides, including the bottom. The other two
treasuries were in general very similar, but only that of Massalia is well
preserved, or assignable to definite foundations: it perhaps became in
later days the treasury of Rome. Only the columns need here be dis-
cussed. They had typical Asiatic bases of the Ephesian type, but their
capitals were of the very rare kind shown in Fig. 46: the double form
has been rejected by some good critics, but is officially regarded as
certain. The type[4] is probably indirectly derived from Egypt, through
Asiatic modifications.

With regard to the dates of these treasuries, it would seem that the
two earlier, those of Cnidus and Clazomenae, date from about the

1 See, for example, the North Door of the Erechtheum, Fig. 57.
2 and 3 See p. 47.
4 See p. 59 for reasons for rejecting Dinsmoor's proposal to name this type
'Aeolic'. [For a very early example of a Greek palm-capital from Frati (Arcades)
in Crete, with a remarkable abacus, see D. Levi in *Ann. R.S.A.* x–xii, 1931, p. 451,
and *A.A.* xlvi, 1931, c. 301 and fig. 38. It is of poros, but seems to have had wooden
shaft and epistyle.]

middle of the sixth century, those of Siphnos and Massalia from its second half.

The great temple of Olympian Zeus below the Acropolis at Athens

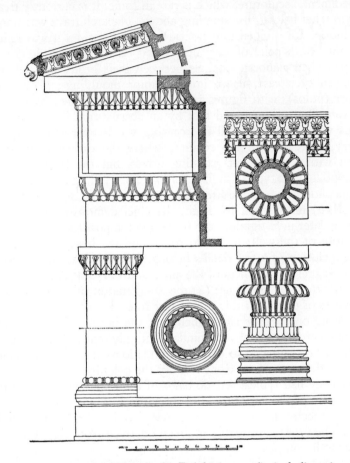

Fig. 46. Treasury of Massalia (?), Delphi (restored): including views of capital and entablature from below, and of base from above. (From *Les Fouilles de Delphes,* II, 1, Pl. XXVII)

was begun in the time of the tyranny, probably by Hipparchus son of Pisistratus. It is probable but not certain that it was planned as an Ionic structure, resembling the second form of the Samian Heraeum, dipteral at the sides, tripteral at the ends and measuring about 141 by 353 feet

on the stylobate: it was finished on these general lines, though with Corinthian columns, in Hellenistic and Roman times. So little of the Pisistratid stage remains—so little was ever built—that it need not detain us here: the temple will claim our renewed attention in a later chapter.[1] It is significant mainly as a symptom of the Ionic current which was setting strongly in Doric waters on the eve of the Persian invasions. The most striking example of this movement is the Throne of Apollo at Amyclae, near Sparta, but something must first be said of the remarkable buildings of Locri Epizephyrii in South Italy, which form with those of its colony Hipponium[2] an isolated Ionic group in this home of Doric. The best preserved temple, that of Marasà, was frequently rebuilt, and both the facts and the dates are disputed. It seems that it was at first a non-peripteral rectangle, measuring about 28 by 85 feet, with a shallow closed adyton, and a shallow porch, perhaps with one central rectangular pillar.[3] The cella had a central row of five columns. This structure was later made more normal, and a peripteral colonnade was added. Later still the whole temple was rebuilt with a shift of orientation: it remained peripteral, and probably had seven columns by seventeen: it measured on the stylobate about 62 by about 150 feet. The technique is singularly excellent, and might suggest a date well on in the fifth century B.C., but the fragments of the superstructure can hardly be much later than the end of the sixth: they may, however, belong, at least in part, to the earlier peripteral structure. They include fragments of columns, dentils, stone tiles, and sculptural groups, probably from acroteria, which seem to date from the middle of the fifth century. The columns resemble those of the Samian Heraeum. The bases have a horizontally fluted torus above a large slightly concave member, which is smooth. There are necking-bands, with lotus and palmette, on the shafts, and the capitals have convex channels, and a curious angle where the volute begins to droop.[4] There is no true abacus, but at the sides an egg-and-tongue moulding runs above the bolster of the volutes. There are also at Locri remains of at least two peripteral Doric

1 See p. 160.
2 Hipponium has an apparently Ionic peripteros, ill preserved, 18·10 m. × 27·50 m. For Ionic in the West see N. Putortì, article cited on p. 367 s.v. *Rhegium* [p. 27 in *Ital. antich.* 1].
3 For this porch scheme we may compare 'Temple A' at Prinia (p. 56 and Fig. 21) and a shrine of the late fourth century B.C. at Agrigentum (*Not. degli Scavi*, 1925, 437 ff.), which had a predecessor, of unknown plan.
4 This form is rare but not unique: it is paralleled in a small capital from Samos (*Ant. of Ionia*, 1, ch. v, Pl. VI) and in a fragment from the temple of Athena at Miletus (*Milet*, 1, 8, Fig. 37): both perhaps date from the fifth century B.C.

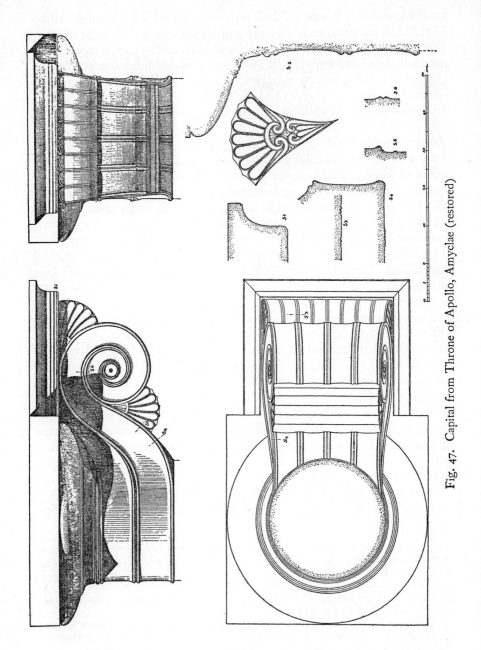

Fig. 47. Capital from Throne of Apollo, Amyclae (restored)

temples, but the most important of these, over sixty-six feet in width, which lies under the Casa Marafioti, shows strong Ionic influences, have five grooves instead of three, pomegranates[1] hang from the viae between the mutules, and the upper part of the cornice is decorated with an elaborately carved leaf-pattern.

The Throne of Apollo at Amyclae which is described by Pausanias (III, 18, 9 ff.) was an elaborate structure, covered with statuary, supporting an ancient colossal bronze statue of very primitive character. The Throne is ill preserved, and its restoration is so uncertain that it cannot be discussed here: it was built by an Eastern Greek, Bathycles of Magnesia, probably in the second half of the sixth century B.C. Attention can here be called only to the startling fusion of Doric capitals with Ionic consoles illustrated in Fig. 47.

It is tempting to speculate how Greek architecture might have developed, had the Doric and Ionic traditions effected a real and fruitful fusion at the beginning of the fifth century. In fact, Amyclae remained a charming eccentricity. For Doric, as a great monumental style, there remained little more than one glorious century, and then irreparable defeat.

1 There is some difficulty in fitting this cornice to the frieze, but all the fragments were found together on the north-east side of the temple: see Orsi in *Not. degli Scavi*, Anno 1911—Supplemento 1912, p. 34, and Figs. 24–26.

[p. 91, nn. 1 and 3. For criticism of Hogarth's account of the earlier remains at Ephesus see Weickert, *Typen der archaischen Architektur*, 1929, p. 16 and for extreme scepticism about all remains assigned to a date earlier than Croesus see E. Löwy, *Zur Chronologie der frühgriechischen Kunst. Die Artemistempel von Ephesos: S.B. Ak. d. Wiss. in Wien, Phil. hist. Kl.* CCXII, 4, 1932.

pp. 95, n. 3 and 98, n. 2. Much has been published on the Samos buildings since this chapter was first printed: see especially E. Buschor, *Heraion von Samos, Frühe Bauten, A.M.* LV, 1930, pp. 1 ff.: I have modified my text to fit these later accounts, but had not room to mention that the Rhoecus temple was preceded by a peripteral temple of the seventh century, with wooden columns, probably 5 × 17, and that this succeeded an earlier peripteral temple of the eighth century, also with wooden columns, itself not the earliest shrine on the site. The cella of each of these early temples seems to have been 100 local feet long.]

Fifth-Century Doric, to the Outbreak of the Peloponnesian War

In the fifth century B.C. Doric temple architecture reached its culmination. It produced some of the world's masterpieces, but it was already haunted by an insoluble mathematical problem, which changes in taste had gradually accentuated. In the fourth it still flourished, but its best days were past, and after Alexander the Great political and aesthetic motives combined to bestow upon the richer and more tractable Ionic the supremacy which it retained till its offspring Corinthian became under Rome the mistress of the world.

It is necessary at this point to define as briefly as possible the nature of the mathematical problem with which Doric was cursed, and to indicate the expedients by which architects attempted to elude its effects. The problem is not easy to explain, and it is usually misstated. It centres in the frieze, and has little or no importance except in rectangular peripteral or prostyle buildings of the temple type. It did not exist at all in circular peripteral buildings. From the earliest times two rules were strictly observed in rectangular peripteral and prostyle buildings. The first, Rule *a*, was that one triglyph must stand over each column and one over each intercolumniation: the exceptions to this rule, in temples, are so rare as to be negligible until Hellenistic times. The second, Rule *b*, which has no exceptions, is this: at each of the four angles[1] of the frieze the two triglyphs which stand above each of the angle columns must be in contact: a pair of metopes or half-metopes must not stand at the corner. These two rules were practically adamantine, and they did not conflict: but there was a third rule, and here the trouble began. Rule *c* was this, that every triglyph which stood above a column or an intercolumniation should stand exactly above the centre of that column or intercolumniation. Rule *c* is irreconcilable with Rule *b*, unless the width of the face of the triglyph is identical with the depth or thickness (from front to back) of the architrave. This is the point hardest to grasp, but the accompanying diagrams (Fig. 48) should make it clear. It must be understood that the face of the triglyph is normally in the same vertical plane as the face of the architrave, the metopes being set

1 *Two*, in a prostyle porch: but it is simplest to speak only of peripteral buildings.

back: and that the architrave, in its long axis, is centred over the columns on which it rests.

Diagram 1 shows (in a schematic form) the upper surface of the architrave lying on the abacus of the angle column, the hidden edges

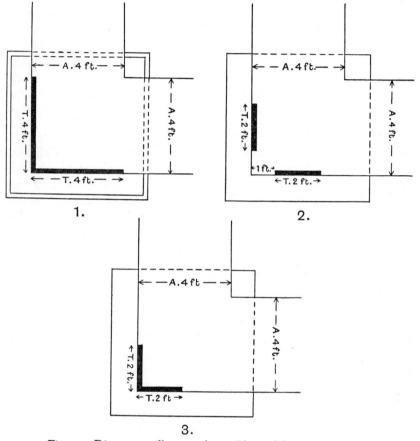

Fig. 48. Diagram to illustrate the problem of the angle triglyph

of the abacus being shown by dotted lines. It is important to observe that the size of the *abacus* has nothing whatever to do with the problem. To make this clear there are shown (in 1 only) two alternative sizes of abacus. The black bars represent two adjacent triglyphs on the frieze which lies above the architrave. They are here shown of a width (marked T) identical with the depth of the architrave (marked A), and it is

obvious that they obey both Rule *b* and Rule *c*. They are exactly centred over the column, and there is no gap at the outer corner. Diagrams 2 and 3 both show the effect of using narrower triglyphs: for the sake of convenience, these triglyphs have been made in each case exactly *half* the depth of the architrave, but the problem is the same whenever the triglyph is, to whatever degree, narrower than the architrave. In 2, Rule *c* is obeyed: the triglyphs are exactly centred on the column, but there is a palpable breach of Rule *b*: there is a gap between the triglyphs at the corner. In 3, with triglyphs of the same size as in 2, Rule *b* has been obeyed, as it was, in fact, always obeyed: the gap has been filled, but Rule *c* has been abandoned, for the angle triglyphs are no longer centred on the angle column. Koldewey[1] invented a convenient formula, which memorizes the whole problem: $\dfrac{A - T}{2}$. This means simply that where the width of the face of the triglyph (T) is less than the depth of the architrave (A), each angle triglyph must be shifted outwards from the position required by Rule *c* (over the centre of the angle column) by *half* the difference between the two measurements A and T. That this is true will be clear from an examination of Diagrams 2 and 3. If A is four feet and T two feet, the truly centred triglyphs of 2 must each be shifted outwards (in 3) by one foot $\left(= \dfrac{4 - 2}{2} \right)$ in order to meet at the corner.

It is obvious that any such shift of the angle triglyph upsets the regularity of the whole scheme of the frieze, and we must now consider when and why this problem became acute, and how it was met. A is never less than T: but in many of the earliest Doric friezes T is approximately equal to A: always less, but often so slightly, that no real difficulty arises. For instance, in Temple C at Selinus the length of $\dfrac{A - T}{2}$ is only about five and a half inches, in Temple D only about two inches, and variations greater than these occur all through both buildings through mere inaccuracy of workmanship. But for various reasons, this state of things could not last. The development of style pursued its inevitable course, governed by a combination of structural and aesthetic considerations too subtle for confident analysis: and by the fifth century B.C. a certain general scheme of proportions was felt to be appropriate, which, despite individual variations, involved in all cases a triglyph

1 Koldewey's formula was $\dfrac{E - T}{2}$, but it is changed here to $\dfrac{A - T}{2}$, since in this book the epistyle is called the architrave.

width very considerably less than the depth of the architrave. $\dfrac{A-T}{2}$ was now a formidable quantity, while accuracy of workmanship and sensitiveness of observation made all irregularities increasingly perceptible. The irregularity could only be removed by equalizing A and T: and this could be done only in one way, by decreasing the thickness —the depth from back to front—of the architrave and the frieze relatively to all the other parts of the elevation. This was impossible for structural reasons. The reduction of the depth of the architrave automatically involved the same reduction in the depth of the frieze as a whole, with a consequent weakening and thinning of the whole mass, which on the façades carried not only the cornices but also the pediments, with their heavy stone or marble sculpture. This change in the thickness of the entablature would also have had a direct aesthetic result: for it would have reduced the total area of the rectangle formed by the upper part of the temple, without affecting its height: and the columns could not be adapted to this change except by either making them more slender in proportion, or reducing their relative height. In fact, despite the obvious disadvantages from the point of view of this particular problem, fifth-century architects actually tended to make their architraves thicker (relatively to the upper column diameter) than most of their predecessors or successors. It may be asked why the width of the triglyphs could not be increased, relatively to the architrave depth, without changing the proportions of the rest of the elevation. The reason was purely aesthetic, but it was none the less decisive. It was now a law of taste that the triglyphs must be upright oblongs, of more or less fixed proportions, and that the metopes must be approximately square: and it was also (as always) a fundamental rule that triglyphs and metopes must be of the same height. Therefore every increase in the width of the triglyphs automatically increased their height, and also the height, and therefore the width, of the square metopes: again, the wider the metopes, the further apart the triglyphs, and the further apart the triglyphs, the further apart the axes of the pteron columns on which they were centred. The *size* of the columns, could of course be increased, without affecting their interaxial measurements, and since all these changes are relative, not absolute, we are back where we started, except for the depth of the architrave (involving the depth of the frieze), which *ex hypothesi* must not be increased, for that would defeat our whole object. We have increased *all* the proportions relatively to the depth of the architrave and the frieze: in other words, we have in fact again decreased

the architrave and frieze depth relatively to *all* the other parts of the elevation.

The irregularity of $\frac{A-T}{2}$ was therefore irremovable: but it could be made less obvious by distribution, and it must now be briefly explained how Greek architects succeeded in distributing it. In the sixth century B.C., it was sometimes frankly admitted and confined to the one point which it naturally affected, the angle metope. In the carefully built 'Temple of Ceres' at Paestum the angle triglyph was duly shifted, but all the other triglyphs were exactly centred: thus the whole of $\frac{A-T}{2}$, in this case about eleven inches, fell upon the angle metope, which was perceptibly wider than any of the rest. In the Olympieum of Agrigentum, built in the first half of the fifth century, there is evidence[1] that the triglyph next to that over the angle column was placed exactly half-way between its neighbour triglyphs, of which that over the angle column was duly shifted to the corner, while the other was centred over its column: consequently the triglyph next to the corner one was not centred over its intercolumniation, and each of the two metopes nearest the angle was larger than the normal by *half* $\frac{A-T}{2}$, the rest being of normal width. But fifth-century architects were rarely content to juggle with the triglyphs alone. They took the much more drastic step of modifying the ground-plan of the temple by contracting the angle intercolumniation ('simple contraction') and sometimes also, though to a less degree, the intercolumniation next to the angle ('double contraction'). These contractions, however, though helped in many cases[2] by the inward tilt of the angle column, were never great enough entirely to solve the problem, and it was still necessary to shift two, or even more, of the triglyphs. In one of the subtlest examples of these methods, the 'Temple of Concord' at Agrigentum, of the second half of the fifth century B.C., we find on the façades three different widths among the ten metopes and three different widths among the five intercolumniations: and the unequal spacing of the columns is here reflected in the jointing of the stylobate, and down to the fourth course of the concealed foundations. It is not surprising that the triglyph problem killed the Doric tradition. Who shall blame the fourth- and third-century architects, who (as Vitruvius[3] tells us) declared that for this reason, and this only, Doric, despite its acknowledged beauty and dignity, was not a fit style for

1 See Koldewey and Puchstein, *Griech. Temp. in Unterit. und Sic.*, p. 163.
2 See p. 117. 3 IV, 3, 1.

temple architecture? Men will not wear inherited chains for ever. Hellenistic architects did, indeed, succeed in removing one awkwardness of the style—the impossibility of widening the intercolumniations, without automatically increasing the height of the frieze. They did this by systematically putting two or even three triglyphs to each inter-columniation—a device occasionally used even in the fifth century for exceptional spans,[1] for instance in the central intercolumniation of the Athenian Propylaea. They thus succeeded in actually lowering the height of the entablature while increasing the distance between the columns, and thereby produced a new and attractive form of Doric. But the change brought no relief to the problem of the angle triglyph, and this new Doric was seldom used for peripteral or prostyle structures. In the charming prostyle temple at Cori in Latium,[2] built in the time of Sulla, the problem is as troublesome as ever, and under the Roman Empire[3] Doric temple architecture almost ceased to exist. It should be added that Vitruvius advises the use of half-metopes at the corners; but this was probably the academic solution of some Hellenistic theorist, and it was rarely, if ever, adopted in antiquity, though it is common in Renaissance and modern work. It is curious to observe in this connexion that in some important fourth-century Ionic temples, for instance that of Artemis at Sardis, the spacing of the façade columns was not equal, but diminished from the centre towards the angles, as it did in the great buildings of the sixth century B.C. It is difficult to see why architects who admitted such an arrangement should have objected to irregular column-spacing in Doric. The explanation seems to be that the fundamental objection was to the actual decentering of the angle triglyph, to which Ionic offers no parallel, since the much smaller and more numerous dentils do not proclaim any definite relation to the columns below. Moreover in some of the most careful fourth-century temples, such as that of Athena at Priene, whose architect Pytheos is one of the earliest objectors to Doric named by Vitruvius, the façade intercolumniations were exactly equal: and this was the rule in Hellenistic Ionic, except that the central intercolumniation was often wider than the rest.

Contraction of the angle intercolumniations, with one surprising exception,[4] the Heraeum of Olympia, does not appear till the second half of the sixth century B.C., when it is found in the 'Temple of Hercules' at Agrigentum, in the temple of Corinth, and in the peripteral

1 See p. 119. 2 See p. 209. 3 See p. 213, n. 1 and p. 344.
4 We cannot be quite sure that this contraction is really significant.

form of the Athenian Polias temple. In the Heraeum it is double on the façades, simple on the flanks: but it should be remembered that widening of the central intercolumniation is not unknown to early Doric, and that in an early hexastyle façade simple contraction, combined with such widening, is absolutely indistinguishable from double contraction: we cannot, in early work, deduce from the flank intercolumniations the *normal* width of those on the façades, and are at liberty to regard as normal either the central intercolumniation or its two neighbours. Double contraction is otherwise almost confined to fifth-century work in Sicily. In G at Selinus, and the other temples mentioned above, we find simple contraction, and it is confined to the façades, where the aesthetic difficulty would be most acute. Simple contraction on all four sides occurs in the sixth century, and is the rule in the fifth: double contraction is usually found on all four sides, and occurs in the temple of Athena (the Cathedral) at Syracuse, in the temple of Segesta, and in the 'Temple of Concord' at Agrigentum. Simple contraction on the façades is combined with double contraction on the flanks in the 'Temple of Poseidon' at Paestum.

It may be thought that too much space has been devoted to this technical problem. No apology is needed, for it was the worm in the Doric bud: but in fifth-century architecture it lay almost concealed, and it need trouble us no further in our contemplation of that glorious blossoming. The subtle refinements of curvature and inclination which are peculiarly characteristic of this century will be most conveniently described and discussed in connexion with the Parthenon. From the great mass of fifth-century Doric material we may select for special consideration three remarkable buildings: the Parthenon and the Propylaea at Athens, and the Olympieum, or 'Temple of the Giants', at Agrigentum. Of the beautiful temple of Aphaia in Aegina, dating from about 490 B.C., and of the temple of Zeus at Olympia (about 460 B.C.), an early example of typically classical work, there is no space to speak here. One feature of the former has been mentioned[1] and one of the columns and the entablature of the latter have already[2] been used to illustrate the general characteristics of Doric. Here it will be enough to add that these two are perhaps the only temples among the many possessing two rows of inner columns in two tiers where there is evidence for the presence of wooden galleries over what we may call the 'aisles': for the temple of Aphaia the evidence is archaeological and con-

1 See p. 86, *n.* 1. 2 See pp. 39 ff. and Fig. 17.

clusive, but for that of Zeus we depend upon Pausanias,[1] and cannot be sure that the arrangement mentioned was part of the original scheme.

The Parthenon is the most beautiful of Greek temples, and, but for a miserable disaster in the late seventeenth century, it might have been also the best preserved. It became a church, and then a mosque, and despite serious internal alterations remained roofed and almost perfect until in 1687 a Venetian bomb ignited the gunpowder stored in it by a Turkish garrison. The whole centre blew out, and henceforth it was a ruin. Its condition and apparent prospects at the opening of the nineteenth century, when Greece was still part of Turkey, went far to justify Lord Elgin in removing to England much of the friezes and almost all that was left of the pedimental sculptures.

This temple does not, for the most part, stand on a natural ground-surface.[2] South of the old Polias temple the Acropolis rock first rises and then slopes rapidly downwards. It is probable that an artificial terrace had made part of this slope available for building in the sixth century B.C., and Buschor[3] has ingeniously argued from certain cuttings still visible in the rock that this terrace carried a very large temple. The cuttings and other evidence suggest that it was at first horseshoe-shaped, with only one pediment, but later rebuilt on fully rectangular lines. It is to this temple that Buschor assigns certain large architectural and pedimental remains (outdoing the Polias temple) which were mentioned[4] in chapter six. Heberdey had conjecturally assigned most of these to a hypothetical one-sided Propylon. Buschor's theory is more attractive, though certainty is scarcely attainable: he supposes that this temple was at first exactly one hundred Attic feet long, and that this, and not the Polias temple, was the traditional 'Hekatompedon'. It is certain, in any case, that the character of the site was completely changed in the closing years of the sixth century B.C. or in the early part of the fifth. A vast substructure of good limestone masonry was then built to carry a new and much larger temple, which was actually begun before the Persian invasion. Its identifiable remains are all of marble, except for the bottom step of the crepis, which is of hard Kara limestone. This temple did not occupy the whole available area. Most critics have assumed that the substructure was intended from the first to be, what it ultimately became, a concealed foundation, masked to the south by

1 V, 10, 10.
[2 For the general scheme of the Periclean Acropolis see note on p. 124.]
3 *Ath. Mitt.* XLVII, 1922, p. 98. [Some critics have rejected Buschor's theories, e.g. W. Kolbe, *Phil. Woch.* 1931, cc. 14 ff. and W. B. Dinsmoor, *A.J.A.* XXXVI, 1932, p. 380: see also W. Dörpfeld, *J.D.A.I.* LII, 1938, p. 14: but see also works named on p. 84, n. 1 *supra*.] 4 See p. 83.

an earth terrace: and they have therefore postulated an abandoned scheme for a limestone temple covering its entire area. Heberdey, however, has suggested, more plausibly, that the substructure was designed as a visible podium, rising high above the southern ground-level, and meant from the first to carry a marble temple not occupying its whole surface. It is certain that this marble temple was planned as a hexastyle Doric building (six by sixteen), measuring about 77 by 220 feet on the stylobate, with a tetrastyle prostyle porch at each end; but it was only a few feet high when the Persians sacked the Acropolis, and its ruins were abandoned till the time of Pericles.[1] The existing building was begun in 447 B.C. The architects recorded are Callicrates and Ictinus; the sculptor Phidias is said to have exercised a general supervision over all Pericles' buildings, but it is probable that Ictinus was the real designer. The new

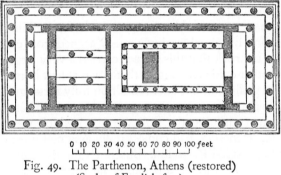

0 10 20 30 40 50 60 70 80 90 100 feet

Fig. 49. The Parthenon, Athens (restored)
(Scale of English feet)

temple (Fig. 49 and Plate IV *a*) was not so long (from east to west) as the substructure, but it was both longer and broader than its marble predecessor. It measures just over 100 by nearly 230 feet on the stylobate. Except for the timber roof, and for clamps and dowels, it was all marble, even to the tiles. The unfinished marble drums of the earlier temple were partly re-used. The pteron was octastyle (eight by seventeen), with a coffered marble ceiling. The columns were about thirty-four and a half feet high, equivalent to about five and a half lower diameters. The cella was divided (like that of the Polias temple) into two unconnected sections, each entered through a hexastyle prostyle porch with short anta-walls. To the east lay a great room one hundred Attic feet long: it contained Phidias' gigantic gold-and-ivory statue of Athena Parthenos, and was surrounded on three

[1 W. Kolbe, *J.D.A.I.* LI, 1936, pp. 1 ff. dates this earlier Parthenon 479 B.C., after the Persian wars.]

sides by a narrow Doric colonnade in two tiers, which perhaps carried a flat timber ceiling under the gabled timber roof. The room behind the western porch (the 'Parthenon' in a narrower sense) was much shallower. Its roof or ceiling was directly supported by four large columns, probably Ionic.[1] Besides these hypothetical columns, the temple had many small Ionic features, and one of the first importance— a continuous frieze running above the prostyle porches and right round the top of the cella wall. We have already seen that this feature was perhaps anticipated in the peripteral form of the Polias temple,[2] and it recurs, incompletely, in three other fifth-century Athenian temples, the 'Theseum' and the temples of Nemesis at Rhamnus and of Poseidon at Sunium.[3] Space forbids any description of these magnificent reliefs and of the sculpture which adorned the metopes and pediments. It should be added that the incomparable proportions of the Parthenon defy simple arithmetical analysis: there is perhaps more hope of explaining them on geometrical lines.

It has already been remarked that the Parthenon is the supreme example of those subtleties of curvature and inclination (commonly called 'refinements'), which best express the unique and austere perfection of Greek architecture. These subtleties have sometimes been denied or dismissed as unintentional. It is true that some of the alleged instances may be due to carelessness, or to later shifting of the fabric, and that others are attested only by doubtfully trustworthy photographs. But it is certain that in many buildings, and especially in Athenian work of the fifth century, various lines which appear at first sight to be straight in themselves, and exactly perpendicular or horizontal, are in fact delicately curved or tilted, and that the thickness of apparently identical columns is subtly varied on definite principles. Of all this the Parthenon is the best proof: for it is made of marble, and its foundations rest on rock. There is no question of subsidence, and the shifts due to man's violence are easily recognizable. Further, the temple has been surveyed with extraordinary accuracy. Nor are these subtleties a modern fancy, for Vitruvius prescribes them, on good Greek

1 It should perhaps be added that the small 'Varvakeion' copy of the gold-and-ivory Athena of this temple shows a column supporting the goddess' right hand, which seems to have a double capital resembling those of the Treasury of Massalia at Delphi (p. 101 and Fig. 46). If this column is an accurate copy of the original, the use of this type of capital is interesting.
2 See p. 88.
3 For the Theseum frieze, see p. 118: for those at Rhamnus and Sunium, see p. 328. In the Parthenon and at Rhamnus there are regulae and guttae under the Ionic frieze. [See also Garitsa, p. 69, n. 4.]

authority. Fifth-century temples sometimes lack them, but we must remember that their planning and execution were laborious, and could not always be afforded. We must also use our commonsense. When critics argue from variations of small fractions of an inch, the thing becomes absurd: even the Parthenon has very considerable undesigned irregularities. The four corners of its stylobate are not perfectly level with one another, and there are notable faults of execution in architrave, frieze and cornice.

Refinements begin in the crepis, or even in its foundations. The stylobate often droops towards all four angles, so that its surface is somewhat like that of a carpet nailed at its corners only, and raised from the floor by a draught. This 'horizontal curvature' is rare before the fifth century, but occurs in the front and back of the temple at Corinth (not only in the stylobate, but in the rock cuttings below its foundations), and in a few other instances, notably the older Parthenon. In the West it is unknown till the fifth century. For Ionic it is not attested before the fourth century, but this may be an accident: it is advised by Vitruvius. In the Parthenon and 'Theseum' at least the stylobate is not really curved, but consists of a series of straight lines, a portion of the circumference of a huge irregular polygon. The rise amounts in the Parthenon stylobate to about two and three-quarters inches on the short sides and about four inches on the long sides.[1]

We may pass next to the columns. It has already been said that all Greek columns show 'diminution': but in the sixth century the profile of the Doric shaft, though not vertical, is usually straight: for Ionic we have not sufficient evidence. In a few early western temples, however, especially at Paestum and Metapontum, we find the diminishing profile strongly curved: both cities were Achaean colonies, and this entasis, as the Greeks called it, was perhaps an Achaean invention. In Greece proper it is doubtful whether it occurs before the fifth century, when it is always subtle, and even subtler, where it occurs, in Ionic[2] than in Doric. In Greek architecture entasis is always subordinate to diminution, though in Hellenistic work the lower part of the column is sometimes cylindrical: the 'cigar-shaped' type, in which the diameter actually increases for about half the height, is unknown in Greek work, at least

[1 See now G. P. Stevens in *A.J.A.* xxxviii, 1934, 533 ff., for the curvature of the Parthenon steps.]

2 The presence of entasis in Greek Ionic is sometimes denied, but it is certain for the North porch of the Erechtheum, though it is absent from its East porch and from the temple of Athena Nike. It is also certain for the temple of Athena Polias at Priene (fourth century B.C., see pp. 147 ff.) and is common in Roman work.

before Roman times. The curve in Greek work is usually a continuous hyperbola, but the Romans used the parabola and other forms, and sometimes made two different curves meet. Another refinement affecting columns is the enlargement of the four angle columns of the pteron. All these are advised by Vitruvius. Further points must be briefly indicated. The chief are the inclination[1] of all pteron columns towards the cella walls, the angle ones having a double inclination, and the backward slope of the chief vertical surfaces, including the cella walls, up to the level of the capitals. For the whole entablature Vitruvius[2] prescribes a forward tilt,[3] and the latest investigations seem to show that the Parthenon obeys this rule, though it has usually been stated that fifth-century practice continued the backward tilt to the top of the frieze, confining the overhang to cornice and antefixes. In the Parthenon and Propylaea the faces of the antae have a forward tilt. These various inclinations are differently used in different temples. When the stylobate is curved, it is usual, perhaps universal, to repeat the curve (as Vitruvius also advises), in architrave, frieze, and cornice. A few temples also show curves *in plan*, usually convex, but occasionally concave. It is likely, however, that these are due to carelessness in laying out.

The explanation of these refinements is far from easy. Vitruvius' masters, probably Ionic architects of the fourth or third century B.C., believed their purpose to be the correction of optical illusions: without them the stylobate would seem to sag, the entablature would seem to recede, the angle columns would look thin against the sky. Ictinus wrote a book on the Parthenon, and the optical theory may well be as old as the fifth century: but it does not follow that it is true, and modern authorities have disputed the scientific facts.[4] It is likely that the different refinements have different ultimate origins: the curvature of the stylobate was perhaps for drainage,[5] the tilting of walls and columns

1 Inclination, like entasis and curvature, is often omitted, especially in Ionic: but the Erechtheum has inclination both in the east and in the north porches. In the north porch all the columns have a double inclination, towards the centre as well as towards the wall; in the east porch only the angle columns are doubly inclined.
2 III, 6, 13.
3 See N. Balanos, in *C.R. Ac. Inscr.* 1925, p. 167.
4 A. D. Browne has lately thrown valuable light on the mechanical effects of settlement in columnar buildings, and has argued that column-inclination and horizontal curvatures were designed to anticipate and neutralize the displeasing effects of such settlement (*Architecture*, v, 1927, pp. 296 ff.).
5 In some temples, for instance that of Athena Polias at Priene (Ionic, fourth century B.C., see pp. 147 ff.), the stylobate is tilted outwards, though not curved, presumably for drainage.

and the thickening of the angle columns for strength, entasis for beauty. In the minds of the men who used them so delicately in the fifth century optical theory and dislike of machine-made straightness may both have played their part. To him who sees the Parthenon even as it stands to-day the elasticity and life which spring from these unnoticed subtleties are a revelation. It matters little if their ultimate secret was hidden even from Ictinus.

The so-called 'Theseum' at Athens (probably a temple of Hephaestus) is remarkable as the best preserved, externally, of all Doric temples. It is perhaps rather earlier than the Parthenon, which on a smaller scale it much resembles.[1] It measures about 45 by 104 feet on the stylobate, and the columns are about nineteen feet high. There is an Ionic frieze, with sculpture, at each end of the cella. At the west it is confined to the end wall of the cella, but at the east both the architrave and the frieze of the cella porch are carried across the pteron and meet the corresponding members of the outer entablature at right angles exactly above the column next but one to the angle on each side.

The Propylaea are in some respects the most interesting and impressive to us of all the Attic works of the fifth century, and they were greatly admired in antiquity. The architect was Mnesicles, and they were built mainly between 437 and 432 B.C.: the material is Pentelic marble. Placed in the only possible position, the western approach of the Acropolis, they completely covered the site of the older Propylaea.[2] In essence the traditional plan was retained—a roofed porch projecting from both the outer and inner sides of a gate in a wall: but the scheme was here complicated by the addition of wings, and by the elaboration of the porches themselves. The full plans were never executed, partly through religious conservatism, which refused to sacrifice ancient sanctuaries to mere magnificence, and partly through the financial stress of the Peloponnesian War. Enough, however, was executed to indicate the architect's intentions, and the main lines of the original scheme have been recovered, notably by the observations of Dörpfeld. Dinsmoor has long been engaged on an intensive study of the building, and several illuminating papers have given a foretaste of the monograph which he promises. A glance at the plan (Fig. 50) and view (Plate IV b) will show the main facts. At the head of the winding road which led up the steep western slope, the visitor found himself faced by a hexastyle Doric façade, crowned with a pediment. It stood upon a platform of four steps, except between the two central

[1 See note on p. 328.] 2 See p. 89.

columns, where the road passed: this intercolumniation was wider than the rest, and carried two triglyphs. The façade was that of a huge prostyle porch: close behind each of the angle columns was an anta, which in each case formed the end of a side-wall, common to both the outer and inner porches. If the visitor passed through the central inter-columniation, he found the rising roadway on which he stood flanked to right and left by two platforms (the true floor of the outer porch), on each of which stood three Ionic columns, carrying a marble architrave, level with the triglyph frieze of the outer façade. These two architraves

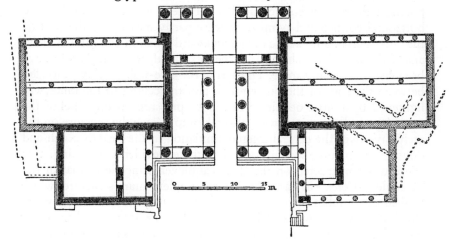

Fig. 50. The Propylaea, Athens (restored and completed according to the supposed original scheme)

helped to carry a system of marble beams and cofferings, decorated with golden stars on a blue ground, which covered the whole porch. This marble ceiling and a similar one in the inner porch were still unrivalled in the days of Pausanias. At the back of the outer porch a solid wall ran right across the structure: the road passed through it by a great gate about twenty-four feet high and nearly fourteen feet wide: the inner width of the whole porch was nearly sixty feet. If the visitor preferred to mount the steps of the western façade, and to pass through one of the outer intercolumniations, he found himself on one of the raised platforms already mentioned, between the Ionic columns and the side-walls. In front of him the great cross-wall was pierced by two doors, a larger and a smaller, at the top of a flight of five steps, the top one of black Eleusinian limestone. There were thus four doors for foot-passengers, in addition to the central gate. Beyond the cross-wall lay

the inner porch, which was exactly like the outer one, except that it was much shallower and had no inner columns: the depth of the outer porch, from anta-face to cross-wall, was between three and four times as great as the corresponding measurement of the inner porch. The façade of the inner porch was almost identical in size with that of the outer porch[1]: and since its stylobate stood between five and six feet higher, there was approximately the same difference in level between the two sections of the roof. Consequently the inner porch had a pediment at its back, which rested on the cross-wall between the two porches: the raking cornice of this pediment was complete, but the horizontal cornice and tympanum were partly masked by the roof of the outer porch. The whole of this awkward junction was little in view, and if the complete scheme had been executed, it would hardly have been visible from any angle. The part of the gate-wall entirely concealed between the roof of the outer porch and the ceiling of the inner was lightened by a large opening,[2] to relieve pressure on the lintel of the central gate. Precautions were also taken to relieve the pressure on the architrave over the central intercolumniation in the eastern porch and doubtless also in the western one, though here evidence is lacking. The frieze was constructed on the same cantilever principle as that of the 'Temple of Ceres'[3] at Paestum. Of the supplementary structures which flanked the porches only one was fully executed, the north-west wing, which the visitor saw above him to the left as he approached the outer porch. This was a rectangular building, at right angles to the porch, with the steps and stylobate of which its own were continuous. In plan it resembled a temple, having a porch with three Doric columns *in antis*, connected with its main room by a door and two windows: but it had no pediment (its low roof had three slopes) and it was linked to the north wall of the western porch. It seems to have been a picture-gallery. The south-west wing was designed, in the main, on the same lines, with the difference that for its west wall an open colonnade was perhaps to be substituted,[4] in order to give easy access to the bastion and temple of Athena Nike. In fact, however, this wing was seriously curtailed, though

1 The columns of the east porch were almost a foot lower than those of the west porch: Dinsmoor in *Anderson and Spiers*, ed. III, p. 133.

2 There were similar openings above the cella porches in the 'Temple of Concord' at Agrigentum. 3 See p. 80.

4 This is so shown in the restored plan (Fig. 50), but Dinsmoor states that unpublished American investigations have shown that the west wall was in fact meant to be solid: he also says that the east fronts of the north-eastern and south-eastern halls were to have been solid walls (*Anderson and Spiers*, ed. III, p. 134).

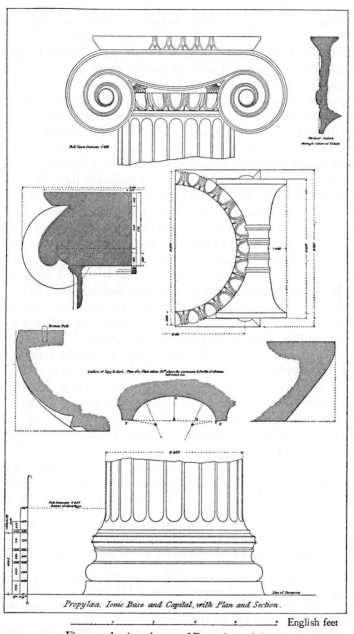

Propylæa. Ionic Base and Capital, with Plan and Section.

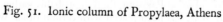
English feet

Fig. 51. Ionic column of Propylaea, Athens

the portion executed approximately balances the north-west wing: some details seem intended to remind the spectator of the architect's disappointment. It is clear that there were also planned two larger halls flanking the eastern porch. The south wall of the north-eastern hall and the north wall of the south-eastern hall would have been formed by the north and south walls of the central building, while a great part of their west walls would have been formed by the east walls of the north-west and south-west wings. An open row of Doric columns would perhaps have given free access to each of these halls from the Acropolis, while half-way back a more widely spaced row of Ionic columns would have helped to support the roof, which would probably have sloped from west to east. Neither hall was ever built, but preparation had been made for the insertion of the roof-beams and rafters of the northern one.

The Ionic columns of the Propylaea (Fig. 51) are perhaps the finest in the world. The bases are of the Attic-Ionic type with the upper torus alone horizontally grooved, and an extra concave moulding at the bottom, which, however, is structurally a part of the stylobate.[1] This is perhaps the earliest form of the Attic base—a simple *doubling* of the old Samian type.[2] The capitals are simple and severe, with slightly concave channel: the echinus is low enough, relatively to the volutes, to allow a beautifully curving line to the lower boundary of the channel, and the palmettes in the corners are not allowed to trespass on the echinus. The general tendency[3] of evolution was for the Ionic capital to shrink both in height and width, so that the eye of the volute, here well outside the perpendicular of the shaft, and well above the horizontal of the bottom of the echinus, approached or touched the point where these lines intersect. The architraves resting on these Ionic columns were reinforced by iron bars.

Finally[4] we may consider one of the strangest of Doric buildings, the temple of Zeus Olympios, or 'Temple of the Giants', at Agrigentum, the Greek Akragas (Fig. 52). This was probably begun by the tyrant

1 In the archaic Doric temple at Pompeii below the lowest column drums was a slightly raised disk, fluted so as to be continuous with the shaft above it: but it is rare for any part of a column to be structurally part of the stylobate. See, however, p. 325.

2 For Samos see Fig. 44. For this view cf. Krischen, *Ath. Mitt.* XLVIII, 1923, p. 87. But the bases of the Athena Nike temple (p. 125 and Fig. 53) suggest rather that the first step was the simple addition of a small torus below the large concave member.

3 See further pp. 157 and 211 for Hellenistic tendencies.

4 The 'Temple of Poseidon' at Paestum, though probably earlier than the outbreak of the Peloponnesian War, has been placed with certain other Western temples in the next chapter, p. 136.

Theron after the great Carthaginian defeat at Himera in 480 B.C., and it was still unfinished when the Carthaginians in their turn sacked Agrigentum in 405 B.C. The city was never again rich enough to complete the work. The temple was famous in antiquity, and the Sicilian historian Diodorus has left us a brief account of its condition in the first century B.C. Unhappily his description does not add much to the evidence of the ruins themselves, and there is great uncertainty about its arrangements. The last standing portions seem to have fallen in A.D. 1401: but the remains would probably have sufficed for a convincing paper reconstruction, had they not been systematically quarried for an eighteenth-century harbour-mole. Even now a searching excavation, with exhaustive observation and measurement, could pro-

Fig. 52. Olympieum, Agrigentum

bably settle many points of doubt. The following facts are not disputed. The building is one of the largest, measured on the stylobate, of all Greek or Roman temples (over 170 by over 360 feet), and its real size was even greater than this statement suggests, for it was pseudo-peripteral. The pteron columns were engaged in a continuous curtain-wall, being indeed half-columns, to which corresponded rectangular pilasters on the inner face of the curtain-wall: the four angle columns were three-quarter columns, and had no inner pilasters. Of these engaged columns there were fourteen on the flanks, and, strangely, seven on the fronts, though there was a double, not a single, row of interior supports. Along the bottom of the outer side of the curtain-wall, and also round the bottoms of the engaged columns, ran an elaborate group of horizontal mouldings, so that these columns seem, at first sight, to

have moulded bases, which bear a slight resemblance to the early Asiatic-Ionic type. There were certainly an architrave, a triglyph frieze, and a horizontal cornice, but all these, like the columns, were constructed of small blocks, and the architrave rested partly on the curtain-wall. Here, however, we may almost say that certainty ends. We know that the interior was divided into three almost equal divisions (a nave and two slightly narrower aisles) by two rows of twelve square pillars, corresponding in position to the pilasters on the curtain-wall: we know also that in each row these square pillars were themselves connected by a curtain-wall, and that at the west end a wall joined, or partly joined, the penultimate pillars of the two rows: but we do not know to what height the pillars or the walls were carried. We also know from the existing remains and from late mediaeval records that the architecture included colossal male and female figures, some twenty-five feet high, with their arms bent back over their necks. Each was built of twelve or thirteen courses of stone. It is however uncertain where these figures were placed, though there is reason to think that they stood at a high point. The majority of authorities have placed them inside the building, somewhere on the inner pillars, but the latest investigations support Koldewey and Puchstein's view that they stood on a ledge in the outer curtain-wall, and helped to support the architrave, which was perhaps further reinforced, like those of the Athenian Propylaea,[1] by an iron bar. It is usually assumed that the original builders intended to roof the whole structure, as Diodorus seems to imply, but it is possible that the central nave was meant from the first to be open to the sky. Pace, who adopts this 'hypaethral' theory, supposes also that the interior was arranged like the atrium[2] of a Roman house, with roofs sloping downwards and inwards from the outer cornice to an entablature carried by the inner pillars, and that there were no pediments at all. This theory is more ingenious than plausible, but it must be allowed that the present lack of evidence makes all reconstruction guess-work.

1 See p. 122.
2 See p. 302. [For the Olympieum and all the Agrigentum temples see now P. Marconi, *Agrigento, Topografia ed Arte*, Florence, 1929.]
[p. 113, n. 2. For the general scheme of the Periclean Acropolis see now G. P. Stevens, *Hesperia*, v, 1936, pp. 443 ff., and for new fragments of acroteria and other details of the Parthenon see W. Züchner, *A.A.* 1936, cc. 305 ff.]

Ionic in the Fifth Century, and Doric and Corinthian in the late Fifth and Fourth

We saw in the last chapter that, though the Ionic style affected fifth-century Athenian Doric, its influence was secondary: but during the same period the practice begun by the tyrants, of building frankly Ionic buildings in Athens, was not abandoned. Of the surviving examples the oldest is probably the famous small temple of Athena Nike, often called 'Nike Apteros', which stands on an artificial bastion projecting from the south-west wing of the Mnesiclean Propylaea. It is known that the architect Callicrates was instructed to build a temple on this site soon after 450 B.C., but it has recently been proved that the bastion on which the existing temple stands was constructed later than Mnesicles' foundations, and the temple is probably not so old as the bulk of the Propylaea. Attempts to distinguish two periods in its architecture and sculpture seem to be fanciful. An earlier altar has been discovered on the original ground-level. The temple, which is of marble, stood till late in the seventeenth century, when the Turks pulled it down to build a battery, but most of its parts remained on the spot, and it was re-erected in 1835, with many small errors, but no substantial incorrectness (Fig. 53).[1] The plan was very simple: there was a single cella, tetrastyle amphi-prostyle, with a three-stepped krepis. It measures on the stylobate about eighteen and a half by twenty-seven feet. The antae are engaged pilasters at the four corners of the cella, and the mouldings of their bases and capitals run all round the cella walls. The back wall has no door: for the front wall, on the east, are substituted two isolated pillars, identical in form with the antae.[2] At the east end the antae were joined to the angle columns and to the adjacent pillars by a metal lattice, so that the porch became, for purposes of accessibility, distyle *in antis*. The monolithic columns are of a simple and severe type. The capitals closely resemble those of the Propylaea, but the bases are an interesting early form of the Attic-Ionic: their very large shallow concave moulding and small lower torus suggest how the Attic form may have developed from the Samian.[3] The architrave was in three fasciae, and there was a sculptured frieze, but no dentils.[4] Probably a little older than the Nike

[1 These errors are being corrected in a new re-erection by the Greek authorities.]
[2 For this arrangement compare the 'Temple of the Athenians' at Delos (p. 328).]
3 See p. 122, n. 2. [4 See further note on p. 146.]

Fig. 53. Temple of Athena Nike, Athens (Durm)
(From *Handbuch der Architektur*, Band 1, J. M. Gebhardt's Verlag, Leipzig, Germany)

temple was a similar marble one, perhaps the Metroon in Agrai, which stood on the south bank of the Ilissus till the close of the eighteenth century, but has since been destroyed except for some slabs of its frieze, recently identified, and now distributed between the museums of Athens, Vienna and Berlin. Luckily it was well published by Stuart and Revett in 1762.[1]

Mention should also be made here of an Athenian Ionic work certainly earlier than either of these temples, the Athenian Colonnade at Delphi, which ran in front of the polygonal supporting-wall of the temple terrace. The monolithic columns, which perhaps had wooden predecessors, were so widely spaced that the entablature must always have been of wood. Nothing certainly remains but the shafts with their attached bases, though a capital has been tentatively associated with them. The bases are remarkable. There is a normal fluted convex moulding below the shaft, but below that comes a single smooth member shaped like a bell.

We come next to the Erechtheum on the Acropolis at Athens. It was perhaps begun about 421 B.C.[2]: work was resumed, after a long period of neglect, about 409 B.C., and it was finished about three years later. A fire seems to have injured it soon after its completion, but it was quickly repaired. It suffered from fire and restoration in Roman times, and was much altered and damaged in the Middle Ages, but has been carefully and skilfully reconstructed.

For perfection of workmanship this temple has never been surpassed. It was profusely decorated both with carved ornament, and with the studied contrast of black Eleusinian limestone and white marble, of which we have already seen an example in the Propylaea. The elaboration of the column-neckings and capitals is almost unparalleled, and was rejected by the general taste of the following centuries. The columns seem to have been copied in the Nereid Monument[3] in Lycia within a quarter of a century of their erection, but the next certain example of their influence upon strictly architectural design is found in the circular[4] temple of Rome and Augustus, erected within a hundred yards of the Erechtheum itself. These copies would perhaps have been condemned by modern critics as examples of Roman extravagance, had their beautiful models perished: it is true that much has been lost in the imitation.

[1 See now H. Möbius in *Ath. Mitt.* LX/LXI, 1935/36, 234 ff.]
2 Possibly before 431 B.C., but *Inscr. Graec.* I, 32, however restored, does not prove this, as Dörpfeld asserts in *Phil. Woch.* 1928, col. 1073.
3 See p. 135. 4 See p. 218.

The plan of the Erechtheum[1] (Fig. 54) would be incomprehensible, did we not know that it was designed to unite in a single structure a number of ancient sanctuaries. Even so the scheme is strange, and

Fig. 54. Erechtheum, Athens (restored)
(Scales of metres and Attic feet of 0·328 m.)

Dörpfeld holds that here, as in the Propylaea, what we see is a torso, curtailed by poverty or superstition: but his theory, to which we must return, has not met with general assent. The architect was faced by an extreme irregularity of ground-level, and the local sanctities forbade such

1 In this plan, which is a restoration, the marble coffers of the porch ceilings and the capitals of the columns and Caryatids are shown as if seen from below.

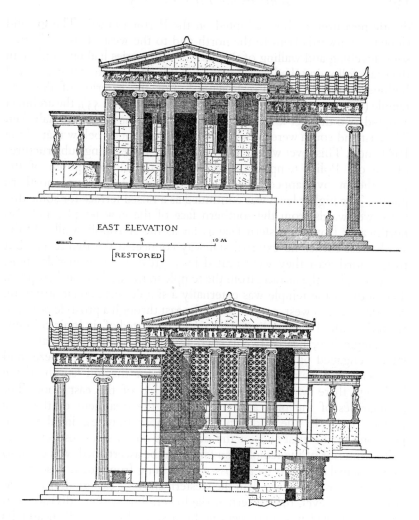

EAST ELEVATION

[RESTORED]

0 5 10 M

WEST ELEVATION

0 5 10 15 20 ENG FT 0 5 10 15 20 AT FT

[RESTORED]

Fig. 55. Erechtheum, Athens (restored)
(Scales of metres, English feet, and Attic feet of 0·328 m.)

drastic measures as those adopted on the Parthenon site. The ground sloped downwards both to the north and to the west. It is likely that some levelling and walling of the various sanctuaries had taken place in the years following the Persian wars, but it is not certain that any roofed buildings preceded the Erechtheum.[1] For the exterior of the new temple (seen both from east and west, restored, in Fig. 55), the architect adopted two distinct levels differing by more than ten and a half feet. The east and south were at the higher level, not much below that of the Parthenon. This level was in part dictated by the existing substructures of the old Polias temple, and the southern wall and porch of the Erechtheum overlapped[2] the foundations of its destroyed northern pteron. The higher level was continued as a raised terrace for some distance westwards from the southern face of the new temple, and also northwards from its eastern face as far as the Acropolis wall. At the south-west corner no external stairway connected the two levels, but to the north-east they were united by a great flight of marble steps, stretching, like the terrace, from the temple to the wall of the Acropolis. The body of the temple was externally a simple rectangular structure, running east and west, entered from the east through a prostyle porch of the full width of the building. This porch consisted of six Ionic columns in a single line, nearly twenty-two feet high, with antae that were merely engaged pilasters: it was crowned with architrave, frieze, and pediment, and its roof line was continued for the full length of the building: there was a window on each side of the east door. The peculiarities of the plan appear partly in the treatment of the west façade, partly in the addition of two more porches, in abnormal positions, at the west ends of the north and south sides respectively.

The interior of the temple,[3] so far as can be ascertained, was cut into two principal divisions by a cross-wall running from north to south, at a point nearer the eastern than the western end: the eastern division was at the higher level, the western at the lower. The western division was itself subdivided into two sections by a second cross-wall, nearer its western than its eastern end: but this cross-wall was not of the full

1 What follows is chiefly based on Stevens and Paton, *The Erechtheum*, 1927. detailed criticisms of this valuable work, by G. W. Elderkin and by W. Dörpfeld, will be found in *Am. Journ. Arch.* XXXI, 1927, pp. 522 ff., and in *Philol. Woch.* 1928, coll. 1062 ff.

2 The position of the pteron of the Polias temple is shown by dotted lines in Fig. 54: see also Fig. 34, p. 81.

3 There is some uncertainty about these arrangements.

height of the building. It is likely that a wall of the same height divided the eastern part of the western section into two chambers separately entered: this wall is shown in Fig. 54. The north and south porches each led into the narrow chamber at the extreme west of the interior. The north porch (Fig. 56) closely resembled the east porch, except that its six Ionic columns, which carried an entablature and pediment, did not stand in a single line: there were four in front, with one

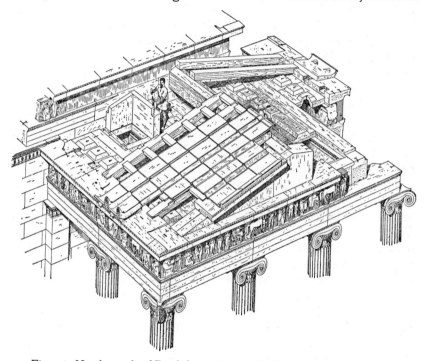

Fig. 56. North porch of Erechtheum (restored, showing structure of roof)

behind each of those at the angles, a common form of the prostyle scheme. Though these columns were about three and a half feet taller than the eastern ones, this increase of size was only about one-third of the difference of ground-level, and the crown of the roof of the north porch met the northern wall of the main building just below its cornice. Both the north and east porch columns[1] are about nine and a half lower diameters in height. The strangest feature is this: the north porch

1 In Ionic the lower diameter is measured immediately above the apophyge.

extended about nine feet beyond the western outer wall of the main building, and a small plain doorway at the end of its back wall led straight into the open precinct of Pandrosos, which lay to the west of the temple. There is evidence that the western[1] outer wall of the main building was at first planned to lie two Attic feet further westwards than it actually does, but even had the plan not been thus changed, a seven-foot overlap would have remained. At the opposite southern end of the westernmost division of the temple stood on the higher level the famous Porch of the Maidens, which contained a private staircase[2] entered at the north-east corner: the staircase led down to the lower level of the interior. This little porch (Plate III *b*) did not reach to the full height of the temple wall. It consisted of a low friezeless entablature carried by six Caryatids, spaced like the columns of the north porch, all standing upon a high continuous pedestal. It is certain that the original plan contemplated a slightly wider spacing of the Caryatids: the limits of the porch would probably have corresponded, as they do now, with the outer west wall and the west cross-wall, and these would have been one Attic foot further apart than they now are.

The western façade (Fig. 55) was a difficult problem for the architect. Architrave, frieze, and cornice ran all round the building, carrying a pediment at the west: and all these corresponded to those of the eastern façade, where they stood upon columns whose bases were more than ten feet above the western ground-level. It was aesthetically impossible to place at the west columns ten feet taller than those at the east. The simplest solution would have been an exact reproduction of the east porch, standing on a ten-foot platform level at the top with the ground to the south and east: but this would have been awkward so near the north porch on the lower level, and the architect fell back upon a compromise. He treated the angles of the western wall as pilasters (like the antae of the eastern end), and placed between them four columns[3] engaged up to a short distance in a low wall, but free above that point,

1 The western inner cross-wall was to have lain one Attic foot further towards the west, so that the westernmost division of the temple would have been one Attic foot wider than it now is.

2 The staircase is not visible in Fig. 54, as it is concealed by the coffers of the porch ceiling.

3 What survives is a Roman reconstruction, perhaps of the late first century B.C., in which there was a continuous wall for the whole height, having engaged columns without and pilasters within, windows being placed in the three central inter-columniations. The details of the original scheme, which are not quite certain, are too complicated to discuss.

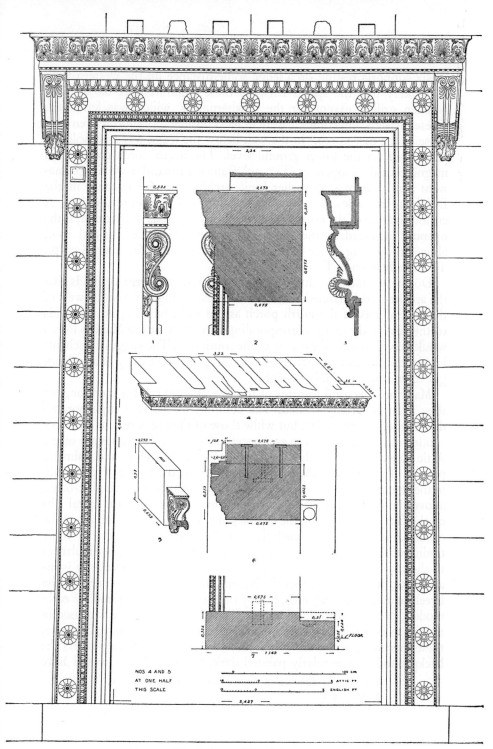

Fig. 57. North door of Erechtheum (restored)

all six supports resting on a ledge some distance up the western wall. It is likely that the spaces between these columns were closed with wooden grilles, except for the southernmost, which was left open. These pilasters and columns were in fact considerably shorter even than those of the east porch. In the wall below the ledge was an absolutely plain door on the lower ground-level. The north porch contained a magnificent door-opening (Fig. 57) framed in marble: we find somewhat similar frames in earlier Ionic architecture, for instance in the Delphian treasuries. The lintel of this door is a Roman restoration. A curious feature of the north porch, of purely religious significance, is the opening arranged in the south-east corner of the ceiling and roof, above an opening in the pavement communicating with a small crypt. This can be seen in Fig. 56.

Dörpfeld's theory cannot be discussed in detail here: he holds that the architect had planned a western wing extending as far to the west of the central axis of the north porch as the main building now extends to the east, and exactly corresponding to it, so that the Maiden Porch would have stood in the centre of the south side. The suggested scheme is aesthetically not altogether satisfactory, but the theory is a brilliant guess, and may possibly be right.

Many architectural features of the Erechtheum call for mention, but they must be briefly treated. The columns of the two large porches differ little, except in size, but while those of the north porch have very subtle entasis,[1] those of the east porch have none. The bases are of the Attic type. The shafts had necking-bands with a lotus and palmette pattern. The capitals (Plate V *a*) differed from the normal type chiefly in the insertion of an extra convex moulding, adorned with a plait-band, above the echinus, and in the curious multiplication of the spiral ribs on the face of the volutes: the capital joint, as at Samos,[2] came above the echinus. It has been argued that all these features reflect old Ionic tradition: this is likely enough, in view of the undoubted resemblances to the capitals of Samos, Naucratis, and Locri, but the evidence is inadequate, unless we consider the Nereid Monument to be older than the Erechtheum. The Caryatids, in any case, seem to be inspired by early models, probably through Delphi. Black Eleusinian stone was used in the frieze as a background to marble figures in relief. Since, however, these marble figures were coloured, and since in all marble reliefs the background was regularly painted dark, this experiment would have

1 For the inclination of these columns, see p. 117, n. 1.
2 See p. 97.

been less startling to the Greeks than to us. An interesting feature of the Erechtheum decoration is the use of 'acanthus' ornament, perhaps for the first time in important architecture, except, probably, for the acroteria of the Parthenon. This decorative element first appeared in the latter part of the fifth century with far-reaching effects: its presence here is a foretaste of the Corinthian capital.

The Erechtheum is an unsatisfactory building. The architect, hampered, like Mnesicles, by religious demands, despaired of producing a harmonious whole. He concentrated interest upon detail, and elaborated ornament with a lavish profusion unknown since the sixth century. His work is the architectural aspect of the general snapping of that tradition of austere restraint to which Pericles' personality had given a splendid but artificial prolongation. It should be added that some archaeologists maintain that Mnesicles himself was the first architect of the Erechtheum, but this is difficult to believe.[1]

Though a work of Asia Minor, the Nereid Monument, bodily removed by Fellows from Xanthos in Lycia to the British Museum, calls for notice at this point, since its connexion with the Erechtheum has been so variously estimated. This was a very rich marble tomb, in the form of a small tetrastyle temple (four by six), standing on a high podium, the area of which, on top, was about twenty-two by thirty-three feet. There was a pronaos and an opisthodomus, but no porch columns. On the podium were two friezes of different height, and there was relief sculpture in the pediments, but there was no frieze between the architrave and the boldly projecting dentils: in compensation, the architrave, as at Assos, was treated as a carved frieze—a striking confirmation of the hypothesis that early Ionic architects felt it impossible to combine dentils with a sculptured frieze above the architrave. Between the columns stood female statues. The general style points strongly to the close of the fifth century B.C., or the opening of the fourth, and it is therefore rash to assume that the capitals are not influenced by those of the Erechtheum, which they very closely resemble, though the possibility of independence cannot be ignored: the bases are of Ephesian type.[2]

The Parthenon and the Propylaea marked the culmination of the Doric style, but the Doric work of the late fifth and of the fourth century is of great beauty and importance. Before we consider the Doric temples of this period erected in old Greece, which have the

1 See Stevens and Paton, *The Erechtheum*, p. 455, n. 1.
[2 See further note on p. 146.]

special interest of providing the earliest examples of the Corinthian capital, something must be said of those built in Sicily and South Italy.

A fine example,[1] usually placed later than the Parthenon, is the so-called 'Temple of Poseidon' at Paestum, a hexastyle structure (six by fourteen) measuring about 80 by 197 feet on the stylobate: but it may well belong rather to the first half of the fifth century. It is remarkable chiefly for its good preservation, and for the fact that part of the small upper row of inner columns still stands in its original position. Even more interesting is the unfinished temple at Segesta in Sicily (also six by fourteen), which measures about 76 by 189 feet on the stylobate. If the cella walls were ever erected, they have been entirely looted, but the outer colonnade with its entablature survives almost intact.[2] We can see and handle the bosses left for the hoisting of the blocks, the protective strips of stone left at the more delicate angles, the still unfluted columns. This is a very carefully planned building, rivalling the Parthenon in the subtlety of its refinements. Another most careful building is the 'Temple of Concord' at Agrigentum (six by thirteen) already mentioned.[3] Both these Sicilian temples may be assigned to the second half of the fifth century.

Returning to Greece proper, we must speak first of the Doric temple of Apollo Epicurius at Bassae near Phigalea in Arcadia (Fig. 58), which contained not only ten engaged Ionic columns, but also one of the first Corinthian capitals in the world's history. Few architectural features have enjoyed such inexhaustible success, and it is a rare privilege to contemplate one of the earliest ancestors of so enormous a posterity. This priceless capital has indeed perished, save for the tiniest fragments: but before its destruction it was drawn by skilful architects, and we can describe it with confidence. The temple stood in a lonely mountain sanctuary. Forgotten in the Middle Ages, it was accidentally rediscovered in 1765, and excavated half a century later. Remains of its sculpture and architecture are now in the British Museum. Pausanias, who saw and admired it, asserts that Ictinus, the architect of the Parthenon, built it after the great plague of 430 B.C.: but the style of

1 Koldewey and Puchstein dated it c. 440 B.C. Dinsmoor (*Anderson and Spiers*[3]) dates it 460 B.C.

2 The ordinary view is that the cella was never built, and that this proves that the pteron of peripteral temples was normally erected first, and this may be right. It should, however, be observed that *almost* complete looting of cella walls is a common phenomenon.

3 See pp. 110 and 112 and p. 120, n. 2.

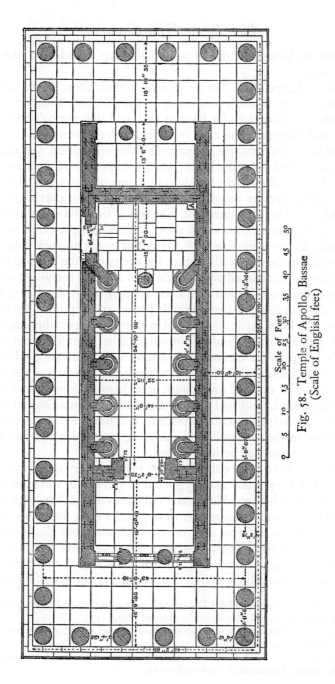

Fig. 58. Temple of Apollo, Bassae
(Scale of English feet)

Scale of Feet
0 5 10 15 20 25 30 35 40 45 50

the frieze sculpture points rather[1] to the last decades of the fifth century B.C.

Its external appearance has no striking peculiarities. It was a Doric peripteros (six by fifteen), measuring on the stylobate about 48 by 126 feet, with the cella set so far back at each end that the colonnade was there pseudodipteral. The cella itself had a deep pronaos and a deep opisthodomus, each distyle *in antis*. But the orientation was unusual, for it was entered from the north, and the internal arrangements were abnormal. The cella was divided into two unequal parts, but[2] they were not definitely separate rooms. The inner and smaller part, or adyton, had a side-door in its eastern wall. The rest of the cella was surrounded by engaged columns attached to short walls which projected from the side-walls. There were five such projecting walls on each side, all at right angles to the side-walls, except for the two at the south end, next the adyton, which slanted northwards at an angle of forty-five degrees. In the gap between this last pair stood a single isolated column, which marked the dividing line between cella proper and adyton. The engaged columns all[3] bore Ionic capitals of a peculiar type: the single free column was almost certainly Corinthian. The inner columns carried on their architrave a carved Ionic frieze, facing inwards, which can scarcely have been visible, if, as seems probable, this part of the temple was roofed. The unusual orientation is perhaps to be explained by the lie of the ground,[4] and had already been adopted in an earlier temple which the surviving structure replaced. Religious needs were satisfied by the door in the east wall of the adyton, opposite which and facing east the cult statue was perhaps placed.

The bases of the Ionic columns (Fig. 59) were very unorthodox: the shafts had a very wide apophyge and a spreading variation of the normal roundel, below which was a tall concave member, with a wide outward sweep, and a similar narrow one under that: that of the Corinthian column was different and more complicated, but also abnormal.

The Ionic capitals (now lost save for fragments and drawings) were of a rare type. They had no normal echinus: the eyes of the volutes were unusually close together, and the upper line of the channel

[1 See further note on p. 146 for Dinsmoor's views on date and other matters.]
2 The Temple at Nemea was similarly planned: see p. 329.
[3 Dinsmoor assigns Corinthian capitals also to the engaged columns which flanked the free column: see note on p. 146.]
4 An approximately north-south orientation is, however, common in early work, e.g. at Neandria, Thermum, Calydon, Eretria.

joining the spirals was hunched upwards in a strong curve. The evidence for the abacus is disputed, and there were possibly two distinct types. Moreover there were single volutes[1] on the front part of the sidefaces also, the junction at the angles being effected, as in ordinary angle capitals, by the projection of the adjoining faces at an angle of forty-five degrees. The capitals thus anticipate the four-sided[2] or 'diagonal' Ionic capital used in Hellenistic and Roman times, itself the forerunner

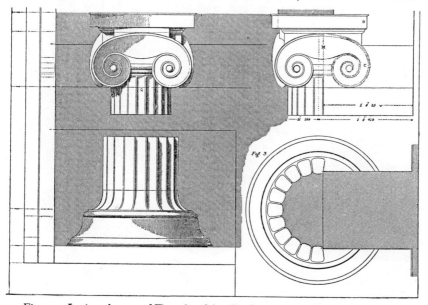

Fig. 59. Ionic columns of Temple of Apollo, Bassae (restored by Cockerell)

of the 'Composite'[3] order, invented in the first century A.D., and exceedingly popular with Renaissance architects. It would seem that the architect was anxious to give these columns a special character as the terminations of tongues of wall, and to avoid the mechanical use of a ready-made free-standing type.[4]

For our knowledge of the Corinthian capital we depend on several illustrations of unequal value. Far the best are those made during the excavation by Haller von Hallerstein, on which that shown here is based (Fig. 59a).[5] It differs from the common later type chiefly in the

1 Cockerell was wrong in conjecturing (see the dotted lines in Fig. 59) that these side faces had two complete volutes.
2 See p. 212 and Plate IX*b*.
[4 See further note on p. 146.]
3 See p. 220 and Plate IX*c*.
[5 See further note on p. 146.]

following respects: (1) the ring of carved leaves at the bottom is very low, so that much of the bell is exposed, though this was adorned with painted leaves: (2) the inner spirals are large: (3) the stems of all the spirals are plain: (4) the large palmette between the inner spirals lies wholly on the bell: (5) the abacus, though with the usual concave sides, was almost plain (except for painted ornament), and heavy. The general tendency of later work[1] is this: (1) the leaves creep up the bell, and are alternately low and high,

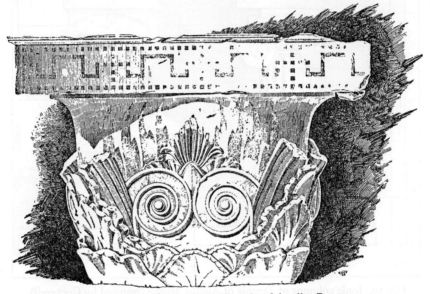

Fig. 59a. Corinthian capital, Temple of Apollo, Bassae
(Restoration based on Haller von Hallerstein's drawings)

so as to form, in effect, two rows: (2) the inner spirals are smaller, though their stems are longer: (3) it is usual for the stems of the outer and inner spirals on each side of each face to emerge from a fluted member called the cauliculus: (4) the palmette climbs on to the abacus, and tends to assume other forms, often dropping a thin stem right down to the leaves: (5) the abacus is lighter, and has more elaborate mouldings. The leaves under the angle spirals should be noticed: in later work these become a sheath springing from the cauliculus: the angle spirals at Bassae had all been mutilated when the capital was found, and their exact form is disputable. It must be added that there is evidence

[1] For an example, see Fig. 69, p. 161.

that the leaves at Bassae were not normal acanthus: one observer compared them to water-lily leaves. Despite all these marks of individuality, the capital is indisputably Corinthian. The origin of the form is uncertain. The shape of the bell recalls the capitals of the Massaliot treasury at Delphi, while the angle spirals may be indebted both to the Ionic corner capital and to the Neandria 'Aeolic' type: some weight must also be given to the use of angle spirals in early Ionic anta-capitals and in non-architectural pillars: the ring of acanthus leaves was perhaps suggested by the necking-bands of the Erechtheum and its predecessors. Tradition associates the Corinthian capital with the metal-worker Callimachus, and the delicate forms suggest metal models: we may observe that in some Syrian[1] buildings of the Roman age all the ornament of the Corinthian capitals was in fact made of metal. The later success of the Corinthian capital was probably due, at least in part, to dislike of the traditional Ionic corner capital, which had always been a tiresome anomaly. The four-sided 'diagonal' Ionic type was a palpable compromise, and the Romans showed sense in giving the palm to the more spontaneous Corinthian. But the early history of the Corinthian capital does not suggest that dissatisfaction with the Ionic corner capital had much to do with its invention.

It will be well to speak here of the other known pioneer Corinthian capitals. A curious experiment in rich acanthus decoration, a thirty-foot column at Delphi, which carried three maidens back-to-back, supporting a tripod, has been ascribed to about the same date as the Bassae temple, but was probably erected soon after the middle of the fourth century B.C. It was not architectural, but its spirit has much in common with early Corinthian, of which the next examples in date are probably a set of capitals from engaged columns inside a circular building, externally a Doric peripteros of twenty columns, which stood in the precinct of Athena Pronaia (the Marmaria terrace) at Delphi. This building, not later than the early fourth century B.C., and perhaps as old as the last years of the fifth, is almost certainly that 'tholos at Delphi' which Theodorus of Phocaea, doubtless its architect, described in a book mentioned by Vitruvius.[2] The diameter of the stylobate was about forty-four feet. It is perhaps no accident that the architect was an Ionian, for here, as in many Doric works of the fourth century B.C., for instance the tholos at Epidaurus and the temples of Tegea and Nemea, a new spirit is moving in the traditional forms, and we feel the dawn of a

1 For instance, the Temple of Bel at Palmyra (p. 222).
2 VII, *praef.* 12.

delightful school, in which the strength and subtlety of Doric are trans-
figured by the grace and delicacy of Ionic. But, as at the end of the
sixth century Doric in Europe rebelled against the beginnings of a
fusion with Ionic, so at the end of the fourth, when the centre of wealth
and power had shifted to Asia, Ionic reasserted its ancient prestige.
We cannot look at the charming Doric colonnades of Hellenistic houses,
or at such pleasing late temples as that of Cori in Latium, without
regretting that this promise should have been crushed by the showy
brilliance of Ionic, so early touched by emptiness and vulgarity. It is

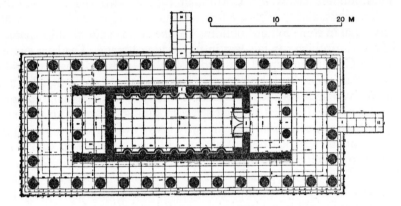

Fig. 60. Temple of Athena Alea, Tegea (restored). (From C. Dugas, *Le
Sanctuaire d'Aléa Athéna à Tégée*, Librairie Orientaliste Paul Geuthner, Paris)

strange that in its last incarnation monumental Doric should have
evolved, as a refinement of internal decoration, a form of capital des-
tined, in Roman hands, to conquer the world. But we must return to
the Delphian tholos.

The Corinthian columns, probably ten in number, stood on a
moulded podium inside the cella: they were only slightly engaged.
The capitals, a restoration of which is shown in Plate V *b*, are indi-
vidually ill preserved, but their main features have been recovered with
certainty. They bore a strong resemblance to the Bassae pioneer. Much
of the bell was bare, and there was a large palmette, entirely below the
abacus. There were large pairs of inner spirals, placed low, as at Bassae,
but it would seem that they did not spring, in the usual way, from the
double ring of acanthus leaves round the base of the capital, but curled
up again to finish in the angle spirals under the abacus. This scheme is

otherwise unknown in Greek Corinthian, but resembles that of a late archaic pillar capital from Megara Hyblaea in Sicily:[1] later terracotta examples of similar pillar capitals have been found at Olympia.

Next in date, among early Corinthian capitals, are probably those of the temple of Athena Alea at Tegea, built by the great sculptor Scopas, perhaps in the second quarter of the fourth century: an earlier temple was burnt in 395 B.C. This temple (Fig. 60), though ill preserved, has been very carefully excavated and published, and is the best illustration

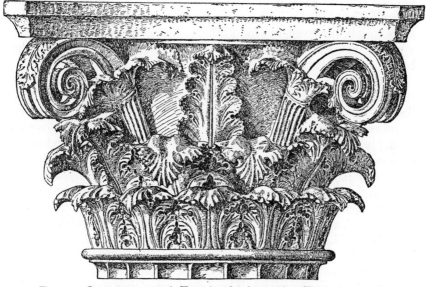

Fig. 61. Corinthian capital, Temple of Athena Alea, Tegea (restored).
(From C. Dugas, *Le Sanctuaire d'Aléa Athéna à Tégée*, Librairie
Orientaliste, Paul Geuthner, Paris)

of fourth-century Doric. It was in plan a simple peripteros, with pronaos and opisthodomus both distyle *in antis*, and was unusually narrow in proportion for its period, having six columns by fourteen in the pteron: it measures on the stylobate about 63 by 156 feet. The columns, which were about thirty-one feet high, were remarkably slender for Doric, just over six lower diameters, and the profile of the echinus has lost almost the last trace of the traditional curve. An unusual feature was a side-door leading into the cella from the northern peripteral colonnade. The interior of the cella resembled that of Bassae, except that the inner

1 See Durm's *Baukunst der Griechen*, ed. 3, 1910, Fig. 310.

columns were engaged to the cella wall, and were all Corinthian. There were fourteen of these, and four pilasters in the angles: an exquisite base-moulding, of Ionic character, ran continuously round the wall and round the feet of the engaged columns and pilasters. The bases of the half-columns somewhat resembled those of the Ionic half-columns of Bassae. The low squat capitals, a restoration of which is shown in Fig. 61, are very striking. At the base of the bell was a double row of shaggy acanthus leaves. The angle spirals sprang from a fluted sheath or cauliculus, crowned with an acanthus leaf, of the type which became orthodox but appears here for the first time. The space between the angle spirals, however, was quite abnormal: instead of inner spirals and a central palmette we find one large acanthus leaf reaching to the bottom of the abacus.

Next come a set of lovely capitals (Plate V *c*), perhaps the most charming ever designed, from the interior of another round building, the tholos of Epidaurus, erected between 360 and 330 B.C. by the younger Polyclitus, a sculptor-architect, like Scopas. This tholos was probably designed to eclipse that of Delphi, and was larger and more elaborate, though not quite so successful: the diameter of the stylobate was about 107 feet. It was a Doric peripteros, with twenty-six outer columns, but its fourteen inner Corinthian columns were free-standing. One unused Corinthian capital was found buried three feet below the ancient level, a strange and delightful gift to posterity. The spirit of these capitals is unlike that of their known predecessors at Bassae, Delphi, and Tegea: Polyclitus aimed not at strength and simplicity, but at delicacy and grace. It will be observed that on the whole they are more normal than any hitherto described. Their chief remaining peculiarity is the independence and bareness of the stems of the spirals; this feature, already abandoned at Tegea, survived in some Hellenistic types of Syria and Egypt, and also in the important group[1] which flourished in Sicily and Italy till the last century of the Roman republic. But the whole treatment has at Epidaurus a life and freshness which were never recaptured.

Another important set of Corinthian capitals are those of the six engaged columns which surrounded the hollow but inaccessible cella, about seven feet in diameter, of the famous small circular monument erected at Athens by Lysicrates in 334 B.C., to celebrate the victory of a chorus which he had provided. In many ways these very florid capitals are less orthodox than those of Epidaurus, but the outer and

[1] See p. 210, Pl. IX *a*. In the 3rd cent. B.C. we find capitals where the outer spirals are independent but the inner spring from cauliculi: see Breccia, *Alexandrea ad Aegyptum*, 1922, Fig. 36.

inner spirals spring together from single sheaths of foliage, in the manner of later work, though not, as at Tegea, from a fluted cauliculus. The cauliculus reappears in the inner half-columns of yet another circular peripteral building, of about the same diameter as the Delphian tholos, the Philippeum of Olympia, built not much later than 338 B.C., in honour of Philip of Macedon, by himself or his son Alexander. Here the eighteen outer columns were Ionic. The Philippeum capitals (Fig. 62) were almost orthodox, with one important exception: the inner spirals and the palmette or flower were omitted, as at Tegea, and the bell was covered with a number of tall upright carved leaves, resembling those painted on the bell of the Bassae capital.

It may be added that the Philippeum and the monument of Lysicrates have Ionic entablatures which are among the oldest surviving examples of the combination of frieze and dentils[1]: the guess may be hazarded that this step was first taken in Greece proper, where the Ionic tradition was an importation.

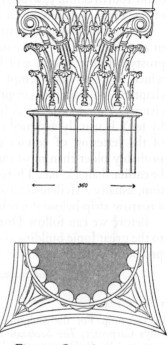

Fig. 62. Corinthian capital, Philippeum, Olympia (restored)

It is time to return to fourth-century Doric: but much need not be added to what has already been said. One of the largest works of the period, the sixth temple of Apollo at Delphi, which reproduced at least in its main lines the plan of its sixth-century predecessor[2], is too ruinous for profitable discussion here. The temple of Zeus at Nemea, of which three columns still stand, was evidently in-

1 For another early example see the Didymaion of Miletus, p. 153. The pseudo-dipteral Ionic temple at Messa in Lesbos (eight by fourteen) has been assigned to the early fourth century, and seems to show this combination: but the temple is probably later, though hardly much after 300 B.C. (see p. 333). The proskenion of the fourth-century B.C. theatre at Epidaurus (p. 166) combined frieze and dentils, but it is perhaps a Hellenistic addition. The oldest example is perhaps the rebuilt form of the old Cabirion of Samothrace (p. 332), which seems to belong to about 365 B.C. 2 See pp. 89 and 326.

fluenced by the Tegean temple, and may be a later work of the same architect: the columns exaggerate the slenderness of their models, being over six and a half lower diameters. Other pleasing Doric temples of the fourth century, which there is no space to describe, are the temples of Asclepius and Artemis at Epidaurus, and the Metroum at Olympia.

An important Arcadian structure of the same period, the Thersilion, or assembly-hall of the Arcadian league, which had a fourteen-column prostyle Doric porch, will be described, along with other buildings which were neither temples, treasuries, nor Propylaea, in a later chapter.[1] In Asia one peripteral Doric temple of simple and dignified character, the temple of Athena Polias Nikephoros at Pergamum (six by ten), is usually assigned to the fourth century B.C., on the strength of the lettering of certain dedicatory inscriptions, but though it is probably older than most buildings in that city, it is doubtful if it can be earlier than 300 B.C. There were two triglyphs to each intercolumniation, usually a Hellenistic feature, and the columns were fluted only for a narrow strip below the echinus.

Before we can follow Doric into the Hellenistic age we must return to the great Ionic buildings of fourth-century Asia, which influenced so profoundly the imagination of Rome:

ad claras Asiae volemus urbes.

1 See p. 174.

[p. 125, n. 4. For the sculptured parapet, not discussed in this book, see now Rhys Carpenter, *The Sculpture of the Nike Temple Parapet*, Cambridge, Mass., 1929, and W. B. Dinsmoor, *A.J.A.* XXXIV, 1930, pp. 281 ff.

p. 135, n. 2. G. Rodenwaldt, *Griechische Reliefs in Lykien, Sitz.-Ber. Preuss. Ak. d. Wiss., Phil.-Hist. Kl.*, 1933, XXVII, p. 1031 (6), regards the late fifth-century date of the Nereid Monument as certain.

p. 138, n. 1 and n. 3. W. B. Dinsmoor (*The Temple of Apollo at Bassae*, Metrop. Mus. Studies, IV, 2, 1933, p. 225) dates the bulk of the exterior c. 450 B.C., but the Ionic and Corinthian capitals, frieze, marble metopes and other details c. 420 B.C. L. T. Shoe, *Profiles of Greek Mouldings*, 1936, p. 120, assigns some elements (e.g. the anta capitals) which Dinsmoor dates c. 450 B.C. to c. 420 B.C.

p. 139, n. 4. Ionic half-columns with capitals resembling those of Bassae, assigned to the late fifth or early fourth century B.C., have been found inside a Doric stoa in the Heraeum of Perachora: see Humfry Payne in *J.H.S.* LII, 1932, p. 242. Dinsmoor considers that the two engaged columns each side of the free column also had Corinthian capitals. He also gives reason for thinking that the statue was in the cella proper.

p. 139, n. 5. Dinsmoor has pointed out that this drawing is not one of Haller's, as I had stated, after E. and R. Wurz, but a more recent restoration based on his drawings.]

Fourth-Century and Hellenistic Ionic, and Hellenistic Doric and Corinthian

At the head of later Ionic stands the fourth-century temple of 'Diana of the Ephesians', which was built of marble, like most others described in this chapter. It replaced the Croesus structure, destroyed by fire, according to the prevailing tradition, in 356 B.C. Eusebius, indeed, records a fire in 395 B.C., but though 356 is suspiciously synchronized with the birth of Alexander the Great, and though the earlier year is easier to reconcile with the known dates of some other Asiatic temples, Aristotle's reference[1] to a recent tremendous burning of the temple supports the usual tradition. The plan of the new Artemisium was closely modelled upon that of its predecessor,[2] though its floor was raised seven feet and the platform was surrounded with a great flight of steps. The new temple, like the old, had both some sculptured column-drums and some square pedestals similarly carved. The position of all these is conjectural, but they were doubtless prominent and probably stood at the west end. The best solution is perhaps Lethaby's—that each pteron column of the front row rested on a carved pedestal, while each pteron column of the second row had its bottom drum carved, with base and plinth below. Other schemes, however, are defensible: for instance[3] *all* the carved drums may have rested upon square pedestals, or the pedestals may have been confined to the porch or porches, as some modern critics suppose, on the rather slight analogy of the temple of Artemis at Sardis.[4] Pliny[5] says that there were thirty-six sculptured columns, and he probably refers to the later temple. The scanty remains of this building (now mostly in the British Museum) are unsurpassed for strength and grandeur. The capitals (Fig. 63), though bolder in treatment, may stand beside Mnesicles' masterpieces, and the decorative relief of the great sima is marvellous in its combination of delicacy and power.

The temple of Athena Polias at Priene[6] (Fig. 64) has already been

1 *Meteor.* III, 371 a, 30. Aristotle was born in 384 B.C.
2 See p. 90 and Fig. 39. 3 See Henderson, *J.R.I.B.A.*, 1915, p. 130.
4 See p. 150. 5 *Nat. Hist.* XXXVI, 95.
6 See p. 45 and Figs. 18 and 19.

used as an illustration of typical Ionic. It may here be added that it was dedicated by Alexander the Great, and that Vitruvius states that it was

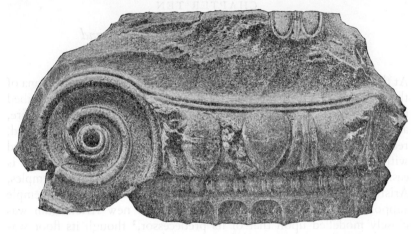

Fig. 63. Capital from fourth-century Temple of Artemis, Ephesus.

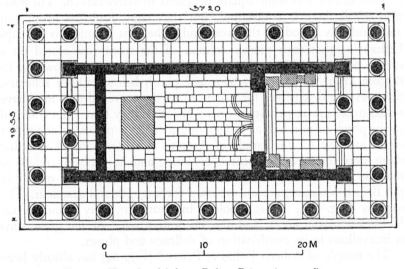

Fig. 64. Temple of Athena Polias, Priene (restored)

built by Pytheos, the architect of the Mausoleum.[1] It was a simple hexastyle peripteros, with eleven columns on its flanks, measuring on the

[1 See note on p. 162.]

stylobate about 64 by 122 feet. It had a deep pronaos, like most Asiatic temples, and also an opisthodomus: each was distyle *in antis*.

The subject of proportions is always difficult and elusive, but this temple well illustrates the general character of fourth-century and Hellenistic design. The architect seems to have aimed at a proportion of length to breadth approximating to 2 : 1. It is mathematically impossible to produce a stylobate of exactly these proportions without abandoning the principle of the equality of all intercolumniations, but a peripteral scheme of six by eleven (in which the number of *intercolumniations* on the flanks is double that on the fronts) gives one of the nearest possible approximations to this relation. Many of the chief measurements of the Priene temple are almost exact multiples of the so-called 'Attic' and Roman foot[1] of 0·295 or 0·296 metres, which was about $\frac{1}{8}$ inch shorter than the English. The lower diameter of the columns is not (as in Vitruvius'[2] scheme) connected with this measure and with the 'modulus' or unit of measurement, for the architect has preferred the incompatible method of making the slightly wider plinths which support the column-bases an exact number of Greek feet wide—in this case, six—and also equal in width to the spaces which separate them. The axes of the columns are thus twelve feet[3] apart, and the edge of the stylobate is divided into six-foot squares alternately free and covered with a plinth. The outer edges of the plinths are almost flush with the edge of the stylobate, which consequently measures just over twenty-one times six feet for the eleven plinths and ten spaces on the flanks, and just over eleven times six feet on the fronts: a proportion, that is to say, of 21 : 11. The cella in the wider sense, being exactly aligned with the pteron columns on fronts and flanks, is 100 feet long, if we exclude the one-foot projection of the base of the anta at each end, and the interior length of the cella proper is fifty feet. The height of the columns was probably about nine times their lower diameter, approximately forty feet. No 'refinements' except entasis have been detected in this temple, though the stylobate is tilted slightly outwards on all four sides, presumably for drainage.

Another important fourth-century temple is that of Artemis or

1 This 'Attic' foot was not used in Athenian buildings before the Roman period: see p. 82, *n.* 2.
2 III, 3, 7: see further, p. 155.
3 For the rest of the description of this temple 'foot' means 'Greek foot of 0·295 metres'.

Cybele at Sardis, the old capital of Lydia. An archaic temple, the successor of a Lydian building, was burnt in the Ionian revolt of 499 B.C. The bulk of the surviving building, which is exceptionally well preserved and measures about 156 by 332 feet on the stylobate, dates from the late fourth century B.C., though there are Roman elements: but it has been argued that part of the foundations dates from the fifth century, and that a few columns of that period were re-used: this however is doubtful. The capitals assigned to this earlier date have floral ornament in the channel above the echinus, and in one case the eggs of the egg-and-tongue are carved with palmettes, an extremely rare feature, paralleled in archaic work at Phanai and elsewhere in Chios.[1] The fourth-century temple was pseudodipteral (eight by twenty), probably the earliest Ionic example of this scheme: but the effect was modified by the fact that the deep prostyle porches reached to within one intercolumniation of the peripteral colonnade. These porches were tetrastyle, with an extra column between the antae and the angle columns. The central pair at each end stood upon square pedestals, which had rough bands intended for carving: the columns on these pedestals were smaller than the rest, and it is these which have been thought to date from the fifth century. The huge rectangular spaces, about forty-four by fifty-seven feet, enclosed by the porches, were perhaps unroofed. The peripteral columns on the façades were unequally spaced, the central being the widest, and the rest gradually decreasing, and all were a little wider than those on the flanks. Such spacing may perhaps be assumed for Ephesus also, but it is not found at Priene, and seems to have ceased in the Hellenistic age.

One more fourth-century building may be here included, though not a temple, the famous Mausoleum of Halicarnassus. This, like the temple of Athena at Priene, was built and described by the architect Pythios, but all his writings have perished. The measurements given by the elder Pliny are corrupt and difficult to understand, and, though much of the building survives, its restoration is still hotly disputed. It was the tomb of Mausolus of Caria, and was finished by his widow Artemisia soon after 353 B.C. Its sculptural decoration was very famous, but its construction was equally admired. It certainly consisted of a temple-like structure on a high basis, carrying a pyramid which was crowned by a chariot-group. It is likely that the basis was rectangular, that the stylobate measured about 100 by 80 feet, and that there was a cella with a pteron of thirty-six Ionic columns, nine by eleven. The pyramid was

1 See p. 331: [also Shoe, *Greek Mouldings*, p. 14].

probably low, and perhaps curved in profile. The style closely resembles that of the Priene temple. There were three sculptured friezes, perhaps two on the basis and one on the cella wall: the latter seems to have been

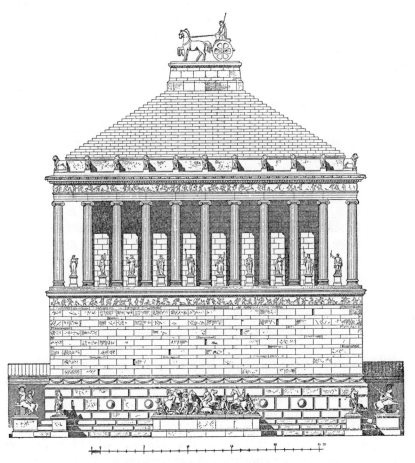

Fig. 65. Mausoleum, Halicarnassus (restored by Adler)

divided into isolated strips, between pilasters corresponding to the columns: there was almost certainly no frieze between architrave and dentils. The restoration here given (Fig. 65) is Adler's: it is doubtful in some points, for instance in placing a frieze above the architrave, but probably right in its main lines.[1]

[1 A recent attempt at restoration is that of H. W. Law, *J.H.S.* LIX, 1939, 92 ff.]

It is difficult to judge of the original appearance of these great fourth century buildings. Their magnificence is indisputable, but it seems likely that, with the possible exception of Ephesus, they lacked freshness and interest. In those of the following centuries we can feel the definite beginnings of ostentation and vulgarity, though they often maintain a very high standard of technical excellence.

We may consider first the gigantic oracular temple of Apollo Didymaios near Miletus (Fig. 66 and Plate VI), which measured about

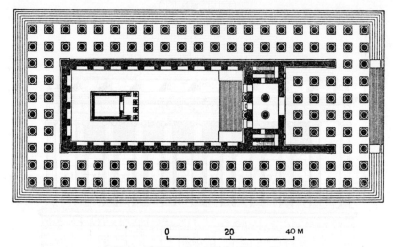

Fig. 66. Didymaion, Miletus (restored)

168 by 359 feet on the stylobate. Its predecessor was burnt in 494 B.C., at the time of that capture of Miletus which Phrynichus dramatized to his cost. The site was deserted till Alexander the Great cleared the Persians from Miletus in 333 B.C. The oracle was at once revived, but no part of the new temple seems to belong to the fourth century, except perhaps the naïskos, or inner shrine. The bulk of the work is of the next two centuries, and the construction dragged on till Roman imperial times.

Despite fire and earthquake three columns still stand. Two of them bear a section of the architrave and part of the frieze: their height, nearly sixty-four feet, is equal to about ten lower diameters. Successive French and German expeditions have at last cleared the site, at enormous expense: the lower parts of the temple are wonderfully preserved.

It is dipteral (ten by twenty-one, outer row) with a deep eastern pro-naos, tetrastyle *in antis*, but with two more sets of four columns behind the front row. Behind the pronaos lay at a higher level a shallow 'inter-mediate room', whose ceiling was carried by two columns: it was not directly accessible from the pronaos, though a huge door connected them: for the threshold of this door (Plate VI) was a block of marble about twenty-six feet long, about seven feet wide, and about five feet high, with no subsidiary steps: clearly oracles were proclaimed from this door to visitors standing below. The bulk of the interior was occupied by a great unroofed court, whose floor lay more than fourteen feet below the pronaos level: it contained the sacred spring and the naïskos which sheltered Canachus' bronze Apollo, an early Sicyonian work restored from Ecbatana by Seleucus Nicator. A splendid flight of steps connected the 'inter-mediate room' through three doors with the court: but from the pronaos the court could be reached only by two descending passages, with ribbed floors, entered by small doors and opening below into two flat-roofed rectangular rooms, which stood in the court to each side of the great staircase. These passages, nearly four feet wide and over eight feet high, were entered through arches and had sloping marble barrel-vaulted ceilings; they passed under a pair of beautiful marble staircases, leading from the 'intermediate room' to the upper parts of the building. The inner wall of the court was flanked with pilasters of late Ionic character, resting upon a dado whose top was level with the floor of the 'intermediate room'. The naïskos stood at the further end of the court, and was a pleasing Ionic temple, tetrastyle prostyle, measuring about twenty-eight by forty-eight feet on its upper step. It is an early example of the combination of frieze and dentils: the frieze is very low, and is decorated with a lotus-and-palmette pattern. The latest parts of the Didymaion seem to be the outer frieze, and some of the pteron columns, especially those at the east end (probably erected in Roman imperial times), which have extravagantly abnormal bases and capitals. Apart from these, all the columns are orthodox Ionic, with Asiatic bases, except for two Corinthian half-columns between the back doors of the 'intermediate room', facing the steps.

Lack of space makes it impossible to speak of any other late Ionic temples except those built by Hermogenes, which owe their fame less to their intrinsic merits than to the general belief that their architect was the chief model and master of Vitruvius, and thus, in some sort, the

oracle of Renaissance Europe. Two of his chief works—the only ones named by Vitruvius—have been explored in modern times: the temple of Dionysus at Teos and that of Artemis Leukophryene at Magnesia on the Maeander. We know from Vitruvius[1] that he left written descriptions of these two temples. It is certain that Hermogenes had admirers in Augustan Rome, for Strabo,[2] Vitruvius' contemporary, reckoned his Magnesian Artemisium superior to that of Ephesus in the finer artistic qualities. It has also been inferred from Vitruvius'[3] extravagant praise, that C. Mucius, who built for Marius a temple of Honos and Virtus, was one of his followers, but this is a mere guess, and the fashion has left little material trace in Roman architecture. Hermogenes' date is now known to be the second half of the second century B.C.[4]

Vitruvius makes it clear that he follows Hermogenes in his account (III, 3, 8) of the octastyle pseudodipteral type of temple, which he wrongly regards as a new invention of Hermogenes: this temple was to have fifteen columns on its flanks. He also derives from Hermogenes the 'eustyle' or 'good' system of column-spacing, not confined to octastyle buildings (III, 3, 6). Doubtless he got his information from Hermogenes' book or books on the temples of Magnesia and Teos. 'Eustyle' is a question-begging term, presumably coined by Hermogenes himself, to describe what was perhaps a modification of an earlier academic classification of column-spacings, which bears little relation to ancient architectural practice. The heads of this classification were pycnostyle, in which the intercolumnar[5] spaces are one and a half times the lower diameter, systyle, in which the figure is two, and diastyle, in which it is three, anything wider being called araeostyle. Eustyle is a modification of systyle, and an exact halfway-house between pycnostyle and diastyle, namely two and a quarter lower diameters: and it has the further feature—in truth no novelty—of an enlargement of the central intercolumniation of each façade, which was to be diastyle. The height of the columns in eustyle is the same as that in systyle, namely nine and a half lower diameters, pycnostyle having ten, diastyle, eight and a half, and araeostyle, eight.

Vitruvius' account of the ideal Ionic cella is not connected by him

1 VII, *praef.* 12. 2 XIV, 1, 40 (c. 467). 3 VII, *praef.* 17.

[4 Hermogenes was formerly assigned to the turn of the third and second centuries B.C., but see A. von Gerkan, *Der Altar des Artemis-Tempels in Magnesia am Mäander*, Berlin, 1929, pp. 27 ff.]

5 Not the *interaxial* measurements, which are, of course, one lower diameter greater: i.e. pycnostyle two and a half, systyle three, etc. This is a common source of confusion. It is probable that Hermogenes and his predecessors, like most modern critics, thought interaxially, but Vitruvius' measurements are always intercolumnar.

with the name of Hermogenes. The description is confused, but his Greek authority perhaps prescribed that the breadth of the cella should be one-third its total length, and that of this length the cella proper should occupy three-sevenths, the pronaos and opisthodomus each two-sevenths, all measurements being interaxial (both for columns and for walls).

Neither of Hermogenes' great temples completely obeys these

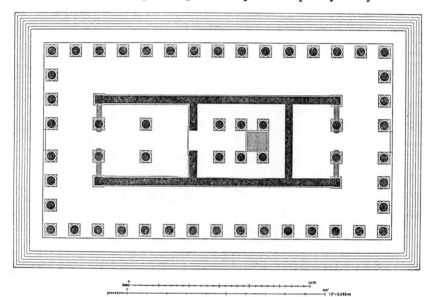

Fig. 67. Temple of Artemis Leukophryene, Magnesia (restored)
(Scales of metres and Greek feet of 0·328 m.)

precepts of proportion for the ground-plan. The Magnesian temple (Figs. 67 and 68) was strictly pseudodipteral,[1] eight by fifteen, and the central intercolumniations of the façades were wider than the rest: but the column-spacing was not eustyle, being slightly narrower than systyle. Hermogenes has in fact here followed the method of Priene,[2] the plinths and inter-plinth spaces being each six Greek feet, except that the central façade spaces are ten feet. Teos, on the other hand, which was hexastyle and not pseudodipteral, was eustyle, except for the central façade

1 The use of wooden ceilings in the pteron of Hermogenes' temples has already been mentioned (p. 68, n. 2).
2 See p. 149. Hermogenes used the old Attic foot of 0·328 m. [But see note on p. 162.]

intervals, which were not enlarged. For the rest it will be best to speak almost exclusively of Magnesia, which alone has been adequately published.

At Magnesia (where all the measurements are certainly interaxial) the breadth of the cella was one-third of its length, as Vitruvius' authority probably prescribed, but the ratio of pronaos, cella, and opisthodomus was 2 : 2 : 1, instead of 2 : 3 : 2. It may be added that, at Magnesia, all the chief interaxial measurements were multiples of

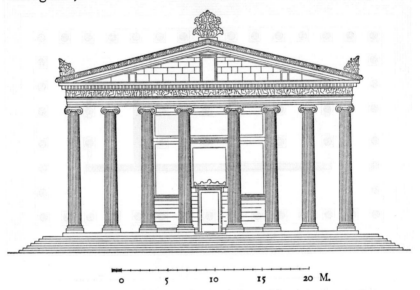

Fig. 68. Temple of Artemis Leukophryene, Magnesia (restored)

four feet, and most were multiples of twelve feet, which is the inter-axial pteron measurement: the cella (in the wider sense) being one hundred and twenty feet by forty feet, while the lengths of pronaos and cella are forty-eight feet, and that of opisthodomus twenty-four feet. Extreme regularity is also found in the spacing of the inner columns, as the plan shows: but this cannot be discussed in detail here.

It will be seen from all this that the schemes of the ground-plans of the temples of Magnesia and Teos bear at least some general resemblance to those prescribed by Vitruvius, but in the proportions of the entab-lature he seems rather to follow the practice of fourth-century archi-tects, and especially that of Pytheos at Priene. It is true that both at Magnesia and at Teos, as in Vitruvius, a frieze ran above the architrave,

and that Pytheos' work almost certainly lacked this feature: but while the Vitruvian frieze is five-eighths the total height of the entablature, that of Magnesia[1] is only five-twelfths. Both at Magnesia and at Teos the capitals are of a late type, the eye of the volute[2] being only just above and just outside the point where the horizontal line of the top of the echinus would intersect the perpendicular line of the upper diameter of the shaft. It has generally been held that this type closely resembles the ideal Ionic capital described by Vitruvius, but the interpretation of his words (III, 5, 5 ff.) is difficult. Such resemblance would, in any case, be no sufficient proof of dependence on Hermogenes, since the Hermogenean type was the natural result of previous evolution, and appears, fully developed, in the fourth century B.C. at the Philippeum[3] of Olympia.

Our general conclusion must be that, except for the special points of eustyle spacing and pseudodipteral planning, there is no cogent reason for deriving any of Vitruvius' rules from Hermogenes: and that in the matter of the proportions of the Ionic column and entablature such a derivation is impossible, except on the difficult assumption[4] that Hermogenes appended to his account of the temples which he had built a quite different scheme for the ideal temple which he had never been allowed to build.

An interesting feature[5] of the Magnesian temple is the presence in the tympanum wall of each pediment of one large and two small doors, doubtless designed to relieve the pressure on the pteron architraves: the principle is as old as the tholos tombs and lion gate of Mycenae, and we shall meet further developments in Roman work.[6] It should further be observed that the Attic column-base here makes one of its earliest appearances east of the Aegean: it was also used at Teos.

This is perhaps the most convenient place to mention, before passing to Hellenistic Doric and Corinthian, an important religious building

1 There is some dispute about the Teos frieze, and it is best left out of the discussion.

2 See pp. 122 and 211. 3 See p. 145.

4 This assumption was made by A. Birnbaum, *Vitruvius und die griechische Architektur*, Vienna, 1914, and criticized by Rhys Carpenter in *Am. Journ. Arch.* xxx, 1926, pp. 259 ff. My discussion of Hermogenes is indebted to both of these critics, as well as to the official publication of Magnesia.

5 Less important is the fact that stone screens connected the columns and antae of both porches, each of which would be entered only through an elaborate stone doorway between the columns. These screens and doors were probably an afterthought of the original architect.

6 See p. 227: also p. 120 for similar openings in earlier Greek buildings.

of the second century B.C., the Great Altar of Pergamum. This struc-
ture, all visible parts of which were of marble, is famous chiefly for its
remarkable reliefs, but it is also of some architectural interest. It was
mostly erected, in all probability, by King Eumenes II, who reigned
from 197 to 159 B.C., but was perhaps continued by his brother and
successor Attalus II, who reigned till 138 B.C. The altar proper, of
which nothing survives but some details of ornamentation, stood on a
huge podium, the top of which was about eighteen feet above the sur-
rounding ground-level. Measured along the foot of the three or four
steps that ran all round its base this podium was about 120 feet in
width by about 112 in length. On the south, east, and north sides the
top of the podium was surrounded by a solid wall, within which stood
a cloister of curious rectangular pillars, with Ionic three-quarter
columns engaged front and back; these pillars were probably erected by
Attalus II, and were never completed. On the west it seems that a
flight of more than twenty steps cut into the podium for a width of
about sixty-eight feet and for a depth of nearly thirty. The solid wall
was not carried across the platform at the top of the steps, but ran out,
like the sides of an open porch, to the ends of the two tongues of the
podium which flanked the flight north and south. A series of Ionic
columns ran all round the outer edge of the podium, outside the solid
wall on the south, east, and north sides and returning along the inner
sides of the two projecting tongues of the podium. It seems certain[1]
that both this series of ordinary columns and the double-column pillars
of the inner cloister were also carried across the western front of the
podium at the top of the flight of steps, with a widening of the central
intercolumniation.

The outer columns carried a friezeless entablature, with dentils, and
were connected by a coffered ceiling with the solid wall and, along the
west front, with the pillars already mentioned. The great frieze, a battle
of gods and giants, was on the outer face of the podium, below the
columns: it rested on an elaborate continuous pedestal, and was crowned
with dentils and cornice. The inner face of the solid wall was also
decorated with relief sculpture.

The Doric buildings of the Hellenistic age, which may conveniently
be held to begin with the third century B.C., must next be briefly con-

1 A coin of the time of Septimius Severus (about 200 A.D.) appears to give a view
of the structure from the west in which these columns and pillars are omitted,
and the altar proper is fully exposed: but this is an intelligible simplification,
and the evidence of the foundations strongly supports the description given
above.

sidered. The most striking feature of the period is the multiplication of triglyphs, two or more often, though not always, appearing over one intercolumniation. This was perhaps an indirect result of other causes, especially the tendency to space columns widely, and the desire for lower entablatures, which involved narrow triglyphs and metopes, since the height of the frieze conditioned their width. The Doric column also tended to become even slenderer than in the fourth century, under the continued influence of Ionic. Doric capitals show much variety. In the late fourth and third centuries, as in the earlier part of the fourth, it was usual for the echinus to have a very straight profile, but it often had considerable projection. Examples of this straight type are common in the Hellenistic temples and porticoes of Pergamum and in the peristyles of houses of the same period at Delos and Pompeii. From the second century onwards it is not uncommon, especially in engaged columns, to find the influence of the Ionic capital, the echinus being a simple moulding of quarter-circle profile, sometimes carved with egg-and-tongue. The Bouleuterion[1] of Miletus, built between 175 and 164 B.C., provides good examples of this type, both smooth and carved. Both types are found in Roman[2] and Renaissance Doric. Ionic features often appear in Doric entablatures, but chiefly in buildings other than temples, and hardly before the second century B.C.: there are, for instance, dentils between triglyph frieze and cornice in the Miletus Bouleuterion.

Hellenistic Doric may conveniently be studied in the great German publication of the excavations of Pergamum in Asia Minor, where there were several temples in this style, though none of great importance. A good example is that of Hera Basileia, which is closely dated by an inscription on its architrave: it was dedicated by Attalus II, who reigned from 159 to 138 B.C. It was a small tetrastyle prostyle structure, about twenty-four by forty feet, facing south on a terrace above the Upper Gymnasium: its northern part was in a cutting in the hill-side, from which it was separated by a narrow passage. The façade was consequently alone important, and only this part was of marble: its importance was further emphasized by the flight of steps which led to the terrace from below, for this flight was continuous with the three broader steps properly belonging to the temple, the two lower of which were carried only a short way back on each side: the effect resembled that of a temple on a raised podium.

1 See p. 179.
2 In late Roman work in Syria the second type, with egg-and-tongue on the echinus, sometimes has an acanthus necking-band, divided from the echinus by a strip of fluted column: a sort of Doric-Ionic-Corinthian 'Composite'.

The most striking features of the design are the slenderness of the columns (over seven and a half lower diameters) and the lowness of the architrave, little more than two-thirds the height of the frieze, which was itself noticeably low, and had two triglyphs to each intercolumniation. The shafts of the columns were twenty-sided polygons, with no flute-hollows: a common feature at Pergamum, though usually confined to the lower part of the shaft. The capitals are missing, but it can be assumed with confidence from contemporary examples that both echinus and abacus were extremely low. The raking cornice had mutules with guttae. There are here many signs of Ionic influence in the details of mouldings as well as in the general proportions, but there is no intrusion of such strikingly Ionic features as column-bases or dentils.

Of Hellenistic Corinthian temples[1] not very much need be said. The capital was freely treated in this period, and many local schools were developed: that of Sicily and Italy will be discussed at a later point.[2] The architects of Imperial Rome usually adopted as their basis that canonic type which has been infinitely reproduced since the Renaissance, though they often enriched and elaborated it; its dominance[3] perhaps began with the action of Sulla in adorning the Temple of Capitoline Jupiter[4] with columns stolen from the Athenian Olympieum, to which we must now turn.

This great temple south-east of the Athenian Acropolis, which measured about 135 by 354 feet on the stylobate, was perhaps the first Corinthian[5] temple on the grand scale. The Seleucid king Antiochus Epiphanes of Syria, in the first half of the second century B.C., resumed, with slight modifications, the abandoned scheme[6] of the Pisistratids, dipteral at the sides, tripteral at the ends. His architect was, most surprisingly, one Cossutius,[7] a Roman citizen by birth but not certainly a Roman. According to Vitruvius he carried the temple as high as the architraves: we know from other sources that the temple was finished by Hadrian, and there is some literary evidence of work in the Augustan age. The height of the columns is nearly fifty-seven feet, equal to about eight and three-quarters lower diameters, less slender than much Roman Corin-

1 The round building in Samothrace (c. 280 B.C.) had inner Corinthian half-columns with capitals of the same general type as those of the Athenian Olympieum. See p. 330.　　　2 See p. 210.

3 The Round Temple near the Tiber may possibly have a prior claim: see p. 211.

4 See p. 200, n. 1.

5 But the large Corinthian temple of Zeus Olbios near Olba in Cilicia seems to be as old as Seleucus Nicator: it has not been adequately published. See p. 334 [including new evidence].

6 See p. 102.　　　7 Vitruvius, VII, *praef.* 15, and *Inscr. Att.* III, 561.

thian, which reaches ten in the first century A.D. and over eleven in the second. The surviving capitals seem to be partly Cossutian, partly Augustan, and partly Hadrianic. Fig. 69 reproduces Penrose's drawing of an apparently Augustan capital, which has every essential mark of the orthodox Roman Corinthian type, though it is exceptionally stiff and severe; the bell is tall, the abacus projects little, and the simple leaves cling

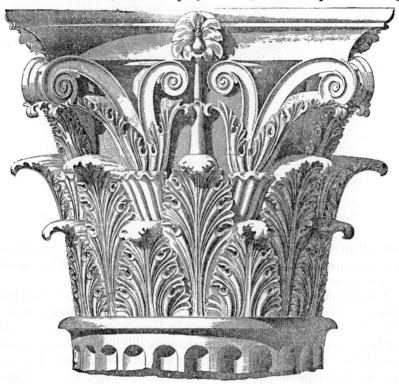

Fig. 69. Capital of Olympieum, Athens (Penrose)

to the bell: the fluted cauliculus is broad and strong. This is the only well published capital, and the points in which it differs from the Cossutian are not very important. The capitals (Fig. 70) of the Propylon of the Miletus[1] Bouleuterion, a work of the same Antiochus, are similar, save that the inner spirals and the flower on the abacus are insignificant, and much of the bell is bare. Vitruvius prescribes a very similar type, except that he lays down that the lower ring of acanthus leaves, the

1 See p. 179.

visible part of the second row, and the remaining space, or 'volute zone', below the abacus, should be equal in height;[1] a scheme roughly true of the Italian type, but unknown in orthodox capitals till the second century A.D., and always rare. The upper leaf-zone is almost always

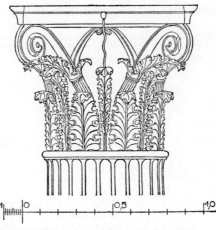

Fig. 70. Capital of Propylon of Bouleuterion, Miletus (restored)

lower than the other two: the relation of these varies, though the volute-zone is usually the highest. Vitruvius perhaps follows the schematic rule of some Hellenistic theorist.

Corinthian was normally a variety of Ionic. Vitruvius[2] considers Doric entablatures equally admissible, and this combination is sometimes found, both in Hellenistic and in Roman times, but it should probably be treated as an eccentricity comparable to the union of Doric entablatures with Ionic columns which Vitruvius[3] condemns. It seems to have been especially popular[4] in the Augustan age, which perhaps accounts for Vitruvius' view.

1 IV, 1, 12. 2 IV, 1, 2. 3 I, 2, 6. 4 See p. 230.

[p. 148, n. 1. M. Schede, *J.D.A.I.* XLIX, 1934, p. 97, shows from the style of the details that everything west of the wall between pronaos and cella was finished only in the second century B.C.

p. 155, n. 2. A. von Gerkan (see p. 154, n. 4), p. 5, n. 1, states that Hermogenes used the 'Attic' foot of 0·2957 m. (see p. 149). I do not know how this is reconciled with the facts given on p. 155.]

Greek Theatres and other Buildings
not Temples or Private Houses

Before passing to the early architecture of Etruria and Rome, we must attempt a rapid survey of some of the chief Greek buildings, from the sixth to the second century B.C., which differed widely in plan from the ordinary temple. Some have already been described, and bare mention must suffice for the stoai or porticoes of many kinds, often of great length and depth, which were built at all periods. Greek and Roman houses and palaces will be discussed together at a later point.[1] Before considering the various unroofed structures used by the Greeks for public gatherings, of which the most important were their theatres, we may examine a few early roofed civil buildings of remarkable character.

The plan of the building usually called Bouleuterion or Council House at Olympia is a remarkable link with the past: but it must be admitted that its identification is disputable, and the function of its parts obscure. In its final form it consisted of two almost identical wings and a smaller central building, but the three parts are separate structures, and seem to differ in date, the north wing being assigned to the sixth century B.C., the south to the fifth, and the central building more doubtfully to the Hellenistic age. It is clear, however, that the north and south wings are designed to balance one another, and the south wing, though in its present form later in date, has the more primitive plan. Each consisted of a rectangular hall, running east and west, open at the east end, except for three columns between the antae which finished its side-walls. There was no porch behind the columns. The west end of each consisted of a curved apse, divided from the main room by a cross-wall, and down the central axis of each ran a row of interior columns: but while the north wing was really rectangular, apart from its apse, the south was a delicate ellipse, with side-walls curving slightly for their whole length. Each wing was about forty-five feet wide and about 100 feet long, externally, and each seems to have had an orthodox Doric entablature all round it. The central building was square, measuring about forty-seven feet each way, and of uncertain character: perhaps

1 See pp. 297 ff.

contemporary with it was a low Ionic colonnade which ran along the front of all three buildings and gave them a certain artificial unity.

Another unusual building not later than the early fifth century is the Lesche or club-house of the Cnidians at Delphi, a plain rectangular room, measuring externally about thirty-one by sixty-one feet, which was probably entered by a door in the middle of one long side. Eight inner wooden pillars, on limestone bases, seem to have divided its interior into a central space and a surrounding passage: the inner face of the walls was adorned with paintings by Polygnotus. There was perhaps a complete roof, with some sort of clerestory scheme for the lighting.

We may now turn to unroofed structures. Of purely political open-air meeting-places little need here be said. It will be enough to mention the Pnyx at Athens, where a bema or rostrum and some seats were carved from the rock of a hill, but most of the citizens stood or sat upon ground artificially levelled and raised with the help of a terrace wall.[1] Theatres are a more serious problem.

This subject is one from which the boldest may recoil: so obscure is the material evidence, so vast the web of controversy which entangles it.[2] Controversy is concerned chiefly with the *skēnē*,[3] the structure which faced the audience beyond the orchestra, and above all with the question whether there was a raised stage. We have, in fact, no adequate knowledge of the form of the skene before the second half of the fourth century B.C.: for the earlier period we depend upon a balance of inconclusive considerations. In many cases the skene was repeatedly reconstructed, and its original form is irrecoverable. We have however sufficient knowledge of some Hellenistic examples, but, before we enter these troubled waters, a word may be said of the less disputable parts of the theatre, auditorium and orchestra. There is literary evidence for the use since early times of wooden stands for spectators, and a disaster to such a structure in the early fifth century is said to have induced the Athenians to give the auditorium a more permanent form. But from the first it would seem that the slopes of natural hillsides were used as far as possible, artificially regularized to various degrees, and strengthened with supporting-walls, especially in front. The oldest traceable form of the Athenian theatre seems to have had its seats cut from the hill in a series of straight lines, which suggest the use of wooden seats, but the seats were usually arranged in circular curves, and tended to occupy

[1 See now K. Kourouniotis and H. A. Thompson, *Hesperia*, I, 1932, p. 90.]
[2 See further note on p. 185.]
3 The strict Greek spelling of *skēnē* and its derivatives is here kept, because the Roman *scaena* etc. were so different.

slightly more than a complete semicircle. From the fourth century, at least, great care was taken about the acoustic properties of the auditorium, and various devices were employed to increase its resonance.

Sometimes, for instance in the fourth century B.C. theatre of Epidaurus, a stone ring, almost flush with the ground, completely encircled the orchestra, which in tragedies and comedies alike was undoubtedly occupied by the chorus: an altar sometimes, at least, stood in its centre. The skene was separated from the auditorium by two open passages (the parodoi), one on each side, which gave access to the orchestra from

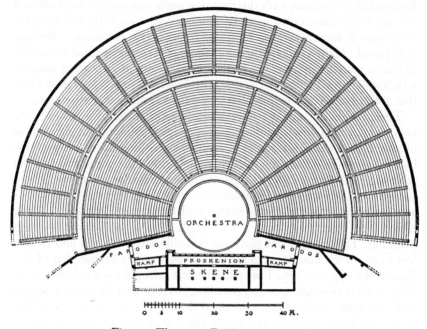

Fig. 71. Theatre at Epidaurus (restored)

outside. The skene itself was a rectangular building, sometimes but not usually longer than the diameter of the orchestra, and often divided internally into three or more rooms. It was usually, but not certainly always, of two storeys in height: a short wing, *paraskēnion*, often ran forward from each of its ends, especially in Greece proper and in the West: these disappeared in the course of the Hellenistic age. We may here add that at Athens[1] the surviving auditorium is mainly the work of Lycurgus towards the close of the fourth century B.C., but there are

[1 See further note on p. 185.]

traces of an unfinished Periclean scheme: little is certainly known of the Lycurgean skene, except that it had paraskenia.

The beautiful theatre at Epidaurus (Fig. 71) was built by Polyclitus the younger in the second half of the fourth century B.C.: it is cleverly designed, with many subtle correspondences of measurement and some ingenious variations from the usual scheme. The auditorium, for instance, has two distinct slopes, the upper part being steeper, and, though the orchestra proper is bounded, as we have seen, by a circular ring of stone, only the central two-thirds of the auditorium has its lower limit strictly concentric with this ring: the parts nearest the skene on each side are made more convenient by being given a slightly wider curve. The skene is ruined, but can be reconstructed with confidence. Its date is disputed. Many critics assign the whole of it to the original structure. If this is true, it supplies the earliest example of an important feature, which must now be discussed, the *proskēnion*: it seems likely, however, that at Epidaurus[1] the proskenion at least is a Hellenistic innovation.

The proskenion was a stone structure, consisting of a row of free columns, or of a row of pillars with engaged columns (in either case usually Doric, though Ionic at Epidaurus), standing upon a low stylobate two or three yards or a little more in front of the skene wall: pillars with engaged columns, as at Epidaurus, seem to be the older type. These supports carried a normal entablature—architrave, frieze and cornice— and were connected with the skene wall by stone or wooden beams, which were regularly covered with a platform of horizontal wooden planking. The level of this platform (usually between eight and twelve feet from the ground) was, in the case of two-storey skenai, that of the floor of the upper storey. The spaces between the pillars or columns were filled with removable wooden panelling, except that the central space, and sometimes two others, contained doors. The upper storey of the skene, visible to the audience above the top of the proskenion, seems, as a rule, to have been plain and simple. It is possible that[2] wooden proskenia were in use before stone ones, but there is not sufficient evidence to establish this as a fact.

What was the function of the proskenion? Vitruvius states that its

1 The proskenion at Epidaurus combined Ionic frieze and dentils: for this feature, see p. 145 and n. 1. [Shoe, *Mouldings*, p. 32, dates it second century B.C.]
2 The theatre of Syracuse, perhaps built before the end of the fifth century B.C., had at first a skene with paraskenia but no proskenion. The paraskenia were removed and a stone proskenion erected in the second half of the third century B.C. Between these periods a wooden proskenion seems to have been built, but its character is obscure. See G. E. Rizzo, *Il Teatro Greco di Siracusa*, 1923.

roof was the stage on which the actors moved, and the archaeological evidence makes it almost certain that for the late Hellenistic age (from the middle of the second century B.C. onwards) this is true. Dörpfeld

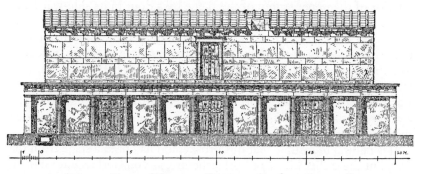

Fig. 72. Skene of theatre at Priene, earlier form (restored)
(From A. v. Gerkan, *Das Theater von Priene*, Verlag B. Harz, Berlin-Vienna)

has long maintained that from first to last the proskenion was merely a background for actors moving in the orchestra, though its roof could be used on the occasions when one actor had to appear at a higher level

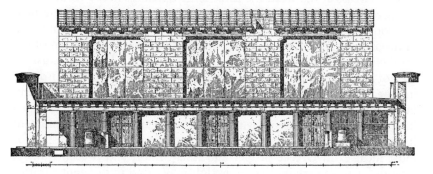

Fig. 73. Skene of theatre at Priene, later form (restored)
(From A. v. Gerkan, *Das Theater von Priene*, Verlag B. Harz, Berlin-Vienna)

than his fellows: but in its extreme form this view is scarcely tenable. The subject is excellently illustrated by the small theatre of Priene[1] (Figs. 72 and 73), which is well preserved, and has been carefully studied by von Gerkan. If we examine the skene as it stood in the second half of the second century B.C., we find that the proskenion was then carried

[1] A general plan of the theatre can be seen in Fig. 84 (plan of central Priene).

back for a short distance round both the front corners of the skene, and that the edge of its top was at these points protected by a stone parapet. Each of the little side-platforms so formed communicated with the interior of the upper storey of the skene by a door in its side-wall: and at the west end a flight of stone steps, in contact with the skene wall, connected the little platform with the ground. Further, the front wall of the upper storey of the skene was pierced by three openings, reaching to its roof, and so wide that the stretches of wall between were little more than pillars. It seems clear that at this date the proskenion roof was a stage on which the actors moved: the large openings made possible a variety of scenic effects, and the side-doors enabled actors to approach the stage from either side.

It is natural to assume that this proskenion had been a stage from the first, but the earlier history of the structure, as von Gerkan interprets it, makes this doubtful. His conclusion may be summarized as follows. For more than a hundred years (from the building of the theatre, about 300 B.C., till towards the middle of the second century) the proskenion roof was comparatively inaccessible. The side-doors in the upper wall of the skene, the carrying of the proskenion back round the corners, the stone staircase at the west, the three large openings in the front wall— all these are innovations. Originally the only approaches to the pro-skenion roof were one small door in the centre of the upper front wall of the skene, and a wooden ladder behind the projecting portion of the proskenion (for it always projected) at the west end. These conclusions are not all certain, but it seems likely that von Gerkan is justified in draw-ing the conclusion that at Priene, at least, there was a definite moment, in the middle of the second century B.C., when the proskenion changed its function. Before that moment it was a background, after that moment it was a stage. Von Gerkan is inclined to generalize this conclusion for most theatres in Greece proper and Asia Minor, and it seems likely, though far from certain, that he is right. We find in different theatres different methods of giving access to the top of the proskenion. Some closely resemble those adopted at Priene; in other cases, for instance at Epidaurus, sloping ramps of earth connected the sides of the proskenion with the ground, or side-doors opened on to its roof from the pro-jecting wings of the skene. The date of these arrangements is often un-certain, but it is doubtful whether any are older than the remodelling of the Priene theatre. Those who hold that the proskenion was invariably a stage attach importance to the fact that its roof was always a flat wooden platform. But since many Greek plays involved the presence

of actors at more than one level, this is not very surprising. A stone roof would have been heavy and expensive, and tiles would have been inconvenient. It must also be remembered that theatres were used for public meetings and for many other purposes besides the performances of tragedy and comedy.

It has been impossible in the space available[1] to do more than touch upon a few salient features of the strictly architectural material: a discussion of the internal evidence afforded by extant plays is here out of the question. In conclusion it must again be emphasized that the effective archaeological evidence hardly carries us back beyond the days of the New Comedy: but the balance of probability is definitely against the existence of a raised stage in the Athenian theatre of the fifth century B.C.

We may now pass to an interesting series of roofed structures which bear a general resemblance to the unroofed assembly-place or to the unroofed theatre.[2] The oldest seems to be the second[3] form of the Telesterion, or Hall of Initiation, at Eleusis, built towards the close of the Pisistratid tyranny, in the second half of the sixth century B.C. This was perhaps the first Greek building designed to shelter under one roof a large number of persons assembled to hear and see something there enacted: the necessity of secrecy in the Mysteries was doubtless the origin of this important innovation. The system of roofing has Egyptian and Persian parallels. From first to last the Telesterion was a rectangular hall, almost square, with seats along the walls, and with its roof carried by a forest of columns placed at the intersecting points of imaginary lines parallel to the four sides. Fig. 74 shows the plan of the existing remains, the latest form being printed in heavy black. The top of the plan is roughly the west[4]: here the ground rises steeply, and is a mass of solid rock. The Pisistratid building can be seen in the north-east corner, the walls being shown in outline, and the positions of the columns as outline squares. The interior at this stage measured about eighty-three

1 For the late Hellenistic theatre, see p. 283: and for other Greek theatres see p. 334. [2 New light has been thrown on this field by the American excavations of the Athenian Agora, which have revealed several important early buildings of this type. See especially *Hesperia*, VI, 1937, for the Old and New Bouleuteria (late sixth and late fifth centuries respectively). The latter resembled the Miletus Bouleuterion. The circular Tholos (c. 470 B.C.) is also important (*Hesperia*, Suppl. IV, 1940, reviewed by me in *Class. Rev.* LV, 1941, p. 41). See also p. xiii *supra*.]
3 The scanty remains of the first form, perhaps of the late seventh century B.C., can be seen inside the Pisistratid building in Fig. 74: parts of the south and east walls remain: the masonry is partly 'polygonal' (see p. 42).
4 It is really north of west, but it is simplest in the description to treat it as due west.

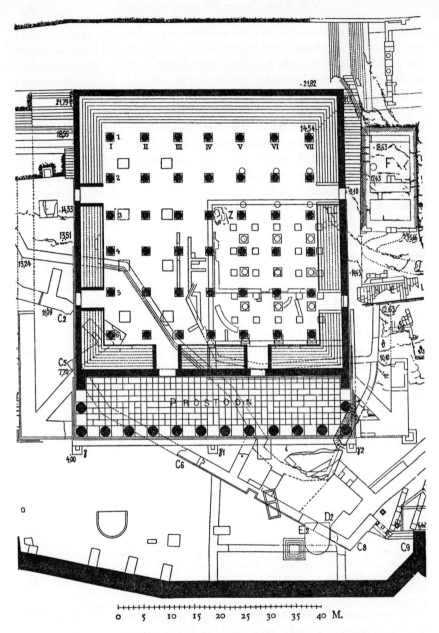

Fig. 74. Telesterion, Eleusis; general plan of existing remains
(North to right, approximately)

feet each way, and there were twenty-five inner columns, five in each direction, probably Ionic and of the full height of the roof-beams. The roof-tiles were marble: the lighting was probably central, as it certainly was later. There was a prostyle Doric porch, perhaps of nine columns, along the whole east front. This building was damaged but not destroyed by the Persians, and after some years a new and much larger scheme was started, probably by Cimon. This involved a great cutting back of the rock to the west. There were to be forty-nine inner columns (seven by seven), but the scheme was never finished, perhaps owing to Cimon's fall in 461 B.C. Places were prepared for the three rows of columns to the north, and for three columns in the south-west corner, twenty-four columns in all: eighteen of these can be seen in Fig. 74, where they are shown as outline circles, some within outline squares. At this stage some sort of temporary structure must have replaced the Pisistratid building. Pericles revived Cimon's plan, and employed Ictinus,[1] who had probably just finished the Parthenon. It seems that Ictinus accepted the Cimonian scheme for the outer walls, but planned new and bold internal arrangements, reducing the number of inner columns to twenty, in five rows of four. He also planned an external pteron, of the full height of the building, on all sides except the west. In Fig. 74 the positions of the eight southernmost columns, which alone were prepared, appear as outline squares, and the only parts of the pteron foundation actually laid, to north-east and south-east, are also shown in outline: but it will now be convenient to turn to Figs. 75 and 76, which give Noack's brilliant restoration of this great design, abandoned, like its predecessor, on the fall of the statesman who supported it. To the west a terrace was cut in the rock, as Cimon had perhaps planned, and along its western edge there was probably to have been a wall pierced with windows: this wall would have turned east at both ends, to finish in antae in line with the pteron columns: between these walls and the hall a great flight of steps on each side would have led up to the terrace. The roofing arrangements are of course conjectural, but Noack's scheme is plausible: he supposes that the roof was to have been pyramidal: the central rectangle (the anactoron) was to have been curtained off, and lit from above by pierced tiles, normally covered, but opened and temporarily curtained before celebrations of the Mysteries. The ritual dramas, such as the pursuit of Persephone, were probably to take place by torchlight in the space round the anactoron, the climax being a flood of morning light from the suddenly

1 Vitruvius, VII, *praef.* 16.

uncurtained centre. It should be added that the seats were so narrow that spectators must have stood on them, and that there were probably wooden galleries above the ground-floor seats. On the fall of Pericles the work was apparently handed over to three new architects, mentioned

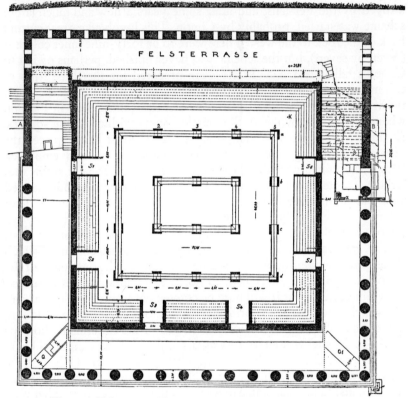

Fig. 75. Telesterion, Eleusis; ground-plan of Ictinus' scheme, conjecturally restored

by Plutarch, who reverted to the general lines of Cimon's scheme. Their plan was retained when the Telesterion was rebuilt after a fire in the second century A.D., which spared parts of their outer wall. It is shown in black in Fig. 74. They abandoned the outer pteron, gave the building a normal gabled roof,[1] with ridge running east and west, and placed forty-two columns inside, seven by six: they also extended

[1] The lines of this roof, and the position of Philo's porch, are indicated in Fig. 76.

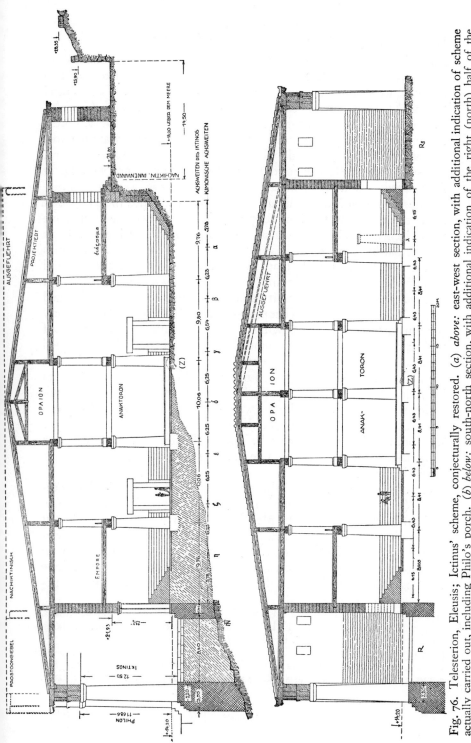

Fig. 76. Telesterion, Eleusis; Ictinus' scheme, conjecturally restored. (*a*) *above*: east-west section, with additional indication of scheme actually carried out, including Philo's porch. (*b*) *below*: south-north section, with additional indication of the right (north) half of the roofing scheme actually carried out: also of one of the later inner columns (*x*). Under each picture is a comparison of the spacing of Ictinus' columns with those of the *earlier* (Cimonian) scheme, with interaxial measurements.

the hall to the west by further rock-cutting. The internal dimensions were now about 170 feet each way. The arrangements for roofing and lighting were retained with necessary modifications. The central 'lantern' (*opaion*) of this scheme is mentioned by Plutarch (*Pericles*, 13). About the middle of the fourth century B.C. a great Doric porch, of twelve columns (first planned for thirteen) with one more at each side, was begun: this was finished by Philo of Eleusis late in the same century, and survived the Roman restoration, though the columns were never fully fluted. The inner architraves must always have been wooden.[1]

The Odeum or Music Hall of Pericles, which adjoined the Theatre of Dionysus at Athens, was long supposed, from literary evidence, to have been circular, but recent excavations have proved that it was a large rectangular building, somewhat resembling the Telesterion. The south wall is lost, but it is likely that it was a little over 200 feet square and contained about eighty columns (perhaps nine by nine), arranged as at Eleusis.[2] Plutarch describes it as 'many-seated and many-columned within' and the bore in Theophrastus would often ask 'How many columns are there in the Odeum?' Pericles' building was largely of timber, and the conical or pyramidal roof is said to have been copied from Xerxes' captured tent. The original building was burnt during the First Mithradatic War in 86 B.C., but it was soon rebuilt on the same plan by Ariobarzanes II of Cappadocia. In this reconstruction, though perhaps not before, the columns were of stone. There may have been a flat ceiling and galleries, but the floor was horizontal, except for seats built against the outer walls. The chief entrance was apparently a Propylaeum in the west wall. The building was intended primarily for musical competitions.

A notable modification of this general scheme is found in the Thersilion (Fig. 77), or assembly-hall of the new-born Arcadian League, built in its mushroom capital Megalopolis soon after Sparta's defeat at Leuctra in 371 B.C. By the beginning of the Christian era the city was almost deserted, and Pausanias[3] saw only the ruins of the Thersilion: but modern research has ascertained the main features of its plan. Like Pericles' Odeum it adjoined a theatre, but the relation of the two struc-

[1 For later investigations at Eleusis see K. Kourouniotis, Ἐλευσινιακά, Athens, 1932, and *Eleusis, a guide...* by K. Kourouniotis, translated by O. Broneer, Athens, 1936. For Philo's porch see P. H. Davis, *A.J.A.* XXXIV, 1930, p. 1.]
[2 A very late inserted wall was at one time mistaken for the true south wall of the Odeum, but my text now follows the latest account that I have seen, *A.A.* 1930, c. 89.]
3 VIII, 32, 1. He describes it as a *bouleuterion*, called 'Thersilion' after its dedicator.

tures is too uncertain for discussion here. The hall was rectangular, but its width was greater than its depth. It measures 218 feet from east to west by 172 feet from north to south. It was far better designed than either the Telesterion or the Odeum for the convenience of a large assembly. Speakers stood on a level space equidistant from the east, north and west walls, but considerably nearer the south one, and all the inner columns, except those south of this space, were placed at the points where lines radiating from its centre would intersect a series of

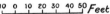

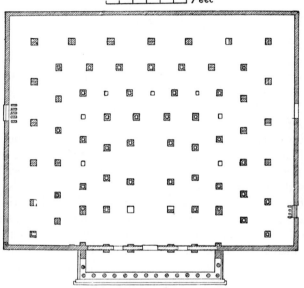

Fig. 77. Thersilion, Megalopolis

five diminishing rectangles inscribed within the building. The obstruction caused by the columns was thus reduced to a minimum, and the doors were placed on blind spots of the outer wall, where the view of the centre was blocked by a line of columns. The seats were possibly in rows parallel to the east, north, and west sides, sloping downwards to the centre from each of these three directions, but some of the evidence suggests that the floor had a steady circular slope, like that of the auditorium of a theatre. The seats may have been raised on a timber framework. The spacing of the columns in the five rectangles differs considerably, those of the middle row (at first the widest) having been

made the closest at some later date: the original interaxial span, thirty-four feet, was no doubt found too great. The columns were of stone, and were probably Doric. We know that the roof was tiled, but there our knowledge of its structure ends. Various clerestory schemes have been suggested. The significance of the arrangement of the columns in the south part of the hall, and the nature of its inner arrangements, are doubtful. There was a great outer Doric porch to the south, facing the theatre, but it did not run the whole length of the front: it had sixteen columns, fourteen in front and one behind each angle column, and it was originally separated from the body of the hall only by four pillars with open spaces between. In the Thersilion the influence of the theatre is superseding that of the Pnyx type of assembly-place.

Of later buildings of this general type, common in the Hellenistic age, it will be enough here to describe two, the Ecclesiasterion of Priene, built at the turn of the third and second centuries B.C., and the Bouleuterion of Miletus, which is about thirty years younger. In both these buildings the resemblance to a theatre is more marked than in any earlier roofed structure.[1]

The Ecclesiasterion,[2] or popular assembly-hall of Priene (Figs. 78, 84, and Plate VII), which could hold about 700 people, is remarkable for two unconnected features: the great span of its timber roof, and the use of the arch in a prominent position in one of its walls. It was an almost square structure measuring externally about sixty-six feet each way, and was hemmed in by other buildings on the southward slope of a hill: to the east it touched the Prytaneum, and to the south a narrow court divided it from the back of the lofty colonnade of the market-place. On the west lay a narrow stepped alley, and only to the north did it face an important street, which was itself far from broad. Though the masonry was magnificent, the absence of external columns and the lack of any important entrance suggest that the architect was chiefly concerned with practical convenience and interior effect. The stone seats are arranged much as in the Thersilion, but advantage is taken of the natural slope: the rectangular space which corresponds to the orchestra of a theatre lies at the south end of the hall. Behind the top row of seats a marble-paved passage ran round three sides of the building, differences of level being cleverly adjusted by flights of steps: between this passage

[1 But see p. 169, n. 2, for the New Bouleuterion at Athens.]
2 There is no strong evidence that this name was applied to this building, but, small as it is, it could probably hold the citizen population of Priene, a town of some four thousand inhabitants. For a general account of Priene, see pp. 189 f.

and the seats stood fourteen pillars, designed to reduce the span of the roof. The seats did not run as far as the south outer wall of the building: they were bounded on this side by two slightly oblique inner walls,

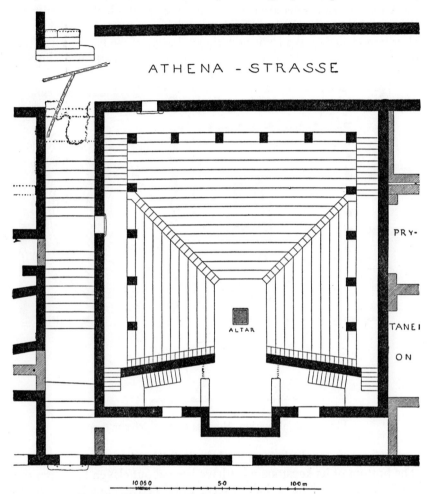

ATHENA - STRASSE

PRY-

TANEI

ON

ALTAR

10 05 0 5·0 10·0 m

Fig. 78. Ecclesiasterion, Priene; original plan (restored)

which created lobbies or ante-rooms, concealed from the body of the hall and containing staircases leading to the upper passage. These lobbies communicated by doors with the narrow court to the south, which was similarly connected with the north portico of the market-

place. The 'orchestral' space extended to the south external wall, which was here (Plate VII) pierced by a semicircular arched window, about fourteen and a half feet in span, an unprecedented[1] phenomenon in the Greek world. This arch was built of separate blocks of uniform size, and its outer face had two fasciae and elaborate crowning mouldings, clearly modelled on the Ionic architrave. It was of the full width of the orchestral space, and sprang directly from the surface of a slightly

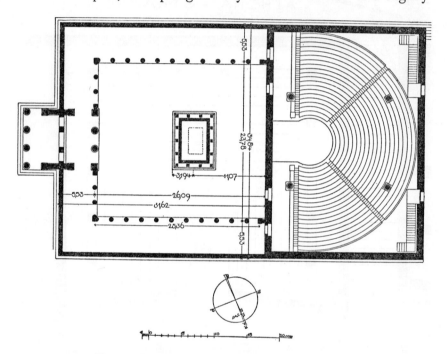

Fig. 79. Bouleuterion, Miletus: original scheme (restored)

projecting course which ran round the building above the orthostatai. The bottom of its keystone must have been about eleven feet from the ground. It opened into a shallow rectangular alcove (containing a stone bench) with low walls, and open to the sky. It is possible that there were other arched windows higher in the walls.

We know nothing of the structure of the roof, but it is possible that the self-supporting triangular truss (absent, as we shall see, from

[1] See pp. 231 f. for the history of Greek arches.

Philo's arsenal, but perhaps known to Vitruvius[1]) was employed, for the free space was some forty-five feet. That there was a roof is almost certain: when excavated the surface was covered with burnt timber and broken tiles, and, though these actually belonged to a late restoration after the span had been reduced by a shifting of the pillars, we can hardly doubt that this late roof had a predecessor.

Fig. 80. Bouleuterion, Miletus: original scheme (restored section)

The Bouleuterion or Council House of Miletus[2] (Figs 79 and 80, Plate VIII *a*) is perhaps the most striking Hellenistic building known. It was excavated in a ruinous state, but careful study has settled its principal features. It was the dominating part of a complicated scheme, for it formed one end of a large cloistered court, which surrounded an elaborate tomb: on the opposite side the court was entered through a stately propylon. The date is known from an inscription: it was built between 175 and 164 B.C. by the same Antiochus Epiphanes who worked at the

1 See p. 182 and Fig. 82 for Philo's arsenal, and for Vitruvius (IV, 2, 1) see p. 389. Some Greek temples had roofs as wide as this as early as the sixth century B.C.: see the cella measurements in Appendix I.
2 There is no special evidence for this name here, but the building is usually so described by modern writers.

Athenian Olympieum. Propylon and tomb have Corinthian capitals, already illustrated,[1] valuable as early dated examples. The Bouleuterion itself was externally a rectangular structure, presenting one long side to the court, which lies to its east: it was in two storeys, of which the lower was treated like a plain podium, the upper like a pseudoperipteral temple, with pediments north and south: it measured externally about 80 by 114 feet. The columns, which were Doric, were all engaged, and those at the angles were replaced by square pilasters: reckoning in these pilasters, the engaged pteron had ten columns by fourteen. The general proportions, however, were well arranged with a view to the total height of the structure, and the effect produced was that of a single building. Six of the thirteen intercolumniations on the east and four of the nine on each of the north and south sides contained windows, the rest being adorned with shields in relief. There were no windows to the west. Internally the building was simply a theatre facing towards the court. The seats, which were curved and occupied more than a semicircle, rested on a solid substructure separated from the east wall by a corridor about seven and a quarter feet wide. The top of the seats was probably level with the stylobate of the engaged columns outside. The corridor, entered from the court through four doors, was on the same level as the orchestral space, which was about twenty-three feet in diameter and was not divided from it by any barrier: at a late date some sort of low stage was erected in the corridor opposite the orchestra. At the back of the building two doors opened on staircases leading to a landing or gallery level with the tops of the seats. There was sitting room for about 1200 to 1500 people. After a late restoration the roof was carried by a number of wooden posts, but it seems at first to have rested on four Ionic columns standing upon rectangular pedestals whose tops were level with the top of the seats: this, however, is not quite certain. The Doric architecture of the exterior shows strong Ionic influence. The columns have, indeed, no bases, but the echinus is carved, in Ionic fashion, with egg-and-tongue, and there are dentils[2] between triglyph frieze and cornice.

Another civil building of the Hellenistic age deserves particular attention, because of its resemblance to the Roman basilica—a type[3] whose name suggests an Eastern Greek origin, but which has not been found outside Italy in pre-Imperial times. This is the 'Hypostyle Hall' of Delos, which can be dated about 210 B.C.—a quarter of a century

1 See p. 161 and Fig. 70. 2 See p. 159.
3 See further pp. 267 ff.

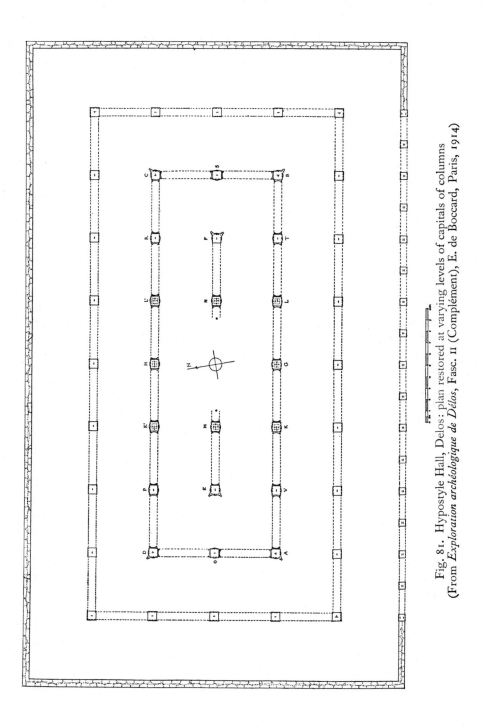

Fig. 81. Hypostyle Hall, Delos: plan restored at varying levels of capitals of columns
(From *Exploration archéologique de Délos*, Fasc. II (Complément), E. de Boccard, Paris, 1914)

earlier than the earliest recorded basilica, the Basilica Porcia at Rome, and a hundred years earlier than the oldest which survives, that of Pompeii.

The Delian hall, described in inscriptions as a stoa or portico, was a large rectangular stone building, in which marble was used only for stylobates, plinths, bases, and capitals. Fig. 81 shows the plan restored at the varying levels of the capitals of the colonnades. Its long axis ran east and west, and it measured internally about 109 by 181 feet. It was in one storey: the east, north and west walls were apparently unbroken, but the south wall was open except for a short stretch at each end. In the opening stood fifteen Doric columns of slender Hellenistic type, with low capitals: the flutes were Ionic, being very deep, and not meeting in sharp arrises: the lower third of the shaft was probably smooth. A poly-triglyphal Doric entablature ran all round the building. Within were forty-four columns, which might be described as arranged in five rows of nine, with the omission of the central column of the central row: but the scheme was clearly one of concentric rectangles. The twenty-four columns of the outer rectangle were Doric, similar to those of the entrance, but larger: the sixteen columns of the next rectangle, which were taller still, were Ionic. Within this inner rectangle stood four Ionic columns, of the same height as the rest, in a single row, with a free space of two normal intercolumniations in the centre. The Ionic columns all had bases of unusual simplicity, consisting merely of one large torus, with the normal fillet and apophyge at the bottom of the unfluted shaft. The capitals, of Hellenistic type, are simply blocked out: the volutes are smooth disks and the echinus has no egg-and-tongue, unless paint supplied the deficiencies. It can be observed in Fig. 81 that two capitals (*E* and *F*, here assigned to the end columns of the central row) had the rare form of double corner columns, with volutes on three faces. It seems certain that the eight columns round the central space (*K'*, *M*, *K*, *G*, *L*, *N*, *L'*, and *H*) carried square Ionic pilasters, of which remains have been found, and that these pilasters formed part of a lantern for the lighting of the interior: but the details of the roofing are conjectural.

Next we may consider one civil building, of the fourth century B.C., our acquaintance with which is of a very unusual kind—the arsenal erected at the Piraeus by Philo of Eleusis for the storing of the tackle of the Athenian navy. It was begun in the twilight of Athenian great-ness, less than ten years before Chaeronea; and within ten years of its completion the disastrous sea-fight of Amorgos crushed for ever the

hopes which sprang from the death of Alexander. The arsenal was destroyed by Sulla, and not a stone of its fabric is known to exist; but we possess an inscription[1] which gives its specifications with extraordinary minuteness. The building, which was mainly of local limestone, was of very narrow proportions, being 400 feet long by fifty-five feet wide[2] externally, with walls two and a half feet thick, set on slightly thicker orthostatai, and twenty-seven feet in height to the top of the triglyph frieze which ran round the building under a horizontal cornice: at each end was a pediment with a raking cornice. There were no exterior columns and no open porch. At each end were two doors two feet apart, nine feet wide, and fifteen and a half feet high, framed in marble and crowned with cornices. These twin doors opened into twin antechambers, roofed with marble, which projected into the interior, and through these the main room was entered. This was divided into nave and aisles by two rows of thirty-five stone columns or square pillars, thirty feet high, and very slender: the marble capitals were only one foot high, which excludes the possibility that they were Corinthian, but is not decisive between Doric and Ionic. To every intercolumniation corresponded a window, three feet high and two feet wide, and there were three windows at each end. Low walls with lattice gates separated the central passage from the aisles, which were almost certainly divided into two storeys by a continuous wooden gallery, open in front; but the interpretation of this part of the inscription is disputable. The most interesting details concern the roof, of which Dörpfeld's restoration is here given (Fig. 82): it was of a heavy type, wasteful of material, but must have been very impressive. Externally it was covered with Corinthian tiles, clay-bedded upon a timber framework, which found direct and continuous supports in the outer walls, in wooden architraves, which connected the capitals of the columns, down the length of the building, and lastly in a central ridge-beam.[3] This ridge-beam was indirectly supported by the columns, through a series of wooden blocks, placed upon the centres of a series of crossbeams which connected each pair of columns across the central space. Architraves and cross-beams were two and a half feet thick, and nearly

1 *Inscr. Graec.* II, 1054.
2 These measurements are all in the Attic foot, presumably that of 0·328 m., which was almost one inch greater than the English.
3 W. Marstrand, *Arsenalet i Piraeus*, Copenhagen, 1922, has lately disputed the existence of this ridge-beam, but the usual interpretation of the inscription seems to be right.

as high, and each timber architrave covered two intercolumniations, a length of over twenty feet.

The famous Pharos or light-house of Alexandria, built by Sostratus

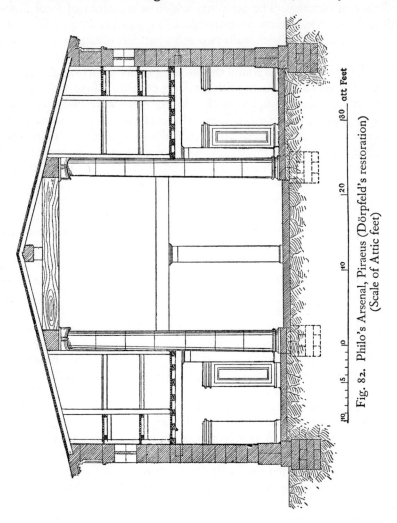

Fig. 82. Philo's Arsenal, Piraeus (Dörpfeld's restoration)
(Scale of Attic feet)

of Cnidus for the first or second Ptolemy early in the third century B.C., is known chiefly from descriptions and from obscure representations on coins and reliefs. It was reckoned one of the wonders of the world, and lasted in good condition. despite some damage in the time

of Julius Caesar, till the eighth century A.D., after which it suffered several collapses and reconstructions, but it survived in some form till the fourteenth century A.D. and much of our knowledge of it is derived from mediaeval Arabic sources. In mediaeval times, and probably from the first, it was in three storeys, each with a slight slope, and set back from that below, the lowest square, the next octagonal, the third round, and the lowest at least was probably never much altered. On top was the actual lantern, about which little is known: it was perhaps a square roofed structure with four open arches, and the original fuel may have been naphtha or petroleum. There was perhaps a great bronze reflector. The lantern was probably crowned with a colossal bronze statue of Isis. There is good evidence that the square of the bottom of the lowest storey measured about 100 feet each way, and the total height in the twelfth century A.D. was over 440 feet.[1] The Pharos was often imitated in antiquity, notably at Ostia by the Emperor Claudius, and perhaps influenced the Moslem minaret.

Lastly a bare mention must here suffice for two types[2] of Greek structure whose importance is less architectural than social, the gymnasium or palaestra and the race-course. The gymnasium was the meeting-place for athletic practice. Its characteristic form was that of a number of porticoes and rooms round a rectangular open space, often surrounded by a cloister colonnade: it had some influence on Roman Baths.[3] The race-course (stadium for men, hippodrome for horses) had a general resemblance to the theatre, but was, of course, long and narrow in shape. Natural slopes were used as far as possible to support the seats: one end was rounded in early times, later both. The hippodrome reached its most magnificent development in the Roman circus.

[1 For the Pharos see G. Reincke, *P.W.* XIX, 1937, c. 1869, and the report in *Proc. Brit. Acad.* XIX, 1933, p. 277, of the work of M. Asin and M. Lopez Otrero on the statements of Ibn al-Shaikh of Malaga (A.D. 1132–1207), unknown to Thiersch.]
[2 Another type, the fountain-building before 300 B.C., is discussed by B. Dunkley in *B.S.A.* XXXVI, 1935–36, p. 142.] 3 See pp. 243 ff. and 258 ff.

[pp. 164, n. 2, and 165, n. 1. For recent work on Greek and Roman theatres see: (i) H. Bulle, *Untersuchungen an griechischen Theatern, Abh. Bay. Akad.* XXXIII, 1928 and *Das Theater zu Sparta, S.-B. Bay. Akad.* 1933, and the series of detailed Leipzig studies (*Antike griechische Theaterbauten*), which began in 1930, especially No. 4 (1931) in which E. Fiechter deals with Megalopolis and Nos. 5, 6, 7 (1935, 1936) in which he deals with the theatre of Dionysus at Athens: all these have been reviewed by me in *J.H.S.* (LIII, 1933, pp. 126 and 303, LIV, 1936, p. 242, LIX, 1939, p. 147), and Fiechter's views on the Athens theatre are criticized by H. Schleif, *A.A.* 1937, c. 26: and (ii) M. Bieber, *The History of the Greek and Roman Theater*, Princeton, 1939.]

Greek and Roman Town-Planning. Etruscan and Early Latin Architecture

It is now time to turn to central Italy: but at this point we may pause to compare Greek and Italian town-planning methods,[1] and to consider certain general differences between the architectural aims of Greece and Rome.

It must be understood at the outset that no account of ancient town-planning can claim completeness or finality. Few towns have been thoroughly explored, and in most of these only the latest stage of development is directly known. If we confine ourselves to actual remains, we are forced, until the Roman Imperial age, to generalize from a very few sites. Before the fifth century B.C., save for a few prehistoric settlements, we know exceedingly little, and even our much fuller knowledge of Roman cities comes chiefly, though not entirely, from such outlying provinces as Britain, Africa, and Syria. There is much valuable literary evidence, but it is difficult to use.

It is likely that in Greece and Asia Minor, till the seventh or sixth century at earliest, most towns were irregular growths, with few fixed features except an open agora or market-place. There was often a fortified hill or acropolis, the site in many cases of a Mycenaean palace, and this hill served in early days as a castle of refuge for the citizens. It contained sanctuaries and temples, and might be the stronghold of a tyrant, but it lay, as a rule, outside the inhabited area. In the towns the only notable buildings were the temples. These occupied sites of traditional sanctity and stood in enclosed precincts of variable size and shape, but the streets and public spaces do not seem to have been designed to isolate or emphasize them. Many Greek towns were not walled before the sixth century B.C., and many remained open till Hellenistic times: Sparta is the most familiar example, but it is not unique. In Greece proper, even in the fifth and fourth centuries, town-walls were largely built of sun-dried brick and timber: scientific fortification scarcely begins till the fourth century, and is chiefly characteristic of Hellenistic cities east of the Aegean.

[1] The following pages are much indebted to A. von Gerkan's *Griechische Städteanlagen*, 1924, though all his conclusions are not here accepted. [See now Fabricius and Lehmann-Hartleben in the article *Städtebau* in *P.W.* IIIA, 1929, c. 1982 ff.: see further note on p. 204.]

Geometric town-planning is associated in ancient literature with the name of Hippodamus of Miletus, who designed Pericles' Panhellenic colony of Thurii in South Italy in 443 B.C., and remodelled Athens' harbour-town, Piraeus, about the same time. The tradition that he also planned the new city of Rhodes in 408 B.C. is almost certainly false: he was probably born about the end of the sixth century. Excavation has shown that his native city, Miletus, destroyed by the Persians in 494 B.C.,

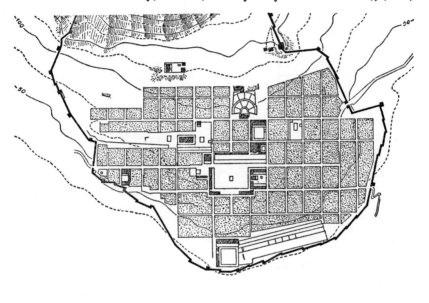

Fig. 83. Priene, simplified ground-plan

was laid out on geometric lines after the Greek victory at Mycale fifteen years later. It may be inferred that Hippodamus learnt his trade from his elders, and got undue credit for introducing Athens to an unfamiliar idea. He may well have made improvements of his own, but these cannot be traced: Aristotle records that his personal affectations irritated the Athenians, and takes pains to refute his excursions into political theory. Hippodamus perhaps associated such town-planning with abstract mathematics, but it probably began as a practical device when new town-sites were being parcelled out by sixth-century Ionian

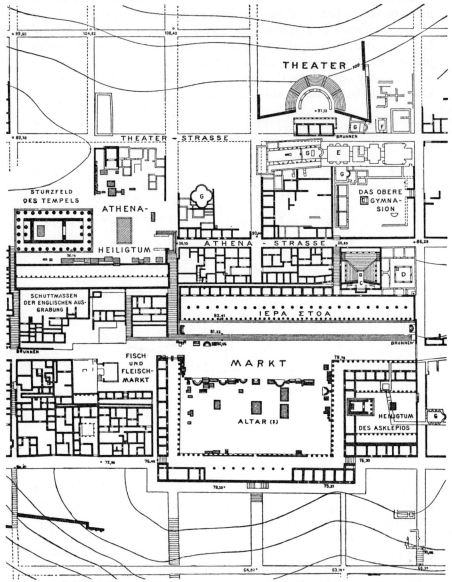

Fig. 84. Priene, plan of central part (restored)

colonists. There is little plausibility in the suggestions that the idea was borrowed from Italy or from the East.

It was difficult to apply geometric schemes to the central parts of existing towns, and there is not much trace of such Haussmannization till Roman days. But from the time of Alexander the Great many old cities were refounded on more defensible or more convenient sites, and a multitude of Alexandrias, Seleucias, and Antiochs sprang up on virgin or village ground. The most important of these were almost certainly Hippodamian, and we possess in Priene one well-explored example of a re-foundation of Alexander's time. Two illustrations are here given (Figs. 83 and 84), one a simplified presentation of the whole area, the other a more detailed plan of the central part. The town was built at the south end of a spur sloping south, east and west. Priene was a small but prosperous market-town, with some four thousand inhabitants. Its population never outgrew it, and though it was not wholly deserted till the thirteenth century A.D. its first construction was so strong and satisfactory that the original scheme was never effaced.

The most striking features may thus be summarized. (1) The walls are typical of the military science of the Hellenistic age. They follow defensible positions and enclose a large area never meant for habitation, including a rocky hill above the town separated by a dip from the mountains beyond. This hill was difficult of access and contained no buildings: it may be loosely called the acropolis. The walls and towers, like much of the town, were of splendid masonry: all were rock-founded and the towers, in accordance with Greek military precept, were not bonded into the walls, which had arched gates. These gates were simple in plan, but in other examples, such as the fourth century B.C. fortifications of Mantinea and Messene in the Peloponnese, the principle of an intermediate court between outer and inner gates is developed with variety and ingenuity. (2) The streets run exactly north-south and east-west. (3) There is one chief east-west street, twice the average width (about twenty-three feet against about eleven and a half feet), which runs from the west gate through the north part of the centrally-placed agora: the east gate lies further north, owing to the lie of the ground. It should be noticed that the large portico north of the agora (marked IEPA ΣTOA in Fig. 84) is a work of the second century B.C., replacing a simpler portico which stretched no further eastward than the agora itself. To the same period belongs the eastward extension of the east portico of the agora, and a large semicircular arch (Fig. 85) which joined the two new porticoes. This arch was for most of its width a mere

ring of stone in mid air: in this part the blocks were of uniform size, being about two feet in height, thickness, and upper width, and tapering to about one foot four inches below. It was purely ornamental, being without threshold or doors: both faces were decorated like an Ionic architrave. Such an ornamental arch is a noteworthy feature at this early date. (4) There is no single north-south street of outstanding importance, though that west of the theatre is rather wider than the average and makes for the centre of the agora. (5) It seems unlikely that the crossing of these two streets is the basis of the town's plan. (6) The essence of the scheme is the equality of the blocks between the streets, which approximate in area to 160 by 120 Greek feet of 0·295 m. (about 155 by 116 English feet): most of these blocks are divided equally

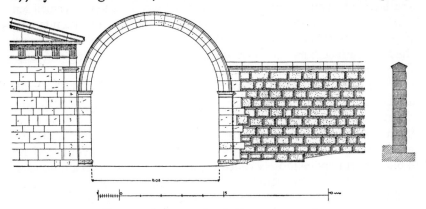

Fig. 85. Ornamental arch, Priene (restored)

between four houses, with common party-walls, though many houses are half this size, on the system of eight to a block. The houses will be described later.[1] (7) Public buildings, including temples, and open spaces are subordinated to the street scheme, one or more blocks being sacrificed to them: no important building stands in or faces the agora.

The city Doura-Europos, on the Euphrates north of Palmyra, has been shown by recent excavations to have been very similar to Priene. It was founded about the end of the fourth century B.C., probably by Alexander's general Seleucus,[2] the first of the Seleucid dynasty. A network of parallel streets running north-west by south-east and north-east by south-west divided it into rectangular blocks measuring about 328 by about 131 English feet (a proportion of five to two). The streets

1 See p. 298.
2 But see p. 375. [See now M. Rostovtzeff, *Dura-Europos and its Art*, 1938 (especially p. 137 for date).]

were all about fifteen feet wide, except for one, about the middle, which was twice that width. This thirty-foot street ran from an important gate in the south-west part of the town wall as far as a ravine to the north east, where it was perhaps closed by a portico: there was no similar street at right angles to it. The walls, as at Priene, followed a defensible line of ground, and ran far away from the houses on all sides but the south-west: they enclosed an isolated citadel.

All this is in accordance with what we know of other geometrical Greek cities, and fits the literary evidence for Hippodamus' methods. Thurii, according to Diodorus Siculus,[1] was laid out with four main streets in one direction and three in the other: he does not suggest that any two dominated the plan.

For Italian town-planning we have little early evidence, but geometric schemes appear in the Bronze Age settlements known as *terre-mare*, and later in the Etruscan town Marzabotto near Bologna, perhaps laid out in the fifth century B.C. The south-west corner of Pompeii, which contains the forum and the chief public buildings, is perhaps based on the intersection of two important streets, and the Stabian and Nolan streets make a notable intersection nearer the middle of the town. It is disputed which of these lies in the original nucleus, but the forum area is probably a later expansion.

There is no doubt that a system of two intersecting main streets, north-south and east-west, in a square or rectangular walled area was traditional in Roman military camps and fortresses, and that many Roman cities grew out of such establishments. There is, moreover, some literary and inscriptional evidence that new cities were laid on this scheme, which had a religious character and was possibly derived from Etruria, though the extant remains[2] of most Etruscan cities throw little light on the matter. The main north-south street was called cardo, the main east-west street decumanus: a gap or pomoerium, of pre-scribed breadth, separated the outermost houses from the walls. In camps the praetorium or head-quarters, which dominated the whole, stood close to the central crossing blocking one of the main approaches.

The oldest city where this scheme can still be clearly traced is Ostia, the port of Rome. Its nucleus was a camp or citadel founded at the close

1 XII, 10.
2 The plan of Marzabotto seems to have been more Hippodamian: it had at least one wide north-south street with narrower streets parallel to it, and at least three east-west streets of the same astonishing width (about fifty feet) as the wide north-south street. Only a very little, however, has been uncovered.

of the fourth century B.C. This was a rectangle measuring about 436 feet by about 393 feet, with four gates, and with a cardo and decumanus which both remained important when the city expanded in Republican

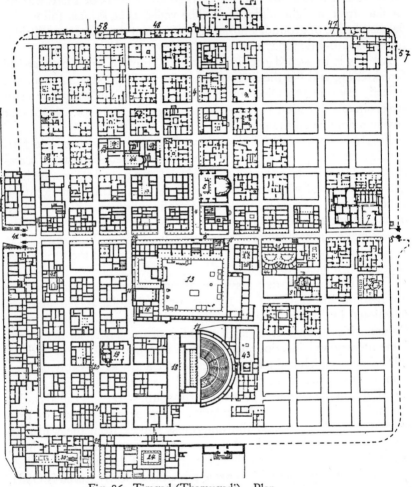

Fig. 86. Timgad (Thamugadi). Plan

and Imperial times. The decumanus in particular was lengthened to form the main thoroughfare of the enlarged city, and the forum was an expansion of the southern half of the cardo: but, though the part of the new city north of the prolonged decumanus had a system of straight

streets intersecting at right angles, there was now no true cardo, and the area to the south was irregular, as was the new town wall.

Under the Empire many camps were almost towns, such as that near Lambaesis in North Africa, built in the second century A.D., and remodelled in the third. Of towns proper laid out in the same epoch with cardo and decumanus we may mention Timgad (Thamugadi) in North Africa (Fig. 86) and Silchester (Calleva Atrebatum) in Britain (Fig. 132). Such towns were probably in most cases designed as walled squares or rectangles, but they often expanded casually, as Ostia did, and were later surrounded by walls of irregular outline.

The connexion of the Roman scheme with that popularized by Hippodamus has been much disputed, but they may have been independent inventions. There is not much evidence for a dominant central cross in Greece or the Near East till the Christian era, when Roman influence is probable or certain. The town on the Acropolis of Selinus, perhaps laid out in the late fifth century B.C., had two streets wider than the rest which crossed at right angles, though not at the centre of the very irregular area: and of Nicaea in Phrygia, probably planned early in the Hellenistic age, Strabo[1] says that it was a square town on a plain, with streets at right angles, and that from a single stone in the middle[2] of the gymnasium the four town gates could all be seen. But in the Greek area such schemes seem to be mere varieties of the Hippodamian scheme, with no special traditional sanction.

It seems likely that the Greek and Italian schemes, whether independent or not, were originally similar in purpose, being designed chiefly to facilitate the equal partition of new town-sites: but the crossing of cardo and decumanus gave the Italian city an initial impetus towards centralization and axial planning. The Greeks of classical times, as we have seen, do not seem to have subordinated their streets or market-places to dominant buildings, axially placed. To them each building was an end in itself, and they were satisfied if it was beautiful and accessible: they did not, so far as we can judge, aim at long vistas and centralized effects. It is true that such effects were unobtainable in the jealously competitive atmosphere of Delphi and Olympia, and difficult to obtain in the old

1 XII, 4, 7 (c. 565).

2 ἀφ' ἑνὸς λίθου κατὰ μέσον ἱδρυμένου τὸ γυμνάσιον. The position of the gymnasium is surprising, but von Gerkan's translation 'from a stone which is near the central gymnasium' is impossible, unless we read ἱδρυμένου, ⟨οὗ⟩ τὸ γυμνάσιον.

casual cities of pre-Hellenistic Greece. In fifth-century Athens Mnesicles' magnificent Propylaea, with their wide-flung symmetrical halls, anticipated and surpassed the Roman vision: but Mnesicles was curbed and thwarted, and the early Hellenistic age seems to have clung to simpler traditions. Whether or not the later Hellenistic architects of Asia Minor and Syria moved towards the ideals of axial planning and mechanical symmetry, in Italy these ideals were abroad before the establishment of the Empire. They are implicit in the plan of the Etruscan temple, accessible only from the front, and sacrificing everything to the façade, and they are expressed in pre-Roman Pompeii, where the temple[1] of Jupiter dominates the colonnaded forum. The ideals find their fullest expression in such late works as the Thermae[2] and Imperial fora[3] at Rome and the great courts of Baalbek,[4] where Italian practice was reinforced by the concentration of despotic power, and by the theocratic traditions of Egypt and the East. In the West the Middle Ages reverted unconsciously to the old Greek method, but the Renaissance consciously revived the Roman ideal, which at present rules the world. Trajan would have felt at home in the Piazza di San Pietro or the Place de la Concorde. These would have puzzled and oppressed an ordinary fifth-century Athenian: Mnesicles would have understood, but perhaps he would have shuddered.

This digression has carried us far from the consideration of early Italian building. We know little of its earliest phases except domestic ground-plans, illustrated by tombs and sepulchral urns. These[5] will be briefly treated at a later point: we are here concerned only with the early temple architecture of Etruria, Latium and Campania, one of the pleasantest manifestations of ancient art. That the Etruscans were Asiatic immigrants is extremely probable: but the date of their arrival in Italy was certainly some centuries before the earliest remains of Etruscan or Latin temple architecture, which may be assigned to the second quarter of the sixth century B.C. The decoration of these early temples is overwhelmingly Greek, and it is doubtful whether any of their structural peculiarities reflect Asiatic tradition.

1 See p. 212.
2 It is instructive to compare the mechanical plan of the Thermae of Caracalla (Fig. 110) with the unsymmetrical scheme of the Thermae of Faustina the Younger (2nd cent. A.D.) at Miletus, a city of Hellenistic traditions, which are Roman in constructional technique (*Milet*, I, 9, 1928, Fig. 115).
3 See p. 292. 4 See p. 222.
5 See pp. 302 ff. For Etruscan tumuli see p. 265.

If we exclude a few stone temples of purely Greek style, such as that of the sixth century B.C. at Pompeii, the early temples of Campania, Latium and Etruria belong to one general type, though with local differences, and may be classed together as Italian. They were mostly built of wood and sun-dried brick, stone being used, at most, for walls and columns, but never for the entablatures, which were always of timber though freely protected with painted terracotta. Many of these temples stood on a high podium, with steps at one end only: this feature, which is rare in Greece, may possibly be Asiatic, and was certainly inherited by Rome from Italian tradition. The ground-plans bore a general resemblance to those of Greece, with certain striking peculiarities. We may first examine the terracotta decorations and the evidence which these provide for the forms of entablature and roofing: they are often the only surviving remains of temples, and still oftener the only datable ones. These terracottas fall mainly into two chronological groups, of which the first begins about 560 B.C., and ceases about a century later. The second is Hellenistic, and there is a break from the first half of the fifth to the middle of the fourth century, not fully understood, but perhaps connected with the battle of Cumae in 474 B.C., when Pindar's patron, Hieron of Syracuse, broke the Etruscan sea-power and crippled Rome's deadliest rival in central Italy. The Hellenistic phase lasted till the opening years of the second century B.C., when this whole provincial timber tradition was swamped by the influx of the fully-developed architecture of the Hellenistic world. From first to last the decoration was almost wholly Greek in character, though made on the spot and applied in special ways: it must have been the work of Greek artists and their pupils, direct or indirect. The closest known parallels to the older phases have been found in north-west Asia Minor and in some of the early temples of eastern Crete. In this period the artistic inspiration was almost certainly in the main Ionian. It will be remembered that the Phocaeans founded Marseilles early in the sixth century and explored the Mediterranean as far as Gibraltar: but we must also allow for Corinthian influence, for which there is both literary and archaeological evidence.

Before describing the actual remains, it will be best to state what is known from other sources of the forms of the timber framework to which they were applied. The best evidence is provided by certain[1] small ancient

[1] Half-a-dozen are known: among the best are the one from Nemi here illustrated and one from Conca, the ancient Satricum.

models found in Italy (Fig. 87), which may be supplemented by Vitruvius' statements, perhaps derived from surviving temples, especially the

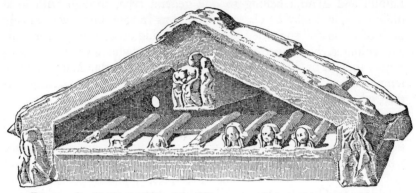

Fig. 87. Small terracotta model of Etruscan pediment, from Nemi

great temple of Ceres Liber and Libera near the Circus Maximus, which he seems[1] to have seen before its destruction by fire in 31 B.C.

There is no space to discuss the difficult details of Vitruvius' language[2]: a brief statement of what seems the best interpretation must suffice, illustrated by Wiegand's restorations (Figs. 88 and 89). The columns of the porch were widely spaced, as we should expect, and the architraves (trabes compactiles) were made of two beams, side by side, pegged and clamped, but with space for air. On the architraves which connected the angle columns with the antae lay a second set of beams, called mutuli, which ran right along the tops of the cella walls, and also projected forwards in front to the distance of one-quarter the height of the columns.

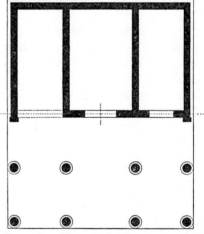

Fig. 88. Vitruvius' Etruscan temple (Wiegand's restoration). (From *La Glyptothèque Ny-Carlsberg*, F. Bruckmann, Munich, 1896–1912)

On the front[3] architrave was built

1 III, 3, 5. 2 IV, 7.

3 This restoration assumes that there was a gable at the back also. It has been argued

the tympanum wall either of timber or of more solid materials, but the details of its construction are doubtful. The ridge-beam (columen) of the gabled roof rested in front on the tympanum, and projected forwards as far as the mutuli did; the tiled roof, resting on a system of rafters (cantherii) and planks (templa), was carried forward to the ends of the mutuli and columen, thus producing a very deep pedimental space. For the nature of the pediment floor we depend chiefly upon the

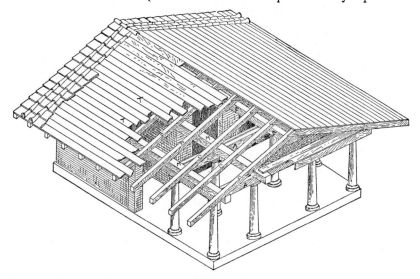

Fig. 89. Vitruvius' Etruscan temple (Wiegand's restoration). $A =$ trabes compactiles; $M =$ mutuli; $C =$ Cantherii; $F =$ columen; $T =$ templa. (From *La Glyptothèque Ny-Carlsberg*, F. Bruckmann, Munich, 1896–1912)

ancient models, which show that originally it was treated as a portion of roof, with flat and covering tiles and antefixes in front, a surprising arrangement. In the Nemi model the ends of the mutuli and columen seem to be faced with terracotta reliefs, perhaps mentioned by Vitruvius as antepagmenta. The roof had also a great lateral projection, as the models show: Vitruvius appears to say that the projection (which continued the downward slope of the roof) should be one quarter of the total measurement from roof to eaves. It will be observed that there were no triglyphs or metopes, but that Vitruvius' Etruscan temple had a roof of three slopes at the back, like the Thermum temple described on p. 66: but neither the text nor the evidence of archaeology lends much support to this view, for which see A. Sogliano in *Acc. Lincei Mem.*, Ser. VI, Vol. I, 1925, p. 237. [See also E. Wistrand, p. 305, n. 1 *infra*.]

that the mutuli, at least along the sides, corresponded to the smooth Ionic frieze: it is uncertain whether there was a corresponding member along the front. On the sides the mutuli were much hidden by the eaves; how much, depends upon the degree of the pitch of the roof, which Vitruvius does not state, and which varies in the models.

Let us now consider the earlier group of terracotta remains. They include terminal tiles, forming a sort of sima or raised gutter above the pediment; continuous frieze slabs,[1] some to be nailed to beams, some to be stuck to the cella walls; simae and antefixes from the side-eaves; acroteria; terracotta casings for wooden beams; upright tiles, elaborately ornamented and perforated, which clearly made a continuous screen, though it is uncertain whether they formed an extra parapet above the pedimental sima or ornamented the ridge of the roof; and lastly hanging terracotta curtains suspended from the edge of the eaves-tiles and painted on both sides. It should be added that the roof-tiles of the lowest row had painted decoration on their under surfaces. The beam-casings, screen-tiles, and curtains[2] are not positively attested except for the later part of the earlier period, between 510 and 460 B.C. The commonest form among these terracottas is a heavy convex moulding at the bottom (hollow, and penetrated by a continuous leaden rod), a fluted strip at the top, with a forward curve, and between these a broad band of relief, decorated at first with processions or scenes of fighting or feasting. Later human subjects are usually absent from these reliefs, but in compensation we find excellent terracotta groups in the acroteria and antefixes; a common type is a group of one satyr with one maenad, in various combinations. Terracotta figures are sometimes placed on the top of the pediments, facing upwards to its peak: most of the figures are now mythological, but the range is limited. There is evidence that the pediment floors were treated as in the models, and pedimental figures are doubtful before the Hellenistic age, though large and magnificent groups of terracotta statues were made in Etruria in archaic times. In the Hellenistic period there was some archaism, but naturalistic vegetable ornament became common and Greek mythology was freely used. The old pediment often gave place to a shallower form containing terracotta statues on Greek lines. The main influence perhaps now came from Greek Campania. A reconstruction, in the Archaeological Museum of Florence, of the pediment of an Etruscan

1 But friezes designed as a continuous composition do not appear till the 3rd century B.C.

2 For a Greek parallel to the curtains, see *Ath. Mitt.* XXXIX, 1914, p. 166, Fig. 4 (Corcyra).

shrine from Vulci is here illustrated (Plate VIII *b*). Though dating from the third century B.C., it preserves the archaic scheme.

Before passing to actual buildings it will be well to describe in more detail the ground-plan of Vitruvius' ideal Tuscan temple (Fig. 88), which is useful as a standard of comparison. The actual remains are often obscure, for the materials were flimsy—even the stone used was often perishable—and many temples were repeatedly remodelled. Vitruvius describes a temple with a triple cella, consisting of three undetached cellae side by side. Its total area, including the porch, is nearly square, length to breadth being as five to six. From front to back the area is divided into halves, (*a*) for the porch and (*b*) for the triple cella. The middle room of the cella occupies two-fifths of the available width. The porch is tetrastyle prostyle, with columns spaced to correspond to the walls between the cellae: half-way back stand either two or four more columns (this point is obscure). Vitruvius allows the substitution of alae or 'wings' for the side-cellae. This probably means the continuation of the side porch columns, pteron-fashion, as far as the back line of the single remaining cella, but not right round: probably the back wall of the single cella was of the full width of the porch, a plan[1] which is actually found. Some, however, hold that the alae were simply side-cellae, with open fronts instead of front walls pierced by doors, and this view is adopted by Wiegand in Fig. 88. The origin of this triple type, which is often found, was certainly religious, but the aesthetic effect was none the less great. Hence sprang the 'heavy-headed low broad' temples of Vitruvius, which were not without influence upon the architecture of Rome and Europe.

The ground-plans of known temples often resemble those of archaic Greece—a simple rectangular cella, with a porch in front, usually prostyle: the cella may have inner divisions, but back porches are doubtfully attested. Both broad and narrow plans are found, of which the broad are perhaps the older. It is not certain that any temples were fully peripteral. As an undoubted example of the single-cella type we may take, despite its lateness, the temple of Aletrium in Latium, the modern Alatri, which is the basis of the somewhat incorrect restoration which stands in the garden of the Villa Giulia at Rome. The abundant terracotta remains are of one age, the third century B.C. This temple had a deep prostyle porch, of only two columns, opposite the antae, a type,[2] as we have seen, rare, but not unknown, in Greece. The position of the

1 See the illustration of the 'Corinthian-Doric' temple at Paestum, p. 202, Fig. 90.
2 See p. 54.

cross-wall which contained the door, some distance behind the antae, is perhaps a late feature.

More definitely illustrative of early construction are the two successive forms of the temple of Mater Matuta at Satricum, which are both early. The first was built about 550 B.C., the second replaced it half a century later, and lasted until Roman times. The first was a small building, with a prostyle porch, and a partial or complete pteron: the second, which has left abundant remains, was larger: differently oriented, but of similar plan. The three-cella type has left many examples, including the temple of Apollo at Veii and two temples at Marzabotto near Bologna: an easily visited specimen is that of Fiesole, whose existing remains date from the first century B.C. Only one will here be described, the Capitolium of Signia in Latium. The stonework and plan of this temple have been assigned to the opening of the fifth century, to which belong most of the terracottas, though the decoration was renewed about two hundred years later and again in the second or first century B.C. Its plan is close to that described by Vitruvius. It stands upon a podium, about ten feet high, and like most Etruscan temples was entered from the south. The porch occupied almost exactly half the total area, which measured about 85 by 134 feet: a scheme which, like the orientation, is probably inherited from the rules of the ancient Etruscan templum, which was not a building, but a rectangular open space, elaborately marked out, used for observations of the heavens. There was a triple cella, with the middle division wider than the others though not to the degree prescribed by Vitruvius. The porch columns were arranged as in Vitruvius, except that there were three rows of four columns, making twelve in all: podium, walls, and columns were of stone, but the entablature was timber and terracotta from first to last.

The surviving substructures of the Capitoline temple at Rome date from its foundation in the late sixth century, and from their evidence, combined with ancient descriptions, it is clear that it was a more or less Vitruvian triple temple. It was burnt[1] in 83 B.C., and often thereafter, but retained to the last many Tuscan features. It seems to have been about 185 feet wide by about 200 feet deep, and to have had a prostyle porch of eighteen columns, in three rows of six, with a row of columns along the sides meeting sideward extensions of the back wall. There was a famous terracotta chariot group, by an Etruscan artist, on the

1 It was after this fire that Sulla adorned it with columns from the Olympieum at Athens.

peak of the pediment. Vitruvius implies that after its first rebuilding it retained wooden architraves, but after its last recorded reconstruction, by Domitian at the end of the first century A.D., the entablature was certainly of marble.

For the forms of Etruscan columns the evidence is scanty, but the commonest form was perhaps a variety of Doric. Either the whole column, or its shaft, was often of wood, sometimes cased in terracotta: but bases, capitals and shafts were often of stone. Vitruvius prescribes a type of Tuscan column, which differs from his Doric column chiefly in the absence of fluting and entasis, though it has diminution, and in the presence of a base, which consisted, from the top downwards, of a small convex moulding, a large convex moulding, and a circular plinth, a disk, it would seem, with vertical sides: the plinth is equal in height to the other two mouldings, and the total height of all three together is half the lower diameter of the shaft: there is a rib near the top of the shaft, and the capital apparently lacks the annuli on the echinus and the moulding on the abacus which he lays down for Doric. No ancient Tuscan column of exactly this form is known: but it bears a general resemblance to much that survives. The Signia temple had unfluted stone columns with strong diminution and entasis, but no capitals or bases were found. Bases with convex mouldings on cylindrical plinths have been found at Orvieto, Alatri, Alba Fucens, the Alban Mount, and elsewhere, and various known capitals, real or depicted, resemble archaic Doric types and especially those of the Paestum temples, where, it will be remembered, the shafts had strong diminution and entasis and ribs, in many cases, below the necking. A complete stone column, probably Etruscan, which was found built into a wall at Pompeii, is ascribed to the sixth century B.C. It stands on a square block of stone, and has a cylindrical plinth, but no mouldings between that and the shaft, and no necking rib: the shaft is unfluted, with exaggerated entasis of the 'cigar' type, the thickest part being about half-way up. Parts of a terracotta capital with cylindrical abacus, and of a terracotta base, with a spreading moulding, together with scraps of terracotta shaft-casing, have been found on the site of the Temple of Apollo at Falerii Veteres. We may tentatively conclude that early Etruscan columns were derived from archaic Doric, before its crystallization in the stone architecture of the sixth century: but we must not exclude the possibility of indirect Greek connexions, especially through Carthage.

Paintings and reliefs, especially on sepulchral monuments, show also

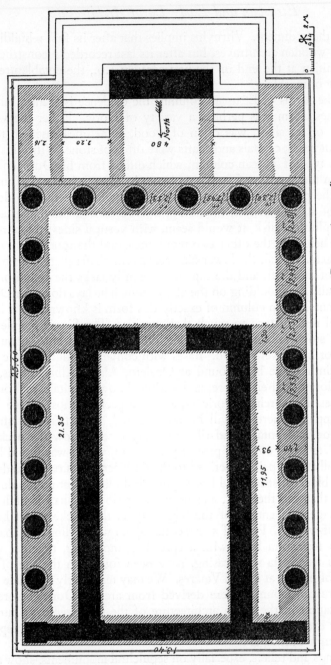

Fig. 90. The 'Corinthian-Doric' temple, Paestum (restored)

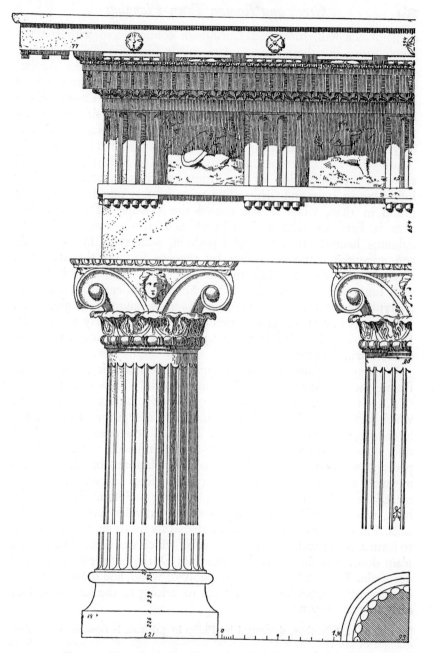

Fig. 91. The 'Corinthian-Doric' temple, Paestum (restored)

acquaintance with Ionic and Corinthian columns and with the tri-glyph frieze, but these seem to date chiefly from the Hellenistic age. An exception must be made for a type of capital resembling the 'Aeolic' of Neandria, found in actual monuments, which is certainly an old form in Italy, perhaps borrowed from the Phoenicians or Carthaginians, though influenced later by Corinthian, and made four-sided; it some-times has human heads or busts projecting from each face, but these may be of Hellenistic origin. The chief example of this type is the 'Corinthian-Doric' temple of Paestum (Figs. 90 and 91), which will serve as an illustration of the fusion of Etruscan and Hellenistic influences in Italy and Sicily. The ruins of this odd building were found in 1830, when it was named the 'Temple of Peace'. The plan is Etruscan with a deep porch and side-colonnades, but no columns behind. It stood on a podium, with steps in front only and measured about forty-four by seventy feet on the stylobate. Capitals and bases are alike unorthodox. The entablature is Doric, with Ionic elements, like that of the Miletus Bouleuterion: there are triglyphs and metopes, but also dentils, and the mutules are abnormal. The date is uncertain. It has been thought to be an early work of the Roman colony founded in 273 B.C.; but it perhaps belongs rather to the following century.

We may associate with the Paestum temple a building much nearer Rome, the temple of Gabii, which may possibly be as old as the late third century B.C. It stood in the middle of a large walled precinct, which was surrounded by Doric colonnades, except for a theatre sunk in the sloping ground to the south. The well preserved cella, of local tufa, about twenty-seven by forty-four feet inside, stands upon a podium with steps to the south. The platform of the podium measures about fifty-eight by seventy-eight feet. In general arrange-ment it resembles the Paestum temple, being peripteral, except at the back, where the side-colonnades meet the extended back wall of the cella. The columns seem to have numbered six by seven, so arranged as to form a deep porch in front of the cella, which was entered through a plain door. The fluted columns were not Doric, but their character is uncertain. The entablature was probably of wood, and there are scraps of terracotta decoration which seem to belong to the late second or early first century B.C.

[p. 186, n. 1. Olynthus, destroyed by Philip in 348 B.C., is now an outstanding example of pre-Hellenistic Hippodamian town-planning: see its excavator, D. M. Robinson, in *A.J.A.* since XXXVI, 1932, and in *P.W.* XVIII, 1939, cc. 325 ff.]

Temple Architecture of the Roman Republic

We must now turn definitely to Rome. It should be understood at once that our knowledge of Republican architecture is disappointingly slight, and its dating largely uncertain. Horace assured the Romans that the sins of their fathers would continue to afflict them until they had thoroughly restored the gods' ruinous temples, and under Augustus' guidance this work was conscientiously taken in hand. Roman architecture is in any case hard to date, especially in Republican and early Imperial times: imitative and eclectic, it reflects a dozen different influences. Increasing acquaintance with materials and methods, combined with deeper study of style and ornament, is gradually dispelling the mists, but there is still much disagreement between good critics. Imperfect as the evidence is, it points to the conclusion that the old Etrusco-Latin school absorbed two successive waves of late Greek influence, the first, coming mainly from South Italy and Sicily, in the third century B.C., the second coming from Greece, Asia Minor, Syria, and Egypt, in the next two centuries. These dates reflect the historical facts of Rome's expansion, southwards and westwards in the Punic Wars, eastwards after the fall of Carthage. In speaking of Roman architecture it is vital to remember that the architecture even of the Empire, especially in the Greek East, was at bottom Hellenistic, and that Rome's political dominance caused no sudden break in its development. At the same time it is certain that the centralization of government had an immense effect, and that the city of Rome was the fountain-head not only of new constructional methods but also of various fashions in ornament and design, which definitely radiated from the capital to the provinces, especially in the West. The majority of architects may have been Greeks by blood, but the engineers, who quietly revolutionized the ideals of architecture, were perhaps mostly Romans.

The most original works of the late Republic and the early Empire are seldom temples: but it will be convenient to clear the ground by a preliminary sketch of the general development of ordinary Roman temple architecture.

The earliest temples of the city of Rome have left little but their substructures, which are important for the history of technique, but have

only a general interest here. One of the chief, the Capitoline temple, has already been described.[1] Apart from engineering works, it is difficult to point to any well-preserved building in or near Rome which can be confidently assigned to a date earlier than 100 B.C. We have seen[2] that Gabii may be an exception, and certain of the temples which we are about to mention are sometimes assigned to the second century B.C.:

but in the dearth of strictly Roman evidence we must frequently turn to an Italian city far south of Rome and much closer to direct Greek influences —the buried city of Pompeii. Its second-century basilica will be described later[3]: here only one of its temples need be considered, that of Apollo (Fig. 92), known till 1882 as the temple of Venus. This was probably built in the later part of the second century B.C., but it was heavily restored between the earthquake of A.D. 63 and the annihilating eruption sixteen years later. Like the temple of Gabii, it stood in a cloistered court, originally of two storeys. This colonnade had at first four-sided[4] Ionic capitals, crowned with a low architrave and a tall triglyph frieze, but

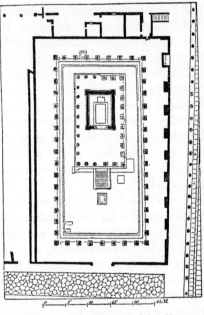

Fig. 92. The temple of Apollo, Pompeii

after the earthquake the whole was made Corinthian by free use of chisel and stucco. The plan of the temple differs from that of Gabii chiefly in this, that the peripteral colonnade here runs round the back also. With this further step of Hellenization, we have arrived at the main elements of the commonest of Roman temple plans. The columns in front, though actually part of an unbroken peripteral ring, are felt to be in truth the columns of an expanded Tuscan prostyle porch. The rest of the colonnade is a superfluity, and has later a constant tendency to shrink to a pseudoperipteral series of engaged half-

1 See p. 200. 2 See p. 204.
3 See p. 268. 4 See pp. 211, 212.

columns (as in the Maison Carrée[1] at Nîmes), or even to a series of pilasters (as in the temple of Cori[2] in Latium). This tendency was encouraged by the general character of Roman town-planning. Roman architects liked to place their temples on the axis of a rectangular space, entered from the centre of the opposite side. Such a scheme, combined with the Etruscan porch and podium, was bound to reduce the importance of side and back views. The columns in the Pompeian temple were Corinthian, but its capitals were forcibly changed, after the earthquake, from the old Italian Hellenistic type[3] to the now established orthodox form. The stone entablature has mostly perished.

Of the few temples generally assigned to the first century B.C. the following will now be described: first the old-fashioned Doric or Tuscan temple which lies under S. Nicola in Carcere at Rome: next the more orthodox late Doric temple at Cori: then, for old-fashioned Corinthian, the round temple at Tivoli, and for orthodox Corinthian that near the Tiber at Rome: and lastly, for orthodox Ionic, the temple of 'Fortuna Virilis' at Rome. Old-fashioned Ionic will be described independently of any temple.

The Doric temple under S. Nicola in Carcere is one of three side by side (the others are Ionic) partly covered and partly absorbed by this church in the area of the vegetable market of ancient Rome. Nothing is visible but the northern edge of its podium and parts of five peripteral columns with their entablature, but Renaissance students record that there was once a marble doorway. The plan is guess-work, but the columns and entablature are interesting. The shafts are unfluted, with diminution but no entasis, and are some seven diameters high: there is a smooth band of slightly thicker shaft just below the echinus, nearly as high as the whole capital above it. The low echinus is nearly straight in profile and quite plain: we must, however, allow for the possibility of lost plastic ornament in stucco. These shafts and the entablature may perhaps show Etruscan influence. The architrave is smooth, crowned with a sort of taenia, and the frieze is also smooth and lacks all Doric features: the cornice too is abnormal, and seems to show some Etruscan affinities. It is clear that this is an old-fashioned temple, whatever its actual date. Delbrück would assign it on grounds of style to the second century B.C. Tenney Frank, however, asserts that all visible parts of the temple are of travertine, and that this precludes so early a date, this admirable material (of which the Colosseum and St Peter's are alike

1 See p. 213. 2 See p. 209. 3 See p. 210.

built) having been unknown till the middle of the second century B.C., and sparingly used for the next hundred years. Partly for this reason

Fig. 93. The Doric temple, Cori (foundations partly exposed)

he identifies the temple with that of Spes, as rebuilt after a fire in 31 B.C., and for its conservatism he quotes the parallel of Pompey's Tuscan temple of Hercules by the Circus Maximus, which Vitruvius compares to those of Capitoline Jupiter and of Ceres Liber and Libera. Some

scepticism is desirable in the matter of identifying and dating building-stones, but the fact that such architectural forms do not prove an early date is established by the small prostyle 'Augusteum' erected between A.D. 40 and 50 by Q. Veranius at Sidyma in Lycia, when governor of that province. This temple has smooth Doric columns without bases, an architrave without a taenia, and a smooth frieze without triglyphs, of a convex Corinthian profile.

The date of the Doric temple at Cori, the ancient Cora (Fig. 93), is not disputed. It belongs to the early first century B.C., and is one of the best preserved of Republican temples. The plan is thoroughly Tuscan: it stands upon a podium once approached by steps from the south, and has a deep tetrastyle prostyle porch, with two columns between each of the angle columns and the cella wall. It measured about twenty-five by forty-six feet, to the front of the porch. The cella is entered through a central door, and there are no antae, but there were pilasters at all four corners in line with the side-columns of the porch, with two more on each side and at the back: this is known from Renaissance drawings, but most of the sides and back of the cella have now perished: the cella was not quite so deep as the porch. The columns are exceedingly slender for Doric, the height being equal to eight and two-thirds lower diameters: this proportion occurs in Roman Ionic, though a proportion of nine or ten is there more usual. They have slight diminution and entasis, and simple bases consisting of one convex moulding below a considerable apophyge: a type, perhaps Tuscan, but certainly also Hellenistic,[1] often found in Roman work. There are eighteen Doric flutes for the upper two-thirds of the shaft: below that the shaft is an eighteen-sided polygon. For this practice of partial fluting there are, as we have seen, Hellenistic precedents, and it is common in Roman and Renaissance work.[2] There is a smooth band below the capital, which has a very low echinus and abacus. The low architrave is Doric and runs, with the triglyph frieze, right round the building. There are three triglyphs (in one case four) to each intercolumniation. The lines of the porch are slightly concave in plan, but this is probably fortuitous, like the irregularity in the triglyphs.

This temple bears much resemblance to the temple of Hera Basileia at Pergamum,[3] but in detail it seems to show the influence of South Italy and Sicily, rather than that of Asia Minor.

1 Compare, for instance, the bases of the Ionic columns of the Hypostyle Hall at Delos, p. 182.
2 For 'cabling' in Roman fluting, see p. 381. 3 See p. 159.

The round 'Temple of Vesta' at Tivoli, about forty-six feet in dia-
meter, is in part very well preserved and excellently illustrates the form of
Corinthian dominant in Italy till the time of Sulla. It stands on a podium,
with steps only opposite the door. The material is concrete for the core of
the podium and for the walls, tufa for the foundations, and travertine for
columns, door, window-frames, and other exposed portions, a mixture of
materials which fits the early part of the first century B.C. The only
columns were the eighteen external ones, of which ten remain: they
bear a normal Hellenistic architrave, frieze and cornice, which last was
joined to the cella wall by slabs of travertine, carved below with two
concentric rings of panels containing elaborate rosettes. The frieze was
adorned with complete ox-heads, connected by heavy garlands, a
Hellenistic motive: from the time of Augustus such ox-heads were
usually skulls.[1] The columns, which are about twenty-three feet high,
have Attic-Ionic bases and eighteen Ionic flutes: their height is equal
to about ten and a half lower diameters: in later Roman Corinthian
columns the height usually ranges between nine and ten lower diameters:
it will be remembered that the columns of the Hellenistic[2] Olympieum
at Athens had a height of less than nine lower diameters. The capitals
(Plate IX *a*) differ in several respects from the canonic type. The outer
and inner spirals rise parallel and independent from the ring of leaves:
all are thick and strong, and the outer have a curious flat form, com-
bined with a corkscrew projection. A large flower stands out from the
upper part of the bell, in the position of the large palmette in the pioneer
capital of Bassae: the acanthus leaves are full, rich, and bold. This type
was prevalent in Pompeii till the first century B.C., and perhaps reached
Italy from Sicily, where it is especially common, though it is found in
Greece and in Hellenistic Egypt. It occurs as far north as Aquileia, near
Trieste. It is clearly an independent branch of the original stock. The
Tivoli capitals were imitated by Sir John Soane, late in the eighteenth
century, on the façade of the Bank of England, where they may
conveniently be compared with the orthodox capitals on the Royal
Exchange: they are refreshing to eyes sated with the million replicas

1 Ox-skulls alternating with rosettes are, however, found in the frieze over the
Ionic columns of the North Propylaea at Epidaurus, assigned to the late fourth
century B.C., and ox-skulls connected by garlands occur in the Bouleuterion of
Miletus (pp. 179 ff.), on the tomb in the courtyard, and ox-skulls, often alternating
with phialai or rosettes, are found on third-century buildings in Samothrace and
at Pergamum. Complete bulls' heads connected by garlands also occur in Augustan
work, e.g. in the temple at Antioch in Pisidia. [See further p. 212, n.]

2 See p. 160.

of their fortunate cousin. The temple was possibly roofed with a low thin concrete dome, but this is unlikely.

Passing from Tivoli to the peripteral round temple beside the Tiber in Rome (Plate X *a*) we find ourselves in the full stream of pure Greek tradition. The temple, now the church of S. Maria del Sole, was perhaps (as Hülsen suggests) dedicated to Portunus, who is known to have had a temple in this neighbourhood. The podium is entirely surrounded by steps in the Greek fashion: there were twenty outer columns, of which one is missing. The core of the podium is of tufa, but the whole of the rest is of Greek marble. The date is much disputed. Tenney Frank, for instance, is inclined to assign the core of the podium to the first half of the second century B.C. but the rest to the early Empire, and few archaeologists believe the visible parts to be earlier than Augustus. Delbrück, however, refuses to dissociate podium and superstructure, and tentatively places the whole in the second century B.C., the date when tradition asserts that marble temples were first built at Rome. In style the columns are of the orthodox school found in the Athenian Olympieum, though some critics see in them features which point to a late Republican or early Imperial date. The complete loss of the entablature makes the dating exceptionally hazardous. The building certainly shows no trace of Italian tradition.

Close to this temple stands a small tetrastyle prostyle structure, of Ionic style, shown in Plate X *b*, preserved as the church of S. Maria Egiziaca. It is usually called the temple of Fortuna Virilis, perhaps rightly. The porch was walled up in the Middle Ages, but has been re-opened. The building is exceptionally perfect, and is an excellent example of Roman pseudoperipteral. It stands on a podium, with steps only in front. The porch, with six free columns, occupies one-third of the length, and there are twelve engaged columns. It is an illustration of that economy in which Rome rivalled Minoan Crete: the core of the podium is concrete, and it is faced with travertine, of which are also all the free columns and the four engaged ones at the angles. The same hard stone is used for all bases and capitals and for the whole entablature of the porch except the tympanum, but all the rest is of soft Anio tufa. Except for the cella entablature, no carved or exposed members are of the softer material. The capitals are of the usual late Hellenistic type[1] with the eyes of the volutes at the point of intersection of the horizontal of the top of the echinus and the perpendicular of the upper diameter of

[1] See p. 157. Good late examples may be seen in the temple at Hebrân in the Ḥaurân, dated by an inscription 155 A.D.

the shaft. This type was prevalent in Imperial Rome, though often in the 'diagonal' four-sided[1] Hellenistic Italian form, fashionable at Pompeii, which never died out and helped to give birth to the 'Composite'[2] capital, beloved of Wren. A specimen of a 'diagonal' capital from a Pompeian house is here illustrated (Plate IX*b*). For the date of this temple there is no external evidence, but students of material and students of style agree in assigning it to the middle or second half of the first century B.C.

We may also consider here the temple of Jupiter which dominates the north end of the Forum at Pompeii, facing south, for it probably belongs in its present form mainly to the earlier part of the first century B.C. In plan it is very Tuscan, having a podium about ten feet high and a hexastyle prostyle porch four bays deep, with twelve free columns: but the forms were purely Greek, and the Corinthian capitals of the porch closely resembled those of the Athenian Olympieum, till later taste made them more florid. The cella had two rows of Ionic inner columns, close to the side-walls: they perhaps supported an upper Corinthian series. A triple pedestal at its further end carried statues of Jupiter, Juno, and Minerva. The inner walls were painted in imitation of marble veneer, a method characteristic of the date given above. Excluding the steps, the temple measures about 49 by 100 feet. Examination of the foundations[3] has shown that an older temple, about ten feet shorter to the south, preceded the existing building. The podium, most of which was built for the older temple, consists for the greater part of that length of three parallel corridors, between eleven and twelve feet wide, with concrete barrel-vaults.[4] It seems certain that this earlier temple had a tetrastyle prostyle porch in two bays, probably with eight columns in all: if so, its entablature must have been of timber.

1 Partly anticipated at Bassae (p. 138). A probably Hellenistic example was found in Calauria (see p. 361).
2 See p. 220 and Pl. IX*c*.
3 See especially A. Sogliano, in *Atti Acc. Lincei*, Ser. VI, vol. I, 1925, pp. 230 ff.
4 Vaulting is discussed in Chapter Fifteen.

[p. 210, n. 1. Patterns of ox-skulls alternating with rosettes or phialai are also found on red-figure vases of the fourth century B.C.: for these and for a discussion of the origin of the motive see J. D. Beazley, *J.H.S.* LIX, 1939, p. 36.]

Temple Architecture of the Roman Empire

We now come to the age of Augustus: and from this point on it will be best to consider separately temple architecture (*a*) in Italy, Western Europe and North Africa, (*b*) in Greece proper, and (*c*) in the East. In each case the fourth century A.D. will be the limit, but some temples will be reserved for treatment in connexion with Roman constructional methods. We must here say good-bye to Tuscan and Doric,[1] which are found henceforth almost exclusively in secular buildings, and mostly as engaged columns or pilasters. Ionic also becomes rare in temple architecture, and almost all temples henceforth described are more or less orthodox Corinthian. It must clearly be understood that no more is attempted than the briefest selection of typical specimens.

Of Augustan temples no better example can be found than the Maison Carrée at Nîmes (Colonia Augusta Nemausus) in the south of France: its date is certain, and its external preservation excellent. Its style seems to be purely Roman, though for refinement of workmanship it is surpassed by some examples at Rome, where decorative marble relief attained in the Augustan age a marvellous purity and delicacy.

The Maison Carrée (Plate XI *b*) is a small hexastyle pseudoperipteral Corinthian temple on a podium. The podium formerly stood on a platform approached by three flights of steps, and surrounded by elaborate porticoes, but these accessories were perhaps of later date. The plan is typical Graecized Roman-Tuscan. There is a deep prostyle porch to the north, three clear bays on each side, and the arrangement is equivalent to that of a peripteral temple, six by eleven, eight of the eleven columns on each side, and the six at the back, being engaged. The temple measures about forty-four by eighty-six feet, to the front of the porch columns. The material is a good local limestone. The columns, which are nearly thirty feet high, are orthodox, with richly carved capitals varying much in freedom of handling. The abaci show an early example of the band of flute-like leaves with which the Romans liked to decorate this part of the capital, especially during the first century of the Empire: it is perhaps a scrap of Tuscan tradition. Above this fluting comes a delicate egg-and-tongue, whose presence in this

1 For a Doric temple of *c.* 161 or 162 A.D. see p. 344 (Temple of Aesculapius at Lambaesis): Lepcis Magna had one of about the same date.

place is typically Augustan. The architrave is in three fasciae, separated by bead-and-reel and crowned by a large egg-and-tongue. The frieze is a magnificent example of the rich but monotonous 'Roman scroll', but on the façade its surface was left smooth for an inscription in bronze letters. A Lesbian moulding of Roman type connects the frieze with the dentils, above which lie a smooth band and an egg-and-tongue below that series of consoles or modillions which the Romans usually placed below the cornice. The consoles are here of an early type, in which the larger swelling is to the outside, and their decoration is comparatively simple.[1] The date is fixed by the traces of inscriptions on the front frieze and architrave: the bronze letters have gone, but nail holes remain. In 1758 Séguier deciphered C. CAESARI. AVGVSTI. F. COS. L. CAESARI. AVGVSTI. F. COS. DESIGNATO. PRINCIPIBVS. IVVENTVTIS: the last two words are on the architrave. These princes are Augustus' grandsons, by Julia and Agrippa. Gaius was consul in A.D. 1 and died in A.D. 3, and Lucius died in A.D. 2, so that this inscription is dated to A.D. 1 or 2. A century later, however, Pelet decided that the first letter was not C but M, and concluded that the princes were Marcus Aurelius and Lucius Verus, and the building a work of the middle of the second century A.D. This view was widely accepted, but in 1919 Espérandieu succeeded in distinguishing two successive inscriptions (a possibility which Séguier had suspected), and thus solved the problem. The earlier occupied the frieze only, and ran M AGRIPPA L F COS III IMP TRIBUN POTEST III COL AVG NEM DAT: a record of the presentation of the temple to the colony of Nîmes,[2] with the exact date 16 B.C. For the later inscription Espérandieu confirms Séguier, and he supposes that the people of Nîmes rededicated the temple as a compliment to Augustus: Agrippa died in 12 B.C. He thinks also that there are traces of yet a third dedication, perhaps made by Tiberius after his accession in A.D. 14. The temple perhaps became the Capitolium of Nîmes. Its later history cannot here be traced. It was injured, like many classical timber-roofed buildings, by the insertion of vaults, but by a miracle it never collapsed.

The Maison Carrée is one of a great number of similar small Augustan buildings. Among the best preserved are the temple of Augustus and Livia at Vienne[3] and that of Augustus at Pola in Dalmatia, which both stand on podia. The former is hexastyle, like the Maison Carrée, but is

1 Another early type is even simpler, rectangular 'beam-ends' with plain mouldings.
2 *C.I.L.* II, 74, from the theatre of Merida in Spain, is a very close parallel.
3 The Vienne temple has a complicated history: see p. 340.

more Tuscan in plan, showing a slight modification of the type found in the Corinthian-Doric temple at Paestum: there are six free columns on each side of the cella, followed by two square pilasters, united by a wall, which meets at right angles the continuous back wall of the building. The front wall of the cella is level with the fourth column from the front on each side, so that the effect is that of a three-bay porch, as in the Maison Carrée. In style this temple is simpler than the Maison Carrée, and its frieze is plain: it resembles the temple at Assisi, which is perhaps a little older and has a purely Greek hexastyle prostyle plan. The Pola temple has a tetrastyle prostyle porch of unfluted Corinthian columns, two bays deep, and fluted Corinthian pilasters at the four corners. It measures about twenty-six by fifty-seven feet to the front of the porch columns. The rich frieze resembles that of the Maison Carrée. The date is about the beginning of the Christian era.

Of temples built or rebuilt in the reign of Augustus in the city of Rome the most interesting are those of Concord and Castor in the Forum Romanum and that of Mars Ultor in the new Forum of Augustus. The Temple of Concord was dedicated by Camillus, early in the fourth century B.C., to celebrate the settlement of the patrician-plebeian conflict. By the Senate's orders it was restored by Lucius Opimius to celebrate the hollow concord won by the death of Gaius Gracchus in 121 B.C., and it was rebuilt by Tiberius, under Augustus, between 7 B.C. and A.D. 10. Of a recorded late imperial restoration the remains (some of which still stand) seem to show no trace. The plan of the Augustan temple was unusual, though not unique, and was due simply to pressure of space. The cella was a rectangle of normal proportions, measuring about 82 by 148 feet, but the hexastyle prostyle porch, which was about fifty-six feet wide and about forty-six feet deep, was in the middle of one of its long sides. The whole temple stood nearly twenty feet above the road level. The interior was decorated with costly marbles, and contained valuable statues: it had inner columns on a dado along the walls, of which fine fragments survive. The porch columns and the frieze are lost, but magnificent fragments of architrave and cornice (Plate XII *a*) have been recovered by excavation. The elegant consoles, of the outline henceforth orthodox, and the low relief of the sima decoration, deserve especial attention. Such delicate surface work is little found in later Rome, except during the classicist revival under Trajan and Hadrian. In general the Empire moved towards deep cutting and strong effects of light and shade, though in the age of Diocletian and Constantine we sometimes find a coarse reversion to earlier ideals.

Of the temple of Castor, between the Basilica Julia and the Atrium Vestae, three columns still stand, with a complete section of the entablature. This fifth-century foundation was rebuilt by Tiberius and dedicated in A.D. 6, and the surviving remains probably belong to this period, though they have sometimes been connected with a later reconstruction in the age of Trajan and Hadrian. The capitals are extraordinarily beautiful: their motive of interlocking inner spirals occurs elsewhere, for example in the great temple of Baalbek in Syria, and has often been imitated, notably by James Gibb, for instance in St Martin's in the Fields in London and in the Cambridge Senate House. The entablature is typically Augustan. The plan was curious. It was octastyle and fully peripteral (eight by eleven), with the cella set back so as to produce the effect of a three-bay porch: but the six inner columns of the front row are connected with the cella by two more columns, and thus form, in plan, a sort of hexastyle prostyle porch. There was a podium twenty-two feet high which apparently contained rooms entered by doors under each intercolumnar space. Excluding the steps, the temple measured about 95 by 133 feet.

Of the Augustan temple of Mars Ultor three fine columns still stand with their architrave: the podium has lately been excavated. The pteron did not pass round the rear of the cella, which was backed into a huge wall[1] built by Augustus to divide his Forum from the neighbouring slums. The cella ended in an apse roofed with a concrete half-dome.

The later temples of Italy and the West must be rapidly surveyed. In seeking for typical examples it will hardly be necessary to go beyond those erected in the city of Rome: and of these some of the most interesting, such as the Pantheon,[2] must be postponed to a later chapter.

The temple of Vespasian, of which three columns survive, was in a cramped position on a podium against the foot of the Tabularium: it had a nearly square cella, and a hexastyle prostyle porch, the front columns of which projected into the steps which led to it. It was begun by Titus but dedicated by Domitian, and was restored by Septimius Severus. The most interesting surviving parts seem to be original, especially the beautiful frieze and cornice (Plate XII*b*), which may instructively be compared with those of the temple of Concord. The illustration is from the partially restored cast made by Valadier, who excavated the temple in 1811 and 1812. The ornaments below and above

1 For such walls, see p. 292.
2 See p. 246.

the frieze and the arrow-head treatment of the dart between the eggs over the dentils are among the features which are[1] characteristically post-Augustan, while the fineness of the execution would almost exclude any date later than Hadrian. It is in fact typically Flavian. The temple measured about sixty by ninety-two feet on the stylobate.

The temple of Antoninus and Faustina is not very ill preserved, having been early converted into a church. The whole of the hexastyle prostyle porch, three bays deep, with much of the cella walls, still stands up to the level of the frieze, and in places up to that of the cornice: a baroque pediment was added to the front of the cella at the beginning of the seventeenth century. Measured to the front of the porch columns the dimensions of the temple are about 68 by 121 feet. The columns are unfluted monoliths of cipollino (white-and-green marble from Euboea), and form one of the earliest surviving examples of this characteristically Roman type. Their capitals are Corinthian, of no special interest: the frieze is decorated with an uninteresting scheme of griffins and candelabra. The temple was originally dedicated by the Senate to Faustina the Elder, wife of Antoninus Pius, on her death in A.D. 141.

The temple of Saturn was one of the oldest of republican Rome, having been dedicated in 498 B.C., and a very little of this structure (in the poor local stone cappellaccio, early abandoned) is embodied in the surviving travertine podium, which seems to date from Plancus' restoration in 42 B.C. The superstructure, however, one of the most conspicuous objects in the Forum, belongs in its present form to the third or fourth century A.D., and is poor bad work, the dying effort of a style no longer expressive of the taste of the age. The columns have shafts of granite, partly monolithic: some are upside down, and the capitals are four-sided Ionic of bad workmanship. There are, however, portions of better decorative work incorporated in the structure, along with late imitations.

The temple architecture of the rest of Western Europe cannot here

1 This arrow-head treatment however, if Pullan may be trusted, was used in the egg-and-tongue of the echinus of the capitals of the temple of Dionysus at Teos, built by Hermogenes about 125 B.C.: see *Antiquities of Ionia*, IV, 1881, Pl. xxv, and V, 1915, p. 12 (Lethaby). At Magnesia the only example of this treatment— a capital from a stoa—is probably a Roman restoration (Humann, *Magnesia am Maeander*, 1904, Fig. 103 and p. 100), and the same may be true of the Teos capitals: cf. *B.C.H.* XLVIII, 1924, p. 506 (report of a French expedition to Teos in 1924): "La dédicace monumentale de la façade avait été refaite à l'époque romaine impériale, ainsi probablement que les parties hautes."

be examined. It has little of peculiar interest,[1] but a word must be said of that of North Africa, where lofty entablatures were popular, giving space for the long inscriptions dear to that verbose population. Especially remarkable is the third-century A.D. 'temple of Minerva' at Tebessa (Theveste), where both architrave and frieze were adorned with pilasters, and an extra cornice was inserted below the frieze. The true cornice and the pediments are lost: in front the frieze was left blank for an inscription. Measured to the front of the tetrastyle prostyle porch the dimensions are about thirty by fifty feet. Another temple of the same century at Tâûghzût or Tigzirt (Rusuccuru) was preceded by a court, whose side-walls continued those of the cella, the whole forming a rectangle about twenty-one by forty-five feet on the outside. The cella was about seventeen feet square inside. Above seven steps stood two columns with strange Composite[2] capitals: these carried no true architrave, but a solid wall, which had one cornice about six feet above the capitals, and another at the top; between one and two feet higher there were probably pediments. Neither here nor at Tebessa is much taste shown, but such bold defiance of tradition has a certain interest.

In Greece proper Imperial temple architecture is mostly imitative and dull: the Hellenic tradition was crushing. The most pleasing work is perhaps the little round temple of Rome and Augustus on the Athenian Acropolis, long since fallen: it was probably without a cella, but had a ring of nine Ionic columns with capitals which were copied from those of the Erechtheum.

Asia Minor is more important. The tradition was predominantly Hellenistic, though some buildings show plainly the influence of Rome[3]: but the tradition was alive and vigorous, as countless fresh and pleasing buildings prove, and old forms were often whimsically handled, as in the early Imperial[4] east front of the Didymaion, with its fantastic capitals and bases. Here it must suffice to speak of one striking work of the early Imperial age, the temple of Zeus at Aezani in Phrygia. Inscriptions prove that this is not later than about A.D. 125, and suggest that it is not much earlier: it has been thought pre-Roman, but its ornament[5]

1 A type of small temple, perhaps of Celtic origin, which is found in Britain and North Gaul—a square or rectangular cella, surrounded by a roofed portico—is architecturally unimportant. See F. Haverfield, *The Romanization of Roman Britain*, 3rd ed. 1915, p. 37, n. 1.
2 See p. 220.
3 For instance the temple at Sidyma mentioned on p. 209. 4 See p. 153.
5 For instance the arrow-head dart in the egg-and-tongue of the abacus, if correctly drawn; see p. 217.

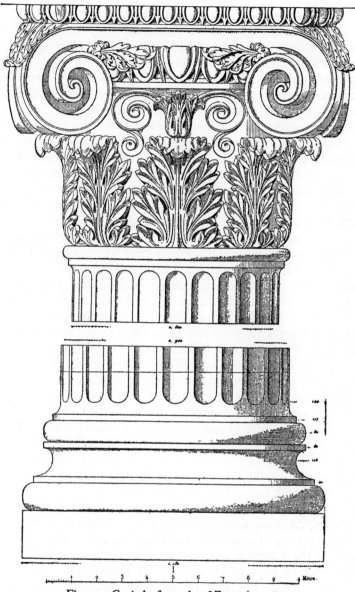

Fig. 94. Capital of temple of Zeus, Aezani
(From Lebas-Reinach, *Voyage Archéologique en Grèce et en
Asie-Mineure*, Firmin-Didot et Cie, Paris, 1888)

confirms the external evidence for a Hadrianic date. It stood on a huge rectangular terrace, and was pseudodipteral, except at the ends, where it was pseudotripteral, having two parallel rows of peripteral columns with space for a third behind. The stylobate measured about 71 by about 120 feet and there were eight columns by fifteen in the outer row. The plan was simple, but there was a vaulted chamber under the cella, reached by a staircase from the opisthodomus. Some of the capitals are remarkable. Those of the pteron were Ionic of Hellenistic proportions, the echinus lying between the level of the eyes of the volutes and that of the top of their first curve: but those of the porches (Fig. 94) were four-sided, and had in addition a necking-band ornamented with a single row of large acanthus leaves. The space between these leaves and the echinus is filled, on each face of the capital, with a scheme of spirals springing from an acanthus ornament. These capitals are in character varieties or forerunners of the Composite type, so popular since the Renaissance, which is essentially a mixture of four-sided Ionic and Corinthian, in varying proportions. The invention is probably Augustan, but the earliest strictly datable examples are perhaps to be found at Rome in the Colosseum, dedicated in A.D. 80, and in the slightly later Arch of Titus (Plate IX c): both these have a double row of acanthus leaves, which gives them a more Corinthian look. Specimens in the North Gate of the Agora at Miletus may be older than any found at Rome, but are certainly of Imperial date. There are many curious later examples, and the type was always freely handled.

In Syria and Palestine there are few Greek or half-Greek buildings earlier than the reign of Augustus. Some partly Greek temples and other buildings in the Haurân, south of Damascus, show Oriental elements in plan and decoration, especially those at 'Arâq al Amîr, Suwaida, and Sî'. They are exceedingly interesting, but in so short a sketch as this it would be impossible to treat them adequately: they date from the second and first centuries B.C.

At Suwaida and Sî' the Oriental elements are certainly due to the Nabataeans, an Arab race, whose kingdom, centred at Petra in the mountains between the Dead Sea and 'Aqaba, extended, about the beginning of the Christian era, five hundred miles from Madâ'in Sâlih in the Hijâz to beyond Damascus. At Petra itself they have left abundant remains, but few of the free-standing buildings there are older than Trajan's annexation in A.D. 105. Hundreds of their rock-cut cave façades, however, are earlier than the Christian era, and the oldest show purely Egyptian and Mesopotamian influences. About the second or first century B.C. Greek columns and en-

tablatures begin to appear in combination with older features. These call for no description here, but it is impossible to ignore an astonishing series of some twenty-five elaborate and almost purely classical rock-cut façades, of which the most famous is the so-called Khazna (Plate XI *a*), which is about 80 feet wide, and about 130 feet high, to the top of the urn on the round building: there are several inner chambers, of which the largest measures about forty feet in every direction. The columns of the lower storey are over forty-one feet high, those above over twenty-nine feet high. Many recent critics assign this and its companions to the first century B.C., and see in them a reflection of the late Seleucid architecture of Antioch, but there are reasons for rejecting this view. At Madâ'in Sâlih almost every type of Petra façade is found, and many are dated by inscriptions to the first century A.D.: but this elaborate classical type is absent. It is true that Madâ'in Sâlih is far from Greek centres, and that such monuments as the Khazna must have been carved by foreign workmen, but it is natural to conclude that these monuments are later than those of Madâ'in Sâlih. Further, though some details of the Khazna have been thought pre-Roman, the general baroque effect is most easily paralleled from works of Trajanic or later times, such as the façade of the Ephesus Library (Fig. 120) or the Round Temple at Baalbek (Plate XIX*a*). The tomb of Ḥamrath at Suwaida in the Ḥaurân, a purely Greek Nabataean building, dated by its inscription to the first half of the first century B.C., is quite unlike the Khazna. It is remarkable for simplicity and restraint, being a square mass, measuring about twenty-nine or thirty feet each way in plan, crowned with a pyramid, and surrounded by twenty engaged Doric columns, about fifteen feet high, with a Doric entablature. Still less can the Khazna be compared to the somewhat later half-Oriental Nabataean temples at Suwaida and Sî'.[1]

It should be added that there are many classical tombs near Jerusalem, mostly rock-cut, whose dates have been similarly disputed: but it is doubtful if any are earlier than the first century A.D.

We must therefore return to the proper subject of this chapter, the architecture of the Imperial age. The most striking Syrian monuments are those of Palmyra and Baalbek.

Palmyra, the modern Tadmor, in an oasis of the Syrian desert, between Damascus and the Euphrates, sprang into fame in the third century A.D., when Odenathus and Zenobia made it for a moment the

[1 Archaeologists now tend to date the Khazna not later than the first century A.D., but there is no certainty. A. Rumpf in Gercke-Norden's *Einleitung in die Altertumswissenschaft*, II, 3, 1931, p. 97 appears to regard it as Hadrianic.]

capital of the Near East: but it was prosperous long before, and recent students assign the chief temple to the beginning of the first century A.D. Of the general scheme of the town, with its colonnaded streets, something will be said at a later point. Here we are concerned only with the Temple of Bel, usually known as the 'Temple of the Sun',[1] which was pseudodipteral, eight by fifteen, with pronaos and opisthodomus, both distyle *in antis*. The columns are Corinthian, but only the bare bells of the capitals are of stone, the ornaments having been of gilt bronze, which has disappeared. East of it lay a great enclosure, the erection of whose walls and Propylaea seems to have covered the period from Augustus to Trajan. Soon after the completion of the temple its plan was completely changed by walling up pronaos and opisthodomus and opening a doorway in the east wall of the cella. This doorway, though not in the centre of the temple, lay on the axis of the Propylaea. One column of the pteron was removed, and pillars with engaged columns on the outside were built against the columns right and left of this gap: between these pillars a great outer door was erected, in the line of the pteron columns, which were evidently now connected by some sort of fence or wall, which has left no trace, and the space above this door, up to the pteron architrave, was filled with masonry. At the same time windows were made in the cella walls.[2]

Baalbek, the ancient Heliopolis, lies in the valley between Lebanon and Antilebanon. It is dominated by a gigantic scheme (Fig. 95) based on a huge rectangular court, with a hexagonal forecourt, both artificially raised above the ground-level. The chief temple, that of Jupiter Optimus Maximus Heliopolitanus,[3] stands on a still higher platform in the centre of the west side of the great court. Its visible substructures include the famous 'trilithon' at the back, a row of three perfectly fitted blocks, twenty feet above the ground-level, each of which measures about sixty-three by twelve by eleven feet. Such megalithic construction is common at Baalbek: the tradition must be native, but none of the work seems to be pre-Roman. The material of almost all Baalbek construction is a hard local limestone.

The temple itself, approached by a broad flight of steps, was probably pseudodipteral, but the cella has utterly perished, and its

1 The deity was a native Baal, identified with Zeus or Helios.

[2 It is now confidently stated that all these arrangements are original, but I find this difficult to believe. It is no doubt true that the motive was the provision of closed *adyta* at each end of the temple. See B. Schulz in the official publication, *Palmyra*, by T. Wiegand, 2 vols., Berlin, 1932, which supersedes the references in my Bibliography.]

3 Again a native deity renamed. The older books assign this temple to the Sun.

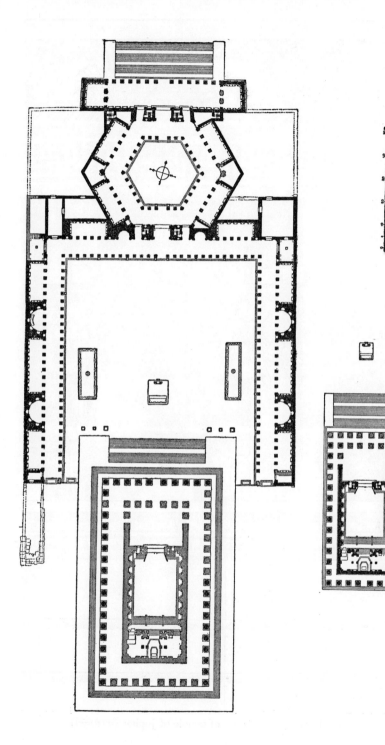

Fig. 95. Baalbek, general plan (surviving parts printed black)
The larger temple is that of Jupiter, the smaller that of Bacchus (?)

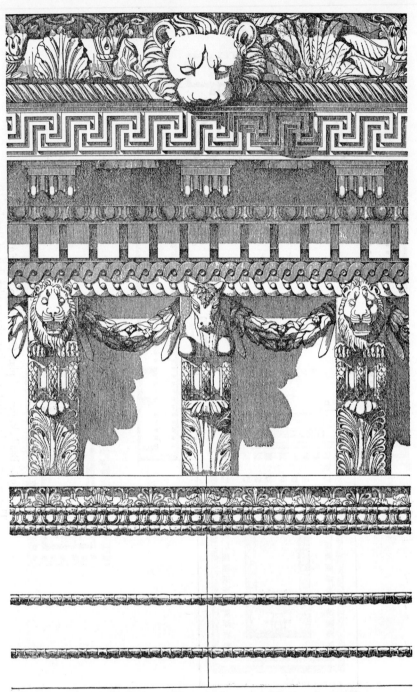

Fig. 96. Baalbek, entablature of temple of Jupiter (restored)

conjectural restoration depends chiefly on the assumption that it is closely copied in the later 'Temple of Bacchus' close by.[1] On the stylobate it measures about 170 by 302 feet, and it was decastyle (ten by nineteen). Much of the pteron still stands, including six columns on the south with a continuous entablature (Fig. 96). The columns are Corinthian and unfluted: including bases and capitals they are about sixty-five feet high. The proportion of height to lower diameter is nine and a half to one, the base, with plinth, being equal to half a lower diameter, the shaft to eight, the capital to one. The frieze is adorned with a scheme of vertical consoles or brackets, carrying the fore part of a beast, alternately a lion and a bull, and joined by hanging garlands in relief. There are five consoles to each intercolumniation. Each is a single volute, resting on an acanthus leaf: the front resembles the bolster of an Ionic capital. Above the frieze come successively a convex moulding with a plait-band, dentils, horizontal consoles, cornice, and sima.

John Malalas, a sixth-century native of Antioch, ascribes the foundation of the great temple to Antoninus Pius, in the middle of the second century A.D., but careful study of the forms, which are uniformly simple and grand, has convinced most recent students that the beginnings of the temple are contemporary with the Roman colony founded by Augustus, and that it was substantially finished by the time of Nero. Many features suggest the Augustan age. The forms of the capitals, some of which have interlocking inner spirals, the treatment of the mouldings, especially the egg-and-tongue, the shape of the horizontal consoles, the key-pattern under the sima, all point in this direction. Even the fantastic frieze, which recalls fifth-century B.C. Persian work, finds its nearest parallels in Hellenistic buildings in Asia Minor and Delos. The more obvious of these features are closely copied in later work at Baalbek itself, but the handling betrays the difference of date.

The courts, with all their decoration, seem to belong to the second century A.D., though some such scheme was probably part of the original design. The rectangular court contained the great altar and two water-basins. It is based on a square of about 340 feet each way, but on every side except the west, where the temple occupies most of the width and intrudes far into the court, this space was at once enlarged by *exedrae*, semicircular or rectangular, divided from the court by columns, and diminished by an open columnar portico, which ran continuously

1 Weigand would copy the 'Temple of Bacchus' more closely than is done in Fig. 95.

Fig. 97. Baalbek, entrance portico (restored)

round these three sides. All the columns in the court were unfluted Corinthian. The exedrae were richly decorated with pilasters and niches, and those which were semicircular had stone half-domes. Porticoes and exedrae rested on two parallel galleries, barrel-vaulted in stone, whose floors were level with the ground outside. The hexagonal forecourt was made up of exactly the same elements, and triple gateways bounded it east and west, the inner being directly flanked with towers. Outside, above a great flight of steps, was a portico (Fig. 97) of twelve columns, larger than those within the courts: this portico was flanked with still larger towers, and its six central columns carried a pediment, the horizontal entablature being continuous for the whole width. The six portico columns, east and west, within the hexagonal court, also carried pediments, and so did the eight central columns of the east portico of the rectangular court. In all four cases the central intercolumniation was wider than the rest, and it is probable that in each this intercolumniation was spanned by a visible arch. This is certain for the east portico of the rectangular court. Here, and probably in the outer portico, the whole horizontal entablature was carried unbroken round the curve of the arch: in the smaller porticoes of the hexagonal court the horizontal entablature was perhaps broken, and spanned by an independent arch with a narrower border. Both methods were common in Asia in imperial times, but only one example seems to be earlier[1] than the second century A.D. This use of the arch was a new solution of the problem which the Mycenaeans met by the 'relieving triangle,' Mnesicles[2] by a cantilever device, and Hermogenes[3] by a door in the tympanum: it involved the vaulting of this part of the roof of the porch. The second method is illustrated by a temple of the second century A.D. at Termessus in Pisidia (Fig. 98). The difference between the methods is unimportant, except in so far as familiarity with the first method prepared men's minds to accept the bold experiment of springing arches direct from columns, of which a conspicuous example occurs in Diocletian's palace[4] at Spalato, in the early fourth century A.D. This practice was in fact, as has often been pointed out, sometimes anticipated before A.D. 79, in the peristyles of houses at Pompeii, but Spalato shows one of its first appearances on a grand scale.

1 The temple of Dushara at Sî' in the Ḥaurân, probably built between 33 B.C. and A.D. 30. For the Arch of Orange, often cited in this connexion, see pp. 293, 294.
2 See p. 120. 3 See p. 157.
4 See p. 319. [A magnificent arcade of this type, built about A.D. 200, has lately been found in the Forum Severianum of Lepcis Magna: see *A.A.* 1938, c. 737 and Fig. 47.]

The smaller 'Temple of Bacchus',[1] which lies parallel to the greater, outside the rectangular court to the south, was perhaps begun in the middle of the first century, but much of its decoration seems to belong to the second. This temple is inferior to its neighbour not merely in size

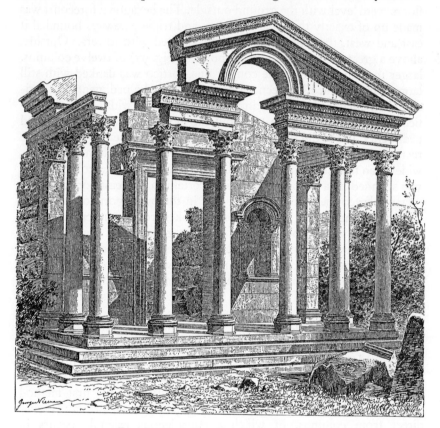

Fig. 98. Temple at Termessus (restored)

(though its area is about that of the Parthenon, and its height much greater), but also in grandeur and delicacy: it is, however, much better preserved, and the cella deserves a detailed description, for no better example of a Roman temple interior survives. It stood on a podium,

1 This name has replaced that of Jupiter in the official German publication: but Thiersch has since argued that it was dedicated to the Syrian *Magna Mater* (*Gött. Nachr.* 1925, pp. 1 ff.).

and measured about 110 by about 214 feet on the stylobate. It was peripteral (eight by fifteen) with a deep hexastyle prostyle porch. The pteron columns, fifty-seven feet high, were unfluted, but the smaller porch columns were fluted: both sets were Corinthian. Columns and entablature alike closely copied the larger temple, but the flowers on the abacus were treated with Gothic freshness and variety. The central intercolumniation of the façades was wide, but it was relieved not by an arch, but by a window in the tympanum: the stone ceiling of the pteron was slightly concave, and most elaborately coffered and carved. A huge door led into the cella, with a flat-arch lintel of three blocks, a surprise in this megalithic area. Within the cella (Plate XIII) two staircase towers flanked the entrance. On a podium along each side-wall stood pilasters with Corinthian capitals, to which fluted Corinthian half-columns were engaged: the flat and round capitals were curiously joined. Between the pilasters were two tiers of decoration, wide arched niches below, and narrower pedimental niches or *aediculae* above. Above the main pilasters ran a complete engaged entablature, carried forward over the half-columns. Above this lay a flat wooden ceiling: the old suggestion that the cella was vaulted is demonstrably false. There were double quarter-columns in the angles next the porch, and six complete half-columns on each side: beyond the last of these, about three-quarters way down the cella, began a platform, right across the cella, at the top of nine steps. After one more repetition of the intercolumnar niches we find on each side a very broad pilaster, beyond which steps led to a still higher platform, under which was a vaulted crypt. From the eastern-most of two smaller pilasters engaged to each of the broad ones the whole upper entablature sprang inwards, at right angles, to join the only large free-standing supports in the temple—two solid pillars, standing on the level of those engaged to the cella walls, and the same distance from the north and south walls respectively that the engaged columns were from one another: from each of these pillars the entablature turned west at right angles, and met a pilaster on the west wall of the cella: it also ran, in an engaged form, all round the west part of the cella. Each of the free pillars, about half-way up, was united to the wall pilaster by an open arch, resting on curious composite capitals, and above these arches was an open aedicula: under the northern arch a door gave access, by steps, to the crypt. The decoration of the west part of the cella was mainly an engaged repetition of the scheme of these open arches and aediculae. Between the free pillars were pedestals, decorated with Dionysiac reliefs, which undoubtedly carried on columns a roofed inner shrine, running back to the west wall of the cella. The cult-statue

probably stood in a niche on this wall, but time and the early Christians have made the details of all these arrangements conjectural. The timber roof of the temple has left notable traces of the highest interest.

The third temple at Baalbek, a circular structure with a stone dome, will be discussed in the next chapter.

Little space is left to speak of the smaller temples of Syria, which maintained a high level of Greek restraint. They mostly lack two common Roman characteristics, deep Tuscan porches[1] and consoles under the cornice, and they affect arched entablatures and decorative niches. These niches tend to terminate in a conch or shell form, in which the lines of the shell usually radiate from the bottom upwards, as they do also in Asia Minor. In Italy, where they occur in and after the Augustan age, they mostly radiate downwards.[2]

One example must here suffice, the Western temple at 'Aṭîl in the Ḥaurân, of A.D. 211. It stood on a hollow podium, moulded above and below, which contained arches for the support of the cella floor. The podium, slightly larger than the temple, measured about 31 by 37 feet. The façade had two Corinthian columns between antae with Corinthian capitals. Halfway back the cella was spanned by a semi-circular arch with a gable top, doubtless of the same slope as the pediment, which is lost: the roof was probably of stone slabs. The entablature, arched over the central intercolumniation, had an architrave with a maeander-pattern, and a frieze adorned with a continuous scroll: the cornice has perished. The front wall of the cella was richly decorated with niches, and elaborate pilasters flanked the door.

Of the architecture of the Imperial age in Egypt it is impossible to speak at all fully, since much of it was Egyptian in character, as that of the Ptolemies had often been, and such work properly forms an epilogue to the history of Egyptian art. It must be enough here to mention one curious classical temple, that of Augustus on the island of Philae. It was a simple structure, remarkable only for its combination of Corinthian columns and pilasters with Doric frieze and cornice: the architrave was stepped, but had taenia, regulae, and guttae. Another Augustan instance of this combination is the arch at Aosta in north-west Italy, and a late Republican example (49 B.C.) is seen in the Inner Propylaea of Appius Claudius Pulcher at Eleusis.[3]

1 Even prostyle porches with one column on the return, so common in Greek work, are very rare: there is an example at Palmyra, the Temple of Baalsamîn.
2 See E. Weigand, *Jahrb. deutsch. arch. Inst.* XXIX, 1914, 64 ff. The two types, however, occur together both at Bostra in Syria in the 2nd cent. A.D. (see p. 375) and in a tomb at Ostia, of the 2nd or 3rd cent. A.D. (*Not. Scavi*, 1928, 150).
[3 See now H. Hörmann, *Die inneren Propyläen von Eleusis*, Berlin, 1932.]

Roman Construction. Arches, Vaults, and Domes

More interesting than the development and decadence of Hellenistic decorative tradition in the temple architecture of the Roman Empire is the simultaneous growth of new constructional techniques.

The Romans were the first builders in Europe, perhaps the first in the world, fully to appreciate the advantages of the arch, the vault and the dome. Both arch and barrel-vault were used ages before in Egypt and Mesopotamia, and in Mesopotamia at least they were used with great boldness and with real understanding of their structural and aesthetic values. The early history of the dome is more obscure, but clay domes seem to have been built from very early times in the Near East, though perhaps not on a large scale. Yet the Greeks, though in early contact with the Nile and not debarred from the Euphrates, were seemingly not roused, even by Alexander's conquests, to any great interest in these alien methods. It may be assumed that vaulting was still practised in Mesopotamia in Hellenistic times, as the use of burnt brick[1] certainly was, but direct evidence seems to be lacking. Strabo's description[2] of the Hanging Gardens of Babylon, with piers, arches and vaults, all of baked brick and asphalt mortar, has been connected with a supposed[3] Hellenistic reconstruction, but this is unproved. Still less can it be affirmed that vaulting on an important scale was practised in such western Syrian centres as Antioch: apart from the masonry roofs of the Didymaion passages[4] and of a few Hellenistic tombs, there is little evidence that either in Syria or in Asia Minor the vault got any footing till Roman architects brought it there. Our deep ignorance of Seleucid Syria must not be forgotten, but it is difficult to believe that any Hellenistic architects were much concerned with the development of vaulting. It is true that the arch made some progress in this period in Asia Minor. It was used in Acarnania, in northwest Greece, for town-gates usually ascribed to the fifth century B.C., and in minor positions elsewhere in the fourth, but its appearance in the gates of Priene about 300 B.C. marks an epoch, for it had never before, to our knowledge, received such prominence in a Greek city with

1 See p. 235.
3 Delbrück, *Hellenistische Bauten in Latium*, II, p. 103.
2 XVI, 1, 5 (c. 738).
4 See p. 153.

high architectural standards. Its use in the next century in the wall of the Ecclesiasterion[1] of the same city is still more notable, but it does not appear that in pre-Roman times arched construction was in any Greek land a serious rival to older methods.[2] In Italy the arch and the true vault perhaps occur in drains and tombs as early as the turn of the sixth and fifth centuries B.C., but the famous arched gates of Etruria[3] are mostly, at least, as late as the third century B.C.

So far we have spoken of the vault and the dome simply as constructional devices: it remains to consider the materials of which they were built. In Egypt vaults with few exceptions were of sun-dried brick: the oldest stone vaults there known date from about 700 B.C. In Mesopotamia vaults were always of brick, sun-dried or baked. It may be doubted whether either vault or dome would have found any great development in Roman hands had their only material been cut stone, whether dry-jointed or mortared. The problems of stone-cutting raised by the simplest variations upon plain barrel-vaults and domes might have fascinated the Greeks, and some pretty experiments were in fact tried by Hellenistic tomb-builders at Pergamum: but such niceties had no attractions for Roman engineers, and in their stone vaulting they were usually at pains to avoid them. Nor would baked brick have been much more manageable. But in concrete they found an ideal medium. It was cheap, for its best ingredients were abundant in Italy: it was economical, for it swallowed all the mason's waste: it was incomparably strong: and it eluded all the stone-cutter's difficulties.

Roman concrete was perhaps influenced by pisé work (compressed courses of earth), for which there is some literary evidence, but in the main it was probably developed from an ancient and widely spread technique—the use, between solid stone facings, of a mixture of rough stones and clay. The essential novelty is the substitution for clay of lime-mortar, which is usually made, in the best Roman work, with volcanic dust. Roman concrete seldom or never consisted of plain lime-mortar, nor was it mixed with its filling beforehand: the method was to lay courses of broken stones (*caementa*) or broken bricks, and to fill each course, when laid, with liquid mortar, which penetrated and solidified it. The mixture was so strong that the external facing could be omitted or reduced to a mere studding of the surface with

1 See p. 178.

[2 For early arches and vaults, see now G. Welter, *Aigina*, 1938, p. 57 (fifth-century tomb), and A. W. Lawrence, *Herodotus*, 1935, n. on I, 93 (sixth-century tomb of Alyattes).]

3 Arched doorways are imitated in an Etruscan urn tentatively assigned to the fourth century B.C., for which see p. 305 and Pl. XXIII. [See further note on p. 266.]

PLATE I

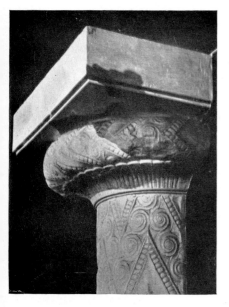

(*a*) Capital of half-column from 'Treasury of Atreus', Mycenae (restored)

(*c*) Terracotta model from Heraeum of Argos (restored)

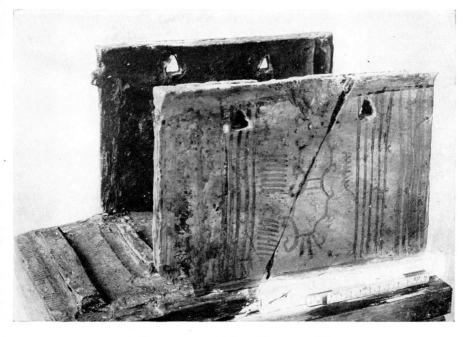

(*b*) Terracotta model from Heraeum of Argos

PLATE II

(*a*) Oldest temple of (Artemis) Orthia at Sparta

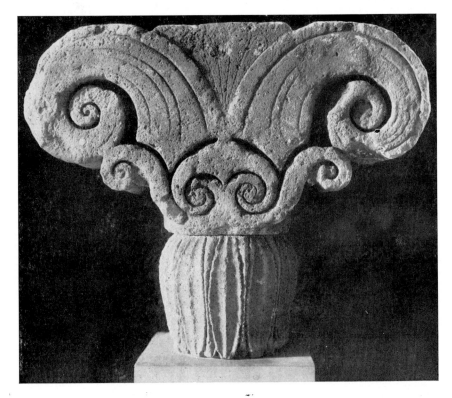

(*b*) Capital from Larisa in Aeolis

PLATE III

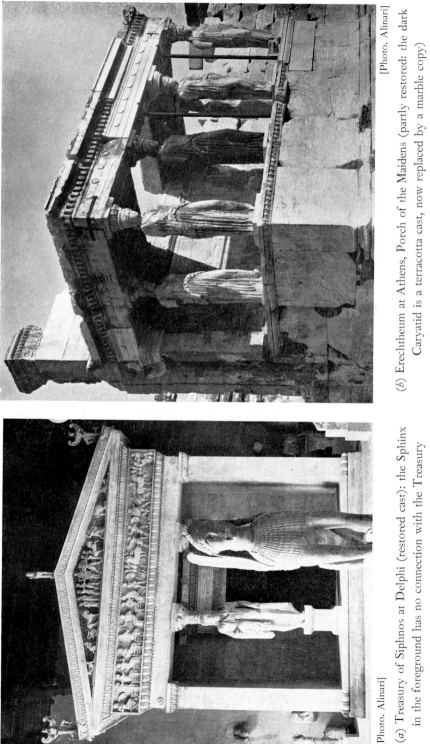

(b) Erechtheum at Athens, Porch of the Maidens (partly restored: the dark
Caryatid is a terracotta cast, now replaced by a marble copy)

(a) Treasury of Siphnos at Delphi (restored cast): the Sphinx
in the foreground has no connection with the Treasury

PLATE IV

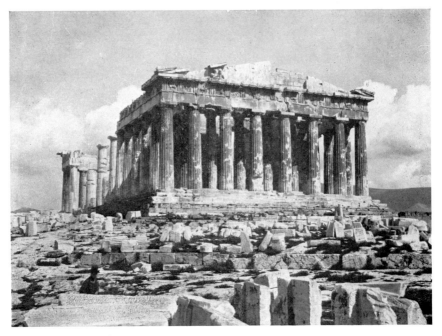

(*a*) The Parthenon, Athens, from the West

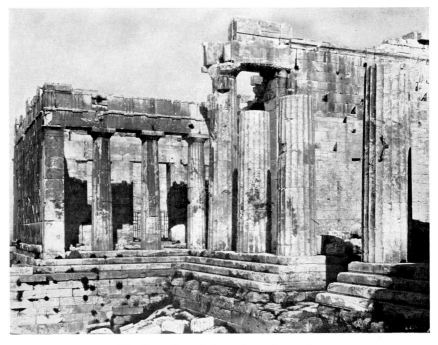

(*b*) The Propylaea, Athens, from the south-west

PLATE V

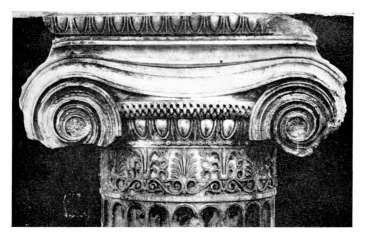

(*a*) Capital of North Porch of Erechtheum, Athens

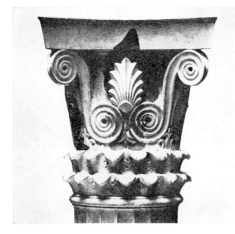

(*b*) Capital from Tholos in precinct of Athena Pronaia, Delphi (restored)

[From *Les Fouilles de Delphes*, II, 4]

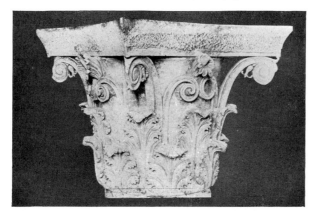

(*c*) Unused capital from Tholos, Epidaurus

PLATE VI

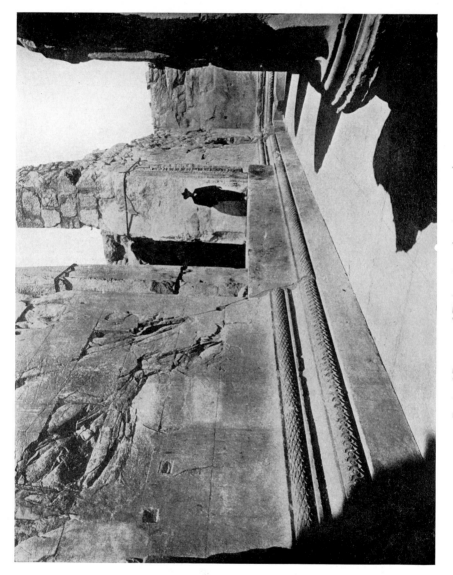

Back of Pronaos of Didymaion, showing great door

PLATE VII

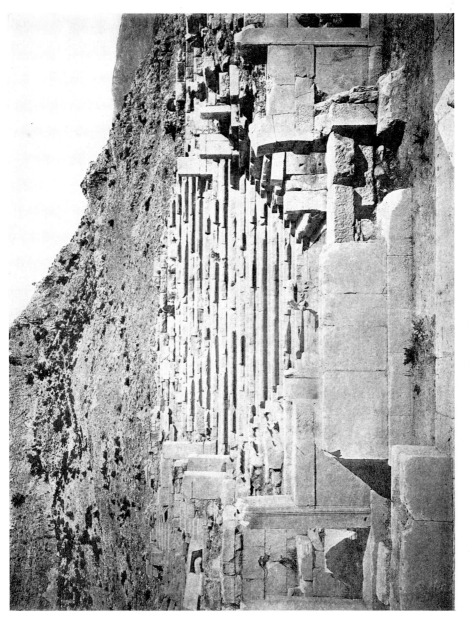

Ecclesiasterion, Priene

PLATE VIII

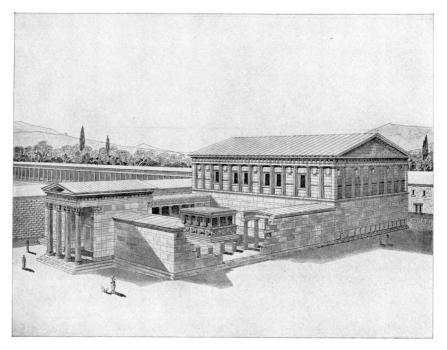

(a) Bouleuterion, Miletus (restored)

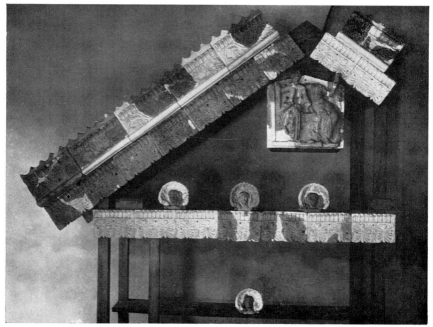

[Photo. Giani]

(b) Pediment of Etruscan shrine from Vulci (restored)

PLATE IX

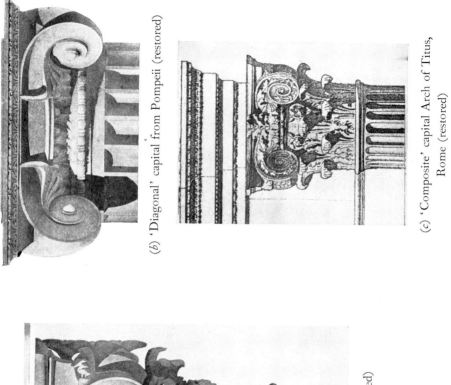

(b) 'Diagonal' capital from Pompeii (restored)

(c) 'Composite' capital Arch of Titus, Rome (restored)

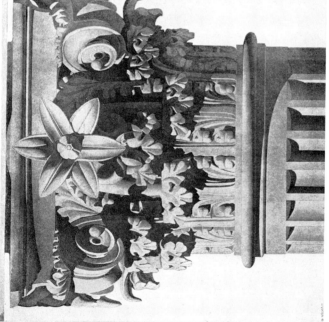

(a) Capital of 'Temple of Vesta', Tivoli (restored)

PLATE X

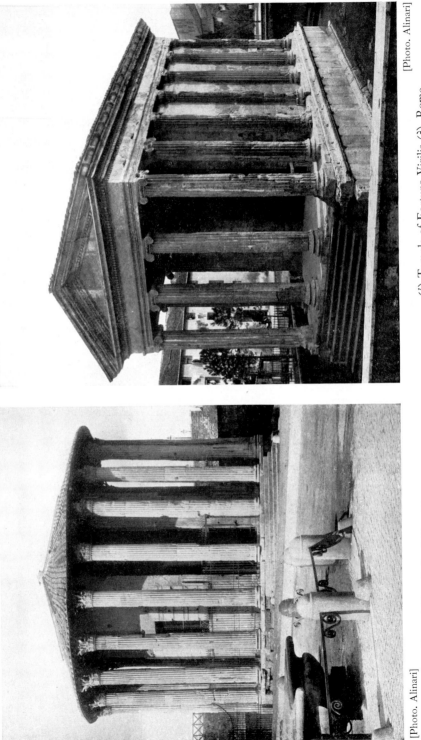

(b) Temple of Fortuna Virilis (?), Rome

(a) Round Temple by Tiber, Rome

PLATE XI

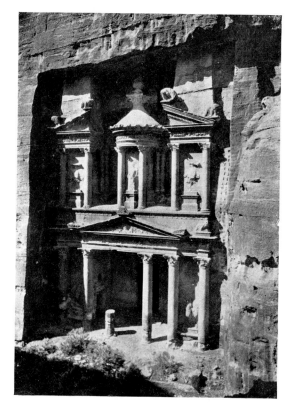

(*a*) Khazna, Petra

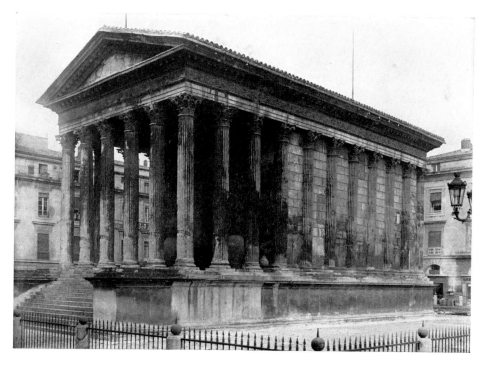

(*b*) Maison Carrée, Nîmes

PLATE XII

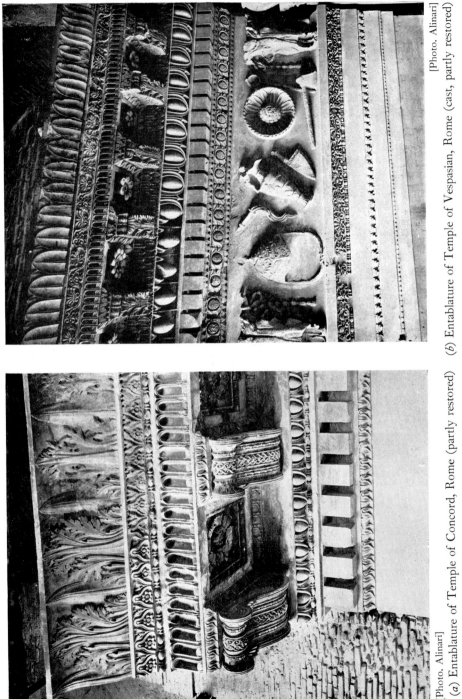

[Photo. Alinari]

(b) Entablature of Temple of Vespasian, Rome (cast, partly restored)

[Photo. Alinari]

(a) Entablature of Temple of Concord, Rome (partly restored)

PLATE XIII

'Temple of Bacchus', Baalbeck (restored)

PLATE XIV

[Photo. Alinari]

(*a*) Pons Fabricius, Rome

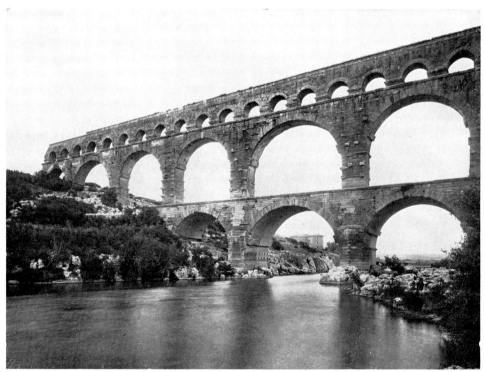

[Phot. Levy et Neurdein, Paris]

(*b*) Pont du Gard, near Nîmes

PLATE XV

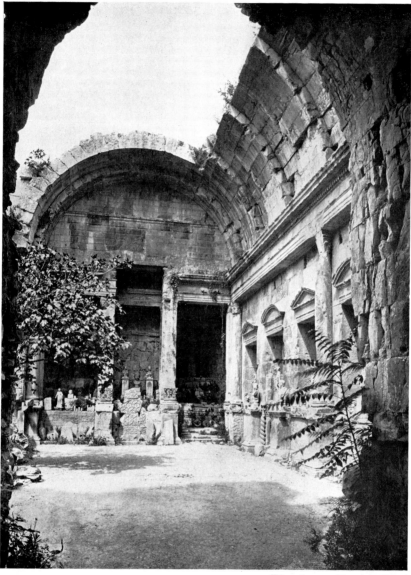

[Phot. Levy et Neurdein, Paris]

'Temple of Diana', Nîmes

PLATE XVI

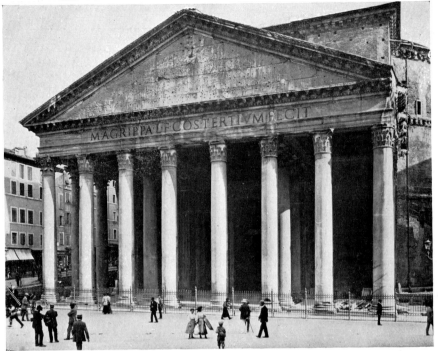

[Photo. Alinari]

(a) Pantheon, Rome

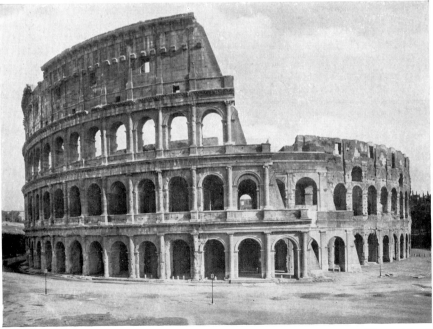

[Photo. Alinari]

(b) Colosseum, Rome

PLATE XVII

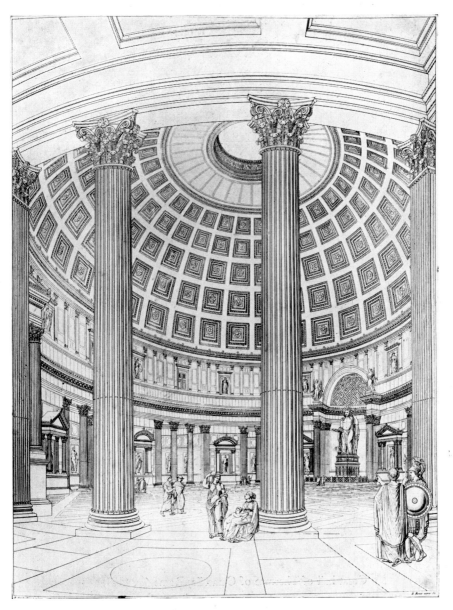

Pantheon, Rome (restored)

PLATE XVIII

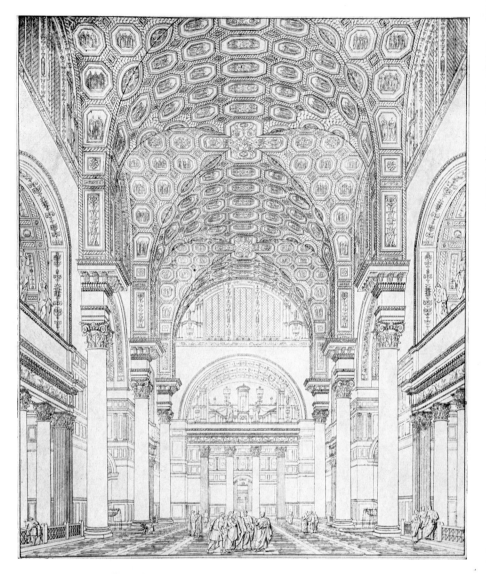

Great hall of Thermae of Caracalla, Rome (restored)

PLATE XIX

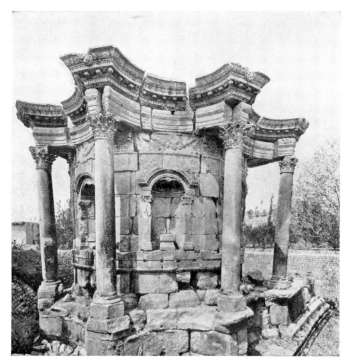

(*a*) Round Temple, Baalbek

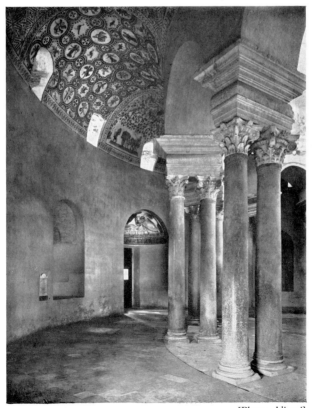

[Photo. Alinari]

(*b*) Santa Costanza, Rome

PLATE XX

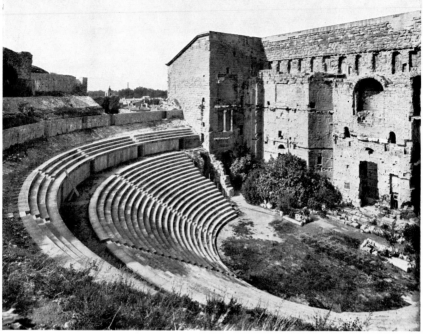

[Phot. Levy et Neurdein, Paris]

(*a*) Cavea and scaenae frons of theatre, Orange

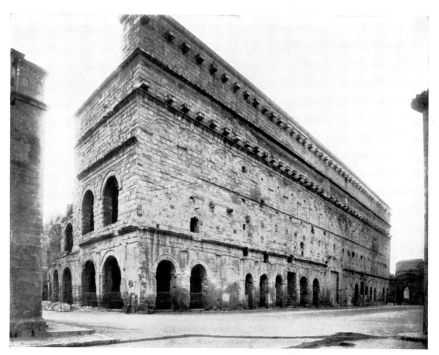

[Phot. Levy et Neurdein, Paris]

(*b*) Back of scaena of theatre, Orange

PLATE XXI

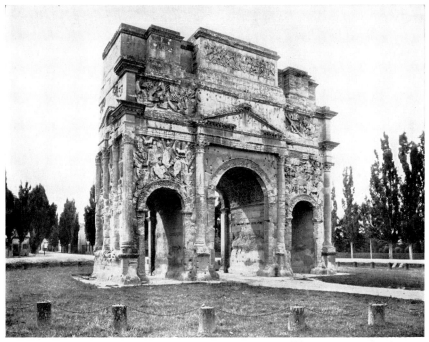

[Phot. Levy et Neurdein, Paris]

(a) Arch of Tiberius, Orange

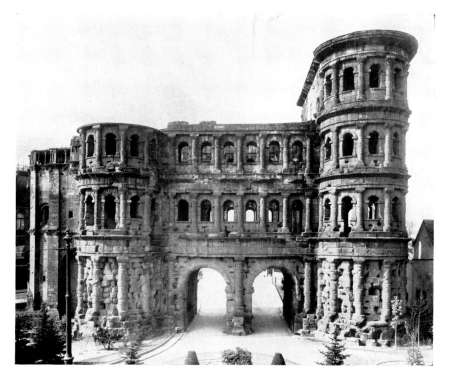

(b) Porta Nigra, Trier

PLATE XXII

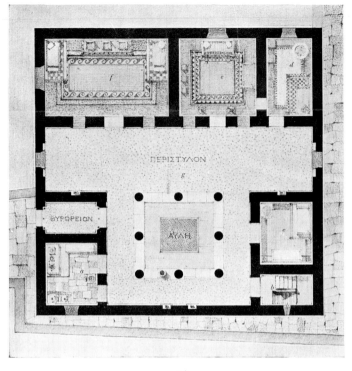

(a)

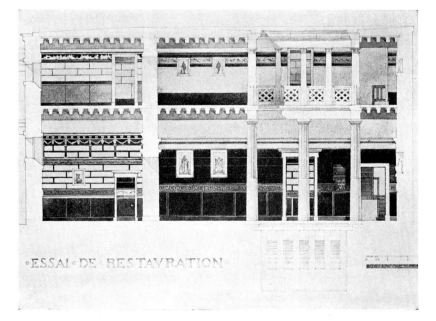

(b)

'Maison de la Collinn', Delos: (a) restored plan: (b) restored section

[From *Exploration Archéologique de Délos*, VIII, Pls. XVI–XVII, XVIII]

PLATE XXIII

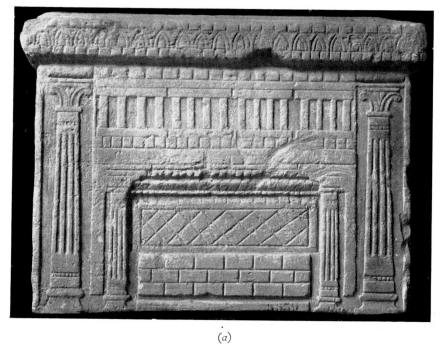

(a)

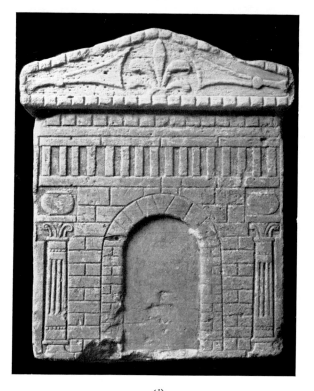

(b)

Etruscan urn, perhaps from Chiusi, side and end views

PLATE XXIV

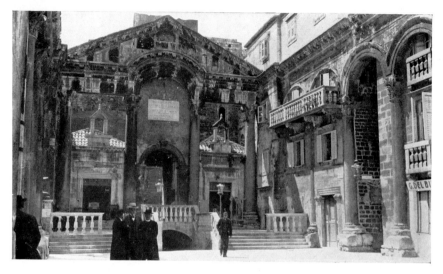

(*a*) Forecourt of vestibule of Diocletian's Palace, Spalato ('Piazza del Duomo')

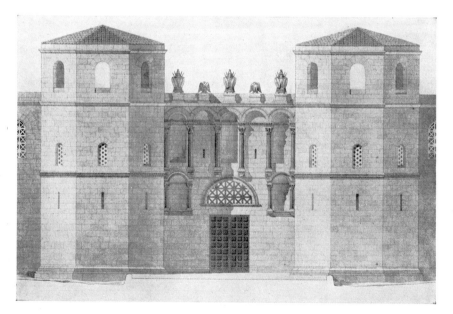

(*b*) 'Golden Gate' of Diocletian's Palace, Spalato (restored—drawing by Hébrard)

stone or brick. The Greeks sometimes used lime as mortar, both in prehistoric and historic times, but it never took an important place in their architecture. They seldom mixed it with rubble as a building material: when they did so, chiefly in Hellenistic times, they often used too little lime, and were forced to employ very solid stone facings, rectangular or polygonal. Gypsum was similarly used in Egypt and Phoenicia, and Theophrastus knew and praised its qualities as mortar, but, when all forerunners[1] have been considered, it must be admitted that concrete, as the Romans used it from the second century B.C. onwards, was in effect a new and revolutionary material. Laid in the shape of arches, vaults and domes, it quickly hardened into a rigid mass, free from many of the internal thrusts and strains which trouble the builders of similar structures in stone or brick. The difficulty lay chiefly in the actual process of erection,[2] when the material was still liquid or semi-liquid. In vertical walls faced with solid masonry the mortar was laid as soon as each successive stone course was in position, and a thin layer of fine wet mortar was used to bond together the successive courses of concrete. Less solid facings were built up in courses, with very strong mortar: the main concrete core was then laid between the two faces, in a temporary frame of planks, and when this was removed a fine mixture was poured in to bind the whole mass together. Arches, vaults and domes were less simple, and our knowledge of the methods employed is chiefly conjectural. Wooden centering was of course necessary. With concrete, as with masonry, the Romans doubtless tried to use as little timber as possible, but the extent to which they were able to dispense with it has certainly been exaggerated. In particular, excessive importance has been attached to a curious system of brick ribs[3] embedded in concrete vaults, which appears about the end of the first century A.D. and was common thenceforth in Rome and Central Italy. It has often been held that these ribs were erected on light centering, before the rest of the vault was begun, and formed a sort of framework

1 A concrete barrel-vault over a well-house at Corinth, lately reported (*Bull. corr. hell.* L, 1926, p. 543, and *Journ. Hell. Stud.* 1927, p. 234), is confidently assigned to the third century B.C. If this date is correct, this is important.

2 For this see especially R. A. Cordingley and I. A. Richmond in *Papers of the British School at Rome*, vol. X, 1927, p. 34.

3 For all this see especially A. Choisy, *L'Art de Bâtir chez les Romains*, Paris, 1873. Choisy was a brilliant pioneer, and exaggerated the importance of some points to which he was the first to call attention. Many of his conclusions have been criticized by Rivoira and others, for instance by G. Cozzo, in his *Ingegneria Romana*, Rome, 1928.

for the support of wooden planks during the rest of the process. It is however very doubtful, in view of the irregularity of their form and of the depth to which they penetrate the concrete, whether they can have served such a purpose. Their function was perhaps rather to give coherence to the concrete during the process of hardening, and to concentrate and canalize the strains and thrusts exerted by the semi-liquid mass. As a rule they seem to have had no real work after the concrete had hardened, but sometimes they were treated, in Gothic fashion, as the framework of the vault, or at least as the facing of such a framework, the intervening web being deliberately lightened by decorative hollowing and by the use of less solid filling material, including empty amphorae. The Romans took no risks and elaborately buttressed the abutments of their vaults, though in many cases the superb quality of their lime-mortar probably made such permanent resistance superfluous when the concrete had finally set.[1]

It should be added that the inner faces of vaults were sometimes covered with a single or double layer of tiles, laid flat upon their surface. It has been argued that these tiles originally formed a shell placed upon a light wooden centering, and that this shell coalesced into a self-supporting mass before the full weight of concrete, which would have required stronger centering, had been superimposed. It is, however, doubtful whether these tiles could have performed such a function, and it is perhaps more likely that they were designed, as Cozzo suggests, to facilitate the application of stucco ornament. All these methods will be illustrated later in this book, in connexion with particular monuments.

The earliest important examples of concrete in the city of Rome are the podia or platforms of the temples of Concord and Castor. Both date from the late second century B.C., and show rather poor technique. Earlier in the same century we begin to find at Pompeii strong lime and rubble walls, studded externally with stones of irregular shape, a system called *opus incertum* by Vitruvius. Exposed points, such as corners and door-posts, were made of stone blocks. In the first century the small facing-blocks became more regular (quasi-reticulate), but the famous reticulate scheme—square-based pyramidal blocks set point-inwards, diamond fashion—is rare before the age of Augustus,[2] of which it is especially characteristic though it continued in use till the second century A.D. The use of baked bricks for corners and door-posts comes

[1 See further note on p. 266.]
2 At Rome true reticulate seems to begin early in the first century B.C.: see Tenney Frank, *Roman Buildings of the Republic*, 1924, p. 58.

in at Pompeii with quasi-reticulate in the first half of the first century B.C., but they appear a little earlier as the material of the columns of the Basilica[1] and in some other columns in the town.

This is interesting, for the earliest known example of baked brick in a Greek building is exceedingly similar. This is a Hellenistic[2] palace at Nippur in Mesopotamia, probably of the early third century B.C., which is Greek in style, but has columns of baked brick in accordance with ancient Mesopotamian practice. These facts support the view that baked brick entered the Graeco-Roman world from Mesopotamia: it is sometimes found in the late Hellenistic period in South Italy. Bricks were of course used much earlier than this in Italy, as in Greece, but they were sun-dried, or sometimes lightly baked, as in the town walls of Arezzo (Arretium) in Etruria, mentioned by Vitruvius and[3] recently discovered.

The use of baked bricks for the facing of walls, apart from exposed points, scarcely begins before the time of Augustus, but becomes increasingly popular under the Empire. Till the reign of Nero, in the middle of the first century A.D., the bricks were usually broken tiles, sawn smooth on one face: thereafter they were usually made for the purpose, in the shape of a right-angled triangle. In either case they were set point-inwards, like the blocks of reticulate. About the same time, or a little later, we find bonding courses of big tiles, *bipedales* measuring two Roman feet each way, running at intervals right through the wall. The gradual changes in the character of mortar, filling material, and brick have been studied in recent years with great care, and afford an invaluable check on the dates of Imperial buildings, especially in Rome: but the details are too technical for discussion here. Some of the phenomena reflect historical events: in the years following Nero's fire of A.D. 64, for instance, the concrete is full of scraps of burnt buildings.

It should be added that from early times it was usual to cover all buildings of importance with stucco, often brightly painted, so that neither without nor within, where marble veneer was often used, were the rubble or brick surfaces usually exposed to view.[4]

Before speaking in detail of the particular buildings here chosen to illustrate the development of concrete vaulting, we may notice a few prominent examples of the use of masonry arches and vaults in the late

1 See p. 268. 2 *Am. Journ. Arch.* 1905, pp. 7 ff.
3 See *Not. d. Scavi*, 1920, pp. 186 ff. So in Greece, in the temple of Despoina at Lycosura, *c.* 180 B.C.
4 Stucco ceilings, flat or curved, suspended from the beams above on a light wooden framework, were common at Pompeii: see Vitruv. VII, 3, 1–4 and A. W. Van Buren, *Journ. Rom. Stud.* XIV, 1924, 112.

Republican and early Imperial periods: many others will be mentioned incidentally at later points. It should be noticed that Roman arches were often flat, but otherwise almost always circular in curve, though not always forming a complete semicircle: domes and vaults, however, occasionally use other curves, but not the pointed Gothic form.

In the second century B.C. we find an unprecedented activity in the construction of bold masonry arches, in the bridges and aqueducts of Rome. The Pons Aemilius, a fragment of which survives in the 'Ponte Rotto', was built in 179 B.C., but the piers of the original construction probably carried a timber roadway. In 142 B.C. it was arched, but the oldest surviving portions seem to date from an Augustan reconstruction. Older even than the original arches of the Pons Aemilius are those which survive from the Aqua Marcia, a six-mile aqueduct built in 144 B.C. The span of its arches is about eighteen feet. The work illustrates Roman care and economy in the choice of materials, for especially strong volcanic tufas from the Anio and Gabii were here used, for the first time, for the piers, the arches, and the water channel, which was further lined with a thick cement of lime and pounded terracotta, but the filling in between the arches was of cheaper tufa. The oldest surviving bridge arches (much repaired) are those of the Pons Mulvius (Ponte Molle) of 109 B.C., by which the Via Flaminia crossed the Tiber, about two miles north of Rome. This bridge, and the excellently preserved Pons Fabricius (Plate XIV *a*) of 62 B.C., in each of which travertine was used, though sparingly, may be taken as typical of their class. In each case, besides the main arches joining the piers, small arches are placed on the piers themselves, to economize material and reduce the weight. The spans are very great: those of the Pons Mulvius are about sixty feet, those of the Pons Fabricius about eighty feet. We know from Vitruvius something of the various methods used for preparing the river-bed for the erection of the piers, but they cannot here be discussed. In many of these works, and notably in the Aqua Marcia, the arches are set back from the piers, so that the wooden centering could be supported without need of scaffolding below. Similar schemes are habitual in Roman arched construction, and are often cleverly combined with traditional decorative forms. A notable illustration of Roman economy in centering may be seen in the famous Pont du Gard[1] (Plate XIV *b*), the great bridge, about 160 feet high, which carried the aqueduct of Nîmes, which is mostly subterranean, across the valley

1 The road-bridge beside it is not ancient: the old parts have been a good deal restored.

of the Gard or Gardon: it was perhaps built in the first century A.D.[1] Here each span is composed of a number of parallel arches[2] simply juxtaposed without interlocking: one timber framework wide enough to support one of these arches could thus suffice for the whole erection. The method, which is found in other Roman buildings in Gaul, was imitated in mediaeval bridges at Avignon and elsewhere: it involves some loss of strength, but time has justified the economy.

A very large number of bridges and aqueducts of the Imperial age survive: they are among the most pleasing works of Rome, for they are singularly free from superfluous ornament and are usually of beautiful proportions. The piers of any one structure are mostly of uniform size, but they are often placed, for practical reasons, at irregular distances. As the arches are all circular in curve, and the level of the tops of the arches must be approximately the same,[3] the arches necessarily spring from the piers at different heights, and their curves form varying portions of the circumference of a circle, up to a complete semicircle: sometimes a single arch springs at a higher point from one of its piers than from the other. Occasionally decorative arches were placed across the roadway of a bridge, either one at each end, or one only, in the middle. One of the widest surviving Roman arches is the single span, nearly 117 feet, of the bridge at Pont Saint-Martin, between Ivrea and Aosta. The magnificent six-arch bridge over the Tagus at Alcantara in Spain, built under Trajan, was partly ruined in the Peninsular and Carlist wars, but repaired and largely rebuilt in 1860. Its two central arches each have a span of about eighty-seven feet.

The rest of this chapter will deal more with concrete vaulting than with masonry construction. It will therefore be convenient at this point to speak of a remarkable example of Roman stone vaulting,[4] the so-called 'Temple of Diana' at Nîmes. The central room of this building (Plate XV), which can hardly have been a temple, is roofed with a barrel-vault still largely preserved, of which the skeleton is formed by a series of stout stone ribs, some distance apart: the gaps between these are filled with thinner slabs lying in cuttings in the upper parts of the

1 Espérandieu (*Le Pont du Gard*, 1926, p. 10) assigns it to the late first century B.C. See further p. 341. [For the aqueducts of Rome see now T. Ashby, *The Aqueducts of Ancient Rome*, edited by I. A. Richmond, 1935.]
2 Four in the lowest range, three in the second, and one in the highest.
3 Not quite, since the road often rises to the centre of the bridge.
4 The date of the 'Temple of Diana' is perhaps the second century A.D. Espérandieu (*Le Pont du Gard*, 1926, p. 9) assigns it to the time of Augustus, but the Composite capitals can hardly be so early. For another example of stone vaulting see p. 319, and for a stone dome see pp. 263 ff.

ribs. The side-walls contain deep niches, crowned alternately with triangular and curvilinear pediments. Between these niches stood engaged columns with Composite capitals, which appeared to support a continuous projecting entablature complete with architrave, frieze, dentils, and cornice: but several of these columns have in fact disappeared without affecting the stability of the entablature. The stout ribs spring over the columns, and their front surfaces project as far as the vertical face of the architrave, though they are set back relatively to the cornice. The weight of the roof is thus scientifically concentrated upon the solid parts of the wall, with at least some potential assistance from the columns. The outward thrust was countered on each side by a lower barrel-vault, covering in each case a narrow side-room, concealed from outside: each of these rooms had its barrel-vault arranged in three horizontal sections, each lying higher than the last, for the accommodation of a staircase, which led on each side to an open arcade, the upper storeys of the side wings[1]: the thrust was finally taken by the thick outer walls of these two side-rooms. Some Roman bridges and aqueducts show somewhat similar methods.

This is perhaps also the most convenient place to say something of the remarkable systems of stone roofing found in Syrian buildings of the Roman Imperial age, especially in the Ḥaurân, east and north of the Sea of Galilee, up towards Aleppo. They form a group of such special character, extending without a break into the Christian architecture of the fifth, sixth, and seventh centuries, that it is impossible here to give them adequate treatment. Some of the private houses will be mentioned at a later point[2]: here it must suffice to describe one striking early example, the basilica (Fig. 99) at Shaqqâ in the Ḥaurân, which is assigned to the last quarter of the second century A.D. This was an almost square stone structure, measuring internally about sixty-five feet in breadth and about sixty in length. There was probably a columnar porch at the east end, and at each end were three doors, of which the central was much the largest. The interior was divided into nave and aisles by seven free-standing square pillars on each side: the width of the nave, including the pillars, was about thirty-two feet. Each pair of free pillars was joined by a large semicircular arch across the nave, and smaller semicircular arches, springing from a lower point, crossed the aisles, connecting the free pillars with long engaged pillars projecting from the side-walls. Each set of transverse arches carried a solid stone

1 Illustrated in Durm's *Baukunst der Römer*, ed. 2, Fig. 270. [See further note on p. 266.]
2 See p. 314 and Fig. 133, and compare the temple at ʿAṭîl, p. 230.

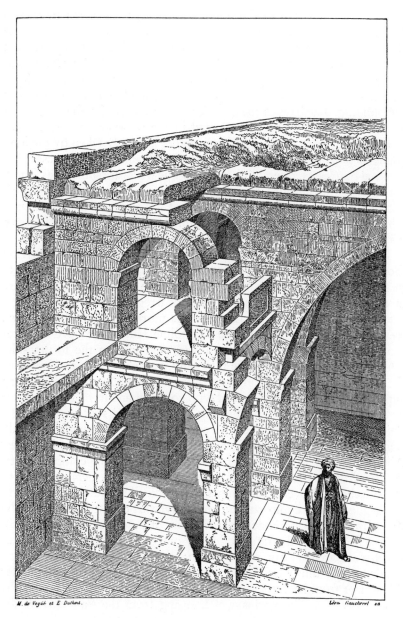

Fig. 99. Basilica at Shaqqâ (restored)

wall of the full width of the building, and on these seven transverse walls, and on the end walls of the building, rested a flat roof of stone slabs, covered by a clay terrace, and surrounded with parapets. Just above the aisle arches, on each side, stone slabs connected the transverse walls, making the floor of a gallery, which was also supported in front by a series of small arches, one to each bay, parallel to the side walls of the building. The bays of the galleries were connected with one another by an upper series of arches pierced in the transverse walls. In this building the thrust of the transverse arches is largely taken by the long engaged pillars at the sides, which are really internal buttresses, but external buttresses, resembling Romanesque work, are sometimes found; for instance in the third-century A.D. palace in the same city, Shaqqâ, where they take the thrust of a series of ten single transverse arches, which carry the flat stone roof of a long hall by means of transverse walls as in the basilica.

For concrete vaulting[1] on a large scale one of the oldest surviving monuments is the Tabularium or Record Office at Rome, finished in 78 B.C., which stood in the hollow between the Capitolium and the Arx at the west end of the forum. It was of irregular outline, covering a total area of about 230 by 144 feet. Its more imposing rooms faced west, on the higher level of the Capitoline Hill: these have been re-modelled or destroyed, but the lower portions, on the forum side, which are partly rock-cut, are internally well preserved, and much of their external decoration can be reconstructed. Above a great masonry supporting-wall, which is backed with concrete and has a strong batter or slope, ran a corridor connecting the north and south ends of the building. This was concealed by a continuation of the supporting-wall, but was lit by small external windows, at the ends of arched alcoves. Above this ran an open gallery, or rather a series of compartments, divided from one another, and from the outside, by piers joined with stone arches. Above these arches a plain projecting course ran all round the inside of each compartment, and above this course, set back to the line of the walls, was a concrete cross-vault of abnormal form (Fig. 100). It was formed by the intersection of two vaults which were not, as usual, semicircular, but were slightly depressed segments of circles. The rectangle thus roofed was not quite square, measuring just under fifteen feet from back to front, and a little less than sixteen feet in the other direction. The groins which spring from the four corners die

1 For earlier examples of vaulting at Pompeii, see pp. 212 (older Temple of Jupiter) and 243 ff. (Stabian Baths).

away before they reach the top. There are other concrete-vaulted rooms, some of which open off the gallery, and one straight staircase of sixty-six steps, running up from the forum level, under the galleries, which is roofed not with a continuously sloping vault, which Roman

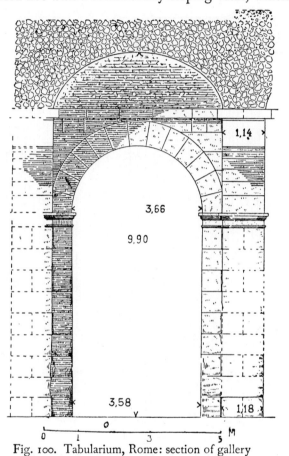

Fig. 100. Tabularium, Rome: section of gallery

architects generally avoided, but with a series of stepped sections of concrete barrel-vaulting.[1] The entrance hall to this staircase had a flat masonry arch as lintel, with a semicircular relieving arch above it, but the space between the arches was filled with masonry.[2] The piers in front

1 Compare the 'temple of Diana' at Nîmes, p. 238, and contrast the Hellenistic Didymaion, p. 153.
2 For later decorative treatment of such arches see p. 321.

of the open gallery were adorned with engaged Doric columns (Fig.
101), resembling those at Cori,[1] with an engaged entablature: the archi-
trave was built, as often in Roman work, on the flat-arch principle.[2]
This is an early example of that divorce between function and decoration,

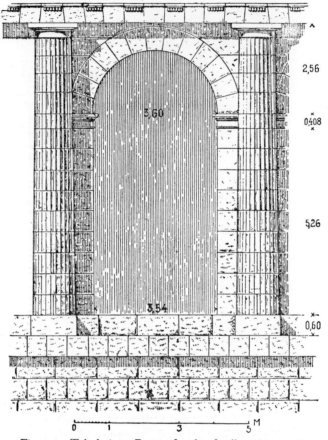

Fig. 101. Tabularium, Rome: façade of gallery (restored)

due partly to the introduction of new structural methods, which is
characteristic of Roman architecture:[3] modern architects have been
driven to similar devices in dealing with steel and ferroconcrete. At the

1 See p. 209.
[2 The Romans also sometimes used the horseshoe arch, especially in Syria and
Spain, but never in important work and seldom structurally.]
3 For a Hellenistic precedent compare the Bouleuterion of Miletus, p. 179 and
Fig. 80.

same time it should be observed that the Romans usually took care to place engaged columns at points of a wall which required extra strength, so that they had a function, though not always that suggested by their form. Similarly, decorative niches usually served to lighten unimportant walls and to economize material.[1] Above the Doric colonnade of the Tabularium there was a Corinthian one of elaborate character, but this seems to have dated from the late first century A.D.

The remaining buildings described in this chapter served a variety of purposes, but, with important exceptions, it was above all in two types of building, bathing establishments (balneae) and palaces, that the Romans developed the science of roofing great spaces with fireproof materials. It should be stated at this point that Strzygowski's view, that the development of vaults and domes during the early Empire was chiefly due to streams of Oriental influence, appears to lack support in the surviving monuments: it is much more reasonable to regard it, with Rivoira, as the increasingly bold experimentation of Roman engineers.

We may begin with the Stabian Baths at Pompeii, which date from the second century B.C., though they were modified in later times. Before their vaulting is described, the common characteristics of all Roman baths, public or private,[2] may be briefly enumerated: they vary enormously in arrangement and in elaboration, but the elements never change. These consist of a series of rooms getting progressively hotter, the frigidarium, with a cold-water basin, the warm tepidarium, and the hot caldarium, usually containing two basins of hot water. There might also be a dressing-room, apodyterium, and a dry sweating-room, Laconicum, often circular. In public baths there was regularly an open-air palaestra, for exercise, usually surrounded by a colonnade, and often provided with a swimming-bath. Until the first century B.C. the rooms were heated by braziers, but the invention, early in that century, of hollow floors, and later of hollow walls, made possible a better system of heating by hot air from furnaces. In the Stabian Baths these new inventions were introduced as an improvement. The roofing of the Stabian Baths may be illustrated from the barrel-vault of the apodyterium, which survived the earthquake of A.D. 63, and the eruption sixteen years later. It measures internally about twenty-two by thirty-seven feet. A simple cornice runs all round the walls below the spring of the vault, which is pierced with two small openings: there is a window

1 Niches of purely structural function were often concealed inside a wall.
2 For a simple private installation see the Boscoreale house, p. 310. Pre-Roman Greek bathing establishments were much less elaborate.

in one of the two end walls, in the lunette between the cornice and the ceiling. More remarkable is the roofing of the frigidarium. This room is square externally, but internally circular, except that each corner has a curved niche, entered through an arch and roofed with a half-dome. A cornice ran round the circular wall above these arches, on which rested a conical dome, a little under twenty feet in diameter, of straight outer and inner profile. This dome did not run to a point, but ended in a large circular opening—an anticipation of Hadrian's Pantheon. The floor was marble-paved, and mostly occupied by a stepped bath-basin. The internal decoration was pleasingly fanciful: the stuccoed walls were painted as a garden with trees, birds, statues, and fountains, with a blue sky above, carried up the dome, where it was studded with golden stars. All the vaulting of these baths was of [1] concrete. With the possible exception of the round temple at Tivoli,[2] this is the earliest known Roman dome. The frigidarium of the baths near the Forum at Pompeii, built in the early first century B.C., was of exactly the same type. This oast-house shape hardly recurs in Roman architecture, but Wren adopted it for the kernel of the dome of St Paul's Cathedral.

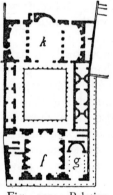

Fig. 102. Palatine, Rome: public apartments

The first Roman building which has been thought to have had a really colossal barrel-vault[3] is Domitian's palace on the Palatine at Rome, built by the architect Rabirius, presumably a Roman, towards the end of the first century A.D. Of the private apartments of this palace, to which most of the visible remains on the Palatine belong, a little will be said at a later point.[4] We are here concerned only with part of the public quarter, which occupied a large rectangular space (Fig. 102), south of the open Area Palatina. It consisted of a garden, surrounded by inner colonnades, and bounded to north and south by two great blocks of building, as well as by minor rooms to east and west. The whole structure had an external colonnade on the north and west sides. Of the

1 Ashby in the third edition of Anderson and Spiers' *Architecture*, 1927 (p. 113), retains from the second edition (1907, p. 262) the statement that the frigidarium dome was "built in masonry laid in horizontal courses", but Delbrück in *Hellenistische Bauten in Latium*, II, 1912, p. 50, implies that this dome is of concrete. [At Pompeii in 1937 I found that the dome is of concrete.] 2 See p. 210.
[3 Most archaeologists now prefer to assume wooden roofs throughout the palace: see A. Boethius, *Göteborg Högskolas Årsskrift*, XLVII, 1941: 8, p. 13.]
4 See p. 310.

southern block, at the top of Fig. 102, there is no space to speak: its central room (*k*) was probably the triclinium, or banqueting-hall. The northern block, at the bottom of Fig. 102, was divided into three sections, side by side, the western (*g*) and central (*f*) being the most important. The central, which is the largest, was probably the Emperor's throne-room, designed to impress visitors with the majesty of Rome. The enormously thick walls (ten feet through) were so divided by niches that they may be regarded as consisting structurally of sixteen huge piers, four at the ends, six at the sides: similar schemes will meet us again and again in Roman work. The whole of this great rectangle has been thought to have been roofed by a concrete barrel-vault. The span is about 105 feet. The danger of the vault thrusting out the walls would be diminished, as in the 'Temple of Diana' at Nîmes,[1] by the presence of the narrower side-rooms, which were strengthened in later times. It is difficult to visualize the interior appearance of this building, if it was vaulted, for what survives is the ruin of its brick and concrete skeleton, to which was applied a decoration of marble veneer, columns, statues, and decorated stucco. But in Roman halls decoration was, in truth, of subordinate importance: architecture, almost for the first time, was now dealing freely with interior spatial effects.

Fig. 103. Subterranean 'Basilica' of the Porta Maggiore, Rome

We may pass next to a building very different in character, the small subterranean 'basilica' discovered near the Porta Maggiore at Rome in 1917. This unique structure (Fig. 103), which was undoubtedly the meeting-place of a mystical sect, was constructed by pouring concrete into hollows cut in the ground. On technical grounds it may confidently be assigned to the first century A.D. The building measures about forty feet by thirty, and consists of a nave divided by six rectangular piers, three a side joined by arches, from lower aisles. Nave

[1] See p. 237.

and aisles are barrel-vaulted, and the nave ends to the west in an apse with a half-dome. The only door, at the east end, opens into a square vestibule, from which a long vaulted passage[1] led to the upper ground-level. From the roof of the vestibule a shaft for air and light, pierced with a window into the nave, ran to the upper surface: there were also ventilation shafts from the corridor. The main lighting was by lamps hung from the roof. The interior was richly decorated with painting and stucco, but there is no space to discuss the aesthetic and religious problems which these present. There is reason to think that the sect using the basilica was forcibly suppressed very shortly after its completion, and that all marble fittings were then removed. A plausible conjecture connects this catastrophe with the fall and suicide of the ex-governor of Africa Statilius Taurus, disgraced by the Emperor Claudius in A.D. 53. He was accused of corruption in his administration, but Tacitus[2] says that the real brunt of the accusation was 'magical superstitions'. It is likely that the basilica lay within this great noble's estate, which the Empress Agrippina is said to have coveted. The building was, of course, not a basilica[3] in the ordinary sense, but its plan has some resemblance to those of the Roman civil basilica and of the basilica of early Christianity. It suggests the possibility that the vexed problem of the origin of that Christian type is to be sought in the previous existence of similar meeting-places of secret pagan sects[4]: there is other evidence for the prevalence of the apse in mystical temples.

From this strange monument we may turn to one of the most famous and glorious works of ancient architecture, the oldest important roofed building in the world that still stands intact, the Pantheon of Rome. The history of this temple is obscure in many respects, but the date of the main block is scarcely doubtful. Despite two inscriptions, one on the frieze of its columnar porch, which asserts that Augustus' minister Agrippa built it in 27 B.C., and another added below, recording a restoration by Septimius Severus and Caracalla in A.D. 202, it is practically certain from the stamps[5] on the bricks that at least everything except

1 Only the lower end of this passage is shown in Fig. 103.
2 *Annals*, XII, 59.
3 For the civil basilica, see pp. 267 ff.
4 See Leroux, *Les Origines de l'Édifice Hypostyle*, pp. 322 ff. (written before the discovery of the subterranean basilica).
5 The value of this evidence has lately been questioned by G. Cozzo, in *Ingegneria Romana*, 1928, who assigns the rotunda to Agrippa's original building: but the test bricks were taken from many different parts of the structure, and all tell the same story. It is really impossible to suppose that they all belong to later restorations. Moreover, the general character of the brick and concrete work is definitely Hadrianic.

this columnar porch is substantially the work of Hadrian in the first quarter of the second century A.D. The history of the porch, which lies to the north of the building, is a more difficult but less important question. Externally (Plate XVI *a*) the building, which was originally faced with white stucco, appears for most of its circumference as an enormous circular mass, somewhat like a brick gasometer, crowned with a cornice, and divided by two lower cornices into three bands, the lowest being the tallest. Above the crowning cornice lies an externally flattish dome, whose lower portion shows as a series of large steps. From the north side projects the prostyle porch, consisting of sixteen Corinthian columns, thirty-eight feet high, with unfluted granite shafts and marble capitals. These are arranged in a front row of eight, connected with the main block by four more pairs, standing at right angles to the front row behind the two angle columns and behind the two columns next but one to the angles. The outer columns carry a normal entablature with a very steep and shallow pediment. The level of the horizontal cornice of the columnar porch is between those of the lower and middle cornices on the circular wall. The roof of the porch was carried on a trussed bronze framework till it was melted into cannon three centuries ago.

This porch does not abut directly on the circular part of the temple, which it is convenient to call the rotunda. Between the two stands a solid projecting structure, of the same material and date as the bulk of the temple. This is as wide as the columnar porch and as high as the rotunda wall, to which it is fitted behind, though it is rectangular in front. Seemingly part of the original design, it is nevertheless not bonded into the rotunda wall, at all events in its upper parts, presumably because the architect, for convenience in the process of construction, preferred to treat the rotunda as a unit. The solid projecting structure has a wide and high central arched opening leading to the single door of the temple, and a much lower semicircular niche to each side. The uppermost cornice of the rotunda is carried round the top of the solid porch, and the cornice next below is also carried across it, so far as the point where it meets the gable roof of the columnar porch: this cornice serves as the lower limit of an engaged pediment, crowned by a raking cornice of the same design. This engaged pediment, the top of which has been destroyed, is a little less steep than the equally wide one of the columnar porch, and lies, as we have seen, at a higher level. The whole entablature of the columnar porch, including its cornice, is carried on pilasters along the side walls of the solid porch as far as the rotunda wall, where it stops dead: the lowest cornice of the rotunda wall likewise stops dead when it meets the solid porch.

This is a strange scheme, and it has been suggested that Hadrian's architect designed the solid projection without intending to place a columnar porch in front of it. This view was based chiefly on the results of certain excavations[1] made in 1892 and 1893, which were held to prove that the foundations of the columnar porch were in part later than those of the rest of the building: it was inferred that the columnar porch was added at some date between the reigns of Hadrian and Septimius Severus. This conclusion raised great difficulties, and recent re-examination[2] of the facts discovered in 1892 and 1893 has thrown great doubt on its validity. Moreover careful investigation of the junction between the columnar porch and the projecting structure has shown that it is almost impossible not to regard them as contemporary with one another, and has made it practically certain that the presence of a columnar porch was contemplated from the first. The conclusion that in its present form the whole Pantheon is Hadrianic seems to be irresistible, though it is possible that some of Agrippa's building was reused in the columnar porch.

It should be added that Cozzo goes much further than this in his criticism of the prevailing view. While assigning the rotunda, as we have seen, to Agrippa's original design, he regards the solid projection and the porch as a single later addition, perhaps of the time of Septimius Severus, on the site of a quite separate building, which was earlier than Agrippa. The original entrance, in his view, was on the other side of the rotunda, to the south, and he maintains that a great hall, still partly preserved, which almost touches the rotunda on that side, but does not appear in Fig. 104, was the original entrance-room, and the first home of the columns of the existing porch. This hall was almost certainly, in late Imperial times at least, part of the Thermae of Agrippa, the bulk of which lay further to the south, but Cozzo holds that it was transferred from the Pantheon to the Thermae at the time when the new entrance was made to the north of the rotunda. This bold theory, which is supported by many arguments of detail, could perhaps be adapted to fit a Hadrianic date for the rotunda, but, even so, it seems very unlikely that it will win general acceptance.

Inside the building (Plate XVII) the vertical circular wall is divided ornamentally into two bands, of which the lower is the taller. A series of Corinthian columns and pilasters on the ground-level carries a com-

1 Published by L. Beltrami, *Il Pantheon*, Milan, 1898.
2 See especially A. M. Colini and I. Gismondi in *Bull. Comm.* 1927, and G. Cozzo, *Ingegneria Romana*, Rome, 1928.

plete entablature, broken only at the entrance and at a niche exactly
opposite to it, above which is a smooth band of wall, diversified
alternately by panelling and by rectangular niches crowned with engaged
pediments. Over these runs a cornice, above which springs the dome,
141 feet in inner diameter: its inner surface, faced with concrete, is
ornamented for the greater part of its height with sunken stepped coffers,
cleverly designed to exaggerate the perspective: their original decoration

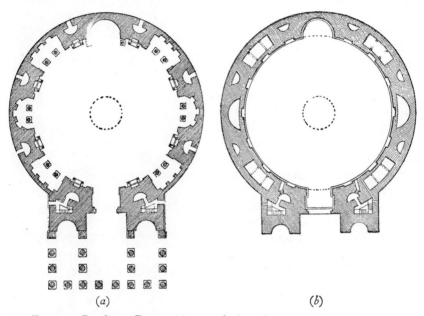

(*a*) (*b*)

Fig. 104. Pantheon, Rome: (*a*) ground-plan, (*b*) section of middle zone

is lost. At the top is a circular hole, about twenty-nine feet across,
entirely open to the sky: this is still lined with an original ring of
ornamented bronze.

It is obvious at a glance that below the level of the entablature of
the Corinthian columns the main wall is not solid and continuous:
it consists, in fact, as the plan (Fig. 104) shows, of eight huge piers,
separated by niches so deep that the walls behind them, alternately
straight and curved, must be regarded as mere curtains, almost without
structural importance. Except at the barrel-vaulted entrance, which

takes the place of a niche, and in the niche directly opposite, which are both crowned by visible arches, the superincumbent wall now appears to rest directly on the entablature carried by the Corinthian columns, of which there are two to each niche, but examination of the structure has shown (Fig. 105) that all the piers are connected by brick arches, springing somewhat above the level of this entablature. These are now concealed in the wall, but the whole of this part has been repeatedly remodelled, and the original design is uncertain: the brick was, of course, never exposed to view. Two vertical walls, radial to the circumference of the building, divided the upper part of the hollow under each of these arches into three compartments: these walls are in line with the columns, and arches in their lower parts concentrate their pressure upon the entablature above the columns and upon the outer wall of the building. Care was likewise taken by means of small concealed arches to concentrate upon the columns the pressure of the walls which filled the spaces between the main arches and the entablature. Segmental arches in the solid piers also joined the main arches which covered the niches.

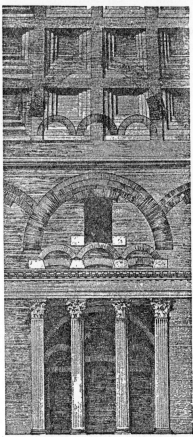

Fig. 105. Pantheon, Rome: showing brick arches in walls and dome

The walls, below the dome, are throughout faced with brick, and the arches over the niches certainly ran as barrel-vaults right through the walls, but the rest of the brickwork seems to have been an ordinary facing for a concrete core. The piers, as the plan shows, were partly hollow, and here too was an elaborate system of relieving arches. The structure of the dome is more problematic. Its visible inner surface is a mere skin of especially light concrete, and its core was certainly faced

within and without with flat bricks tilted slightly inwards, with large
bonding tiles at intervals. Though it is often asserted that the whole
fabric was of brick, it seems more likely that the brick was simply facing
for an ordinary concrete core. The dome, like the walls, contains a system
of relieving arches, but these are imperfectly known. There was
certainly an arch in the lowest part of the dome, above each of the great
niches, corresponding to those just described in the upper zone of the
vertical wall: but these arches in the dome[1] were not, like those below,
connected with one another by segmental arches over the piers. The
brick facing of the dome was not vertical, but did not slope forward so
steeply as the concrete surface, which grows thicker from the bottom
upwards. Above the arches already mentioned almost everything is
uncertain, and the elaborate schemes of relieving arches published by
Piranesi and others are demonstrably fanciful. How the dome was
actually erected can only be guessed, but the technical difficulties of such
construction are sometimes exaggerated.

The structure of this marvellous building is intensely interesting, but
those who enter it for the first time are not likely to think chiefly of its
engineering problems, for its simple design is overwhelmingly noble.
The satisfying effect of the interior is perhaps partly due to the fact that
the inner diameter of the dome is equal to the height of its top from the
floor. The scheme of lighting from a single central opening is extra-
ordinarily successful, and experience shows that in so huge a building
the inconvenience of rain is trivial.

Except for the conical roofs of the frigidaria of the baths at Pompeii
all the domes so far mentioned were placed over purely circular rooms,
whose outer walls afforded a natural and easy support for them: and in
these frigidaria there was a circular inner wall which was equally con-
venient. It is much harder to rest a dome on an internally square
structure, and the only satisfactory solution for the problem is the use
in the four angles of triangular 'pendentives', which are themselves
portions of a sphere. The function of the pendentives is to provide a
firm circular base for the dome. The curve of the dome may be made
continuous with that of the pendentives, but more commonly, for the
sake of additional height, the dome has a different curve. This is the
type, for instance, of Santa Sophia at Constantinople. In St Peter's at
Rome and its descendants a cylindrical drum divides the dome from the

[1] Cozzo (*Ingegneria Romana*, 1928, p. 273) asserts that such segmental arches must
have existed, but Beltrami (*Il Pantheon*, 1898, p. 27) says that test borings in 1892
and 1893 proved their absence. [See further note on p. 266.]

top of the pendentives. There are many practicable cruder solutions of the problem: the top of the square may, for instance, in small buildings, be converted into an octagon by blocks laid across the angles, and thence, if desired, into a polygon, and the circle of the dome may then be placed upon the octagon or polygon.[1] In larger buildings the same result can be obtained by 'squinch' arches across the angles. These solutions are anticipated in the corbelled 'domes' of some Etruscan tombs and occur in work of the Imperial age, es-

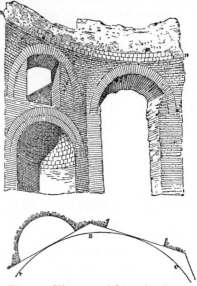

pecially in Syria, but Roman archi-tects early began to feel their way towards the pendentive, and in a very few instances they almost reached it; for instance in a room of Domitian's palace on the Pala-tine and in some tombs. But their pendentives were unskilfully de-signed: it was not clearly under-stood that they ought to be portions of a spherical surface, and they were sometimes flat, and sometimes con-tinued to a certain height the re-ceding angle of the walls from which they sprang. The most suc-cessful Roman example is probably that found (Fig. 106) in two corre-sponding domed octagonal halls (externally square) of the Baths of Caracalla,[2] described later in this chapter, where pendentives form the transition from the octagon to

Fig. 106. Thermae of Caracalla, Rome: sketch and ground-plan of part of octagonal hall. The line *ABC* shows the projection of the dome between the points *m* and *n*

the circle of the dome: but even here the sharp angle of the walls runs for some distance up the pendentive. The method was, in fact, not fully understood or systematically exploited in important buildings till Byzantine times. There is no good evidence that it was known at an earlier date anywhere in the East.

Hadrian's villa near Tivoli, the ancient Tibur, about fifteen miles from Rome, of which more will be said in the last chapter, contained several

1 For instance in the 'kalybe' at Umm az-Zaitûn in the Haurân, of A.D. 282 (p. 346). See also the account of the 'Tower of the Winds' at Athens, of *c.* 50 B.C., p. 338. [2 Mr Marshall Sisson in *J.R.S.* xxxiv, 1944, 149, calls attention to domes at Gerasa resting on pendentives: see *J.R.I.B.A.* 1927. G. Horsfield, in the official *Guide to Jarash*, dates them 2nd cent. A.D.]

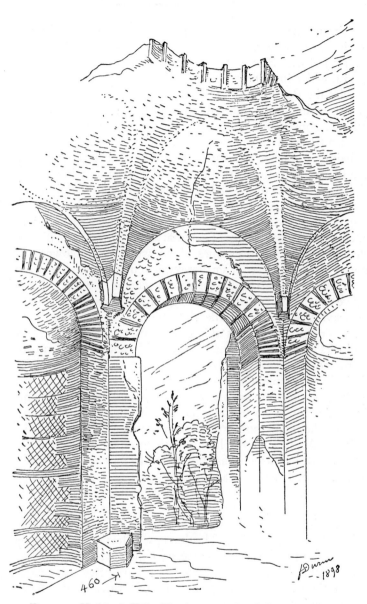

460 →

Fig. 107. Hadrian's Villa, Tivoli: vestibule of 'Piazza d'Oro'
(From *Handbuch der Architektur*, Band II, J. M. Gebhardt's Verlag,
Leipzig, Germany)

interesting experiments in the construction of domes, roughly contemporary with the Pantheon. One of the best preserved is that in the vestibule (Fig. 107) of the 'Piazza d'Oro', the structure marked *K* to the left of Fig. 134, which in many ways, including the central opening at the top, resembles the Pantheon, though it is much smaller, its inner diameter, excluding niches, being about thirty-four feet. Its walls, like those of the Pantheon, consist essentially of eight piers, on which the pressure is concentrated, with the intervening stretches of wall reduced, for most of their height, to niches alternately curved and rectangular. But whereas in the Pantheon this construction is buried externally in a single round wall, here the backs of the niches display externally their internal shape, and the building is a sort of octagon, with sides alternately straight and curved, between which the piers show as powerful buttresses, connected above by a series of external arches. Inside, the piers are connected by arches over the niches, above which, in the lower part of the dome, is an upper series of smaller semicircular niches. The form of the dome further emphasizes the octagonal scheme, for it consists of eight concave segments, with re-entrant groins between: the groins spring from travertine blocks. Inside the building, at the re-entrant angles, there was originally a series of free columns, which appeared to support the blocks under the groins but probably had little or no structural importance.

This dome is a pleasing example of economy and ingenuity, and displays its true structure with revolutionary frankness. It is by no means unique: the Serapeum in the same villa had a very similar dome, and there are other contemporary and later examples. The so-called Temple of Minerva Medica, a nymphaeum perhaps connected with the Licinian Gardens at Rome, which was built about the middle of the third century A.D., is a domed structure about eighty feet in diameter resting on ten piers, which are strengthened by external buttresses. Between the piers at the ground level are recesses most of which are enclosed by apse-like curved walls: the upper part of the vertical wall is pierced with large windows between the piers. The dome, which is externally stepped, has a framework of ten brick ribs corresponding to the piers and buttresses. Two special buttresses of very great size were placed against the piers opposite the entrance, perhaps because of a threatened collapse at the time of erection.

The Baths of Caracalla, built early in the third century A.D., contained several domes besides those already mentioned. The largest, about 115 feet across, covered the caldarium or Laconicum, a great

circular room (marked 9 in Fig. 110), very ill preserved, which pro-
jected from the south side of the main block of the bathing establish-
ment proper. It rested, as usual, on eight piers, which were here united
by arches, over windows, just under the dome, and also by a second
series of arches lower down, a scheme which gave the upper openings
some apparent resemblance to a Romanesque triforium. The inner
faces of the piers were curved, but the arches were all straight, and the
transition to the circle of the dome was accomplished by clumsy pen-
dentives. The inner surface of the dome was faced with flat tiles, a
feature already discussed,[1] and its weight was reduced by the insertion
of hollow pots, the first important example[2] of a method which was
scientifically developed in early Byzantine times, especially at Ravenna.

There is a remarkable dome in Diocletian's Mausoleum[3] in his famous
palace at Spalato (Salona), on the Dalmatian coast, which will be de-
scribed at a later point[4]: it was built about the beginning of the fourth
century A.D. The Mausoleum, visible in the plan of the palace, Fig. 135,
is well preserved, in spite of some drastic alterations, due to its con-
version into a cathedral. Externally it is octagonal, each side of the
octagon measuring about twenty-six feet. It stands on a podium about
eleven feet high, under which is a domed crypt. It was surrounded
externally by twenty-four Corinthian columns, some of which have
been removed: they are about twenty-one feet high, including the
isolated pedestals on which they stand: the capitals of those at the
angles of the octagon are curiously adapted to their position, having
five-sided abaci. These columns carried a tiled penthouse roof: there
was a tetrastyle porch, but this was destroyed in the Middle Ages to
make room for a campanile and its details are uncertain. The external
columns are mostly granite, but a few are marble, and of these two are
fluted, a rare feature at Spalato: here and elsewhere in the palace we can
detect the adaptation of ready-made members from older buildings, but
the borrowing shows moderation and taste. The cella walls, built of
masonry without mortar, are about ten feet thick, but they are reduced
by eight deep internal niches, alternately rectangular and curved, to the
usual scheme of eight great piers: the door opens into one of the rect-
angular niches. The inner diameter, apart from the niches, is about
forty-three feet. Between the niches eight granite Corinthian columns,

1 See p. 234.
2 As the earliest known example, Ashby cites a villa of *c.* A.D. 123 in the Roman
Campagna (*The Roman Campagna in Classical Times*, 1927, p. 155).
3 That the building was Diocletian's Mausoleum is probable but not certain.
4 See pp. 317 ff.

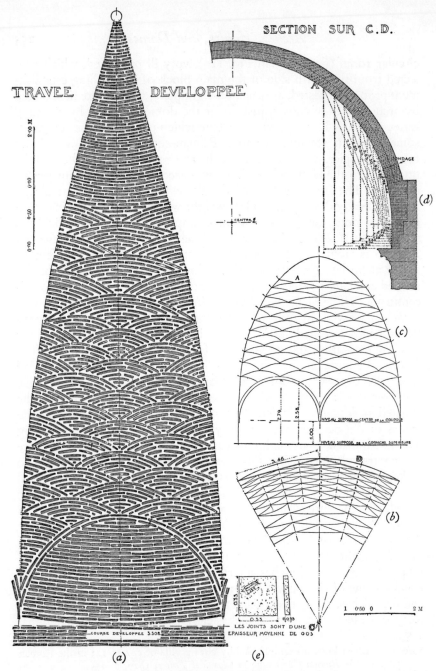

SECTION SUR C.D.

TRAVEE DEVELOPPEE

(d)

(c)

(b)

(a)

(e)

Fig. 108. Dome of Diocletian's Mausoleum, Spalato
(restored drawing by Hébrard)

(*a*) True elevation of $\frac{1}{12}$ of the interior: (scale of metres on left)
(*b*) Plan showing $\frac{1}{6}$ of the interior
(*c*) Section showing the same
(*d*) Section along the line *C–D* in (*b*) } (scale of metres on right)
(*e*) A brick from the dome

about thirty feet high, stand against the wall, carrying projecting sections of an engaged entablature. Above these stand on the cornice eight similar but much smaller columns, alternately of granite and porphyry. These columns have no bases, and their capitals are alternately Corinthian and Composite: their entablature follows the lines of that below: immediately below this upper entablature a broad carved frieze runs all round the inner wall. Owing to their projection these columns do not pretend to help in carrying the semicircular dome, which starts nearly four feet above the top of the upper cornice.

The structure of the dome (Fig. 108), whose inner apex is about seventy-one feet above the floor, is very interesting. It consists of a double shell of bricks, with wide mortar joints, each shell being about a foot thick. The bricks of the inner shell are arranged at the bottom in twelve large semicircular arches. Between and for a broad belt above these they are placed in a network of small segmental arches, suggestive of a fish's scales, in which every brick forms part of an arch: but below the semicircular arches and in the upper part of the dome the bricks lie in ordinary horizontal courses. This complicated system is not carried through to the outer shell. Externally the dome was expanded by the use of light concrete into an octagonal pyramid, and doubtless had tiles of terracotta or bronze: the existing tiles are modern. It has been suggested that there was originally a central opening, but more probably light came only from an open relieving-arch over the lintel of the door. The dome seems to have been adorned internally with mosaic, as that of the circular vestibule[1] of the palace proper certainly was.

The dome of Santa Costanza at Rome (Fig. 109 and Plate XIX *b*), which also still stands, takes us to the very limit of the period to which this book is confined, for it may be later than Constantine[2] and is certainly not earlier. Its great interest lies in the fact that here, for the first time, the hemispherical dome, about thirty-six feet in diameter, rests on

1 See p. 319. The earliest known dome so decorated seems to be that of an underground sanctuary of Hercules in the Roman Campagna, assigned by its discoverer Ashby to the second century A.D. It was semicircular, nearly twenty feet in diameter, and had a central opening: the mosaic was white, with no pattern. See *Papers of the British School at Rome*, III, 1906, p. 204. Spalato provides the first known examples of large domes so decorated.

2 Rivoira (*Roman Architecture*, English ed., pp. 238 ff.) thinks that Constantine built it between 324 and 326 A.D., with the intention of being buried there himself: the more usual view is that it was built as the mausoleum of his daughter Constantina, who died in A.D. 354, and was almost certainly buried there. Constantine himself died in A.D. 337. See Hülsen in Toebelmann's *Römische Gebälke*, 1923, p. 137.

a drum carried by an arcade of columns. The apex of the dome is about sixty-three feet from the floor. These columns are arranged in twelve pairs. The columns of each pair are very close together, and stand radially to the circumference, carrying an isolated section of complete entablature, and these twelve sections of entablature are connected by open arches in the solid wall which supports the drum on which the dome rests: this wall is as thick as the length (about five feet) of the piece of architrave in each section of entablature. The outward thrust which the dome might exert on the drum is counteracted by an almost continuous barrel-vault, which connects the wall carried by the columns, at a point just above the tops of its

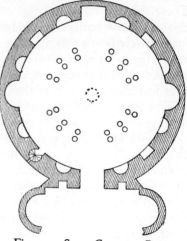

Fig. 109. Santa Costanza, Rome

arches, with an outer wall about ten feet thick: the diameter of the space enclosed by the outer wall is about seventy-two feet. The drum rose as a visible clerestory pierced with twelve arched windows, high above the roof of this barrel-vaulted ambulatory. The door was masked by a vestibule with apsidal ends, and the outer wall was externally continuous, but internally divided by the door and by three great niches into four sections. The columns are grouped in four corresponding sections, the arches opposite the door and the large niches being wider than the rest: each of the four sections of the wall contains three lesser niches. The dome itself resembles in shape that of the Pantheon, and originally had a central opening. It was built of concrete with brick ribs and bonding-tiles at intervals.

The great public bathing establishments of the Empire, known as Thermae, exhibited some of the boldest developments of Roman vaulting. The oldest were built by Agrippa between 25 and 12 B.C., but the two best preserved are those of Caracalla and those of Diocletian: it is likely that Nero's Baths, and still more Trajan's, the work of Apollodorus of Damascus, established the general type followed by later architects. The Baths of Caracalla were built chiefly by that Emperor, who reigned from A.D. 211 to 217, but they were finished by Alexander Severus about twenty years after his death. The essential

elements of this vast structure (Fig. 110) are those of every Roman bath, but greatly elaborated. The main building lay towards the north end of a rectangular substructure, about twenty feet high, measuring about 1080 feet each way, parts of which contained vaulted chambers used for furnaces and other purposes. The whole substructure, partly laid out in gardens, was surrounded by a wall. The chief entrance was in the centre of the north side. To the south, behind the gardens, lay a stadium and the reservoirs, which were fed by the Marcian aqueduct.

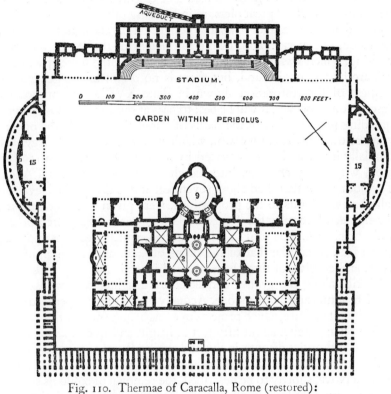

Fig. 110. Thermae of Caracalla, Rome (restored):
the north is roughly at the bottom

Curved projections or exedrae on the east and west sides contained such subsidiary buildings as libraries and the two octagonal halls already mentioned.

The main building was an ingenious but mechanically symmetrical complex of rooms and open spaces of various heights, some of more

than one storey: the exact purpose of many is conjectural. Enough has already been said of the domes in this building[1]: at least equally important is the development of groined cross-vaulting which it illustrates. The lesser instances may be ignored for the sake of the great rectangular hall (2 in Fig. 110) which formed the central and dominant feature of the whole block. This has often been regarded as the tepidarium or room of moderate warmth, but it has no heating arrangements and is more probably the apodyterium or changing-room. Its internal dimensions are about 170 by 82 feet. The essential supports of its concrete roof were eight great piers, as in so many other Roman buildings, arranged in two parallel rows and connected by eight arches, three at each side, one at each end, of the full height of the top of the cross-vaulting, which was in three bays. The details of the upper part of the hall are largely conjectural, but there is no doubt of the general correctness of the restoration shown in Plate XVIII. For purposes of description, however, it will be best to pass at once to the closely corresponding principal hall of the Baths of Diocletian, built in the opening years of the fourth century A.D., which survived the Middle Ages substantially intact and was converted by Michelangelo between 1560 and 1570, with many changes, into the church of S. Maria degli Angeli. The floor was established about seven feet above the original level, and false bases, ruinous to the proportions, were given to the columns: in the eighteenth century the domed caldarium was unwisely incorporated with the church. The roof of this great hall, which measures about 200 by 80 feet, rests, like that of the Baths of Caracalla, upon eight huge piers, and consists of three bays of quadripartite vaulting, with strong brick ribs along the groins, connected by a lighter web whose filling consists of tufa and pumice stone. Actually the vaulting appears to spring from the entablature, which projects over eight huge monolithic columns of Egyptian granite, about fifty feet in height and five in diameter, and modern authorities dispute, in this and similar Roman examples, how far such columns helped to take the pressure of the vault. It is clear that in the Basilica Nova, shortly to be described, the removal of columns similarly placed has not, at least in all cases, caused the collapse of the vaulting, which seems to have become a monolithic mass incorporated in the piers against which the columns stood: but it is possible that the removal or destruction of such columns has hastened the collapse of some at least of these vaults, for instance those of the great hall in the Baths of

[1] See pp. 252 and 254 for the octagonal halls in the exedrae and for the large caldarium or Laconicum.

Caracalla. Be that as it may, it would be rash to assume, even if the columns have no function, that they were also meant to have none. The recent expert report on the dome of St Paul's Cathedral in London shows how difficult it is for an architect to foretell what all the strains and thrusts of a domed or vaulted structure will actually be. That the Romans were prepared for dangerous thrusts in their great vaulted halls is abundantly clear from their elaborate buttressing, some of which must now be described: it is far from certain that they expected these strains to cease when the whole mass was finally solidified.

The eight piers of the great hall were joined at the top, along the four sides of the rectangle, by arches of the height of the vaulting, and were also connected by a lower range of arches, which opened, both at the sides and at the ends of the hall, into a series of interconnected rooms, of lesser height: of these rooms those to the sides at least may be regarded as part of the same whole, being comparable to the bays of a cathedral aisle. The space between the lower and upper arches was filled in with a clerestory wall, pierced with very large windows, each divided by vertical strips or mullions into three lights. The expected thrusts were elaborately countered. The three rooms of each side-aisle were separated by great walls, pierced with large arched doorways, and these walls acted as buttresses to the main piers. Each side-room was roofed with a separate barrel-vault at right angles to the main axis of the hall, so that there was no pressure on their outer walls. The buttress-walls were carried up above the roofs of the side-rooms to meet the springing of the diagonal ribs of the main vault. They were differently finished on the two sides, but the visible parts of both sets, above the aisle roofs, were pierced with arches, giving them a resemblance, not wholly fanciful, to flying buttresses. Nor was the architect satisfied with the resistance of these great walls, for in every case an additional buttress was placed against their outer face: some of these outer buttresses had a further function as stairway towers. The ends of the great hall and of its aisles were strengthened by the juxtaposition of lower rooms with ribbed cross-vaults. The scientific excellence of the whole scheme eclipses interest in the decoration, which has mostly perished, but was undoubtedly of great richness and magnificence.

The Basilica Nova of Maxentius[1] (Fig. 111), finished by Constantine after A.D. 313, is perhaps, even in ruin, the most impressive of all Roman monuments. It was larger than the great halls of the Thermae, but differed from them in no important respect, except that it was isolated

[1] For the basilica in general, see the next chapter, pp. 267 ff.

from the complex of rooms hitherto associated with such a structure. The increase in size lay almost wholly in length, and in the width of the aisles, for the nave was not much wider than those of the halls of the Baths of Caracalla and Diocletian, being a little over eighty feet. The increased width of the aisles, relatively to the nave, had a structural

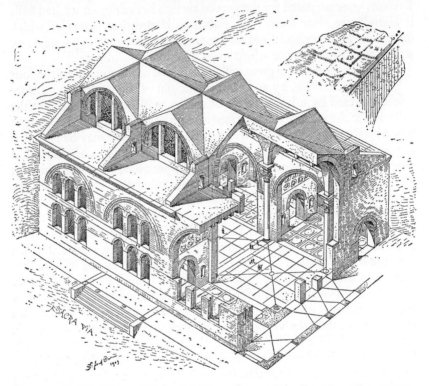

Fig. 111. Basilica Nova of Maxentius, Rome (restored by Durm). *Above to right:* fragment of vaulting with impressions of tiles. (From *Handbuch der Architektur*, Band 11, J. M. Gebhardt's Verlag, Leipzig, Germany)

reason. In an isolated building such extra buttresses as those of Diocletian's hall would have been unsightly, and it was therefore necessary to make the walls between the bays of the aisles long enough to sustain unaided the expected thrust of the main vault. These walls closely resembled those of Diocletian's hall, having arches between the bays and above the aisle roof: they had sloping tops, like those on the southwest side of that hall. The main vaulting was also similarly constructed,

with brick ribs and a lighter web, and appeared to spring from mono-lithic columns: its highest point was 114 feet above the floor. The barrel-vaults of the aisles had brick ribs with deeply coffered brick be-tween. The outer walls of the aisles were pierced with two rows of arched openings, three to a bay in each row; the lower were doors on the ground-level, and were confined to the long sides, but the upper were windows which ran all round the building. There were also huge clerestory windows in the lunettes of each bay of the nave, and similar windows at each end. At the east end was a narrow entrance-hall about half as high as the aisle walls, with a concrete roof: it had an arched opening at each end and five more to the east, and communicated with the interior by five doors. The presence of this entrance-hall did something to strengthen the east wall, and the same function was performed at the west end by an apse, almost as wide as the nave. Constantine spoilt the unity of the plan by shifting the chief entrance to the more convenient south side, where he added a columnar porch, and by throw-ing out a second apse in the central bay of the north aisle. The Basilica Nova, indestructible by fire, was a masterpiece of simplicity and grandeur. Its least effective feature was the separation of the bays of the aisles, though the arched doors between them minimized incon-venience. The building stood for hundreds of years, despite neglect of the fabric. It was substantially intact in the seventh century, when Pope Honorius I removed the bronze tiles which protected the outside of the roof, but it was in ruins four centuries later. Only the north aisle still stands, with some of the springing of the central vault.[1]

Another striking example of late Roman vaulting[2] is the temple of Venus and Rome, just east of the Basilica Nova. This was originally designed by the Emperor Hadrian, but the surviving superstructure is of the age of Maxentius, who is known to have restored it after a fire, though its concrete platform, which measures 475 by 328 feet and was surrounded by a colonnade, is original. The core of the temple consists of two barrel-vaulted cellae with very thick outer walls. Each cella ends in an apse, and the two apses stand back to back in the middle, con-cealed, however, by the continuity of the outer walls. Externally the temple was normal, being pseudodipteral, with marble Corinthian columns, ten by twenty. It is of the same order of magnitude as the largest Greek temples, measuring on the stylobate about 156 by 345 feet.

The Romans very seldom built domes entirely of masonry; the best

[1 See further note on p. 266.]
2 There is some fine late concrete vaulting, well worth a visit, in the Roman baths incorporated in the Hôtel de Cluny in Paris.

example is that of the curious round temple at Baalbek (Fig. 112 and Plate XIX *a*) already mentioned.[1] The details of its ornament resemble those of the 'Temple of Bacchus' and the Propylaea of the great temple, but seem to be in great part as late as the early third century A.D.

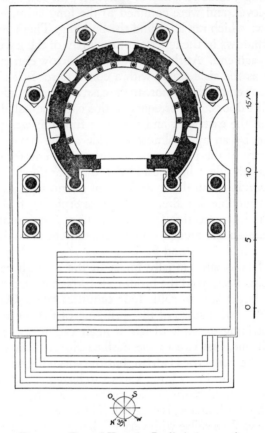

Fig. 112. Round Temple, Baalbek (restored)

The whole structure has been ascribed to the reign of the Emperor Philip the Arabian, on one of whose coins it is thought to be represented, but Weigand has recently argued that the general scheme and part of the decoration go back to the early second century A.D. The dome has fallen, but enough remains to show that it was left,

[1] See p. 230.

like much else in the temple, in an unfinished state. The plan is based on an ingenious geometrical scheme, which cannot here be explained. As in so many other Roman buildings, a large part of the wall is essentially a ring of pillars united by thin curtain walls, for there are five deep semicircular niches on the outside, though they occupy only the middle part of the wall, which is just under four feet thick. A straight north wall, containing the door, cuts off a large part of the circumference. The building stands on a rectangular podium about nine and a half feet high, and has a rectangular prostyle porch, wider than the cella, consisting of two parallel rows of four columns each, the middle pair in the back row being engaged to form the antae of a shallow porch in front of the straight north wall. There are also four Corinthian columns, with five-sided Corinthian capitals, placed pteronwise round the circular cella: their entablature is designed in a series of concave loops, the central parts of which rest on the cella wall above the niches. These sections of entablature are in fact horizontal arches, so placed as to transfer any thrust which the dome might exert on the weakest part of the walls to the heavy masses of masonry which rested on the columns. It is not known exactly how the porch was designed, but the width of the central intercolumniation suggests the use of some form of arch. It is possible that the architect meant to give the whole structure a single timber roof, which would have been like that over an apsidal rectangular building, but it seems that this was never fully executed. The inner diameter of the cella is just over twenty-nine feet.

The effect of the whole building is startlingly baroque. To an unprejudiced eye there is much that is pleasing in its bold defiance of convention: far more thought has gone to its design than to that of the average Graeco-Roman temple.

We may close this chapter[1] with a very few words about a remarkable type of Roman structure, the solid circular Mausoleum, derived from the great tumuli built by the Etruscans from the seventh century B.C. onwards. The Etruscan tumuli were sometimes as much as 160 feet in

[1] Before the subject of construction is left a word must be said of one important feature of Roman masonry, though lack of space precludes a full discussion of the topic. At least from the third century B.C. Roman builders tended to use a standard block of about 4 Roman feet by 2 by 2 (about 1·20 × 0·60 × 0·60 m.). In free-standing walls these blocks were laid in alternate courses of 'headers' and 'stretchers', *i.e.* courses consisting of two rows of blocks laid lengthwise alternated with courses consisting of single blocks running right through the wall. This method saved labour in the quarries and was structurally sound. In Greek work it was sporadic and exceptional till the Hellenistic age.

diameter: they were mainly of earth, but rested on a round rock-cut or masonry drum, and were honeycombed with chambers and galleries. One of the most famous Roman examples is the tomb of Caecilia Metella on the Appian Way, which dates from the reign of Augustus: it stood on a square podium. More important are the Mausolea of Augustus and Hadrian. That of Augustus, about 280 feet in diameter, is known from ancient descriptions to have been planted with trees and crowned with the Emperor's statue. Internally it was reinforced with rings and radiating arms of concrete walling, between which lay chambers, some barrel-vaulted, some roofless, but mostly filled with earth, contrived to neutralize the thrusts of the superincumbent earth and masonry. The magnificent outer wall, faced with travertine and carrying a Doric entablature, was seventeen feet thick and of great height.

Hadrian's Mausoleum, famous as the Castle of S. Angelo, was of the same general type, but the circular drum rose from a square podium (about 285 feet each way), as in the tomb of Caecilia Metella; it is likely, however, that the addition of this podium was an afterthought during the erection. There was a garden on the great drum, above which rose, on a square basis, a circular structure of much smaller diameter, probably crowned with a chariot-group. The height was perhaps about 180 feet.

[p. 232, n. 3. These gates are dated later and later. See summary by Chandler Shaw, *Etruscan Perugia*, Baltimore, 1939, p. 25, who himself puts the gates of Perugia second or early first century B.C. I. A. Richmond, *J.R.S.* XXIII, 1933, thinks Sullan: P. J. Riis, *Acta Archaeol.* v, 1934, p. 65, thinks 100 B.C. or a little earlier, and barely allows the true arch in Italy before the third century B.C.

p. 234, n. 1. For the origin of Roman vaulting see now H. Glück, *Der Ursprung des römischen und abendländischen Wölbungsbaues*, Vienna, 1933 (reviewed by me in *J.R.S.* XXV, 1935, p. 111).

p. 238, n. 1. For the 'Temple of Diana' see now R. Naumann, *Der Quellbezirk v. Nîmes*, Berlin and Leipzig, 1937 (reviewed by me, *J.R.S.* XXVIII, 1938, p. 106).

p. 251, n. 1. It is now suggested that these smaller arches reached inwards only to the point from which the true constructional dome, flatter than the visible coffered surface, sprang: see A. v. Gerkan, *Gnom.* v, 1929, p. 277, also *A.A.* 1932, c. 486, but compare T. Ashby, *J.R.I.B.A.* XXXVII, 1930, p. 115. It now seems certain that the dome proper is entirely made of concrete, the caementa being of lava and yellow tufa in alternate horizontal layers, and the elaborate arches in it seem to be a myth: see G. Rosi, *Bull. Comm.* LIX, 1932, p. 227, and T. Ashby, *J.R.S.* XXIII, 1933, p. 4.

p. 263, n. 1. For the Basilica Nova see now A. Minoprio, *B.S.R. Pap.* XII, 1932, p. 1, correcting some of Durm's restorations. V. Müller, *A.J.A.* XLI, 1937, p. 250, emphasizes, after A. Boethius, the influence of an old Italian type of market-building complex both on the remarkable vaulted Market of Trajan (illustrated in *J.R.S.* XXIII, 1933, Pl. III) and less directly on the Basilica Nova, but I still prefer to stress the influence of the Thermae. Müller's article ('The Roman Basilica') contains a good survey of recent discoveries and theories with new suggestions: he regards the liking for a 'cross-axis' as an Italic trait influencing the growth of the basilica.]

Basilicas, Theatres, Amphitheatres, and other Roman Monuments

Enough has now been said, in view of the limits of this book, of Roman construction in general, and of two great types of Roman building, temples and public baths. Of the many other kinds only the most important can here be described, and this chapter will deal chiefly with basilicas, theatres, amphitheatres, and monumental arches.[1] Of these theatres and amphitheatres, in particular, throw much additional light on Roman construction.

It has already been stated[2] that no Hellenistic building strictly comparable to the basilica exists in Greece or Asia Minor: but there are many different kinds of basilica, and few show any features so remarkable that their existence need cause much astonishment. Many basilicas have the clerestory system of lighting, by which the aisles, as in a Gothic church, are lower than the nave. We have spoken of some examples of this system, especially the Basilica Nova,[3] and the mysterious building near the Porta Maggiore,[4] which would doubtless have been so lighted had it not been subterranean: but this system cannot be regarded as an essential feature of the type, for it is absent from the oldest known example, that at Pompeii, shortly to be described, though this building had aisles, and from many later ones, such as those of Timgad and Trier, which were plain rectangular or apsidal halls with no inner columns at all. Leroux[5] has classified basilicas under two heads, the Greek and the Oriental, the former being entered, like a temple, from one of the narrow ends, and being normally divided by columns into nave and aisles, the latter being entered from one of the long sides, and normally having inner columns arranged in one or more concentric rectangles. The classification is convenient, but its importance is disputable: the Pompeii basilica combines the differentiae of both types, and the 'Oriental' arrangement of inner supports is found in the Lesche of the Cnidians at Delphi and also, almost complete, in the cella of the Parthenon.

It is hardly possible to frame any general definition of the basilica

1 The circus will not be described: see p. 185 for its Greek predecessors.
2 See p. 180. 3 See p. 261. 4 See p. 245.
5 *Les Origines de l'Édifice Hypostyle*, 1913, pp. 280 ff.

more detailed than this: that it is a roofed hall, usually rectangular or apsidal, and often with inner columns, serving much the same purposes as the forum, which it normally adjoins, namely general social and commercial intercourse and the hearing of law-suits: for the latter purpose there is usually a special erection, the tribunal, at one end, for the presiding magistrate. Compared to the forum, it has the disadvantage of being less spacious, and the advantage of being protected from wind and rain. Even this wide definition is perhaps too particular, for it is possible that the Pompeii basilica was mainly roofless. The erection of such halls was an obvious improvement on the traditional colonnades of the Greek agora, and perhaps began in the Greek cities of South Italy,

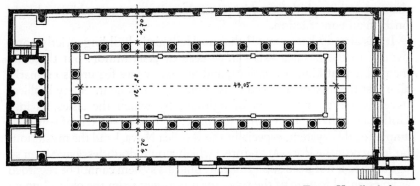

Fig. 113. Basilica, Pompeii (measurements in metres). (From *Handbuch der Architektur*, Band II, J. M. Gebhardt's Verlag, Leipzig, Germany)

though the name suggests rather one of the Hellenistic kingdoms, such as Egypt or Syria. We have seen[1] that the Hypostyle Hall of Delos, built about 210 B.C., goes far to anticipate the 'Oriental' type.

The oldest recorded basilica was the Basilica Porcia, built at Rome by the elder Cato in 184 B.C. This had three sisters in the city before the end of the second century B.C., and by the first century A.D. basilicas seem to have been almost universal in towns with any pretensions to importance.

The basilica at Pompeii (Fig. 113) appears, from stylistic considerations, to have been built about a quarter of a century before Sulla planted the Roman colony in 80 B.C.: its lower limit is fixed by the fact that one C. Pumidius Dipilus scratched his name on it on October 3rd, 78 B.C. The building may be indebted to Neapolitan prototypes, but its

1 See p. 180 and Fig. 81.

measurements are based not on a Greek but on an Oscan foot: it is possible that its model should be sought in the lost second-century basilicas of Rome, mistress of Italy long before the plantation of the Pompeian colony. That it was a basilica is certain, for several idlers have scribbled the word on the outer wall beside one of the entrances. It ran east and west, measured about 180 by about 79 English feet, and was divided by twenty-eight large brick columns into a central space with a surrounding corridor. It seems certain, from the size of their diameter, that these columns did not carry an upper tier. and it also seems certain that the outer walls were as high as the columns, so that there was no clerestory. These walls had on their inner face engaged columns for part of their height, and above that sections of wall pierced alternately with windows and with open spaces containing groups of small columns. It is disputed whether the central space was covered: perhaps the whole building had a gabled timber roof, with a flat ceiling, but it is now widely held[1] that the centre was open to the sky. The main entrance was from the narrow end to the east, through five doors, divided by piers and columns; a small courtyard lay here, between the basilica and the colonnade at the south-west end of the forum. There was also a door in the middle of each long side. At the west end was a tribunal in two storeys, of which the lower was partly underground. The tribunal was of the full height of the building, but north and south of it lay two lower rooms, one on each side. The material of the walls was lava-rubble and lime, but tufa masonry was used for the piers, door-posts, and angles. The whole was stuccoed, and decorated internally in the so-called 'incrustation' style, a plastic imitation in stucco of marble veneer, which is characteristic of the second century B.C. The brick columns, which were also stuccoed, have already been mentioned.[2]

The next oldest basilica of which much remains is the Basilica Aemilia, which lies north-west of the Roman Forum: but, though its plan seems to date from the close of the Republican period, it is so imperfectly excavated and published that it will be more instructive to describe the similar though later Basilica Julia on the opposite side of the

1 See A. Sogliano in *Acc. Nap. Mem.*, N.S. II, 1913, pp. 117 ff. There is evidence of drainage arrangements round the edge of the central space, and one or two tiles have been found there: but the presence of windows in the outer wall, which Sogliano admits, is perhaps sufficient to account for the drainage precautions and is a fact difficult to reconcile with the absence of a roof. [V. Müller (see p. 266) holds that there was a roof.]

2 See p. 235.

Forum. The original building, constructed by Julius Caesar, does not survive. Augustus rebuilt it on a new plan, which was probably in the main that of the existing remains, though the actual work seems to be mostly later than subsequent fires in the late third century A.D. The plan consists of a great central space, measuring about 52 by 269 feet, with double aisles on all four sides, separated from the central space and from one another by square piers, with engaged pilasters. The whole rectangle measures about 160 by 330 feet. What survives probably dates from the age of Diocletian, the close of the third century A.D. The piers were connected by groined concrete vaulting. There were no continuous outer walls: a third row of piers took their place, so that the plan looks like that of a tripteral temple, without a cella. There was probably a second storey, similarly schemed, except over the central space, and perhaps a clerestory wall, pierced with windows, over the innermost row of piers, carrying the cross-beams of a timber roof, which may have been concealed by a flat ceiling: but possibly the central space was not roofed. On the south side, away from the forum, a row of rooms at least two storeys high was attached to the outer row of pillars.

Of later basilicas, that of Maxentius and Constantine has already been described.[1] The basilica of Timgad in North Africa, visible to the right of the forum (13) in Fig. 86, which measured about 52 by 108 feet, lay with one of its long sides beside the forum, from which it was entered by two doors, but was planned internally on the long axis, since a raised tribunal stood at one short end, and three niches, two square and one round, at the other. It had no inner columns and was roofed with timber. A series of rooms, as in the Basilica Julia, opened from the side opposite the forum. The date is the early second century A.D.

A remarkable late basilica is that of Trier or Trèves (Augusta Treverorum) on the Moselle, which is wonderfully preserved, and is now in use as a church, having survived through the Middle Ages as a residential palace. It was probably built by Constantine early in the fourth century A.D. It is a plain rectangular hall, with a timber roof, about ninety-one feet wide internally, and almost exactly twice as long, with the addition of a semicircular apse, not quite as wide as the nave and about forty-three feet deep, at the short north end. There are no inner divisions, but the apse is divided from the nave by a great 'chancel-arch' and has a higher floor-level. The very thick walls are

1 See p. 261.

of brick-faced concrete and have two tiers of large arched windows, nine to a tier in each long side, four to a tier in the apse. Between the windows the walls are strengthened by buttress-pilasters, over ninety feet high, connected above by semicircular arches. The south front is entirely modern, but it was certainly the chief entrance, and was preceded by a columnar portico: there is also a small door at the north end of each long side, and just north of each of these a spiral staircase, lit by tiny windows, in the thickness of the wall. There are internal niches round the apse. The floor was hollow and heated by hot air.

The curia, or meeting-house of senates and municipal councils, was usually a plain rectangular hall, without inner columns, sometimes having a niche or an apse at the end opposite the door. Other similar buildings connected with civil administration were often placed beside the curia.

We must now pass to Roman theatres and amphitheatres. There are many surviving examples, and no more can here be attempted than a general sketch, illustrated by a few important specimens.

The Roman theatre, like the Roman drama, was Greek in origin, but in the earliest known examples, and in Vitruvius' description, it differs in several respects from all known Greek theatres of classical or Hellenistic times. It will be well to state the main differences at once.

The Greek theatre, consisted, as we have seen,[1] of two quite separate parts, a high auditorium, which in plan somewhat exceeded a semicircle, and a much lower stage-building, or skene: the curve of the lowest seats, round the orchestra, could be completed or nearly completed, as a circle, without cutting the front line of the skene, or even that of the slightly projecting proskenion, where there was one. In the Roman theatre the auditorium, or cavea, which was semicircular, was united as a single structure with the stage-building, so that vaulted passages were necessary to make the orchestra accessible at the point of junction: 'boxes' for important spectators were often placed over these passages. The walls of the stage-building, or scaena, were as high as the top of the cavea. The stage, or pulpitum, projected so much farther than the proskenion that the orchestra was reduced to a semicircle: moreover, while the proskenion was high enough for actors to pass beneath it into the orchestra, and its front was treated as a colonnade, closed only with wooden panels and doors, the pulpitum was low, and usually had a solid front wall, though this was sometimes pierced with doors giving access to the space beneath, especially when the pulpitum

1 See pp. 164 ff.

was floored with planks. In Roman theatres the orchestra was part of the auditorium: it was often arranged in broad steps for the accommodation of moveable chairs for distinguished spectators, and sometimes contained decorative tanks. The skene with its proskenion was usually not longer than the diameter of the orchestra, but the pulpitum was normally about twice as long and the scaena often longer still. The front wall of the skene proper was simple in design, but the wall behind the Roman stage, the scaenae frons, was usually decorated with an elaborate scheme of columns and niches in two or more tiers. Lastly, though the Romans, like the Greeks, preferred to use hill-sides for their theatres, they were often obliged, especially in large cities, to build them on flat ground, and this practice led to important developments in the structure of the cavea.

The origin of these Roman peculiarities is conjectural. They are not all the result of steady evolution in the design of the Hellenistic theatre. As late as the second century B.C., long after adaptations of Greek plays were first staged at Rome, the Large Theatre at Pompeii was built on a purely Greek plan, and it seems likely that at Sparta an essentially Greek theatre was erected under Augustus: nowhere do we find any real transition. From the late Republican period onwards many old theatres in Italy, Sicily, Greece, and Asia, including the Large Theatre at Pompeii, were wholly or partly Romanized, but the Romanization was always a drastic remodelling. It has been recognized for many years that the solution of the problem must be sought in the long period when Roman theatres were built only of wood, and in the influence on stage construction of the farces popular in South Italy, the Greek phlyakes, and the Oscan Atellanae, much played at Rome. For the phlyakes we have the evidence of vase paintings, which show actors on a wooden stage, sometimes high, sometimes low. For the wooden period of Roman theatre-building we have nothing but literary records of the scantiest sort, but it seems that at Rome theatrical architecture was long confined to a wooden stage, in front of which the spectators stood. A censor's attempt to build a permanent wooden theatre in 150 B.C. was stopped by the Senate, who refused to allow the use of seats, though we hear even earlier of plays in the Circus, which the spectators could watch sitting. In 58 B.C., however, the aedile M. Scaurus was allowed to build a wooden theatre of unprecedented magnificence, and three years later Pompey, inspired, it is said, by the beauty of the Greek theatre at Mitylene, gave Rome her first stone theatre. Vitruvius[1] speaks of many

I V, 5, 7.

wooden theatres built at Rome every year, but he gives no details, except that they had *tabulationes complures*, 'much planking' or 'many floors'.

The oldest surviving theatre planned and built under a strictly Roman government is the Small Theatre at Pompeii, an early work of the Roman colony planted by Sulla in 80 B.C. This is a rectangular structure (Fig. 114), which was undoubtedly covered with a roof, as an

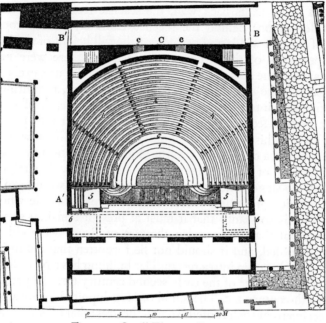

Fig. 114. Small Theatre, Pompeii

inscription testifies. Fiechter[1] has ingeniously argued that this building supplies the key to the character of Roman theatrical architecture, and for this and other reasons it deserves a careful description. In plan it is simply a small theatre, of generally Roman type, fitted into a rectangle of stone walls of uniform height by the Procrustean method of slicing off those parts of the cavea which would normally project beyond the limits of the stage. The cavea, which rests on a solid substructure, has the ordinary curved form, and the gaps left by this curve at the two back corners were used for staircases, entered by doors (*c, c*) from a

1 *Die baugeschichtliche Entwicklung des antiken Theaters*, 1914, pp. 78, 83, etc.

vaulted corridor (*C*) behind, itself entered by two doors (*B, B'*). The space between cavea and stage was greater than in most Roman theatres, but the orchestra was of purely Roman character, having four wide circular steps (1) for moveable seats. There were arched parodoi or side-entrances (*A, A'*), above which were platforms (5, 5), with three seats behind each, to serve as boxes. The stage was low and deep, and extended to the outer walls on each side. It could be entered from the outside at each end (6, 6), and there were three important and two small doors in its back wall, the scaenae frons, which had only painted decoration: behind the scaenae frons lay a deep room, the scaena, of the full width and perhaps of the full height of the building. The upper parts of the structure are lost, but there were probably windows under the roof. The main portion of the theatre, excluding the scaena behind the scaenae frons, is almost a square, measuring about ninety-five feet internally each way. The internal depth of the scaena is about thirteen feet, and the cavea could hold about 1500 people.[1]

As it stands, this theatre is obviously a compromise between a rectangular hall and a curvilinear theatre. Fiechter supposes that behind it lies a tradition of rectangular wooden theatres, with straight seats parallel to the stage. The theory is attractive, for it would explain the Roman practice of linking cavea and scaena into a single whole: but the evidence is so scanty that it must at present remain a guess. We have no proof that the wooden theatres of Rome were either rectangular or roofed, and it should not be forgotten that the fitting of a curvilinear auditorium into a rectangular building has a precedent in the Miletus Bouleuterion[2] of the early second century B.C. and perhaps also in the fourth-century B.C. Thersilion of Megalopolis.[3] There are several other specimens of such roofed Roman theatres: that of Aosta, in North Italy, which perhaps dates from the last years of the Republic, differs from the Pompeian in having a curved back wall parallel to the seats of the cavea. Some later examples are very small; for instance, two in Pisidia, one at Termessus, to hold 600 people, and another at Cretopolis to hold 200. Both had the simplest possible plans: the larger had masonry walls, about three feet thick, and measured about seventy-four feet inside each way. To such little theatres, used for music and recitations, the name Odeum was often applied, but the term was scarcely technical. It is enough to recall the Odeum of Pericles at Athens,[4] and to point

[1 H. Bulle, *Untersuchungen an griech. Theatern*, 1928, p. 205, holds that the wide steps and stage are later insertions in an orchestra reaching to the back wall.]
2 See p. 179: also p. 169, n. 2. 3 See p. 174. 4 See p. 174.

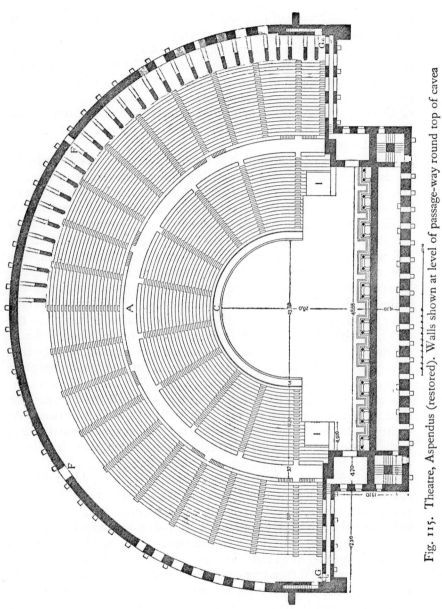

Fig. 115. Theatre, Aspendus (restored). Walls shown at level of passage-way round top of cavea

to the famous Odeum of Herodes Atticus in the same city, which was almost certainly an ordinary Roman theatre, with a roofless auditorium.

There is not space here to attempt a description of the chief surviving Roman theatres in chronological order. It will be better to start with one of the most perfect of all, that of Aspendus in Asia Minor, and then to point out, by comparison with some others, and especially with that of Orange, near Avignon in France, which is the best preserved in Europe, some of the features distinctive of the various regions of the Roman Empire.

Aspendus lies near the mouth of the river Eurymedon in Pamphylia, on the south coast of Asia Minor. Inscriptions prove that the theatre (Fig. 115), which is entirely of masonry, was built about the middle or in the second half of the second century A.D. The cavea is hollowed from a hillside, but the theatre is almost wholly Roman in character, though the curve of the seats slightly exceeds a semicircle. The cavea, which has a diameter of about 313 feet, had, like many other Roman theatres, a covered passage-way round the top: this was remodelled in antiquity. The cavea could seat about 7000 people, and 500 more could be placed in the orchestra. The stage, a little over five feet high and about twenty-three feet deep, was floored with wood. The scaena is as high as the cavea, to which it is united. It does not extend for the whole width of the cavea, with the straight side of which it is connected by projecting side-walls, versurae, just below the two ends of the great passage or prae-cinctio, which divided the seats into two tiers. The height of the scaena was seventy-five feet, its length about two hundred and five, and the clear space between its front and back walls a little over thirteen. At each of its ends was a staircase with seven rectangular windows at the back, leading to its upper storeys, of which there were two, though all inner divisions have now disappeared. The back wall, just over half of which is shown in Fig. 116, had on the ground floor five doors, diminishing in size from the middle one, and six windows. Next came an important storey, with nine rectangular windows, set back in large arched openings to increase the windows' apparent height. This storey was adorned with a series of pilasters, carrying a continuous architrave, which is carried over each opening as an arch. The next storey has the same number of plain windows, and then come two rows of projecting corbels, nine in each row, the upper set pierced with circular holes, the lower containing circular sinkings in their upper surface. Between the two rows is a series of square window-like openings.[1] The function of these corbels

1 In the plan, Fig. 115, the walls of scaena and cavea are shown at the level of these openings.

and openings will be discussed after the rest of the scaena has been described.

The scaenae frons, or front wall of the scaena, is well preserved: there are traces of marble veneer, and most of the lost detail can be restored with confidence (Fig. 117). Five doors, exactly corresponding to those in the back wall, led on to the stage, and there were two tiers of decoration, each consisting of ten pairs of free-standing columns, the lower probably of marble, the upper of granite: no capitals survive. In each row each pair of columns supported a section of entablature, complete with architrave, frieze and cornice; this entablature was carried back at

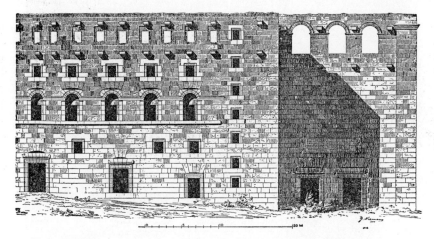

Fig. 116. Theatre, Aspendus: back wall of scaena (just over half is shown: the inscribed tablet above the doors to the right is modern)

right angles to the wall, and there continued in an engaged form. In the upper row each section of free entablature was crowned with a pediment. Those at the outer edge had half-pediments, with straight raking cornices, finishing dead at the sides: the next three pairs, on each side, had successively curved, straight, and curved pediments. The two pairs on each side of the centre had straight half-pediments, like those at the outer edges, but the whole scheme was pulled together by engaged continuations of the raking cornices of these central half-pediments on the face of the scaenae frons, making, with the engaged entablature below, a large complete central pediment, whose tympanum was adorned with sculpture in relief. All the pediments had statues as side acroteria, and there were niches with sculpture between the pairs of columns, and also three windows in the first storey. The versurae or

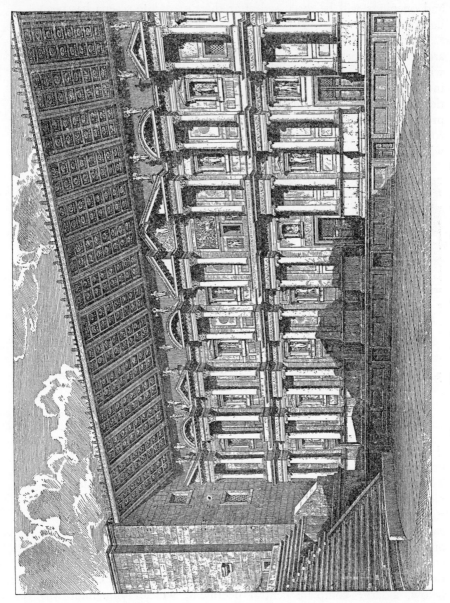

Fig. 117. Theatre, Aspendus: scaenae frons (restored)

side-walls which flanked the stage were almost unadorned, though each had two windows: in the upper part of each side wall is a sinking which marks the line of a wooden roof over the stage, sloping downwards away from the spectators to the scaenae frons. Its main beams evidently rested on a series of battlement-like piers (irregularly heightened in post-classical times) which crowned the scaenae frons, and thence continued across the scaena to its back wall, which they met at the level of the openings between the two rows of corbels already mentioned. These openings seem to have served the double purpose of holding a framework to fix the ends of the beams and of discharging rain-water outside the building. It is necessary to assume further a lower roof or ceiling, of lighter construction and sharper slope, which met the scaenae frons above the peak of the central engaged pediment but below the unsightly piers on which the main beams rested. The corbels on the back wall certainly held wooden masts: similar corbels were placed all round the cavea, and must have served to support an awning over the seats. These conclusions are reinforced by even clearer traces in the theatre at Orange, the Roman Arausio, to which we must now turn.

This theatre has often been considered contemporary with that of Aspendus, but in its main features at least it is probably as old as the first century A.D., though later than the neighbouring theatre of Arles, begun under Julius Caesar and finished under Augustus, which shows traces of the Greek type almost entirely lacking at Orange. The cavea, which is not well preserved, is larger than that of Aspendus, being about 340 feet in diameter. It is partly hill-cut, but a sunk passage runs between its back wall and a strong retaining-wall in the hill-side. Outside staircases led to this part of the top of the cavea, which was crowned all round by a covered colonnade. The free-standing parts of the theatre are built as a honeycomb of roofed galleries and staircases. This was the normal Roman practice in free-standing theatres and amphitheatres. The outer wall of such structures shows as a framework of piers connected by two or more superimposed series of arches, and usually decorated with engaged columns and entablatures, like those of the Doric gallery of the Tabularium.[1] The uppermost band of the wall is often the outer face of a covered gallery above the cavea, and may be solid or pierced with square windows. This system of construction was economical of material and greatly increased the accessibility of the various tiers of seats: it also provided covered walks for the spectators during storms. The passages were roofed in various ways, usually with

1 See p. 242.

stone or concrete barrel-vaulting: sometimes, for instance in the amphi-theatres of Arles and Nîmes, we find short sections of barrel-vaulting at right angles to the passage, and resting on stone cross-beams: some-times there were flat stone ceilings. An attempt will be made to make the main elements of one such structure clear in the description of the Colosseum.[1]

At Orange, as at Aspendus, the most striking feature is the scaena (Plates XX *a, b*). At a glance the two scaenae look much alike, but the differences between them are considerable. That of Orange is not, like that of Aspendus, a rectangular building with straight front and back walls. It consists mainly of a straight back wall, with a series of turret-like projections, of various outline, in front, most of which contain isolated but accessible rooms. These turrets, which are the scaenae frons, formed a much livelier background for columnar decoration than the plain wall of Aspendus. Again, at Orange the back wall extends con-tinuously for the full width of the cavea, the angles beyond the limits of the stage being filled in with huge rectangular blocks behind the versurae. The dimensions of the back wall, which Louis XIV called 'la plus belle muraille de mon royaume', are thus far greater than those at Aspendus: it is about 340 feet long and 120 high. On the ground-level it has externally a series of arched openings, with the usual pilasters and entablature, and the same decoration runs along the sides of the angle blocks, where there are two arched openings on the ground-level, and two on the first storey. The number of arched openings on the ground floor in the back wall itself is seventeen, and there are four blind arches. Three of the openings lead through to the stage, and these are distinguished from the rest by flat-arch lintels, with closed relieving-arches above: in two the lintel is level with the tops of the round arches of the other openings, but the central one is much higher. The rest of the openings lead into small closed rooms, except for the two at each end, which lead into the square angle blocks behind the versurae. Despite the pilaster decoration, it is clear that the lower part of this wall, including a plain strip above the openings, was originally concealed by some structure now lost, which has left traces of its side-walls and also of the position of its roof, which was straight for most of its length but slanted downwards at the ends. Even without these traces it would be necessary to assume that there was at least an open portico along the wall to shelter and conceal those actors who entered the stage from the back: the second-century A.D. theatres of Duqqa and Timgad,[2] in

1 See p. 285. 2 Visible in Fig. 86.

North Africa, which, like Orange, had no true scaena, each had such a portico at the back. Above the roof came a line of blank arcading, then a cornice, then, at a considerable interval, a projecting band of masonry, rounded on top, and lastly, at a still greater interval, the crowning cornice of the wall. There is a row of pierced corbels a little below the top, and a second row lower down, just over the cornice above the blind arcading. The two rows of corbels and the rounded band of masonry between them will be discussed at a later point.

The actual versurae, or walls which flank the stage, are as high as the back wall, but the other walls of the square angle blocks are lower, except for short sections at the angles. The lowest are the outer side-walls, while the tops of those which face the cavea slope down from the higher to the lower level: these slopes and levels show how the roofing of the angle blocks was arranged. The top of the cavea itself seems to have been a little lower than the lowest part of the outer walls of the angle blocks, and therefore considerably lower than the scaenae frons: this is an unusual scheme, and its significance will shortly be discussed.

The scaenae frons was apparently adorned with three tiers of columnar decoration, except for the central part, flanking the chief door, where there were two tiers only, and in the upper part, above the door, a great niche, probably for an Emperor's statue. A podium, which followed the line of the various projections, carried the lowest tier of columns, which stood farther from the walls than most published restorations suggest: some bits of the marble cornices still remain embedded in the walls. The pulpitum was about forty-three feet wide, at the widest, and had a straight front wall: here, as in many other Roman[1] theatres, there are clear traces of the arrangements for lowering into a trench, behind this wall, the curtain which hid the stage from the spectators. The pulpitum was boarded, and four steps led up on to it from the back doors. There were boxes above the arched entrances which led to the orchestra on each side, and in the orchestra were probably three broad steps, like the four at Pompeii,[2] for the chairs of distinguished spectators.

It remains to consider the pierced corbels and rounded band at the back, and the indications of a roof over the stage. The facts, though clear, are usually misrepresented. The general system closely resembled that of Aspendus. Sunk in the inner face of the back wall of the scaena was a series of plain rectangular niches, the tops of which were level

1 For a possible Greek precedent at Syracuse see G. E. Rizzo, *Il Teatro Greco di Siracusa*, p. 79. 2 See p. 274.

with the rounded band on the outer face. On the versurae, as at Aspendus, are traces of a roof, sloping backwards, at such a level that its tiling would come just above the tops of these niches: and at this level the whole length of the outer wall is pierced with a series of small holes, close together, which lead through to sunk channels on the upper surface of the rounded band, designed to shoot rain-water from the stage roof clear of the wall: the flat under-surface of the rounded band is undercut, to prevent water creeping back to the wall. It is clear that the niches contained a timber framework and that beams supporting a ceiling at a sharper slope, as at Aspendus, ran from the front of the upper roof to the bottom of the niches, roof and ceiling being connected by wooden ties. The whole system was self-supporting, for the lower beams rested on the top of the scaenae frons, which, wherever it is preserved, is cut at the proper angle for their reception, at a height which varies according to its distance at any point from the back wall and which is always that required by beams of this slope. The roof could not fall forward, even over the centre of the stage, except by levering up the whole top section of the back wall, which is a solid mass of masonry twenty-three feet high and more than four feet thick. It is often stated that masts in the corbels on the outer face of the back wall carried cables or chains fastened to the front of this roof as an extra support. This theory is not plausible in itself, and Caristie, in the middle of the nineteenth century, was not even the first to demonstrate its impossibility. In fact, though all the corbels are pierced except three to the east and two to the west, the rounded band between them is pierced, to allow the erection of masts, at twelve points only, namely between the six pairs of corbels which begin at the fourth from the corner on each side: and it is only at these twelve points that the necessary cuttings have been made in the projecting cornice at the top of the wall. It is therefore certain that there were only twelve masts on the back wall, all outside the limits of the stage, and it is likely that similar corbels and masts ran all round the cavea, and that the sole function of all the masts was to hold cables supporting awnings over the auditorium. At the same time the superfluous piercing of almost all the surviving corbels probably indicates a change of plan during the erection of the theatre. Caristie guessed that the scaena was originally designed to be no higher than the cavea, with a system of awnings over the stage as well as over the auditorium, and that the provision of a wooden roof was an afterthought, which involved the heightening of the scaena.

The vast elaboration of permanent decoration on the scaenae frons of the Roman theatre must have been distracting to the spectators, but it had the merit of making realistic scenery impossible. It is true that Vitruvius,[1] in his account of the Roman theatre, speaks of triangular pieces of apparatus in the spaces on each side of the stage, 'which spaces', he says, 'the Greeks call περίακτοι': these structures had different pieces of painted scenery on each of their three faces, and were turned at a change of scene. Pollux,[2] who gives a fuller description, more plausibly applies the name περίακτοι ('revolving') to the contrivances themselves: the word was feminine, and the noun μηχαναί ('machines') seems to be understood. It is, however, unlikely that such machines were in fact used in the elaborate stone theatres of the Roman Imperial age, though they seem to have left traces in some late Hellenistic theatres,[3] for instance at Elis and Eretria. The origin of the columnar scheme is disputed. It has been thought that the columns on the scaenae frons represent the proskenion, pressed back, as it were, against the face of the skene, but it is perhaps more likely that they are the translation into stone of painted decoration applied to the skene itself in late Hellenistic times: such decoration seems to be imitated in some late reliefs and in wall-paintings from Herculaneum and Pompeii.

The amphitheatre is a type of structure without known Greek precedents. This is not surprising, for its primary purpose was to seat the spectators of gladiatorial fights and other brutal shows, which Athens long refused to tolerate. Amphitheatres were never common in Greece or Asia, though under the Empire they early became universal in the Latin West. It is likely, however, that the Romans borrowed the type from the half-Greek Campanians, who, like the Etruscans, were enthusiasts for such sports long before they were known at Rome, where they took place at first in the forum without special seating arrangements. Vitruvius does not mention the amphitheatre, and advises architects to bear gladiatorial shows in mind when designing a forum.[4] The earliest surviving amphitheatre is in Campania, at Pompeii. This is older than any mentioned by ancient writers, for it was built, like the Small Theatre, in the early days of Sulla's colony, planted in 80 B.C. The earliest stone amphitheatre at Rome was built in 30 B.C. Of the many surviving examples it must here suffice to

1 V, 6, 8. 2 IV, 126.
3 See Frickenhaus in Pauly-Wissowa, *Real-Encyclopädie*, s.v. *Skene*, vol. III *a*, col. 491.
4 V, 1, 1.

describe this of Pompeii, and the culmination of the type, the enormous Colosseum of Rome.

The Pompeian amphitheatre lies just inside the eastern angle of the city walls, and is oval in plan, with its main axis approximately north and south: its extreme measurements are about 460 by 345 feet. It is more capacious

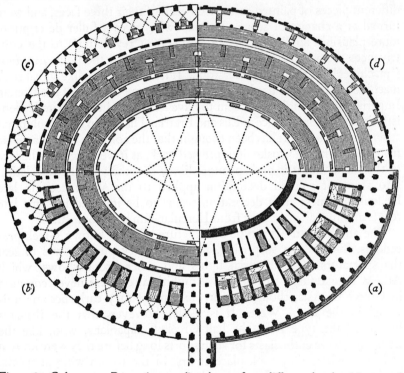

Fig. 118. Colosseum, Rome (restored): plan at four different levels: (*a*) ground floor, (*b*) first floor, (*c*) second floor, (*d*) top floor. The arrangements shown in (*c*) and (*d*) differ from those described in the text of this book

than it looks from outside, since the arena is sunk below the surrounding ground-level. The seats are supported on a solid mass of earth, ending in a broad terrace, which is kept in place by an outer wall strengthened by a series of great buttresses joined at the top by plain arches. The mass of earth is pierced only by a broad corridor at each end,[1] leading to the arena; by a narrow passage at one side, by which corpses were removed

1 That to the south takes a right-angle turn westward, to avoid the city wall.

through the 'Gate of Death'; by an oval corridor, on the arena level, behind the lowest range of seats and under the second; and by two passages on the south side leading to this oval corridor. The upper terrace, which carried a series of arched boxes, could be reached by out-side staircases. Stone seats were added from time to time, but for a century or so some of the spectators sat on the ground or on wooden benches: there were special places of honour where distinguished spectators sat on moveable chairs. Awnings were stretched from masts, as in theatres. The spectators were protected from the arena by a wall with a metal grille.

The Colosseum (Fig. 118, 118 *a* and Plate XVI *b*), which could perhaps hold some 45,000 people, is the supreme example of Roman skill in supporting an auditorium on a vast framework of corridors and stair-cases. Strong and economical structure is here marvellously combined with convenience of circulation. It was begun by Vespasian between A.D. 69 and 79, on the site of the great lake of Nero's Golden House, and con-tinued and completed by his sons Titus and Domitian. The upper part was more than once damaged by lightning in antiquity, and several ancient restorations are recorded. The oval of the plan measures about 617 by 512 feet: the corresponding measurements of the arena are 289 by 180. As at Pompeii and elsewhere, a wall with a metal fence pro-tected the spectators. There was an elaborate system of subterranean passages and chambers under the arena, as in many other amphitheatres, though not at Pompeii.

The outer wall of the building rested on eighty piers connected by stone barrel-vaults, and faced externally with three-quarter Doric or Tuscan columns[1] carrying an Ionic entablature, which ran all round the building, and internally with Doric pilasters: concentric with these was a second ring of similar piers, decorated with Doric pilasters, and then a third. Between these three rings of piers two parallel corridors, barrel-vaulted in concrete, ran all round the building: this vaulting was raised quite clear of the arches which opened between the piers. The piers of the innermost of the three concentric rings were not, like the outer ones, free-standing, but formed the lower parts of the outer ends of eighty walls[2] radiating from the arena, which supported the two chief

1 These columns have bases, of one torus on a plinth, convex necking-rings, and moulded abaci: the entablature is of Ionic type. There is no sufficient ground for labelling them Tuscan rather than Doric.
2 These walls seem to have been built, for the sake of rapid construction, as a series of rough pillars, joined by brick arches, which were not made continuous till a later stage of the work. See G. Cozzo, *Ingegneria Romana*, 1928, pp. 216 ff.

zones of seats, the maenianum primum and the maenianum secundum, which were of marble: all the higher zones of seats were of wood, so that

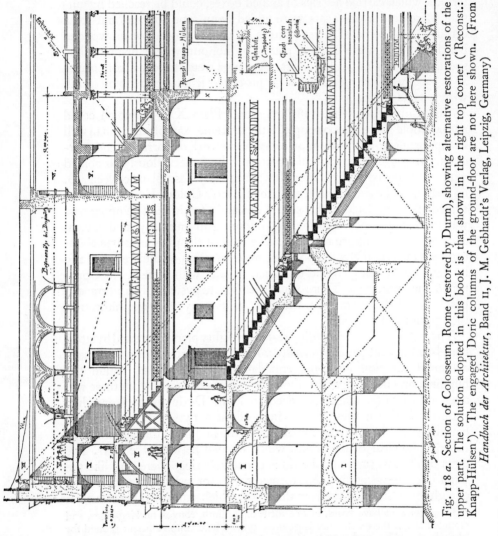

Fig. 118 a. Section of Colosseum, Rome (restored by Durm), showing alternative restorations of the upper part. The solution adopted in this book is that shown in the right top corner ('Reconst.: Knapp-Hülsen'). The engaged Doric columns of the ground-floor are not here shown. (From *Handbuch der Architektur*, Band II, J. M. Gebhardt's Verlag, Leipzig, Germany)

the heavy marble seating was entirely supported by these radiating walls. These walls were interrupted on the ground-level by two more concentric vaulted corridors nearer the arena, and the spaces between them

were utilized for staircases and passages, all vaulted. In front of the maenianum primum was a terrace or podium, above the actual wall of the arena. The visible piers of the ground-floor rested on concealed travertine piers of larger area, buried to the depth of about twenty feet.

The outer corridor and the external arcading were almost exactly duplicated on the first floor, except that the three-quarter columns were here Ionic instead of Doric. The vaulting of the ground-floor corridor, as we have seen, was higher than that of the vaults which led to it from the outer arches: it was so much higher that the floor of the first-floor corridor lay well above the cornice of the entablature carried by the ground-floor columns, and the whole second system of arches columns and entablature was separated from the first by a band of wall, which was treated as a podium, brought forward as pedestals under the columns of the second series. Since the first-floor corridor had barrel-vaulting just like that of the corridor below it, there was a similar space, treated in the same way, between the cornice above the Ionic columns and the third system of arcading on the second floor, where the columns were Corinthian. The outer corridor of the first floor was the only high corridor in the upper part of the building: the inner corridor on this floor, unlike that below it, was roofed with groined cross-vaulting, hardly at all higher than the arches which entered it from the sides, and a second still lower corridor ran between its roof and the pavement of the second floor, containing staircases. The top of the maenianum secundum was flush with the floor of the second storey, and reached as far back as the inner wall of its second concentric corridor, which was pierced with doors and windows. Above this point there is some un-certainty about the arrangements. The outer corridor of the second floor was treated like the inner one of the first floor: it had low cross-vaulting and carried a second passage above, containing staircases. The inner corridor on this floor seems to have supported on its roof a range of wooden seats, covered with a flat wooden roof supported by an open colonnade. The exterior of the top storey differed entirely from the three already described. Above the cornice over the Corinthian columns came a podium with pedestals, like those below, but the wall above this was continuous, without arcading, and flat Corinthian pilasters took the place of three-quarter columns on the pedestals: the whole was crowned with a heavy cornice supported by consoles. In alternate sections of the upper-most podium and in the other sections of the flat wall between the pilasters were rectangular windows: these two rows of windows seem to have lighted respectively two superimposed outer corridors, the highest

vaulted structures in the building. The roof of the upper corridor seems to have formed a platform flush with the wooden roof over the top seats, below the level of the top of the outer wall. This platform was probably used by the sailors who manipulated awnings stretched over the auditorium. Corbels for the fixing of masts still exist on the outer face of the wall. The total height is about 157 feet.

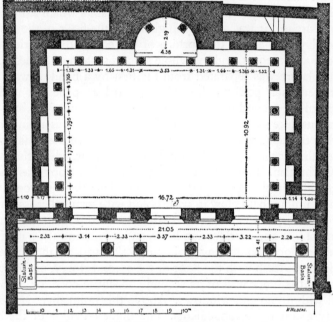

Fig. 119. The Library, Ephesus (restored)

The exterior walls and the vital parts of the inner ones were of travertine,[1] clamped with iron set in lead, but weaker masonry and brick-faced concrete were used in less important places, and all the vaulting,

1 The uppermost range of the outer wall differs in construction from the rest. Only its outer half is of solid travertine: the inner half is a thick mass of concrete, full of scraps of travertine: and the travertine facing is partly made from worked blocks taken from older buildings. It is possible that in the main these peculiarities go back to the original erection, under Titus or Domitian. Cozzo has pointed out that it was desirable to reduce the number of solid blocks to be hoisted to this height, and also to use up the mason's waste from the lower storeys: the re-used masonry may have come from Nero's Golden House: it contains, however, some demonstrably later material; for instance, an inscribed block of the time of Nerva, Domitian's successor (*C.I.L.* vi, 332–54).

except in the outer arches, was of concrete. The barrel-vaulting of the high corridors contains brick ribs, one of the earliest instances of the device: most of the lower corridors have plain groined concrete cross-vaulting.

It is pleasant to turn from such monuments of Roman brutality to the subject of Roman libraries,[1] but architecturally these are far less important, and a brief description of the best preserved example must here suffice. This is the library at Ephesus, built, as two inscriptions show, by the consul Tiberius Julius Aquila, in honour of his father Tiberius Julius Celsus Polemaeanus, a former governor of Asia, towards the end of Trajan's reign, about A.D. 115. The Romans borrowed their library plans from the later Greeks, but the only great Hellenistic library hitherto discovered, that of Pergamum, is ill-preserved. The Ephesian library was a rectangle (Fig. 119), entered from one of the long sides: it faces east, as Vitruvius advises. It was hemmed in by other buildings, and partly sunk into rising ground, so that only the façade (Fig. 120) was externally important. This, however, was richly and whimsically decorated, in a manner strongly suggestive of a scaenae frons. It was found in ruins, but the restoration is quite certain. At the top of nine steps of the full width of the building, flanked by statue-bases, stood eight columns, about two feet in lower diameter, on low square pedestals in front of the façade, which was pierced with one large and two small doors, above which were windows with marble grilles. These columns were grouped in four pairs, connected by separate sections of entablature, the spaces between the pairs being in front of the doors. The columns in each pair were about seven and a half feet apart, from axis to axis, but the interaxial measurements between the pairs were about twelve feet opposite the central door, about ten and a half feet opposite the side doors. The columns had Attic bases, smooth shafts, and Composite capitals. The sections of entablature were returned to pilasters on the wall, along which they were continued in an engaged form: between the pilasters were rectangular niches, containing statues. Upon each of these four sections of free entablature stood two unfluted Corinthian columns, but by an astonishing scheme the eight upper columns were paired differently from those below. The end columns were left solitary, each being connected with the wall behind by a single block of projecting entablature, and the six central columns were joined in three pairs by three sections of entablature, which ran

[1] For Roman provincial libraries in general and especially that of Timgad (? late 3rd cent. A.D.), see R. Cagnat in *C. R. Ac. Inscr.* XXXVIII, 1909, I, 1 ff.

like bridges above the gaps between the pairs below. The central
section, which lay directly over the chief door, carried a rectilinear
pediment, but the other two had curved ones: the single columns at the
sides had nothing above their horizontal cornices. There were pilasters
and a continuous engaged entablature on the upper half of the wall, as

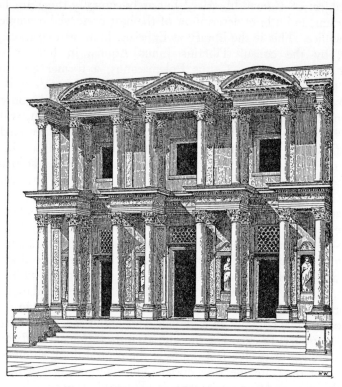

Fig. 120. The Library, Ephesus (restored)

on the lower, and between each pair of united columns was a rect-
angular window. The internal arrangements on the ground floor are
clear, but the restoration of the upper parts is conjectural. The walls
were double, except on the entrance side, and except for a block of
extra thickness in the middle of the west wall, opposite the central door,
which contained a semicircular apse more than fourteen feet across.
Passages about three feet wide ran between the outer and inner walls,
each accessible by a narrow door at its east end: the northern passage
ends, on the west side, in steps leading down to a vaulted chamber

under the apse, in which was found a marble sarcophagus, doubtless that of the founder's father. Similar double walls are found in the Pergamum library: the object was clearly to keep the papyri from damp, which would be especially dangerous when the building was built into the earth. On the inside of the inner walls were ten rectangular niches for bookshelves, three on the south side, three on the north, and four on the west: these niches were about eighteen inches deep, about six feet high, and about three feet wide. Except to the east a continuous podium ran round the inside of the room, on which, close to the wall, stood a line of small columns, which probably supported an upper row. It is likely that these columns carried two superimposed galleries giving access to two upper rows of book-niches: these galleries may have been reached by wooden stairs in the concealed passages already described. The large niche opposite the door contained two columns against the wall, and probably a large statue of Athena: Juvenal[1] summarizes the articles needed to restore a nobleman's burnt library as 'books, cases, and a Minerva to put in the middle'.

Before we pass to Greek and Roman private houses two character-istic Roman features deserve a brief mention, colonnaded streets and monumental arches, both typical of the rather pretentious magnificence of the Empire: and in connexion with the former a word must be said of the Imperial Fora of Rome. The origin of the practice of flanking streets with colonnades is hotly disputed. The most famous examples are in Syrian towns of the later Imperial age, such as Palmyra, Gerasa, and Bostra. In Timgad, founded in A.D. 100, the cardo and decumanus are flanked by such colonnades (visible in the plan, Fig. 86), which are, however, interrupted at each street crossing, while in the Syrian towns they are sometimes connected at such points by arches, and some-times have four-sided arches at important intersections: the colonnades are not always confined to the two main streets. It has usually been assumed that the custom arose in Syria or Asia Minor during the Hel-lenistic age, and these streets are not a far cry from such schemes as the eastward extension of the Priene agora,[2] with its monumental arch. There is, however, no good literary or monumental evidence for the fully-developed type in this area till the close of the Hellenistic period. Josephus, who was born in A.D. 37,[3] states that Herod the Great, who

1 III, 219. 2 See p. 189 and Fig. 84.
3 *Bell. Jud.* I, 425 (21, 11); *Ant. Jud.* XVI, 148 (5, 3). Malalas, a later writer, but a native of Antioch, seems to ascribe the colonnaded streets there to Tiberius (p. 232, =Migne, XCVII, 360 A); see R. Förster in *Jahrb. deutsch. arch. Inst.*, XII, 1897, pp. 121 ff.

died in 4 B.C., paved with marble and adorned with a colonnade on each side a famous long street at Antioch on the Orontes, and there is definite inscriptional evidence that the colonnaded streets at Olba and Pompeiopolis in Cilicia on the south coast of Asia Minor existed in the time of Augustus and Tiberius, though most of the columns are very much later. On the other hand, there was apparently a colonnaded street at Ostia,[1] the port of Rome, as early as the first part of the first century B.C. and certainly another at Herculaneum before A.D. 79. The evidence at present available cannot settle the question whether such streets were a Roman or Hellenistic invention, but they almost certainly reached their greatest development under the Roman Empire. In the Syrian towns already mentioned these columns often carried brackets for statues projecting from their shafts.

The spirit expressed by colonnaded streets perhaps found its most magnificent outlet in the series of fora by which Julius Caesar and successive Emperors extended the cramped area of the old Forum Romanum, ultimately linking it with the Campus Martius, under the slopes of the Quirinal hill. The chief common characteristics of these huge squares were their strictly axial and symmetrical planning, with temples or other monuments either in the middle of one side or in the centre of the open space, and the practice of surrounding them with very high walls, which isolated them from the surrounding streets. They were all freely provided with surrounding porticoes. The latest largest and most splendid was that built for Trajan, in the first decades of the second century A.D., by Apollodorus of Damascus. This was part of a great symmetrical scheme. Beyond the forum proper lay a basilica, the Basilica Ulpia: next came a court flanked with libraries, which contained the famous marble Doric column, 100 Roman feet high, containing a spiral staircase adorned with a continuous spiral relief commemorating the Dacian wars and crowned with the Emperor's statue. Last came an addition made by Trajan's successor Hadrian, a court surrounded by porticoes with the temple of the deified Trajan in the centre. The forum proper was entered through a magnificent gate, and the sides were bowed out in great semicircular curves. The full width was over 620 feet. The basilica was a huge roofed rectangular hall, of the same general type as the Basilica Julia, but with columns in place of rectangular piers. The free central space was eighty-two feet wide, nearly twenty feet wider than the corresponding part of the Basilica Julia. Its main

1 See G. Calza, *Ostia* (English edition), p. 92, and C. Weickert in *Gnomon*, III, 1927, p. 88.

axis lay at right angles to that of the forum, and beyond each of its short ends lay a huge hemicycle, perhaps not roofed. Trajan's Column is the ancestor of a long line of similar monuments, from that of Marcus Aurelius at Rome to the Colonne Vendôme in Paris. It is an unsatisfactory and unimaginative type, especially when adorned, as in these three instances, with spiral reliefs, impossible to appreciate except in a series of drawings or photographs.

The monumental or triumphal arch is another individual and unattractive Roman invention.

Arched town-gates,[1] as we have seen, occur in the fourth and third centuries B.C. in Asia Minor and in Italy, and Priene provides the earliest surviving example,[2] from the second century B.C., of a purely ornamental arch at the entrance of a market-place: but this was a very simple affair. At Rome there is literary evidence for the erection by Roman magistrates of monumental arches carrying statuary as early as the opening of the second century B.C., but the oldest which still exist date, with a few doubtful exceptions, from the reign of Augustus.

From this period nearly twenty survive, mostly in Italy and Gaul, though there are two in Istria and Dalmatia and perhaps one or two in Greece. Later examples are commonest in North Africa, especially from the second and third centuries A.D. The term 'triumphal arch' is Roman, but late, and they were in fact erected on various occasions. Some were placed inside the walls of newly-founded colonies to mark the limit of the pomoerium[3]: others led into fora or stood at the ends of bridges, and a few were town-gates: many served no practical purpose. They usually carried statues, commonly of gilt bronze, and they were frequently decorated with reliefs, often commemorative of historical events.

The earlier specimens mostly have single archways: the piers were always adorned with four or more engaged columns or pilasters variously arranged, and there was not infrequently an engaged pediment on each principal face. Fully detached columns are first found under Hadrian, in the second century A.D. The columns are always Corinthian or Composite, but occasionally, as in the Arch of Augustus at Aosta, these carry a Doric entablature.[4] Arches with two openings of equal size are rare, but there is one of the time of Tiberius at Saintes on the Charente.

The combination of one large and two smaller archways is rare before the second century A.D. A notable exception is the arch at Orange

1 See pp. 231 f. 2 See p. 189 and Fig. 85.
3 See p. 191. 4 See pp. 162 and 230.

(Plate XXI *a*), which received a bronze dedication to Tiberius, perhaps not originally contemplated, in A.D. 21, and may date from the Augustan or even the late Republican age. This is an elaborate but excessively ornate work, too complicated for full description here. The engaged Corinthian columns stood on podia, and carried a complete horizontal entablature, which ran round the whole. There were pediments supported by two engaged columns over the central archway on each face, which had a span of over sixteen feet, and also, unusually, on the sides of the building, where they were supported by four engaged columns. The entablature was set back over the side archways on each face of the building and also between the central columns on the sides, where there were arches in the tympanum of the pediment, below which, however, the horizontal entablature was carried across in an engaged form, so that it is doubtful whether the architect was imitating an arched entablature such as we have met at Baalbek and elsewhere.[1] The arches here may represent arched windows in the tympanum, an entirely different device, but they are probably a mere decorative adornment of this monument, with no prototype in genuine construction. Above the peaks of the four pediments ran a second cornice, and above that[2] a crowning attic of considerable height, treated as a series of pedestals, varying in width and in degree of projection. There was figure decoration on the main frieze, and almost the whole available surface was covered with reliefs. The vaults of the archways had hexagonal coffering. The arch erected in the Forum Romanum in honour of Augustus in 19 B.C., after the return of the Parthian standards, is known from coins to have had three openings, but it has perished.

As an example of simpler Augustan work, dating from about 8 B.C., we may mention that of Susa (Segusio) at the foot of an Alpine pass thirty-five miles west of Turin, perhaps the most pleasing which exists: this has a single arch with a span of about nineteen feet, and the total height is about forty-seven feet. Later arches were often very elaborate, for instance the so-called Arch of Trajan[3] at Timgad with three openings, which probably belongs to the second half of the second century A.D., and paraded as the west gate of the town. It was nearly forty feet high: the central arch had a span of nearly fourteen feet, the others of about eight feet. The existence of four-sided arches at the junction of streets has already been mentioned[4] in connexion with the

1 See p. 227.
2 E. Fiechter suggests that this attic is a later addition: see F. Noack in *Vorträge der Bibliothek Warburg* (1925/6), 1928, p. 170.
3 Marked 41 in Fig. 86. 4 See p. 291.

colonnaded streets of Roman Syria: the best known example is the Arch of Janus at Rome.[1]

Lastly a word may conveniently be said here of genuinely defensive town-gates, though no attempt can be made to treat this subject exhaustively. They are often single arches, but as early as the second century B.C. we find at Pompeii gates consisting of an outer and inner vaulted passage, separated by an unroofed court. This type is found also in Augustan work, as at Aosta, where there is a small archway each side of the large one, and the gate is flanked with towers. Under the early Empire, with its promise of indefinite peace, town-gates were often built or remodelled with more thought for magnificence than for strength, but we may close with a splendid late example, decorative but strong, the famous Porta Nigra (Figs. 121 and 122, and Plate XXI *b*) at Trier,[2] which seems to date from the late third or early fourth century A.D. It was converted into a two-storey church in the eleventh century but was restored in the nineteenth, a twelfth-century apse on the east side being, however, allowed to remain. The original gate, which was part of the ring of town-wall, consisted of an open central court, entered on each side through two arches of equal height, and flanked by two great towers, rounded on the north, outside the town, but otherwise straight-sided. The outer arches could be closed only by portcullises,[3] but there were strong gates in the inner arches. The greatest width of the whole structure is about 118 feet, its depth about fifty-two feet without the towers, about seventy-two feet with them. Externally three tiers of engaged columns, with entablatures, are carried right round the building, making three boldly-marked storeys: the lowest and tallest tier carries the entablature over the gate-arches. The towers on each side had one additional storey, with a fourth tier of columns, except on the side of the court: the east tower has lost its top storey. Between all the columns, except in the lowest range, are large arched windows. Internally the towers contained five storeys, for there was an intermediate floor half-way up the lowest external storey: the floors, which have perished, were of wood, and the internal staircases must have been of the same material. Each storey of each tower was an apsidal hall, measuring internally about twenty-two by fifty-five feet. All the halls except the top one had arched windows on the court side also, but there were no engaged columns on the inner faces. The two

[1 For monumental arches see now the exhaustive article by Kähler, *P.W.* VII A, 1939, cc. 373–493.] 2 See p. 270.
3 Slits for these portcullises and holes for wooden posts to strengthen the inner doors when closed can be seen in Figs. 121 and 122.

halls of the third storey and the two of the fourth were connected by galleries, which ran behind the arched windows above the gate-arches:

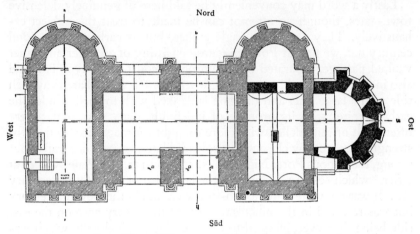

Fig. 121. Porta Nigra, Trier: ground-floor plan (black portions and barrel-vaulting in East Tower are mediaeval)

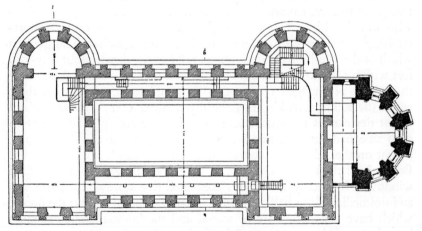

Fig. 122. Porta Nigra, Trier: first-floor plan (black portions are mediaeval, stairs modern)

these galleries also had windows facing the court. The building is of sandstone, and mortar is used only in the foundations: the jointing is admirable, but the decorative work of the columns and entablature was only roughly blocked: the columns were apparently to have been Doric.

Greek and Roman Houses and Palaces

The subject of private houses is complicated, for there was great variety of arrangement, and generalization is deceptive. Such evidence as we have, both literary and archaeological, suggests that till Hellenistic times town houses were mostly unpretentious, though little stress can be laid on the fact that they were often built of sun-dried brick, for this, though cheap, was an excellent material if kept dry, and was used, as Vitruvius points out, by Mausolus of Caria in his famous palace. We hear, however, of expensive country houses in the fifth and fourth centuries B.C., and the residences of kings, tyrants, and very rich men were doubtless at all periods tolerably luxurious. From the time of Alexander the Great onwards we have good archaeological material from many sites, but for the earlier classical period we depend largely upon allusions in Aristophanes, Xenophon, Plato, and the orators, since the actual remains are mostly ill-preserved or insufficiently investigated.[1] It would seem that Greek houses in early times were low, two storeys perhaps being usual, and that everyone who could afford it had some sort of inner court (αὐλή) on which the chief rooms opened. There was often a porch (πρόθυρον) open to the street outside the front door (αὔλειος θύρα), and sometimes a second door (perhaps called μέταυλος θύρα) at the end of a passage leading to the αὐλή. The better houses had one or more colonnades on the sides of the court, but there is very little evidence for complete peristyles before the Hellenistic age. A broad room or loggia, entirely open to the court, was a common feature: it was often behind one of the colonnades. Gardens existed, and the front door was not always the only approach. Separate women's quarters (γυναικωνῖτις) certainly existed, and in country houses these could sometimes[2] be isolated by the locking of one strong door. But the significance of this should not be exaggerated, and in small houses the γυναικωνῖτις was probably a single room. One motive for such precautions, which might escape a modern observer, is mentioned by Xenophon, the wish to keep the male and female slaves apart at night. Upper storeys sometimes had projecting balconies. Such projections are said to have been taxed by the tyrant

[1 See further note on p. 321.] 2 Xenophon, *Oecon.* 9, 5.

Hippias[1] towards the close of the sixth century B.C., and later[2] they were forbidden altogether. There is much evidence for rows of un-detached houses with common walls. The plan here given (Fig. 123) is that of a very individual stone-built house, assigned to the fifth century B.C., at Dystus in Euboea. Notable points are the open porch, the two doors in the passage, and the two courts, of which the inner has a sort of loggia with three pillars in front of it. The upper storey is in part preserved.

Of the many known Hellenistic town-sites the most important are Priene[3] and Delos. The houses of Priene, many of which date from the late fourth century B.C., were built in unusually monumental fashion:

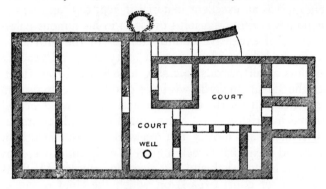

Fig. 123. House at Dystus, Euboea

their façades were largely faced with bossed ashlar masonry, and the inner walls, at least in their lower portions, were also of masonry, though of a rougher sort: there was probably sun-dried brick in the upper parts. The rooms were often of considerable height, as much as eighteen or twenty feet. The most interesting feature of these houses is the prevalence of a scheme strongly reminiscent of the megaron of the Mycenaean palace. They had inner courts, but never, till quite late times, complete peristyles, and there was almost always, on the north side, one room less deep than wide completely open to the court. This room was flanked by antae, between which, in the larger houses, stood two columns: a central door led from this room into a large room of the same width, but less wide than deep, the chief room of the house. These two rooms together are in plan almost exactly like a megaron with its

1 [Aristotle], *Oecon.* 2, 1347 *a*, 4.　　　2 Aristotle, 'Aθ. Πολ. 50.
3 For the general plan of Priene, see pp. 189 f. and Figs. 83 and 84.

porch, except that side rooms often open from the larger one. The illustrations show the plan of one such house—numbered XXXIII—in its original form (Fig. 124), and Wiegand's restoration of it (Fig. 125). We may notice the πρόθυρον set back, the passage to the αὐλή, continued along its side as a small portico, and the megaron-like scheme of the two chief rooms. The restoration has authority for the slender Doric columns and their entablature, but it is not certain that the 'megaron'

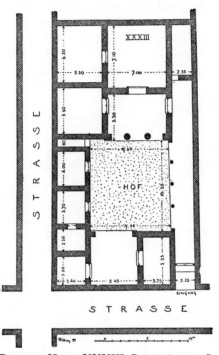

Fig. 124. House XXXIII, Priene (restored)

was emphasized by a special gabled roof and pediments, and the house may have been wholly or in part two storeys high. This house was afterwards combined with its neighbour, and a sort of peristyle court contrived, with thicker and taller columns to the north: a type called Rhodian by Vitruvius, and found both at Delos and at Pompeii.

At Delos, and also at Thera, the houses were largely poor and crowded, with only such irregular inner courts as could be contrived, without the luxury of colonnades or loggias: but the true peristyle is found as early as the third century B.C., which is the date of the oldest

known Delian houses, and was often introduced into originally simpler houses, when the owner could afford it. The peristyle was also a feature of the third-century B.C. palaces of Pergamum and Alexandria: there were at least two in each of these, but the Pergamene palace, which alone has been excavated, was a comparatively small and seemingly unpretentious structure, despite the proverbial richness of the kingdom: some of the private houses at Pompeii surpassed it in size.

The Delian houses, rich and poor, had mostly two storeys, but no more: the windows on the ground-floor were placed high enough to foil the inquisitive, but the upper storeys had many of various shapes and sizes. Most of these houses had simple doorless latrines[1] near the street, into a stone drain beneath which they directly drained: they were

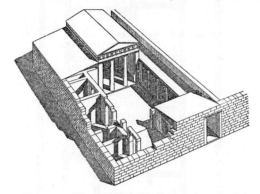

Fig. 125. House XXXIII, Priene (restored)

flushed only with slops, and the surface water of the streets did not enter the drains. For drinking the houses depended on rain, which was carefully collected and led into vaulted cisterns under the courts: the wells were untrustworthy, for the island lacks true springs. In few houses were there rooms on more than two or three sides of the court, but the entrance door was usually so placed that it opened into a passage between rooms. The richer, peristylar, type may be illustrated by the 'Maison de la Colline' (Plate XXII *a*, *b*), which occupied an isolated plot between streets. The plan was exceptionally regular. The house was almost exactly square, and the court lay in the middle of the south side, and occupied, with its porticoes, about half the total width of the house. The east, west, and south porticoes were unusually narrow: the south portico lay against the outer wall of the house. The north

1 Similar latrines have been found at Priene.

portico was twice the depth of the others, and also twice the length, for it was continued east and west to the outer walls of the house, a rare scheme, suggestive of the alae of the Pompeian atrium, shortly to be described.[1] The south-west and south-east blocks, bounded by the outer walls, the peristyle, and the side extensions of the north portico, were each divided into a wide and a narrow room. In the south-west block the narrow room to the north was the vestibule, with indications of a door at each end: the wide room, in the corner of the house, was the kitchen. In the south-east block the relative positions of the wide and narrow room were reversed: the narrow room was in the corner, and contained a wooden staircase leading to the upper floor. North of the long north portico lay the chief ground-floor rooms. This northern block was divided into two equal halves: to the west lay a single large room, with two windows on the portico and one on the street to the west: this was the chief room of the house. The east half of the block was divided into a square room, with two windows on the portico and one on the north street, and a narrower room, with one window to the north, in the north-east corner. Each of these three rooms had a door into the portico, and the two smaller were connected by another door. The portico itself was lit by a window in the west wall: that in the east wall, shown in the plan, is doubtful: at night lamps were placed in six niches, visible in the plan. The walls were decorated with painted stucco, which is well preserved, but the painting shown in Plate XXII*b*, a restored section, is imaginary, though such work is common at Delos. There was, however, a plain black-and-white chessboard mosaic in the open part of the court, beneath which lay a typical vaulted cistern. The upper floor has almost wholly perished, but it is evident that most if not all the bedrooms, and the latrine, were upstairs. There must have been a gallery round the court, and an upper range of small columns, but these have disappeared.

It is obvious that this house differs fundamentally from the Priene type, and this is equally true of the less symmetrical Delian examples. Its resemblance to the Pompeian atrium, which is really superficial, will be discussed at a later point.[2] It is noticeable that this house has no room entirely open in front: such rooms occur at Delos, but they are rare in peristyle houses, and are also absent from very poor ones. In this case the extensions of the north portico served somewhat the same purpose.

An example of the Rhodian peristyle at Delos is the House of the

1 See p. 303. 2 See p. 305.

Trident. One colonnade (in this case that to the west) had higher columns than the rest, and the junction was managed by consoles projecting from the shafts of the angle columns of this colonnade, at the level of the capitals of the other three sides.[1] It should be added that it was not rare in Delos for the upper floor to be much more luxurious than the lower: it was often an independent flat, with a separate staircase.

Vitruvius[2] describes a very elaborate and luxurious Greek house, with two courts separately entered. The first, which he calls gynaeconitis, contained what he calls prostas and oecus, which seem to be the two rooms of the 'megaron' scheme of Priene: this court is in fact a fusion of the Priene and peristyle types. The second, andronitis, is purely peristylar, and admits of the Rhodian variety. Guests' quarters are also described: these perhaps lay between the two courts.

For Roman houses the mass of evidence is overwhelming, but for the pre-Imperial period we depend chiefly upon Pompeii, where the houses were originally Oscan rather than Roman but present a clearly defined Italian type.

A few words must here suffice for the prehistoric and Etruscan houses of Italy. There is good evidence for the existence of round huts: such, for instance, was the house of Romulus, preserved or renewed till a late date on the Capitol, and we have many round urns, which obviously imitate huts. But there is also evidence for rectangular plans as early as the Bronze Age in the Terremare already mentioned.[3] We know little in detail of early Italian or Etruscan house-plans. Some urns and tombs which throw light upon roofing will be mentioned later.

The oldest houses at Pompeii, which date from the fourth or early third century B.C., consist of various rooms grouped axially and symmetrically round a central space, which is obviously that described by Vitruvius[4] as the atrium, a feature which, he declares, was unknown to the Greeks. Vitruvius distinguishes five types of cavum aedium, by which he clearly means five alternative methods of roofing the atrium: namely, the Tuscan, the Corinthian, the tetrastyle, the displuviate, and the testudinate. Vitruvius and Varro[5] regard the atrium or cavum

1 For a Rhodian peristyle at Palmyra see *Syria*, VII, 1926, p. 86. [Another at Delos is the 'Maison des Masques': see next note.]
2 VI, 7. [A. Rumpf in *J.D.A.I.* L, 1935, pp. 1 ff., identifies the insula south-east of the Delos theatre, containing the 'Maison des Masques' (see J. Chamonard in *B.C.H.* LVII, 1933, pp. 98 ff., and *Expl. Arch. de Délos*, XIV, 1933), as a Vitruvian Greek house, but the excavators were probably right in dividing the insula into three or four separate dwellings.]
3 See p. 191.　　　　4 VI, 3 ff.　　　　5 *L.L.* V, 161 ff.

aedium as a room, the chief room of the house. This view has been challenged in modern times, but before the problem is discussed it will be best to describe an almost pure example of the atrium type, one of the oldest considerable Pompeian houses, the so-called House of the Surgeon (Fig. 126). The house was originally symmetrical,[1] for the part on the right of the plan at first corresponded to that on the left. Apart from this extension it measures, to the back of the tablinum (4), about fifty-two by sixty-five feet. The front door led through the fauces (1) into the atrium (2), measuring about twenty-six by thirty-three feet, into which opened several rooms, three of which had a special character: the tablinum (4) opposite the door, and the two alae (5) right and left of the tablinum. The tablinum recalls the Greek prostas: it was always open to the atrium for its whole width, and its open side was usually flanked with pilasters and crowned with an entablature. At the back was either a large door, as here, or a window-

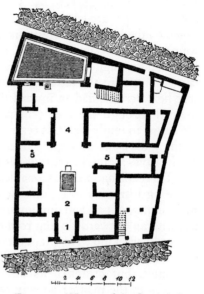

Fig. 126. 'House of the Surgeon', Pompeii

opening: the front could be curtained, the back closed by doors or shutters. The alae went right through from the atrium to the outer wall, and were quite open on the side of the court. There were upper rooms, except over the tablinum, lit by windows in the outer walls, and sometimes having balconies.[2] Sometimes there was a continuous open colonnade on the first floor, and sometimes a loggia, with two columns between antae: in such cases the upper rooms must have been bathed in light and air. Except in the oldest examples, such as this, where ashlar masonry was used, the houses were usually faced with stucco, often gaily painted, or adorned with decorative relief-work. Behind the tablinum there was often a small garden, sometimes, as originally in this case, entered from the tablinum through a portico.

1 Later it was expanded, and converted into an inn. The room to the left of the entrance was then given a door on to the street.
2 Balconies (maeniana) are imitated in some of the Etruscan house-urns.

Such was the general scheme. What are we to make of it? In the first place it must be noticed that in the oldest houses there were no columns or pillars in the atrium, though there was a drained tank in the middle of its floor, to which undoubtedly corresponded a hole in the roof.[1] The names given by Vitruvius themselves suggest that the columnar types are later: for while the types without inner columns are called by the Latin words testudinate, displuviate, and Tuscan, that with four columns is called tetrastyle, that with more than four Corinthian: both names suggest Greece. Vitruvius tells us that in the Tuscan cavaedium, as in the tetrastyle and Corinthian, the roof, whose struc-ture he describes, had an inward tilt in all four directions, so that rain drained through the hole (compluvium) into the tank (impluvium). He seems to imply that this type of roof was invented to avoid damage to the walls by rain escaping from gutters: the simple throwing of rain off the eaves would be objectionable in the crowded conditions of town life. This explanation is reasonable, and there seems no good ground for doubting Vitruvius' assertion that there existed a type called displuviate,

with compluvium and impluvium, but with an outward sloping roof of the ordinary kind. He praises this type for its good lighting, especially in winter, but criticizes its disad-vantages in the manner already de-scribed. Some Etruscan house-urns (Fig. 127) and tomb-ceilings seem to represent houses built on the dis-pluviate principle. Such buildings may have been modifications of Vitruvius' last class, the testudinate or 'tortoise-backed', which is a fully roofed house, presumably with a cen-tral hall going up to the roof,[2] though Vitruvius speaks of upper-storey

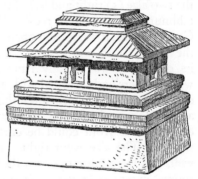

Fig. 127. House-urn from Chiusi (Clusium), in R. Museo Archeo-logico, Florence. (From *Handbuch der Architektur*, Band II, J. M. Geb-hardt's Verlag, Leipzig, Germany)

rooms in it and may possibly, as some suppose, have had in mind the Ostian type described below. The alae, which always extend to the outer wall, may have been designed for the purpose of lighting the central space in such a house, though at Pompeii they rarely contain windows.[3] This, the traditional view, is not unchallenged, and a rival theory

[1 But see note on p. 321.]
2 So clearly in Varro's description (*L.L.* v, 161 ff.): he calls it *testudo*.
3 There is a large window in the left ala of the 'House of Sallust', of the second century B.C., but it is perhaps not original.

has commanded wide assent.[1] This theory holds that the atrium is not a room tending to become a court, but a court so contracted that it might be mistaken for a room: the tablinum is regarded as the house proper, the true kernel of the complex, and the whole scheme a shrunken descendant of such a group as the great court of Tiryns, with its megaron opening on a cloistered yard. Ingenious as this view is, it seems more likely that the old Pompeian type is in origin a country or village house, with minor rooms grouped round a central hall, adapted to the cramped conditions of town life, and beginning, when we first meet it, to feel the influence of the entirely distinct Greek peristyle type.

Fiechter[2] accepts the derivation of the Tuscan atrium from a displuviate Italian peasant house, which was one large room with a roof of four slopes, but regards the Pompeian type as a fusion of this with a more palatial Etruscan house, rectangular and gabled like a temple, from which the tablinum and alae are inherited. This theory finds some support in Etruscan tomb-architecture, and there are a few house-urns which evidently represent Etruscan palaces of temple-like design. Plate XXIII *a, b* shows the most remarkable of these, which was perhaps found at Chiusi (Clusium) and is now in the R. Museo Archeologico at Florence. It is carved in soft stone, and reproduces a building of good masonry, with a pediment and a large arched door at each end. There are 'Aeolic' pilasters at the angles, and what seems to be a loggia along one side, though its detailed interpretation is difficult. It is tentatively assigned to the fourth century B.C. It should be added that some Etruscan tombs and urns seem to represent flat-roofed houses, and that a roof of this type, with a central opening, has recently been found at Pompeii.

An important feature of the Pompeian house is its strictly axial plan, which has no counterpart in Greece: the two halves are absolutely symmetrical, and the intersection of the axis of the fauces and tablinum with that of the alae reminds us of the cardo and decumanus of the Roman town. It is instructive to compare with the House of the Surgeon at Pompeii (Fig. 126) the Maison de la Colline at Delos (Plate XXII *a*), which is unusually regular for a Greek house, and may possibly have felt Italian influence. Though the scheme of the main walls in the Maison de la Colline is perfectly axial, with symmetrical spaces corresponding to the alae, we find on the main axis, in place of

1 See especially Patroni, *Rendic. Lincei*, 1902, pp. 467 ff. [E. Wistrand, *Eranos*, XXXVII, 1939, p. 1, supports Patroni with new arguments.]
2 In *Festgabe Hugo Blümner*, 1914, pp. 210 ff., and in Pauly-Wissowa, *Real-Encyclo-pädie* s.v. *Römisches Haus*, vol. 1*A*, col. 985.

the tablinum, the dividing wall between two rooms, and all the subdivisions substitute a balancing rhythm for axial symmetry: the entrance is from one side, and not even from the centre of that side.

In the second century B.C. and to a decreasing extent later we often find at Pompeii, in large houses, a Greek peristyle added to the atrium, usually behind it: and a passage on one side of the tablinum connects the atrium with the peristyle. This is now usually called the andron, after Vitruvius, who however actually[1] says that the word was used for a passage between two peristyles. The chief rooms seem, as a rule, to have continued to stand round the atrium, and the peristyle was perhaps mainly a garden, though partially surrounded by rooms: but it had the

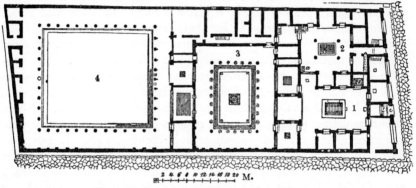

Fig. 128. 'House of the Faun', Pompeii

advantage of greater privacy. A strikingly luxurious late Pompeian house is the House of the Faun (Fig. 128), which had a Tuscan atrium (1), a tetrastyle atrium (2), a peristyle (3), and a peristylar garden (4): it is really two houses thrown into one. We may observe several shops included in the block, but disconnected from the house. This is a common feature.[2]

The Pompeian house was by no means the only Roman type, and the true atrium[3] hardly occurs outside Italy. Apart from country houses, of which we shall speak in a moment, the town houses of the Eastern and African provinces were usually Greek in plan, and Ostia and Rome itself show an entirely different form. The atrium and peristyle are both wasteful of space. They suited leisurely country towns, where ground was cheap, but in great cities it was necessary, for all but the very rich,

1 VI, 7, 5.
[2 See further note on p. 321.]
3 For an atrium at Olympia see *Olympia, die Baudenkmäler*, 1892, p. 75, Fig. 36.

to reduce unroofed space to the minimum required for light and air, and to run houses up far above the traditional limit of two storeys.

This type of house, which may conveniently be called Ostian, has the following features. The houses were in several storeys, probably four or five, and each storey repeated the plan of those below. The original number of storeys can be deduced with some confidence from the thickness of the walls preserved, from the height of the surviving storeys and from the legal limit of about sixty-eight English feet[1] fixed by Augustus for Rome, which was reduced by Trajan[2] to about fifty-eight: Nero[3] perhaps renewed the former or anticipated the latter limit after the great fire of A.D. 64. The houses often formed continuous rows of almost identical design and presumably identical height, with narrow covered alleys (angiportus) at intervals, on the ground-level only. Rooms of special traditional form and unusual height, such as the tablinum, were eliminated. The various floors were quite independent, forming flats often themselves subdivided into separate suites, each with one or two chief rooms larger than the rest. There were stone staircases at frequent intervals, opening directly on to the street. Other characteristics were the number and largeness of the windows, which were often glazed with gypsum[4]: the absence of recognizable bath-rooms, kitchens, chimneys, or latrines: and the fact that water, though laid down the streets, was not carried above the ground-floor. These houses shared with those of Pompeii a fondness for balconies (maeniana) in the upper storeys. The roofs were probably for the most part flat terraces, common to a whole row of houses: very few tiles have been found.

The ground-floor often consisted wholly or partly of shops or ware-houses, and there was much variety in the general arrangements. A long narrow court behind a row of houses, parallel to the street, was not uncommon, and small inner courts occur, sometimes adorned with fountains. Sometimes we find an alley cutting off a street corner, with shops facing into it: sometimes a house consists of two parallel blocks divided by a narrow court parallel to the street and connected on the first floor by an arched bridge. The houses were mostly faced with brick, perhaps usually not stuccoed: the arch, semicircular, segmental, or flat, was freely used, not only for windows and doors, but also for such purposes

1 Strabo, v, 3, 7 (c. 235): seventy Roman feet (of 0·296 m.).
2 [Aurelius Victor], *Épit.* 13, 13: sixty Roman feet.
3 Tacitus, *Ann.* xv, 43, *cohibita aedificiorum altitudine.*
4 The Romans also used window-glass, *e.g.* at Herculaneum and Pompeii: specimens from Silchester are in the Reading Museum.

as the support of staircases, which were mostly of stone and very rarely had open 'wells'. The ground-floor rooms often had vaulted ceilings: these occur less commonly on the first floor, but not higher up. Mosaic floors are found even in the upper rooms. This account may be illustrated by two reconstructions (Figs. 129 and 130): the roofs should perhaps have been shown flat and the brick walls not stuccoed.

A few of the better and older Ostian houses were of Pompeian type,

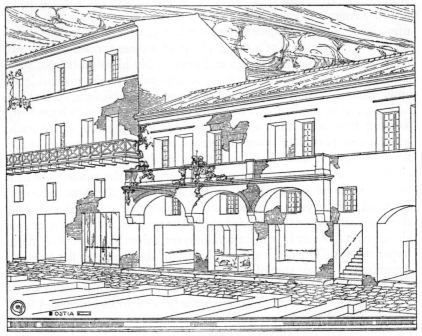

Fig. 129. Houses in 'Via di Diana', Ostia (restored)

sometimes much modified. Some of the streets were flanked with arcades of pillars, with open colonnades above. The general impression of the whole town, as all observers have remarked, is astonishingly modern: it is clear that Rome in the late Imperial age differed far less in outward appearance from a twentieth-century city than has usually been supposed.

The actual remains of houses of this type at Ostia mostly belong to the third century A.D., but several are older, and there is evidence of a general change in the first half of the first century A.D., when some

houses of Pompeian type are known to have been replaced by others of the new model. In Rome itself the actual remains of this kind are scanty

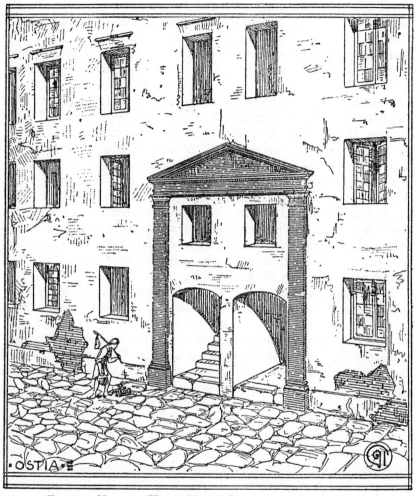

Fig. 130. House in 'Via dei Vigili', Ostia: central part (restored)

and late, but Martial and Juvenal were familiar with high tenement houses in the latter part of the first century A.D., and Vitruvius describes them as typical of Augustan Rome.

Roman country houses naturally show quite different tendencies.

Our knowledge hardly goes back beyond the last century of the Republic. In that period, and in the first century of the Empire, we already find two distinguishable though overlapping types, the town gentleman's suburban or country villa, and the genuine farm-house. It will be best to describe the farm-house type first, for it is one of the elements that went to the making of the more sophisticated villa. A country house at Boscoreale, near Pompeii (Fig. 131), which seems to date from the first half of the first century B.C., will serve as an illustration, though it is somewhat luxurious. Its total area, excluding the threshing-floor (T), was about 77 by 131 feet. The court or farmyard (A), entered at the south-west corner, was surrounded on three sides by porticoes. B is the kitchen, H the stable, C to F a small bathing-establishment, with a latrine (G); C is the furnace-room, D the apodyterium, E the tepidarium, and F the caldarium. O is the bakery, N the dining-room, P contains wine-presses, and R was an open court for fermenting wine. Y and Z contain the oil-press and olive-crusher, and S is a barn. K, L, and the three V's were sleeping-rooms, but the better living-rooms were probably in the upper storey, especially in the south-east corner. In A, 1 and 5 are cisterns, 2 a wash-basin and 3 a lead reservoir on a pillar, which supplied the baths and stable with water, through a second reservoir, 2, in the kitchen (B).

The gentleman's villa has much resemblance to the richer type of town house, but the atrium is usually omitted, or retained in a modified form, and the kernel of the house is commonly a large peristyle, round which the chief rooms are grouped, often in a casual or straggling way. A large peristylar garden is a common adjunct. Domitian's palace on the Palatine was somewhat of this type: the living-rooms were grouped round a large peristyle, and there were two other peristylar areas: one the large garden already mentioned,[1] between the throne-room and triclinium groups, the other a more private sunk garden, with one curved end, the so-called 'Palatine Stadium', which lay beyond the private apartments to the east. The famous 'Villa of the Papyri' near Herculaneum, of the first century B.C., had a degenerate atrium, a square peristyle, and a huge oblong peristylar garden. In such 'peristyle villas' we find a tendency to emphasize the exterior by elaborate entrance porticoes, as in the Villas of Diomedes and Fannius Sinistor near Pompeii, or by continuous external colonnades. This last feature was anticipated in the Leonidaeum at Olympia, a large official residence,

1 See p. 244.

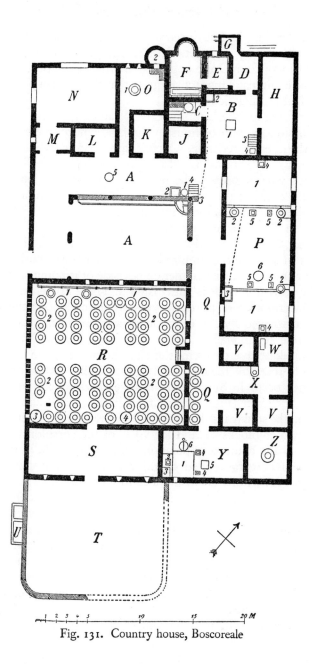

Fig. 131. Country house, Boscoreale

originally erected in the fourth century B.C.: it was a rectangle, measuring externally 263 by 243 feet, with rooms grouped round an inner peristyle of forty-four Doric columns, and had a low outer colonnade of 138 Ionic columns. This fact suggests that the Roman peristyle villa may have had Hellenistic models.

The increasing emphasis on the exterior and a growing sense of the freedom possible in country-house planning seem to have combined to drive out the interior peristyle, which is rare in ordinary villas after the first century A.D. There was indeed a gigantic peristyle, the Piazza d'Oro, in Hadrian's villa, shortly to be described, which was built between A.D. 120 and 140, but this was really a peristylar garden, and the important buildings were concentrated at one end.

Already in the first century A.D., if not earlier, we find country houses which have completely abandoned the idea of the inner court, and consist of a single rectangular block, with a closed corridor along one side, or an open portico, either on one side or running all round the block. The 'corridor villa' is anticipated in Thera in Hellenistic times, and both 'corridor' and 'portico' types are found among the villas of Campania destroyed by the eruption of A.D. 29: both types are also plainly represented in wall-paintings of the same period. We find cases where such villas have two wings at right angles, or even three, when they begin to resemble the old peristyle type again. Both corridor and portico types occur in Syria, and they are characteristic of Gaul and Britain. In Silchester (Fig. 132), founded in the second half of the first century A.D., the square insulae produced by the Roman street-plan were largely treated as blocks of land for villas of the corridor and portico types: clearly the country population refused to be fully urbanized. We even find here four-sided corridor houses (for instance, Insula XIV in Fig. 132) wholly enclosing a central court.

It is impossible to enter here into all the varieties that these forms assume. Sometimes the façade of the single-block type was emphasized by a tower at each end, as in the sea-front of Diocletian's palace[1]: sometimes, especially in the three-sided type, the centre of the back portion was curved backward. It may be added that in the north of Europe it was common to apply to living-rooms[2] the system of heating by hollow walls and floors, which in Italy was chiefly confined to bathing establishments.

At this point a word may be said of the very curious houses of

1 See p. 319.
2 The system is even found in such buildings as the Basilica at Trier (p. 270).

Fig. 132. Plan of Silchester (Calleva Atrebatum). (Scale of English feet, top right-hand corner)

Syria, found especially in the Ḥaurân.[1] Owing to lack of wood, many houses here were built entirely of stone, even to the door-posts and shutters: they are consequently well preserved, and many are still inhabited. Most of them lie outside the period treated in this book, since they date from the fourth to the seventh century A.D., when the district was ruined by the Arab invasion, but some are as old as the third. A typical house at Dûma is here illustrated (Fig. 133)[2]: it measures

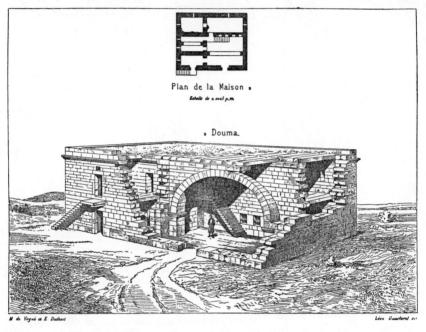

Plan de la Maison .

Echelle de 0.0025 p.m.

, Douma.

M. de Vogüé et E. Duthoit *Léon Gaucherel sc.*

Fig. 133. House at Dûma, showing interior construction

externally about thirty-three by forty-one feet. There is no sort of peristyle. The plan is rectangular, and the bulk of the house is in two storeys, but the great living-room is of the full height. The ceilings and roofs are of stone slabs, where necessary assisted by arches, with a clay terrace on top: there are flights of stone steps within and without. Light enters only through doors and narrow windows.

But these houses lie outside the main stream of tradition: we must return to Western Europe. Many rich villas, such as those described by

1 For this district, see also p. 238.
2 This house has been wholly destroyed since de Vogüé published it.

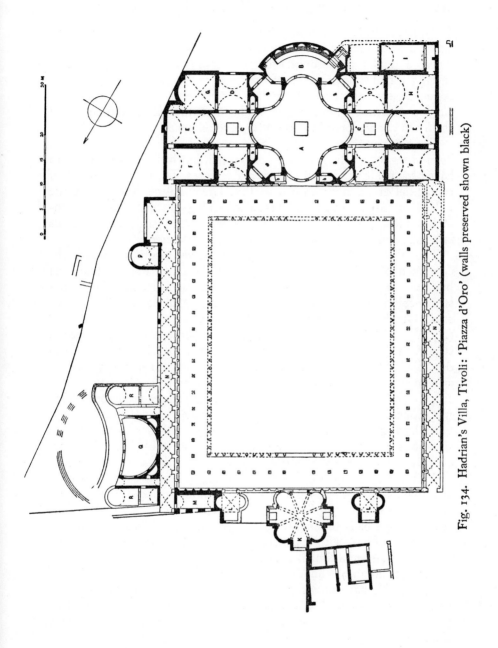

Fig. 134. Hadrian's Villa, Tivoli: 'Piazza d'Oro' (walls preserved shown black)

the younger Pliny, were very loose and straggling in plan, and contained a great variety of disconnected blocks and porticoes of various types, designed for use in different seasons and different moods: bathing establishments were of course a common feature. The most extraordinary collection of separate structures is found in Hadrian's famous villa near Tivoli, which has been mentioned more than once,[1] chiefly in connexion with structural developments.

The various parts of the villa were called after famous cities and sanctuaries which the Emperor had visited, but little attempt seems to have been made to reproduce their real features. The villa had two chief residential areas, now known as the 'Great Palace' and the 'Little Palace' or 'Academy'. There were also bathing-establishments and sun-baths, at least three theatres, a stadium or enclosed garden, and various large structures of unexplained or doubtful character.

The 'Piazza d'Oro' group (Fig. 134) already mentioned was a self-contained block in the southern part of the Great Palace. The chief buildings lay at the south end of a huge garden surrounded by a one-storey colonnade, with an inner row of columns, like an ordinary Greek stoa. Outside this colonnade, to east and west, ran covered passages (*N*, *N*), with cross-vaulted roofs, which perhaps carried a second storey. The domed vestibule to the north (*K*) has already been described.[2] The main block, to the south, consisted of many vaulted apartments, surrounding a large central room (*A*), of very curious shape. Eight principal piers seem to have carried arches, above which was probably a dome with a central opening: the thrust of this dome was taken by four apses in the corners (3, 3, 3, 3), and there was a strange sinuous line of columns between the piers. The whole building, however, is in ruins, and the details of its reconstruction are conjectural.

A full description of the rest of Hadrian's villa cannot here be attempted, for it would be unintelligible without great detail. The architect's fancy has run riot in fantastic conceptions, but there were some striking large halls of simple design, especially one great basilica-like banqueting room, with a peristylar scheme of inner columns, which seems to have had a timber roof.

The first important building described in this book was the palace of Cnossus. We have now rapidly surveyed the architectural history of nearly three thousand years, and may fittingly close with another palace, one of the last great architectural works of pagan Rome, Diocletian's palace at Salona in Dalmatia, which was finished in the

1 See pp. 252 ff. and 312. 2 See p. 254 and Fig. 107.

opening years of the fourth century A.D. The modern town of Spalato or Split lies largely within its enormous walls, about seven feet thick and

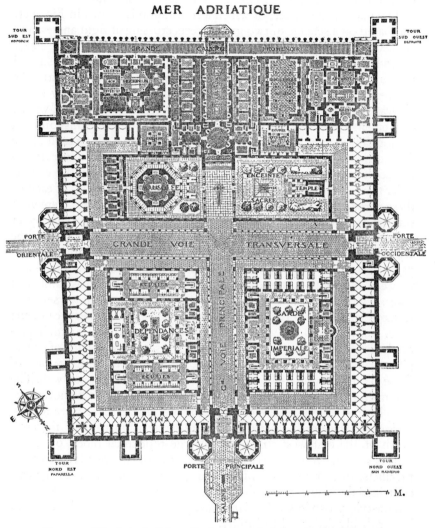

Fig. 135. Diocletian's Palace, Spalato (restored drawing by Hébrard)

about sixty feet high, which formed a slightly irregular rectangle, about half a mile in circumference. The contrast between this powerful fortress

and Hadrian's haphazard palace recalls that between Tiryns and Cnossus. Tivoli mirrors the easy confidence of an unchallenged Empire. Spalato has known barbarian irruptions and the dread of dissolution.

The plan of the palace, of which a restoration is shown in Fig. 135, was based on a scheme of two great streets crossing at right angles, and connecting four gates in the centres of the four walls: but at the south end, which lay along the sea—at the top of Fig. 135—the Emperor's actual residence stretched right across the enclosure, from east to west, and the southern part of the north-south road, though its line was clearly marked, was replaced by a domed vestibule and a rectangular hall. It will be convenient to describe the rest of the site before considering this southern section. There were large square towers outside but touching each of the four corners of the outer wall, and similarly placed octagonal towers flanked each of the western, northern, and eastern gates: six smaller rectangular towers stood in the middle of the intervening stretches of each of these three walls. The western, northern, and eastern gates[1] were very similar, each consisting of an outer and inner gateway, separated by an open court. The stretches of the great streets east, north, and west of the central crossing were flanked by colonnades. The northern limit of the palace proper is roughly marked by the rectangular towers half-way between the south-east and south-west corners and the east and west gates. The rest of the area was surrounded by a continuous series of rectangular rooms in two storeys, backed against the inner face of the outer wall: these rooms were probably the quarters of the guard. Those on the ground-floor were entered from a cross-vaulted portico of square pillars joined by arches, which opened on to a continuous street: each of those in the upper storey had a large arched window in the outer wall. The two main streets were flanked by Corinthian colonnades, with horizontal entablatures, except at the central crossing where there were arches. In each of the north-eastern and north-western quarters of the area, north of the east-west street, was a large residential block of which little is known. Immediately south of the east-west street lay two open precincts, to east and west of the north-south street. That to the east contained the Mausoleum,[2] already described: that to the west contained a tetrastyle prostyle Corinthian temple, often assigned to Aesculapius but probably dedicated to Jupiter.

1 The northern gate is illustrated in Plate XXIV *b*. The traditional names of these gates, 'Golden' to the north, 'Silver' to the east, 'Iron' to the west, and 'Brazen' to the south, date only from the sixteenth century.
2 See pp. 255 ff. and Fig. 108.

This temple stood on a podium: the external dimensions of its cella were about thirty by thirty-two feet, and the walls were nearly four feet thick. It had a stone barrel-vault about two feet thick, and deeply coffered, which has stood intact to the present day. It is now exposed to the sky, but probably had an outer roof, continuing the line of the pediments. Under the cella was a crypt, with a concrete barrel-vault.

Between the precinct of the Mausoleum and that of the temple of Jupiter, immediately south of the central crossing, the last section of the north-south street was flanked by a very remarkable Corinthian colonnade (Plate XXIV *a*), with arches springing direct from the capitals: it formed a long rectangular forecourt to the actual porch of the palace proper, which consisted of four red granite Corinthian columns, with an arched entablature over the central intercolumniation, carrying a pediment. This forecourt was about forty-three feet wide and about seventy-nine feet long. There were six columns on each side, about seventeen feet high: all were monolithic, and except for the two to the north on each side, which were of cipollino (white-and-green Euboean marble), all were of the same granite as those of the porch: the columns were joined by a screen, and on each side a gate in the central intercolumniation gave access to the two precincts lying to east and west.

The porch led into a domed vestibule, externally square. The dome, which is ruined, was of brick and concrete, and was about thirty-six feet in inner diameter. It began about fifty-six feet above the floor, and was decorated with mosaic. Behind this vestibule the palace proper stretched east, west, and south to the outer walls. The ground here drops rapidly to the sea, and there was a vaulted ground-floor, which is now our chief guide in reconstructing the upper storey, mostly lost, where the chief rooms stood. Hébrard and Zeiller explored and measured all that is accessible of these lower rooms, often under conditions of extreme discomfort. The following description will deal chiefly with the upper storey, so far as its restoration is reasonably certain.

The domed vestibule opened into a great hall, which continued the line of the north-south street. It was about thirty-six feet wide and about 102 feet long, and must have risen well above the surrounding buildings: its roof was probably of timber. At the south it opened, as did the other chief rooms, into a great gallery, about twenty-four feet wide and about 520 feet long, which ran right along the sea front, from angle tower to angle tower. At each end, and in the centre, was an open loggia, containing two marble Corinthian columns, with the entablature arched over the central intercolumniation. In each of the two

stretches, east and west of the central loggia, the gallery had twenty-one arched windows, between which, on plain corbels, connected by an ornamental band of cyma recta profile, stood engaged columns of an extremely simplified Corinthian type. These columns carried a horizontal entablature, arched at one point in each stretch, in both cases one intercolumniation east of the centre. The windows under these arches were enlarged, and behind each lay one of the chief apartments of the palace. That behind the arch in the western stretch was the largest room of all, measuring about forty-five feet by about 105 feet, probably timber-roofed, and perhaps about forty-five feet high: that to the east was perhaps a dining-room, combining barrel-vaults and a dome. Narrow courts flanked all the great halls, and there were also living-rooms, baths, and other apartments of various kinds. There was certainly a considerable stretch of wall above the arcades on the south face of the gallery, but the chief buildings must have towered high above it, making a pleasing contrast to the almost exact regularity of the façade. Under the gallery was a lower corridor on the sea level, lit only by slits, and forming externally a plain podium for the arcade. This lower corridor was reached by a passage from the domed vestibule, and had in the middle a small plain water-gate (the 'Brazen Gate'), with an open relieving-arch over the lintel, leading on to a jetty.

The resemblance of the south front to that of one type of Roman villa has already been remarked,[1] and the scheme of the residential quarter follows the villa tradition, but the general arrangement of the whole enclosure is clearly based upon the fortified frontier camp. The closest parallel is the fortress at Mogorjelo,[2] on the borders of Dalmatia and Herzegovina, which is probably slightly earlier than Diocletian's palace. The fortifications are extremely similar, and there is a palatial residence at one end of the enclosure, which does not, however, reach to the outer walls, and which has its chief façade, with projecting wings, on the inner side. Libanius' description[3] of the palace in the 'New City' of Antioch, written in A.D. 360, shows that this building, which seems to have been begun by Gallienus and finished by Diocletian, bore much resemblance to Spalato. The 'New City', which lay on an island, was circular, but it had two intersecting colonnaded streets, and the palace,

1 See p. 312.
2 See Hébrard and Zeiller in *Spalato*, 1912, p. 157, and Swoboda in *Römische und Romanische Paläste*, 2nd ed., 1924, Fig. 69, both after C. Patsch, *Bosnien und Herzegovinen in römischer Zeit*.
3 *Or.* XI, 204–206.

which stretched along the river, lay right across the line of one of the main streets, leaving a short stretch of roadway between the central crossing and its entrance, which was more beautiful than the rest and served as Propylaea. It must be remembered[1] that the praetorium in the Roman camp regularly lay across one of the main streets.

In detail, the most striking features of the palace are arches springing direct from column-capitals, engaged columns standing on isolated corbels, and decorative open relieving arches over flat-arch lintels. None of these devices is new except perhaps the second. We have already discussed arches springing direct from capitals[2]: the use of open and decorated relieving arches is often found in the second and third centuries A.D. in Syria, for instance in the great palace at Inkhil in the Haurân and in the temple at Isriya (Seriane) north of Palmyra. All these features, except the first, found only in the approach to the palace portal, can be seen in the northern or 'Golden Gate', here illustrated (Plate XXIV*b*). It is obvious at a glance that the style of this building shows a new decorative spirit. A fresh breath is coming into the exhausted classical tradition, and we stand on the threshold of the Byzantine and the Romanesque.

1 See p. 191. 2 See p. 227 and n. 4.

[p. 297, n. 1. For the Greek house see now D. M. Robinson, *P.W.* 1938, col. 223 (supplementary to the article *Haus* in *P.W.* VII, 1912, col. 2523: I have seen only an offprint kindly sent me by the author), *Prähistorische u. griechische Häuser*. The Olynthus houses (fifth and fourth centuries B.C.) are very important and show a definite 'prostas' type, with one large room to the north, open as a portico on to a court, but extending beyond it: this type is connected with such Delian structures as the 'Maison de la Colline' (Pl. XXII): see also J. W. Graham in *Excavations at Olynthus*, pt. VIII (*The Hellenic House*, joint-author D. M. Robinson), 1938, and E. Wistrand, *Om grekernas och romarnas hus*, Eranos, XXXVII, 1939, p. 1.

For palaces of the archaic and classical periods see now Larisa in Aeolis (*P.W. l.c.* c. 251) and the magnificent building at Vouni near Soli in Cyprus (*ib.* c. 254, and E. Gjerstad, *A.J.A.* XXXVII, 1933, p. 588, and *The Swedish Cyprus Expedition*, III, Stockholm, 1937), but neither is wholly or originally Hellenic: Vouni has two main periods from c. 500 to c. 380 B.C., the first in native Cypriot style, the second adding Hellenic elements, including the transformation of some rooms into a megaron, about the middle of the fifth century.

pp. 304, n. 1 and 306, n. 2. Excavation has shown that some of the oldest Pompeian atria, including that of the 'House of the Surgeon', at first lacked impluvia, and it has been argued that they were then unroofed courts. Emphasis has also been laid on the use from the third century B.C. on of external colonnades with large windows helping to light the atrium. The tetrastyle type, through the addition of upper balconies, tended to become a mere light-well: see R. C. Carrington, *J.R.I.B.A.* XLI, 1934, p. 393, and in his excellent *Pompeii*, Oxford, 1936. For Hellenistic Egypt see A. R. Schütz, *Der Typus des hellenistisch-ägyptischen Hauses*, Würzburg, 1936.]

Select Chronological Tables of Greek, Etruscan, and Roman Buildings from 1000 B.C. to 330 A.D.

NOTE:—*All measurements are in metres. Except in List G, which includes buildings of all types, temples associated with a definite deity are described by the deity's name alone, without the addition of the word Temple.*

A.

EARLY TEMPLES AND TREASURIES TO WHICH NO DEFINITELY DORIC, AEOLIC, OR IONIC FEATURES CAN BE ASSIGNED

(None of these buildings is of marble.)

I. Greece Proper and the West.

Date B.C.	Place	Dedication or name	Dimensions of plan	Remarks
? 10th cent.	Thermum	'Megaron B'	7·30 (north) by 21·40	See p. 53 and Fig. 20
9th cent.	Perachora	Hera Akraia	c. 5·50 × c. 8·00	Apsidal: see p. 61
? 9th cent.	Thebes	? Apollo Ismenius (oldest)	?	Burnt in 8th cent. B.C. Probably no columns: walls of stone and sundried brick: perhaps curvilinear
? 9th or 8th cent.	Sparta	Orthia (oldest)	c. 4·50 × ?	See p. 53 and Plate II*a*
? 8th or 7th cent.	Corone (Longà) in Messenia	? Apollo Corynthius ('Temple Δ')	5·05 × over 10·00	See p. 54 and Pausanias, IV, 34, 6. Single row of inner columns. One of a group of very early buildings on this site
c. 580	Gaggera near Selinus	'Megaron' of Demeter Malophoros	9·52 × 20·41	See p. 55
c. 580	Olympia	Treasury of Gela	c. 11·00 × c. 13·20	See p. 55. Addition of Doric porch to one long side early in 5th cent. B.C. increased dimensions to c. 13·20 × c. 13·40
? 6th cent.	Bassae (Mount Cotilius)	(*a*) ? Aphrodite	6·47 × 15·43	See p. 55
		(*b*) ? Artemis	5·74 × 9·25	

II. Aegean Islands and the East.

Date B.C.	Place	Dedication or name	Dimensions of plan	Remarks
? 10th cent.	Karphi	Temple	?	Rectangular, but plan complex and obscure: see p. 61
8th cent.	Dreros	Temple	5·50 × 9·50	Rectangular: see p. 61
7th cent.	Prinia	(a) 'Temple A'	5·925 (front) and 6·35 (back) × 9·70	See p. 56 and Fig. 21
		(b) 'Temple B'	c. 5·50 × c. 18·00	See p. 57. Very irregular shape
7th cent.	Gortyn	Apollo Pythios	c. 19·00 × c. 16·70	See p. 57
7th cent.	Vroulia (Rhodes)	Chapel	4·66 and 4·70 × 8·38	Traces of Minoan tradition. Altar two-thirds way back, low platform behind it. Sun-dried brick walls
? 7th cent.	Dreros	Temple of Apollo Delphinios	10·70 × 24·00	Resembles Prinia temples: column-bases of Minoan type
? 7th cent.	Delos	'Oikos of Naxians'	10·30 (west) and 9·70 (east) × 25·50	Purpose doubtful. Had at first central line of eight pairs of wooden columns, side by side and very close together, sunk in holes in rock. Early in 6th cent. B.C. eight Ionic marble columns replaced them: porch (distyle *in antis*) perhaps of same date. Later, prostyle opisthodomus added and other changes made
? 7th cent. late	Delos	'First Temple North' (? Apollo: πώρινος νεώς)	c. 10·00 × c. 15·60	Ill-preserved. ? Four columns between antae of porch
? 6th cent.	Palaikastro in Crete	Dictaean Zeus	?	Little survives but terracotta ornaments

B.

'AEOLIC' TEMPLES

(None of these buildings is of marble.)

Date B.C.	Place	Dedication or name	Dimensions of plan	Remarks
7th cent.	Neandria	Temple	c. 9·30 × c. 21·00	See p. 57 and Figs. 22 and 23
7th or early 6th cent. (cella older)	Larisa in Aeolis	Temple	3·25 × 6·25	See p. 59 and p. 61 n. and Plate II*b*
? 7th cent.	Nape	? Apollo Napaios	?	See p. 58: capitals found at Kolumdado

Appendix I

C.

DORIC TEMPLES AND TREASURIES TO 150 B.C.

(*Where any of these buildings is mainly of marble, the fact is stated.*)

[All temples marked * have pronaos and opisthodomus each distyle *in antis*.]

Date B.C.	Place	Dedication or name	Dimensions of cella with porches and adyta	Number of pteron columns	Inner columns	Dimensions of stylobate	Remarks
Early 7th cent.	Thebes	Apollo Ismenius (second temple)	?	?	?	?	Ill-preserved: part of a column drum (*c.* 0·08 high) of one piece with stylobate
c. 640	Thermum	Apollo	*c.* 4·60 × *c.* 32·00	5 × 15	Single	12·13 × 38·23	See p. 66 and Fig. 20. For similar temples in the same precinct see p. 67
? *c.* 640	Delphi (Marmaria)	Athena Pronaia	?	Probably peripteral	?		See p. 65 and Fig. 25: the oldest form of this temple
Late 7th cent.	Olympia	Hera (Heraeum)	*10·72 × 40·62	6 × 16	See p. 63	18·75 × 50·01	See p. 62 and Fig. 24 for this temple and its predecessors
? Late 7th cent.	Delphi	Treasury of Kypselos	6·50 × 13·00	None	None		Later became Treasury of Corinth
? 7th cent.	Gonnos in Thessaly	Temple	*c.* 8·00 × *c.* 10·00 (greatest measurements)				See p. 55 for this and Homolion. Horse-shoe plan
c. 600	Cyrene	Apollo (oldest)	*c.* 10·00 × *c.* 23·25	6 × 11	Double	*c.* 16·75 × *c.* 30·05	See p. 67
Early 6th cent.	Corcyra (Garitsa)	Artemis	9·40 × 34·66	8 × ?	?	*c.* 21·94 × *c.* 47·50	See p. 69 and Fig. 26
? *c.* 580	Delphi	Old Tholos	Diameter 3·54	13 (in ring)	None	Diameter 6·32	See p. 85. Frieze of 20 triglyphs and 20 metopes
c. 575	Syracuse (Ortygia)	? Apollo (perhaps rather Artemis)	*c.* 11·60 × ?	6 × ? 17	None	*c.* 21·60 × ?	See p. 69. Pronaos distyle *in antis*: back uncertain [see C. Picard *R.A.* 6e sér. x, 1937, 115
c. 575	Syracuse (by Anapos)	Zeus Olympios (Olympieum)	?	6 × 17	None	*c.* 22·10 × *c.* 62·40	See p. 69
c. 575	Tarentum	Temple	?	?	?	?	See p. 71
? *c.* 575	Megara Hyblaea	Temple	7·75 × 28·40	? 6 × ? 15	None	17·55 × 41·40	Ill-preserved
† *c.* 570	Selinus	'Temple C'	10·48 × 41·63	6 × 17	None	23·93 × 63·765	See p. 71 and Figs. 27 and 28

[† E. Gàbrici in *Mon. L.* xxxv, 1933, 67 maintains this dating, but many critics assign it to the middle or second half of 6th cent.: see E. Langlotz, *Zur Zeitbestimmung der…Vasenmalerei*, 1920, 37; B. Ashmole, *Proc. Brit. Acad.* xx, 1934; W. Darsow, *Sizil. Dachterrakotten*, 1938, 110. The dates of other Selinus temples are affected by this dispute. E. Pfuhl in *A.M.* xlviii, 1923, p. 169 n. 2, accepts Langlotz's late dating of the metopes of temples C and F, but suggests that they are later than the rest of the structure. The dates in this table are probably too early, but it is difficult to fix alternatives.]

Date B.C.	Place	Dedication or name	Dimensions of cella with porches and adyta	Number of pteron columns	Inner columns	Dimensions of stylobate	Remarks
? *c.* 570	Aegina	Aphaia (older)	? *c.* 7·00 × ? *c.* 14·50	None	? Double		See p. 69. Foundations lost: distyle *in antis*. Very archaic remains. A still earlier shrine (? middle of 7th cent.) has left terracottas
c. 565	Paestum (=Posei-donia)	? Poseidon ('Basilica')	13·37 and 13·52 × 42·95	9 × 18	Single	24·525 × 54·295	See p. 75 and Figs. 30 and 30*a*. [For other early temples near Paestum see p. 81, n. 1]
†*c.* 560	Selinus	'Temple D'	9·87 × 39·28	6 × 17	None	23·53 × 55·96	See pp. 73, 75. Front porch distyle *in antis*, but antae are engaged columns, so that the effect is tetrastyle prostyle: adyton
†*c.* 560	Selinus	'Temple F' or 'S'	9·20 × ?	6 × 14	None	24·23 × 61·83	See pp. 73, 75 and Fig. 29. Probably closed anteroom: adyton
? *c.* 560	Selinus (Gaggera)	Shrine	3·02 × 5·22	None	None		See pp. 54, 55. Two monolithic prostyle columns: entablature of a single piece, architrave in two fasciae, no frieze, no mutules on cornice
? *c.* 560	Assos	Temple	7·97 × 22·33	6 × 13	None	14·03 × 30·31	See p. 84 and Fig. 36
? *c.* 560	Athens (Acropolis)	Athena Polias	12·30 × 33·50	None [?]	See p. 83		See p. 82 and Figs. 34 and 35. Later made peripteral (see *c.* 520 B.C.). [For recent arguments that this temple was peripteral from the first see p. 84 n. 1]
c. 550	Pompeii	Greek Temple	? *c.* 8·00 × ? *c.* 16·00	? 7 × ? 11	None	17·24 × 17·779	Ruined before A.D. 79. Possibly once longer. Bottoms of some columns worked on stylobate (not certainly original)
? *c.* 550	Eretria	Apollo Daphne-phoros	?	Perhaps peripteral	Single (? wooden)		See p. 72. Sculptures *c.* 520 B.C. Lies over curvilinear buildings. Rebuilt peripteral (*c.* 21·00 × *c.* 43·00) early in 5th cent. B.C.
First half of 6th cent.	Sunium	Athena (older)	*c.* 5·15 × *c.* 8·40	None	None		See p. 55. Prostyle porch of two columns
c. 540 (to *c.* 470)	Selinus	Apollo ('Temple G' or 'T')	*c.* 25·00 × *c.* 85·00	8 × 18	Double	50·10 × 110·36	See p. 85 and Figs. 37 and 38

[† See note on p. 324.]

Date B.C.	Place	Dedication or name	Dimensions of cella with porches and adyta	Number of pteron columns	Inner columns	Dimensions of stylobate	Remarks
c. 540	Corinth	Apollo	*c. 12·26 × c. 42·00	6 × 15	Double	21·36 × 53·30	See p. 87. [Date confirme by pottery, S. S. Wein berg, *Hesperia*, VIII, 193 191.] For remains of larger Doric temple se p. 362
c. 530	Paestum	'Temple of Ceres'	7·814 × 23·627	6 × 13	None	14·527 × 32·875	See p. 76 and Figs. and 32
c. 530	Orchomenus in Arcadia	Temple in lower city	c. 5·93 × c. 26·50	6 × 13	None	13·33 × 31·22	Distyle *in antis*: adyton or opisth domus
? *c.* 520	Athens (Acropolis)	Athena Polias (peripteral)	*12·30 × 33·50	6 × 12	See p. 83	21·34 × 43·44	See p. 88 and Fig. 3 (See also *c.* 560 B.C.)
c. 520	Metapontum	Temple ('Tavole Paladine')	?	6 × 12	?	c. 15·80 × c. 33·20	See p. 75
c. 513 to 505	Delphi	Apollo ('Fifth' or Alcmaeonid temple)	?	6 × 15	?	c. 21·65 × c. 58·00	See p. 89. The olde Doric building with su stantial *marble* elemen The 'Fourth' temp burnt in 548 B.C., pe haps formed the kern of the 'Fifth'
c. 510	Olympia	Treasury of Megara	6·40 × 13·40	None	None		See p. 45 n. 2. Distyle *antis*
? *c.* 510	Delphi	Treasury of Athens	6·68 × 9·75	None	None		Distyle *in antis*. *Marb* [The official view Audiat in *F. de D.* 1933) is still for *c.* 4 B.C.]
c. 510	Agrigentum (=Akragas)	'Hercules'	*13·90 × 47·65	6 × 15	None	25·34 × 67·00	See pp. 85, 86, 111
c. 510	Locri Epizephyrii (Casa Marafioti)	Temple	?	?	?	? c. 20·00 × ? c. 40·00	See p. 103
c. 505	Delphi (Marmaria)	Athena Pronaia (second)	7·71 × 20·57	6 × 12	None	13·25 × 27·449	? Amphidistyle *in antis*
? *c.* 500	Corcyra (Cadachio or Kardaki)	Temple	7·38 × ?	6 × ?	None	11·90 × ?	See p. 71. No frie East end with porch fallen over cliff a perished. Has been signed to Hellenis age
? *c.* 500	Rhamnus	Themis (or Nemesis, older)	6·40 × 10·70	None	None		See p. 42 n. 3. Distyle *antis*. Polygonal wa *marble-like limestone* columns and details *limestone*

Date B.C.	Place	Dedication or name	Dimensions of cella with porches and adyta	Number of pteron columns	Inner columns	Dimensions of stylobate	Remarks
c. 490	Caulonia	Temple	*c. 9·00 × c. 29·00	? 6×? 14	None	18·20 × 41·20	
c. 490	Sunium	Poseidon (older) (formerly called Athena)	*c. 9·00 × c. 21·20	6×13	? Double (close wall, ? engaged)	13·12 × 30·34	Destroyed by Persians before completion
? c. 490	Athens (Acropolis)	Athena Parthenos (older Parthenon)	?	6×16	Probably double	23·510 × 66·888	See p. 113 [and p. 114 n. 1 for alternative date 479 B.C.]. *Marble*
c. 490	Aegina	Aphaia (later) (formerly called Athena or 'Jupiter Panhellenius')	*8·01 × 22·54	6×12	Double	13·80 × 28·50	See p. 112. The somewhat earlier 'temple of Aphrodite' [probably Apollo] in Aegina (c. 500 B.C.) has not yet been fully published: its predecessor (c. 600 B.C.) has left a large semicircular antefix and a very archaic capital. [See G. Welter, *Aigina*, Berlin, 1938, for all this and *A.A.* 1938, 17, for the capital.]
c. 490	Selinus	'Temple A'	*8·80 × c. 28·70	6×14	None	16·235 × 40·237	Has adyton. 'Temple O,' ill-preserved, was very similar
c. 490	Selinus	? Hera ('Temple E' or 'R')	*14·23 × c. 49·70	6×15	None	25·324 × 67·823	Has adyton
c. 480	Agrigentum	Zeus Olympios (Olympieum)	Pseudo-peripteral	7×14 (engaged)	See p. 122 and Fig. 52	52·85 × 110·00	See p. 122 and Fig. 52. Some would date the beginning earlier than 480
c. 475–450 (and c. 325–300)	Delos	Great Temple of Apollo	*7·20 × 20·55	6×13	None	13·72 × 29·78 (foundations)	Long break in building. *Marble*
c. 470	Syracuse	Athena (now Cathedral)	*c. 12·50 × c. 42·00	6×14	None	c. 22·00 × c. 55·00	
c. 470	Agrigentum	'Juno Lacinia'	*9·45 × c. 28·00	6×13	None	16·895 × 38·13	
c. 460	Olympia	Zeus	*16·03 × 48·68	6×13	Double	27·68 × 64·12	See p. 112 and Fig. 17
c. 450	Paestum	'Poseidon'	*13·485 × c. 46·00	6×14	Double	24·285 × 59·99	See p. 136

Date B.C.	Place	Dedication or name	Dimensions of cella with porches and adyta	Number of pteron columns	Inner columns	Dimensions of stylobate	Remarks
? †c. 450– 440	Athens	? Hephaestus ('Theseum')	*c. 8·00 × c. 22·55	6 × 13	None	13·72 × 31·77	See p. 118. *Marble*
447– 432	Athens (Acropolis)	Athena Parthenos (later Parthenon)	21·72 (E.) and 22·34 (W.) × 59·02 (N.) and 59·83 (S.)	8 × 17	See p. 114 and Fig. 49	30·86 × 69·51	See p. 113, Fig. 49 and Pl. IV a. *Marble*
c. 440	Agrigentum	'Concord'	*9·68 × c. 27·40	6 × 13	None	16·23/ 16·91 × 39·44/ 39·35	See pp. 110, 112, 120 n. 2, 136
? †c. 435	Rhamnus	Nemesis	*c. 6·50 × c. 15·00	6 × 12	None	c. 10·10 × c. 21·30	See p. 115. Unfinished. Ionic frieze above each cella porch, arranged as in 'Theseum' at Athens (p. 118). *Marble*
c. 430	Segesta	Temple	Cella destroyed ?	6 × 14	?	c. 23·25 × c. 57·50	See p. 136. Unfinished
? †c. 425	Sunium	Poseidon (later)	*c. 9·00 × c. 21·20	6 × 13	? None	13·48 × 31·15	See p. 115. Modelled on its predecessor (see c. 490). Ionic frieze over each porch carried across pteron and continued round interior of each end of pteron. *Marble*
c. 420	Delos	'First Temple North', 'Temple of the Athenians'	9·686 × 17·01	None	None		See p. 125, n. 2. Hexastyle amphiprostyle: curious plan. *Marble.* [For this and the Great Temple of Apollo see now *Expl Arch. de Délos,* XII 1931]
? c. 420	Bassae, near Phigalea	Apollo Epicurius	c. 9·00 × c. 29·50	6 × 15	See p. 138 and Fig. 58	14·63 × 38·29	See p. 136 and Figs. 58 59 and 59a. An older temple (late 7th cent. has left only tiles
c. 410	Argos (near)	Hera (Heraeum)	c. 10·00 × c. 27·00	?	?	c. 17·40 × c. 38·00	See p. 145. Its predecesso (? late 7th cent.), burn in 423, has left littl trace
c. 405	Delphi	Treasury of Sicyon (later)	6·35 × 8·43	None	None		For older remains under i see pp. 71 and 89 ('Ol Treasury of Syracuse' and Old Tholos (? c. 580
c. 400	Delphi (Marmaria)	'Great Tholos'	Outer diameter 8·41	20 (in ring)	10 Corinthian, slightly engaged	Diameter 13·50	See p. 141 and Pl. V b *Marble*

[† Dinsmoor now dates 'Theseum' 449–4, Sunium 444–0, Rhamnus 436–2. See *Hesperia,* IX, 1940, 47 and *Proc Amer. Philol. Soc.* LXXX, 1939, 152 and 163–5. Shoe, *Mouldings,* dates 'Theseum' 450–40, Rhamnus c. 43 Sunium c. 423.]

Date B.C.	Place	Dedication or name	Dimensions of cella with porches and adyta	Number of pteron columns	Inner columns	Dimensions of stylobate	Remarks
? c. 390	Oropus	Amphiaraus	c. 14·25 × c. 28·50	None	Double (? Ionic, un-fluted)		Pronaos has six Doric columns between antae faced with Doric half-columns. No adyton or opisthodomus. Traces of reconstruction: dating disputed
c. 380	Epidaurus	Asclepius	c. 7·00 × c. 16·40	6×11	None	c. 11·90 × c. 23·00	See p. 146. Pronaos distyle *in antis*: no opisthodomus
c. 375	Olympia	Mother of the Gods (Metroum)	*7·12 × 13·80	6×11	? double, close walls	10·62 × 20·67	See p. 146
c. 370	Thebes	Apollo Ismenius (third temple)	*9·30 × 21·60	6×12	None	22·83 × 46·25	
c. 360–c. 330	Delphi	Apollo ('Sixth' and last temple)	?	6×15	Probably none	c. 21·65 × c. 58·00	Follows plan of 'fifth' temple (see c. 513 to c. 505). *Marble* only for details
c. 360	Tegea	Athena Alea	*10·80 × 33·284	6×14	See p. 143 and Fig. 60	19·16 × 47·52	See p. 143 and Figs. 60 and 61. [E. Pfuhl, *J.D.A.I.* XLIII, 1928, thinks that decorative forms are later (after 350 B.C.).] *Marble*
c. 350	Epidaurus	Tholos (Thymele)	Outer diameter c. 14·65	26 in ring	14 Corinthian in ring	Diameter 21·82	See p. 144 and Pl. Vc. *Marble*. The frieze of the entablature of the Corinthian columns is convex in profile: friezes convex or with double curvature are common in Roman Corinthian, but never predominant
c. 330	Nemea	Zeus	*c. 11·60 × c. 31·10	6×12	See Remarks	c. 20·00 × c. 42·50	See p. 145. Six inner Corinthian columns each side, close to wall, joined across cella by two more, making a sort of adyton as at Bassae (see Fig. 58)
c. 330	Epidaurus	Artemis	c. 8·20 × c. 12·10	None	See Remarks		See p. 146. Hexastyle prostyle porch, 8 columns in all. Ionic inner columns on three sides, those at back close to wall. Two similar worse preserved temples (? Themis and ? Aphrodite)

Date B.C.	Place	Dedication or name	Dimensions of cella with porches and adyta	Number of pteron columns	Inner columns	Dimensions of stylobate	Remarks
c. 325–300	Delos	Apollo					Work resumed (see c. 475–450)
c. 320	Stratos	Zeus	*9·59 × 20·49	6 × 11	See *Remarks*	16·64 × 32·44	Fluting incomplete. Probably inner Ionic columns on three sides, perhaps carrying frieze and dentils. Cella possibly hypaethral
? c. 290	Pergamum	Athena Polias	*7·25 × c. 16·80	6 × 10	None	12·27 × 21·77	See p. 146
c. 280	Samothrace	Arsinoeion: dedicated to the 'Great Gods' by Arsinoe, daughter of the first Ptolemy	Outer diameter c. 19·00	None	See *Remarks*		Circular: plain wall below, ring of 44 Doric antae above joined by curtain walls and carrying Doric entablature. To these antae corresponded inside Corinthian half-columns. Roof apparently low and conical. *Marble*
? c. 260	Samothrace	Cabiri (new temple)	Extreme measurements of foundations are 13·12 × 39·61, widened to 14·50 for the porch, whose steps lay outside the line of the cella walls	None	Double		Narrow cella, externally rectangular, entered from the south, with a shallow segmental apse inside the north end. Abnormal prostyle porch with two rows each of six columns: the rows are two intercolumniations apart, and are arranged like the 14 easternmost peripteral columns of 'Temple C' at Selinus in Fig. 27. *Marble*
? c. 250	Agrigentum	Dioscuri	?	6 × 13	?	? c. 14·00 × ? c. 31·50	? Restoration of 5th-cent. building: see *Rev. Arch.* 5ᵉ sér. XXVIII, 1928, p. 138
c. 180	Lycosura	Despoina	11·15 × 21·34	None	None		See p. 235 n. 3. Hexastyle prostyle. Greek brick, ill-baked, and poor mortar
c. 150	Pergamum	Hera Basileia	c. 7·00 × c. 11·80	None	None		See p. 159. Façade *marble*

D.

(All these buildings are mainly of marble, unless otherwise stated.)

IONIC AND CORINTHIAN TEMPLES AND TREASURIES TO 150 B.C.

(a) Ionic.

Date B.C.	Place	Dedication or name	Dimensions of cella with porches and adyta	Number of pteron columns	Inner columns	Dimensions of stylobate	Remarks
? c. 565	Naucratis	Apollo	?	?	?	?	See p. 98 for this and the other Naucratis temples, and Fig. 45. Columns *limestone* (later *marble*). Cella probably sun-dried brick
c. 565	Delphi	Treasury of Cnidus	?	None	None		See p. 100
c. 560	Ephesus	Artemis ('Croesus temple')	c. 25·40 × c. 80·50	Dipteral: 8 × 20 (? 9 at back)	? Double	55·10 × 109·20	See p. 90 and Figs. 39 to 42. For its earlier stages see p. 91
c. 560	Samos	'South Building'	c. 13·10 × c. 39·00	8 × 17	Single	c. 23·80 × c. 45·60	See p. 98 for further details. *Limestone*
c. 560	Samos	Hera (older Heraeum)	c. 25·00 × c. 71·00	Dipteral 10 × 21	Double	c. 50·50 × c. 103·00	See p. 95 for this 'Rhoecus temple' and its predecessors. Partly *limestone*, partly *marble*
c. 550	Delphi	Treasury of (?) Clazomenae	?	None	None		See p. 100
c. 530	Delphi	Treasury of (?) Massalia	c. 6·25 × c. 8·55	None	None		See p. 101 and Fig. 46
c. 530	Delphi	Treasury of Siphnos	6·134 × 8·547	None	None		See p. 100 and Pl. III*a*
c. 510	Athens	Zeus Olympios (older Olympieum)	?	Dipteral and tri-pteral 8 × ? 20	?	42·90 × 107·70	See p. 102. *Limestone*. Unfinished and not certainly meant to be Ionic: see further under c. 170 B.C. (Corinthian)
Late 6th cent.	Paros	Temple	c. 16·50 ×?	None	?		Porch c. 7·70 deep. Exquisite details
Late 6th cent.	Naxos	Temple	13·77 × 34·92	None	Double		See p. 90. Two porches distyle *in antis*, two cellae. Unfinished
Late 6th cent.	Chios (Phanai)	Apollo Phanaios	?	?	?	?	See p. 150. Diameter of column-bases about ⅓ that of those of 'Croesus temple' at Ephesus, about 1½ that of those of Treasury of Massalia at Delphi
Late 6th cent.	Chios (Pyrgi)	?	?	Probably none	Probably none	?	Diameter of column-bases slightly greater than that of those of Treasury of Massalia at Delphi

Date B.C.	Place	Dedication or name	Dimensions of cella with porches and adyta	Number of pteron columns	Inner columns	Dimensions of stylobate	Remarks
c. 525 and later	Samos	Hera (Heraeum)	*c.* 27·40 × *c.* 81·00	Dipteral and tri-pteral. 8 and 9 × 24	None	54·58 × 111·50	See p. 95 and Figs. 43 and 44. Partly *limestone*, partly *marble*
? *c.* 470	Locri Epize-phyrii	Temple of Marasà	*c.* 9·60 × *c.* 33·60	? 7 × ? 17. Possibly 6 in front, 7 behind	Probably none	*c.* 17·40 × *c.* 43·80	See p. 103. *Limestone.* For the oldest form of un-known style (*limestone*, 8·43 × 25·86), probably of early 6th cent., see pp. 90 and 103
? *c.* 470 and later	Sunium	Athena (later)	11·50 × 16·00	See *Re-marks*	4, in square	14·78 × 19·34	Mentioned by Vitruvius, IV, 8, 4. Pteron only on E. and S. sides, number of columns uncertain, but probably Ionic. All columns probably later than cella. Date doubt-ful. Walls perhaps sun-dried brick. Columns *marble*
c. 450	Athens	Temple on Ilissus	*c.* 5·70 × *c.* 12·40	None	None		See p. 125. Perhaps the Metroon in Agrai
? mid-5th cent.	Miletus	Temple of Athena	?	? 6 × ? 10	?	? 16·764 × ? 24·628	See p. 103 n. 4. Stood on podium. Evidence is extremely scanty
c. 425	Athens	Athena Nike ('Nike Apteros')	5·381 × 8·268	None	None		See p. 125 and Fig. 53
c. 421–407 (main-ly)	Athens	Erechtheum	13·004 × 24·073, at foot of lowest step	None	None		See p. 127 and Figs. 16, 54 to 57 and Pls. III *b*, V *a*
? *c.* 365	Samothrace	Cabiri (re-building of old temple)	*c.* 11·00 × *c.* 27·50	None	?		Enlargement in marble, in Ionic, of a small archaic Doric temple, with primitive mutules (see p. 43 n. 3)
c. 356	Ephesus	Artemis (later temple)					See p. 147 and Fig. 63. Plan approximately same as 'Croesus temple' (see under *c.* 560), except for additional steps
c. 335 (and later)	Priene	Athena Polias	11·84 × 29·48	6 × 11	None	19·55 × 37·20	See pp. 147 and 162 n. and Figs. 18, 19 and 64
c. 335	Olympia	Philippeum	*c.* 8·30	18 in ring	12 Corin-thian half-columns	Diameter *c.* 14·00 (founda-tions *c.* 15·50)	See p. 145 and Fig. 62. *Limestone*

Date B.C.	Place	Dedication or name	Dimensions of cella with porches and adyta	Number of pteron columns	Inner columns	Dimensions of stylobate	Remarks
Late 4th cent.	Priene	Asclepius	6·97 × 12·02	None	None		Tetrastyle prostyle porch
c. 330 (and later)	Didyma near Miletus	Apollo Didymaios	c. 28·90 × c. 80·75	Dipteral 10 × 21	See p. 152 and Fig. 66	51·13 × 109·41	See p. 152, Fig. 66 and Pl. VI. The Naïskos (see p. 153) measured 8·590 × 14·536
c. 325	Sardis	Artemis or Cybele	22·50 × 67·50	Pseudo-dipteral 8 × 20	Double	c. 48·50 × c. 104·00	See p. 149. The stylobate measurements are here given without regard to the special arrangements of the steps at the west end
? c. 280	Messa in Lesbos	Temple	14·91 × 32·67	Pseudo-dipteral 8 × 14	None	22·214 × 39·974	See p. 145 n. 1. Date much disputed. *Limestone*
? c. 250	Sminthe	Apollo Smintheus	c. 10·00 × c. 28·00	Pseudo-dipteral 8 × 14	None	c. 23·00 × c. 40·00	Ten steps all round
After 197	Magnesia on the Maeander	Zeus Sosipolis	7·38 × 15·82	None	None		See p. 48 n. 8. Pronaos tetrastyle prostyle, opisthodomus distyle *in antis*. Perhaps work of school where Hermogenes was trained
c. 175	Delos	? Artemis ('Temple D')	c. 10·00 × c. 15·00	None	None		Hexastyle amphiprostyle. *Marble*, but inner walls of *gneiss*, doubtfully assigned to an earlier temple
c. 130	Magnesia on the Maeander	Artemis Leukophryene	c. 14·75 × c. 41·00	Pseudo-dipteral 8 × 15	Double	31·30 × 57·70	See p. 155 and Figs. 67 and 68. Scanty remains of archaic Ionic predecessor
c. 130	Teos	Dionysus	c. 11·00 × c. 28·00	6 × 11	None	c. 18·50 × c. 35·00	See pp. 154 ff.

(*b*) Corinthian.

For buildings with Corinthian *inner* columns or half-columns, see (i) under *Doric*, Bassae *c.* 420, Delphi ('Great Tholos') *c.* 400, Tegea *c.* 360, Epidaurus (Tholos) *c.* 350, Nemea *c.* 330, Samothrace *c.* 280; and (ii) under *Ionic*, Olympia (Philippeum) *c.* 335. See also the Choregic Monument of Lysicrates (List E (*b*) under 334), and the Bouleuterion of Miletus (List E (*b*) under *c.* 170).

Date B.C.	Place	Dedication or name	Dimensions of cella with porches and adyta	Number of pteron columns	Inner columns	Dimensions of stylobate	Remarks
? *c.* 290	Diocaesarea (Uzundja Burdj) a few miles west of Olba in Cilicia	Zeus Olbios	?	6 × 12	?	*c.* 22·00 × *c.* 40·00	See footnote[1] and p. 160 n. 5
c. 170	Athens	Zeus Olympios (later Olympieum)	*c.* 19·00 × *c.* 75·00	Dipteral and tripteral 8 × 20	?	41·10 × 107·75	See p. 160. Finished under Hadrian, *c.* A.D. 130

1 The temple of Zeus Olbios is known only from brief reports and a small photograph (*Jahreshefte d. österr. arch. Inst.* XVIII, 1915, Beiblatt, p. 27, fig. 9). An inscription proves that a portico on the west side of the precinct was originally roofed by Seleucus Nicator (306–281 B.C.): the temple need not be of the same period, but the description of the capitals by Herzfeld and Guyer (*Arch. Anz.* 1909, 434 ff.) and the photograph both suggest an early date. The bottom third of the columns (*c.* 42 feet high) was hardly fluted. Seleucus was ancestor of Antiochus Epiphanes, who built the first certainly Corinthian temple, the Olympieum at Athens, *c.* 170 B.C. [Now briefly described by J. Keil and A. Wilhelm in *Mon. As. Min. Antiq.* III, Manchester, 1931, 47, figs. 67, 68. They agree on the Seleucan date, and the drawing of the capital (fig. 67) fully confirms it. Mr A. W. Lawrence, who has seen the temple, thinks that it may be as early as Alexander, and that historical considerations make that likely.]

E.

GREEK STRUCTURES OTHER THAN TEMPLES, TREASURIES, OR PRIVATE HOUSES TO 150 B.C.

(*a*) Unroofed Theatres. [See also p. 185 n.]

(In almost every case the skene at least was frequently remodelled at later dates.)

Date B.C.	Place	Remarks
From 6th cent. (Especially *c.* 330)	Athens (Theatre of Dionysus)	See p. 164
c. 400	Syracuse	See p. 166 n. 2
? *c.* 400	Thoricus	Auditorium of irregular shape perhaps based on ancient assembly-place: no trace of skene
c. 350	Megalopolis	Skene, etc. of wood till late date, for reasons of local convenience
c. 330	Epidaurus	See p. 165 and Fig. 71
c. 300	Priene	See p. 167 and Figs. 72, 73 and 84
c. 300	Sicyon	

Date B.C.	Place	Remarks
c. 300–260	Delos	
? c. 300	Eretria	Probable date of oldest skene: whole theatre rebuilt in (?) 3rd cent. B.C.
c. 280	Ephesus	Rebuilt in late Hellenistic times (c. 150 B.C.) and frequently in Roman times (from c. A.D. 40 onwards)
? c. 230	Pleuron (New) in Aetolia	Skene built against city wall, perhaps without upper storey. Has been dated 2nd cent. B.C.
? c. 230	Segesta	
? c. 210	Tyndaris	
c. 200	Magnesia on the Maeander	Partly 4th-cent. B.C. Skene ill-preserved
c. 200	Pompeii (Large Theatre)	Perhaps rather later
c. 170	Pergamum	Skene, etc. of wood till 1st cent. B.C.
c. 160	Delphi	
? c. 150	Oropus	

(*b*) Structures other than Unroofed Theatres.

Date B.C.	Place	Name	Remarks
? Late 7th cent.	Eleusis	Telesterion (oldest)	See p. 169 and Fig. 74
c. 525	Eleusis	Telesterion (Pisistratean)	*Ibid.*
? c. 525	Amyclae	Throne of Apollo	See p. 105 and Fig. 47
Late 6th cent.	Athens	Old Bouleuterion	See p. 169 n. 2
? 6th and 5th cent.	Olympia	Bouleuterion	See p. 163
? c. 490	Athens	Propylaea (older)	See pp. 89, 118
? c. 475	Delphi	Stoa or Colonnade of the Athenians	See p. 127. The interaxial measurement was 3·57
c. 470	Athens	Tholos	See p. 169 n. 2
c. 468–465	Delphi	Lesche of Cnidians	See p. 164
437–432	Athens	Propylaea (Mnesiclean)	See p. 118, Figs. 50, 51 and Pl. IV *b*
? c. 435	Athens	Odeum of Pericles	See p. 174
c. 430	Eleusis	Telesterion (Periclean)	See p. 171 and Figs. 74 to 76
? c. 405	Xanthos	'Nereid Monument'	See p. 135
Late 5th cent.	Athens	New Bouleuterion	See p. 169 n. 2
c. 370	Megalopolis	Thersilion	See p. 174 and Fig. 77
c. 353	Halicarnassus	Mausoleum	See p. 150 and Fig. 65
c. 347–329	Piraeus	Philo's Arsenal	See p. 182 and Fig. 82
? c. 340	Delphi	Column of the Dancing Maidens	See p. 141. Some assign it to the first quarter of the fourth century
334	Athens	Choregic Monument of Lysicrates	See p. 144
319	Athens	Choregic Monument of Nicias	Interesting as a dated example of late 4th-cent. Doric
? c. 300	Messene	Assembly Hall	Resembles Priene Ecclesiasterion, but has circular orchestra
c. 300	Priene	Arched town-gates	See p. 231
? c. 290	Alexandria	Pharos	See p. 184
Between 285 and 247	Samothrace	'Ptolemaion': propylon dedicated by Ptolemy II	Hexastyle amphiprostyle, with richly decorated Ionic capitals: there is an arch in the substructure
c. 210	Delos	Hypostyle Hall	See p. 180 and Fig. 81

Date B.C.	Place	Name	Remarks
c. 200	Priene	Ecclesiasterion	See p. 176, Fig. 78 and Pl. VII. Notium, near Colophon, possessed a somewhat similar building, probably Hellenistic: see also Messene (? *c.* 300) *supra*
c. 180	Pergamum	Great Altar	See pp. 157, 158
? *c.* 175	Tyros (= 'Arâq al-Amîr) in Syria	Palace of Hyrcanus	Remarkable mixture of Hellenistic and Oriental styles. The date and attribution are not certain. It may be a century older
c. 170	Miletus	Bouleuterion	See pp. 159, 161, 179, 180, 210 n. 1, Figs. 70, 79, 80 and Pl. VIII *a*.
? *c.* 160	Pergamum	Library	The building is in poor condition: it may date from the 3rd cent. B.C.

F.

TEMPLES IN THE ETRUSCAN-LATIN TRADITION TO 150 B.C.

The existence of a great number of such temples can be inferred from discoveries of architectural terracottas. Only a selection of those which have left indications of their plan or exceptionally rich terracottas is here attempted.

Century B.C.	Place	Dedication or name	Remarks
Mid-6th	Satricum (= Conca)	Mater Matuta	See p. 200. Single narrow cella: external colonnade, except at back: *c.* 12·00 × *c.* 24·00. Rebuilt larger, different orientation, *c.* 500 B.C. Repaired *c.* 200 B.C.
Late 6th	Falerii Veteres (= Città Castellana)	? Mercury ('Sassi Caduti')	Plan obscure: rich terracottas, some of 4th to 2nd cent. B.C. Several other temples, including one of Apollo (p. 201), some of late 6th cent. B.C.
Late 6th and 4th	Marzabotto, Acropolis	Three (? five) temples	See p. 200. Two (*c*) and (*e*) had triple cella: (*c*) measured 19·00 × *c.* 22·80. Another (*d*) was 9·00 square, with projection 2·80 wide on S. side, ending in three steps: podium has heavy mouldings: but both (*b*) and (*d*) were perhaps altars, not temples
Late 6th	Signia (= Segni)	Capitolium	See p. 200. Triple cella: rebuilt *c.* 300 B.C.
Late 6th	Rome	Capitolium	See p. 200. Triple cella. Many early architectural terracottas have been found at Rome, and other temples of this school at Rome are known from tradition
? Late 6th	Veii	Apollo	See p. 200. Triple cella, *c.* 18·50 wide. Terracottas

Century B.C.	Place	Dedication or name	Remarks
5th	Lanuvium (= Città Lavinia)	Juno Sospita	? Triple cella. Terracottas
Early 5th to early 3rd	Orvieto (= Volsinii, probably), Pozzo della Rocca	Temple	Triple cella. Terracottas chiefly of ? early 4th cent. Podium measures 16·90 × 21·91, with addition of 6·15 for steps. Inner measurements of the three cellae: 3·80, 5·48, 3·80
Late 4th/3rd	Falerii Veteres (= Città Castellana)	Juno Curitis ('Celle')	Triple cella. Details obscure
3rd	Aletrium (= Alatri)	Temple	See p. 199. Single cella, with two prostyle columns, c. 8·00 × c. 15·00
? Late 3rd	Gabii	Temple	See p. 204
? 2nd	Paestum	'Corinthian-Doric' Temple	See p. 204 and Figs. 90, 91. Possibly 3rd cent.

To this list may be added the triple-cella temples of Florentia (Florence) and Faesulae (Fiesole), probably Capitolia, but their surviving remains are not older than the 1st cent. B.C. The earlier form of the Temple of Jupiter at Pompeii (see p. 212) probably had a wooden entablature: it perhaps belonged to the 3rd or 2nd cent. B.C. [Add the late 6th cent. temple of Dea Marica on the site of Minturnae: see P. Mingazzini in *Mon. L.* XXXVII, 1938, 693.]

G.

GREEK AND ROMAN BUILDINGS OF ALL KINDS FROM 150 B.C. TO A.D. 330

(All temples have Corinthian columns, unless otherwise stated.)

I. Roman Republican Period (150–31 B.C.).

Date B.C.	Place	Name	Remarks
144	Rome	Aqua Marcia	See p. 236
? 2nd half of 2nd cent.	Ancyra (= Angora)	Temple of Rome and Augustus	[Formerly dated c. A.D. 1–10, but see now D. Krencker and M. Schede, *Der Tempel in Ankara*, 1937]
c. 120	Pompeii	Temple of Apollo	See p. 206 and Fig. 92. Originally 'diagonal' Ionic
? c. 120	Pompeii	Stabian Baths	See p. 243
109	Rome (near)	Pons Mulvius	See p. 236
c. 105	Pompeii	Basilica	See p. 268 and Fig. 113
c. 100	Pompeii	Temple of Isis	Rebuilt, partly with old materials, after earthquake of A.D. 63. Individual plan
? c. 100	Rome	Carcer or Tullianum (strictly only the lower chamber was the Tullianum)	Curious subterranean circular structure, nearly 7·00 in diameter, with flat stone vault, much repaired: above is a vaulted trapezoidal chamber (sides measure from 3·60 to 5·00) of c. 100 B.C. Date of lower chamber perhaps 3rd cent. B.C., but often thought much older

Date B.C.	Place	Name	Remarks
c. 90	Rome	Two Ionic temples under S. Nicola in Carcere	See p. 207
c. 85	Agrigentum	'Oratory of Phalaris'	Lately proved by an inscription to be a Heroum dedicated to a Roman matron about this date. Tetrastyle prostyle, combining Ionic columns with Doric entablature
c. 80	Rome	Temple near S. Nicola ai Cesarini. (? Hercules Magnus Custos)	Circular peripteral (? 16 columns), 14·82 in diameter
c. 80	Tibur (=Tivoli)	Round temple by waterfall ('Temple of Vesta')	See p. 210 and Pl. IX *a*
c. 80	Tibur (=Tivoli)	Rectangular temple by waterfall ('Temple of the Sibyl')	Ionic, pseudoperipteral
c. 80	Praeneste (=Palestrina)	Temple of Fortune	A complicated group of buildings, on a series of terraces, of much structural and decorative interest
c. 80	Cora (=Cori)	Doric temple	See p. 209 and Fig. 93
c. 80	Pompeii	Temple of Jupiter (later form)	See p. 212
? *c.* 80	Lagina	Temple of Hecate	Pseudodipteral, 8×11. [Perhaps some 40 years earlier: see Schober, A., *Der Fries des Hekataions von Lagina*, Baden bei Wien, 1933, p. 26.]
78	Rome	Tabularium	See p. 240 and Figs. 100, 101
c. 75	Pompeii	Small Theatre	See p. 273 and Fig. 114
c. 70	Pompeii	Amphitheatre	See p. 283
c. 70	Suwaida	Tomb of Hamrath	See p. 221
62	Rome	Pons Fabricius	See p. 236 and Pl. XIV *a*
55	Rome	Theatre of Pompey	See p. 272. Little survives but substructures: plan in *Forma Urbis* (for which see p. 3 n. 2)
c. 54–34	Rome	Basilica Aemilia	See p. 269. This is perhaps date of main lines of surviving structure: some parts date from 78 B.C., others from restorations of 14 B.C. and A.D. 22. Original date was 179 B.C.
c. 50	Athens	Horologium of Andronicus of Cyrrhus ('Tower of the Winds')	See footnote[1]. Described by Vitruvius (I, 6, 4) and mentioned by Varro (*R.R.* III, 5, 17)
49	Eleusis	Inner Propylaea	See p. 230

1 Marble octagonal building, *c.* 7 m. in inner diameter, 12·80 m. high: covered with a self-supporting conical roof of 24 marble slabs, converging on a hole filled with a sort of Corinthian capital. These slabs follow externally the octagonal outline of the walls but are rounded within: the walls are octagonal inside as outside. There is a circular cornice, with the profile of an Ionic architrave, at the top of the wall inside and another circular cornice a short distance below: between these two cornices, in each angle, is a small Doric column. There are also two richer

Date B.C.	Place	Name	Remarks
? c. 40	Rome	Temple of 'Fortuna Virilis' (?)	See p. 211 and Pl. X b. Ionic
? c. 40	Augusta Praetoria (= Aosta)	Roofed theatre	See p. 274
? c. 40	Asisium (= Assisi)	Temple of Minerva	See p. 215. Hexastyle prostyle, steps carried back between columns which thus stand on pedestals
? c. 40	Glanum (= S. Rémy)	Monument of the Julii	
36	Rome	Regia	Very ancient structure, rebuilt in 148 B.C. and again (in marble) in 36 B.C. Trapezoidal plan, but with rectangular temple-like portion, with engaged pilasters and false windows
? c. 35	Suwaida (perhaps the ancient Soada or Dionysias)	Peripteral temple	See p. 220. Capitals of Corinthian type, but abnormal, as are the bases: so at Sî'
33/32–13/12	Sî'	(a) Temple of Ba'al Shâmîn	See p. 220. Later parts, in purely Oriental style, A.D. 50–100
		(b) Temple of Dushara (Nabataean wine-god) (probably later than (a))	See p. 227 n. 1. Earliest known example of arched architrave

NOTE:—With the Sî' temples may be grouped two other Nabataean temples of partly Oriental character in the Ḥaurân, those of Sûr and Saḥr, which must belong to the later part of the 1st cent. B.C. or the earlier part of the 1st cent. A.D.

II. Augustus and Tiberius (31 B.C.–A.D. 37).

Date	Place	Name	Remarks
31 B.C.	Rome	Circus Maximus	Existed earlier and often restored
? c. 31 B.C.	Rome	Doric Temple under S. Nicola in Carcere	See p. 207
? c. 31 B.C.	Rome	Round Temple by Tiber (? Temple of Portunus)	See p. 211 and Pl. X a
? c. 30 B.C.	Arausio (=Orange)	'Arch of Tiberius'	See pp. 293 f. and Pl. XXI a. Has been dated 49–44 B.C., and also later
? c. 30 B.C.	Arelate (=Arles)	Theatre. Amphitheatre	See p. 279. Both perhaps begun under Julius Caesar
? c. 30 B.C.	Nemausus (=Nîmes)	Amphitheatre	Closely resembles that of Arles. [Date disputed: Espérandieu, *L'Amphithéâtre de Nîmes*, 1933, says Augustan, but Naumann (see p. 266) says early 2nd cent. A.D.]

cornices at lower points, which follow the lines of the walls: the upper of these has dentils and is one of the earliest cornices supported by consoles, which are of an early type. The building was a combined sundial and water clock, was exactly orientated, and carried a bronze Triton as weather-cock. Two prostyle distyle porches, the columns having capitals of a fairly common late variety of Corinthian: no spirals, single row of acanthus leaves below, upright leaves on the ball. The same Andronicus set up a sundial which has been found in Tenos.

Date	Place	Name	Remarks
29 B.C.	Rome	Temple of Divus Julius	Begun *c.* 40 B.C.
28 B.C.	Rome	Mausoleum of Augustus	See p. 266
27 B.C.	Ariminum (=Rimini)	Arch of Augustus	The earliest surviving dated monumental arch: served also as a city gate
c. 25 B.C.	Augusta Praetoria (=Aosta)	Arch of Augustus	See pp. 230, 293
c. 20 B.C.	Rome	Tomb of Caecilia Metella	See p. 266
16 B.C.	Nemausus (=Nîmes)	'Maison Carrée'	See p. 213 and Pl. XI*b*
25–12 B.C.	Rome	Thermae of Agrippa	See p. 258
13–9 B.C.	Rome	Ara Pacis Augustae	
13 B.C.	Rome	Theatre of Marcellus	Planned by Julius Caesar. Remains perhaps in part 40–30 B.C. Plan in *Forma Urbis*
8 B.C.	Segusio (=Susa)	Arch of Augustus	See p. 294
7 B.C.–A.D. 10	Rome	Temple of Concord	See p. 215 and Pl. XII*a*
2 B.C.	Rome	Temple of Mars Ultor	See p. 216
c. A.D. 1	Pola	Temple of Augustus	See p. 214
Before A.D. 3	Pompeii	Temple of Fortuna Augusta	
? Between 31 B.C. and A.D. 1	Sparta	Theatre	See p. 272. At first of Greek type, Romanized probably in the Antonine period, and often modified thereafter
? *c.* A.D. 1	Askalon	Bouleuterion and peristyle of Herod the Great	Small theatre-like room at end of narrow Corinthian peristyle (columns on plinths and pedestals)
? *c.* A.D. 1	Palmyra	Temple of Bel	See p. 222: formerly 'Temple of the Sun'
? *c.* A.D. 1	Antioch in Pisidia	Temple of Augustus and Mēn	See p. 210 n. 1
A.D. 6	Rome	Temple of Castor	See p. 216
? From *c.* A.D. 10	Heliopolis (=Baalbek)	Temple of Jupiter	See p. 222 and Figs. 95, 96
Between 54 B.C. and A.D. 12	Rome	Basilica Julia	See p. 269 for later history
Between 27 B.C. and A.D. 14	Vienna (=Vienne)	Temple of Augustus and Livia (previously of Rome and Augustus)	See p. 214. This is probably the original date of the façade, at first dedicated ROMAE ET AVGVSTO CAESARI DIVI F., but the back part of the temple is older than the rest: the façade was rededicated on Livia's apotheosis in A.D. 42. For the evidence (similar to that for the Maison Carrée) see Formigé, J., *R.A.* 5ᵉ sér. XXI, 1925, 153
Between 27 B.C. and A.D. 14	Athens	Temple of Rome and Augustus	See pp. 127, 218. Ionic
A.D. 19	Saintes	Monumental Arch	See p. 293. Originally formed entrance to a bridge
? *c.* A.D. 20	Pola	Temple of Poseidon	Resembles Temple of Augustus in same city (*c.* A.D. 1)

III. Caligula to Vitellius (A.D. 37–69).

Date A.D.	Place	Name	Remarks
Between 40 and 50	Sidyma	Augusteum	See p. 209. Abnormal Doric
? *c.* 50	Nemausus (= Nimes) (near)	Pont du Gard	See p. 236 and Pl. XIV *b*. The date is uncertain. Formigé and Espérandieu assign it to time of Augustus, Rivoira to *c.* A.D. 150, Stübinger leaves date open
? *c.* 50	Arausio (= Orange)	Theatre	See p. 279 and Pl. XX *a*, *b*
c. 50	Rome	'Basilica' by Porta Maggiore	See p. 245 and Fig. 103
c. 50	Jerusalem	'Tomb of Absalom,' 'Tomb of the Kings,' etc.	See p. 221. Mainly rock-cut: the 'Tomb of the Kings' was probably built in her lifetime for Queen Helen of Adiabene, who died *c.* A.D. 60
62	Rome	Thermae of Nero	See p. 258. Ground-plan known
64–69	Rome	Domus Aurea of Nero	Destroyed after Nero's death, but much preserved under later constructions
c. 66	Rome	Atrium Vestae (House of the Vestals)	Date of first Imperial reconstruction after the fire of A.D. 63. The republican building, which absorbed the *Domus Publica* in A.D. 12, has left traces. There was a court, which had a peristyle at least from Flavian times: it received its final enlarged form, familiar to visitors to the Forum, under Septimius Severus. In early times *Atrium Vestae* had a wider meaning

IV. Flavian Emperors (A.D. 69–96).

Date A.D.	Place	Name	Remarks
c. 75–82	Rome	Colosseum	See p. 285, Figs. 118, 118 *a*, and Pl. XVI *b*
c. 80	Rome	Thermae of Titus	Ill-preserved: contained large cross-vaulted rooms, one with a span of 23·10 m. (*c.* 76 feet)
c. 80	Rome	Temple of Vespasian	See p. 216 and Pl. XII *b*
c. 82	Rome	Arch of Titus	See p. 220 and Pl. IX *c*
? *c.* 90	Puteoli (=Pozzuoli)	Amphitheatre	

Date A.D.	Place	Name	Remarks
c. 90	Rome (Palatine)	Palace	See pp. 244, 310, Fig. 102. Parts are older (especially time of Tiberius), parts later (especially time of Septimius Severus)
c. 90–97	Rome	Forum of Nerva	Mainly built by Domitian: important remains

V. Nerva, Trajan, Hadrian (A.D. 96–138).

Date A.D.	Place	Name	Remarks
? *c.* 100	Rome	Amphitheatrum Castrense	Brick-faced concrete: pilasters, etc. of brick. Has also been dated early 1st cent. A.D., and early 3rd cent. A.D.
? *c.* 100	Sagalassus	Temple of Apollo Clarius	Ionic
? *c.* 100	Heliopolis (=Baalbek)	Beginning of 'Temple of Bacchus' and possibly of Round Temple (see under ? *c.* A.D. 245)	See pp. 228, 264, Figs. 95, 112, Pls. XIII, XIX*a*
105–116	Alcantara in Spain	Bridge over Tagus	See p. 237. This is at all events the date of the monumental arch in the centre of the bridge
? *c.* 110	Thamugadi (=Timgad)	Capitolium	
c. 113	Rome	Forum, Basilica (Ulpia), and Column of Trajan	See p. 292. Temple of Divus Trajanus added A.D. 119 or later
114–117	Beneventum	Arch of Trajan	Larger imitation of the Arch of Titus
c. 115	Ephesus	Library	See p. 289, Figs. 119, 120
? *c.* 115	Rome	Thermae of Trajan	See p. 258
c. 120	Rome	Pantheon	See p. 246, Figs. 104, 105, Pls. XVI*a*, XVII
? *c.* 120–200	Heliopolis (=Baalbek)	Great courts, and much of decoration of 'Temple of Bacchus'	See pp. 225, 228, Figs. 95, 97, Pl. XIII
? *c.* 120 (or earlier)	Petra	Khazna	See p. 221, Pl. XI*a*. (Perhaps earlier.)
123–124	Tibur (=Tivoli)	Hadrian's Villa	See pp. 252, 312, 316, and Figs. 107, 134. The date given is that of the majority of the brick-stamps
c. 125	Aezani	Temple of Zeus	See p. 218, Fig. 94. Ionic and composite
? *c.* 125	Lambaesis	'Praetorium'	Stone structure of Janus type with arched gateways at centre of camp
? *c.* 125	Pergamum	Trajaneum	
? *c.* 125 to *c.* 200	Lepcis or Leptis Magna	Basilica	Double row of inner columns, apse at each end: total length *c.* 90 m.
c. 126	Rome	Palace in Horti Sallustiani	[Contains round structure with dome like that of Piazza d' Oro and still more like the 'Canopus' at Tivoli (see K. Lehmann-Hartleben and J. Lindros, *Opusc. Archaeol.* I, 1935, 197)]

Date A.D.	Place	Name	Remarks
c. 130	Athens	Olympieum (completion)	See p. 160
c. 130	Thamugadi (=Timgad)	Basilica	See p. 270
131	Palmyra (=Tadmor)	Temple of Baalsamîn	See p. 230 n. 1. Weigand thinks begun in 1st cent. A.D.
135	Rome	Temple of Venus and Rome	See p. 263. Rebuilt by Maxentius A.D. 307
c. 135	Rome	Mausoleum of Hadrian	See p. 266
? *c.* 135	Aphrodisias in Caria	Temple of Aphrodite	Ionic
c. 138	Cyzicus	Temple of Hadrian	Destroyed except for substructures: probably resembled the temple at Aezani (see *c.* A.D. 125), but was much larger (*c.* 133×252 feet): Hadrian probably finished an abandoned scheme, as in the Olympieum of Athens

VI. Antonine Emperors (A.D. 138–193).

Date A.D.	Place	Name	Remarks
Between 133 and 161	Sagalassus	Temple of Antoninus Pius	
c. 140	Sufetula (=Subaiṭila)	Capitolium	Three pseudoperipteral temples side by side, central one Composite, the others Corinthian
? *c.* 140	Nemausus (=Nîmes)	'Temple of Diana'	See p. 237, Pl. XV. [Perhaps rather *c.* 120.]
After 141	Rome	Temple of Antoninus and Faustina	See p. 217
145	Rome	Temple of Divus Hadrianus	
? *c.* 150	Thugga (=Duqqa)	Theatre	See p. 280
? *c.* 150	Cuicul (=Jamîla)	Theatre	
c. 150	Thamugadi (=Timgad)	Theatre	See p. 280
? *c.* 150	Bostra (=Bosrâ eski Shâm)	Theatre	The best preserved Roman theatre after Aspendus
? *c.* 150	Philadelphia in Ammonitis (='Ammân)	Theatre	
c. 150	Gerasa (=Jarash)	Temple of Artemis	[Has court and Propylaea, finished *c.* A.D. 180. See C. H. Kraeling, *Gerasa*, New Haven, 1938]
c. 155	Aspendus	Theatre	See p. 276, Figs. 115, 116, 117
155	Hebrân	Temple	See p. 211 n. 1. Ionic

Date A.D.	Place	Name	Remarks
161–166	Gerasa (=Jarash)	Temple of Zeus	
161 or 162	Lambaesis	Temple of Aesculapius	Doric with shafts of Greek type (fluted without bases): curious ground-plan
c. 162	Athens	Odeum of Herodes Atticus	See p. 276
163	Tripolis (=Tripoli)	Janus Arch	The best-preserved specimen, with that at Lepcis Magna (c. A.D. 200)
c. 165	Thamugadi (=Timgad)	'Arch of Trajan'	See p. 294
c. 165	Philadelphia in Ammonitis (='Ammân)	Temple of ? Zeus on Acropolis	
c. 167	Thugga (=Duqqa)	Capitolium	
Between 161 and 169	Cuicul (=Jamîla)	Basilica	Has a general resemblance to the Basilica of Timgad
c. 176–193	Rome	Column of Marcus Aurelius	See p. 293
c. 180	Saccaea (=Shaqqâ)	Basilica	See p. 238 and Fig. 99
? c. 180	Seriane (=Isriya)	Temple	See p. 321
? c. 190	Inkhil	Palace	See p. 321
191	Aere (=Aṣ-Ṣanamain)	Temple of Tyche	
195	Thugga (=Duqqa)	Temple of Saturn	Triple cella behind elaborate cloister court

VII. Pertinax to Alexander Severus (A.D. 193–235).

Date A.D.	Place	Name	Remarks
c. 200	Rome (Palatine)	Part of Palace	See under c. 90 A.D.
c. 200	Damascus	Temple-precinct of Jupiter Damascenus	Contains the famous propylaea with arched entablature
c. 200	Kiakhta	Bridge	Dated by inscription: single span of 34·20. Two large free columns flank approaching roadway at each end. Kiakhta is c. 35 miles north of Samosata, on a tributary of the Euphrates
? c. 200	Cyzicus	Amphitheatre	One of the few known in Greece or Asia Minor: another has been found at Pergamum. For a list of those recorded see Friedländer, s.v. *Amphitheatres* p. 351 *infra*

Date A.D.	Place	Name	Remarks
c. 200	Rusuccuru (= Tâûgh-zût)	Temple of the Genius of the Municipium Rusuccuru	See p. 218
c. 200	Lepcis or Leptis Magna	Arch of Septimius Severus	Janus Arch: very well preserved
203	Rome	Arch of Septimius Severus	
204	Rome	Porta Argentariorum	[See now D. E. L. Haynes and P. E. D. Hirst, Supplementary B. S. R. Pap., 1939]
208	Lambaesis	Capitolium	Double temple, ingeniously arranged
? *c.* 210	Theveste (= Tebessa)	'Temple of Minerva'	See p. 218
? *c.* 210	Thugga (= Duqqa)	Temple of Caelestis	
211	'Atil	Western Temple	See p. 230
209–211	'Atil	Northern Temple	Almost identical with the preceding
212	Vazi Sarra (= Henchir-Bez)	Temple of Mercurius Sobrius	
214	Theveste (= Tebessa)	Janus Arch	
c. 215	Rome	Thermae of Caracalla	See pp. 252, 258–260, Figs. 106, 110, Pl. XVIII
216	Cuicul (= Jamîla)	Triumphal Arch of Caracalla	Called *arcus triumphalis* in its inscription (*C.I.L.* VIII, 8321)
229	*Ibid.*	Large Temple	

VIII. Maximin to Foundation of Constantinople (A.D. 235–330).

Date A.D.	Place	Name	Remarks
c. 240	Thysdrus (= Al-Jam')	Amphitheatre	Modelled on Colosseum. Unfinished
c. 240	Rome	'Torre de' Schiavi' (Mausoleum)	Circular domed structure: crypt with central column surrounded by circular barrel-vault. Imitated *c.* A.D. 307 in Mausoleum of Romulus, son of Maxentius
? *c.* 245	Heliopolis (= Baalbek)	Round Temple	See p. 264, Fig. 112, Pl. XIXa. For possible earlier dating see under ? *c.* 100 A.D. and also p. 264
c. 245	Philippopolis in the Haurân (= Shuhba)	Temple of Philip the Arabian	Also many other buildings, including theatre, palace, baths, etc.
c. 250	Rome	'Temple of Minerva Medica' (nymphaeum)	See p. 254
c. 275	Rome	Temple of the Sun	

Date A.D.	Place	Name	Remarks
282	Umm az-Zaitûn	'Kalybe'	See p. 252 n. 1. Open shrine, with concrete dome with light filling material over square room, clumsily converted into octagon, and finally into an irregular thirty-two-sided polygon. Called in inscription (dated) τὴν ἱερὰν καλύβην. The dome, which has mostly perished, must either have had a tall cylindrical drum, or have been of an upright egg-shape
3rd cent.	Saccaea (=Shaqqâ)	Palace	See p. 240
? Late 3rd cent.	Thamugadi (=Timgad)	Library	
c. 300	Salona (=Spalato or Split)	Diocletian's Palace	See pp. 227, 255, 312, 316, Figs. 108, 135, Pl. XXIV a and b
? c. 300	Augusta Treverorum (=Trier or Trèves)	Porta Nigra	See p. 295, Figs. 121, 122, Pl. XXI b
306	Rome	Thermae of Diocletian	See p. 260
c. 307	Rome	Mausoleum of Romulus, son of Maxentius	See Rome, 'Torre de' Schiavi,' c. A.D. 240
c. 307–315	Rome	Temple of Romulus, son of Maxentius	Circular domed building, flanked by two rectangles with apses. [Perhaps really the 'Urbis Fanum.']
? c. 310	Augusta Treverorum (=Trier or Trèves)	Basilica	See p. 270
310–313 and c. 320	Rome	Basilica Nova	See p. 261, Fig. 111
311	Rome	Circus of Romulus, son of Maxentius	
c. 315	Rome	Arch of Constantine	Embodies much older material
? c. 315	Rome	Arch of Janus Quadrifrons	See p. 295
? c. 320	Rome	Temple of Saturn	See p. 217. Details from Trajan's Forum incorporated
c. 325 (or later)	Rome	S. Costanza (Mausoleum)	See p. 257, Fig. 109, Pl. XIX b

Select Bibliography (up to 1928), of Prehistoric, Greek, Etruscan, and Roman Architecture from the earliest times to 330 A.D.

NOTE.—*Numerals in ordinary type in brackets after place-names refer to pages of this book, numerals in italics to text illustrations, Roman numerals (capitals) to plates. Where publications later than 1928 are now mentioned in the text, an asterisk is placed against the heading and a page reference added in square brackets.*

A. LIST OF THE CHIEF PERIODICALS, DICTIONARIES AND COLLECTIONS CITED, WITH ABBREVIATIONS (IN ALPHABETICAL ORDER OF ABBREVIATIONS)

A.A.	*Archäologischer Anzeiger* (in *J.D.A.I.*).
A.D.	*Antike Denkmäler* (continuation of *Mon. Inediti*).
᾿Α. Δελτ.	᾿Αρχαιολογικὸν Δελτίον.
A.J.A.	*American Journal of Archaeology* (New Series).
A.M.	*Mitteilungen d. deutsch. Arch. Inst., Athenische Abteilung.*
Acc. L. Mem.	*Memorie d. r. Accad. dei Lincei (classe di scienze morali etc.).*
Acc. L. Rend.	*Rendiconti d. r. Accad. dei Lincei (classe di scienze morali etc.).*
Acc. Nap. Atti	*Atti d. r. Accad. di archeologia etc., Soc. R. di Napoli.*
Acc. Nap. Mem.	*Memorie d. r. Accad. di archeologia etc., Soc. R. di Napoli.*
Acc. Pont. Mem.	*Memorie d. Pontificia Accad. Romana di Archeologia.*
Acc. Pont. Rend.	*Rendiconti d. Pontificia Accad. Romana di Archeologia.*
Afr. It.	*Africa Italiana* (continuation of *Notiziario archeologico*).
Ann. Inst.	*Annali dell' Inst. di Corrispondenza archeologica.*
Ann. R.S.A.	*Annuario d. r. Scuola archeologica di Atene.*
Archaeol.	*Archaeologia.*
B.C.H.	*Bulletin de correspondance hellénique.*
B.S.A.	*Annual of the British School at Athens.*
B.S.J. Bull.	*British School of Archaeology at Jerusalem, Bulletin.*
B.S.R. Pap.	*Papers of the British School at Rome.*
Bay. Abh.	*Abhandlungen d. bayer. Akad. d. Wissenschaften.*
Berl. Abh.	*Abhandlungen d. preuss. Akad. d. Wissenschaften zu Berlin (Philos.-hist. Klasse).*
Berl. S.B.	*Sitzungsberichte d. preuss. Akad. d. Wissenschaften zu Berlin.*
Boll. Arte.	*Bollettino d'Arte del Ministero della pubblica Istruzione.*
Bull. Comm.	*Bullettino della commissione archeologica municipale.*
Byz.	*Byzantion.*
C.I.L.	*Corpus Inscriptionum Latinarum.*
C.R. Ac.	*Comptes rendus de l'Acad. des Inscriptions.*
D.S.	Daremberg et Saglio, *Dictionnaire des antiquités grecques et romaines.*
Denk. Ak. Wien.	*Denkschriften d. Akad. d. Wissenschaften,* Vienna.

Ditt.	Dittenberger, W., *Sylloge Inscriptionum Graecarum*, 3rd edn., 1915–1924.
'Ε. 'Α.	Ἐφημερὶς ἀρχαιολογική.
Gnom.	*Gnomon.*
I.G.	*Inscriptiones Graecae.*
Ist. Lomb. Mem.	*Memorie d. r. ist. lombardo di scienze e lettere.*
Ist. Lomb. Rend.	*Rendiconti d. r. ist. lombardo di scienze e lettere.*
J.D.A.I.	*Jahrbuch d. deutsch. arch. Inst.*
J.H.S.	*Journal of Hellenic Studies.*
J.R.I.B.A.	*Journal of the Royal Institute of British Architects.*
J.R.S.	*Journal of Roman Studies.*
Jahresh.	*Jahreshefte d. österr. arch. Inst. in Wien.*
Kl.	*Klio.*
Mém. Ac. Inscr.	*Mémoires de l'Acad. des Inscriptions.*
Mem. Amer. Ac. Rom.	*Memoirs of the American Academy in Rome.*
Mon. Inediti.	*Monumenti inediti pubbl. dall' Inst. di Corrispondenza archeologica* (continued as *Antike Denkmäler*).
Mon. L.	*Monumenti antichi pubbl. p. cura della r. Accad. dei Lincei.*
N.S.	*Notizie degli scavi di antichità.*
Neap.	*Neapolis.*
Not. Arch.	*Notiziario archeologico* (continued as *Africa Italiana*).
P.W.	Pauly-Wissowa's *Real-Encyclopädie d. class. Altertumswissenschaft.*
Phil. Woch.	*Philologische Wochenschrift.*
Philol.	*Philologus.*
Πρ.	Πρακτικὰ τῆς ἐν Ἀθηναῖς ἀρχ. ἑταιρίας.
R.A.	*Revue archéologique.*
R.E.G.	*Revue des études grecques.*
R.M.	*Mitteilungen d. deutsch. Arch. Inst., Römische Abteilung.*
Syr.	*Syria.*
Y.W.	*Year's Work in Classical Studies.*
Z.G.A.	*Zeitschrift f. Geschichte d. Architektur.*

NOTE:—The progress of excavation research and publication is summarized regularly or at intervals in various periodicals, including *A.A.*, *A.J.A.*, *B.C.H.*, *Gnom.*, *J.D.A.I.*, *J.H.S.*, *R.A.*, *R.E.G.*, *Y.W.* and Bursian's *Jahresbericht üb. d. Fortschritte d. klass. Altertumswissenschaft* with its *Beiblatt*, *Bibliotheca Philologica Classica*.

An exhaustive bibliography for the years 1914 to 1924 will be found in Marouzeau, J., *Dix années de bibliographie classique*, II, Paris, 1928, especially pp. 624 to 788. [Continued as *L'année philologique*, appearing annually.]

B. GENERAL WORKS

(1) General histories of ancient architecture and books dealing with large problems of construction and decoration.

(a) Greek, and Greek with Roman (and Etruscan). [p. xi]

Borrmann, R. *Die Baukunst des Altertums.* Leipzig, 1904.
Marquand, A. *Handbook of Greek Architecture.* 1909.
Noack, F. *Die Baukunst des Altertums.* Berlin, 1910.
Durm, J. *Die Baukunst der Griechen.* 3rd ed. Leipzig, 1910. (*Handbuch der Architektur,* II Teil, I Band.) The 2nd ed., Leipzig, 1892, contains a valuable bibliographical Index by von Duhn, F.
Benoit, F. *L'Architecture: Antiquité.* Paris, 1911.
Bell, E. *Hellenic Architecture.* 1920.
Anderson, W. J. and Spiers, R. P. *The Architecture of Greece and Rome.* The 3rd ed. is in two volumes, 1927; Part I, *The Architecture of Ancient Greece,* revised and re-written by Dinsmoor, W. B.; Part II, *The Architecture of Ancient Rome,* revised and re-written by Ashby, T.

(b) Roman (and Etruscan).

Durm, J. *Die Baukunst der Etrusker: Die Baukunst der Römer.* 2nd ed. Stuttgart (now Leipzig), 1905. (*Handbuch der Architektur,* II, 2.)
Cagnat, R. and Chapot, V. *Manuel d'Archéologie Romaine.* 2 vols. Paris, 1916, 1920. (Especially vol. I.)
Toebelmann, F. *Römische Gebälke.* Ed. Fiechter, E. and Hülsen, C. Heidelberg, 1923 (text and plates). (Deals chiefly with *decoration.*)
 See also Weigand, E. (1914 and 1924), under *Heliopolis* (= *Baalbek*), p. 376 *infra*; and see further under *Roman materials and methods,* (2) (*d*) *infra.*
 Strzygowski, J., has dealt with Oriental and other foreign influences on Roman architecture in a series of publications from *Orient oder Rom?* Leipzig, 1901, onwards. Here it is enough to refer to his *Ursprung der christlichen Kirchenkunst,* translated by O. M. Dalton and H. J. Braunholtz as *Origin of Christian Church Art,* 1923.

(2) Special aspects of construction and decoration. [Attic walls, p. xi]

(a) Iron in Greek architecture.

Dinsmoor, W. B. *A.J.A.* XXVI, 1922, 148.

(b) Terracotta in Greek and Etruscan architecture. [p. xi]

Koch, H. *Dachterrakotten aus Campanien.* Berlin, 1912: *R.M.* XXX, 1915, 1.
Van Buren, E. D. *Figurative Terracotta Revetments in Etruria and Latium.* 1921.
—— *Archaic Fictile Revetments in Sicily and Magna Graecia in the VI and V centuries B.C.* 1923.
—— *Greek Fictile Revetments in the Archaic Period.* 1926.
Luce, S. B. and Holland, L. B., articles in *A.J.A.* (see list *A.J.A.* XXV, 1921, 266).
Robinson, D. M. *A.J.A.* XXVII, 1923, I.

(c) Colouring of Greek temples.

Fenger, L. *Die Dorische Polychromie.* Berlin, 1886. (For later studies see especially under *Aegina,* Furtwängler, 1906, under *Athens* (*b*) (ii), Wiegand, 1904, and under *Olympia,* Curtius, 1890–7, pp. 355, 360, 369 *infra.*)

(d) Roman materials and methods. [266 n.]

(a) IN THE REPUBLICAN PERIOD

Delbrück, R. *Hellenistische Bauten in Latium.* 2 vols. Strassburg, 1907, 1912. (Especially II, 42.)
Frank, T. 'Roman Buildings of the Republic.' *Papers and Monographs of the American Academy in Rome,* III. Rome, 1924.

Choisy, A. *L'Art de Bâtir chez les Romains.* Paris, 1873.
Van Deman, E. *A.J.A.* xvi, 1912, 230, 387.
Rivoira, G. T. *Architettura Romana.* Milan, 1921. (Translation *Roman Architecture* by Rushforth, G. McN., 1925.)
Cozzo, G. *Ingegneria Romana.* Rome, 1928.
See also Durm, J., under *General histories* (*b*), p. 349 *supra.*

(e) Pediments of Roman temples.

Colini, A. M. *Bull. Comm.* LI (1923) 1924, 299.

*(3) Types of ground-plan and their evolution. [26 n. 3, 266 n., 305 n.]

See under *Orchomenus* (Bulle, 1907), p. 354 *infra*: also:
Altmann, W. *Die italischen Rundbauten.* Berlin, 1906
Leroux, G. 'Les Origines de l'Édifice Hypostyle,' *Bibl. des Écoles Franç. d'Athènes et de Rome,* Fasc. 108, Paris, 1913. (Especially for the Basilica.)
Boethius, C. A. *B.S.A.* xxiv, 1919–21, 161.
Pace, B. *Mon. L.* xviii, 1922, 327. (For list of buildings with single row of inner columns.)
Schultze, R. *Basilika.* Berlin and Leipzig, 1928.

(4) Particular members, mouldings, etc.

*(a) Minoan and Mycenaean columns. [p. xii]

Meurer, M. *J.D.A.I.* xxix, 1914, 1.

*(b) Doric column. [68 n.]

Kawerau, G. *Z.G.A.* II, 1908–9, 227.
Bühlmann, M. *Z.G.A.* vi, 1913, 229.
Wilberg, W. In *Jahresh.* xix–xx, 1919, 167.

*(c) Ionic column. [60 n. 3]

Puchstein, O. *Die ionische Säule.* Leipzig, 1907.
Von Luschan, F. 'Entstehung und Herkunft der ionischen Säule.' (*Der alte Orient,* xiii.) 1912.
Lehmann-Haupt, C. F. 'Zur Herkunft der ionischen Säule.' *Kl.* xiii, 1913, 648.
Braun-Vogelstein, J. 'Die ionische Säule.' *J.D.A.I.* xxv, 1920, 1.
Wurz, E. and Wurz, R. 'Die Entstehung der Säulenbasen des Altertums unter Berücksichtigung verwandter Kapitelle.' *Z.G.A.* Beiheft 15. Heidelberg, 1925.
Butler, H. C. *Sardis,* 1925 (v.s. *Sardis,* p. 374 *infra*).

*(d) Corinthian capital and palm-capital. [101 n. 4]

Homolle, T .*R.A.* 5ᵉ Sér .iv, 1916, 17.
Weigand, E. *Vorgeschichte des kor. Kapitells.* Würzburg, 1920.

(e) Composite capital.

Patroni, G. In *Miscellanea di studi critici in onore di Ettore Stampini.* Turin and Genoa, 1921, 151.
Murray, S. B. *Hellenistic Architecture in Syria.* 1921, 19.

(f) Sima and its decoration.

Schede, M. *Antikes Traufleisten-Ornament.* Strassburg, 1909.
Marconi, P. *Boll. Arte,* vi, Ser. 2, 1927, 385 (for Doric lion-head spouts).

*(g) *Mouldings.* [61 n.]

Dinsmoor, W. B. *A.J.A.* xiv, 1910, 178, *Bucrania* [212 n.].
Weickert, C. *Das lesbische Kymation.* Leipzig, 1913.
[Add *Acroteria* [49 n. 2], *Mutules* [43 n. 3], *Triglyphs* [390], *Walls* [p. xi], *Windows* [51 n. 1].

*(5) Entasis and other 'refinements.' [116 n. 1]

See below (p. 360) under *Athens* (a) *General,* Penrose, 1882, and under *Athens* (b) (viii),
 Erechtheum, Stevens and Paton, 1927: also:
Goodyear, W. H. *Greek Refinements.* 1912.
Dombart, T. In *P.W.* Suppl. iv, 1924, s.v. *Entasis.*
Stevens, G. P. 'Entasis in Roman Architecture,' *Mem. Amer. Ac. Rome,* iv, 1924, 121.
Balanos, N. *C.R. Ac.* 1925, 167 (for Parthenon).
Browne, A. D. *Architecture,* v, 1927, 296.

*(6) Theatres. [185 n.]

See below, under place-names, and also:
Dörpfeld, W. and Reisch, E. *Das griechische Theater.* Athens, 1896.
Puchstein, O. *Die griechische Bühne.* Berlin, 1901.
Haigh, A. E. *The Attic Theatre.* Ed. 3 by Pickard-Cambridge, A. W. 1907.
Fiechter, E. *Die baugeschichtliche Entwicklung des antiken Theaters.* Munich, 1914.
Frickenhaus, A. *Die altgriechische Bühne.* Strassburg, 1917.
Bieber, M. *Die Denkmäler zum Theaterwesen im Altertum.* Berlin and Leipzig, 1920.
 (Contains very full bibliographies.)
Frickenhaus, A. In *P.W.* iii, A, 1927, s.v. *Skene.*
For the decoration of Roman scaenae, Hörmann, H., *J.D.A.I.* xxviii–xxix, 1923–4, 275 is
 valuable.

(7) Amphitheatres.

The fullest list is in Friedländer, L., *Darstellungen aus der Sittengeschichte Roms,* Part ii, 8th ed.,
 1910, 567, but this has not been brought up to date from earlier editions.
 See also Leclercq, H. in *Dictionnaire d'Archéologie Chrétienne,* s.v., and *P.W.* and *D.
 S.* s.v.

(8) Roman town gates.

Schultze, R. *Bonner Jahrbücher,* cxviii, 1909, 280.

*(9) Roman monumental arches. [295 n. 1]

Frothingham, A. L. *A.J.A.* viii, 1904, 1.
Curtis, C. D. *Suppl. Papers of Amer. School of Class. Studies in Rome* ii. New York, 1908.
Spano, G. *Neapolis,* i, 1913, 144.
Nilsson, M. P. *B.C.H.* xlix, 1925, 143.
Noack, F. *Triumph und Triumphbogen,* Bibliothek Warburg, Vorträge 1925–6, Leipzig,
 1928, 147.

(10) Private houses and palaces.

*(a) *Greek.* [321 n.]

See below, pp. 363, 364, 371, 377 under *Delos, Dystus, Priene, Thera*; also:
Fiechter, E. In *P.W.* vii, 1912, s.v. *Haus.*
Rider, B. C. *The Greek House.* 1916.

*(*b*) *Roman.* [321 n.]

> See below, under *Calleva* (p. 362), *Ostia* (p. 369), *Pompeii* (p. 370), *Rome* (p. 371), *Salona* (p. 373), *Thamugadi* (p. 356), *Tibur* (p. 377): also:
> Fiechter, E. *Das italische Atriumhaus*, in *Festgabe Hugo Blümner*, Zurich, 1914, 210, and s.v. *Römisches Haus* in *P.W.* I, A, 1920, 961, and for country-houses and palaces:
> Swoboda, K. M. *Römische und Romanische Paläste.* 2nd ed. Vienna, 1924.
> Tanzer, H. H. *The Villas of Pliny the Younger.* New York, 1924.

*(11) Town-planning. [186 n. 1, 204 n.]

> Haverfield, F. *Ancient Town-Planning.* 1913.
> Cultrera, G. *Acc. L. Mem.* Ser. v, XVII, 1923, 359.
> von Gerkan, A. *Griechische Städteanlagen.* Berlin and Leipzig, 1924.
> Tscherikower, V. *Philol.* Suppl. Bd. XIX, Heft 1, 1927.
> Tritsch, F. *Kl.* XXII (N.F. IV), 1928, 1.

(12) Eastern influence on archaic Greece.

> Poulsen, F. *Der Orient und die frühgriechische Kunst.* Leipzig, 1912.
> Karo, G. *A.M.* XLV, 1920, 106.

(13) Ancient authorities.

(*a*) *Pausanias.*

> (1) Text alone.
> Ed. Spiro, F. 3 vols. Leipzig, 1903.
> (2) Text, translation and commentary.
> Hitzig, H. and Blümner, H. 3 vols., Berlin, 1896–1910.
> Jones, W. H. S. Loeb Library. 6 vols. (In progress.)
> For the Athenian chapters add Jahn and Michaelis, *Arx Athenarum*, 1901 (see under 'Acropolis (General)', p. 360).
> (3) Translation and commentary, with full bibliographies.
> Frazer, J. *Pausanias's Description of Greece.* 6 vols. 1898.

(*b*) *Vitruvius.*

> (1) Text alone.
> Ed. Krohn, F. Leipzig, 1912.
> (2) Text, translation and commentary.
> Choisy, A. 4 vols. Paris, 1909.
> (3) Translation.
> Morgan, M. H. Harvard, 1914.
> (4) Index of words.
> Nohl, H. *Index Vitruvianus.* Leipzig, 1876.
> *(5) Treatises, etc. [3 n. 1, 196 n. 3].
> Birnbaum, A. 'Vitruvius und die griechische Architektur,' *Denk. Ak. Wien.* Vienna, 1914.
> Sackur, W. *Vitruv und die Poliorketiker. Vitruv und die christliche Antike.* Berlin, 1925.
> Rhys Carpenter. *A.J.A.* XXX, 1926, 259.

(*c*) *Pliny the elder.*

> Jex-Blake, K. and Sellers, E. *The Elder Pliny's Chapters on the History of Art.* 1896. (Text and translation, with commentary, of the chief parts concerning art and architecture.)

(*d*) *Forma Urbis* (marble plan of Rome of period of Septimius Severus).

> (*a*) Full bibliography and discussion:
> Kubitschek, W. In *P.W.* x, 1919, 2029–40.

(*b*) Edition:

Jordan, H. *Forma Urbis Romae.* 1874. Many fragments have been found since.

(*e*) *Building Inscriptions.*

(1) Greek:

Among the most important are those connected with the Erechtheum (see p. 360) with Philo's Arsenal at the Piraeus (see p. 370) and with the fourth-century temple of Apollo at Delphi (see p. 363).

Fabricius, E. *De architectura Graeca commentationes epigraphicae,* Berlin, 1881.

Lattermann, H. *Griechische Bauinschriften.* Strassburg, 1908.

Ebert, F. *Fachausdrücke d. griechischen Bauhandwerks,* I, *Der Tempel,* Würzburg, 1910.

(2) Latin:

See especially Wiegand, T. (1894) under *Puteoli,* p. 371.

C. GENERAL AND DETAILED BIBLIOGRAPHY FOR THE PERIOD BEFORE 1000 B.C.

I. Before 1000 B.C.

Only a small selection of sites and publications is given.

(a) General. [26 n.]

Schuchhardt, C. *Schliemann's Excavations.* 1891.

Tsountas, C. and Manatt, J. I. *The Mycenaean Age.* 1897.

Maraghiannis, G. *Antiquités Crétoises.* Candia. I (text by Pernier, L. and Karo, G.), 1906; II (text by Karo, G.), 1911; III (text by Seager, R. B.), 1915; with full bibliographies: each volume has 50 plates. Vol. III deals with Cnossus only.

Burrows, R. *The Discoveries in Crete.* 2nd ed. 1908.

Noack, F. *Ovalhaus und Palast in Kreta.* Leipzig and Berlin, 1908.

Dussaud, R. *Civilisations préhelléniques.* 2nd ed. 1914.

Fimmen, D. *Die kretisch-mykenische Kultur.* 1921.

Karo, G. and Bürchner, L. In *P.W.* XI, 1922, 1718, s.v. *Kreta.*

Glotz, G. *La Civilisation Égéenne.* Paris, 1923. Translated by Dobie, M. R. and Riley, E.M. as *The Aegean Civilization,* 1925.

Bossert, H. T. *Altkreta.* Berlin, 1923.

Wace, A. J. B. In *Cambridge Ancient History,* I, 1923, 589; II, 1923, 431.

Bell, E. *Prehellenic Architecture in the Aegean.* 1926.

Hall, H. R. *The Civilization of Greece in the Bronze Age.* 1927.

(*b*) *Individual sites in alphabetical order.*

Chamaezi (oval house, 7, *1*).

Xanthoudides, S. 'Ε. 'A. 1906, 126. (Discussed by most writers on Crete.)

Cnossus (8, *2a, 2b, 3, 4*).

*(i) Palace of Minos. [26 n.]

Evans, A. J. *The Palace of Minos at Knossos.* I, 1921; II (in two parts), 1928. (In progress.)

(ii) 'Little Palace.'

Evans, A. J. *Archaeol.* LXV, 1914, 59.

(iii) Tombs.

Evans, A. J. *Archaeol.* LIX, 1905, 2; LXV, 1914, 1.

Gla (33).

Frazer, J. G. *Pausanias.* V, 1898, 120.

Gomme, A. W. In *Essays and Studies presented to William Ridgeway,* 1913, 116.

Gournia.

Hawes, C. H. and Boyd, H. *Gournia.* Philadelphia, 1912.

Hagia Triada (16).

Halbherr, F. *Ist. Lomb. Mem.* XXI, 1899–1907, 235.

Korakou.

Blegen, C. W. *Korakou.* Boston and New York, 1921.

Mallia.

B.C.H. XLVIII, 1924, 492; XLIX, 1925, 470; L, 1926, 574; LI, 1927, 495.

Melos, Phylakopi (20).

Atkinson, T. D. and others. *Excavations at Phylakopi.* 1904.

Mochlos.

Seager, R. B. *Explorations in the island of Mochlos.* Boston and New York, 1912.

*Mycenae (palace, 27; tholos tombs, 32, *15*). [pp. x, xii, 32 n.]

Schliemann, H. *Mycenae.* 1898.

Wace, A. J. B. and others. *B.S.A.* XXIV, 1919–21, 185; XXV, 1921–3.

Nirou-chani.

Xanthoudides, S. ’E. ’A. 1922, 1.

Orchomenus in Boeotia (houses, 24; tholos tomb, 32).

Frazer, J. *Pausanias*, v, 1898, 187.

Bulle, H. ‘Orchomenos I,’ *Bay. Abh.* XXIV, 1907, 2.

Palaikastro.

Bosanquet, R. C. and Dawkins, R. M. Papers in *B.S.A.* VIII, 1901–2 to XII, 1905–6 and Supp. Paper 1 to *B.S.A.*, 1923.

Phaestus (16, *5*).

Pernier, L. *Ann. R.S.A.* I, 1914, 357.

Pseira.

Seager, R. B. *Excavations in the island of Pseira.* Philadelphia, 1910.

Thera, *v. infra* p. 377.

Thermum (‘Megaron A,’ 51, *20*), *v. infra* p. 377.

Thessaly (‘megara,’ 25, *12*).

Tsountas, C. Αἱ προϊστορικαὶ ’Ακροπόλεις Διμηνίου καὶ Σέσκλου. Athens, 1908.

Wace, A. J. B. and Thompson, M. S. *Prehistoric Thessaly.* 1912.

Tiryns.

*(a) Palace (27, *13*, *14*) and general. [27 n. 3]

Schliemann, H. and Dörpfeld, W. *Tiryns.* Leipzig, 1886. English translation, 1886.

Frickenhaus, A. and Rodenwaldt, G. *Tiryns, Die Ergebnisse.* I, II. Athens, 1912.

*(b) Round building (24). [24 n. 1]

Dragendorff, H. *A.M.* XXXVIII, 1913, 334.

*Troy (21, *9*, *10*, *11*). [26 n.]

Dörpfeld, W. *Troja und Ilion.* Athens, 1902.

Leaf, W. *Troy.* 1912.

[Add *Asine [26 n.], *Eutresis [5 n. 1], *Karphi [26 n.] and *Thermi [ib.].]

D. DETAILED BIBLIOGRAPHY FOR THE PERIOD AFTER 1000 B.C.

(Arranged alphabetically in order of districts and sites.)

NOTES.

(i) *Theatres, Amphitheatres*, and *Monumental Arches* and sites demanding notice only on account of these are not included, except in the case of special publications of unusual importance: for the rest reference must be made to the general works on these types named above (p. 351).

(ii) Further bibliographical notes will be found in many of the general works named above (p. 349), especially in Durm’s two Handbooks: also in Frazer’s *Pausanias* (see p. 352).

(iii) Modern Arabic place-names are as far as possible transliterated on a uniform system: but for convenience of reference the spellings most commonly found in archaeological books, which follow various systems, are placed in the alphabetical list, with cross-references to the ancient names.

Acarnania (early arches, 231).
 Heuzey, L. *Le Mont Olympe et Acarnanie.* Paris, 1860.
 Noack, F. *A.A.* 1916, 215.

Aegina.
 (a) Temple of Aphaia (69, 75, 86, 112, 325, 327) and general. [232 n. 2, 327]
 Furtwängler, A. and others. *Aegina.* 2 vols. Munich, 1906.
 (b) Temple of *Apollo* ('*Aphrodite*') (327). [327]
 A.J.A. XXIX, 1925, 107.
 Gnom. II, 1926, 120.

Aere (= *Aṣ-Ṣanamain*), *v. Syria*, p. 375.

Aetolia, *v. Calydon, Thermum.*
 Also Woodhouse, W. J. *Aetolia.* 1897.
 Powell, B. *A.J.A.* VIII, 1904, 137. (For the walls of *Oeniadae.*)
 *[Add *Taxiarchis* (temples) [61 n.]]

Aezani, *v. Asia Minor*, p. 358.

Africa, Roman.
 (a) General.
 (i) *Algiers and Morocco.*
 Gsell, S. *Les Monuments Antiques de l'Algérie.* 2 vols. Paris, 1901. Henceforth called *Gsell.*
 Special periodicals include *Revue Africaine* and *Bulletin arch. du Comité des Travaux historiques.*
 (ii) *Tripoli.*
 Consult *A.A.* 1926, 127 and *Afr. It.* I, 1927, 159–162.
 (iii) *Tunis.*
 Guérin, V. *Voyage Archéologique dans la Régence de Tunis.* 2 vols. Paris, 1862. Henceforth called *Guérin.*
 Cagnat, R. and Gauckler, P. *Les Monuments Historiques de la Tunisie*; I^e Partie, *Les Monuments Antiques:* (i) *Les Temples Païens.* Paris, 1898. Henceforth called *Cagnat-Gauckler.*
 Special periodicals include *Revue Tunisienne.*
 (b) Individual sites.
 (i) *Cuicul* (= *Jamîla*) (theatre, 343; basilica, 344; monumental arch, 345).
 Ballu, A. *Les Ruines de Djemila (antique Cuicul).* Alger, 1921.
 Cagnat, R. *Musée Belge*, XXVII, 1923, 113.
 (ii) *Lambaesis.*
 (a) General (193).
 Ballu, A. *Tébessa, Lambèse, Timgad.* Paris, 1894.
 Gsell, I, 115 n. 2. (For earlier literature.)
 (β) Camp and 'Praetorium' (193, 342). The camp was about 1 kilometre from the city of Lambaesis.
 Gsell, I, 76.
 Cagnat, R. *L'Armée romaine d'Afrique.* Paris, 1892, 497.
 —— *Mém. Ac. Inscr.* XXXVIII, 1909, 217.
 (γ) Capitolium (345).
 Gsell, I, 143.
 (δ) Temple of Aesculapius (344).
 Gsell, I, 140.
 Cagnat, R. *Acc. Pont. Mem.* I, part I, 1923, 81.

Africa, Roman (continued)

 *(iii) *Lepcis* or *Leptis Magna* (basilica, 342; Arch of Septimius Severus, 345). [arcade in Forum, 227 n. 4]

 Romanelli, P. *Leptis Magna.* Rome, 1926. The chief publication.

 Bartoccini, R. *Afr. It.* I, 1927, 53.

 —— *Guida di Lepcis (Leptis Magna).* Rome and Milan, 1927.

 (iv) *Rusuccuru* (= *Táûghẓût*) (temple, 218, 345).

 Gsell, I, 148.

 (v) *Sabratha.*

 Bartoccini, R. *Guida di Sabratha.* Rome and Milan, 1927.

 (vi) *Sufetula* (= *Subaiṭila*) (Capitolium, 343).

 Cagnat-Gauckler, I, 14 ff.

 (vii) *Thamugadi* (= *Timgad*) ('Arch of Trajan,' 294, 344; basilica, 270, 343; Capitolium, 342; theatre, 280, 343).

 (*a*) General (193, *86*).

 Boeswillwald, E., Cagnat, R. and Ballu, A. *Timgad.* Paris, 1905.

 Ballu, A. *Les Ruines de Timgad.* Paris, 1911. (Describes the discoveries of 1903–10.) Special references to these books are not here given, but see also:

 (*β*) Theatre and basilica.

 Ballu, A. *Théâtre et forum de Timgad.* Paris, 1902.

 (*γ*) Library (346).

 Cagnat, R. 'Les Bibliothèques Municipales de l'Empire Romain,' *Mém. Ac. Inscr.* 1909, I.

 (viii) *Theveste* (= *Tebessa*) (Janus arch, 345; 'Temple of Minerva,' 218, 345).

 Gsell, I, 133.

 (ix) *Thugga* (= *Duqqa*) (Capitolium, 344; other temples, 344, 345; theatre, 343).

 Cagnat-Gauckler, I, 1, 25, 82.

 (x) *Thysdrus* (= *Al-Jam‘*) (amphitheatre, 345).

 Canina, L. *Ann. Inst.* XXIV, 1852, 241.

 —— *Mon. Inediti,* v, Pls. 42–44.

 Guérin, I, 90.

 (xi) *Tripolis* (Janus arch, 344).

 Strong, E. *Scultura Romana,* II, Florence, 1926, 260.

 Aurigemma, S. *Boll. Arte,* II, 1926, 554.

 (xii) *Vaẓi Sarra* (= *Henchir-Beẓ*) (Temple of Mercurius Sobrius, 345).

 Cagnat-Gauckler, I, 6.

Agrigentum, v. Magna Graecia and Sicily, p. 367.

Akragas, v. Agrigentum, s.v. *Magna Graecia and Sicily,* p. 367.

Alatri, v. Aletrium, s.v. *Etruria,* p. 365.

Alcantara in Spain (Roman bridge, 237, 342).

 Hübner, E. *Ann. Inst.* XXXV, 1863, 173.

 —— *Mon. Inediti,* VI, VII, 1857–63, Pls. 73–75.

Aletrium, v. Etruria, p. 365.

Alexandria in Egypt.

 (*a*) General.

 Breccia, E. *Alexandrea ad Aegyptum.* Bergamo, 1914.

 *(*b*) Pharos (184, 335). [185 n.]

 Adler, F. *Der Pharos von Alexandria.* Berlin, 1901.

 Thiersch, H. *Pharos: Antike Islam und Occident.* Leipzig and Berlin, 1909.

 Rivoira, G. T. In *Architettura Musulmana,* 1914, 148. (Translation by Rushforth, G. McN., *Moslem Architecture,* 1918.)

Al-Jam‘, v. Thysdrus, s.v. *Africa, Roman,* p. 356.

‘Ammán, v. Philadelphia in *Ammonitis,* s.v. *Syria,* p. 376.

Amyclae (throne of Apollo, 105, 335, *47*).
 Fiechter, E. *J.D.A.I.* XXXIII, 1918, 107.
 Klein, W. *A.A.* 1922, 6.
 Buschor, E. *A.M.* LII, 1927, 1.

Ancyra (= *Angora*), *v. Asia Minor*, p. 358.

Angora, v. Ancyra, s.v. *Asia Minor*, p. 358.

Antioch on the Orontes, v. Syria, p. 375.

Antioch in Pisidia, v. Asia Minor, p. 358.

Aosta, v. Augusta Praetoria, p. 361.

Aphrodisias in Caria, v. Asia Minor, p. 358.

'Arâq al-Amîr, v. Tyros, s.v. *Syria*, p. 377.

Arausio (= *Orange*).
 (*a*) General.
 Caristie, A. N. *Monuments antiques à Orange.* Paris, 1856–7.
 Peyre, R. *Nîmes, Arles, Orange, Saint-Rémy.* 4th ed. Paris, 1923.
 (*b*) Theatre (279, 341, XX *a*, *b*).
 Formigé, J. *C.R.Ac.* 1916, 155.
 (*c*) 'Arch of Tiberius' (293, 294, 339, XXI *a*).
 Couissin, P. *R.A.* 5ᵉ sér. XIX, 1924, 29.

Arelate (= *Arles*) (theatre, 279, 339, amphitheatre, 339).
 Constans, L. A. *Arles antique.* Paris, 1921.

Argos and neighbourhood.
 (*a*) Heraeum (54, 145, 328).
 Waldstein, C. and others. *The Argive Heraeum.* 2 vols. Boston and New York, 1902.
 Frickenhaus, A. and Müller, W. *A.M.* XXXVI, 1911, 27.
 *(b) Terracotta temple models from Heraeum (54, I *b*, *c*). [61 n.]
 Müller, K. *A.M.* XLVIII, 1923, 52.

Arles, v. Arelate.

[Arcades (= *Frati*), *v. Crete*, p. 362]

Asia Minor, see *Assos, Ephesus, Magnesia on the Maeander, Miletus, Priene, Sardis.*
 Also:
 (*a*) General.
 (i) *Antiquities of Ionia* by various writers (Society of Dilettanti), I, 1769; II, 1797; III, 1840; IV, 1881; V, 1915. Henceforth called *Ant. Ion.*
 (ii) Texier, C. *Description de l'Asie Mineure.* 3 vols. Paris, 1839–49 (untrustworthy). Henceforth called *Texier.*
 (iii) Fellows, C. *Journal written during an excursion in Asia Minor.* 1839. Henceforth called *Fellows, Asia.*
 (iv) Fellows, C. *An account of discoveries in Lycia.* 1841. Henceforth called *Fellows, Lycia.*
 (v) Newton, C. T. *Halicarnassus, Cnidus, Branchidae,* I (Plates), 1862; II (Text in two parts), 1862, 1863. Henceforth called *Newton.*
 (vi) Texier, C. and Pullan, A. P. *The Principal Ruins of Asia Minor.* 1865. Henceforth called *Texier-Pullan.*
 (vii) Perrot, G. and Guillaume, E. *Exploration archéologique de la Galatie et de la Bithynie.* 2 vols. Paris, 1872. Henceforth called *Perrot-Guillaume.*
 (viii) *Reisen in Südwestlichen Kleinasien.*
 I. Benndorf, O. and Niemann, G. *Reisen in Lykien und Karien.* Vienna, 1884. Henceforth called *Benndorf-Niemann.*
 II. Petersen, E. and von Luschan, F. *Reisen in Lykien, Milyas und Kibyratis.* Vienna, 1889. Henceforth called *Petersen-Luschan.*
 (ix) Lebas, P. and Landron, E. *Voyage Archéologique en Grèce et en Asie Mineure.* Paris, 1851 and after. Here quoted as from reprint by Reinach, S. Paris, 1888. Henceforth called *Lebas-Reinach.*
 (x) Humann, K. and Puchstein, O. *Reisen in Kleinasien und Nordsyrien.* (Text and Atlas.) Berlin, 1890. Henceforth called *Humann-Puchstein.*

Asia Minor (continued)

 (xi) Lanckoroński, Graf K., Niemann, G. and Petersen, E. *Städte Pamphyliens und Pisidiens.* Vienna, I (Pamphylia), 1890; II (Pisidia), 1892. Henceforth called *Lanckoroński.*

 (xii) Heberdey, R. and Wilhelm, A. 'Reisen in Kilikien,' *Denk. Ak. Wien, Philos. Hist. Kl.* XLIV, Abt. VI, Vienna, 1896. Henceforth called *Heberdey-Wilhelm.*

 NOTE:—Special references to *Plates* in these publications are given only when their text cited lacks clear cross-references.

(*b*) *Individual sites.*

 Aezani (Temple of Zeus, 218, 342, *94*).
 Texier, I, 97, Pl. 23.
 Fellows, Asia, 137.
 Texier-Pullan, 42.
 Lebas-Reinach, 142.
 Körte, A. In *Festschrift für Otto Benndorf,* Vienna, 1898, 209.

 **Ancyra* (=*Angora*) (Temple of Rome and Augustus, 337). ⌊337]
 Texier, I, 172, Pls. 64–69.
 Texier-Pullan, 45.
 Perrot-Guillaume, I, 295, 313.

 Antioch in Pisidia (Temple of Augustus and Mēn, 210 n. 1, 340).
 Robinson, D. M. *Art Bulletin,* IX, 1926, 5.

 Aphrodisias in Caria (Temple of Aphrodite, 343).
 Ant. Ion. III, 68.
 Fellows, Lycia, 33.
 Texier, III, 160, Pl. 150.
 Texier-Pullan, 47.
 Mandel, G. *C.R.Ac.* 1906, 179.
 Vagts, R. *Aphrodisias in Karien.* Borna-Leipzig, 1920.

 Aspendus (theatre, 276, 343, *115, 116, 117*).
 Lanckoroński, I, 102.

 Cretopolis (Odeum, 274).
 Lanckoroński, II, 101.

 Cyzicus (amphitheatre, 344; Temple of Hadrian, 343).
 Hasluck, F. W. *Cyzicus,* 1910, 187.

 Euromus, v. Labranda.

 **Halicarnassus* (Mausoleum, 150, 335, *65*). [151 n. 1.]
 Newton, I, 72.
 Smith, A. H. *Catalogue of Sculpture in the British Museum,* II, 1900, 65.
 Adler, F. *Das Mausoleum zu Halikarnassos.* Berlin, 1900.
 Lethaby, W. R. *Greek Buildings represented by Fragments in the British Museum,* 1908, 37.
 Bühlmann, J. *Z.G.A.* II, 1908–9, 1.
 Krüger, E. *Bonner Jahrbücher,* CXXVII, 1922, 84.
 Krischen, F. *Ibid.* CXXVIII, 1923, 1.

 Kiakhta (bridge, 344).
 Humann-Puchstein, 393.

 Labranda (Temple of Zeus Labraundos, with windows, 51 n. 1).
 (To be distinguished from *Euromus,* once falsely identified with it, which has a Roman Corinthian Temple of Zeus, published as 'Iackly' in *Ant. Ion.* I, 55 and elsewhere.)
 Lebas-Reinach, 47.

 **Lagina* (Temple of Hecate, 338). [338]
 Newton, II, 2, 554.
 Chamonard, J. *B.C.H.* XIX, 1895, 235.

 **Larisa in Aeolis* (Aeolic capitals and terracotta frieze, 47, 59, II *b*; palace, 321 n.; temple, 61 n., 323). [xiii, 61 n., 321 n.]
 Kjellberg, L. *Uppsala Universitets Årsskrift,* 1903, 30; *A.A.* XXI, 1906, 265.
 Koch, H. *R.M.* XXX, 1915, 1.

Asia Minor (continued)

 Lycia (rock-cut tombs, 48 n. 4). See *Xanthos* below (p. 359) for Nereid Monument.
 Fellows, *Lycia;* Benndorf-Niemann; Petersen-Luschan.
 Neandria (temple with Aeolic capitals, 57, 323, *22, 23*).
 Koldewey, R. *LI Programm zum Winckelmannsfeste,* 1891.
 **Olba* (colonnaded streets, 292; Temple of Zeus at *Diocaesarea,* 160 n. 5, 334). [334]
 Heberdey-Wilhelm, 84.
 Bent, T. *J.H.S.* XII, 1892, 220.
 Herzfeld, E. and Guyer, S. *A.A.* 1909, 434.
 Keil, J. and Wilhelm, A. *Jahresh.* XVIII, 1915, *Beibl.* 7.
 Weickert, E. *Gnom.* III, 1927, 88.
 Paphlagonia (rock-cut tombs, 48 n. 4).
 Leonhard, R. *Paphlagonia.* Berlin, 1915.
 Pompeiopolis (colonnaded streets, 292).
 Heberdey-Wilhelm, 87.
 Sagalassus (temples, 342, 343, and theatre).
 Lanckoroński, II, 127.
 Sidyma (Augusteum, 209, 341).
 Benndorf-Niemann, I, 61.
 Sminthe (Temple of Apollo Smintheus, 333).
 Ant. Ion. IV, 40; V, 30.
 Teos (Temple of Dionysus, 154, 333).
 Ant. Ion. IV, 35; V, 10, 13, 28.
 Béquignon, Y. and Laumonier, A. *B.C.H.* XLIX, 1925, 281.
 See also p. 157 n. 4 *supra.*
 Termessus (temple, 227, *98*; Odeum, 274).
 Lanckoroński, II, 43, 99.
 **Xanthos* (Nereid Monument, 135, 335). [146 n.]
 Benndorf-Niemann.
 Smith, A. H. *Catalogue of Sculpture in the British Museum,* II, 1900, I.
 Lethaby, W. R. *Greek Buildings represented by Fragments in the British Museum,* 1908, 178.
 —— *J.H.S.* XXXV, 1915, 208.
 Niemann, G. *Das Nereiden-Monument in Xanthos.* Vienna, 1922.
 Krischen, F. *A.M.* XLVIII, 1923, 69.
 Schuchhardt, W. H. *A.M.* LIII, 1927, 94.
 On the date problem see also Schröder, B. *J.D.A.I.* XXIX, 1914, 154 (references to
 previous views); Körte, A. *J.D.A.I.* XXXI, 1916, 274; Neugebauer, K. A. *J.D.A.I.*
 XXXV, 1920, 31.

Askalon, v. Syria, p. 375.

Aspendus, v. Asia Minor, p. 358.

Aş-Şanamain, v. Aere, s.v. Syria, p. 375.

Assos (temple, 84, 325, *36*).

 Clarke, J. T. and others. *Report on the Investigations at Assos,* 1881. *Papers of the Arch.*
 Inst. of America, Class. Series I. Boston, 1882.
 —— *Report on the Investigations at Assos,* 1882, 1883. *Papers of the Arch. Inst. of America,*
 Class. Series II. Boston, 1898.
 —— *Investigations at Assos*: drawings and photographs of the buildings and objects dis-
 covered during the excavation of 1881–1882–1883, edited by Bacon, F. H. Cambridge,
 Mass., 1902–21.
 Sartiaux, F. *R.A.* 4e sér. XXII, 1913, I, 359; XXIII, 1914, 191, 381.

Athens.

 **(a)* General. [p. xi]
 For literature before 1905, see Judeich, W., *Topographie von Athen,* Munich, 1905, and
 Frazer, J. G., *Pausanias's Description of Greece,* I, 1898, which books also contain
 valuable accounts of most of the buildings.

Athens (continued)

Special mention must, however, be made of

Stuart, J. and Revett, N. (and other writers in the later volumes). *The Antiquities of Athens*, I, 1762; II, 1787; III, 1794; IV, 1816; Suppl. 1830.

Penrose, F. C. *An Investigation of the Principles of Athenian Architecture.* 2nd ed. 1888. (Especially for Parthenon, Propylaea, 'Theseum,' and Olympieum.)

Smith, A. H. *Catalogue of Sculpture in the British Museum*, I, 1892; and II, 1900.

General works since 1905 include:

Lethaby, W. R. *Greek Buildings represented by Fragments in the British Museum.* 1908.

Weller, C. H. *Athens and its Monuments.* 1913.

NOTE:—Buildings dealt with in Smith's *Catalogue* and Lethaby's *Greek Buildings* have the notes *Smith* or *Lethaby*.

(*b*) Acropolis: *(i) General. [124 n.]

For the Acropolis in general, consult:

Jahn, O. and Michaelis, A. *Arx Athenarum a Pausania descripta.* 2 vols. 3rd ed. Bonn, 1901 (text, commentary, inscriptions, and illustrations).

D'Ooge, M. L. *The Acropolis of Athens.* 1908.

Schede, M. *Die Burg von Athen.* Berlin, 1922.

*(ii) Early buildings, except earlier Parthenon and earlier Propylaea (81, 88, 325, 326). [84 n. 1, 88 nn. 2, 3]

Wiegand, T. and others. *Die archaische Poros-Architektur der Akropolis zu Athen.* Cassel and Leipzig, 1904.

Dickins, G. *Catalogue of the Acropolis Museum*, I, 1912.

Heberdey, R. *Altattische Porosskulptur.* Vienna, 1919.

von Duhn, F. *A.M.* XLVI, 1921, 70.

Buschor, E. *A.M.* XLVII, 1922, 53, 81, 92, 106.

*(iii) Earlier Parthenon (113, 327). [84 n. 1, 113 n. 2, 114 n. 1]

Hill, B. H. *A.J.A.* XVI, 1912, 535.

(iv) Later Parthenon (113, 135, 327, *49*, IV *a*).

Michaelis, A. *Der Parthenon.* 2 vols. Leipzig, 1870, 1871.

Collignon, M. *Le Parthénon.* Ed. 2, revised by Fougères, G., 1926.

Smith, Lethaby.

(v) Earlier Propylaea (89, 118, 335).

Weller, C. H. In *A.J.A.* VIII, 1904, 35.

(vi) Later Propylaea (118, 335, *50, 51*, IV *b*).

Bohn, R. *Die Propyläen der Akropolis zu Athen.* Berlin and Stuttgart, 1882.

Dörpfeld, W. *A.M.* X, 1885, 38, 131.

Dinsmoor, W. B. *A.J.A.* XIV, 1910, 143.

Smith, Lethaby.

(Dinsmoor's promised monograph on *The Propylaea and the Entrance to the Acropolis* should supersede all previous work.)

*(vii) Temple of Athena Nike (116 n. 2, 125, 332, *53*). [146 n.]

Stevens, G. P. *A.J.A.* XII, 1908, 398.

Orlandos, A. K. *A.M.* XL, 1915, 27.

Welter, G. *A.M.* XLVIII, 1923, 190.

Blümel, C. *Der Fries des Tempel der Athena Nike.* Berlin, 1923.

Dinsmoor, W. B. *A.J.A.* XXX, 1926, 1 (for the sculptured parapet, not discussed in this book).

Smith, Lethaby.

(viii) Erechtheum (127, 332, *16, 54–57*, III *b*, V *a*).

Dörpfeld, W. *A.M.* XXVIII, 1903, 465; XXIX, 1904, 101; XXXVI, 1911, 39.

—— *J.D.A.I.* XXXIV, 1919, 1.

Weller, C. H. *A.J.A.* XXV, 1921, 130.

Stevens, G. P. and Paton, J. M. *The Erechtheum.* Cambridge, Mass., 1927: gives text of all inscriptions.

Elderkin, G. W. *A.J.A.* XXXI, 1927, 522.

Dörpfeld, W. *Phil. Woch.*, 1928, 1062.

Smith, Lethaby.

Athens (continued)
 (ix) Temple of Rome and Augustus (127, 218, 340).
 Dörpfeld, W. *A.M.* XII, 1887, 264.
 —— *A.D.* I, 1888, 3.
 Snijder, G. A. S. *R.A.* 5ᵉ sér., XIX, 1924, 223 ff.
(c) Buildings not on Acropolis. [For buildings in Agora see p. 169 n. 2: for Pnyx, p. 164 n. 1.]
 (i) Horologium of Andronicus (Tower of the Winds) (338).
 Stuart, J. and Revett, N. *The Antiquities of Athens*, I, 1762, 13.
 Gräf, B. In Baumeister, A. *Denkm. des klass. Altertums*, III, 1888, 2114.
 Rehm, A. *P.W.* VIII, 1913, 2426.
 Orlandos, A. K. 'A. Δελτ. V, 1919, Παράρτ. 14.
 Graindor, P. *Byz.* III, 1926, 29.
 Kubitschek, W. *Grundriss d. antiker Zeitrechnung.* Munich, 1928, 195.
 *(ii) Ilissus, Temple on (127, 332). [127 n. 1]
 Stuart, J. and Revett, N. *The Antiquities of Athens*, I, 1762, 7.
 Dörpfeld, W. *A.M.* XXII, 1897, 227.
 Studniczka, F. *J.D.A.I.* XXXI, 1916, 169, and in *A.D.* III, 3, 1914–15, 36.
 Lethaby.
 (iii) Odeum of Herodes Atticus (276, 344).
 Versakis, F. 'E.'A. 1912, 161.
 (iv) Monument of Lysicrates (144, 335).
 Philadelpheus, A. 'E.'A. 1921, 83 ff.
 Smith, Lethaby.
 (v) Monument of Nicias (335).
 Dörpfeld, W. *A.M.* X, 1885, 219; XIV, 1889, 62.
 *(vi) Odeum of Pericles (174, 335). [174 n. 2]
 Kastriotis, P. 'E.'A. 1922, 5.
 —— *A.A.* 1927, 345.
 (vii) Olympieum (102, 160, 331, 334, 69).
 Weigand, E. *J.D.A.I.* XXIX, 1914, 77 n. 1.
 Gütschow, M. *J.D.A.I.* XXXVI, 1921, 60.
 Welter, G. *A.M.* XLVII, 1922, 61 and XLVIII, 1923, 182.
 *(viii) Theatre of Dionysus (164, 334). [185 n.]
 Welter, G. *A.A.* 1925, 311.
 *(ix) 'Theseum' (118, 328). [328 n.]
 Sauer, B. *Das sogenannte Theseion.* Berlin and Leipzig, 1899.
 Bates, W. N. *A.J.A.* V, 1901, 37.
 Smith, Lethaby.
'*Atîl, v. Syria*, p. 375.
Augusta Praetoria (= *Aosta*) (Arch of Augustus, 230, 293, 340; Augustan town-gate, 295; roofed theatre, 274, 339).
 Promis, C. *Le Antichità di Aosta.* Turin, 1862.
Augusta Treverorum (=*Trier, Trèves*) (basilica, 270, 312 n. 2, 346; and Porta Nigra, 295, 346, *121, 122*, XXI*b*).
 Schmidt, C. W. *Baudenkmäler Triers, Röm. Periode.* Trier, 1845.
 von Behr, H. *Zeitschrift für Bauwesen*, LVIII, 1908, 361, 574.
 Krüger, E. *Die Trierer Römerbauten.* Trier, 1909.
Baalbek, v. Heliopolis, s.v. *Syria*, p. 376.
Bassae, v. Phigalea.
Beneventum (Arch of Trajan, 342).
 Snijder, G. A. S. *J.D.A.I.* XLI, 1926, 94.
Bosra, v. Bostra (=*Boṣrâ eski Shâm*), *v. Syria*, p. 375.
Cadachio, v. Corcyra.
Calauria (diagonal Ionic capital, 212 n. 1).
 Wide, S. and Kjellberg, L. *A.M.* XX, 1895, 277.

Calleva Atrebatum (=*Silchester*) (town plan and houses, 193, 312, *132*).
 A series of articles in *Archaeol.*; latest plan in vol. LXI, 1909, 2.
 Fox, G. E. and St John Hope, W. H. In *Victoria History of Hampshire*, I, 1900, 350.
Calydon (Temple of Artemis, 65 n. 4, terracotta metopes, 67 n. 3). *v. Aetolia.*
 Also Poulsen, F. and Rhomaios, K. *Erster vorläufiger Bericht über die dänisch-griechischen Ausgrabungen v. Kalydon.* Copenhagen, 1927.
Caulonia, v. Magna Graecia, p. 367.
**Chios* (early Ionic temples, 150, 331). [150 n. 1
 Kourouniotis, K. 'A. Δελτ. I, 1915, 64.
Città Castellana, v. Falerii Veteres, s.v. *Etruria*, p. 365.
Città Lavinia, v. Lanuvium, s.v. *Etruria*, p. 365.
Conca, v. Satricum, s.v. *Etruria*, p. 366.
Cora (=*Cori*) (Doric temple) (111, 209, 338, *93*).
 Delbrück, R. *Hellenistische Bauten in Latium.* II. Strassburg, 1912, 23.
 von Gerkan, A. *R.M.* XL, 1925, 167.
Corcyra.
 **(a)* Garitsa (Temple of Gorgon Pediment, 69, 324, *26*). [69 n. 4]
 Versakis, F. Πρ. 1911, 164.
 Dörpfeld, W. *A.M.* XXXIX, 1914, 161, and (with Loeschke, G.) *A.A.* 1914, 46.
 Rhomaios, K. A. 'A. Δελτ. VI, 1920–1, 165.
 **(b)* Cadachio *or* Kardaki (friezeless Doric temple, 71, 326). [71 n. 2]
 Railton, W. In *Antiquities of Athens*, Suppl. vol. 1830.
 Dörpfeld, W. *A.A.* 1912, 248; 1914, 48.
 Dinsmoor, W. B. *B.C.H.* XXXIV, 1912, 472 n. 2.
Cori, v. Cora.
Corinth.
 **(a)* Temple of Apollo (87, 326). [326]
 Powell, B. *A.J.A.* IX, 1905, 44.
 (b) Larger temple (326).
 Frazer, J. G. *Pausanias's Description of Greece*, 1898, III, 37.
 Cook, A. B. *Zeus*, II. 2, 1925, 915.
 (c) Hellenistic concrete vault (233 n. 1).
 B.C.H. L, 1926, 543.
 J.H.S. 1927, 234.
Corone (=*Longà*) (early temples, 54, 322).
 Versakis, F. 'A. Δελτ. II, 1916, 65.
Cotilium, v. Phigalea.
Crete. For Minoan period see pp. 353, 354 *supra.*
 **(a)* Dreros (early temples, 61 n., 323). [61 n.]
 Xanthoudides, S. 'A. Δελτ. IV, 1918, Παράρτ. 25.
 (b) Gortyn (Temple of Pythian Apollo, 57, 323).
 Savignoni, L. *Mon. L.* XVIII, 1907, 181.
 (c) Palaikastro (Temple of Dictaean Zeus, 323).
 Bosanquet, R. C. *B.S.A.* XI, 1904–5, 298.
 Sieveking, J. *A.A.* 1921, 349.
 **(d)* Prinia (early temples, 56, 323, *21*). [57 n.]
 Pernier, L. *Ann. R.S.A.* I, 1914, 18.
 **[Add *Arcades* (=*Frati*) (early capital) [101 n. 4].]
Cretopolis, v. Asia Minor, p. 358.
Cuicul (=*Jamîla*), *v. Africa, Roman*, p. 355.
Cyprus ('Aeolic' capitals, 60), *v. Ionic column*, p. 350.
 **[Add *Vouni* (palace) [321 n.].]
**Cyrene* (Temple of Apollo, 67, 324). [68 n. 1]
 Pernier, L. *Afr. It.* 1927, 126.
Cyzicus, v. Asia Minor, p. 358.
Damascus, v. Syria, p. 375.

Delos.
(a) General. [328.]
> Homolle, T. and others. *Exploration archéologique de Délos.* 1902 (unfinished).
> This will ultimately be the chief authority. At present it has only touched a small number of the chief buildings (see below).
> The best general book is:
> Roussel, P. *Délos.* Paris, 1925. (Brief on architecture.)
> The best general summary is:
> Courby, F. 'Le Sanctuaire d'Apollon Délien,' in *B.C.H.* xliv, 1921, 174, which is usefully criticized by Picard, C. and Replat, J. in *B.C.H.* xlviii, 1924, 217, and by Vallois, R. *ibid.* 411. In these articles reference will be found to the bibliography of most of the temples and treasuries, including the 'Oikos of the Naxians' (323).
> For other buildings:

(b) Hypostyle Hall (180, 335, *81*).
> *Expl. arch. de Délos* (see above), Fasc. i, 1909, and Fasc. ii, 1914.

(c) Private Houses (300, XXII *a, b*).
> *Ibid.* Fasc. viii, 1922 and 1924.

Delphi.
(a) General.
> Homolle, T. and others. *Les Fouilles de Delphes.* 1902– . (In progress.) Henceforth called *F.D.*
> Poulsen, F. *Delphi.* Translated by Richards, G. C. 1920.
> Pomtow, H. In *P.W.* Suppl. iv, 1924, 1189. (In progress.) Henceforth called *Pomtow.*

(b) Temple of Apollo (89, 145, 326, 329).
> *F.D.* ii, Fasc. i, 1915; Fasc. ii, 1921; Plates, 1920.
> Replat, J. *B.C.H.* xlvi, 1922, 435.
> For the inscriptions dealing with the fourth-century temple see *Ditt.* 236–253.

(c) Other Doric buildings.
> *(i) Old Tholos (85, 324), 'Old Treasury of Syracuse' (71, 328), Treasury of Sicyon (328) and others. [85 n. 1, 89 n.]
> Courby, F. *B.C.H.* xxxv, 1911, 132.
> Dinsmoor, W. B. *B.C.H.* xxxvi, 1912, 439.
> *B.C.H.* xlvi, 1922, 510; xlviii, 1924, 480.
> Pomtow, 1248.
> (ii) Marmaria, Temples of Athena Pronaia (65, 324, 326, *25*) and others, and 'Great Tholos' (141, 328, V *b*).
> *F.D.* ii, Fasc. iv, 1925.
> *(iii) Treasury of Athens (326). [326]
> Agard, W. *A.J.A.* xxvii, 1923, 17 and 322. (With full bibliography.)
> Pomtow, 1278.

(d) The four Ionic Treasuries.
> Dinsmoor, W. B. *B.C.H.* xxxvii, 1913, 1.
> (i) Treasuries of Clazomenae? and Massalia? (100, 331, *46*).
> Dinsmoor, W. B. *A.J.A.* xxvii, 1923, 164.
> *F.D.* ii, Fasc. iii, 1923, 1. (Chiefly Massalia.)
> Pomtow, 1377. (Clazomenae.)
> (ii) Treasuries of Cnidus and Siphnos (100, 331, III *a*).
> No adequate publication: it must be enough to refer here to the following articles, which will put the student on the track of the rest.
> Courby, F. *R.A.* 4ᵉ sér. xvii, 1911, 197 ff.
> Pomtow, 1252 (Siphnos); 1270 (Cnidus).
> Daux, G. and de la Coste-Messelière, P. *B.C.H.* li, 1927, 1.

(e) Lesche of Cnidians (164, 335).
> Homolle, T. *B.C.H.* xx, 1896, 637.
> Bourguet, E. In *D.S.* 1904, s.v. *Lesché.*

Delphi (continued)
　(*f*) Athenian Colonnade (127, 335).
　　　Pomtow, 1299.
　(*g*) Column of the dancing Maidens (141, 335).
　　　Best discussion is in Poulsen's *Delphi* (see above), 246.
　　　See also Lawrence, A. W. *Later Greek Sculpture*, 1927, 95.
　(*h*) Polygonal terrace wall (42).
　　　Pomtow, 1394.
Didyma, *v. Miletus.*
Dionysias, *v. Suwaida*, s.v. *Syria*, p. 377.
Djemila, *v. Cuicul* (= *Jamîla*), s.v. *Africa, Roman*, p. 355.
Doura-Europos, *v. Syria*, p. 375.
Dreros, *v. Crete*, p. 362.
Dugga, *v. Thugga* (= *Duqqa*), s.v. *Africa, Roman*, p. 356.
Dûma, *v. Syria*, p. 376.
Duqqa, *v. Thugga*, s.v. *Africa, Roman*, p. 356.
Dystus (house, 298, *123*).
　　　Wiegand, T. *A.M.* xxiv, 1899, 458.
El Djem, *v. Thysdrus* (= *Al-Jam'*), s.v. *Africa, Roman*, p. 356.
**Eleusis* (Telesterion, 42, 169, 335, *74, 75, 76*). [174 n. 1]
　　　Noack, F. *Eleusis, die baugeschichtliche Entwicklung des Heiligtums.* Text and plates. Berlin
　　　　and Leipzig, 1927.
　　*[Add *Propylaea, Inner* [230 n. 3].]
Elis (terracotta triglyphs).
　　　See references on p. 67 n. 3.
Ephesus.
　(*a*) *General.*
　　　Picard, C. 'Éphèse et Claros,' *Bibl. éc. fr. d'Ath. et de Rome*, Fasc. 123, 1922.
　*(*b*) *Earlier Artemisium* (90, 331, *39, 40, 41*, 42). [105 n.]
　　　Benndorf, O. and others. *Forschungen in Ephesos.* 1. Vienna, 1906.
　　　Hogarth, D. G. and others. *Excavations at Ephesus.* 1908.
　　　Lethaby, W. R. *J.H.S.* xxxvii, 1917, 1.
　(*c*) *Later Artemisium* (147, 332, *63*).
　　　Wood, J. T. *Discoveries at Ephesus.* 1877.
　　　Smith, A. H. *Catalogue of Sculpture in the British Museum*, ii, 1900, 165.
　　　Lethaby, W. R. *Greek Buildings represented by Fragments in the British Museum*, 1908, 1.
　　　Fyfe, T. *J.R.I.B.A.* 1914.
　　　Henderson, A. E. *Ibid.* 1915, 130.
　(*d*) *Library* (289, 342, *119, 120*).
　　　Wilberg, W. *Jahresh.* viii, 1905, *Beibl.* 61; ix, 1906, *Beibl.* 59; xi, 1908, 118.
　(*e*) *Theatre* (335).
　　　Benndorf, O. and others. *Forschungen in Ephesos.* ii. Vienna, 1912.
　　　Hörmann, H. *J.D.A.I.* xxviii–ix, 1923–4, 275.
Epidaurus.
　(*a*) *General* (including *Propylaea*, 210 n. 1).
　　　Defrasse, A. and Lechat, H. *Épidaure.* 1895.
　　　Kavvadias, P. *Fouilles d'Épidaure.* 1. Athens, 1893.
　　　―― Tὸ ἱερὸν τοῦ Ἀσκληπιοῦ ἐν Ἐπιδαύρῳ. Athens, 1900.
　(*b*) *Tholos* (144, 329, V c).
　　　Kavvadias, P. *Berl. S.B.* 1909, 536.
　　　Noack, F. *J.D.A.I.* xlii, 1927, 75.
　(*c*) *Temple of Asclepius* and *Temple of Artemis* and its companions (146, 329).
　　　Kavvadias, P. Πρ. 1905, 44; 1906, 91.
　*(*d*) *Theatre* (166, 334, *71*). [166 n. 1]
　　　Fossum, A. *A.J.A.* xxx, 1926, 70.

Eretria (Temple of Apollo Daphnephoros, 72, 325).
 Kourouniotis, K. Πρ. 1900, 53.
 —— *A.D.* III, 1914–15, 3.
 Karo, G. *A.A.* 1911, 122.
 Studniczka, F. *A.A.* 1921, 323. (For account of angle in raking cornice.)

Etruria (with early *Latium* and with *Etruscan* sites outside *Etruria*).
 (*a*) *General.*
 Dennis, G. *The Cities and Cemeteries of Etruria.* 2nd revised ed. 1878. Reprinted since.
 Martha, J. *L'Art Étrusque.* Paris, 1889.
 Wiegand, T. In Jacobsen's 'La Glyptothèque Ny-Carlsberg,' II, *Les Monuments Étrusques et Égyptiens.* Livr. XVIII. Munich, 1904.
 Fenger, L. *Le Temple Étrusque.* Copenhagen, 1909.
 Rizzo, G. E. *Bull. Comm.* XXXVIII (1910) 1911, 281; XXXIX (1911) 1912, 23. (For temple-models.)
 Milani, L. A. *Il R. Museo Archeologico di Firenze*, Florence, 1911 (and later reprints: references to edition of 1923). Henceforth called *Milani.*
 Van Buren, A. W. *A bibliographical guide to Latium and Southern Etruria.* Rome, 1916. Henceforth called *A. W. v. Buren.*
 Della Seta, A. *Museo di Villa Giulia.* I. Rome, 1918. Henceforth called *Seta.*
 Solari, A. *Topografia storica dell' Etruria*, Pisa, I, 1918, II, 1914; III (with bibliography), 1915; Bibliographical Appendix, 1915.
 Van Buren, E. D. *A.J.A.* XXIII, 1919, 158. (For general dating.)
 —— *Figurative Terracotta Revetments in Etruria and Latium.* 1921.
 Fell, A. A. L. *Etruria and Rome.* 1924.
 Ducati, P. *Etruria Antica.* 2 vols. Turin etc. 1925. (Especially II, 127.) Henceforth called *Ducati.*
 Patroni, G. *Ist. Lomb. Rend.* Ser. ii, LXIX, 1926, 343.
 Rosi, G. *J.R.S.* XV, 1925, and XVII, 1927, 59. (For rock-cut tombs.)
 Randall-Maciver, D. *The Etruscans.* 1927. The same author's larger books, *Villanovans and Early Etruscans*, 1924, and *The Iron Age in Italy*, 1927, are very important, but hardly touch any architecture beyond tombs and tumuli: see especially *Villanovans*, p. 255.
 (*b*) *Individual sites*: where *A. W. Van Buren, Seta, Milani*, or *Ducati* is given, the student is referred to those works for bibliographical references.
 (i) *Aletrium* (=*Alatri*) (temple, 199, 337).
 Winnefeld, H. *R.M.* IV, 1889, 143.
 Seta, 213; *Ducati*, II, 126.
 (ii) *Clusium* (=*Chiusi*) (urn perhaps from Chiusi, 305, XXIII).
 Milani, 159.
 Bandinelli, R. Bianchi. *Mon. L.* XXX, 1925, 210–552, esp. 482.
 (iii) *Faesulae* (=*Fiesole*) (temple, 200, 337).
 Galli, E. *Fiesole, gli Scavi, il Museo Civico.* Milan, *n.d.* (Records excavations up to 1912.) *N.S.* 1925, 28. (For the resumed excavations of 1923–4.)
 Ducati, II, 131.
 (iv) *Falerii Veteres* (=*Città Castellana*) (temples, 201, 336).
 Taylor, M. and Bradshaw, H. C. *Papers of B.S.R.* VIII, 1916, 1.
 A. W. Van Buren, 13; *Seta*, 166; *Ducati*, II, 130.
 (v) *Florentia* (=*Florence*) (temple, 337).
 Ducati, 131.
 (vi) *Gabii* (temple, 204, 337).
 Delbrück, R. *Hellenistische Bauten in Latium*, II, 1912, 5.
 A. W. Van Buren, 19.
 (vii) *Lanuvium* (=*Città Lavinia*) (Temple of Juno Sospita, 337).
 A. W. Van Buren, 13; *Seta*, 230; *Ducati*, 130.
 Mon. L. XXVII, 1922, 293.

Etruria (continued)
 (viii) *Marzabotto.*
 (*a*) General plan (191).
 Brizio, E. *Mon. L.* I, 1891, 249.
 (*b*) Temples (200, 336).
 Ducati, 132.
 (ix) *Orvieto* (=*Volsinii*, probably) (temple, 337).
 Pernier, L. and Stefani, E. *N.S.* 1925, 133, 158.
 (x) *Satricum* (=*Conca*) (Temple of Mater Matuta, 200, 336).
 Seta, 251; Ducati, 130.
 (xi) *Signia* (=*Segni*) (Capitolium, 200, 336).
 Delbrück, R. *Das Capitolium von Signia.* Rome, 1903.
 Seta, 216; Ducati, 138.
 (xii) *Veii* (Temple of Apollo, 200, 336).
 Giglioli, G. Q. *N.S.* 1919, 35.
 Ducati, 140.
 (xiii) *Volci* (=*Vulci*) (terracotta shrine, 198, VIII *b*).
 Ducati, P. *Storia dell' Arte Etrusca*, 384, 388; Milani, 265.
 *[Add *Minturnae* (temple) [337], *Perugia* (arched gates, 232) [266 n.].

Euromus, v. *Labranda*, s.v. *Asia Minor*, p. 358.
Faesulae (=*Fiesole*), v. *Etruria*, p. 365.
Falerii Veteres (=*Città Castellana*), v. *Etruria*, p. 365.
Fiesole, v. *Faesulae*, s.v. *Etruria*, p. 365.
Florence, v. *Florentia*, s.v. *Etruria*, p. 365.
Florentia, v. *Etruria*, p. 365.
Gabii, v. *Etruria*, p. 365.
Gerasa (*Jarash*), v. *Syria*, p. 376.
Glanum (=*S. Rémy*) (Monument of the Julii, 339).
 A.D. I, 1891.
Gonnos and *Homolion* (early curvilinear temples and terracotta metopes, 55, 67 n. 3, 324).
 Arvanitopoullos, A. S. Πρ. 1910, 241; 1911, 286, 315.
Gortyn, v. *Crete*, p. 362.
Halicarnassus, v. *Asia Minor*, p. 358.
Hebrán, v. *Syria*, p. 376.
Heliopolis, v. *Syria*, p. 376.
Henchir-Bez, v. *Vazi Sarra*, s.v. *Africa, Roman*, p. 356.
Herculaneum (colonnaded street, 292; Villa of the Papyri, 310).
 (*a*) General.
 Ruggiero, M. *Storia degli scavi di Ercolano.* 1885.
 Furchheim, F. *Bibliografia di Pompei Ercolano e Stabia.* Naples, 1891.
 Waldstein, C. and Shoobridge, L. *Herculaneum Past, Present and Future.* 1908. (Full bibliography.)
 Gall, R. In *P.W.* VIII, 1913, 532.
 (*b*) Villa of the Papyri (310).
 Comparetti, D. and De Petra, G. *La Villa Ercolanese dei Pisoni.* Turin, 1883.
Hipponium, v. *Magna Graecia and Sicily*, p. 367.
Homolion, v. *Gonnos*.
Inkhil, v. *Syria*, p. 376.
Isriya, v. *Seriane*, s.v. *Syria*, p. 376.
Jamîla, v. *Cuicul*, s.v. *Africa, Roman*, p. 355.
Jarash, v. *Gerasa*, s.v. *Syria*, p. 376.
Jerusalem, v. *Syria*, p. 376.
Kiakhta, v. *Asia Minor*, p. 358.

Labranda, v. *Asia Minor*, p. 358.

Lagina, v. *Asia Minor*, p. 358.

Lambaesis, v. *Africa, Roman*, p. 355.

Lanuvium (=*Città Lavinia*), v. *Etruria*, p. 365.

Larisa in Aeolis, v. *Asia Minor*, p. 358.

Lepcis or *Leptis Magna*, v. *Africa, Roman*, p. 356.

Lesbos.

 (*a*) Nape (Aeolic temple, capitals from Kolumdado, 58, 323).
 Wace, A. J. B. *J.H.S.* XLI, 1921, 275.

 (*b*) Messa (temple, 145 n. 1, 333).
 Koldewey, R. *Die Antiken Baureste der Insel Lesbos.* Berlin, 1890, **47.**
 Lattermann, H. *Griechische Bauinschriften.* Strassburg, 1908, 96.
 Schede, M. *Antikes Traufleisten-Ornament.* Strassburg, 1909, 73.
 Krischen, F. *A.M.* XLVIII, 1923, 89.
 *[Add *Thermi* (megara) [26 n.].]

Locri Epizephyrii, v. *Magna Graecia and Sicily*, p. 367.

Longà, v. *Corone.*

Lycia, v. *Asia Minor*, p. 359.

Lycosura (Temple of Despoina, 235 n. 3, 330).
 Leonardos, B. Πρ. 1896, 93.
 Dickins, G. *B.S.A.* XII, 1905–6, 109.

Magna Graecia and Sicily.

 (*a*) *General.*
 Koldewey, R. and Puchstein, O. *Die griechischen Tempel in Unteritalien und Sicilien.* 2 vols. Berlin, 1899.
 Van Buren, E. D. *Archaic fictile revetments in Sicily and Magna Graecia.* 1923. Henceforth called *Van Buren, Sic.*

 (*b*) *Individual sites.* See Koldewey and Puchstein for *Agrigentum (Akragas), Locri Epizephyrii, Metapontum, Paestum (Poseidonia), Pompeii, Segesta, Selinus, Syracuse, Tarentum* and also:
 *(i) *Agrigentum (Akragas).* [124 n. 2]
 (α) Olympieum (122, 327, 52).
 Pace, B. *Mon. L.* XXVIII, 1922, 173.
 Marconi, P. *Boll. Arte*, Ser. ii, vol. 6, 1926–7, 33.
 (β) 'Oratory of Phalaris' (338).
 Marconi, P. *N.S.* 1926, 106.
 (ii) *Caulonia* (temple, 327).
 Orsi, P. *Mon. L.* XXIII, 1916, 685.
 (iii) *Hipponium* (Ionic temple, 103).
 Orsi, P. *N.S.* 1921, 476.
 (iv) *Locri Epizephyrii.*
 (α) *General.*
 Oldfather, W. A. In *P.W.* XIII, 1927, 1289.
 (β) Ionic temple of Marasà (103, 332).
 von Gerkan, A. In *Milet*, I, 8, 1925, 64.
 (γ) Doric temples (103, 326).
 Orsi, P. *N.S.* 1915, 175.
 —— *Mon. L.* XXV, 1918, 353.
 (v) *Megara Hyblaea* (temple, 324).
 Orsi, P. *Mon. L.* XXVII, 1922, 154.
 (vi) *Paestum (Poseidonia)* [and *Silaris (Foce del Sele)*] [81 n. 1].
 (vii) *Pompeii* (Greek temple, 122 n. 1, 325, and Etruscan column, 201).
 Patroni, G. and Cozzi, S. *Acc. Nap. Mem.* N.S. I, Part I, 1911, **211.**
 For other buildings at Pompeii, see *Pompeii*, p. 370 *infra.*
 (viii) *Rhegium* (=*Reggio-Calabria*) (architectural terracotta, 67 n. 3).
 Putortì, N. *Rivista Indo-greco-italiana*, x, 1926, 59, 95 [=*Italia antichissima*, I, 1929, 1].

Magna Graecia and Sicily (continued)

 (ix) Selinus. [61 n., 73 n. 1, 324]

 (*a*) General.

 Hulot, J. and Fougères, G. *Sélinonte.* 1910. In this book will be found (p. 271) the prostyle shrine of simple type in the Gaggera precinct (54, 55, 325).

 Gàbrici, E. *N.S.* 1920, 69; 1923, 104.

 (b) 'Temple C' (72). [73 n. 1]

 Montuoro, P. *Acc. L. Mem.* Ser. vi, 1, 1925, 282.

 Van Buren, Sic. 55.

 (x) Syracuse. [324, Temple of Apollo or Artemis]

 (α) Temple of Athena (112, 327).

 Orsi, P. *N.S.* 1915, 175.

 —— *Mon. L.* xxv, 1918, 353 ff., esp. 715.

 (β) Theatre (166 n. 2, 281 n. 1, 334).

 Rizzo, G. E. *Il Teatro Greco di Siracusa.* 1923.

Magnesia on the Maeander (temple of Artemis, 154, 333, *67, 68*; temple of Zeus Sosipolis, 48 n. 8, 333; theatre, 335). [154 n. 4, 162 n.]

 Humann, C. *Magnesia am Maeander.* Berlin, 1904.

Marzabotto, v. Etruria, p. 366.

Megalopolis.

 (*a*) General.

 Gardner, E. A. and others. *Excavations at Megalopolis.* 1892.

 (*b*) Thersilion (174, 335, *77*).

 Benson, E. F. and Bather, A. G. *J.H.S.* xiii, 1892–3, 319, 328.

 *[Add Theatre, 185 n.]

Megara Hyblaea, v. Magna Graecia and Sicily, p. 367.

Messa, v. Lesbos, p. 367.

Messene.

 Assembly Hall (335).

 A.J.A. xxx, 1926, 360.

Metapontum, v. Magna Graecia and Sicily, p. 367.

Miletus (with *Didyma*).

 (*a*) *General.*

 Wiegand, T. and others. *Milet. Die Ergebnisse der Ausgrabungen und Untersuchungen.* Berlin, 1906– . (In progress.) Henceforth called *Milet.*

 (*b*) *Agora, Composite capitals of North Gate* (220).

 Milet, i, 7, 1924, 93.

 (*c*) *Bouleuterion* (161, 179, 336, *70, 79, 80*, VIII *a*).

 Milet, i, 2, 1908 (Knackfuss, H.).

 Ibid. i, 7, 1924, 279. (Corrections by Knackfuss.)

 (*d*) *Didymaion* (152, 218, 333, *66*, VI).

 Rayet, O. and Thomas, A. *Milet et le golfe latmique.* 2 vols. and atlas. Paris, 1877–80.

 Pontremoli, O. and Haussoullier, B. *Didymes.* Paris, 1904.

 Wiegand, T. 7er und 8er *vorläufiger Bericht. Berl. Abh.* v, 1911, and i, 1924.

 (*e*) *Temple of Athena* (103 n. 3, 332).

 Milet, i, 8, 1925, 52.

Mycenae.

 (*a*) For Mycenaean period, see p. 354 *supra.*

 (b) Doric temple (69). [69 n. 5]

 See the general publications of Mycenae (p. 354 *supra*), and also:

 Kourouniotis, K. *J.D.A.I.* xvi, 1901, 19.

 Koch, H. *A.M.* xxxix, 1914, 251.

Nape, v. Lesbos, p. 367.

Naucratis (Early Ionic temples, 98, 331, *45*).
 Flinders Petrie, W. M. and others. *Naukratis.* Part I, 1886; Part II, 1888.
 Prinz, H. *Funde aus Naukratis,* VII^er Beiheft zu *Kl.* Leipzig, 1908.
Naxos (temple, 90, 331).
 Welter, G. *A.M.* XLIX, 1924, 17.
Neandria, v. Asia Minor, p. 359.
Nemausus (=*Nîmes*).
 (*a*) *General.*
 Peyre, R. *Nîmes, Arles, Orange, Saint-Rémy.* 4th ed. Paris, 1923. Henceforth called *Peyre.*
 (b) Amphitheatre (339). [339]
 Peyre, 9.
 (*c*) *Maison Carrée* (213, 340, XI *b*).
 Espérandieu, E. *La Maison Carrée.* Nîmes, 1922.
 Peyre, 14.
 (*d*) *Pont du Gard* (236, 341, XIV *b*).
 Stübinger, O. *Die römische Wasserleitungen von Nîmes und Arles.* Z.G.A. Beiheft 3, Heidelberg, 1910.
 Espérandieu, E. *Le Pont du Gard.* Paris, 1926.
 Peyre, 34.
 (e) 'Temple of Diana' (237, 343, XV). [266 n.]
 Pelet, A. *Essai sur le Nymphée de Nîmes.* Nîmes, 1852.
 Peyre, 28.
Nemea (Temple of Zeus, 145, 329).
 Clemmensen, M. and Vallois, R. *B.C.H.* XLIX, 1925, 1.
 A.J.A. XXXI, 1927, 421.
Nîmes, v. Nemausus.
Oeniadae, v. Aetolia.
Olba (with *Diocaesarea*=*Uzundja Burdj*), *v. Asia Minor,* p. 359.
Olympia.
 (a) General. [61 n. Treasury of Gela]
 Curtius, E. and others. *Olympia: Die Ergebnisse der vom Deutschen Reich veranstalteten Ausgrabungen.* 5 vols. text and 5 vols. Atlas. Berlin, 1890–7. (Especially Textband II, Tafelband I, 1892. *Die Baudenkmäler,* by Dörpfeld, W. and others.)
 Gardiner, E. N. *Olympia, its History and Remains.* 1925.
 These two works deal with all the buildings, and the following additional references to publications later than the *Ergebnisse* will suffice.
 (b) Heraeum (62, 324, *24*). [68 n.]
 Weege, F. *A.M.* XXXVI, 1911, 163.
 Dörpfeld, W. *A.M.* XLVII, 1922, 30.
 (*c*) *Temple of Zeus* (41, 75, 112, 327, *17*).
 Smith, J. K. *Mem. Amer. Ac. Rom.* IV, 1924, 153.
[Olynthus (town-planning, private houses). [204 n., 321 n.]]
Orange, v. Arausio.
Orchomenus in Arcadia (temple, 326).
 Blum, G. and Plassart, A. *B.C.H.* XXXVIII, 1914, 71.
Oropus (Temple of Amphiaraus, 329).
 Versakis, F. *A.M.* XXXIII, 1908, 247; Πρ. 1909, 119; 1913, 113.
 B.C.H. XLVI, 1922, 491.
Orvieto, v. Etruria, p. 366.
Ostia (plan of town and colonnaded streets, 191, 292; houses, 307, *129, 130*).
 Calza, G. *Mon. L.* XXIII, 1916, 541; XXVI, 1920. *N.S.* 1923, 177; 1925, 54; and *Ostia: Guida Storico-monumentale,* also obtainable in English translation by Wreden-Cooke, R., *Ostia: Historical Guide to the Monuments.* Milan-Rome, n.d. (The plan is dated 1925.) For discussion of the Ostian and Pompeian types, see especially Patroni, G., *Acc. L. Rend.* 1902, 210.

Paestum, v. *Magna Graecia and Sicily*, p. 367.

Palaikastro, v. p. 354 and *Crete*, p. 362.

Palmyra (=*Tadmor*), v. *Syria*, p. 376.

Paphlagonia, v. *Asia Minor*, p. 359.

Paros (temple, 331).

Welter, G. *A.M.* XLIX, 1924, 23.

*[*Perachora* (61 n., 322). [61 n.]]

Pergamum.

Conze, A. and others. *Altertümer von Pergamon.* 8 vols., with many Atlases. Berlin, 1885– . (In progress.)

Pontremoli, E. and Collignon, N. *Pergame.* Paris, 1900.

Detailed references are unnecessary, except to the volumes of the *Altertümer*, namely, Great Altar (157, 336), III, i, 1906; Library (289, 336), II, 1885; Temple of Athena Polias (146, 330), II, 1885; Temple of Hera Basileia (159, 330), VI, 1923; Theatre (335), IV, 1896; Trajaneum (342), V, ii, 1895.

Perugia, v. *Etruria*, p. 366.

Petra, v. *Syria*, p. 376.

Phigalea.

(a) Mount Cotilius temples (55, 322).

Kourouniotis, K. 'E.'A. 1903, 151.

(b) Bassae, earlier temple of Apollo (138, 328).

Kourouniotis, K. 'E.'A. 1910, 271.

*(c) Bassae, later temple of Apollo (75, 136, 328, *58, 59, 59 a*). [146 n.]

Cockerell, C. R. *The Temples...at Aegina...and Bassae.* 1860.

Lethaby, W. R. *Greek Buildings represented by Fragments in the British Museum*, 1908, 171.

Rhomaios, K. A. 'E.'A. 1914, 57. (Especially for Ionic capitals.)

Gütschow, M. *J.D.A.I.* XXXVI, 1921, 44. (For the Corinthian capital.)

Wurz, E. and Wurz, R. *Die Entstehung der Säulenbasen, etc.* Heidelberg, 1925, 108. (For the Corinthian capital.)

Philadelphia in *Ammonitis* (=ʿ*Ammân*), v. *Syria*, p. 376.

Philippopolis in the *Ḥaurân* (=*Shuhba*), v. *Syria*, p. 376.

Piraeus.

(a) Philo's Arsenal (182, 335, *82*).

Choisy, A. *Études sur l'architecture grecque.* I. 1883. (Gives text of this and other building inscriptions with translation and commentary.)

Dörpfeld, W. *A.M.* VIII, 1883, 147.

Marstrand, V. *Arsenalet i Piraeus.* Copenhagen, 1922.

The inscription is *I.G.* II, 2, 1054; Ditt. 969; Roberts, E. S. and Gardner, E. A. *Introduction to Greek Epigraphy*, II, 1905, 360. See also *I.G.* II, 2, 807.

(b) Town-plan (187).

See *Town-planning*, p. 352 *supra*.

Pola (temples, 214, 340).

Tamaro, G. *N.S.* XX, 1923, 211.

Pompeii. For *Greek temple* and *Etruscan column*, v. *supra*, under *Magna Graecia and Sicily*, p. 367.

*(a) *General.* Only a small selection of the literature is given. [321 n.]

Full bibliography to 1891 in Furchheim, F. *Bibliografia di Pompei, Ercolano e Stabia.* Naples, 1891.

Mazois, F. *Les Ruines de Pompéi.* 4 vols. Paris, 1824–38. (Very important.)

Overbeck, J. *Pompeji.* 4th ed., revised by Mau, A. Leipzig, 1884.

Mau, A. *Pompeji in Leben und Kunst.* 2nd ed. Leipzig, 1908. (Translated by Kelsey, F. W. as *Pompeii, its Life and Art*.) Contains full bibliographical notes: a bibliographical supplement (*Anhang*) to the second German edition was published at Leipzig in 1913.

Van Buren, A. W. 'The Past Decade of Pompeian Studies,' *Class. Journal*, XV, 1920, 404.

Della Corte, M. *Pompeji, Die Neuen Ausgrabungen.* Valle di Pompei, 1926.

Van Buren, A. W. *A Companion to Pompeian Studies*, Rome, 1927. (Collection of ancient authorities and inscriptions.)

Pompeii (continued)

Recent general books include:

Ippel, A. *Pompeji.* Leipzig, 1925, and revised edition (6th) of Mau, A., *Führer durch Pompeji.* Leipzig, 1928.

Pernice, E. *Pompeji.* 1926.

(*b*) *Special studies.*

(i) Plan of town (191).

Van Buren, A. W. *Mem. Amer. Ac. Rome,* II, 1918, 67; V, 1925, 106.

Sogliano, A. *Acc. L. Mem.* Ser. vi, i, 1925, 221.

*(ii) Basilica (268, 337, *113*). [269 n. 1]

Sogliano, A. *Acc. Nap. Mem.* N.S. II, 1913, Part I, 117.

Schultze, R. *Basilika.* Berlin and Leipzig, 1928, 1.

(iii) Temple of Jupiter (212, 337, 338).

Sogliano, A. *Acc. L. Mem.* Ser. vi, i, 1925, 230.

*[Add *Small Theatre* (273, *114*) [274 n. 1].]

Pompeiopolis, v. Asia Minor, p. 359.

Poseidonia (Paestum), v. Magna Graecia and Sicily, p. 367.

Pozzuoli, v. Puteoli, p. 371.

Praeneste (Temple of Fortune, 338).

Delbrück, R. *Hellenistische Bauten in Latium,* I, 1907, 47.

Bradshaw, H. C. *B.S.R. Pap.* IX, 1920, 233.

Priene.

*(*a*) General, and Temple of Athena. [162 n.]

Wiegand, T. and Schrader, H. *Priene.* Berlin, 1904, in which all buildings discussed or mentioned in this book will be found: add for the question of the frieze of the Athena temple:

Wilberg, W. *A.M.* XXXIX, 1914, 72.

von Gerkan ,A. *A.M.* XLIII, 1918, 165.

See also Lethaby, W. R. *Greek Buildings…in the British Museum,* 1908, 185.

(*b*) Theatre (167, 334, *72, 73, 84*).

von Gerkan, A. *Das Theater von Priene.* Munich, 1921.

Dörpfeld, W. *A.M.* XLIX, 1924, 50.

Prinia, v. Crete, p. 362.

Puteoli (= *Pozzuoli*) (important inscription dealing with the erection of a gate in 105 B.C.).

Wiegand, T. *Jahrbücher f. class. Philologie,* Suppl. XX, 1894, 659.

C.I.L. X, 1781.

S. Rémy, v. Glanum, p. 366.

Rhamnus (temples, 42 n. 3, 115, 326, 328). [328 n.]

The Unedited Antiquities of Attica (Society of Dilettanti), 1817, 41.

Lethaby, W. R. *Greek Buildings represented by Fragments in the British Museum,* 1908, 148.

Orlandos, A. K. *B.C.H.* XLVIII, 1924, 305.

Rhegium, v. Magna Graecia and Sicily, p. 367.

Rhodes (early shrine at *Vroulia,* 323).

Kinch, K. F. and Kinch, H. *Fouilles de Vroulia,* Berlin, 1914, 8.

Rome.

Only a very small selection can be given.

*(*a*) General. [p. xii]

(i) The works named under *General Histories of Ancient Architecture (Roman)* and under *Roman materials and methods in the Republican period* and *in the Imperial period,* pp. 349 and 350 *supra.* For circular buildings, see Altmann, W., *Die italischen Rundbauten.* Berlin, 1906.

(ii) Jordan, H. *Topographie der Stadt Rom im Altertum,* Berlin, I, 1, 1878; I, 2, 1885; I, 3, revised by Hülsen, C., 1907; II, 1871. (This is invaluable, especially I, 3, which has an excellent index.)

Middleton, J. H. *The Remains of Ancient Rome.* 2 vols. 1892.

Lanciani, R. *Ruins and Excavations of Ancient Rome.* 1897.

—— *Ancient and Modern Rome.* 1925.

Rome (continued)

Hülsen, C. *The Roman Forum.* Translated by Carter, J. B. Rome, 1906. (Revised form of the second German edition, 1905.) Supplement, *Die neuesten Ausgrabungen auf dem Forum Romanum.* Rome, 1910.

Kiepert, H. and Hülsen, C. *Formae Urbis Romae Antiquae.* 2nd ed. Berlin, 1912. (Three plans of ancient Rome with a valuable *Nomenclator Topographicus* of monuments, with full reference to ancient authorities and modern investigations.)

(*b*) *Individual monuments.* (Henceforth *Delbrück* = Delbrück, R. *Hellenistische Bauten in Latium,* 2 vols., Strassburg, 1907, 1912; *Toeb.* = Toebelmann, F. *Römische Gebälke,* 1923; *Frank* = Frank, T. *Roman Buildings of the Republic,* 1924, for all of which see p. 349 *supra.*)

(*a*) *Agrippa, Thermae of* (248, 258, 340).
Hülsen, C. *Die Thermen des Agrippa.* Rome, 1910.

(*β*) *Antoninus and Faustina, Temple of* (217, 343).
Bartoli, P. *Mon. L.* XXIII, 1914, 949.

(*γ*) *Aqua Marcia* (236, 337).
Delbrück, I, I.
Frank, 137.

(*δ*) *Atrium Vestae* (341).
Van Deman, E. B. *Atrium Vestae.* Washington, 1909.

(*ε*) *Augustus, Arch of, in Forum* (294).
Toeb. 13.

(*ζ*) *Augustus, Mausoleum of* (266, 340).
Cordingley, R. A. and Richmond, I. A. *B.S.R. Pap.* X. 1927.
Colini, A. M. and Giglioli, G. Q. *Bull. Comm.* LIV (1926) 1927, 192.

(*η*) *Basilica Aemilia* (269, 338).
Van Deman, E. B. *A.J.A.* XVII, 1913, 14.
McDaniel, W. B. *A.J.A.* XXXII, 1928, 155.
Toeb. 27.
Frank, 66.

(*θ*) *'Basilica,' subterranean, by Porta Maggiore* (245, 341, *103*). (This has already a large literature, for which, and for good description and discussion, see Carcopino, J. *La Basilique Pythagoricienne de la Porte Majeure.* Paris, 1927.)
Bendinelli, G. *Mon. L.* XXXI, 1926, 601.

(*ι*) *Caecilia Metella, Tomb of* (266, 340).
Toeb. 9.
Frank, 144.

(*κ*) *Capitolium (Temple of Jupiter Capitolinus)* (200, 336).
Paribeni, R. *N.S.* 1921, 38.

(*λ*) *Castor, Temple of* (216, 234, 340).
Frank, T. and Stevens, G. P. *Mem. Amer. Ac. Rome,* V, 1925, 79.

(*μ*) *Colosseum* (285, 341, *118*, *118a*, XVI *b*).
Cozzo, G. *Ingegneria Romana.* Rome, 1928, 203.

(*ν*) *Concord, Temple of* (215, 234, 340, XII *a*).
Robert, H. F. and Marceau, H. *Mem. Amer. Ac. Rome,* V, 1925, 53.
Toeb. 42.

(*ξ*) *Constantina, Mausoleum of* (?) (= *S. Costanza*) (257, *109*, XIX *b*). See p. 257 n. 2.

(*o*) *Constantine, Arch of* (346).
Walton, A. *Mem. Amer. Ac. Rome,* IV, 1924, 169.
Buschor, E. *R.M.* XXXVIII–IX, 1923–4, 52.

(*π*) *'Fortuna Virilis,' Temple of* (211, 339, X *b*).
Fiechter, E. *R.M.* XXI, 1906, 220.
Frank, 134.
von Gerkan, A. *Gnom.* I, 1925, 366.

Rome (continued)

(ρ) *Forum Holitorium, temples under S. Nicola in Carcere* (207, 338, 339).
Delbrück, R. *Die Drei Tempel am Forum Holitorium in Rom.* Rome, 1903.
Frank, 126.

(σ) *Hadrian, Mausoleum of* (266, 343).
Pierce, S. R. *J.R.S.* xv, 1925, 75.

(τ) *S. Nicola ai Cesarini, Temple* (338).
Marchetti-Longi, G. *Bull. Comm.* xlvi (1918) 1920, 127.
Frank, 130.

*(υ) *Pantheon* (246, 342, *104*, *105*, XVI a, XVII). [266 n.]
Beltrami, L. *Il Pantheon.* Milan, 1898.
Borrmann, R. Lecture reported in *A.A.* 1921, 249. (For the inner decoration in particular.)
Colini, A. M. and Gismondi, I. *Bull. Comm.* liv (1926) 1927, 67.
Cozzo, G. *Ingegneria Romana.* Rome, 1928, 257.

(φ) *Pons Aemilius, Pons Fabricius* and *Pons Mulvius* (236, 337, 338, XIV a).
Delbrück, i, 3, 12 (also ii, Pl. II).
Frank, 139–42.

(χ) *Portunus (?), Temple of (Round Temple near Tiber)* (211, 339, X a).
Delbrück, ii, 43.
Frank, 136.

(ψ) *Regia* (339).
Toeb. i.
Frank, 81.

(ω) *Sun, Temple of* (345).
Toeb. 108.

(αα) *Tabularium* (240, 338, *100*, *101*).
Delbrück, i, 23 (also ii, Pl. III).

(ββ) *Trajan, Column of* (292, 342).
Lehmann-Hartleben, K. *Die Trajanssäule.* 2 vols. Atlas. Leipzig, 1926.

(γγ) *Tullianum* (337).
Frank, 39.

*[Add *Basilica Nova* (261, *111*) [266 n.], *Market of Trajan* [*ib.*], *Palace in Horti Sallustiani* [342] and *Porta Argentariorum* [345].]

Rusuccuru (=*Tâûghzût*), v. *Africa, Roman*, p. 356.
Sabratha, v. *Africa, Roman*, p. 356.
Saccaea (=*Shaqqâ*), v. *Syria*, p. 376.
Sagalassus, v. *Asia Minor*, p. 359.
Saḥr, v. *Syria*, p. 376.
Salona (=*Spalato, Split*) (Palace of Diocletian, including Mausoleum and Temple of Aesculapius, 227, 255, 312, 316, 346, *108*, *135*, XXIV a, b).
Adam, R. *Ruins of the Palace of the Emperor Diocletian at Spalato.* 1764.
Niemann, G. *Der Palast Diokletians in Spalato.* Vienna, 1910.
Hébrard, E. and Zeiller, J. *Spalato, Le Palais de Dioclétien.* Paris, 1912.
The case for Syrian and Oriental influence at Spalato is best stated by:
Strzygowski, J. In *Studien aus Kunst und Geschichte Friedrich Schneider zum siebzigsten Geburtstage gewidmet.* 1906, 325.
Against this, Weigand, E. finds that the details of ornamental motives are most closely connected with Asia Minor, and to a less extent with the city of Rome: see *J.D.A.I.* xxix, 1914, 88.

*Samos (Heraeum and independent peripteral building, 90, 95, 98, 103, 331, 332, *43*, *44*). [105 n.]
Wiegand, T. and others. *Erster vorläufiger Bericht über die von dem Königl. Mus. unternommenen Ausgrabungen in Samos.* Berl. Abh. v, 1911.
Buschor, E. *Gnom.* iii, 1927, 188.
Samothrace (Cabirion, 330, 332, Arsinoeion, 330, Ox-skulls, 210, n. 1).
Conze, A. and others. *Archäologische Untersuchungen auf Samothrake*, Vienna, 1875.
—— *Neue arch. Untersuch. auf Samothrake*, Vienna, 1880.
Thiersch, H. *Z.G.A.* ii, 1908–9, 88.

Sardis (Temple of Artemis or Cybele, 149, 150, 333).
 Butler, H. C. *Sardis*. Vol. II. Part I. Leyden, 1925.
 Vallois, R. *R.E.G.* XXXIX, 1926, 367.
Satricum (= *Conca*), *v. Etruria*, p. 366.
Sbeitla, *v. Sufetula* (= *Subaiṭila*), s.v. *Africa, Roman*, p. 356.
Segni, *v. Signia*, s.v. *Etruria*, p. 366.
Segusio (= *Susa*) (Arch of Augustus, 294, 340).
 Ferrero, E. *L'Arc d'Auguste à Suse*. Turin, 1901.
 Studniczka, F. *J.D.A.I.* XVIII, 1903, 1.
Selinus, *v. Magna Graecia and Sicily*, p. 368.
Seriane (= *Isriya*), *v. Syria*, p. 376.
Shaqqâ, *v. Saccaea*, s.v. *Syria*, p. 376.
Shuhba, *v. Philippopolis*, s.v. *Syria*, p. 376.
Sî', *v. Syria*, p. 377.
Sicily, *v. Magna Graecia and Sicily*, p. 367.
Sidyma, *v. Asia Minor*, p. 359.
Signia (= *Segni*), *v. Etruria*, p. 366.
Silchester, *v. Calleva Atrebatum*, p. 362.
Sminthe, *v. Asia Minor*, p. 359.
Soada, *v. Suwaida*, s.v. *Syria*, p. 377.
Spalato, *v. Salona*.
Sparta.
 (*a*) Temple of Athena Chalkioikos (57 n. 1).
 B.S.A. XIII, 1906–7, 137.
 (b) Temple of (Artemis) Orthia (53, 322, II *a*). [53 n. 2]
 Dawkins, R. M. *B.S.A.* XIV, 1907–8, 1.
 (c) Theatre (272, 340). [185 n.]
 Woodward, A. M. *B.S.A.* XXVI, 1923–5, 119; XXVII, 1925–6, 175.
Split, *v. Salona*.
Stratos (Temple of Zeus, 330).
 Courby, F. and Picard, C. *Recherches archéologiques à Stratos*. Paris, 1924.
Subaiṭila, *v. Sufetula*, s.v. *Africa, Roman*, p. 356.
Sufetula (=*Subaiṭila*), *v. Africa, Roman*, p. 356.
Sunamin, *v. Aere* (=*Aṣ-Ṣanamain*), s.v. *Syria*, p. 375.
Sunium (Temples of Athena and Poseidon, 55, 115, 325, 327, 328, 332). [328 n.]
 Dörpfeld, W. *A.M.* IX, 1884, 324.
 Staïs, B. 'Ε.'Α. 1900, 112; 1917, 168.
 Orlandos, A. K. 'Α. Δελτ. I, 1915, 1.
 — 'Ε.'Α. 1917, 213.
Sûr, *v. Syria*, p. 377.
Susa, *v. Segusio*.
Suwaida, *v. Syria*, p. 377.
Syracuse, *v. Magna Graecia and Sicily*, p. 368.
Syria (*with Palestine and neighbouring regions*).
 (*a*) *General*.
 (i) Vogüé, C. J. M., Comte de. *La Syrie Centrale*. Paris, 1865–77. (Henceforth called *Vogüé*.)
 (ii) Brünnow, R. E. and Domaszewski, A. *Die Provincia Arabia*. 3 vols. Strassburg. 1904, 1905, 1909. (Henceforth called *B.D.*)
 (iii) The publications of the American Archaeological Expedition to Syria in 1899–1900, and of the Princeton University Archaeological Expeditions to Syria in 1904–5 and 1909.
 (*a*) Part I of the publications of the American Expedition:
 Garrett, R. *Topography and Itinerary*. New York, 1914. (Henceforth called *Amer. I.*)

Syria (continued)

(β) Part II of the same:

Butler, H. C. *Architecture and the other Arts.* New York. 1904. (Henceforth called *Amer. II.*)

(γ) Part III of the same:

Prentice, W. K. *Greek and Latin Inscriptions.* New York, 1908. (Henceforth called *Amer. III.*)

(δ) Part IV of the same:

Littmann, E. *Semitic Inscriptions.* New York, 1904. (Henceforth called *Amer. IV.*)

(ϵ) Division II of the publications of the Princeton Expeditions:

Butler, H. C. *Ancient Architecture in Syria.* Leyden, 1907–20. Divided into Section A (*Southern Syria*) in seven parts, and Section B (*Northern Syria*) in six parts. (Henceforth called *Princeton II.*)

(ζ) Division III of the same:

Greek and Latin Inscriptions in Syria. Leyden, 1907–22. Divided exactly as Division II, Section A being by Littmann, E. and others, Section B by Prentice, W. K. (Henceforth called *Princeton III.*)

(η) Division IV of the same:

Semitic Inscriptions. Section A, *Nabataean Inscriptions*, by Littmann, E. 1914. (Henceforth called *Princeton IV.*)

(iv) Murray, S. B. *Hellenistic Architecture in Syria.* 1921. (A useful short summary. Henceforth called *Murray.*)

(*b*) *Individual sites.*

Aere (= *Aṣ-Ṣanamain*) (Temple of Tyche, 344).

Princeton II, A, 5, 316.

Antioch on the Orontes (colonnaded streets, 292; palace, 320, 321), *v. Town-planning* (p. 352 supra): also:

Müller, K. O. *Antiquitates Antiochenae.* Göttingen, 1839.

Förster, R. *J.D.A.I.* XII, 1897, 103.

Askalon (Bouleuterion and Peristyle, 340).

Palestine Exploration Fund Quarterly Statement. January, 1924, 24.

'*Atîl* (temples, 230, 345).

Amer. II, 343.

B.D. III, 103. (Corrects Butler's dating.)

Weigand, E. *J.D.A.I.* XXIX, 1914, 59 n. 2.

Murray, 15.

Bostra (= *Boṣrâ eski Shâm*).

(i) Temple (?), with two types of conch (230 n. 2).

Princeton II, A, 4, 247.

B.D. III, 22.

(ii) Theatre (343).

Vogüé, 40.

B.D. III, 47.

Princeton II, A, 4, 273.

Damascus (temple-precinct of Jupiter Damascenus, 344).

Watzinger, C. and Wulzinger, K. *Damaskus, die antike Stadt.* Berlin and Leipzig, 1921. (Heft 4 of *Wiss. Veröff. d. deutsch-türk. Denkmalschutz-kommandos*, ed. by Wiegand, T.)

*_Doura-Europos_ (town-plan, 190). [190 n. 2]

Cumont, F. *Fouilles de Doura Europos.* Paris, 1926.

Tscherikower, V. *Philol.* Suppl. Bd. XIX, Heft 1, 1927, 88. (He points out that the attribution of the foundation to Seleucus Nicator rests on an emendation in Isidorus of Charax of Νικάνορος to Νικάτορος. He assigns it to Nicanor, a general of Antigonus, killed in 313. This would put the foundation a few years earlier.)

Syria (continued)

Dúma (house, 314, *133*).
 Vogüé, 52.
 Princeton II, A, 5, 342. (Records its disappearance.)

**Gerasa* (=*Jarash*) (colonnaded streets, temples, propylaea, 291, 343, 344). [252, 343]
 Schumacher, G., *Zeitschrift d. deutsch. Palaestina-Vereins*, xxv, 1902, 109.
 B.D. ii, 233, 253.
 B.S.J. Bull. 3, 1923, Pls. II–V: 7, 1925, 98, Pls. I, II.

Hebrán (Ionic temple, 211 n. 1, 343).
 Princeton II, A, 5, 323.

Heliopolis (=*Baalbek*) (temples and courts, 222, 263, 264, 340, 342, 345, *95, 96, 97, 112*, XIII, XIX *a*).
 Weigand, E. *J.D.A.I.* 1914, 37, *Jahrb. f. Kunstwissenschaft*, 1924, 77, 165.
 Weigand, T. and others. *Baalbek.* Berlin and Leipzig. 1 text and 1 plates, 1921 (Temple of Jupiter and courts). ii, 1923 (Temple of Bacchus and Round Temple). iii, 1925 (Medieval period). See also p. 228 n. 1 *supra*.

Inkhil (Palace, 321, 344).
 Princeton II, A, 5, 312.

Jerusalem (rock-cut tombs, 221, 341).
 Durm, J. *Bauk. der Römer.* 2nd ed. 1905, 759. (References to earlier literature.)
 Delbrück, R. *Hellenistische Bauten in Latium*, ii, 1912, 148.
 Otto, W. In *P.W.* vii, 1912, 2837, s.v. *Helena*, 6.

Kiakhta, v. Asia Minor, p. 358.

**Palmyra* (=*Tadmor*) (Temple of Bel, 222, 340. Temple of Baalsamîn, 230 n. 1, 343; colonnaded streets, 291). [222 n. 2]
 Wood, R. *Ruins of Palmyra.* 1758. (For the inscriptions see the next entry.)
 Amer. I, 73; *II*, 49; *IV*, 57.
 Murray, S. B. *A.J.A.* xix, 1915, 268.
 Murray, 24.
 Wiegand, T. *Kunstchronik*, 1923, 807.
 Gabriel, A. *Syr.* vii, 1926, 71.
 Hutton, C. A. *J.H.S.* xlvii, 1927, 102. (For Wood's note-books, now in the Library of the Society for the Promotion of Hellenic Studies.)

**Petra* (rock-cut façades, and other structures, including Khazna, 220, 221, 342, XI *a*). [221 n. 1]
 Dalman, G. *Petra.* Leipzig, 1908.
 —— *Neue Petra-Forschungen.* Leipzig, 1912.
 B.D. i, 125–424, 480–510. (Full bibliography.)
 Bachmann, W., Watzinger, C. and Wiegand, T. *Petra.* Berlin and Leipzig, 1921. (Heft 3 of the publication quoted under *Damascus, supra*.)
 Kennedy, Sir A. B. W. *Petra, its History and Monuments.* 1925.

Philadelphia in *Ammonitis* (= '*Ammán*) (temple, 344; theatre, 343).
 Princeton II, A, 1, 38, 47.

Philippopolis in *the Haurán* (= *Shuhba*) (temple, theatre, palace, baths, 345).
 Amer. II, 376.
 B.D. iii, 147.

Saccaea (= *Shaqqá*) (basilica, 238, 344, *99*; palace, 240, 346).
 Vogüé, 47, 55.
 Amer. II, 365, 370.

Sahr (temple, 339).
 Princeton II, A, 7, 441.

Seriane (= *Isriya*) (temple, 321, 344).
 Amer. II, 76.

Sî' (Temple of Ba'al Shâmîn, 220, 339; Temple of Dushara, 227 n. 1, 339).
 Vogüé, 31.

Syria (continued)
 Amer. II, 334.
 Princeton II, A, 6, 374 (Ba'al Shâmîn), 385 (Dushara).
 Murray, 11.
Sûr (temple, 339).
 Princeton II, A, 7, 428.
Suwaida (perhaps the ancient *Soada* or *Dionysias*) (tomb of Ḥamrath, 221, 338; temple, 220,
 339).
 Vogüé, 29, 39.
 Amer. II, 324, 327.
 B.D. III, 88.
 Murray, 8.
Tyros (= '*Arâq al-Amîr*) (Palace of Hyrcanus, 336).
 Otto, W. In *P.W.* IX, 1916, 532 (s.v. *Hyrkanos*).
 Princeton II, A, 1, 1.
 Murray, 6.
Umm aẓ-Zaitûn ('kalybe,' 252 n. 1, 346).
 Vogüé, 43.
 Princeton II, A, 5, 361. (Contains further details about the dome.)
Tadmor, *v. Palmyra*, s.v. *Syria*, p. 376.
Tâûghẓût, *v. Rusuccuru*, s.v. *Africa, Roman*, p. 356.
Taxiarchis, *v. Aetolia*, p. 355.
Tebessa, *v. Theveste*, s.v. *Africa, Roman*, p. 356.
**Tegea* (Temple of Athena Alea, 143, 329, *60*, *61*). [329]
 Dugas, C. and others. *Le Sanctuaire d'Aléa Athéna à Tégée au* IV*e siècle*. 1924.
Teos, *v. Asia Minor*, p. 359.
Termessus, *v. Asia Minor*, p. 359.
Thamugadi (=*Timgad*), *v. Africa, Roman*, p. 356.
Thebes (Temple of Apollo Ismenius, 322, 324, 329).
 Keramopoullos, A. D., 'Α. Δελτ. III, 1917, 33.
Thera (houses, including anticipations of the corridor type, 299, 312).
 Hiller von Gaertringen and others. *Thera*. 3 vols. Berlin, 1899–1904, especially III, 137.
 See Swoboda, K. M. *Römische und Romanische Paläste*. Vienna, 1924, 30.
**Thermum* ('Megaron A,' 'Megaron B,' temples, 51–53, 65–67, 322, 324, *20*). [67 n. 1.] *v. Aetolia*:
 also:
 Kawerau, G. and Sotiriades, E. *A.D.* II, 1902–8, 5.
 Rhomaios, K. 'Α. Δελτ. I, 1915, 225; VI, 1920–1, 158.
 Dörpfeld, W. *A.M.* XLVII, 1922, 43.
 Van Buren, E. D. *Greek Fictile Revetments in the Archaic Period*, 1926, 64.
Theveste (= *Tebessa*), *v. Africa, Roman*, p. 356.
Thugga (= *Duqqa*), *v. Africa, Roman*, p. 356.
Thysdrus (= *Al-Jam'*), *v. Africa, Roman*, p. 356.
Tibur (= *Tivoli*).
 (*a*) Hadrian's Villa (252, 312, 316, 342, *107*, *134*).
 Winnefeld, H. *Die Villa des Hadrian bei Tivoli* (III *Ergänzungsheft des J.D.A.I.*). 1895.
 Gusman, P. *La Villa Impériale de Tibur* (*Villa Hadriana*). Paris, 1904.
 Reina, V. *N.S.* 1906, 313. (Official plan of actual remains.)
 Lanciani, R. *La Villa Adriana*. Rome, 1906.
 Taramelli, A. *N.S.* XIX, 1922, 287.
 Chillman, J. *Mem. Amer. Ac. Rome*, IV, 1924.
 (*b*) 'Temple of the Sibyl' and 'Temple of Vesta' (210, 338).
 Delbrück, R. *Hellenistische Bauten in Latium*, II, 16.
Tigẓirt, *v. Rusuccuru* (= *Tâûghẓût*), s.v. *Africa, Roman*, p. 356.
Timgad, *v. Thamugadi*, s.v. *Africa, Roman*, p. 356.

Tiryns.
 (*a*) For Mycenaean period, see p. 354 *supra.*
 *(*b*) 'Doric temple' and Doric details (36, 67 n. 2). [36 n. 8, 68 n.]
 See the general works named on p. 354, especially:
 Dörpfeld, W. In Schliemann's *Tiryns,* 1886, 293.
 Frickenhaus, A. *Tiryns.* I. Athens, 1912.
 Rodenwaldt, G. *J.D.A.I.* XXXIV, 1919, 95 n. 2.
 Blegen, C. W. *Korakou.* Boston and New York, 1921, 130.
Tivoli, v. Tibur.
Trèves, v. Augusta Treverorum.
Trier, v. Augusta Treverorum.
Tripolis, v. Africa, Roman, p. 356.
Tyros (= *'Arâq al-Amîr*), *v. Syria,* p. 377.
Umm aẓ-Zaitûn, v. Syria, p. 377.
Vaẓi Sarra (= *Henchir-Beẓ*), *v. Africa, Roman,* p. 356.
Veii, v. Etruria, p. 366.
Vienna (= *Vienne*) (Temple of Augustus and Livia, pp. 214, 340).
 Formigé, J. *R.A.* 5ᵉ sér. XXI, 1925, 153.
Volci (=*Vulci*), *v. Etruria,* p. 366.
Volsinii (= *Orvieto,* probably), *v. Etruria,* p. 366.
Vouni, v. Cyprus, p. 362.
Vroulia, v. Rhodes, p. 371.
Vulci, v. Volci s.v. *Etruria,* p. 366.
Xanthos, v. Asia Minor, p. 359.

Select Glossary of Architectural Terms

NOTE. This list is mainly but not entirely confined to words used in this book, with their ancient equivalents. No attempt is made to give all technical terms known from ancient writers or inscriptions.

Latin and Greek equivalents are given in brackets after each modern term. An obelus (†) is prefixed to Greek words which lack ancient authority *in the exact sense of the modern term*: to words which lack *all* direct ancient authority, but can reasonably be inferred by close analogy from authentic terms: and to Greek terms known only from Latin writers or in Latin transcriptions. When the Latin word is identical with the modern term the letter (L) is substituted for the full word.

All Greek words mentioned in this Appendix, together with a few other terms not here repeated, are collected with cross-references in an alphabetical list at the end.

A. GENERAL LIST

Abacus (L: †ἄβαξ). See pp. 42, 46. Vitruvius, the only authority apart from glossographers, confines *abacus* to Ionic and Corinthian capitals and calls the Doric 'abacus' *plinthus*.

Abutment. Any solid structure which receives the thrust of an arch or vault.

Acanthus (L: ἄκανθα). See p. 135.

Acroterium (L: ἀκρωτήριον). See p. 49. The pedestal blocks on which they stood are called βάθρα. The word *fastigium* sometimes means 'acroterium,' especially in Pliny's *Natural History*.

Adiectio. See Entasis.

Adyton (*adytum*: ἄδυτον). Inner sanctuary, holy of holies. The word is applied by modern writers, usually in its Greek form, especially to an inner room reached from the cella of a temple. See p. 39.

Agora (*forum*: ἀγορά). An open space in a Greek or Roman town, serving as a market-place and general meeting-place: the agora or forum was often surrounded or partly surrounded by porticoes, especially in Hellenistic and Roman times. There are differences between the Greek and Roman types, and it is best not to interchange the names.

Ala (L.). (*a*) See p. 199. (*b*) See p. 303.

Albarium. See Stucco.

Amphidistyle, amphiprostyle etc. In such compounds *amphi*- implies that the same form is used at front and back. Vitruvius uses *amphiprostylos* (†ἀμφιπρόστυλος).

Amphitheatre (*amphitheatrum*: ἀμφιθέατρον). See p. 283.

Anactoron (ἀνάκτορον). A sacred building, or an especially sacred part of such a building: used chiefly in connection with the Mysteries. See p. 171 for the anactoron of the Eleusis Telesterion.

Anathyrosis (†ἀναθύρωσις: the verb ἀναθυροῦν is used in this sense in inscriptions). See p. 42.

Ancon. See Console.

Andron (L: ἀνδρών). (*a*) in Greek, an apartment in a house reserved for men, especially a dining-room: (*b*) in Latin, see p. 306. Vitruvius (VI, 7, 5) expresses surprise at the Latin meaning.

Andronitis (L: ἀνδρωνῖτις) = Andron (*a*), or more widely 'men's quarters.'

Anta (L: παραστάς, which also means 'pilaster' generally, or 'jamb'). See p. 39. The Greek for *in antis*, according to Vitruvius, was †ἐν παραστάσιν.

Antefix (*antefixum*). See p. 49. Covering-tiles ending in antefixes seem to be described in Athenian inscriptions as καλυπτῆρες ἀνθεμωτοί (lit. 'covering-tiles adorned with floral decoration'). Pliny, *N.H.* xxxv, 152, says of Butades of Sicyon *primus personas tegularum*

extremis imbricibus imposuit, 'he first placed masks on the ends of covering-tiles': this clearly refers to antefixes.

Antepagmentum. See Jamb, and p. 197.

Anthemion (ἀνθέμιον). A band of floral ornament, usually lotus (*q.v.*) alternating with palmette (*q.v.*).

Antithema (ἀντίθημα or ἀντίθεμα: inscriptions of the fifth century B.C. do not distinguish between ε and η, but ἀντίθεμα occurs in later inscriptions: there is no literary evidence). See p. 43: the term is used of the backing, e. g. of steps, as well as of that of architrave and frieze. In inscriptions the word is usually plural (ἀντιθέματα = the blocks which make up the backing): in the Erechtheum inscriptions such blocks are called ἀντίμοροι (*sc.* λίθοι or πλίνθοι).

Apodyterium (L: ἀποδυτήριον, ἀπόθεσις). See p. 243.

Apophyge (Vitruvius' terms are *apophysis*: †ἀπόφυσις, and *apothesis*: †ἀπόθεσις. The modern term seems to be a corruption of *apophysis*). See p. 46.

Apophysis. See Apophyge.

Apothesis: (*a*) See Apodyterium. (*b*) See Apophyge.

Apse (*apsis*, chiefly late: the Greek ἁψίς, lit. 'wheel,' is used of arches and vaults, and of the curved seats in a theatre). A curved recess, usually semicircular, projecting from or substituted for one of the straight walls of a building.

Apsis. See Apse.

Araeostyle (*araeostylos*: †ἀραιόστυλος). See p. 154.

Arch (*arcus, fornix*: ἁψίς, ψαλίς. The Greek and Latin terms are also applied to vaults (*q.v.*)). A series of stones or bricks placed side by side with their joints radiating in such a manner that they can support one another and also a superincumbent weight while bridging a space too wide for any one of them to cover singly. Arches usually bridge an opening in a wall or the free space between two isolated supports, but they are also built into walls as 'relieving' or 'discharging' arches, in order to divert pressure from arches or lintels at a lower point. See pp. 231 ff., and see pp. 293 ff. for 'triumphal' arches: see also Voussoir.

Architrave (*epistylium*, ἐπιστύλιον). See p. 43. Vitruvius calls the wooden architraves of Tuscan temples *trabes compactiles* (see p. 196).

Arcus. See Arch.

Arris. The sharp edge formed by the angular contact of two flat or curved surfaces: used chiefly of the ridge between two Doric flutes (see p. 41).

Ashlar (*opus quadratum*: the blocks are called in Latin *saxa quadrata*, in Greek πλίνθοι, lit. 'bricks', or πλινθίδες). A rectangular block of hewn stone, or masonry made up of such blocks.

Asser. See Roofing.

Astragal (*astragalus*: ἀστράγαλος). See p. 38. In Greek inscriptions rounded mouldings are sometimes called ἀστράγαλοι, even before being carved with the bead-and-reel, but the name (= 'knuckle-bones') implies the ornament. In the Erechtheum inscriptions such unfinished astragals are called ἀργοί ('unworked'). See also Cymatium and Lesbian cymatium.

Atlantes (ἄτλαντες). Male figures used as architectural supports: this was the Greek term, for which the Romans, according to Vitruvius (VI, 7, 6), substituted *telamones*. There is evidence that Telamon was an alternative name for Atlas, who carried the sky.

Atrium (L). See p. 302.

Attic (adjective): (*atticurges*, †Ἀττικουργής). See p. 46 for the Attic type of Ionic column-base: also applied by Vitruvius (IV, 6, 6) to a certain type of door.

Attic (noun): (*a*) A storey above the main cornice, e.g. in 'triumphal' arches (see p. 294).
(*b*) Hence, in private houses, the top storey under the roof, or a room in such a storey.
Both meanings lack ancient authority.

Atticurges, *v.s.* Attic (adjective).

Balneae (L: irregular plural of *balneum*, which is rare: βαλανεῖον, commoner in plural βαλανεῖα). See p. 243 etc., and see also Thermae.

Balteus (L). A carved band which often encircles the pulvinus (*q.v.*) of the Ionic capital, seeming to compress it: visible in Fig. 51.

Barrel-vault. See Vault.

Base (*basis* and βάσις mean 'basis,' 'support,' 'pedestal,' and the like, sometimes vaguely 'foot,' but seldom if ever 'column-base': the circular Ionic and Corinthian column-base is *spira*, σπεῖρα: this term can be confined to a single torus moulding, but it can also be extended to include a square plinth under the base proper: it can also be applied to the base of an anta or to its continuation as a wall-base). See p. 46.

Basilica (L: †βασιλική). See p. 267. There is no clear case of the use of βασιλική or βασιλικὴ στοά for a basilica before the Roman period.

Basis. See Base.

Bead-and-reel. See Astragal, and p. 38.

Bed-mould. A strip under any projecting member, especially that under the corona of the cornice: its face may be a plain flat fillet, as usually in Doric, or moulded or decorated in various ways, as usually in Ionic.

Bipedales (L.). See p. 235.

Bouleuterion (βουλευτήριον). Meeting-place of the βουλή or senate in a Greek city. See pp. 174, n. 3, 179.

Brick (*later*: πλίνθος). Both ancient words when used alone generally mean a sun-dried brick (*later crudus*: πλίνθος ὠμή or γηΐνη): a baked brick is *later coctus* or *testaceus, testa*: πλίνθος ὀπτή. The burnt bricks or tiles used as facing to Roman concrete are usually called *tegulae*. See pp. 4, 234, etc. See also Plinth and Ashlar for other meanings of πλίνθος and of its Latin transcription *plinthus*.

Bucranium (†L: †βουκράνιον, βουκεφάλιον). An ox-head or ox-skull in relief used as a decorative motive, often combined with garlands or alternating with rosettes or phialai. See p. 210.

Cabling. A convex moulding often used to fill up the concave fluting of Roman columns for the lower third of the shaft.

Caementicium. See Concrete.

Caementum (L.). See p. 232. Sometimes loosely used by ancient writers in the sense of 'concrete,' *q.v.* Also in feminine form *caementa*.

Caldarium (L). See p. 243.

Camara or Camera. See Vault.

Canalis (L). See Channel.

Cantherius (L: κανθήλιος found in Attic inscriptions: the usual Greek equivalent is σφηκίσκος). A rafter. See p. 197 and see also Roofing.

Capital (*capitulum*: ἐπίκρανον, κιόκρανον). See pp. 42, 46, 139, etc.: ἐπίκρανον can also be equivalent to ἐπικρανῖτις, for which see Epicranitis.

Capitulum. See Capital.

Capreoli. See Roofing.

Cardo (L). See p. 191.

Caryatid (*caryatides* [plural], Vitruvius: καρυάτιδες. The Caryatids of the Erechtheum are called κόραι in the building inscriptions, but the word, in this or a closely similar sense, is as old as the fourth century B.C.: see Athenaeus, VI, 241 *e*). See p. 100.

Cauliculus (L). See pp. 140, 144, etc.

Cavaedium. See Cavum aedium.

Cavea (L: *theatrum* and θέατρον are both used to mean 'auditorium' as well as in the wider sense of 'theatre': no more special Greek term seems to have good authority). See p. 271.

Cavum aedium (L, also *cavaedium*). See p. 302.

Cella (L: ναός = Attic νεώς, σηκός: the Greek terms are not usually confined to the narrower sense of 'cella,' though 'naos' is often so used by modern writers). See p. 39.

Centering. A temporary structure, usually of wood, placed under arches, vaults, and domes to support them while they are being built.

Channel (*canalis*). See p. 46.

Clamp (*securicula*: πελεκῖνος; both words strictly imply the 'swallow-tail' type: more general terms are δεσμός (plural δεσμά) and δέμα). See pp. 4, 42.

Coffer (*lacunar, laquear*: φάτνωμα). Flat ceilings, whether of stone or wood, were usually constructed by placing small beams at right angles across the main beams, and covering the square openings thus formed with square frameworks closed with flat lids. In the inscrip-

tion describing the wooden ceiling of the East Cella of the Erechtheum the main beams are σελίδες, the framework of small beams κλιμακίς (lit. 'ladder'), the square frameworks πλαίσια, the lids καλύμματα: κλιμακίς and πλαίσιον occur in the same sense in a Delian inscription. The stone ceilings of the Erechtheum porches are illustrated in Figs. 54 and 56.

Colonnade (*porticus*: στοά). (*a*) A row of columns supporting an entablature. (*b*) A building of accessible character, with its roof supported by one or more rows of columns, one at least of which rows usually replaces one of the main outer walls, after the fashion of a cloister. *Porticus* and στοά can also mean 'porch.'

Columen. See p. 197, and see also Roofing.

Column (*columna*: κίων, στῦλος). See pp. 5, 41 ff., 64, etc. The English and Latin words are not applied to supports of square or rectangular section, which are called *pillars*, *q.v.*, but κίων and στῦλος seem to have been ambiguous.

Compactilis (L). 'Fastened together': for *trabes compactiles* see p. 196.

Compluvium (L). See p. 304. Plautus *Mil. Glor.* 287 uses *impluvium* (*q.v.*) of the opening in the roof, usually called *compluvium*.

Composite. See p. 220.

Concrete (*structura caementicia, structura, opus structile, caementicium*). See p. 232: *caementum* (*q.v.*) is sometimes used by Roman writers loosely for 'concrete.'

Console (*ancon, parotis*: †ἀγκών, †παρωτίς, οὖς). See p. 100. Horizontal consoles under a cornice (see pp. 214, 225) are called 'modillions': a slightly more general word for a projecting stone or timber support or bracket is 'corbel.'

Contractura. See Diminution.

Corbel. See Console.

Corbelling. The bridging of an opening in a wall or the roofing of an enclosed space by means of series of overlapping horizontal courses, without the use of the arch principle. For an example see the 'dome' of the 'Treasury of Atreus,' Fig. 15.

Corinthian (Corinthius: Κορίνθιος). (*a*) Capital, see pp. 139 ff. (*b*) Cavaedium, see pp. 302, 304. (*c*) Frieze, see p. 329.

Cornice (*corona*, *q.v.*, used also in narrower sense: γεῖσον). See pp. 43, 47. The 'raking' or sloping cornices over the pediments, or the blocks of which they are composed, are called in inscriptions γεῖσα ἐπὶ τοὺς αἰετούς, γεῖσα καταιέτια. In the inscription about Philo's Doric porch at Eleusis (see p. 174) the blocks of the horizontal and raking cornices are distinguished as γεῖσα Δωρικά and γεῖσα Ἰωνικά, presumably because the raking cornice has no mutules (*I.G.* II⁵, 1054 b/c).

Cornice-casing. See p. 68.

Corona (L). See pp. 43, 47. In Latin *corona* means either the whole cornice or (as in modern usage) its projecting member only.

Covering tile (*imbrex*: καλυπτήρ). See p. 49.

Crepido. See Crepidoma.

Crepidoma (*crepido*: κρηπίδωμα, κρηπίς). See p. 41. In Greek these terms were usually confined to the stepped outer edge of the platform of a temple, the rest of which was called στρῶμα at Athens, στοιβά in the Peloponnese.

Crepis. See Crepidoma.

Cross-vault. See p. 240. The intersection of two barrel-vaults. See also Groin, Vault.

Crypta (L: κρυπτή). See Cryptoporticus.

Cryptoporticus (L). A vaulted subterranean corridor. *Crypta* (κρυπτή) has a similar but wider meaning.

Cuneus (L: κερκίς). (*a*) One of the wedge-shaped sections of the seating of a theatre or amphitheatre, bounded by stairs and horizontal passages. (*b*) A voussoir (*q.v.*). There is no evidence for κερκίς in sense (*b*).

Curia (L). See p. 271.

Cyma (κῦμα, very rare in this sense, except in diminutive κυμάτιον: see under Lesbian cymatium). See p. 37, and n. 4, and p. 61 n.

Cymatium (L, also in form *cumatium*: κυμάτιον). A moulding: used by Vitruvius and by many modern writers especially of the 'echinus' of the Ionic capital. In inscriptions (e.g. those of the Erechtheum) κυμάτιον is used both of the ovolo and of the cyma reversa,

and these κυμάτια are regarded as unworked (ἀργά) until they are carved respectively with egg-and-tongue and leaf-and-dart. See further under Lesbian cymatium.

Dado. The lower portion of a wall when clearly marked off from the upper portion, for instance by the use of panelling or by mouldings above and below, like those of a pedestal.

Decastyle (*decastylos*: †δεκάστυλος). Having ten columns in a line: especially used of a peripteral temple with ten columns at the front and back (e.g. Fig. 66).

Decumanus (L). See p. 191.

Denticulus. See Dentil.

Dentil (*denticulus*). See p. 47. As the Greek for 'dentils' γεισήποδες and γεισηπόδισμα are sometimes given by modern writers, but according to Pollux (1, 81) γεισιποδίσματα are projecting upper storeys, γεισίποδες the beams supporting them, and in inscriptions (which have the correct spelling with η) the words are confined to wooden beam-ends and cornices or the like supported by them. See also Metope.

Diastyle (*diastylos*: †διάστυλος). See p. 154.

Diazoma (L: διάζωμα). A horizontal passage separating tiers of seats in a theatre or amphitheatre.

Diminution (*contractura*). See p. 41.

Dipteral (*dipteros*: †δίπτερος). With a double pteron or external colonnade: see p. 71, n. 3.

Displuviate (*cavum aedium displuviatum*). See pp. 302, 304.

Distyle (*distylos*: †δίστυλος). Having two columns: most commonly used of porches 'distyle in antis' (*v.s.* Anta).

Dodecastyle (*dodecastylos*: †δωδεκάστυλος). Having twelve columns in a line. See Decastyle.

Dome (*hemisphaerium*, Vitruvius: †ἡμισφαίριον; there seems to have been no established ancient term, and domes are usually described by periphrastic expressions).

A vault converging upwards and inwards towards a single centre, and having as its base a ring of masonry, commonly circular but sometimes elliptical or polygonal, which is usually but not necessarily at a point some height above the floor. In strict language the term 'dome' is sometimes confined to vaults of this type when built of blocks the joints between which radiate from one or more centres on the principle of the arch, those constructed on some other principle, such as 'corbelling' (*q.v.*), being called 'false domes': but the name is never denied to concrete domes though these are in effect solid homogeneous masses.

Doric (*Doricus*: Δωρικός). See pp. 39 ff. etc. The meaning of *cymatium doricum* in Vitruvius IV, 6, 2 is uncertain. See also Cornice, Frieze.

Dowel (*subscus*: γόμφος, πόλος, ἧλος usually means rather 'nail,' but all these words have a variety of senses). See pp. 4, 42.

Drum (*a*) *of a column* (*scapus*: σφόνδυλος). See p. 41.

(*b*) *of a dome*. A cylindrical ring of vertical wall raising the curved part of a dome above the circular or polygonal base produced by pendentives or by some other device over a space not circular in plan: the word is not usually applied to buildings like the Pantheon, in which the dome rests upon a circular ring of vertical wall starting at the ground level. See pp. 251 ff.

Eaves. The overhanging edge of a sloping roof.

Ecclesiasterion (ἐκκλησιαστήριον). Hall for the meeting of the ἐκκλησία or sovereign assembly of a Greek city. See p. 176. Vitruvius defines ἐκκλησιαστήριον as *minusculum theatrum*, 'a tiny theatre' (VII, 5, 5).

Echinus (L: ἐχῖνος). See pp. 42, 46. The word *echinus* is not applied by Vitruvius to the *cymatium* of the Ionic capital, as it is in this book. In Greek it is found only in lexicographers and ambiguously. The flat strip with incised hollows on the lower part of the Doric echinus (see p. 42) is called *annuli* ('rings') by Vitruvius.

Egg-and-dart, egg-and-tongue. See pp. 38 etc. 'Egg-and-dart' is best confined to the late arrow-head form (see p. 217 n. 1). The term *cymatium*: κυμάτιον (*q.v.*) sometimes implies the presence of egg-and-tongue or leaf-and-dart, as the case may be: *v.* Cymatium.

Empolion (ἐμπόλιον). See p. 42.

Engaged columns. Columns so attached to a wall that a portion of their circumference (usually between a quarter and a half) is cut off by the line of the wall. Rectangular pillars similarly engaged are called 'pilasters.'

Enneastyle (†*enneastylos*: †ἐννεάστυλος). With nine columns in a line. See Decastyle.

Entablature. See p. 37 and n. 1. There is no comprehensive Greek or Latin term.

Entasis (*adiectio quae adicitur in mediis columnis*, Vitruvius, III, 3, 13: †ἔντασις, *ibid.*). See p. 116. Vitruvius' phrase suggests the 'cigar-shaped' Roman type (see p. 116), but for a description he refers the reader to a diagram, now lost.

Epicranitis (ἐπικρανῖτις, *sc.* πλίνθος or λίθος, ἐπίκρανον). See pp. 48, 50.

Epistyle, Epistylium. See Architrave.

Eustyle (*eustylos*: †εὔστυλος). See p. 154.

Euthynteria (εὐθυντηρία). See p. 41.

Exedra (L: ἐξέδρα). (*a*) An open recess, for sitting in, often containing stone seats: it may be rectangular or curvilinear in plan. (*b*) A seat. The ancient terms have a somewhat wider range of meaning than is customary in modern use.

Extrados. The upper surface of an arch or vault.

Eye (*oculus*: ὀφθαλμός). The disk or button at the centre of a volute-spiral. See p. 46.

Fascia (L). See p. 47.

Fastigium. See Acroterium and Pediment.

Fauces (L). See p. 303 and Fig. 126. The meaning there given to *fauces* is that championed by A. Mau and others, but Vitruvius' words (VI, 3, 6) are ambiguous, and by *fauces* he may mean the passage beside the *tablinum* now commonly called **andron**, *q.v.* Large Roman houses sometimes have the front door set back in an opening: in such cases the space outside the door was called *uestibulum* (*q.v*), that inside *prothyra*, according to Vitruvius, VI, 7, 5, who equates Greek πρόθυρα with Roman *ante ianuas uestibula*, Greek †διάθυρα (not otherwise recorded) with Roman *prothyra*. In ordinary Latin speech both *fauces* and *vestibulum* are used loosely in a variety of senses.

Fillet (*quadra*: ταινία). A narrow raised band with straight profile. See p. 37. The authority for ταινία refers only to woodwork. See also **Taenia**.

Flat tiles: see **Rain-tiles.**

Flute (*stria*: †ῥάβδος, implied by ῥάβδωσις 'fluting,' ῥαβδωτός, ἀ(ρ)ράβδωτος, 'fluted,' 'unfluted'). See p. 41, etc. The horizontal fluting of the torus of the Ionic base, of which the same Greek terms are used in inscriptions, is sometimes called 'reeding.' See also **Cabling.**

Fornix. See Arch, Vault.

Forum. See Agora.

Foundations (*fundamentum*: θεμέλιον: both often in plural). The buried substructure on which the visible parts of a building rest.

Frieze (*a*) Doric. (No single Latin term: the Greek τρίγλυφος, pl. τρίγλυφα, means (i) a triglyph, (ii) a Doric frieze of triglyphs and metopes.) See p. 43.

(*b*) Ionic and Corinthian (*ʒophorus*: †ζῳοφόρος, εἰδοφόρος, κοσμοφόρος. The Erechtheum inscriptions contain no single word for 'frieze,' but the expression ὁ Ἐλευσινιακὸς λίθος πρὸς ᾧ τὰ ζῷα ('the (black) Eleusis limestone against which are the figures'), occurs in connexion with it (see p. 134): this is consistent with the term ζῳοφόρος implied by Vitruvius' *ʒophorus*). See pp. 47 ff.

Frigidarium. See p. 243.

Gable-roof. A roof of two slopes, triangular in section, also called 'pitched roof.' See also **Pediment.**

Geison. See Cornice.

Groin. The sharp edge or arris produced by the intersection of two vaults.

Guilloche. An ornament formed by two or more intertwining bands, leaving circular spaces in the centres: also called 'plait-band.' See an example in Fig. 96.

Guttae (L). See p. 43. Also called 'trunnels.'

Gymnasium (L: γυμνάσιον). See p. 185, and see also **Palaestra.**

Gynaeconitis (L: γυναικωνῖτις). See p. 297.

Hawksbeak. See p. 37.

Helix (L: ἕλιξ). A spiral. Vitruvius uses the expression only of the inner spirals of the Corinthian capital, calling its outer spirals *uolutae*, which is also his term for the volutes of the Ionic capital. Callixenus, quoted by Athenaeus (v, 206 *b*), also uses ἕλικες of the spirals of the Corinthian capital.

Hemicycle (*hemicyclus, hemicyclium:* ἡμίκυκλον, ἡμικύκλιον). A semicircular recess: by

modern writers, but not by ancient, usually limited to recesses, such as those in Trajan's Forum (p. 292), too large to be called *exedrae* (*q.v.*).

Hemisphaerium. See Dome.

Heptastyle (†*heptastylos*: †ἑπτάστυλος). Having seven columns in a line. See Decastyle.

Heroum (L: ἡρῷον). Shrine or chapel dedicated to a deified or semideified dead person.

Hexastyle (*hexastylos*: †ἑξάστυλος). Having six columns in a line. See Decastyle.

Hippodrome (*hippodromos*: ἱππόδρομος). See p. 185.

Hypaethral (*hypaethros*: ὕπαιθρος). Open to the sky, unroofed.

Hyperthyrum. See Lintel.

Hypotrachelium. See Necking.

Imbrex. See Covering tile.

Impluvium (L). See p. 304, and Compluvium.

Interaxial. 'Interaxial' measurements are from centre to centre, e.g. of adjacent columns, instead of from surface to surface, as in 'intercolumnar' measurements. See p. 154.

Intercolumnar. See Interaxial.

Intercolumniation (*intercolumnium*: μετακιόνιον, μεταστύλιον). The 'intercolumnar' space between two adjacent columns.

Intersectio. See Metope.

Intrados. The under surface of an arch or vault.

Ionic (*Ionicus*:'Ἰωνικός). See pp. 45 ff. *etc.*, and see also Cornice, Frieze.

Jamb (*antepagmentum, postis*: σταθμός, pl. σταθμοί or σταθμά, παραστάς, which also means 'anta' or 'pilaster'). The side member of a door- or window-frame: *antepagmentum*, which really means 'facing,' is used of less solid posts than *postis*.

K. For terms derived from Greek words beginning with K see under C.

Laconicum (L: †Λακωνικόν). See p. 243.

Lacunar. See Coffer.

Laquear. See Coffer.

Later. See Brick.

Leaf-and-dart. See p. 38, and also Cymatium.

Lesbian cymatium (*cymatium Lesbium*, Vitruvius, IV, 6, 2: Λέσβιον κῦμα, Aeschylus Fr. 73, Nauck: but the exact meaning is not certain in either passage). The cyma reversa moulding: see p. 37 and n. 4. Vitruvius in the same passage uses the obscure phrase *astragalus Lesbius*.

Limen. See Lintel.

Lintel (*supercilium, limen*, which also means 'threshold'; where there is ambiguity, *limen superum*: ὑπερτόναιον, ὑπέρθυρον. In Vitruvius, IV, 6, *hyperthyrum* is a frieze course between the lintel of a door and a cornice higher up). A single piece of wood or stone placed horizontally over a door, window, or other opening in a wall, to support the superincumbent weight.

Lotus. A favourite Greek ornamental motive, often combined with the palmette. Alternate lotus flowers and lotus buds can be seen in the archaic necking-band in Fig. 45 and alternate lotus and palmette on the sima and on the underside of the cornice of the Treasury of Massalia (?), Fig. 46.

Maeander (μαίανδρος). Key pattern: see an example in Fig. 96.

Maenianum (L: δρύφακτος, which also means 'lattice'; τὰ ὑπερέχοντα τῶν ὑπερῴων, 'the projecting parts of upper rooms'). A balcony or projecting upper storey. Used also of the tiers of seats in amphitheatres: see p. 286.

Marble (*marmor*: λίθος). Crystalline limestone. In Greek architectural language λίθος without epithet usually means 'marble,' though it can be applied to all kinds of stone. Names for particular marbles favoured by the Romans, such as 'cipollino,' are not used in this book without explanation of their meaning.

Megaron (μέγαρον). For conventional modern use see p. 20. In Homer μέγαρον probably means 'hall,' but in later Greek it has many other meanings, including 'temple,' 'inner sanctuary,' 'underground cavern.'

Metope (*metope*: μετόπη, μετόπιον). See p. 43. Vitruvius (III, 5, 11) also states that the Greeks used the word μετόπη as an equivalent for *intersectio*, a term which he applies somewhat obscurely to the Ionic dentil course, apparently in the sense of the gaps between the dentils:

but the word 'metope' is never used in this sense by modern writers. The entirely distinct word μέτωπον is sometimes used in inscriptions of a pillar or section of wall dividing the two halves of a double door or window.

Modillion. See Console.

Modulus (L: †ἐμβάτης, according to Vitruvius, IV, 3, 3). A unit of measurement adopted in planning the proportions of a building. Vitruvius obtains his modulus for temples by dividing the breadth of the stylobate into a certain number of equal parts (e.g. $11\frac{1}{2}$ for a eustyle tetrastyle Ionic temple, $24\frac{1}{2}$ for a eustyle octastyle Ionic temple, 42 for a hexastyle Doric temple): in eustyle Ionic temples the lower diameter of the columns is to measure one modulus, in Doric temples two moduli, and the modulus is similarly applied to all the other important dimensions. See Vitruvius, III, 3, 7, IV, 3, 3, etc.

Monolithic (μονόλιθος). Made of a single stone. For the application of this term to columns, see p. 42.

Monopteral (*monopteros*: †μονόπτερος). Having a roof supported by columns, but no cella. Vitruvius so defines the word in IV, 8, 1 (*aedes rotundae..monopteroe sine cella columnatae*), but in VII, Praef. 12, if the text is sound, he applies it to Hermogenes' temple of Dionysus at Teos, apparently in the sense of 'with a single pteron, peripteral.'

Moulding. A continuous outline or contour of definite shape given to the edge or surface of an architectural member. See Cymatium.

Mutule (*mutulus*, also in sense 'mutulus,' *q.v.*). See p. 43.

Mutulus (L). See p. 196.

Naos (ναός, Attic νεώς). As a technical term now commonly used as equivalent to 'cella,' but the Greek word means 'temple.' See Cella.

Necking, Necking-band (*hypotrachelium*: αὐχήν, ὑποτραχήλιον). The upper part of the shaft of a column, just below the capital, when differentiated from the rest by the omission of fluting or by the presence of grooves or of a convex moulding as a lower limit: often adorned with carved ornament. See p. 98, etc.

Necking-grooves. See p. 41.

Nymphaeum (L: νυμφαῖον). Literally 'a temple of the Nymphs,' but applied rather vaguely to Roman pleasure-houses, especially when containing flowers, fountains, and statues.

Octastyle (*octastylos*: †ὀκτάστυλος). Having eight columns in a line. See Decastyle.

Oculus. See Eye.

Odeum (L: ᾠδεῖον). See pp. 174, 274.

Oecus (L: οἶκος). See p. 302. The Greek word has many meanings, including 'house' and 'temple,' but from Homer onwards often means a room: Vitruvius and late Greek writers use it technically of especially large and important rooms in private houses. The οἶκος of the Naxians (see p. 323) is obscure.

Opaion (ὀπαῖον). See p. 174. 'Lantern': central part of a roof pierced and raised for the admission of light. The word is the neuter of ὀπαῖος, applied to pierced tiles in Greek Comedy, where the noun ὀπή is also common in the sense of 'smoke-hole,' 'chimney-opening.'

Opisthodomus (*posticum*: ὀπισθόδομος). See p. 39. Greek usage supports the sense given to 'opisthodomus' in this book, which is the meaning usually implied in modern books: but French and Italian writers sometimes use 'opisthodomus' in the sense of 'adyton' (*q.v.*).

Opus albarium. See Stucco.

Opus caementicium, Opus structile. See Concrete.

Opus quadratum. See Ashlar.

Opus reticulatum. See Reticulate.

Opus tectorium. See Stucco.

Orthostates (ὀρθοστάτης). See p. 50.

Ovolo. A quarter-round moulding, or a variation on it, such as the 'echinus' of the Greek Ionic capital: its typical ornament is egg-and-tongue. See p. 38, and see also Cymatium.

Palaestra (L: παλαίστρα). See p. 185. Strictly 'palaestra' has a narrower meaning than 'gymnasium,' namely 'wrestling-school,' but it is often used in a very wide sense.

Palmette. See p. 60. Alternate palmette and lotus can be seen in the ornaments of the sima and of the underside of the cornice of the Treasury of Massalia (?), Fig. 46. See also Anthemion.

Paraskenion (*parascaenium*: παρασκήνιον). See p. 165.

Parotis. See Console.

Pastas (L: παστάς). Given by Vitruvius as an alternative for *prostas*, *q.v.* Has a variety of senses in ordinary Greek usage, but commonly means a room or porch open on one side: the name is perhaps derived from παστός in the sense 'curtain.' [See now p. 161 of J. W. Graham, *op. cit.* p. 321 n. *supra*]

Pediment (*fastigium*: ἀ(ι)ετός, α(ι)έτωμα). See p. 48. The ancient terms can also mean 'gable-roof' generally; *fastigium* can also mean 'acroterium,' and αἰετός can mean *tympanum*, *q.v.*: pedimental statutes were called τὰ ἐναιέτια. See also Pteron.

Pendentive. See p. 251.

Pentastyle (*pentastylos*: †πεντάστυλος). Having five columns in a line. See Decastyle.

Periaktoi (περίακτοι). See p. 283.

Peripteral (*peripteros*: περίπτερος). See p. 39. By ancient writers occasionally used of an *interior* 'peristyle.'

Peristyle (*peristylum, peristylion*: περίστυλος, περίστυλον). See pp. 297 ff. In both ancient and modern writers usually confined to a colonnade round the *inside* of a court or room, or to a court or room so adorned, but occasionally used of an *external* 'peripteral' colonnade.

Pila. See Pillar.

Pilaster (*anta*: παραστάς). An engaged pillar. See Engaged columns.

Pillar. Strictly 'pillar' can be applied to any free-standing architectural support, but it is convenient to differentiate it from 'column' and to confine it to a free-standing support of square or oblong section, especially when treated as a decorative feature comparable in importance to the column. Such pillars are rare in classical architecture, and seem to have no clearly defined technical names, though κίων and στῦλος could probably be applied to them. The Latin *pila* is used of free-standing masonry supports of square or oblong section, but chiefly to piers having no decorative pretensions.

Pitched roof. See Gable-roof.

Plait-band. See Guilloche.

Plinth (*plinthus*: πλίνθος). See p. 46. (*a*) A square block placed under an Ionic column-base. (*b*) A low projecting course, plain or moulded, at the foot of a wall. The Latin word is used by Vitruvius also of the abacus of the Doric capital. The Greek word most commonly means (*a*) a brick (sun-dried or baked), (*b*) a rectangular block of ashlar masonry, also called πλινθίς.

Podium (L: †πόδιον, βάθρον, βάσις). A pedestal: used especially by Vitruvius and modern writers of the raised basis, moulded above and below, and with steps at the principal end only, which is characteristic of Etruscan and Roman temples (p. 200, etc.), and is found in Greek work, e.g. in the Great Altar of Pergamum (p. 158).

Polos (πόλος). (*a*) A cylindrical member on the heads of Caryatids, e.g. at Delphi (p. 101): how far Greek usage justifies this meaning is disputable. (*b*) A dowel, *q.v.*

Polygonal. See p. 42. Polygonal construction seems to be described by Aristotle, *Eth. Nic.* v, 14 1137 b 30, in the phrase ὥσπερ καὶ τῆς Λεσβίας οἰκοδομῆς ὁ μολίβδινος κανών· πρὸς γὰρ τὸ σχῆμα τοῦ λίθου μετακινεῖται καὶ οὐ μένει ὁ κανών ("just like the leaden strip used in Lesbian construction: for the strip is bent to fit the shape of the stone, and does not remain unchanged"). From this passage it would appear that the exact shape of each stone to which another had to be fitted was recorded by pressing a strip of lead against its edge: the commentary of Michael of Ephesus (11th or 12th cent. A.D.) confirms this interpretation. See C. Weickert, *Das lesbische Kymation*, 1913, 8.

Polytriglyphal. Having more than one triglyph to a single intercolumniation.

Porch. (*a*) In temples: see Pronaos. (*b*) In houses: see Fauces, Prothyron.

Poros (πῶρος, πώρινος λίθος). Usually employed, by ancient and modern writers, as a vague term for limestones coarser than marble. See J. G. Frazer, *Pausanias's Description of Greece*, 1898, III, p. 502. There are exact ancient definitions, but they do not fit the ordinary usage.

Portico. (*a*) Colonnade (*q.v.*). (*b*) Porch (*q.v.*).

Posticum (L). See Opisthodomus.

Praecinctio (L). See p. 276.

Pronaos (L: πρόναος, πρόδομος, πρόστασις, προστάς). See p. 39. Vague words for 'porch,' such as *porticus* and στοά, are sometimes used in the same sense. It is sometimes said that πρόστασις and προστάς are used only of prostyle porches, but the evidence does not establish this.

Propylaea, propylaeum, propylon (L: πρόπυλον, προπύλαιον, both usually in plural). See pp. 13, 29, 118.

Proscaenium. See Proskenion.

Proskenion (*proscaenium*: προσκήνιον). See p. 166.

Prostas (L: προστάς). See p. 302, and see also Pronaos. Vitruvius uses *prostas* only in speaking of private houses, giving *pastas* (*q.v.*) as an alternative name.

Prostyle (*prostylos*: †πρόστυλος). See p. 39.

Prothyron (L: πρόθυρον: both often in plural). See pp. 297, 299, and see also Fauces. The Greek πρόθυρον was undoubtedly outside the front door: see Plato *Symp.* 175 A and D, where the same porch is called both πρόθυρον and πρόθυρα, and *Protag.* 314 C.

Prytaneum (L: πρυτανεῖον). The official headquarters of the administrative organization of a Greek city, usually containing a 'common hearth' and a perpetual fire. It commonly had the form of a private house, as for instance at Priene, whose Prytaneum can be seen in the plan, Fig. 84, marked 'D,' to the right of the Ecclesiasterion, which is marked 'C': the two buildings can easily be traced with the help of Fig. 78. Some modern writers falsely identify the Athenian Prytaneum with the circular Tholos in which the Prytaneis dined.

Pseudodipteral (*pseudodipteros*: †ψευδοδίπτερος). See p. 73, etc.

Pseudoperipteral (*pseudoperipteros*: †ψευδοπερίπτερος). See pp. 123, 206, 213.

Pteroma. See Pteron.

Pteron (L, *pteroma*: πτερόν, †πτέρωμα, περίστασις). See p. 39 etc. The simple *pteron*, implied by *peripteros* and the like, is rare and late in this sense in ancient writers, but is a conveniently short expression for 'peripteral colonnade.' The names πτερόν and πτέρωμα are said by ancient lexicographers to have been also applied to temple roofs or pediments. See also Peripteral.

Pulpitum (L). See p. 271.

Pulvinus (L). The volute-member of the Ionic capital in its side view. See p. 47.

Pycnostyle (*pycnostylos*: †πυκνόστυλος). See p. 154.

Quadra. See Fillet.

Quadratum. See Ashlar.

Quasi-reticulate. See p. 234.

Rafter. See Roofing.

Rain tile (*tegula*, when opposed to *imbrex*: the Greek words σωλήν, στεγαστήρ lack good early authority in this sense, and 'stroter': στρωτήρ, which modern writers often use, seems to have been applied only to roof-timbers (see Roofing). Rain tiles are usually called simply κεραμίδες, or κεραμίδες ἀγελαῖαι ('common tiles'). See p. 49 and see also Tile.

Raking cornice. See Cornice.

Ramp. A sloping causeway or track leading from a lower to a higher level. See p. 41.

Reeding. See Flute.

Regula (L). See p. 43.

Relieving arch. See Arch.

Relieving triangle. A triangular space (left open or filled with a light slab) contrived over lintels in Mycenaean architecture, to relieve pressure. The sides of the triangle were formed by the corbelled convergence of the blocks of the wall. See pp. 27, 33.

Respond. A pilaster or pier, engaged in a wall, which supports one end of an architrave or arch, the other end being carried by a support, usually free-standing, which is not part of the same wall.

Reticulate (*opus reticulatum*). See p. 234.

Roofing. The ancient roofs for whose form we have evidence usually differ so much from ordinary modern forms that the use of such technical expressions as 'king-post,' 'purlin,' etc. is better avoided. Greek inscriptions give many technical terms, including μετόμναι 'main horizontal cross-beams', κορυφαῖα 'ridge-beams' (probably), σφηκίσκοι or δοκίδες

'sloping rafters,' ἐπιβλῆτες, στρωτῆρες or ἱμάντες 'slats or planks laid across the rafters,' καλύμματα 'wooden sheathing under the tiles, or under the clay bed on which the tiles rested.' The degree of elaboration and the exact meaning of the terms seem to have varied, for we find roof-frames consisting (*a*) of σφηκίσκοι, ἱμάντες, καλύμματα, tiles: (*b*) of δοκίδες, ἐπιβλῆτες, ἱμάντες, tiles: (*c*) of σφηκίσκοι, ἱμάντες, tiles. See Stevens and Paton, *The Erechtheum*, 1927, p. 368, and see p. 182 and Fig. 82 of this book. For Etruscan roofing see p. 196 and Fig. 89. In general the equations *columen* = κορυφαῖον, *cantherius* = σφηκίσκος, *templum* = ἱμάς, *asser* = κάλυμμα may be accepted as correct: the phrase in which Vitruvius is thought to describe the self-supporting triangular truss is *transtra et capreoli* (IV, 2, 1) or *transtra cum capreolis* (V, 1, 9). In the Puteoli inscription (see p. 371) the tiles rest on *opercula*, which rest on *asseres*, which rest on *trabiculae*, which rest on *mutuli*.

Rosette (κάλχη). A circular floral ornament, e.g. on the jambs and lintel of the North door of the Erechtheum (Fig. 57).

Roundel. See pp. 37, 38.

Scaena (L: σκηνή). See pp. 164, 271.

Scandulae. See Shingles.

Scapus. See Drum.

Scotia (L: †σκοτία, †τροχίλος). See p. 46. Vitruvius (III, 5, 2) says *scotia quam Graeci τροχίλον dicunt.*

Securicula. See Clamp.

Shingles (*scandulae*). See p. 49. Slabs of wood used as tiles. Cornelius Nepos, quoted by Pliny, *N.H.* XVI, 36, says that shingle roofing was universal at Rome till the war with Pyrrhus (*c.* 280 B.C.).

Sima (L: σιμή, only in Hesychius. The names authenticated by inscriptions are ἡγεμόνες λεοντοκέφαλοι for the sections of the sima above the horizontal cornice and παραιετίδες ἡγεμόνες λεοντοκέφαλοι for the lowest angle blocks of the sima above the raking cornice. Presumably παραιετίδες ἡγεμόνες would describe the remaining unpierced sections of the sima above the raking cornice. Vitruvius, III, 5, 13, gives *epitidas* (accusative) as the Greek name, doubtless a corruption of ἐπαιετίδας). See p. 48.

Skene (*scaena*: σκηνή). See p. 164.

Soffit. The exposed under-surface of an architectural member, especially of an architrave or cornice.

Spira. See Base, Torus.

Squinch arches. Small arches placed across the inner angles of a rectangular structure, in order to convert the rectangle into an octagon. See p. 252.

Stadium (L: στάδιον). See p. 185.

Stereobate (*stereobata*: †στερεοβάτης). Vitruvius (III, 4, 1) defines *stereobatae* as the walls under the columns above the ground-level: he seems to treat the *stylobate* (*stylobata*: στυλοβάτης), which is the actual course of pavement on which the columns rest, as a separate member above the stereobate. Possibly he was thinking of the podium of Roman temples. Modern writers use the term in various ways, and it is best avoided.

Stria. See Flute.

Structura and Structura caementicia. See Concrete.

Stucco (*opus albarium* or *tectorium*: κονία, κονίαμα). A coating applied to sun-dried brick, coarse stone, light wooden frameworks, etc. The finest stucco was made of powdered marble, but there were many varieties. See especially Vitruvius, VII, 2, 1—7.

Stylobate. See Stereobate, and see also p. 41.

Subscus. See Dowel.

Supercilium. See Lintel.

Systyle (*systylos*: †σύστυλος). See p. 154.

Tablinum (*tab(u)linum*). See p. 303.

Taenia (L: †ταινία). See p. 43. The Greek ταινία has relevant authority only in the sense of a 'fillet' in woodwork.

Tectorium. See Stucco.

Tegula. See Brick, Tile.

Telamones. See Atlantes.

Temenos (τέμενος). A reserved piece of ground, especially a sacred precinct.

Templum (L). Besides the common sense 'temple' *templum* has two technical meanings for which (*a*) see p. 197 (Etruscan roofing), and see also Roofing; (*b*) see p. 200 (Etruscan augury).

Tepidarium (L). See p. 243.

Testa. See Tile.

Testudinate (*cavum aedium testudinatum, testudo*). See pp. 302, 304.

Tetrastyle (*tetrastylos*: τετράστυλος). (*a*) (Of a temple.) Having four columns in a line. See Decastyle. (*b*) (Of an atrium.) Having four inner columns arranged in a square. See pp. 302, 304.

Theatre (*theatrum*: θέατρον). See pp. 164 ff. and 271 ff., and see also Cavea.

Thermae (L: †θέρμαι). See p. 258. At Rome the name was confined to a limited number of large establishments, smaller baths being called *balneae*, *q.v.*

Tholos (*tholus*: θόλος). A circular building.

Tile (*tegula, testa*: κεραμίς, κεραμίδιον; the tiles were sometimes called collectively ὁ κέραμος 'the tiling,' *lit.* 'the clay'). See p. 49, and see also Antefix, Covering tile, Rain tile, Sima. Both *tegula* and κεραμίς are sometimes applied to tiles not of terracotta, especially to those of marble. The tiles next the eaves are ἡγεμόνες (*primores*).

Torus (L: σπεῖρα). See p. 46 and Base.

Trabes compactiles (L). See Architrave.

Transtra. See Roofing.

Travertine. A strong calcareous building stone used at Rome. See p. 207.

Triclinium (L: τρίκλινος, τρικλίνιον). A dining-room, strictly with three couches.

Triglyph (*triglyphus*: τρίγλυφος). See p. 43 and Frieze. [For the use of triglyphs to decorate altars, fountains, etc., close to ground-level, see R. Demangel, *B.C.H.* LXI, 1937, 421.]

Tripteral (†*tripteros*: †τρίπτερος). With a treble pteron or external colonnade.

Tristyle (†*tristylos*: †τρίστυλος). Having three columns in a line, as in some porches (e.g. the 'Basilica' at Paestum, Fig. 30).

Trochilus. See Scotia.

Trunnel. See Guttae.

Tufa. A common Roman building-stone, formed from volcanic dust. There are many varieties, differing in quality.

Tuscan (*Tuscanicus*). The Latin word for Etruscan. See Atrium.

Tympanum (L: †τύμπανον, ἀ(ι)ετός). See p. 48 n. 6.

Vault (*camera* or *camara, arcus, fornix*: καμάρα, ἀψίς, ψαλίς). A roof or ceiling of brick or stone supported on the principle of the arch (*q.v.*), or a roof of similar shape constructed of a mass of concrete. The chief ancient kinds are the barrel-vault, in the form of a half-cylinder, the cross-vault, formed by the intersection of two barrel-vaults, and the dome and half-dome. See pp. 231 ff. 'False vaults' on the corbelling principle are also found, for instance in Etruscan tombs. Except *camera* and καμάρα the ancient terms can also mean 'arch.'

Versura (L). See p. 276.

Vestibulum. See Fauces.

Via (L). See p. 43.

Volute (*uoluta*: †ἕλιξ). See p. 46, and see also Helix. It is possible that ἕλιξ was used of the Ionic volute, but evidence seems to be lacking.

Voussoir (*cuneus*). One of the wedge-shaped blocks making up an arch. The central voussoir is called the 'key-stone' (ὀμφαλός in [Aristotle], *De Mundo* 399 B 30, a work ascribed to *c.* 100 A.D.).

Zophorus. See Frieze.

B. REFERENCE LIST OF GREEK TERMS MENTIONED
IN THIS BOOK

NOTE. *Most of these words will be found in easy transcriptions in the Glossary, c being usually given for κ and y for v. Wherever any difficulty could arise a full reference is here given.*

†ἄβαξ. See Abacus.
ἀγελαῖος. See Rain tile.
†ἀγκών. See Console.
ἀγορά.
ἄδυτον.
α(ἰ)ετός, α(ἰ)έτωμα. See Pediment, Tympanum.
αἴθουσα. See p. 35.
ἄκανθα. See Acanthus.
ἀκρωτήριον.
†ἀμφιδίστυλος, ἀμφιπρόστυλος. See Amphidistyle, amphiprostyle.
ἀμφιθέατρον.
ἀναθυροῦν, †ἀναθύρωσις. See Anathyrosis.
ἀνάκτορον.
ἀνδρών.
ἀνδρωνῖτις.
ἀνθέμιον.
ἀνθεμωτός. See Antefix.
ἀντίθεμα, ἀντίθημα.
ἀντίμορος. See Antithema.
ἀποδυτήριον.
ἀπόθεσις. See Apodyterium, Apophyge.
†ἀπόφυσις. See Apophyge.
†ἀραιόστυλος.
ἀ(ρ)ράβδωτος. See Flute.
ἀστράγαλος.
ἄτλαντες.
†ʼΑττικουργής. See Attic (adjective).
αὔλειος θύρα. See p. 297.
αὐλή. See pp. 35, 297.
αὐχήν. See Necking.
ἀψίς. See Apse, Arch, Vault.

βάθρον. See Acroterium, Podium
βαλανεῖον. See Balneae.
†βασιλική. See Basilica.
βάσις. See Base, Podium.
βουκεφάλιον. See Bucranium.
†βουκράνιον.
βουλευτήριον. See Bouleuterion.

γεισηπόδισμα, γεισήπους. See Dentil.
γεῖσον. See Cornice.
γόμφος. See Dowel.
γυμνάσιον.
γυναικωνῖτις.

†δεκάστυλος.
δέμα. See Clamp.
δεσμός. See Clamp.
διάζωμα.
†διάθυρα. See Fauces.
†διάστυλος.
†δίπτερος.
†δίστυλος.
δοκίς. See Roofing.
δρύφακτος. See Maenianum.
†δωδεκάστυλος.
Δωρικός.

εἰδοφόρος. See Frieze.
ἐκκλησιαστήριον.
ἕλιξ. See Helix, Volute.
†ἐμβάτης. See Modulus.
ἐμπόλιον.
ἐναιέτια. See Pediment.
†ἐννεάστυλος.
†ἔντασις.
ἑξάστυλος.
ἐξέδρα.
†ἐπαιετίς. See Sima.
ἐπιβλής. See Roofing.
ἐπικρανῖτις.
ἐπίκρανον. See Capital, Epicranitis.
ἐπιστύλιον. See Architrave.
†ἑπτάστυλος.
εὐθυντηρία.
†εὔστυλος.
ἐχῖνος.

†ζῳοφόρος. See Frieze.

ἡγεμών. See Sima, Tile.
ἧλος. See Dowel.
ἡμικύκλιον, ἡμίκυκλον.
†ἡμισφαίριον. See Dome.
ἡρῷον. See Heroum.

θέατρον. See Cavea, Theatre.
θεμέλιον. See Foundations.
†θέρμαι.
θόλος. See Tholus, and p. 36.

ἱμάς. See Roofing.
ἱππόδρομος.

Ἰωνικός.

κάλυμμα. See Coffer, Roofing.
καλυπτήρ. See Covering tile.
κάλχη. See Rosette.
καμάρα. See Vault.
κανθήλιος. See Cantherius.
καρυάτιδες.
καταιέτιος. See Cornice.
κεραμίς, κεραμίδιον, κέραμος. See Tile.
κερκίς. See Cuneus.
κιόκρανον. See Capital.
κίων. See Column, Pillar.
κλιμακίς. See Coffer.
κονία, κονίαμα. See Stucco.
Κορίνθιος.
κορυφαῖον. See Roofing.
κοσμοφόρος. See Frieze.
κρηπίδωμα, κρηπίς.
κρυπτή. See Crypta.
κῦμα.
κυμάτιον.

†Λακωνικόν.
λαύρη. See p. 35.
λεοντοκέφαλος. See Sima.
Λεσβία οἰκοδομή. See Polygonal.
Λέσβιον κῦμα. See Lesbian cymatium.
λίθος. See Marble.

μαίανδρος.
μέγαρον. See Megaron and p. 35.
μεσόμνη. See Roofing.
μετακιόνιον. See Intercolumniation.
μεταστύλιον. See Intercolumniation.
μέταυλος θύρα. See p. 297.
μετόπιον, μετόπη. See Metope.
μέτωπον. See Metope.
μονόλιθος.
†μονόπτερος.

ναός. See Cella, Naos.
νεώς. See Cella, Naos.
νυμφαῖον.

οἶκος.
†ὀκτάστυλος.
ὀμφαλός. See Voussoir.
ὀπαῖον.
ὀπισθόδομος.
ὀρθοστάτης.
ὀρσοθύρη. See p. 36.
οὖς. See Console.
ὀφθαλμός. See Eye.

παλαίστρα.

παραιετίς. See Sima.
παρασκήνιον.
παραστάς. See Anta, Jamb, Pilaster.
†παρωτίς. See Console.
παστάς.
πελεκῖνος. See Clamp.
†πεντάστυλος.
περίακτοι.
περίπτερος.
περίστασις. See Pteron.
περίστυλος, -ον.
πλαίσιον. See Coffer.
πλινθίς. See Ashlar.
πλίνθος. See Ashlar, Brick, Plinth.
†πόδιον.
πόλος. See Dowel, Polos.
πρόδομος. See Pronaos.
πρόθυρον. See Fauces, Prothyron.
πρόναος.
προπύλαιον, πρόπυλον.
προσκήνιον.
προστάς. See Pronaos, Prostas.
πρόστασις. See Pronaos.
†πρόστυλος.
πρυτανεῖον.
πτερόν, †πτέρωμα.
†πυκνόστυλος.
πώρινος, πῶρος. See Poros.

†ῥάβδος, ῥάβδωσις, ῥαβδωτός. See
 Flute.

σελίς. See Coffer.
σηκός. See Cella.
σιμή. See Sima.
σκηνή. See Skene.
†σκοτία.
σπεῖρα. See Base, Torus.
στάδιον.
σταθμός. See Jamb.
στεγαστήρ. See Rain tile.
†στερεοβάτης.
στοά. See Colonnade.
στρωτήρ. See Rain tile, Roofing.
στυλοβάτης.
στῦλος. See Column, Pillar.
†σύστυλος.
σφηκίσκος. See Roofing.
σφόνδυλος. See Drum.
σωλήν. See Rain tile.

ταινία. See Fillet, Taenia.
τέμενος.
τετράστυλος.
τρίγλυφος. See Frieze, Triglyph.
τρικλίνιον, τρίκλινος.

†τρίστυλος.
†τροχίλος. See Scotia.
†τύμπανον.

ὕπαιθρος.
ὑπέρθυρον. See Lintel.
ὑπερτόναιον. See Lintel.
ὑποτραχήλιον. See Necking.

φάτνωμα. See Coffer.

ψαλίς. See Arch, Vault.
†ψευδοδίπτερος.
†ψευδοπερίπτερος.

ᾠδεῖον. See Odeum.

GENERAL INDEX

Ordinary numerals refer to pages; italic numerals to illustrations in the text;
Roman capital numerals to Plates